# MEET THE NEVER-END
## OF MODERN PHO

D1016411

Should I use a fully automatic camera or one with manual controls? What are the principles of successful photographic composition? How do I analyze photographs?

This state-of-the-art guide answers all your questions about photography—from selecting the right camera to mounting finished photos. Whether you are working indoors or out, with still lifes or live action, landscapes or people, *The Basic Book of Photography* is filled with new material and technical advice of immense value for the amateur snapshooter and the experienced photographer alike. With a superbly illustrated text, this comprehensive and authoritative handbook belongs on every photographer's shelf.

# THE BASIC BOOK
# OF PHOTOGRAPHY
## *The One and Only Guide You Need*

Tom Grimm and Michele Grimm are a husband-and-wife photographic team who have spent more than 25 years traveling the globe in search of the perfect photographic image. They now have a library of more than 150,000 color photographs, many of which have been published worldwide. Tom has been a photography instructor at the University of California at Irvine, and as a couple they have led numerous photographic tours and workshops. The Grimms are authors and illustrators of 12 other adult and children's books. Tom also has written *The Basic Darkroom Book*, a companion photography guide available from Plume.

*Cover photograph by Michele Grimm: When these lorikeets in Australia were attracted to some food on the ground, Michele noticed they made the pattern of a flower. Leaning over their colorful heads with a zoom lens, she quickly composed the image in her viewfinder and caught the unusual effect on film. Being alert for picture possibilities develops your "photographic eye" and is the key to success with your camera.*

*counter, load indicator, view window, autowind, film prewind, autorewind, film pressure plate*

**Changing Partially Exposed Rolls of Film   28**
*film rewind procedures, frame counter, leader retriever, changing bag, reload procedure, APS mid-roll change*

**Making Multiple Exposures   30**
*double/multiple exposures, multiple exposure control, multiexposure mode*

**Understanding Film Speeds (ISO)   33**
*latent image, slow-speed, medium-speed, and high-speed/fast films, ASA, DIN, and ISO film speed rating systems, ISO chart, interrelationships of film speeds, relationship to exposure, exposure meters, auto-exposure cameras*

**Comprehending Shutter Speeds   37**
*shutter speed control dial and LCD information panel, focal plane shutters, specific shutter speeds, B (bulb) and T (time) shutter settings, time exposures, lock-screw cable release, trigger-lock and programmable remote cords, interrelationships of shutter speeds*

**Adjusting Lens Openings   40**
*aperture/diaphragm, specific f/stops, interrelationships of f/stops, lens focal length, full stops and half-stops, click stops, interrelationships of lens openings and shutter speeds, auto-exposure cameras, multimode exposure cameras, programmed mode, specialized programmed modes, shutter-priority mode, aperture-priority mode*

**Figuring Focus   46**
*autofocus cameras, autofocus lenses, autofocusing, fixed/free focus, zone focus, autofocusing single lens reflex cameras (lens focusing ring, focus control switch, focus detection area, and in-focus indicator), focusing screen, automatic lens aperture, manual focusing single lens reflex cameras (split-image rangefinder and microprism focusing collar), distance scale, infinity, point of focus indicator, infrared focus indicator, viewfinder coverage and magnification, high-eyepoint viewfinders, eyecup, diopter correction control, eyepiece correction lenses*

# Contents

**Smile, Say "Cheese"   xxiii**

**1 OPERATING YOUR CAMERA   1**
*camera instruction manual*

**The "Best" Camera   3**

**The 35mm Revolution   3**
*various types of cameras: small-, medium-, and large-format*

**Single Lens Reflex or Compact Camera?   7**
*various camera names, various automatic features, viewfinder differences, parallax error, focusing differences, shutter differences*

**Protecting Your Camera   16**
*camera strap, case, bag, precautions, maintenance*

**Safeguarding Your Lenses   19**
*cleaning, lens shade, protective filters, lens cap*

**Holding the Camera   21**
*camera movement/shake, shutter release technique, self-timer, vibration reduction/image stabilization, cable release and remote cord, mirror lock-up, eyepiece shutter/blind*

**Loading Your Camera—for Sure   23**
*autoload, film leader, take-up spool, cassette, chamber, rewind crank/knob, loading mark, transport reel, sprocket holes, manual loading, film rewind button, transport indicator, frame*

For various reasons this book was possible
because of Tom's parents,
Dr. and Mrs. W. W. Grimm,
and these friends—
Charles B. and Charles C. Adams,
George Day, Thomas R. Smith, Paul B. Snider,
Eugene J. Voss, Daniel Woodley.
*Thanks.*

PLUME
Published by the Penguin Group
Penguin Books USA Inc., 375 Hudson Street,
New York, New York 10014, U.S.A.
Penguin Books Ltd, 27 Wrights Lane,
London W8 5TZ, England
Penguin Books Australia Ltd, Ringwood,
Victoria, Australia
Penguin Books Canada Ltd, 10 Alcorn Avenue,
Toronto, Ontario, Canada M4V 3B2
Penguin Books (N.Z.) Ltd, 182–190 Wairau Road,
Auckland 10, New Zealand

Penguin Books Ltd, Registered Offices:
Harmondsworth, Middlesex, England

First published by Plume, an imprint of Dutton Signet,
a division of Penguin Books USA Inc.

First Printing, May, 1974
Sixth Printing (Revised Edition), October, 1979
Twelfth Printing (Third Edition), November, 1985
First Printing (Fourth Edition), August, 1997
10  9  8  7  6  5  4  3  2

REGISTERED TRADEMARK—MARCA REGISTRADA

LIBRARY OF CONGRESS CATALOGING-IN-PUBLICATION DATA:

Grimm, Tom.
  The basic book of photography / Tom and Michele Grimm ; photographs by Michele Grimm
and Tom Grimm ; drawings by Ezelda Garcia and Cindy King. — 4th ed.
      p.  cm.
Includes index.
ISBN 0-452-27825-2
  1. Photography—Handbooks, manuals, etc.   I. Grimm, Michele.   II. Title
TR146.G696   1997                                                              97-11488
770—dc21                                                                         CIP

Printed in the United States of America
Set in Bookman Light

# THE BASIC BOOK OF PHOTOGRAPHY

## FOURTH EDITION

## Tom Grimm
## and
## Michele Grimm

*Photographs by*
*Michele Grimm and Tom Grimm*

*Drawings by*
*Ezelda Garcia and Cindy King*

A PLUME BOOK

**Dealing with Depth of Field  53**
*depth of field scale and chart, techniques to determine and control depth of field, depth of field preview device, hyperfocal distance*

**Recognizing Some Common Photo Abbreviations  59**

## 2 DETERMINING EXPOSURE  61
*types of exposure meters: built-in and hand-held*

**Setting the Film Speed (ISO)  61**
*LCD information panel, film speed dial, range of film speeds/ISO numbers*

**Setting the ISO Automatically with DX-Coded Films  63**
*DX (data exchange), film speed controls, exposure index (EI)*

**Understanding Automatic Exposure (AE) Controls  65**
*auto-exposure (AE) cameras, multimode exposure, exposure mode selector/control dial, programmed (P) mode, aperture-priority (A) mode, shutter-priority (S) mode, manual (M) mode, specialized programmed exposure modes, aperture-preferred cameras, shutter-preferred cameras*

**Understanding Exposure Metering Systems  69**
*through-the-lens (TTL) metering, averaging meters, center-weighted metering, spot metering, multizone metering, off-the-film (OTF) flash metering, automatic aperture, open-aperture/full-aperture metering, depth of field preview, stop-down metering*

**Working with Exposure Override Controls  73**
*exposure lock/memory lock, backlight mode, exposure compensator, exposure compensation dial, manual exposure*

**Bracketing for the Best Exposure  77**
*bracketing technique, exposure latitude, autobracketing*

**Concerning Exposure Meter Photocells  79**
*selenium cell, cadmium sulfide (CdS) cell, silicon photo diode (SPD), silicon blue cell (SBC), metering range, exposure value (EV), sensitivity warnings*

**Dealing with Exposure Meter and Camera Batteries  81**
*battery check, battery sizes, battery types (alkaline, lithium, nickel-cadmium, nickel metal hydride, replaceable and rechargeable), battery precautions*

## Considering Hand-held Exposure Meters  85
*reflected-light and incident-light readings, flash meters, color temperature meters, exposure lock, averaging and spot meters, angle of acceptance, zero adjustment*

## Simple Alternatives for Setting Exposures  89
*film instruction data, f/16 rule of thumb, experienced guess*

## Making Accurate Exposure Readings  91
*proper exposure, highlight detail, shadow detail, middle/average tone, extremes in contrast, exposing for the main subject, multizone metering, spot metering, hand reading, photographic gray card, bracketing, exposure latitude, Ansel Adams Zone System*

# 3 CHOOSING LENSES  102
*interchangeable lenses, focal length, subject image size, angle of view/field of view*

## Types of Lenses  103
*normal/standard lens, telephoto lens, wide-angle lens, fish-eye lens, circular fish-eye lens, full-frame fish-eye lens, ultra-wide-angle lens, list of lens focal lengths and angles of view, fixed/single focal length, zoom lens, variable aperture zoom lens, macro lens, close-up lens, diopter, extension tubes and bellows, autofocus lenses, camera types with permanently mounted lenses*

## Determining the Quality and Cost of Lenses  110
*technical jargon, cost, optical quality, aspheric lens, maximum lens opening, sharpness, internal focusing, image stabilization, gray-market lenses*

## Mounting Lenses  114
*bayonet, breech-lock, and screw mounts*

## All About Autofocus Lenses  115
*focus control switch, focus mode selector, single shot focus, focus priority, continuous focus, release priority, predictive autofocus, film advance control, single frame and continuous advance, high-speed and low-speed continuous advance, electronic rangefinder, in-focus indicator, focus detection area, cross-type and multi AF sensors, wide area and spot area autofocusing, eye-control autofocusing, focusing on off-center subjects, autofocus lock, passive phase detection and active*

*infrared autofocus systems, AF assist/autofocus illuminator beam, autofocusing limitations, interchangeable focusing screens, freeze/trap focus*

**Praising Zippy Zoom Lenses   121**
*uses, features, macro/close-focus capabilities, variable focal length/varifocal lenses, one-touch and two-touch controls*

**Tips for Using Telephoto Lenses   124**
*uses, types, camera movement concerns, tripod, pistol grip and shoulder brace support, maximum lens aperture, depth of field, lens extender/converter, reflex-type mirror/catadioptric telephoto*

**Working with Wide-Angle Lenses   130**
*focal lengths, uses, distortion, depth of field, keystoning, perspective-correction/control lens*

**Making It Big with Macro Lenses   133**
*macro/micro/close-focus lenses, reproduction ratios, critical focus, ring light, lens reversing/macro adapter ring*

**Creating Large Images with Close-up Lenses   136**
*accessory lenses, diopter, focusing ranges, variable close-up lenses, sizes, focusing and framing, parallax error*

**Nonoptical Options for Making Close-ups   139**
*extension tubes and bellows*

**4 FINDING OUT ALL ABOUT FLASH   141**
*fill flash, flashbulbs, electronic flash*

**Day and Night Uses of Flash   142**

**Farewell to Flashbulbs   143**

**Types of Flash Equipment   144**
*built-in flash, automatic flash operating range, red-eye reduction, accessory flash unit, shoe-mount flash, hot shoe, accessory shoe, handle-mount flash, flash bracket, studio flash, modeling lights, ring light/macro flash*

**Determining Flash Power   147**
*light output, flash guide number, zoom flash head, light output control, flash exposure test*

**Understanding Flash Synchronization   149**
*focal plane shutters, fastest shutter speeds, hot shoe, flash cord sockets, flash synchronization test*

**Features of Shoe-Mount Flash   153**
*brands, feature summary, dedicated autoflash, flash mounting foot, universal dedicated autoflash, hot shoe modules, automatic flash exposure/autoflash, TTL (through-the-lens) autoflash, off-the-film (OTF) flash metering, flash mode selector, automatic fill flash, non-TTL autoflash, photocell sensor, automatic flash operating ranges, LCD information panel, indicator bar, distance scale, sensor coverage, manual flash control, on/off power switch, flash status signals (ready light and sufficient light indicator/confidence light), open flash/test flash button, tilting and rotating flash head, secondary flash head, catchlight, bounce card, bare-bulb flash, auto-zoom flash head, flash coverage/angle of illumination, wide-angle flash adapter/diffuser, telephoto flash adapter, zoom head adjustment button, AF assist/auto illuminator beam, in-focus indicator, red-eye reduction, preflashes, red-eye reduction pen, flash exposure bracketing, flash exposure compensation, light output/variable power control, slow sync, ghosting, rear-curtain/second curtain/trailing sync, normal/first curtain/leading sync, high-speed sync, repeating/multiple/stroboscopic flash, slave flash, wireless/remote slave flash, radio slave, "use flash"/"flash needed" signals*

**Facts About Flash Batteries   168**
*types (replaceable and rechargeable), recycle time, number of flashes, power-saving/thyristor circuitry, choosing lithium, alkaline, or nickel-cadmium batteries, battery packs, battery life, battery tester, AC adapter*

**Concerns About Flash Cords and Connections   171**
*off-camera flash, types of flash cords, TTL sync/remote cord, non-TTL remote sensor cord, PC cord, faulty cord test, hot shoe flash socket (PC) adapter, wireless remote flash, remote flash sensor, radio slave*

**Figuring Manual Flash Exposures   173**
*flash mode selector, flash guide number, light output/variable power control, light output f/stop and flash-to-subject equivalents, interrelationships of film speeds, flash-to-subject distances, and f/stops*

## Fill Flash for More Flattering Photos   178

*fill/fill-in/synchro-sunlight flash, balance with the ambient light, dedicated TTL autoflash for fill flash, non-TTL autoflash for fill flash, manual flash for fill flash, adjustments for manual fill flash (light output/variable power control, zoom flash head, reposition camera/flash, and covering head with handkerchief), indoor fill flash, lighting ratios*

## Bounce Flash for Better Pictures   184

*flat/on-camera flash, bounce flash techniques, bounce light reflector, bounce light exposure for dedicated TTL autoflash, sufficient light indicator, open flash button, manual exposure for bounce flash, photographic umbrella*

## Other Useful Flash Techniques   187

*flash meter, off-camera flash, multiple flash, multiple flashes (for open flash/painting with light, to increase the light, and to increase depth of field), multiple exposure control, repeating flash mode, flash with color filters, filtered fill flash, flash color balance, close-ups with flash*

## Practical Considerations with Flash   193

*uniform illumination, shadows, flash position, reflective objects, checking closed eyes*

## 5 SELECTING FILMS   196

*name brands, private label/store brands, film box, film data, data sheet, expiration date, shelf life, professional film, consumer/amateur film, refrigerated storage, premium film*

## Types of Film   199

*color negative/color print film, color reversal/color positive/color transparency/color slide film, black-and-white film, daylight film, tungsten film, tungsten light, color balance, color temperature, kelvins (K), filters, color sensitivity, panchromatic films, definition, sharpness, resolution/resolving power, graininess*

## Special-Purpose Films   204

*infrared film, copy film, duplicating film, instant slide film, processing Polaroid's instant slide film, black-and-white reversal film, black-and-white chromogenic film, two-for-one/gimmick film*

**Speeds of Film   207**
*ISO number, slow-speed, medium-speed and high-speed/fast
films, relative sensitivity of films, exposure equivalents,
exposure index (EI), push and pull processing, ASA, DIN, ISO,
DX symbol, film speed control, reciprocity effect*

**Sizes of Films   211**
*35mm film, cassettes, film leader, bulk film/long rolls, APS film,
roll film, cartridge film, subminiature film, disc film, sheet/cut
film, film holders, film packets*

**Processing of Films   214**
*fast-photo minilabs, demanding good quality, custom labs,
special processing, wholesale photofinishers, mail-order
photofinishers, prepaid processing mailers, cost of processing,
do-it-yourself processing*

**Color and Black-and-White Films Currently Available   218**
*choosing a film, lists of color negative (print), color reversal
(slide), and black-and-white films*

# 6 IMPROVING PHOTOS WITH FILTERS   225
*general filter facts (names, colors, numbers, and materials),
accessory lenses, screw-in filters, step-up rings, series filters,
filter adapters, series filter coverage, slip-on adapters, set-
screw adapters, bayonet mounts, filter holder, filter systems,
filter manufacturers, removing filters, general categories (light-
balancing, conversion, color compensating, correction, and
contrast filters), vignetting, autofocusing cautions*

**Understanding Filter Factors   231**
*exposure compensation, chart of exposure changes, checking
through-the-lens (TTL) meters, resetting hand-held meters*

**Three Filters for All Films   233**
*ultraviolet (UV)/haze filter, skylight filter, polarizing filter,
circular and linear polarizing filters, neutral density (ND)
filters, chart of ND filters, graduated ND filters*

**Filters for Color Photography   241**
*general categories, why and when to use filters, light-
balancing filters, chart of light-balancing filters and effects,
warming filters, conversion filters (types and uses), fluorescent
light filters, color compensating (CC) filters*

**Filters for Black-and-White Photography  247**
*panchromatic films, correction filters, contrast filters, Kodak
Wratten filters, chart with filter numbers, former names, colors,
filter factors and exposure increases, primary and
secondary/complementary colors, filter color absorption and
transmitting characteristics, other attributes and uses*

**Filters for Fun and Special Effects  251**
*star/cross-screen filter, star effect, diffusion/soft-focus filter,
spot/clear-center filter, fog filter, accessory lenses, multiple-
image lens, split-field lens, diffraction filters, motion filters*

## 7 CONSIDERING ACCESSORY EQUIPMENT  256

**Tips About Tripods  256**
*various uses, avoiding camera shake (self-timer, cable release,
and remote cord), tripod brands, construction, legs, leg locks,
elevator post, feet, various heads, spirit level, foam insulation,
carrying strap and case, minipod, pistol grip, shoulder brace,
C-clamp, beanbag, unipod*

**Considerations About Camera Bags  266**
*hard cases, soft-sided bags, construction, material, shoulder
strap, closures, bag configurations and access, identification,
hip and chest bags, photo backpacks, photo vests*

**Multiple Choices with Multifunction and Data Backs  269**
*data back, multifunction back, multicontrol back*

**Fast Filming with Motor Drives  270**
*autowinder, motor drive, frames per second, speed controls,
time-lapse photography, remote controls*

**Buying Used Accessory Equipment  272**

## 8 USING POINT-AND-SHOOT AND OTHER CONVENIENCE CAMERAS  274
*Instamatic, disc, compact 35mm, APS, single-use and instant
cameras*

**Mastering 35mm Compact Cameras  276**
*point-and-shoot/lens-shutter cameras, active infrared and
passive phase detection autofocus systems, infinity lock,
focusing zones, fixed focus lens, focusing frame, autofocus lock,*

*macro/close-up mode, parallax error, real image viewfinders, auto-exposure, overriding auto-exposure, backlight mode, exposure compensation, night, bulb/time, and TV modes, range of shutter speeds and f/stops, vibration reduction, DX-coded film cassettes, single and dual focal length lenses, zoom lenses, maximum f/stop, midrange and super zooms, built-in autoflash, flash range, red-eye reduction, preflash, flash-off button, auto fill-flash mode, flash-on button, autowind, auto rewind, film loading mark, film rewind button, prewind, film frame counter, film cassette window, self-timer, variable self-timer, panoramic format, data back and special functions, LCD information panel, battery power, solar power, weatherproof and waterproof cameras*

## Avoiding Compact Camera Calamities  291
*pitfalls to avoid and techniques to remember*

## Better Snapshots with APS (Advanced Photo System) Cameras  292
*APS film, film status indicators, mid-roll change, magnetic coating, back-printing, photo file index print, print format control, framing masks, photo players, photo scanners, print quality, camera features, information exchange (IX)*

## Simple Shooting with Single-Use Cameras  297
*one-time-use camera, flash, waterproof and panoramic models, film types, speeds and number of exposures, print sizes, focus range, lens focal lengths, lens openings, shutter speeds, flash range, viewfinders, shirt-pocket models, shooting tips, film frame counter*

## Almost Gone but Not Forgotten: Instamatic and Disc Cameras  300
*availability of cameras and films*

## On-the-Spot Prints with Polaroid Instant Cameras  301
*history, peel-apart and integral films, automation, current models and features, instant films, film sizes, development times, lighten/darken exposure control dial, print storage, tips for using instant cameras, 35mm instant films*

## The Impact of Convenience Cameras  305

## 9 EXPERIMENTING WITH DIGITAL CAMERAS AND COMPUTER PHOTO ELECTRONIC IMAGING 307

*digital cameras, electronic imaging, film and photo scanners, hard drive, personal computer (PC), floppy disk, photo CD, digital video (DV) imaging, photo editing software, manipulating images, digital camera history*

### Resolution Is the Key to Digital Image Quality 309

*image quality, pixels, high and low resolution, random access memory (RAM), megabytes (MB), memory cards/modules, downloading images*

### Digital Camera Details 311

*appearance, viewing systems, features, lens openings, shutter speeds, focusing, built-in flash, camera controls, number of images, batteries, computer cable, charge coupled device (CCD), bits of color, pixels, memory storage, memory buffer, recycle/capture rate, camera lenses, camera care, brand names, camera quality and cost, obsolescence*

## 10 COMPOSING EFFECTIVE PHOTOGRAPHS 316

### Pictures with a Purpose 316

### Have a Center of Interest 318

### Put the Main Subject Off Center 318

*rule of thirds, dividing the horizon*

### Get in Close 320

### Keep the Horizon Straight 320

### Watch the Background 321

### Check All Angles 322

### Try Leading Lines 324

### Frame the Subject 325

### Vary the Format 326

### Include Size Indicators 327

### Focus for Effect 328

*depth of field use*

### Expose Accurately 331

**Include Some Action   332**
*stop-action, point of reference, chart of suggested shutter speeds, peak of action, panning, using flash, slow shutter speeds, blurring, zooming*

**Use Good Timing   338**
*time of day*

**Consider Color   340**
*also for black-and-white photography*

**Use Your Imagination   341**
*breaking the rules, experimentation*

# 11 LEARNING ABOUT LIGHTING   344
*natural and artificial light, ambient/existing/available light*

**Basic Types of Lighting   346**
*front/flat lighting, side lighting, backlighting, silhouette, cross lighting*

**Outdoor Lighting Concerns   348**
*directional and diffused lighting, soft and hard lighting, subjects in the shade, top lighting, color casts, light-balancing filter, shadows, backlighting, rainbows, sunsets*

**Indoor Lighting, Especially for Portraits   352**
*umbrella reflector, bounce lighting, portrait lighting plans, main light, fill light, accent/hair light, snoot, barn doors, background light, seamless paper, cross lighting, tungsten/hot light, portrait lighting setups at home, photoflood bulbs, tungsten-halogen bulbs, safety precautions for hot lights, flash, modeling lights*

# 12 PHOTOGRAPHING UNDER SPECIAL CONDITIONS   359

**Shooting with Existing Light and at Night   360**
*existing/available/ambient light, chart of trial exposures, shutter speeds, time exposures, flash use, high-speed films, increasing film speed, push processing, fast lenses, figuring exposure, exposure techniques, nighttime subjects including fireworks and the moon, photographing television images, choice of films, bracketing exposures, reciprocity effect*

**Creating Close-ups and Making Photographic Copies   369**

*photomacrography, photomicrography, reproduction ratios, use
of macro/micro lenses, use of lens reversing technique, use of
extension tubes and bellows, chart of subject magnifications,
use of lens extender/lens converter/tele-extender/teleconverter,
use of accessory close-up lenses, diopters, variable close-up
lens, focusing and framing concerns, parallax error, exposure,
exposure factors, film plane, film plane indicator, critical
focusing, plane of focus, depth of field, depth of field preview,
avoiding camera movement, flash for close-ups, ring
light/macro flash, photographic copying, lighting copy subjects,
duplicating 35mm slides, slide duplicator, slide copying
adapter, film choices, cleaning slides*

**Having Fun with Infrared Films   383**

*characteristics, uses, film speeds, filters, black-and-white
infrared film (types, filters, exposures, special handling, and
focusing), infrared focus indicator, color infrared film (type,
exposures, filters, handling, and special processing)*

**Making Multiple Exposures   387**

*techniques, multiple exposure control, multiexposure mode,
exposure, overlapping images, overlapping colors, flash use,
light output/variable power control, open flash/test flash button,
repeating/multiple/stroboscopic flash, careful composition,
subject suggestions including full moon and ghost images,
rear-curtain/second curtain/trailing sync, making a
physiograph, multiple-image lens, sandwiching images*

**Flying with Your Camera   395**

*general advice, focusing, active infrared autofocus, infinity
lock, subjects, weather, timing, shutter speeds, filters,
chartering aircraft*

**Adventuring Underwater with a Camera   398**

*waterproof single-use cameras, waterproof 35mm automatic
compact cameras, sports cameras, amphibious cameras,
Nikonos, SLR underwater camera, waterproof camera
housings (brands, types, features, and depth limitations),
water's effect on light, decrease in light intensity, flash use,
color absorption, light diffusion, backscatter, light refraction,
effective lens focal lengths, figuring focus, film choices,
equipment care, photography beneath the sea, fish tank
photography (techniques, lighting, and flash exposures),
marine aquariums*

**Shooting Through Binoculars  411**
*binocular and camera choice, mounting, focusing and framing, effective focal length, support, effective f/stop opening, exposure adjustment*

**Trying a Telescope  412**
*camera choice, mounting, telescope camera adapter, earth's rotation, subjects (moon and stars), astrophotography, star trails, techniques, exposures*

**Working with a Microscope  414**
*camera choice, mounting, light sources (tungsten and flash)*

## 13 TRAVELING WITH A CAMERA  416

**What to Photograph  416**
*research, "shoot list," tell a story, picture categories, people pictures, candid pictures, payment for pictures, size indicators, get in close, aerial views, traveling by tour bus, overall views and close-ups, waiting for better photo situations, editing*

**Some Practical Advice  421**
*safeguards for equipment, theft, cameras in a car, protection from rain, snow, and salt water, cold weather concerns, vibration, photo vest*

**Equipment to Take  424**
*camera choices, auto-exposure control, testing new and repaired cameras, lens choices, close-up images, camera bags, flash, batteries, tripod, cable release and remote cord, two camera bodies, one type of film, one type of photography*

**Film Brands and Prices  428**
*overseas purchase, expiration date, processing included*

**Which Film Speeds?  430**
*slow-, medium-, and high-speed films, mid-roll change*

**How Much Film?  430**
*more than you think, discard boxes, carrying film*

**Protecting and Processing Film  431**
*airport security checks, damage by X ray, processing en route, fast-photo minilabs*

**Mailing Film for Processing  433**
*prepaid processing film mailers, precautions*

**Identifying Film 433**
*ID system, keeping a daily record*

**Regulations Against Photography 434**
*camera and film limits, forbidden pictures*

**U.S. Customs Considerations 436**
*registering equipment, duty percentages, camera insurance*

**Buying Photo Equipment Abroad 437**
*no bargain prices, warranty agreements, gray-market merchandise, helpful photo words in six languages*

# 14 PROCESSING FILMS AND PRINTS 440

**Processes for Color and Black-and-White Films 442**
*film types (negative/print film and positive/reversal/transparency/slide film), color film processes (C-41, E-6, and K-14), processing kits, black-and-white film developers*

**Processing in Black-and-White 443**
*latent images, processing steps (developer, stop bath, and fixer), contact proof sheets, enlargements*

**Developing Film 445**
*tank, thermometer, and other equipment, time and temperature, chemicals, chemical contamination, useful capacity, loading film in tanks, test run, processing step-by-step, air bubbles, washing, hypo clearing agent, negative storage*

**Printing Contact Proof Sheets 449**
*magnifier/loupe, cropping, chemicals, print washer, tray siphon, drying equipment (drying rack/screens, print dryer, photographic blotters, and ferrotype tin), contact printer/printing frame/proofer, exposure procedures, antistatic brush, safelights, developer temperature, development time and range, developing procedure, print tongs, washing, hypo clearing agent*

**Selecting Enlarging Papers 455**
*brands, contrast, graded contrast papers, variable contrast/multigrade/multicontrast/selective contrast papers, printing filters, filter drawer, filter holder, enlarger color head, paper aspects (image tones, tints, surfaces, and weights),*

*paper speeds, processing characteristics for resin-coated and fiber-base papers, sizes, quantities*

### Choosing an Enlarger  459
*sizes, brands, lenses, lamphouse, illumination systems (color head, diffusion head, condenser head, and cold-light head), negative carriers (glass and glassless), focusing, baseboard, filter drawer, filter holder, enlarger timer, enlarging magnifier/focuser, enlarging easel, paper safe*

### Making Enlargements  466
*procedure, test print, exposure, washing, drying, exposure adjustments, reciprocity effect, exposure compensation charts, magnification, enlarging meter, exposure manipulation (burning-in and dodging), toners, multiple images, diffusion filter, texture screens, Sabattier effect, photograms, darkroom plan*

### Analyzing Any Faults in Your Photographs  472
*image contrast, overexposures, underexposures, unexposed film*

### Other Errors  474
*fuzzy pictures, black spots, light spots, overlapping images, outdated film, improper color balance, faulty flash photos, red-eye*

## 15 SHOWING OFF YOUR PHOTOGRAPHS  477

### Editing Your Photos  477

### Selecting the Best Images for Display  478
*contact proof sheet, index print, magnifier/loupe, changes in contrast and colors, internegatives, scanning and digitizing, print sizes, paper surfaces (sheen and texture), cropping images*

### Mounting and Framing Enlargements  480
*mount board/backing board, archival mount and mat boards, dry mounting tissue, dry mounting press, mat borders, mat cutter, framing, nonglare glass, harmful exposure to light*

### Converting Photos for Computer and Video Display  483
*photo scanners, video processors, photo CD*

**Projecting Slides and Pleasing Your Audience 485**
*planning, cleaning slides, slide projectors (sizes, types, bulbs, condenser lenses, and heat-absorbing glass), projection lenses (focal length, zoom lens, flat-field and curved-field lenses), remote focusing and autofocusing, slide popping, glass mounts, Newton's rings, slide trays/magazines, rotary trays, stack loader, marking slide mounts, remote slide-changing control, automatic timer, dissolve control unit, projection screens, screen sizes, screen surfaces (matte, beaded, and lenticular), slide sorter/light box, editing and arranging, successful presentation, keystoning, audience considerations*

## 16 FINDING YOURSELF IN PHOTOGRAPHY 497

**Photo Books, Magazines, and Newsletters 497**

**Photo Advice and Sources on the Internet, CD-ROM Discs, and Videotape 499**

**Photo Schools, Workshops, Tours, Clubs, and Contests 501**

**Photography for Profit 503**
*selling photos, photo credit lines, model releases, property releases, becoming a professional photographer*

**Appendix A: A Glossary of Photographic Terms 506**

**Appendix B: Weights and Measures 550**

**Index 553**

# SMILE, SAY "CHEESE"

We hope you will help us clear up a popular misconception that photographers take pictures. Cameras *take* pictures; photographers *make* pictures. By deciding the composition of a photograph, and by selecting the film and focus and exposure, we determine what the picture will be. Your camera is simply the tool that makes the photograph possible. In many ways it's the equivalent of an artist's palette and paintbrush. The resulting picture, not your equipment, reveals what kind of photographer you are.

And also remember that whether your picture is good or bad is a personal judgment. Even the esteemed professionals who judge photo contests have different criteria for deciding whether a photograph is a winner or loser. You'd be surprised at the behind-the-scenes arguments by contest judges over the merits of one picture versus another. The point is that if the final print or transparency is what you expected or wanted it to be, then the photograph is a good one. Winning a nationwide contest or a neighbor's praise does not determine if you're a good photographer. You do. There are, however, some valid criteria for you to use in judging your work.

We assume you are past the snapshot stage and want to be more creative with your camera in order to produce pictures that make you happy. And proud.

First we'll discuss the operation of cameras and other equipment in detail so you'll know best how to handle your photographic tools. Whether you use the most modern electronically-controlled computerized camera or a decades-old mechanical model, we describe their features—and differences. You'll also find out what you want to know about lenses and light meters, flash and filters, f/stops and film, and everything else. At the back of the book you'll find a comprehensive

glossary of photographic terms so you'll know what the lensman's lingo means and can look up unfamiliar terms as you go along.

And, very important, you'll find a discussion of composition and the elements of making a good, if not great, picture. When you learn and apply the ideas of leading lines, the rule of thirds, size indicators, framing, and many other techniques of good composition, you'll be on your way to making effective photographs.

In the two decades or so since writing the first edition of this book, photography has grown in stature as one of the most popular leisure activities for people of all ages. Stroll down any street in North America and you'll undoubtedly see someone carrying a camera.

One reason is that manufacturers eagerly joined the computer-chip generation to produce cameras that are easy to operate and almost guarantee good results. Automation has enticed folks who once were klutzes with a camera to boast that photography is now their favorite hobby.

This fourth edition covers the latest in electronic achievements that make the mechanical aspect of photography so easy—autoload, autowind and autorewind, autofocusing, auto-exposure, and auto-flash. In this up-to-date book you'll also learn about filmless digital cameras and the impact of electronic imaging on traditional photography.

Accompanying information about today's state-of-the-art cameras are details about faster color and black-and-white films, as well as the array of other improved photo products that range from zoom lenses to camera bags. Most of all, this much-revised volume continues to show you how to put cameras and equipment of all types to practical use so you can become a better photographer. Welcome to the enjoyable "new" world of photography!

By the way, this guide is a companion volume to Tom's book about processing and printing color and black-and-white photographs, also published by Plume/Penguin. If you want to make the best possible pictures, and finish the job you start when you press the shutter release, *The Basic Darkroom Book* offers step-by-step instruction.

—Michele & Tom Grimm
*The Florida Keys*
*February 1997*

# OPERATING YOUR CAMERA

"Don't tell me how a camera works, just tell me how to take a good picture."

Each term during the first meetings of Tom's photography classes at the University of California, a few students would make that plea. It's understandable. To the novice, all those dials, levers, buttons, and other parts of an adjustable camera are frightening.

But like the new driver who is learning about cars for the first time, you need to know how your camera functions. Only when you know how it works, and all its capabilities, will you be able to get the pictures you want. Did you know, for instance, that by shooting directly into the sun during the day you can make the sun look like a brilliant star glittering with light rays in a nighttime sky? It's possible—if you know how to fully operate your camera.

Our first advice: *Study and understand your camera's instruction manual.* And reread it often. In fact, several times a year you should look over your camera manual because there are special tips and directions peculiar to each camera that are often forgotten. If you've lost your manual, buy another one or photocopy a friend's. Just be sure you have the manual, and read it often.

And remember, if you buy a camera overseas, be sure to ask for the instructions in English. We've seen American tourists in Tokyo with new Nikons wondering what all those Japanese characters in their manuals really mean.

The first chapters of this book explain how to work your camera and equipment, including lenses, flash, filters, and accessory gear, such as tripods. We also discuss film and exposures. That's followed by information on how to compose effective photographs and utilize various photographic techniques, as well as darkroom procedures

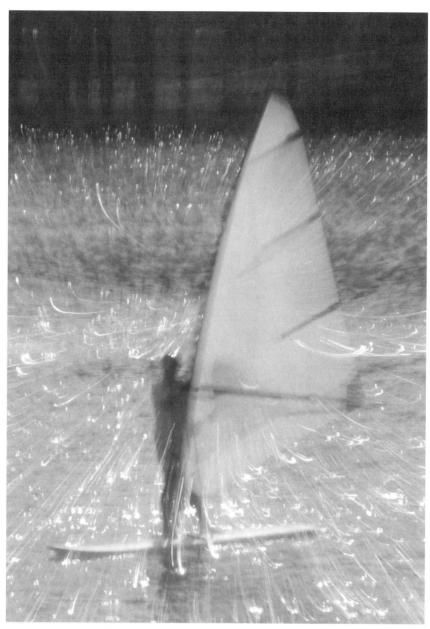

1. To be creative with any camera, you need to understand how it operates. In this photograph of a windsurfer, with the camera mounted on a tripod, a slow shutter speed ($1/8$ second) was used so there would be time to change the focal length of a telephoto zoom lens (from 80mm to 200mm) during the exposure in order to create streaks from sunlight reflecting off the water. Zooming is one technique for portraying motion in still photography.

for processing and printing your own films, and ways to display your photographs.

Anytime you want a brief description of any subject, check Appendix A, "A Glossary of Photographic Terms," beginning on page 506. To easily find more details about any subject, refer to the Index, which begins on page 553.

## The "Best" Camera

"I want to buy a new camera and wonder which one you think is best?"

Professional photographers get that inquiry all the time. When someone asks us what camera to buy, we reply that we don't know. And we don't. Cameras are an individual thing, and whichever one makes you happy is the best camera for you. After reading this book, however, you should have a good basis for your decision. For instance, if you just do casual photography on vacation trips, using a 35mm compact camera would be more practical than lugging around a 6 × 6 medium-format camera.

Cost is a determining factor, of course. But remember, while an $850 camera may be better in quality than a $250 or a $15 camera, it is the person behind the lens that usually makes the difference in results. We have little interest in compulsive camera and equipment buyers; they are not photographers. They're too busy discussing camera accessories or polishing their camera cases to recognize and make a good picture.

The quality or price of equipment does not reflect the quality or worth of its owner as a photographer. Regardless of the type or age of your camera, never be ashamed of it. And don't be belittled by a guy with a camera bag full of goodies. Ask him to show you his results, not his equipment. When someone starts bragging that he has a lot of equipment, we interrupt and ask to see some of his pictures instead. We hope you are a *photographer* and not just a camera and accessory collector.

## The 35mm Revolution

If there is anything in photography's history that was especially responsible for helping cameras become an exciting part of today's creative society, it was the introduction of the 35mm camera, which is named for the size of the film it uses. Modern 35MM COMPACT CAM-

2. The most versatile of today's popular cameras are 35mm single lens reflex (SLR) models that have manual as well as automatic controls for exposure and focusing. Common features include film autoload, autowind, and autorewind; this model also has a built-in autoflash.

ERAS and SINGLE LENS REFLEX (SLR) CAMERAS are the favorites of most amateur and professional photographers. And for good reasons. They are versatile, durable, economical, and produce exceptional results.

The dominance of 35mm cameras, including popular SINGLE-USE CAMERAS, is being challenged by smaller-format APS (ADVANCED PHOTO SYSTEM) CAMERAS, as well as electronic DIGITAL CAMERAS. But it will take considerable time—if ever—before the quality of APS or digital images matches or surpasses that of 35mm photographs.

You should know that cameras are generally categorized according to the size of the film they use and are referred to as small-, medium-, or large-format cameras. See Illustration 3 to compare the relative sizes of films for different camera formats, and the sizes of images they produce.

SMALL-FORMAT CAMERAS include 35mm cameras, a name indicating that the width of the films they use is 35 millimeters (mm). The actual size of the image recorded on the film is smaller than the film itself, because there are sprocket holes running along both edges of 35mm film to help guide it through the camera. The area of the images made by 35mm cameras measures 24mm wide × 36mm long.

Much less common are older 35MM HALF-FRAME CAMERAS, which make smaller-size images. They use 35mm film but only produce an

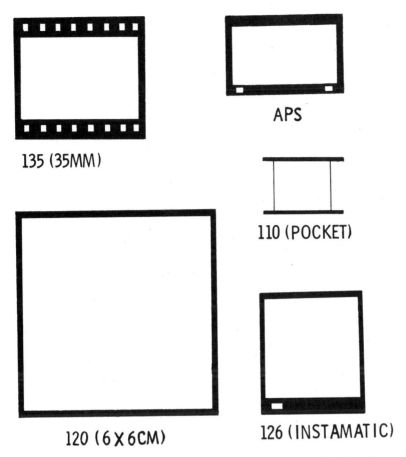

135 (35MM)

APS

110 (POCKET)

120 (6 X 6CM)

126 (INSTAMATIC)

3. Film frames vary in the shape and size of their image areas. The five films represented here are identified by their official size numbers and the names by which they are often better known.

image area measuring 18mm wide $\times$ 24mm long. This is half the size of the image made by regular 35mm cameras, and is the reason they are called half-frame cameras. (An attraction of half-frame cameras is that you can take twice as many pictures on a roll of 35mm film.)

Other small-format cameras include APS cameras, which are smaller than 35mm cameras and use smaller film. APS films have a width of 24mm, but unlike 35mm films, they are simply identified as APS films rather than by millimeter size. As to the actual image area produced by APS cameras, it measures 16.7 $\times$ 30.2mm, which is nearly 42 percent smaller than images made by 35mm cameras.

MEDIUM-FORMAT CAMERAS are larger than 35mm and APS cameras. They are favored by advertising and fashion photographers, who like

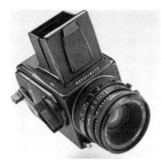

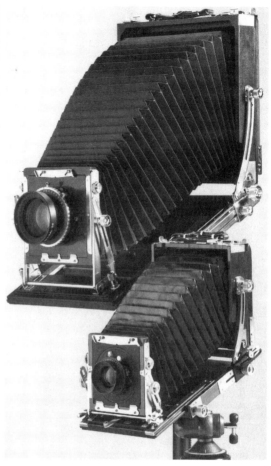

4. Medium-format cameras, like this Hasselblad, are popular with many professional photographers. The cameras commonly use 120-size roll film that is 6cm (2³/₈ inches) wide.

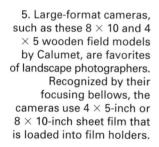

5. Large-format cameras, such as these 8 × 10 and 4 × 5 wooden field models by Calumet, are favorites of landscape photographers. Recognized by their focusing bellows, the cameras use 4 × 5-inch or 8 × 10-inch sheet film that is loaded into film holders.

to use films that are larger in size than 35mm and APS films because bigger negatives and transparencies are easier to view and to handle. (Also, the quality of the image is often better on larger-size films, depending on the use intended for the photograph; see the chapter on films beginning on page 196.)

The films for medium-format cameras measure 6 centimeters (2³/₈ inches) wide. The width has nothing to do with their names; the films are identified as either size 120 or 220 roll film. The only difference between the two is that 220 film is twice as long as 120 film, which means you can make twice as many exposures.

Depending on their design, medium-format cameras produce a square or rectangular image, or both. Cameras with a square format produce an image area 2¹/₄ × 2¹/₄ inches and were originally known as 2¹/₄ CAMERAS. Nowadays they are known as 6 × 6 CAMERAS because

the width of the film (not the image) is 6 centimeters (cm) in metric measurement.

Many medium-format cameras produce a rectangular film format rather than a square film format. Those cameras are called 6 × 4.5, 6 × 7, OR 6 × 9 CAMERAS. They are named for the *width of the film*, 6cm, and the *length of the image* they produce: 4.5cm, 7cm, or 9cm. (The *width of the image* is actually 5.7cm.) Yes, we know that all these image and film measurements may be confusing, but it's the only accurate way to compare the relative sizes of films and images.

Some medium-format cameras can be fitted with various inter-changeable FILM MAGAZINES, which are sometimes called FILM BACKS, to produce those rectangular formats, 6 × 4.5, 6 × 7, and 6 × 9, as well as the square 6 × 6 format. There are even film backs that allow 35mm films and Polaroid instant films to be used with medium-format cameras. In regard to the size of the image area, a 6 × 6cm film is nearly four times as large as a 35mm film.

There are also LARGE-FORMAT CAMERAS, most often called STUDIO CAMERAS and VIEW CAMERAS, which are used by studio, portrait, and landscape photographers. These cameras are designed for even larger film sizes, commonly 4 × 5 inches or 8 × 10 inches (10.2 × 12.7cm or 20.3 × 25.4cm). Like medium-format cameras, however, they are too big or too expensive for casual camera users.

In general, unless you need or simply like a large negative or transparency for your photographic purposes, the 35mm camera is probably ideal. Its film is readily available in color and black-and-white to produce either negatives for making prints or positives (slides) for projection.

Special films, like infrared, are also available in 35mm size. Films for 35mm cameras come in lighttight metal film cassettes to make either 12, 24, or 36 exposures. Some 35mm films are sold in 100-foot (30-meter) rolls, known as BULK FILMS, so you can load your own film cassettes for the exact number of exposures desired.

If you are eager to make pictures in any and all situations, the 35mm camera is light enough to tote around, small enough to be unobtrusive, and simple enough to operate. Chances are you have a 35mm camera or will eventually purchase one for your photographic pursuits. Which one?

## Single Lens Reflex or Compact Camera?

While camera manufacturers produce dozens of different models, the most popular 35mm cameras are two basic types. Smallest in

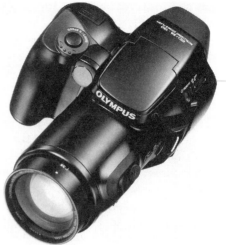

6. Because they are virtually automatic, compact 35mm cameras are known as point-and-shoot cameras. The most useful models have override controls so you can make some manual adjustments for focusing and exposure.

7. A "bridge" between 35mm compact and single lens reflex cameras is the zoom lens reflex (ZLR) camera; like compact cameras, its lens is a permanent part of the body, but a ZLR features a reflex viewing system like that of single lens reflex cameras.

size and easiest to operate are COMPACT CAMERAS, which are also known by other names, including POINT-AND-SHOOT CAMERAS and LENS-SHUTTER CAMERAS. Because of their automatic operation and simplicity, compact cameras appeal especially to beginners and to snapshooters who take "record" pictures of birthdays and other memorable occasions, such as vacation trips.

The most versatile 35mm cameras are SINGLE LENS REFLEX CAMERAS, which are commonly called SLR CAMERAS. They are larger and more complex to operate than compact cameras, but are the favorites of many professional photographers as well as serious amateurs.

A hybrid of these two basic types of 35mm cameras are little-known ZOOM LENS REFLEX CAMERAS, also called ZLR CAMERAS. Sometimes referred to as BRIDGE CAMERAS or ALL-IN-ONE CAMERAS, they offer photographers more creative control than compact cameras but do not have all of the features of single lens reflex cameras.

Nowadays there are dozens of name brands and hundreds of models of 35mm cameras. Among the major manufacturers of single lens reflexes are Canon, Contax, Leica, Minolta, Nikon, Olympus, Pentax, Ricoh, Vivitar, and Yashica. The same companies also make 35mm compact models, as do Argus, Fuji, Kodak, Konica, Rollei, Samsung, and others. The cost of 35mm cameras ranges from less than $50 for simple compact models to several thousand dollars for professional SLRs.

Although 35mm cameras had been available for more than a half

century, their sales got a big boost in the mid-1980s with the introduction of AUTOFOCUS, which promised sharply focused images at the push of a button. In a relatively short time, thanks to computer chips and micromotors, other automatic features appeared—all designed to enable photographers to concentrate on the subjects of their pictures and worry less about operating the camera.

Among those electronically controlled features that are now common in the most popular 35mm compact and SLR cameras are AUTOLOAD, which makes putting the film in the camera almost foolproof, and AUTOWIND, which automatically advances the film after every exposure so you won't miss any shots. Most cameras also have AUTOREWIND to return the 35mm film to its lighttight cassette after the final exposure is made. An especially welcome feature is AUTO-EXPOSURE, which automatically sets the shutter speed and lens opening (f/stop)—all you have to do is press the shutter release button. Also helping you get well-exposed pictures is AUTOFLASH, which turns on a built-in electronic flash whenever the existing light is too low for a good exposure; advanced SLR cameras also feature DEDICATED AUTOFLASH, which sets the proper exposure when an accessory flash unit is used.

If most everything is automatic on today's SLR and compact 35mm cameras, what makes them different? A major distinction is that photographers can be more creative with single lens reflex cameras because you also have *manual control* of important functions, particularly setting the lens opening and shutter speed and focusing the lens. Compact cameras, on the other hand, are fully automatic and allow little or no manual control of exposure and focusing adjustments.

Single lens reflex cameras also extend your creativity because their lenses can be removed and interchanged. By switching from a normal lens to a wide-angle lens, a telephoto lens, a zoom lens, and other types of lenses, you can easily alter a subject's image size and appearance to improve your pictures. By comparison, the lens of a compact camera is a permanent part of the camera body and can limit your choices when you are composing photographs.

Also distinguishing SLRs from compact cameras are their viewing and focusing systems. An advantage of the VIEWING SYSTEM of single lens reflex cameras is that the photographer sees in the viewfinder exactly what the camera lens transmits to the film—you're looking through the same lens. (Thus the reason for the camera's name: *single* lens reflex.) This same-lens viewing is usually accomplished with a mirror and a prism as follows.

A so-called INSTANT-RETURN MIRROR (or QUICK-RETURN MIRROR) de-

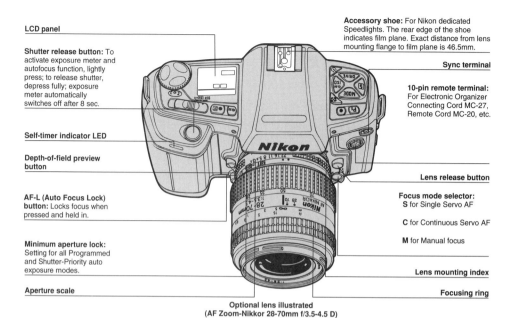

**LCD panel**

**Shutter release button:** To activate exposure meter and autofocus function, lightly press; to release shutter, depress fully; exposure meter automatically switches off after 8 sec.

**Self-timer indicator LED**

**Depth-of-field preview button**

**AF-L (Auto Focus Lock) button:** Locks focus when pressed and held in.

**Minimum aperture lock:** Setting for all Programmed and Shutter-Priority auto exposure modes.

**Aperture scale**

**Accessory shoe:** For Nikon dedicated Speedlights. The rear edge of the shoe indicates film plane. Exact distance from lens mounting flange to film plane is 46.5mm.

**Sync terminal**

**10-pin remote terminal:** For Electronic Organizer Connecting Cord MC-27, Remote Cord MC-20, etc.

**Lens release button**

**Focus mode selector:** S for Single Servo AF

C for Continuous Servo AF

M for Manual focus

**Lens mounting index**

**Focusing ring**

Optional lens illustrated
(AF Zoom-Nikkor 28-70mm f/3.5-4.5 D)

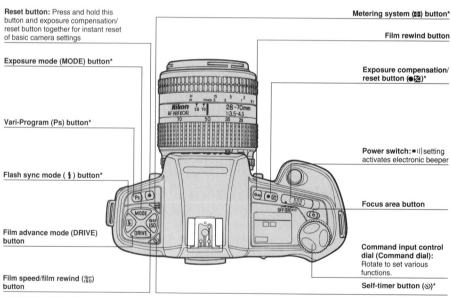

**Reset button:** Press and hold this button and exposure compensation/reset button together for instant reset of basic camera settings

**Exposure mode (MODE) button***

**Vari-Program (Ps) button***

**Flash sync mode ( ⚡ ) button***

**Film advance mode (DRIVE) button**

**Film speed/film rewind (⚙ISO) button**

**Metering system (⊠) button***

**Film rewind button**

**Exposure compensation/reset button (●⊠)***

**Power switch:** ●))) setting activates electronic beeper

**Focus area button**

**Command input control dial (Command dial):** Rotate to set various functions.

**Self-timer button (⟳)***

* Used with command dial

8–11. Modern single lens reflex (SLR) cameras have numerous features and controls. Detailed diagrams, such as these for the Nikon N90 model, can be found in camera instruction manuals. Note that all figures and marks shown in the LCD (liquid crystal display) panel do not appear simultaneously. (Illustrations courtesy of Nikon Corporation.)

**Eyepiece shutter lever:** Used to prevent stray light from entering viewfinder.

**AE-L (Auto Exposure Lock) lever:** Sliding and holding lever in locks auto exposure.

**Vari-Program list**

**Viewfinder/LCD panel illumination button:** Press to illuminate viewfinder and LCD panel, useful in dim light. Illumination automatically switches off 8 sec. after you remove your finger from button.

**Battery holder**

**Battery holder lock screw**

**Camera strap eyelet**

**Tripod socket**

**Camera back lock releases:** To open camera back, slide camera back lock releases together.

**CPU contacts:** Don't touch!

**Film cartridge confirmation window**

**Viewfinder eyepiece**

**Focusing screen type B:** Interchangeable with optional type E screen

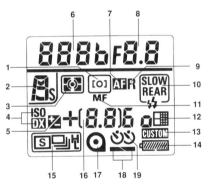

### LCD panel indications

1. Focus area
2. Exposure mode
3. Metering system
4. Film speed setting mode
5. Exposure compensation
6. Shutter speed
7. Autofocus
8. Aperture
9. Release/Focus priority
10. Flash sync mode/Red-Eye Reduction
11. Manual focus

12. Electronic Organizer*
13. Custom*
14. Battery
15. Film advance mode
16. Frame counter/Vari–Program/ISO speed/Self-timer duration/compensation value
17. Film loading
18. Film advance and rewind
19. Self-timer

*Appears only when Data Link System is in use.

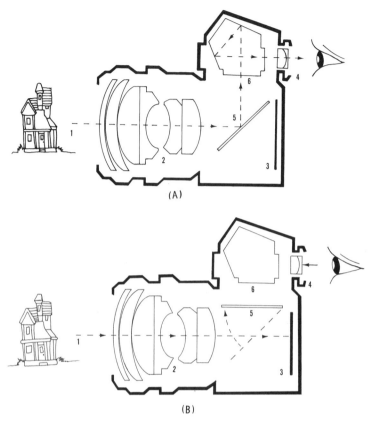

12. The optical system of a 35mm single lens reflex (SLR) camera is shown for viewing and for exposing film. (A) For viewing, the image of the subject (1) is transmitted by the camera lens (2) to a mirror (5) that reflects it into a prism (6) that inverts the image so you will see it correctly in the viewfinder (4). (B) For exposing the film, the mirror (5) flips up, which allows the image of the subject to reach the film (3), but momentarily prevents you from seeing the image through the viewfinder.

flects the subject coming through the camera lens into a PENTAPRISM (or a PENTA-MIRROR) that projects the image right side up into the photographer's eye. When the shutter release is pressed, the mirror instantly flips out of the way and the image is projected through the opened shutter onto the film. When the shutter closes, the mirror flips back and allows you to see the subject again.

This brief blackout of the subject is hardly noticeable and doesn't bother photographers at fast shutter speeds, such as 1/125 second and shorter. Although uncommon, a few SLR models avoid any blackout whatsoever by featuring a stationary PELLICLE MIRROR that reflects the image to the photographer's eye and also permits the

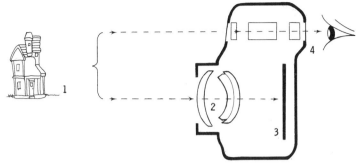

13. In the optical system of a 35mm compact camera, as well as other rangefinder-type cameras, the image of the subject (1) is transmitted by the main camera lens (2) to the film (3) while you see the subject through an optical viewfinder (4).

image to be transmitted to the film; since the mirror doesn't have to flip out of the way, there is never any blackout.

As to the viewing system of compact cameras, such a blackout is of no concern because you see the subject through an optical viewfinder, while the film records the scene through the main camera lens. However, there can be a potential problem, called PAR-ALLAX ERROR, when framing close-up subjects in the viewfinder. If you are very close to a subject, the viewfinder gives a different view to the photographer's eye than the camera lens does to the film, unless you have one of the better compact cameras that features PARALLAX COR-RECTION or PARALLAX COMPENSATION. Otherwise, you think you're get-ting a close-up of a flower but the picture that results is missing the top of the blossom (see Illustration 177).

The FOCUSING SYSTEMS of compact and single lens reflex cameras are also different in a major way: SLR models can be focused manu-ally as well as automatically, while compact cameras are designed exclusively for automatic focusing. Take note that single lens reflex cameras manufactured prior to the mid-1980s, and even a few cur-rent SLR models, offer manual-only focusing. To focus manually, you turn the LENS FOCUSING RING back and forth on the camera lens until the image appears sharp in the viewfinder. (Read more about focusing later in this chapter.)

Another advantage of single lens reflex cameras allowing photog-raphers more creativity is that they can be shot at a greater range of shutter speeds than compact cameras. (The shutter, of course, determines *how long* the film is exposed to the light coming through the lens.) In the compact type, the shutter is part of the lens and is usually limited mechanically to a speed of 1/500 second or slower.

14. Leaf shutters are found in 35mm compact cameras and most other rangefinder-type cameras. This type of shutter is built into the lens and features overlapping metal leaves that open and close when the shutter release button is pressed.

15. Focal plane shutters are found in single lens reflex (SLR) cameras. This type of shutter is built into the camera body instead of the lens. It features a pair of flexible curtains or a set of metal blades that travel horizontally or vertically just in front of the film plane. In the case of horizontally traveling curtains that are depicted here, when the shutter release is pressed, the first curtain (1) opens, which allows light to reach the film until followed by the second curtain (2). The time delay between the first and second curtains, or a set of shutter blades, depends on the shutter speed.

The shutter has a number of overlapping metal leaves that open and close when the shutter release is pressed. It's called by various names: BETWEEN-THE-LENS SHUTTER, LEAF SHUTTER, and LENS-SHUTTER.

The shutter in a single lens reflex, on the other hand, usually is a pair of flexible cloth curtains or a set of metal blades that travel across and just in front of the film's surface. They move right to left, or top to bottom. Called a FOCAL PLANE SHUTTER, it returns to its starting position when the film is advanced and the shutter is recocked. Since the curtains or blades travel only in one direction after the shutter is released, speeds up to 1/8000 second can be reached.

Such ultrafast shutter speeds are sometimes needed to stop sports action or wildlife. At the other extreme, the shutters of single lens reflex cameras can be set to make exposures at least as long as 1 second, and sometimes up to 30 seconds. Exposures of an infinite amount of time can be made when the shutter is set at B or T, the settings for a time exposure, as when photographing the lights of a city's skyline after dark.

In summary, the most versatile type of 35mm camera today is the SINGLE LENS REFLEX CAMERA. The main reasons: The lenses on a SLR can be changed, and the photographer sees exactly what the film will

record. These factors make a big difference when you are composing pictures. Furthermore, computer-chip circuitry and other technological improvements have led to the development of smaller and lighter-weight SLR models, with emphasis on electronic exposure controls. In addition to auto-exposure, other automatic features that make single lens reflex cameras convenient to use include autofocus lenses, autowind (or motor drive) to advance the film, autorewind, and dedicated flash units that automatically set the correct flash exposure.

For snapshooters, 35MM COMPACT CAMERAS have some advantages over SLR cameras, including being easier to use, lighter in weight, smaller in size, quieter in operation, and less expensive. No wonder they are especially popular for occasional picture-taking. However, compact cameras can limit your creativity as a photographer, and therefore are not recommended for frequent or serious shooting.

A final word of caution: Any so-called goof-proof camera is never that. While a top-of-the-line automatic model may have all sorts of special features, that doesn't mean it will take any better pictures than a basic manual model. The reason a picture turns out well is because of you, the photographer, not the camera. In reality, when

16. With a single lens reflex (SLR) camera you can compose a photograph with more confidence because the viewfinder shows you exactly what will be recorded by the film.

buying a camera, remember that the most automatic camera with a host of "whistles and bells" may cause you the most grief. Not only are there increased opportunities for malfunctions, photographers often find they never use even a small number of the camera's special features.

Most important, regardless of the specific camera you choose, to be a successful photographer you need to understand the basics of how a camera operates and how film is properly exposed. If your camera—automatic or not—fails to produce the photographs you expected (say they were underexposed, for example), you must be able to figure out the reason why and take steps to avoid such disappointing pictures in the future.

## Protecting Your Camera

Regardless of the camera you use, there are some things you should know and practice immediately. One is so simple that many people don't think about it and later have regrets. Use a CAMERA STRAP.

Whether or not your camera is in a case, you should have it attached to a strap that can be attached to you. A dropped camera means disaster. The best prevention is to have a strap attached to the camera that can be hung around your neck or wrapped around your wrist. Make sure the strap is a good one, and attach it to the camera with "O" RINGS rather than clips that snap on and can become unfastened accidentally. Someone is bound to bump you when you least expect it and knock the camera from your hands. Or suddenly you may need both hands free and have to release your grip on the camera. So get a camera strap, and use it.

Another way to protect your camera is with a CAMERA CASE. How-

17. Smart photographers always use a camera strap.

ever, if the case gets in your way while shooting, be sure to take it off. You must make sure your camera is easy to use; dangling case covers can slip in front of your lens or viewfinder and you'll miss pictures.

While we never recommend that you abuse your camera, don't baby it either. Use it. Remember that your camera is only your tool for making pictures. Respect it, but don't be so afraid your camera will get harmed that you fail to get your pictures.

By the way, don't be surprised to find that many of today's camera bodies and lens barrels are made not of metal but of plastic. Be assured that the plastic, most commonly a fiberglass-reinforced polycarbonate, is very durable. Plastic has become a preferred material in camera and lens construction because it is lighter in weight than metal and can be molded instead of machined, which helps reduce costs.

There are some PRECAUTIONS TO TAKE to prevent accidental damage to your camera when it's not in use. Heat and humidity are major enemies. Always keep cameras and other photo gear out of direct sunlight or hot storage places, such as automobile glove compartments and rear window ledges. High temperatures can loosen the lens elements, affect your camera's lubrication, and temporarily cause LCD (liquid crystal display) information panels to go black and be unreadable. Also, sunlight coming through an uncapped lens may focus its rays on the curtain of an SLR's focal plane shutter and burn it. Remember in your youth how you set dry leaves on fire by focusing the sun's rays through a magnifying glass? Heat harms film, too.

A good suggestion: If you carry camera equipment in your car's trunk, which can get very hot during the summer, place the equipment and film in an inexpensive Styrofoam ice chest (without ice) for insulation from the heat.

Also remember to keep your photo gear away from damp storage areas where mildew might develop. If storing cameras in high-humidity areas, prevent moisture damage by including a desiccating agent, such as SILICA GEL, in the storage box.

Moisture, which condenses when you go from air-conditioning to humid outdoor conditions, or when you escape from a cold winter's day into a heated house, should be allowed to evaporate before you use the camera. When shooting in inclement weather, be sure to wipe off rain or snow from your camera. Take special care at the beach or on a boat to clean off any salt water or spray; use a cloth dampened with fresh water.

At the beach, also guard against sand; keep your camera in a

camera bag or some other sand-free protection, such as a self-sealing plastic bag. Exterior dust should always be wiped off. Occasionally check the inside of your camera for any dust, too, and carefully brush or blow it away. This is very important after a dusty day in the field, as at a motorcycle or car race.

Don't bang your camera unnecessarily. A sturdy, well-padded CAMERA BAG offers worthwhile protection by absorbing bumps and rough handling. There are dozens of different designs and sizes of camera bags. Some are too bulky or heavy to carry comfortably, so try them out in the camera store by filling up various bags with your photo equipment to see how everything fits and how the bags feel on your shoulder. Camera bags are discussed in detail in Chapter 7, "Considering Accessory Equipment."

One CAMERA MAINTENANCE tip: Check all exposed screws periodically, including around the lens mount of SLR models. High-speed vibration, especially during jet airplane flights, can loosen the screws on your camera. A set of small jeweler's screwdrivers will allow you to tighten them. Otherwise, you should not attempt any camera repairs yourself; the insides are more complicated than you can ever imagine.

By the way, if you have your camera repaired or cleaned by a

18. Take extra precautions at the beach to safeguard your camera and equipment from sand and salt water.

photo service shop, always shoot a test roll of film immediately afterward to make sure everything is working okay. Occasionally something goes wrong and important pictures can be lost if you haven't tested the camera after it comes back from the shop. Many an overseas trip has been ruined by a recently repaired camera that suddenly jams.

One plea: Whenever and wherever you are taking pictures, don't casually discard your film boxes—our cities and countryside are too littered as it is. Many tourist areas seem to be ankle-deep in film cartons, so don't contribute your photographic waste. And remember to save the plastic film can to protect your exposed roll of 35mm film prior to processing.

## Safeguarding Your Lenses

A major mistake of unknowing photographers is failing to keep the optics of their camera lenses clean. A dirty front or rear lens element diffuses the light before it reaches the film, which results in unsharp pictures. A clean lens ensures the clearest possible photographs. On the other hand, cleaning a lens too often, or improperly, may damage its special optical coatings. These coatings cut down the LENS FLARE that sometimes occurs when light strikes the glass or plastic elements.

A very convenient way to clean lenses is with a MICROFIBER LENS CLEANING CLOTH, sold at camera shops and eyeglass stores. The microfibers of this lint-free cloth easily wipe away fingerprints and dust. The reusable cloth can be washed, and will last for years. Keep one in your camera bag and dedicate it *exclusively* to cleaning camera lenses and viewfinders.

Another safe way to clean lenses is with PHOTOGRAPHIC LENS TISSUE, which is inexpensive and available at every camera store. Avoid regular eyeglass tissues; some are chemically treated and may damage the camera lens coatings. When a lens is especially dirty, as with fingerprints, a special liquid PHOTOGRAPHIC LENS CLEANER can be used with the lens tissue.

Never wipe dust off a lens with your fingers. Some photographers blow away the dust, fog the lens with their breath (careful, saliva is harmful), and wipe it with a microfiber lens cleaning cloth or lens tissue. A camel's-hair brush is okay for dusting lenses, unless the brush itself is dirty. If used to clean other parts of the camera, brushes may pick up enough residue to smear the lens. Restrict use of any lens brush to your lenses.

19. To protect a camera lens from dirt and scratches, use an ultraviolet (UV) filter. The seemingly clear filter requires no increase in exposure. Sometimes called a haze filter, it also reduces ultraviolet radiation to improve picture quality, especially of scenic views.

The use of a LENS SHADE can offer some protection from physical harm to a camera lens. Sometimes called a LENS HOOD, this extended metal, plastic, or rubber ring is built into or attaches to the front of the lens and helps ward off rain, snow, and fingerprints. Lens shades prevent light from falling directly on the lens surface, too, which helps avoid LENS FLARE.

In any case, almost full protection of your camera lens can be assured by covering it with an ULTRAVIOLET FILTER. This seemingly clear glass filter guards the lens from dust, fingerprints, and possible scratching. When compared with the cost of your lens, the filter is very inexpensive, and it can be cleaned with less caution.

An ultraviolet filter, also known as a UV FILTER or HAZE FILTER, is actually designed to reduce the ever-present ultraviolet radiation, which is invisible to the human eye but not to photographic film. By cutting ultraviolet radiation, the UV filter improves picture quality, especially of distant scenes. (It does not decrease the effects of smog, fog, or mist.) Some filter manufacturers produce what they call a SKYLIGHT FILTER, which is similar to the UV filter and is recommended for color films; either one is a good choice for lens protection.

Of course, a plastic or metal LENS CAP offers the best protection. However, it may get bothersome taking a lens cap off for a shot and then putting it back on. You avoid this inconvenience by using a UV or skylight filter instead. (Happily, use of such filters requires no change in exposure settings.) We buy a UV filter for each of our lenses and keep them on at all times, except when using other filters. We'd rather replace a scratched or damaged ultraviolet filter than a much more expensive camera lens. When putting our photo gear away for the day, we cover the UV filters with lens caps for full lens protection.

## Holding the Camera

Another simple rule to remember regarding the use of your camera is to hold it steady. *More pictures are ruined by camera movement than for any other reason.* With a little practice you can avoid this all-too-common bugaboo, which is also called CAMERA SHAKE.

The easiest way to start is by shooting at a shutter speed of 1/125 second, or faster. That way your shutter helps cancel out any movement you might make. Some photographers prefer 1/250 second for this reason. Other shutter speeds can and should be used for creative effects, but keeping your shutter at 1/125 second or 1/250 second for average situations helps avoid camera shake.

When shooting at any shutter speed, a common mistake that can result in camera movement is to jab at the shutter release. The SHUTTER RELEASE BUTTON should be *pressed* gently. Practice in front of a mirror and see if you are moving the camera when you press the shutter release. You may have to arch your finger more. Try it.

Another thing you can do in front of a mirror is to check the way you are holding your camera. It should rest comfortably in your

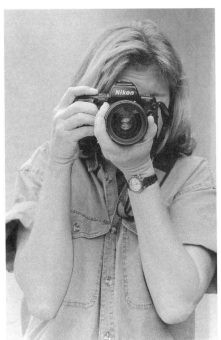

20. Brace your arms against your body to help hold your camera steady, whether it is in a horizontal position (left) or a vertical position (right).

hands, be easy to turn from a horizontal to a vertical position, and be held in a manner that enables you to press the shutter release and use the other controls without difficulty.

As you practice holding your camera steady, think of your body as a tripod: stand with your feet slightly apart for best support. Keep the arm with the hand that supports the camera next to your body, preferably resting on your ribs as a brace. Exhale your breath before pressing the shutter release. Eventually you should be able to shoot at speeds as slow as 1/30 second, sometimes less, without moving your camera. Keep practicing.

Among high-tech 35mm compact cameras is a type featuring electronic VIBRATION REDUCTION in its lens to help you avoid blurring pictures when hand-holding the camera at slow shutter speeds. And at least one SLR telephoto zoom lens features similar IMAGE STABILIZATION, which eliminates or lessens the effects of camera movement while allowing you to shoot hand-held pictures at slow shutter speeds, such as 1/60, 1/30, or even 1/15 second.

Most of the longer and heavier telephoto lenses require fast shutter speeds or something more than human support, such as a tripod. Otherwise, you need to improvise some means of support to help keep the camera steady: try pressing the camera and lens against the side of a building or a tree, or resting it on a chair or the floor or a fence post.

If the light level is low and you have to shoot at slow shutter

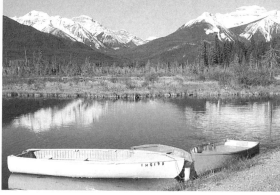

21–22. For the most effective composition, always consider how your subject might look in a vertical format as well as the more common horizontal format. This scene is near Banff, Canada.

speeds, it's often a good idea to trip the shutter by activating the camera's SELF-TIMER while the camera is held steady by a tripod or other support. There will be no movement of the camera because you will not be touching it when the shutter is released. Most modern 35mm cameras have an electronic self-timer that will fire the shutter 10 seconds or so after you press the shutter release button. On some cameras, the self-timer can be set to take two exposures in succession. A small red light blinks on the front of the camera to signal you that the self-timer is operating and about to open the shutter. On some models, this countdown is also signaled by an electronic beeping sound.

Another option for reducing the chance of camera movement, especially during time exposures, is to activate the shutter with a CABLE RELEASE. This flexible cable usually screws into the shutter release and has a plunger at the opposite end that allows you to trip the shutter without pressing the release on the camera with your finger. Instead of this mechanical cable release, cameras with electronically controlled shutters often use a REMOTE CORD. It plugs into a socket on the camera body and has a push button at the other end that is pressed to close a circuit and fire the shutter.

By the way, to avoid even the slightest possibility of camera shake during a time exposure, some of the better SLR cameras feature MIRROR LOCK-UP in the viewing system. This moves the viewfinder's instant-return mirror out of the way before the shutter opens, and keeps it locked up until after the shutter closes, to prevent any vibration.

In addition, some SLRs also have an EYEPIECE SHUTTER, also called an EYEPIECE BLIND, that you activate with a lever to close off the viewfinder's eyepiece. This prevents stray light from adversely affecting the camera's metering system during an automatic time exposure.

After learning how to protect, hold, and support your camera and its lens, the most important thing to know is how to load the camera with film—and make sure it is loaded correctly. Many photographers, even the pros, occasionally shoot a roll of film only to discover that it never advanced in the camera. The result: a blank roll, and some profanity perhaps.

## Loading Your Camera—for Sure

The best advice for successfully loading your 35mm camera with film is to follow the instructions in your camera manual. While the procedure is basic, different cameras have different film-loading

23. Many 35mm cameras are autoload models that load the film automatically. After you insert the film cassette into the film chamber with the film's emulsion (dull) side facing the lens, take care to pull the film leader from the cassette until it reaches the film loading mark (see arrow) located next to the film take-up spool. Otherwise the autoload mechanism may not engage the film when the camera back is closed, and you must begin the procedure again (see text).

mechanisms. Fortunately, many 35mm cameras feature AUTOLOAD and thread the FILM LEADER onto the FILM TAKE-UP SPOOL automatically. Most older models require you to manually attach the leader of the film to a permanent or removable take-up spool in the camera.

Although AUTOLOAD CAMERAS are designed to load film easily and properly, they are not always foolproof. To correctly load film in 35mm autoload cameras, the basic procedure is to open the camera back and insert the lighttight FILM CASSETTE (or film magazine, as Kodak calls it) into the space on the left-hand side, the FILM CHAMBER. You may have to pull up the REWIND CRANK or REWIND KNOB to do this. The cassette will only fit properly when the film's light-sensitive (dull) side, the EMULSION, is facing the lens. You then draw the leader, the film's narrow end that sticks out from the film cassette, past the shutter curtain (don't touch it!) toward the take-up spool. Stop when the tip of the leader reaches the FILM LOADING MARK.

If you inadvertently pull too much film from the cassette, carefully turn the cassette spool by hand to draw the film back until there is no slack; you may have to remove the cassette from the camera to do this. Before closing the camera back, make certain the film is centered and lies flat; the extended lip of the film cassette should be flush with the camera body, not sticking up. Some camera manuals instruct you to be sure that the film sprockets or teeth from the FILM TRANSPORT REEL are sticking through the SPROCKET HOLES on the bottom edge of the film before closing the camera back.

With 35mm autoload cameras, when the shutter release is first pressed after the camera back has been closed, the film automatically advances to frame number 1 and the first picture is ready to be taken. In case the film leader does not automatically engage the take-up spool, usually the shutter release locks, an "error" message flashes on the camera's LCD information panel instead of showing

the frame number "1," or an electronic beeping sound is made—all to warn you that the film is not properly loaded and to signal that you must begin the autoload procedure again.

For LOADING FILM MANUALLY, the basic procedure is the same as for autoload cameras, except that the film leader must be manually inserted into the take-up spool. Before closing the camera back, release the shutter to advance the film until the sprocket holes on *both* sides of the film are engaged in the sprockets of the film transport reel. (See Illustration 24 for more details.)

It seems that economy-minded photographers who manually load cameras always try to get an extra frame on their 36- or 24-exposure rolls by closing the camera back after engaging only the film leader's single set of sprocket holes. Sometimes the film slips, and the result is no photographs at all! So give up that extra frame and save a whole roll. Make sure the sprocket holes on *both* sides of the film are engaged before closing the camera's back.

You can always check whether your manually loaded film is

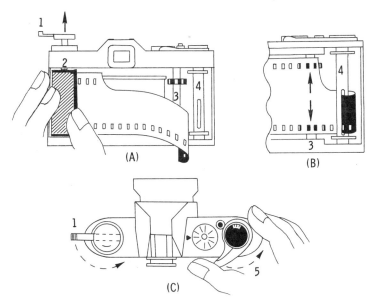

24. Older 35mm cameras lacking an autoload feature must be loaded carefully to be sure the film will be drawn from the film cassette onto the film take-up spool. Follow these steps: (A) Pull up the film rewind crank (1) to insert the film cassette (2) into the camera, then push the crank back down. (B) Insert the film leader in the take-up spool (4), and advance the film, making sure sprocket holes along both sides of the film are engaged in the camera sprockets (3). Close the camera back and continue advancing the film by cocking the shutter (5) until the rewind crank (1) moves. This indicates the film is correctly loaded and winding onto the take-up spool.

advancing properly. After closing the camera back, advance the film and release the shutter once more. Next, because the film is not tightly wound in the cassette, *carefully* take up tension on the film by slowly winding the rewind crank or knob in the direction of its arrow. Do not press the FILM REWIND BUTTON. When the slack is gone, advance the film and watch the rewind crank or knob to see if it moves. If it does, then the film is being properly advanced onto the take-up spool. If not, the leader has slipped off the spool or the film has come off the sprockets. Open the camera back and see what's wrong.

As they shoot a roll of manually loaded film, some photographers also watch the rewind crank or knob when winding the film to make sure it is still advancing. This is unnecessary with some cameras, because they have a FILM TRANSPORT INDICATOR that visually shows you that the film is advancing.

With manually loaded cameras, and even some autoload models, you should be aware that the FILM FRAME COUNTER does not indicate whether there is film in the camera, or whether film is advancing. The film frame counter begins counting when the camera back is closed, *with or without film inside*. If you are unsure if there is film in a 35mm SLR camera, make several turns on the rewind crank or knob to check for tension, which will be evident if the camera is loaded. (Do not press the film rewind button during this test.)

While some cameras feature a FILM LOAD INDICATOR to indicate when a film cassette is in the camera, most autoload models have a small FILM VIEW WINDOW in the camera's back that shows you whether a film cassette is in the camera. The window also lets you see information printed on the cassette that identifies the film type, the film speed, and the total number of exposures that can be made.

Automatic cameras featuring AUTOWIND advance the film automatically after each exposure until the end of the roll is reached, and then the shutter release stops functioning. With manually operated cameras, when you get near the end of the roll and approach the 24th or 36th exposure, advance the film carefully. Do not force it if you feel resistance; you've come to the end of the roll.

Films are usually attached securely to their spools in the cassette, but occasionally they pull free. If this happens, take your camera to a camera shop so that the exposed film can be safely transferred to another cassette. Otherwise, if you open the camera back in the light, the film outside the cassette will be ruined.

Note that a few 35mm cameras have a FILM PREWIND feature that automatically winds all the fresh film onto the camera's take-up spool immediately after you load the cassette and close the camera

25. Modern 35mm and APS cameras feature autowind to advance the film and cock the shutter so you'll always be ready for the next picture, as of this hiker on a mountain trail in Switzerland.

back. That way, after each frame of film is exposed, it winds into the lighttight cassette; if the camera back is ever opened before the roll is finished, the film that has already been exposed will not be ruined.

Remember that the film must *always* be wound back into the cassette before you open the camera back. With cameras featuring AUTOREWIND, some models begin rewinding automatically when the end of the roll is reached. Or you may have to push a FILM REWIND BUTTON or lever to activate a motor that winds the film back into its cassette. To rewind the film in manually operated cameras, free the camera's take-up spool by pressing the film rewind button, then turn the film rewind crank or knob in the direction of its arrow. (You may have to hold in the rewind button.)

With some autorewind cameras, after rewinding stops and you open the camera's back to remove the cassette, the very tip of the film leader still shows. If that happens, we recommend that you manually turn the film's spool to *completely* rewind the leader into the cassette. If you leave the leader out, one day you'll grab a previously exposed roll and run it through your camera again. Result: double exposures and a ruined roll. If all the film is inside the cassette, you know the film has been exposed. Don't worry about light leaking into the cassette's opening; its felt lining is designed to keep light out even when the film is wound completely inside.

Here are two tips when loading film. First, make sure your camera is clean inside. The FILM PRESSURE PLATE that holds the film flat against the frame opening must be free of dust and grit to prevent scratching of the film's shiny protective backing. Also clean any rollers or surfaces that come in contact with the film's emulsion (dull) side.

Second, LOAD FILM IN SUBDUED LIGHT. Simply find some shade or at least turn your back against the sun. Bright sunlight may leak into the cassette and fog your film, especially if you are shooting high-speed film, which is very sensitive to light.

## Changing Partially Exposed Rolls of Film

Although many camera manuals fail to mention it, occasionally you'll want to change the film in your 35mm camera to another type before shooting the entire roll. Must you expose the remaining frames or waste them by rewinding the film back into the cassette? No. What you want to do is rewind the film until only its *leader* remains outside the cassette, so that you can reload the same film in your camera at a later time. The procedure to follow to save the unused film depends on whether your camera features autorewind or is rewound manually; some SLR cameras with a MOTOR DRIVE offer both options.

In all cases, the first step is to note from the camera's FILM FRAME COUNTER the number of exposures already made on the partially exposed roll you are going to remove.

Regarding autorewind cameras, some models leave the tip of the film leader showing after the film is rewound; check to see if that is the case with your camera. If not, you must stop the autorewind action before the film and its leader are rewound entirely into the cassette. If your camera instruction manual offers no advice on how to do this, try these suggestions. After starting autorewind, watch the film frame counter and when it returns to "0," *immediately* turn off the power to stop the rewind motor. Experiment to see if this can be done by using the camera's on/off switch, opening the camera back, or breaking the battery circuit by opening the battery chamber; try these options with an unwanted roll of film.

For manually operated cameras, press the film rewind button and *slowly* rewind the film until you *hear* the leader pull free from the take-up spool or feel the film tension relax when the leader pulls free. Stop! Open the camera back and the film leader should be visible.

26. Photographers should know how to switch in mid-roll from one type of film to another (see text). When indoors, as at this natural history museum in Los Angeles, you may want to change to a high-speed film from a slower-speed film or to a tungsten film from a daylight film.

If all the film was accidentally wound back inside the cassette because you manually rewound it too fast or the autorewind action wasn't stopped in time, you have lost future use of the unexposed frames—unless you take the cassette to a camera shop where the film leader can be retrieved from the cassette for a small fee. Or you can do this yourself by buying an inexpensive FILM LEADER RETRIEVER device.

On the other hand, if you don't rewind all but the film leader into the cassette, the film remaining on the camera's take-up spool will be exposed to light and ruined when you open the camera back. If you are uncertain, open the camera back in a totally dark room or inside a CHANGING BAG. (This is also an option with an autorewind camera that cannot be stopped before the film leader disappears into the cassette.)

The lighttight changing bag serves as a portable darkroom. Total darkness is provided inside the bag, but for extra safety against light leaks, you should not use it in direct sunlight. To save a partially exposed roll of film, the camera is zipped into the bag and then you put your arms into the bag through two sleeve openings that have elastic to create a lighttight seal. Open the camera back, carefully pull the exposed portion of the film from the take-up spool, and then wind it by hand back into the film cassette until only the leader remains.

After rewinding the partially exposed film, write or scratch on its leader the number of exposures already made on that roll. Also mark the cassette to remind yourself that the film has been partially

exposed. Later, when you're ready to use its unexposed frames, note the number of previous exposures marked on the leader and reload the film cassette in your camera in the normal manner. The next step is to keep advancing the film and releasing the shutter until you are two frames past the number of previously exposed frames.

However, to prevent light from striking the previously exposed frames, first cover the lens with a lens cap, or press the front of the camera lens against your body. Or zip up the camera in a changing bag to keep the light out when the shutter is released. Be aware that an auto-exposure camera may "lock up" and not permit the shutter release to work if light does not reach the film or the camera's lens cover is closed; if possible, switch the camera to manual operation in order to advance the film.

For extra protection against reexposure while advancing the film, you can limit the amount of light that might possibly reach the film by manually setting your shutter to its fastest speed (at least 1/500 second) and the lens aperture to its smallest opening (f/16, f/22, or f/32). In order to prevent double exposure of the last pictures you shot before removing the roll, remember to advance the film until the frame counter shows that the film has gone two frames past its previously exposed portion.

Take note that some APS (Advanced Photo System) cameras feature MID-ROLL CHANGE, which means you can rewind a film back into its cassette at any time in order to change to a different type or speed of APS film. When that first film is reloaded into the camera, it will automatically advance to the first *unexposed* frame remaining on the roll so you can continue taking pictures from the point where you stopped to exchange the film for another.

## Making Multiple Exposures

Exposing the same film frame more than once may be desirable in order to create special effects by making DOUBLE EXPOSURES or even MULTIPLE EXPOSURES. Many modern 35mm single lens reflex cameras allow you to do this quite easily, usually by activating a MULTIPLE EXPOSURE CONTROL that allows the shutter to be recocked one or more times without advancing the film or the film frame counter. Also, some compact cameras feature a MULTIEXPOSURE MODE that permits two or more exposures to be made on the same film frame.

Other 35mm camera models are designed to prevent accidental double exposures by advancing the film every time the shutter is

cocked, and they have no provision for making multiple exposures. However, with a little experimentation and practice, you can bypass that protective feature and recock the shutter without advancing the film in order to make additional exposures on the same film frame. The following procedure (see Illustration 27) works for most older 35mm *manually operated* cameras, but check your camera manual for specific multiple exposure instructions, if any.

First, take up any slack in the film in the cassette by carefully turning the camera's film rewind crank or knob. Next, hold the crank or knob in place so the film's tension is not lost, press the film rewind button to free the take-up spool, and then recock the shutter. You're now ready to reexpose the same film frame to make a double exposure. You can also repeat the procedure for additional exposures.

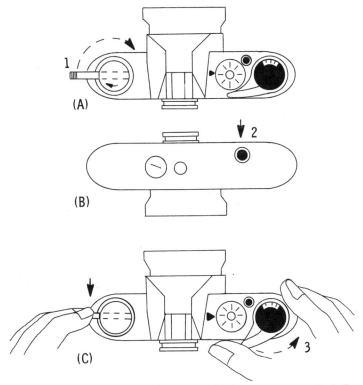

27. Most modern 35mm cameras have a multiple exposure control. For older models without this feature, follow these steps to make double exposures: (A) After making the first exposure, take up the tension of the film in the cassette by turning the film rewind crank (1). (B) Depress the film rewind button (2), usually located on the bottom of the camera. (C) Hold the film rewind crank firmly and cock the shutter (3), making sure the film rewind button is still depressed. The second exposure can now be made.

Sometimes, however, the FILM PRESSURE PLATE is weak and too much film slack, or tension, allows the film frame to move slightly. The result is that the frames are not perfectly aligned and your two images will not overlap exactly as you expected. Always make some practice shots to see how your camera performs using this method of double or multiple exposure. A discussion of other methods and additional tips on how to properly expose for multiple exposures begins on page 387.

It is very important to become familiar with the VARIOUS PARTS AND FEATURES OF YOUR CAMERA in order to fully understand how to operate it. Diagrams with numbered identification are provided in every camera instruction manual. The example in this book (see Illustrations 8–11) can be used for reference for electronically controlled SLR cameras. Remember, however, that not all cameras have the same features, nor are those features located in the same positions; it's best to refer to the identification diagram for your specific camera.

To reiterate, currently the most versatile 35mm camera for professionals and amateurs alike is the single lens reflex type with electronic controls and features that include autofocus and autoexposure. The remarks that follow in this chapter about understanding exposure, focus, and depth of field are applicable to 35mm SLR cameras as well as many other types of cameras. However, the special characteristics of 35mm compact cameras, APS (Advanced Photo System) cameras, single-use cameras, and instant cameras are discussed in more detail in Chapter 8.

Regardless of the type of camera you use, one of the most basic and important factors in producing a successful photograph is PROPER EXPOSURE. Does the picture look as you intended, or is it too dark or too light? Of course, you can create a certain mood by purposely underexposing or overexposing a subject. However, most photographs are meant to represent the scene as the photographer saw it—and proper exposure is necessary in order to achieve that goal.

Making effective photographs depends a great deal on how well you understand the three major factors concerning exposure—film speeds, shutter speeds, and lens openings—and their interrelationships.

## Understanding Film Speeds (ISO)

The shutter speed and lens opening that the camera sets automatically or that you set manually to make an exposure largely depends on how sensitive the particular film is to light. Early films were not very sensitive and required long exposures. Old-time portrait photographers even used neck braces to keep their subjects' heads from moving while the shutter was open. Advances in chemistry enabled more sensitive films to be produced so pictures could be made with shorter exposure times. And since those films needed less exposure to register an image, faster shutter speeds could be used to enable photographers to stop action and clearly capture moving subjects.

Technical details aside, film is a piece of acetate or polyester that is coated on one side with light-sensitive chemicals. Light striking that coating, called the EMULSION, makes an invisible LATENT IMAGE that is only seen after being acted on by other chemicals during processing. What's important to photographers is knowing just how sensitive the emulsion of a film is to light, which is described as its FILM SPEED.

Based on its sensitivity to light, a film is generally said to be a SLOW-SPEED FILM, a MEDIUM-SPEED FILM, or a HIGH-SPEED FILM. (A

28. A choice of slow-, medium-, and high-speed films allows you to shoot in all photographic situations and light conditions. To capture these lazy lions in their shaded enclosure at the San Diego Zoo, a high-speed (ISO 400) film was used with a telephoto lens on a hand-held camera.

high-speed film is also called a FAST FILM.) As you might imagine, a high-speed film requires less light to make an image than a slow-speed film.

But how do you tell *exactly* how sensitive a film is to light in relation to all other films? A numerical rating system gives each film a specific film speed, commonly known as its ISO. The system was established by the International Standards Organization (ISO) and was adopted early in the 1980s by Kodak and other film manufacturers.

Prior to that time there were two sets of numbers to indicate film speeds. One rating system was determined by the American Standards Association, abbreviated ASA, and became the standard in the United States. Overseas in Europe, the German Deutsche Industrie Norm rated film speeds with a different numerical scale, abbreviated DIN.

The current ISO RATING SYSTEM is simply a combination of ASA and DIN numbers for films of the same speed. For example, a film formerly rated ASA 100, which is identical in speed to 21 DIN, is now identified as ISO 100/21°.

**For purposes of clarity in this book, film speeds will be indicated only by the first portion of the ISO number and will be written, for example, as ISO 100.** (This is the former ASA value; we follow the convention of photographic publications in ignoring the former DIN value when giving ISO film speeds.)

Because older cameras or exposure meters may carry only the ASA or the DIN film speed designations, you may need to know the equivalents as indicated side by side in the current ISO film speed system. They're listed in the following chart with the former ASA separated by a slash mark (/) from the former DIN.

As you'll note from the listing of ISO film speeds, there is a considerable range of speeds. In actuality, there are few films at the very slow and very fast ends of the range; the film speed limits of current 35mm films are ISO 25 to ISO 3200. Each different type of film is manufactured with only a few different film speeds, such as ISO 100, 200, and 400, which is the most common range of film speeds for color print films.

## ISO FILM SPEEDS

|         | 80/20°   | 400/27°  | 2000/34° |
|---------|----------|----------|----------|
|         | 100/21   | 500/28   | 2500/35  |
| 25/15°  | 125/22   | 640/29   | 3200/36  |
| 32/16   | 160/23   | 800/30   | 4000/37  |
| 40/17   | 200/24   | 1000/31  | 5000/38  |
| 50/18   | 250/25   | 1250/32  | 6400/39  |
| 64/19   | 320/26   | 1600/33  | 8000/40  |

An extensive list of current color and black-and-white films—and their ISO film speed ratings—appears in the forthcoming chapter that discusses films in more detail (see page 218).

As you'll discover, films have various characteristics in addition to film speed, which is why there are so many different types of films on the market. But what is especially important at this point is to understand the INTERRELATIONSHIPS OF FILM SPEEDS in regard to exposure.

You should always remember that the ISO NUMBERS tell you exactly how sensitive a film is to light in relation to all other films. For instance, a film rated ISO 64 is twice as sensitive as one rated ISO 32. Likewise, an ISO 200 speed film is twice as sensitive as an ISO 100 speed film, as is an ISO 1600 film compared with an ISO 800 film.

In each of these examples, and in all others when the film speed is doubled (2X), it will take two times as much light to make an exposure with the slower speed film as it does with the one rated at the higher speed.

29. Interrelationships of film speeds. Film speeds are represented by ISO numbers, which indicate how much more sensitive or less sensitive to light one film is in relation to another film. As depicted here, an ISO 400 film is twice (2X) as sensitive as an ISO 200 film and four times (4X) as sensitive as an ISO 100 film. Stated another way, an ISO 100 film is one-half (1/2X) as sensitive as an ISO 200 film and one-fourth (1/4X) as sensitive as an ISO 400 film (see text).

You can also state such ISO relationships conversely: An ISO 32 speed film is one-half as sensitive as an ISO 64 speed film, just as an ISO 100 film is one-half as sensitive as an ISO 200 film, and an ISO 800 film is one-half as sensitive as an ISO 1600 film.

By the same token, in each of the examples just cited, and in all others when the film speed is halved ($\frac{1}{2}$X), it will take one-half as much light to make an exposure with the higher speed film as it does with the one rated at the slower speed.

These film speed relationships can be extended mathematically. For example, an ISO 400 film is four times as sensitive to light as an ISO 100 film, and thus requires one-fourth ($\frac{1}{4}$X) as much light to make an exposure. Or, put the opposite way, an ISO 100 film is one-fourth as sensitive as an ISO 400 film and requires four times as much light to make an exposure. See Illustration 29.

To compare the sensitivity of films, you can make similar mathematical calculations for any film speed, not just those in the examples just mentioned. Refer again to the ISO film speed chart on page 35, and try it. Note that a few of the figures may have to be rounded off to the *standard* film speed numbers listed in the chart. For instance, an ISO 125 film is considered to be twice as sensitive as an ISO 64 film, even though two times 64 equals 128. (There is no ISO 128 film.)

If you study the ISO film speed chart, you'll notice that every third number is either twice (2X) or one-half ($\frac{1}{2}$X) the other number, depending on which direction you go on the chart.

Why should you care about these interrelationships of film speeds? Because they are also interrelated with the two exposure controls on your camera: the shutter speed and the lens opening (f/stop). When more light or less light is required to make a proper exposure, depending on the speed of the film you are using, you increase or decrease the amount of light by adjusting one or both of those controls. The interrelationships of shutter speeds and lens openings are explained later in this chapter.

As you probably realize, in order to make a proper exposure you should use an EXPOSURE METER, which "reads" the amount of light reflected by your subject or falling on it. Always remember that before the meter can correctly determine the shutter speed and lens opening to set for a proper exposure, you first must set the meter according to the ISO speed of your film so the meter knows how sensitive that film is to light.

Some exposure meters are hand-held models, but most meters are now built into the cameras themselves and they are capable of automatically setting the exposure. In addition, the metering systems

in many SLR cameras will give you the exposure information that's needed to *manually* set the shutter speed and lens opening, if desired. (A discussion of how to use built-in and hand-held exposure meters begins on page 69.)

Although you may depend on an AUTO-EXPOSURE CAMERA to automatically adjust shutter speeds and lens openings for proper exposures, it is still important for you to understand those two controls and how to use them creatively. By learning all about exposure settings, you can predict how your pictures will turn out, even when they are taken with an automatic camera. Don't be a photographer who just points the camera, shoots, and hopes for the best.

## Comprehending Shutter Speeds

Of the camera's two basic exposure settings, SHUTTER SPEEDS are easier to comprehend than lens openings. Shutter speeds determine *how long* light is allowed through the opened shutter to expose the film. These speeds are normally indicated on a SHUTTER SPEED CONTROL DIAL or in a LCD (LIQUID CRYSTAL DISPLAY) INFORMATION PANEL on 35mm single lens reflex cameras. Shutter speeds are also found on a control ring on the lenses of older non-SLR cameras, commonly called rangefinder cameras, which have leaf-type shutters. To manually set a shutter speed, you turn the shutter speed control dial (or lens ring) to a number that represents a fraction of a second or more and determines how long the shutter will be open. Note that most compact cameras feature auto-exposure and their shutter speeds cannot be adjusted by the photographer.

As to the range of shutter speeds, some electronically controlled FOCAL PLANE SHUTTERS in 35mm SLR cameras will make exposures as long as 30 seconds and as brief as 1/8000 second. With 35mm compact cameras, shutter speeds may only range from 1 second to 1/500 or 1/1000 second.

Always remember that the shutter speed dial or lens ring should never be set *between* the marked shutter speed positions, because inaccurate exposures and possible damage to the shutter mechanism may result. Sometimes there are exceptions to this rule for cameras with electronically controlled shutters; check your camera instruction manual.

On modern single lens reflex cameras, the SPECIFIC SHUTTER SPEEDS—from the longest exposure to the shortest—often include the following: 30 seconds, 15, 8, 4, and 2 seconds, 1 second, 1/2 second, 1/4, 1/8, 1/15, 1/30, 1/60, 1/125, 1/250, 1/500, 1/1000, 1/2000,

1/4000, and 1/8000 second. One SLR model even shoots as fast as 1/12,000 second. By comparison, very early cameras had standard shutter speeds of 1/25, 1/50, 1/100, and 1/200 second. Obviously, in terms of fractions of a second, the higher the number, the faster the shutter speed. That means that to stop action, such as at a sporting event, a fast shutter speed of 1/1000 or 1/2000 second would be a good choice. If you want the action to be blurred, a slow shutter speed such as 1/15 or 1/30 second would give that result.

For speeds longer than from 1 second to 30 seconds, you must set the shutter speed control dial to B or T. Most cameras today only have the B SHUTTER SETTING, which means bulb. Some also have a T SHUTTER SETTING, which means time. Both are used for TIME EXPOSURES.

30. In addition to helping control exposure, shutter speeds can be adjusted in order to blur or stop the motion of subjects, such as this street performer doing tricks on roller skates.

The difference is that with a B setting, you must hold the shutter release button down to keep the shutter open. If you release the pressure on the button, the shutter closes. The B setting can be traced to the early days of photography, when photographers made an exposure by squeezing a rubber bulb connected by an air hose to the shutter. The length of time the cameraman kept the bulb squeezed determined the length of time the shutter would remain open. (Note that the bulb setting does not refer to flashbulbs.)

When the shutter release is pressed with the setting on T, the shutter will remain open until the photographer presses the shutter button a second time. This frees the photographer from having to keep the shutter release depressed.

However, the same thing can be accomplished when making time exposures on the more common B shutter setting by using a LOCK-SCREW CABLE RELEASE or a TRIGGER-LOCK or PROGRAMMABLE RE-MOTE CORD. After screwing the flexible cable release into the camera's cable release socket, the cable's plunger is pressed to open the shutter, and a lock screw is tightened to keep it depressed. When the time exposure is complete, you release the lock screw and the plunger pops out to close the shutter. For cameras with electronically controlled shutters, a remote cord with a push-type trigger is plugged into a socket on the camera. You depress the trigger to open the shutter, which remains open until you release pressure on the trigger. The trigger can be locked to keep the shutter open for long time exposures. More sophisticated remote cords can be programmed for the total minutes and/or seconds of the time exposure. When the remote cord is triggered, the shutter opens for the programmed amount of time and then closes automatically.

Knowing the range of shutter speed settings and how to control them is not enough. You must also understand the INTERRELATION-SHIPS OF SHUTTER SPEEDS, because these are also interrelated with lens openings and film speeds.

31. Interrelationships of shutter speeds. Shutter speeds are represented by fractions of a second, which indicate how much more light or less light is admitted by one shutter speed in relation to another shutter speed. As depicted here, 1/60 second allows twice (2X) as much light to reach the film as 1/125 second, while 1/250 second admits one-half (1/2X) as much light as 1/125 second (see text).

For example, depending on the direction you turn the shutter speed control dial to the next shutter position, you either double (2X) or halve ($\frac{1}{2}$X) the amount of light that reached the film at the previous setting. Thus, switching from 1/125 to 1/250 second, you cut in half the amount of time the light has to reach the film. In doing so, you decrease the amount of light by one-half ($\frac{1}{2}$X). Or, switching from 1/125 to 1/60 second, you double the amount of time the light has to reach the film. In this case, you increase the amount of light two times (2X). See Illustration 31.

## Adjusting Lens Openings

Companion to shutter speeds in regard to exposure are LENS OPENINGS, which are also known as LENS APERTURES and LENS DIA-PHRAGMS. The relative size of the lens opening is indicated by numbers called F/STOPS.

Basically, the f/stop number indicates the relative amount of light that is allowed to pass through the lens. The smaller the number, such as f/2, the larger the lens opening and thus the greater the

32. The lens aperture, indicated by numbers called f/stops, can be adjusted to help control exposure. A small f/stop was used to purposely underexpose and create this silhouette of a surfer. The photograph was made with a telephoto zoom lens from a nearby fishing pier.

amount of light passing through the lens. A larger number, such as f/16, indicates that a smaller amount of light is passing through the lens. In this regard, it is easiest to think of the f/stop numbers as fractions.

Modern cameras have identical f/stop numbers, but the RANGE OF F/STOPS depends on the particular lens design and manufacturer. The most common f/stops—in order of size from the largest opening to the smallest—are f/2, f/2.8, f/4, f/5.6, f/8, f/11, and f/16. Some lenses may also have smaller openings, f/22 and f/32. At the other end of the scale, a few may have a wider f/1.2 or f/1.4 opening, or a nearby number such as f/1.5 or f/1.7. On some lenses, the largest opening may be only f/3.5 or f/4.5. Older lenses often had standard f/stop markings of f/3.5, f/4.5, f/6.3, and f/8.

As with shutter speeds and film speeds, you must understand the INTERRELATIONSHIPS OF F/STOPS. How much light passes through the lens is relative to the change from one f/stop to another. Moving from one f/stop number to the next closest f/stop either doubles (2X) the amount of light passing through the lens or cuts the amount of light in half (1/2X). It depends on the direction you move the f/stop— toward the wider lens opening (smaller f/stop number) or toward the smaller lens opening (larger f/stop number).

For example, if the lens opening is set at f/8 and you move it to the next largest opening, f/5.6, double the amount of light passes through the lens. Thus, the film receives twice (2X) the amount of light at f/5.6 as it does at f/8.

Going from f/8 to the next smaller opening, f/11, cuts the light coming through the lens in half. So the film receives one-half (1/2X) the amount of light at f/11 as it did at f/8. See Illustration 33.

You will recall how moving from one *shutter speed* to the next closest one either doubles or halves the amount of light. Because changing the *lens opening* from one f/stop to the next closest one also doubles or halves the amount of light, by now you should see

33. Interrelationships of lens openings. Lens openings are represented by numbers known as f/stops, which indicate how much more light or less light is admitted by one lens opening in relation to another lens opening. As depicted here, f/5.6 allows twice (2X) as much light to reach the film as f/8, while f/11 admits one-half (1/2X) as much light as f/8 (see text).

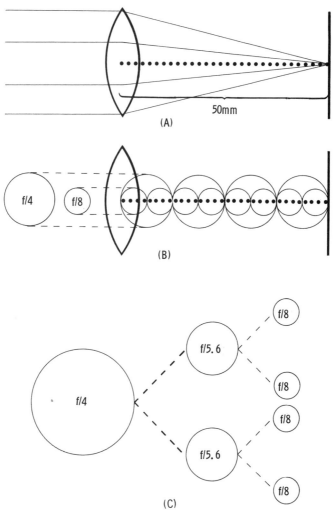

34. It's worthwhile to understand the relationships between focal length and f/stops. (A) The focal length of any lens is determined by measuring the distance from the optical center of the lens to the point behind it where light rays from an object at infinity are brought into focus (as on the camera's film plane). The example shows a 50mm lens. (B) Regarding f/numbers, they indicate what fraction of the focal length the lens diameter is. As illustrated, the diameter of an f/4 lens opening is one-fourth the focal length of the lens, while the diameter of an f/8 lens opening is one-eighth the focal length. Thus the diameter of a lens set at f/4 is twice that of an f/8 lens opening. (C) Because the diameter of an f/4 lens is twice that of an f/8, the area of an f/4 lens opening is four times as great as the area of an f/8 opening. Therefore, a lens set at f/4 admits four times as much light as a lens set at f/8. The area of an f/4 lens opening is twice as great as an f/5.6 opening, and thus doubles the amount of light admitted. Similarly, the area of an f/5.6 lens opening is twice as great as an f/8 opening, and admits double the amount of light.

how f/stops and shutter speeds are mathematically interrelated in regard to exposure.

However, while you might easily recognize how the next closest shutter speeds either double or halve the length of time during which light is allowed through the shutter onto the film, the f/stop numbers may not be as clearly understood. Don't you double the amount of light that passes through the lens at f/8 by moving the f/stop to f/4, instead of f/5.6 as indicated in the illustration? No. Following is an explanation, but don't let it throw you; also refer to Illustration 34.

The amount of light transmission is determined by the ratio of the diameter of the lens opening to the FOCAL LENGTH of the lens. (Technically, focal length is the distance from the optical center of a lens to the point beyond the lens where the light rays from an object at infinity are brought into focus.) The F/STOP NUMBER actually indicates what fraction the lens diameter represents in regard to the focal length of the lens.

For example, a lens set at f/8 has a diameter one-eighth its focal length. And a lens set at f/4 has a diameter one-fourth its focal length. Since the diameter of an f/4 lens is twice that of an f/8 lens (with the same focal length), its area is four times as great. That means a lens set at f/4 allows four times as much light to pass through than when it is set at f/8. So if you only want to double the amount of light passing through at f/8, f/5.6 would be the correct setting.

Confused? Don't worry about it; better mathematicians than we have worked out the f/stop number scale. Just accept it as fact. And remember that moving the f/stop to the next closest number either doubles or halves the amount of light passing through the lens, depending on the direction you move the f/stop.

Going toward a wider lens opening (a smaller f/stop number) is called "opening up the lens" or "going to a wider stop." Selecting a smaller opening (a larger f/stop number) is called "stopping down the lens" or "going to a smaller stop."

A FULL STOP refers to any one of the major stops listed previously. A HALF STOP refers to the midpoint between any two major stops. Actually, the f/stop can be set *anywhere* on the scale; it does not have to be set exactly on or between the marked f/stop numbers, even though some lenses have notches, called CLICK STOPS, to mark when the aperture is set to a full-stop or half-stop position.

Since it can be varied by any amount, think of adjusting the lens opening (f/stop) as using a car's accelerator. Shutter speeds, on the other hand, would be similar to a car's gear shift—they should be set

at marked positions to assure accurate speeds and to avoid mechanical damage. (As mentioned previously, some electronically controlled shutters allow settings to be made in between the marked speeds; check your camera instruction manual for specific advice.)

Why should you care about f/stops? For one thing, the lens opening you select helps determine depth of field—that is, how much of the picture area will be in focus (see later in this chapter). Just as important, as we emphasized earlier, f/stops are interrelated with shutter speeds and help determine the proper exposure for your film.

To understand the INTERRELATIONSHIPS OF F/STOPS AND SHUTTER SPEEDS in regard to exposure, you should first recall how the f/stops themselves are interrelated. As a review, if a lens that is set to f/8 is opened to a wider aperture, f/4, how much more light will that larger lens opening admit? Answer: f/4 admits four times as much light as f/8. (Since f/4 lets in twice as much light as f/5.6, and f/5.6 lets in twice as much light as f/8, f/4 lets in four times as much light as f/8—see Illustration 34-C.) Conversely, f/8 lets in only one-fourth as much light as f/4.

You can put such knowledge to practical use in terms of figuring proper exposures. For example, say an exposure meter reading indicates that the proper exposure for a lens that is set at f/4 requires a shutter speed of 1/250 second. If the lens is then set to a smaller

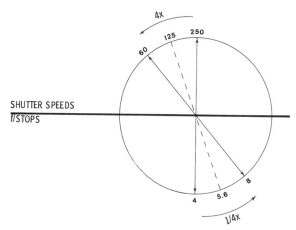

35. Study the interrelationships of shutter speeds and lens openings in regard to exposure. Although 1/60 admits four times (4X) as much light as 1/250 second, f/8 admits only one-fourth (¹/₄X) as much light as f/4. As a result, 1/250 second at f/4 and 1/60 second at f/8 both allow the same amount of light to reach the film, as does 1/125 second at f/5.6—each combination of shutter speed and f/stop gives the same exposure (see text).

aperture, f/8, what should the shutter speed be? Answer: 1/60 second. Because f/8 admits only one-fourth as much light as f/4, you have to slow down the shutter speed to increase the light by four times. (Since 1/125 second lets in twice as much light as 1/250 second and 1/60 second lets in twice as much light as 1/125 second, you let in four times as much light slowing the shutter speed from 1/250 to 1/60 second.) See Illustration 35.

We understand if you are confused, but knowing the interrelationships of lens openings and shutter speeds is necessary when you want to change one or the other. For example, if an exposure meter reading for a proper exposure is 1/125 second at f/5.6, it's easy to set comparable shutter speeds and f/stops without making additional meter readings. Using the matching scale shown in Illustration 36, you can see how various combinations of shutter speeds and f/stops will produce identical exposures.

Among the reasons for changing shutter speeds is to show motion in your photographs. This can be done by blurring the action with a slow shutter speed or stopping the action with a fast shutter speed. Also, in dim-light situations you may need a slow shutter speed to allow enough time for an image to be recorded on the film. And if sharp focus is required, a small f/stop opening should be used to extend the depth of field, and that often means a slower shutter speed is required.

Until the era of electronically controlled cameras arrived in the 1980s with AUTO-EXPOSURE (AE), adjusting shutter speeds and lens openings was always done manually by the photographer. The most versatile 35mm single lens reflex cameras now offer several auto-exposure modes. These so-called MULTIMODE EXPOSURE CAMERAS let

36. As the illustration shows, various shutter speed and f/stop combinations give the same exposure as 1/125 second at f/5.6. For example, 1/30 second at f/11 and 1/1000 second at f/2 admit the same amount of light as 1/125 second at f/5.6.

you choose aperture-priority, shutter-priority, programmed, and sometimes specialized auto-exposure modes, plus MANUAL EXPOSURE.

Multimode SLR cameras, as well as most 35mm compact cameras, feature a PROGRAMMED (P) exposure mode that automatically determines and sets both the shutter speed and the f/stop for a proper exposure. The shutter speed/aperture combinations are programmed by computer chips, allowing you to literally "point and shoot" the camera without any concern for exposure settings. (When using the programmed mode on an SLR camera, you must preset the aperture of the lens to its smallest f/stop opening.)

Some SLR models also have SPECIALIZED PROGRAMMED EXPOSURE MODES, sometimes labeled as Picture, PIC, or Vari-program modes. They automatically set exposures that the camera's computer chips figure will give the best results for certain subjects or situations, such as sports action, landscapes, portraits, and close-ups. Programmed auto-exposure allows you to react instantly to photo situations that suddenly occur, especially if your camera also features autofocus, because all you have to do is aim and shoot.

With multimode cameras set to the SHUTTER-PRIORITY (S) exposure mode, the photographer chooses a shutter speed and the camera's exposure metering system automatically sets the f/stop. When the camera is set to the APERTURE-PRIORITY (A) exposure mode, however, the procedure is reversed: the photographer selects an f/stop and the electronically controlled shutter automatically adjusts its speed to provide the exposure determined by the camera's exposure metering system. All these exposure controls are discussed in more detail in the following chapter.

## Figuring Focus

Out-of-focus photographs are disturbing if not altogether worthless. Sometimes a fuzzy photo is the result of camera movement rather than poor focusing, but proper focusing—whether automatic or manual—is often neglected. The basic rule is: Focus on the most important part of your picture. With portraits, for instance, focus should be on the eyes of your subject. Also remember that focusing is most critical when you are close to a subject, and when using a telephoto-type lens.

Be aware that even if your subject looks sharply focused in the viewfinder of your camera, it may not appear in sharp focus in the photograph. DEPTH OF FIELD actually determines how much of the

37. A simple adjustment in focus can make a great change in a photograph. The grillwork in the windows of a temple in India was shot in two ways. Here the camera lens was focused on the closest window in order to show the grill's detail.

38. In this case, the camera lens was focused on the window on the opposite side in order to show patterns in the grillwork. Such selective focusing is an example of the many ways to use a camera creatively.

picture from foreground to background will be in sharp focus, and this important concept will be explained later in this chapter. First, you should become familiar with various viewing and focusing systems for different types of cameras.

For example, subjects in the viewfinders of most compact cameras always appear sharp to your eye, while those in the viewfinders of single lens reflex cameras may not. That's because compact cameras have two lenses: one for viewing that is a nonadjustable lens and shows everything in focus, and a second lens that transmits the scene to the film and is adjusted for focus. On the other hand, SLR cameras have a single adjustable lens for both viewing the scene and transmitting it to the film, so if your subject looks out of focus in the viewfinder, it may be out of focus in the finished photograph (depending on the depth of field).

A significant decrease in the number of unsharp images can be attributed to the advent of 35mm AUTOFOCUS CAMERAS, including SLRs with AUTOFOCUS (AF) LENSES. They put an end to the frustrations of manual focusing for most photographers, especially those with less than perfect eyesight and those whose reflexes are too slow to focus sharply on moving subjects.

Autofocusing is common to most 35mm compact cameras, as well as APS cameras. They have permanently mounted lenses and cannot be focused manually, except for a few APS single lens reflex models. TO AUTOFOCUS A COMPACT CAMERA, you just aim it so your main subject is within the FOCUSING FRAME in the center of the viewfinder, and then press the shutter release button. As simple as it may seem to operate, autofocus is not foolproof. Autofocusing pitfalls for 35mm compact cameras, and ways to overcome them, are described in detail in Chapter 8.

By the way, you should be aware that many inexpensive compact cameras have FIXED FOCUS; no focusing adjustments can be made. These lenses, which are sometimes advertised as FOCUS-FREE LENSES, are designed to keep everything in focus from a minimum distance of 3, 4, or 5 feet (0.9, 1.2, or 1.5 meters) to infinity. As long as you are no closer to your subject than the minimum distance indicated in the camera's instructions, everything you see in the viewfinder will be in focus in the photograph.

Other inexpensive and mostly older cameras feature ZONE FOCUS. Instead of exact focusing distances, three symbols are marked on the lens focusing ring, and the photographer manually adjusts the focus according to whether his subjects are very close, nearby, or at a distance. Often the symbols are a single head to represent the point of

focus for portraits, the heads and shoulders of three persons to sym-
bolize the focus point for group shots, and the outline of a mountain
to indicate the focus setting for scenic pictures.

As to FOCUSING 35MM SINGLE LENS REFLEX CAMERAS, a few models
allow only manual focusing, but the most versatile SLRs are capable
of both autofocusing and manual focusing. To focus an SLR manu-
ally, you look through the viewfinder and turn the LENS FOCUSING RING
of the lens until the main subject appears sharp to your eye (see
Illustration 39). Make certain the FOCUS CONTROL SWITCH on the lens
and the FOCUS MODE SELECTOR on the camera are both set to manual
(M) before manually focusing an autofocus SLR.

To autofocus an SLR, first you aim the camera so your subject is
at least partially located within the FOCUS DETECTION AREA marked by
a circle or brackets in the viewfinder, then you slightly depress the
shutter release button, which activates a micromotor to automati-
cally adjust the focus of the lens. The focus control switch on the
lens must be set to automatic (A), and the focus mode selector on the
camera must be set to one of its two automatic modes, which are
generally known as SINGLE SHOT (S) and CONTINUOUS FOCUS (C). (More
details appear in the chapter about lenses.)

Because single lens reflex cameras have interchangeable lenses,
including wide-angle, telephoto, zoom, and macro, designing auto-
focus lenses for SLRs presented a special challenge to manufac-
turers. As a preliminary step, a few manual-focus models were
introduced in the early 1980s with an electronic IN-FOCUS INDICATOR in

**(A)**                           **(B)**                           **(C)**

39. Camera focusing systems vary, as do the images of subjects you see in or out
of focus in the viewfinder. With *manual focus* cameras, the subject is out of
focus when a twin image (or split image) (A), or a fuzzy image that often is exag-
gerated in a center circle (B), appears in the viewfinder. The subject is in focus
only when it appears sharply defined (C). With *autofocus* cameras, a fuzzy image
appears in the viewfinders of SLR cameras until the lens focuses on your subject;
subjects in the viewfinders of compact cameras always appear sharp to your eye,
whether or not they are in focus. Check specific details about your camera's
focusing system in the instruction manual.

the viewfinder. The feature has since been updated and incorporated into modern autofocus and manual-focus SLR cameras.

It is now a sophisticated rangefinder that signals when your subject is in sharp focus with an audible beep and/or a tiny light or round symbol appearing in the viewfinder. There are usually three visual indicators: a solid green or black circle that appears when the lens is in focus, and a pair of opposing red or black directional arrows that take turns appearing when the lens is not in focus. The arrow that is illuminated points in the direction the lens must turn, whether adjusted automatically or manually, in order to bring the subject into focus.

Autofocus lenses have improved considerably over a short span of years. Today's models feature quicker response time, greater accuracy, lighter weight, smaller size, and much less cost than the early AF lenses. In Chapter 3 you'll learn more about the use and abilities of SLR autofocus lenses, as well as some of their limitations.

Focusing is always more difficult in dim light, although the viewfinders of most SLR cameras feature a bright FOCUSING SCREEN. In addition, SLR lenses usually have an AUTOMATIC APERTURE that always remains open at its widest f/stop to admit the maximum amount of light for easier focusing. When the shutter is fired, the aperture stops down to make the exposure and then automatically reopens to its maximum f/stop. If the lens aperture is not automatic, you should open it manually to the widest f/stop for focusing, then stop down to the correct f/stop for proper exposure.

Some SLR cameras that can only be focused manually have a focusing screen that features a SPLIT-IMAGE RANGEFINDER to help you focus. (It is not found on autofocus models that can also be focused manually.) This rangefinder causes two identical subject images to be seen in a circle in the center of the viewfinder until you turn the lens focusing ring to bring them together as one sharp overlapping image.

Also on some manual-focus-only SLRs, the split-image circle is surrounded by another focusing aid, a MICROPRISM FOCUSING COLLAR that shimmers when your subject is out of focus and clears up when the subject is in sharp focus. In dim light, or with lenses that have a limited maximum aperture, one-half of the split image may appear black, especially if your eye is not centered in the viewfinder. If part of the split image goes black, you'll have to rely on the microprism collar and the overall focusing screen to determine when the subject is in focus.

The focusing ring on all SLR lenses is engraved with a DISTANCE SCALE to indicate the point of focus. The scale is usually marked in

both feet and meters; if the double set of numbers confuses you, cover either the meter scale or the footage scale with black tape or with ink from a felt-tipped pen.

On the distance scale, you'll notice that the greater the distance, the fewer the footage or meter designations given. The point or distance at which everything beyond will be in focus, INFINITY, is indicated by an elongated eight on its side, ∞, or INF.

The distance scale is actually the most basic focusing aid, because you can measure or guess the number of feet or meters to your subject and then use the scale to set that distance at the POINT OF FOCUS INDICATOR (also called the DISTANCE INDICATOR or DISTANCE INDEX) on the lens barrel.

Some lenses are also marked with an INFRARED FOCUS INDICATOR, which is a red R, line, or dot that indicates where to set the distance scale when shooting with *black-and-white* infrared film. This type of film records not only light energy but infrared radiation, so its point of focus is slightly different from the focus point for conventional films. Focus as you would normally, then reset the distance to the red R, line, or dot. Generally this change is so slight that no focus compensation is required with lenses having a focal length of 50mm or less that are stopped down to at least f/8—thanks to their considerable depth of field. Also, disregard the infrared focus indicator

40. One guideline for good composition is to fill up the film frame with your subject, which means you should only include in your viewfinder what you want to see in the photograph. However, viewfinder coverage varies from camera to camera, so check the instruction manual to know the specific coverage of your model (see text).

when using *color* infrared films; their point of focus is similar to that for conventional films. (Photographing with infrared films is discussed in detail beginning on page 383.)

An important component in focusing systems is the camera's viewfinder, and two aspects are of particular interest, especially VIEWFINDER COVERAGE. You should be aware that what you see in the viewfinder may cover only about 90 percent of what is recorded on the film. In other words, there is about 10 percent more of your subject captured on film than is seen in your viewfinder. Only a few professional-model SLR cameras have viewfinders that actually show 100 percent of the image the film will record.

However, don't feel cheated, because the edges of the image you don't see in the viewfinder are routinely cropped (i.e., eliminated) by the automatic photofinishing machines that make most of today's snapshot-size prints, or are covered up by the plastic or cardboard mount that surrounds slide transparency images. Thus, what you see in the viewfinder is pretty much what should appear in the final photo.

Of course, the negative or transparency image may not have been cropped proportionally on all edges. If a portion of the picture you saw in the viewfinder does not appear in the print or slide, check the negative or remove the transparency from its mount to look for the missing part of your subject, then have the print remade or the slide remounted to include it. Technical specifications listed in most camera manuals will indicate the approximate viewfinder coverage, so you'll be able to figure the additional percentage of your subject that will appear on the film.

The camera's specifications should also indicate VIEWFINDER MAGNIFICATION. Ideally, for a 35mm SLR camera it would be 1.0X magnification, which means you'd view a life-size image of what the film sees through a normal 50mm lens focused at infinity. In reality, viewfinder magnification is considerably less, often only 0.7X (seventenths life-size). Of course, the greater the magnification, the easier it is to view your subject and focus the image.

Older SLRs boast the most magnification, about 0.9X, but that was before exposure metering and other data were displayed inside the viewfinder. In order to accommodate the LCD (liquid crystal display) and LED (light-emitting diode) information displays spawned by auto-exposure, autofocusing, and other features of modern SLRs, the focusing screen in the viewfinder had to be reduced in size, and magnification of the subject's image diminished accordingly.

To put a positive spin on viewfinders with reduced magnification, camera manufacturers termed them HIGH-EYEPOINT VIEWFINDERS and

promised photographers that they would be able to see everything easily in the viewfinder, even if they wore eyeglasses.

Since it is imperative to get your eye as close to the viewfinder as possible, manufacturers had earlier introduced a rubber EYECUP as an accessory. An eyecup prevents eyeglasses from being scratched on the viewfinder's eyepiece, and blocks light from your peripheral vision so it is easier to view and focus on your subject.

A welcome feature on better SLR cameras is a DIOPTER CORRECTION CONTROL, which can be adjusted to sharpen your vision within the viewfinder. After focusing on a subject, you turn a small knob on the viewfinder that adjusts its optics to correct for your particular eyesight so the image will appear as sharp as possible.

If there is no diopter control, the eyepiece on some viewfinders can be changed to one of a specific diopter that corrects for any farsightedness or nearsightedness in your vision. These optional EYE-PIECE CORRECTION LENSES, or the adjustable built-in control for diopter correction, allows photographers to remove their eyeglasses when using the camera, if desired.

The best aid to focusing and framing may be to simply change the way you hold the camera to your face. Sometimes your nose gets in the way and that keeps your eye too far from the viewfinder; turn your head slightly so the camera back rests against one cheek. Just remember that you must be able to see the full image within the viewfinder in order to focus and frame properly.

## Dealing with Depth of Field

Aside from basic focusing, the concept of DEPTH OF FIELD plays a very big role in the outcome of your pictures. You can assume that the specific part of the subject on which you focus will turn out sharp in the resulting photograph, but how much more of the picture will also be in focus? It depends on several factors: the focal length of your lens, the f/stop used, and the distance at which the lens is focused.

To help you accurately determine—and control—how much of the picture area will be in sharp focus from foreground to background is a DEPTH OF FIELD SCALE. With small-format cameras, it is common on manual focus lenses and also found on some SLR autofocus lenses. (While the concept of depth of field applies to all lenses, most automatic compact cameras have no depth of field scale and offer no way to manually control depth of field.)

Unfortunately, SLR zoom and telephoto lenses, especially auto-

41. The aperture setting (f/stop) and focusing distance of a lens determines depth of field—how much of the picture area will be in focus. To make only the nearest pelican wood carvings stand out in sharp focus, the lens was focused on them and set to its widest opening, f/2.8.

42. Using a small lens opening increases depth of field. The focusing distance was kept the same as in the first picture, but the lens aperture was stopped down to f/22, which brought all of the carved birds (and the background) into sharp focus (see text).

focus types, often lack a depth of field scale. However, a DEPTH OF FIELD CHART may be included with the lens instructions and can be used in place of an actual scale on the lens to figure the extent of the picture area that will be in focus.

Most convenient is the depth of field scale because it is engraved on the lens barrel and available for quick reference. The scale consists of matched pairs of numbers that correspond to f/stops. They are located on either side of the POINT OF FOCUS INDICATOR on the lens. Because of space limitations, not all the corresponding f/stop numbers are always included on the depth of field scale. Some are represented by lines, while others you'll have to imagine as being there. For instance, if 5.6 is missing from the scale, you know it falls midway between 4 and 8.

Some camera lenses, like Nikon's manual-focus lenses, use a color-coded depth of field scale; colored lines on the lens barrel correspond to the colors of the f/stops engraved on the aperture control ring.

Remember that the scales vary according to the lens. Some types of lenses, such as wide-angle lenses, offer considerable depth of field and the scale is more spread out. For lenses with limited depth of field, such as telephoto lenses, the scale will appear jammed together. Regardless, the scale will tell you how much of your photograph will be in focus.

Here's the procedure. After focusing on your main subject and making an exposure meter reading to determine the f/stop and shutter speed settings for a proper exposure, check the lens depth of

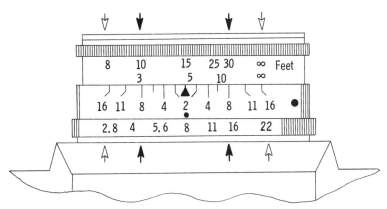

43. Figure depth of field on this 50mm lens. With the lens focused at 15 feet and its opening at f/8, the subject area from 10 to 30 feet away will be in focus (see black arrows). If the lens opening is reduced to f/16, depth of field increases and subjects from 8 feet to infinity will be sharply focused (see white arrows).

field scale. First note the f/stop selected, and find the corresponding pair of numbers on the depth of field scale. Then look opposite those numbers to the distance scale on the lens focusing ring. The footage (or meter) markings that appear indicate how much of the picture area will be in sharp focus.

For instance, in the diagram of the 50mm lens in Illustration 43, with the focus at 15 feet and the f/stop set at f/8, the reading opposite the two 8s on the depth of field scale indicates that the area from 10 to 30 feet will be in focus.

Change the point of focus and the depth of field will also change. Similarly, change the f/stop and the depth of field will increase or decrease. Referring again to Illustration 43, by stopping down the lens to f/16, everything from 8 feet to infinity will be in focus. Opening the lens to its widest f/stop, f/2, reduces the in-focus area to subjects at 15 feet. At f/4, depth of field increases and includes everything from 13 to 20 feet. Thus, the smaller the f/stop, the greater the depth of field. And conversely, the wider the f/stop, the less depth of field you'll get.

Using the depth of field scale (or chart) is not just a way to check how much of your picture area will be in focus *after* you've focused. You can use depth of field creatively to make certain that only a specific portion of the picture area is in focus, as when you want to isolate your subject and make it stand out from a distracting background. Do this by focusing on the *closest* object you want to be sharp, and note that distance on the lens focusing scale. Then refocus on the most *distant* object you want in focus and note that distance on the focusing scale.

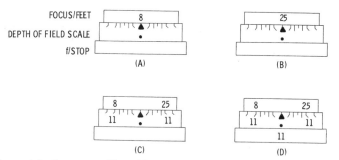

44. To be certain that a specific subject area will be in focus, you can put depth of field to practical use. (A) First focus on the nearest object (8 feet) you want in focus. (B) Then focus on the most distant object (25 feet) you want in focus. (C) Next turn the lens focusing ring until those two distances (8 and 25 feet) fall within a matched set of numbers (11) on the lens depth of field scale. (D) Then set the f/stop to the corresponding number (f/11). Finally, make an exposure reading to determine the correct shutter speed to use with f/11, which is the f/stop required for the desired depth of field (8 to 25 feet).

Now manually turn the focusing ring until the two distances you noted fall within a *matched* set of numbers on the depth of field scale. Then set your lens opening to the f/stop number corresponding to the selected pair of numbers on the depth of field scale. Finally, after making a manual exposure reading, or using the aperture-priority mode on an auto-exposure camera, set the correct shutter speed for the f/stop you're using. Frame and shoot. You've got the picture you wanted with the focus you needed. See Illustration 44.

Remember, of course, not to refocus visually through the viewfinder (nor switch to autofocus) after you've set the lens focusing ring to accommodate the two limits of focus within the depth of field scale. Although your subject may not look sharp in the viewfinder, the picture area indicated on the depth of field scale according to the f/stop you've selected will be in focus.

Sometimes, regardless of how much you stop down (to f/16,

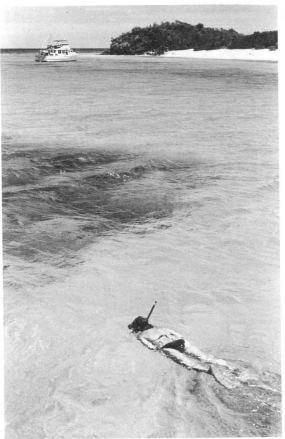

45. A small lens opening (f/stop) was used to achieve great depth of field so that everything in this picture would be in sharp focus—from the snorkeler in the foreground to the boat in the background (see text).

for example), the area from foreground to background may be too vast to allow you to get it completely in focus. To overcome this, move back from the nearest foreground subject you require in focus, or change to a lens with greater depth of field, such as a wide-angle lens.

Without a depth of field scale or chart for reference, photographers using single lens reflex cameras must trust their eyes to show them what will be sharply focused. You can do this best with the aid of a DEPTH OF FIELD PREVIEW DEVICE, which is found on some SLR cameras. Since the lenses of modern SLRs feature an automatic aperture that is always open to the widest f/stop for easy focusing and viewing, many camera manufacturers have included a special button, lever, or switch that will stop down the lens to any selected f/stop number.

Because a smaller f/stop opening increases depth of field, photographers get a visual idea when looking in the viewfinder through a stopped-down lens of how much of the picture area will be in sharp focus. However, it is a guess at best. The smaller f/stop openings also mean a darker view in the finder and more difficulty in seeing the overall subject area. The sharpness of a person's vision varies, too.

If you focus lenses manually, and a sudden picture situation occurs that doesn't give you time to focus critically in the viewfinder, knowing the HYPERFOCAL DISTANCE of a lens can be very helpful. With it, you can quickly set the focus and be certain how much of the picture area will be sharply focused without even looking. In technical terms, hyperfocal distance is the point of focus at which subjects from half that distance to infinity are in focus. It varies according to the focal length of a lens and the f/stop used. In practical terms, hyperfocal distance tells you how close you can get to a subject to keep it and everything beyond it in focus.

To easily determine the hyperfocal distance of a lens, set the f/stop desired and then turn the lens focusing scale until its infinity mark is opposite that f/stop number on the depth of field scale. The hyperfocal distance is now opposite the point of focus indicator. The distance on the lens focusing ring opposite the other identical f/stop number on the depth of field scale will indicate the point closest to the camera that will be in focus. It will be half the hyperfocal distance.

For example, referring to Illustration 46, with a 50mm focal length lens and its aperture at f/8, turn the focusing ring until the infinity mark is opposite 8 on the depth of field scale. The distance opposite the point of focus indicator on the lens is 30 feet. This is the hyperfocal distance of a 50mm lens at f/8. Looking opposite the other 8 on the depth of field scale shows that 15 feet is the point closest

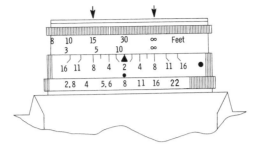

46. Hyperfocal distance is the point of focus at which subjects from half that distance to infinity are in focus. In this illustration, with a 50mm lens set at f/8, the hyperfocal distance is 30 feet. As the black arrows indicate, when the lens is set to this hyperfocal distance of 30 feet, the subject area from 15 feet to infinity will be in focus.

to the camera that will be in focus. Correctly, it is half the hyperfocal distance of 30 feet. Using this example, you could quickly set the lens opening to f/8 and the focusing ring to 30 feet, and would know that everything in the picture from 15 feet to infinity would be in focus.

Of course, if the exposure meter reading calls for a lens opening other than f/8, the hyperfocal distance and thus the subject area in focus would change. Likewise, the shutter speed would have to be readjusted for a proper exposure. Always remember that under the same lighting conditions, whenever you change the f/stop you must change the shutter speed, and vice versa; auto-exposure cameras will make these adjustments automatically. More information about determining exposure follows in the next chapter.

## Recognizing Some Common Photo Abbreviations

In this first chapter we have given a few abbreviations that also appear frequently in photographic magazines and other literature. Although these and other abbreviations are described at the end of the book in Appendix A, "A Glossary of Photographic Terms," here's a summary of meanings for some of the more common abbreviations relating to cameras and photography.

AA = size of batteries often used to power cameras, flash, and other photo equipment

AE = auto-exposure; short for automatic exposure

AF = autofocus

APS = Advanced Photo System; commonly refers to a small-format type of automatic camera

ASA = American Standards Association; commonly refers to former rating system in the U.S. for film speeds; now superseded by ISO (see below)

CdS = cadmium sulfide; type of light-sensitive cell in an older camera's exposure metering system or an older hand-held exposure meter

DIN = Deutsche Industrie Norm; commonly refers to German (European) rating system for film speeds; now superseded by ISO (see below)

DX = data exchange; a symbol indicating a film cassette is encoded to electronically set an automatic camera with the film's speed, number of exposures, and exposure latitude

EE = electric eye; a name for early auto-exposure cameras; also, a photocell sensor (now rare)

EI = exposure index; correct term for the speed of a film whenever that film is rated at other than its official ISO film speed; also abbreviated E.I.

EV = exposure value; system of numbers to indicate the range of sensitivity of a camera's exposure metering system or a hand-held exposure meter

f/ = f/stop; a number that indicates the relative size of the lens opening (aperture)

ISO = International Standards Organization; commonly refers to a system of numbers indicating the relative speed (i.e., sensitivity) of films

LCD = liquid crystal display; electronic-powered information panels in cameras, flash units, and exposure meters that present digital readouts to the user

LED = light-emitting diode; tiny light(s) signaling various functions in cameras and other photo equipment

OTF = off-the-film; generally indicates that the camera's exposure metering system reads the light at the film plane; usually for flash exposures

P&S = point-and-shoot; unflattering term for compact type of automatic camera

SBC = silicon blue cell; type of light-sensitive cell in a camera's exposure metering system or a hand-held exposure meter

SPD = silicon photo diode; type of light-sensitive cell in a camera's exposure metering system or a hand-held exposure meter

SLR = single lens reflex; most versatile type of 35mm camera

TTL = through-the-lens; generally indicates that the camera's exposure metering system reads the light that passes through the lens

# Determining Exposure

P hotographers most always depend on an EXPOSURE METER (also called a LIGHT METER) to determine the proper exposure for their pictures. Modern 35mm SLR and compact cameras feature BUILT-IN EXPOSURE METERING SYSTEMS, but there also are HAND-HELD EXPOSURE METERS used independently of the camera. Both built-in and hand-held meters incorporate a photocell that "reads" the light reflected by your subject, or falling on your subject, and then indicates the lens opening (f/stop) and shutter speed that should produce a perfectly exposed picture. When the meter is built into an AUTO-EXPOSURE CAMERA, it even sets that exposure for you.

However, an exposure meter is far from being foolproof. You must know how these light-reading meters operate, and how to best use them in order to obtain the photographic results you want. Three important aspects of exposure—film speeds, shutter speeds, and lens openings—were discussed in the previous chapter. Be certain to read that information before continuing with this chapter.

## Setting the Film Speed (ISO)

The first step in making an exposure reading is especially important: the meter must be set to the speed (ISO) of the film you are using. That indicates to the exposure meter how sensitive the particular film is to light, which enables the meter to calibrate exposure settings accurately. If the meter's ISO setting is incorrect, all of the meter's exposure calculations will be wrong.

Setting the ISO on built-in and hand-held meters depends on whether ISO numbers are shown on an LCD (liquid crystal display) information panel or on a film speed dial. With an LCD INFORMATION

47. Computerized exposure metering systems built into today's cameras are remarkable for their ability to determine the best exposure. A through-the-lens (TTL) multizone metering system automatically set the exposure for this young Tarahumara Indian mother and child in Mexico.

PANEL, the full range of ISO numbers is digitally displayed in succession as you rotate a control dial or press buttons to set the speed of the film. With a FILM SPEED DIAL, the ISO numbers are engraved on the dial, which you turn to set the appropriate film speed. However, dots or lines are used to indicate some of the ISO numbers because the dial is too small to show the full range of actual numbers. The ISO film speeds that those dots or lines represent will be found in the camera or meter instruction manual.

Otherwise, you can refer to the full range of ISO settings in the following chart. Those numbers in boldface type are the ones most often engraved on film speed dials, while the italicized figures represent those usually indicated only by dots or lines.

## RANGE OF FILM SPEEDS (ISO) ON EXPOSURE METERS

| | | | |
|---|---|---|---|
| **6** | *40* | *250* | **1600** |
| *8* | **50** | *320* | *2000* |
| *10* | *64* | **400** | *2500* |
| **12** | *80* | *500* | **3200** |
| *16* | **100** | *640* | *4000* |
| *20* | *125* | **800** | *5000* |
| **25** | *160* | *1000* | **6400** |
| *32* | **200** | *1250* | |

## Setting the ISO Automatically with DX-Coded Films

Fortunately, most of today's 35mm cameras have a built-in exposure metering system with a feature known as DX, an abbreviation that can be thought of as DATA EXCHANGE. Any film cassette marked DX is capable of presetting the camera's exposure meter with the appropriate film speed (ISO). That means you don't have to physically set the ISO number; it's done automatically when the film cassette is loaded in the camera. After being introduced by Kodak in 1984, this very welcome innovation was adopted by all film and camera manufacturers.

Every 35mm film with a DX symbol has a black-and-silver pattern on the film cassette that touches electrical contacts in the film chamber of a DX-compatible camera to automatically set the film speed. DX-coded film and cameras solved an age-old problem: incorrect exposures caused by photographers who changed to a film with

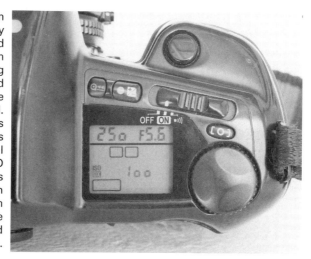

48. Modern 35mm cameras automatically preset the film speed for the built-in exposure metering system when loaded with any film cassette showing a DX symbol. Many single lens reflex (SLR) models will confirm the actual ISO setting in an LCD information panel, as shown here (100). In addition, you can bypass the DX feature and set the film speed manually (see text).

a different ISO speed but forgot to change the exposure meter's ISO setting accordingly.

The metering system in 35mm compact cameras always sets to the DX-coded film speed automatically; there is no way for you to set the film speed manually. However, the metering system in single lens reflex cameras can be set to the film speed manually by the photographer or automatically by the DX-coded film cassette. For automatic operation, you must first set the SLR's film speed control to DX. For manual operation, you set the control to a specific ISO number.

What happens if your SLR camera's film speed control is set to DX but you load a cassette with a defective DX code or one without a DX code, such as infrared film? Some cameras will give a visual and/or audible warning, or lock the shutter release; check your camera's instruction manual so you'll know what to expect.

Be careful that you don't accidentally change the film speed setting. The film speed control on some cameras is easily moved, and it may shift off DX or to a different ISO number without your noticing it. It's smart to occasionally check that the film speed setting for your exposure metering system is correct for the film in your camera. And remember to always check this when changing from one type of film to another with a different speed.

Here's how to check the film speed being used by your SLR's metering system when the film speed control is set to DX. For cameras with an LCD information panel, you can press a FILM SPEED BUTTON to display the specific ISO number of the film in the camera. If there is no LCD panel to show the actual ISO, take an exposure

meter reading at the DX setting, then turn the film speed dial to the ISO of the film in the camera and take another exposure meter reading of the same subject—the two meter readings should be identical.

With an SLR camera, if you ever want to expose a roll of DX-coded film other than at its rated speed, you must change the film speed control from the DX setting to the specific film speed desired. One reason photographers change from the film's actual ISO to a different film speed is to purposely underexpose or overexpose the film for special effects. Take note that this revised film speed, since it is not the film's official ISO, is more accurately called its EXPOSURE INDEX, abbreviated EI.

For example, photographers shooting color slide film who want more color saturation may underexpose slightly, such as by rating an ISO 50 film at an exposure index of 64, the equivalent of one-third f/stop underexposure. And those shooting black-and-white film who want more detail in the shadows may overexpose, such as by rating an ISO 400 film at an exposure index of 320 or 250, the equivalent of one-third or two-thirds f/stop overexposure, respectively.

Also, rating a film's speed at a higher exposure index, such as an ISO 400 film at EI 800 or an ISO 1600 film at EI 3200, is sometimes done in low-light or action-stopping situations when a photographer needs a high-speed film but does not have it available; such changes in film speed ratings require special processing for proper exposure results. (Read more about "pushing" films to higher exposure indexes in Chapter 5.)

## Understanding Automatic Exposure (AE) Controls

The advent of exposure meters made it easier to figure correct exposures, but photographers still had to manually adjust the LENS APERTURE (F/STOP) and SHUTTER SPEED before taking a picture. Attempts at automation began back in 1938 with Kodak's introduction of the first ELECTRIC EYE (EE) CAMERA.

Fully automatic exposure control finally arrived during the last decade of the twentieth century and prompted a worldwide boom in amateur photography. Thanks to computer-chip technology, sophisticated automatic exposure systems in modern cameras swept aside the past frustrations of getting properly exposed pictures.

49. An advantage of auto-exposure cameras is that you can react quickly to make candid shots—as when strollers passed this wall mural in Venice, California—without taking time for manual exposure readings and adjustments.

Today's AUTO-EXPOSURE (AE) CAMERAS make life simple for photographers. After framing your subject in the camera's viewfinder, you *slightly* depress the shutter release button to activate a photocell that reads the light being reflected by your subject and triggers a microcomputer to instantly adjust both the lens opening and shutter speed for a proper exposure. (The film is exposed when you fully depress the shutter release button.) Automatic exposure is the main reason for the popularity of 35mm compact cameras, dubbed point-and-shoot (P&S) cameras, and their more versatile big brothers, 35mm single lens reflex (SLR) cameras.

Basic automatic exposure had evolved into some seemingly complex SLR cameras with at least three auto-exposure options. In order to give the photographer complete control of exposure, these so-called MULTIMODE EXPOSURE CAMERAS feature a choice of PROGRAMMED (P), APERTURE-PRIORITY (A), SHUTTER-PRIORITY (S), as well as MANUAL (M) exposure control.

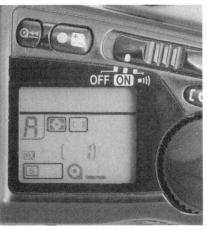

50. Single lens reflex (SLR) cameras featuring multimode exposure have an exposure mode selector or control dial for choosing programmed (P), shutter-priority (S or Tv), aperture-priority (A or Av), or manual (M) exposure. These two cameras have been set to aperture priority (A).

To select a specific auto-exposure mode or manual exposure, the SLR camera's EXPOSURE MODE SELECTOR or CONTROL DIAL is turned to the appropriate letter designation (P, A, S, M), or turned until the letter designation appears in the camera's LCD information panel. The exposure mode you select is also indicated in the viewfinder. Note that some camera manufacturers designate aperture-priority as Av (for aperture value) and shutter-priority as Tv (for time value).

In the PROGRAMMED (P) MODE, the camera automatically sets both the shutter speed and lens opening for a correct exposure. Its micro-computer is preprogrammed with a series of shutter speed and f/stop combinations based on the ISO film speed setting, the amount of light transmitted through the lens, and the focal length of the lens being used. It favors faster shutter speeds to prevent blurred pictures caused by camera shake, especially with the use of a telephoto lens. Photographers select programmed auto-exposure for quick operation of the camera and to concentrate on the picture's composition without having to worry about exposure. It's the ideal choice for candid photography, so that you'll always be ready to take an impromptu picture.

In the APERTURE-PRIORITY (A OR Av) MODE, you set the lens opening and the camera's microcomputer automatically sets the shutter speed. By selecting the f/stop, you have control of depth of field— how much of the picture area from foreground to background will be in sharp focus.

In the SHUTTER-PRIORITY (S OR Tv) MODE, you set the shutter speed

and the camera's microcomputer automatically sets the lens opening. Selecting the shutter speed gives you control over stopping the action with a faster speed, or creating the feeling of motion by letting the action blur with a slower shutter speed.

The MANUAL (M) MODE is used to override automatic exposure and give personal control of exposure to the photographer, who selects and sets *both* the shutter speed and the lens opening. This allows you to purposely overexpose or underexpose the film by shooting at various shutter speeds or f/stops, a technique called BRACKETING (see later in this chapter).

Many multimode auto-exposure SLR cameras have another feature, a so-called PICTURE, PIC, or VARI-PROGRAM MODE, which is a selection of specialized preprogrammed exposure modes for common shooting situations or subjects. Most often included are portraits, landscapes, sports or action, close-ups, night scenes, and/or silhouettes. Each mode is designated by a symbol (also called an icon) or an abbreviation, such as a face or PO for portraits, a mountain or LA for landscapes, and a flower or CU for close-ups.

Camera manuals give specific details concerning which mode to select for the effect desired—such as landscapes, which presets a smaller lens opening to put both foreground and background in sharp focus. Keep in mind, however, that such *preprogrammed picture exposure modes are not foolproof and often will not produce the image you envisioned.* For instance, the close-up (CU) program often sets a wide lens opening to limit how much of the picture area will be in focus so that the main close-up subject stands out sharply against a fuzzy background. Obviously, if you want both the close-up subject *and* the background to be in focus, using the close-up picture mode would be a mistake; instead, you must choose an f/stop setting that gives increased depth of field (see page 55).

Before becoming fully computerized, auto-exposure SLR cameras offered a single auto-exposure mode, in addition to manual exposure control. Those early models, some of which are still in use, were either aperture-priority *or* shutter-priority.

To use those older cameras featuring aperture-priority, sometimes called APERTURE-PREFERRED CAMERAS, the shutter speed dial is turned to the A or Auto position and the photographer sets the f/stop. When the shutter release button is pressed, the shutter speed is automatically set to correctly expose the film. To shoot with those older cameras featuring shutter-priority, sometimes called SHUTTER-PREFERRED CAMERAS, the lens aperture ring is turned to the position marked A or EE (electric eye) and the photographer sets the shutter

51. Once you fully understand your camera's auto-exposure controls, you can concentrate on composition and your subject rather than worrying about proper exposure.

speed. The f/stop is automatically set when the shutter release button is pressed to expose the film.

As mentioned earlier, today's popular compact cameras feature auto-exposure, but unlike with modern SLR cameras, there is no choice of AE modes, nor can exposures be set manually. However, some models feature a few controls to override or adjust the automatic exposures; a detailed discussion of 35mm compact cameras begins on page 276.

## Understanding Exposure Metering Systems

Auto-exposure cameras rely on built-in exposure metering systems, which have become fully computerized and very sophisticated. Initially photographers had only hand-held exposure meters to read the light and suggest the lens opening and shutter speed to set on the camera for a proper exposure. Then photocells became part of 35mm cameras. A photocell receptor was positioned on the front of the camera to read the light and send signals to a fluctuating needle in the viewfinder; by turning the lens aperture control ring or shutter

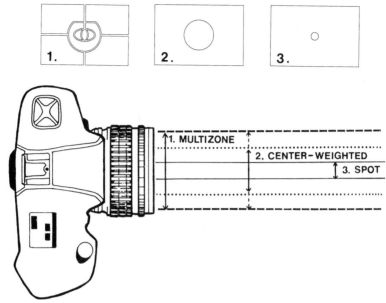

52. Many single lens reflex (SLR) cameras offer a choice of sophisticated through-the-lens (TTL) exposure metering systems. Camera instruction manuals often have diagrams to indicate specific areas of the subject covered by each system, as seen in the viewfinder. A switch on the camera gives you a choice of (1) multizone metering, which reads and evaluates several segments of the overall scene, (2) center-weighted metering, which reads the overall scene but gives the most emphasis to subjects in the center of the viewfinder, and/or (3) spot metering, which reads a very limited portion of the subject area, as indicated by a small circle or rectangle in the viewfinder.

speed dial to align a pointer or pair of brackets with that needle, the photographer set the correct exposure. On some later models, an LED (light-emitting diode) signaled when the exposure was properly set.

A major improvement was made when the photocell was positioned *inside* SLR cameras so it would speed the light coming through the lens for even more accurate exposures. An internal photocell also prevented some problems, such as when a camera strap or finger inadvertently blocked the exterior photocell and resulted in inaccurate light readings and subsequent exposures. Following this milestone of THROUGH-THE-LENS (TTL) METERING were further refinements.

At first, TTL metering systems were acting only as AVERAGING METERS to read the light intensity of an overall area, usually whatever is seen in the viewfinder. A refinement was CENTER-WEIGHTED METERING, which reads an overall area but is more sensitive to the

middle of that area, where the main subjects of many pictures are likely to be located. To give photographers even more control of exposure, SPOT METERING became an added feature, by being able to measure the light value of a very limited area seen in the viewfinder. This allows individual readings of bright areas and shadow areas, and distant subjects.

Most remarkable, and vital to the ongoing success of 35mm SLRs as auto-exposure cameras, was the advent of MULTIZONE METERING. Also termed EVALUATIVE, MULTIPATTERN, MULTISEGMENT, MULTISENSOR, or MATRIX METERING by camera manufacturers, multizone metering reads the light from various parts of the picture area and instantly computes the best exposure. Before automatically setting the lens opening and shutter speed in a matter of milliseconds, the camera's microcomputer can analyze the brightness and contrast of as many as three to sixteen segments of the scene in the viewfinder.

Additionally, the metering systems in most current auto-exposure cameras calibrate with built-in or external accessory flash units for perfectly exposed pictures, especially daylight shots with flash that provide well-balanced illumination to fill in shadows on people's faces and brighten dull scenes. This usually incorporates THROUGH-THE-LENS (TTL) METERING that reads the flash light at the film plane, which is sometimes called OFF-THE-FILM (OTF) FLASH METERING and provides exceptional accuracy for flash exposures (see page 155).

Since many advanced SLRs offer a choice of three metering systems, you must turn a dial on the camera to the symbol or icon that represents the type of metering you want to use: multizone, center-weighted, or spot. The camera's instruction manual usually diagrams the specific areas covered by each metering system so you will know what area of the scene in the viewfinder is being read and to what degree it affects the meter reading.

For example, the CENTER-WEIGHTED METERING SYSTEM is usually designated by a large circle in the middle of the viewfinder. The camera manual indicates the percentage of the meter's sensitivity concentrated in that circle, such as 75 percent, with the area outside the circle influencing the meter reading by 25 percent.

The SPOT METERING SYSTEM is most often indicated by a smaller circle in the middle of the viewfinder, and the area it covers represents 100 percent of the meter reading; the area outside the circle has little or no influence.

A MULTIZONE METERING SYSTEM covers the entire scene in the viewfinder, but the number, location, and design of its various light-reading zones appear only in a camera manual diagram, not in the viewfinder itself. Because of its uncanny ability to determine the best

53. In unusual lighting situations, if your camera features a choice of metering systems and you are unsure which one to use, try them all—multizone, center-weighted, spot—and compare the results to help you decide the best exposure.

54. The late afternoon shot of downtown Los Angeles and a freeway was rather dull (top), so the photographer waited until the sun went down and the city lights and car lights came on to make a more interesting photograph.

exposure under many varied light conditions, multizone metering is the most popular choice for auto-exposure control. It can be used with manual exposure control as well. In some sophisticated SLR models, the distance at which the lens is focused (i.e., point of focus) and/or the location of a main subject that's off-center in the

viewfinder are also computed as part of multizone metering systems to ensure a correct exposure. One advanced Nikon model has a unique sensing system that even evaluates the colors of your subject when calculating the proper exposure.

You should be aware that the lenses on modern SLR cameras feature an AUTOMATIC APERTURE, which permits what is termed OPEN-APERTURE or FULL-APERTURE METERING. That means the lens stays at its widest opening for accurate framing, focusing, and metering of the scene in the viewfinder. Only when the shutter release is fully depressed to expose the film does the lens aperture close down to the preselected f/stop. After exposure, the lens automatically opens again to its widest f/stop. This automatic stopping down and opening up of the lens aperture is instantaneous.

Note that some SLR cameras offer DEPTH OF FIELD PREVIEW, which is activated when the photographer pushes a button or lever to temporarily override the automatic aperture feature and stop down the lens to the f/stop preselected for exposure of the film. This way he can visually check the depth of field (i.e., the subject area in focus) prior to taking the picture.

Early-model SLRs lack open-aperture metering. They require STOP-DOWN METERING, which means the lens aperture actually closes down as the photographer adjusts the f/stop to the correct exposure indicated by the meter. As a result, the viewfinder will get darker as you decrease the amount of light coming through it by stopping down the lens. If a small f/stop is required, say f/11 or f/16, the image you see will be very dim. To focus accurately, you may need to open up the lens to its widest f/stop in order to see better, and then stop down again to the aperture required for a proper exposure.

## Working with Exposure Override Controls

The metering systems in cameras can be fooled by the light conditions—especially very contrasty scenes with bright areas and dark shadows—and the resulting picture may not be what you anticipated. Fortunately, auto-exposure cameras have at least one or two override controls that allow you to alter the automatic exposure settings.

Most common in SLR cameras is an EXPOSURE LOCK, also called a MEMORY LOCK. Instead of using the automatic exposure for the scene that is framed by your viewfinder, you re-aim the camera so that the metering system reads a specific area or an alternate scene that you believe will give the correct exposure. You push the exposure lock

55. An exposure reading was made solely for the face of this girl so that the backlight falling on the top of her head and shoulders would not influence the meter and result in an underexposure (see text).

button or lever to hold that specific exposure, then reframe the original scene in the viewfinder and fully press the shutter release button to take the picture. This requires some dexterity and practice, because one finger is slightly depressing the shutter release button to activate the metering system while another finger is pushing the exposure lock button or lever. (With some SLR autofocus cameras, the exposure lock may be combined with an autofocus lock.)

One caution: Using multizone metering to make the alternative reading is not recommended. That's because such an evaluative-type meter reads various segments of the *overall* scene in the viewfinder and reliably calculates the best exposure in most lighting situations. When you are employing the exposure lock, it's best to use center-weighted or spot metering for reading a *specific* area of a scene.

For example, if the sun is behind your subject and shining toward the camera, and you think this may cause the metering system to underexpose the photograph, you take a spot or center-weighted reading of the main subject only (eliminating the sun), and lock in that exposure.

In these backlight situations, the same thing can be accomplished by some 35mm compact cameras that feature a BACKLIGHT MODE. Activating it overrides the regular automatic exposure and overexposes the film by one and one-half to two f/stops to compensate for the sunlight that's shining toward the camera and adversely affecting the metering system.

Another exposure override control that's a feature of many modern SLR cameras is an EXPOSURE COMPENSATOR. It purposely overexposes or underexposes by an exposure value that you set. Depending on the camera model, the range varies from one to five f/stops,

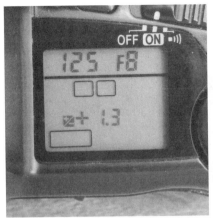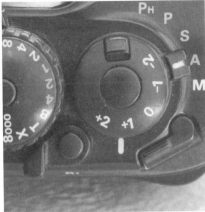

56. Many single lens reflex (SLR) cameras feature exposure compensation. It allows you to purposely overexpose or underexpose the camera's automatic exposure readings. The exposure compensator controls on these two models have been set to increase (+) exposure by one-and-a-third f/stops (see text).

57. The photographer of these inquisitive South American animals thought the very dark background might adversely affect the camera's automatic exposure readings and overexpose his white-haired subjects. To prevent the problem and ensure better automatic exposures, he set the camera's exposure compensator to one-half f/stop underexposure (-.5). That way he could concentrate on composing the llamas and alpacas through a telephoto lens, instead of spending time to manually bracket exposures.

which can be set in plus or minus (+/−) increments of one-third or one-half f/stops. Between the major numbers (1, 2, 3, 4, 5) that flank the 0 (normal exposure) setting on an EXPOSURE COMPENSATION DIAL are lines or dots to mark the one-third or one-half f/stops, or they appear in an LCD information panel as fractions: .5 (one-half f/stop), .3 (one-third f/stop), and .7 (two-thirds f/stop).

For example, if you shoot on automatic exposure at the beach or on the ski slopes, the extra-bright light reflecting off the sand or snow can trick your meter into underexposed scenes. To compensate, you might set the exposure compensation dial to +1 or +2 (overexposure) to increase exposure of the film automatically by one or two f/stops. *Always remember to reset the compensator to its normal exposure (0) position before you resume taking pictures under normal conditions.*

As an ALTERNATIVE EXPOSURE COMPENSATOR, you can use the camera's film speed control dial and rotate it to a higher or lower ISO number to purposely underexpose or overexpose the film. (Compact cameras that exclusively utilize the film's DX code to preset the film speed have no ISO control dial.)

For example, if you're using an ISO 100 film but set the camera's film speed control to ISO 200, the film will be underexposed by one f/stop. Or, by setting the camera to ISO 50 when using ISO 100 film, the film will be overexposed by one f/stop. For two f/stops underexposure with ISO 100 film, adjust the film speed dial to ISO 400; for two f/stops overexposure, turn it to ISO 25.

To underexpose or overexpose by other than full f/stops, adjustments can be made in one-third stop increments by turning the film speed control to an adjacent ISO number. For instance, an ISO 100 film can be underexposed by one-third f/stop by turning the dial from ISO 100 to ISO 125, and by two-thirds f/stop by moving it to ISO 160. Likewise, an ISO 100 film can be overexposed by one-third f/stop by adjusting the dial to ISO 80, and by two-thirds f/stop by setting it at ISO 64. See the chart with the range of film speeds on page 35.

Finally, you should remember that another way to override automatic exposure is simply to switch to MANUAL EXPOSURE—a feature of SLR cameras with multimode exposure—and then manually adjust the f/stop and shutter speed controls to what you believe is the best exposure. When the camera is in the manual metering mode, an LCD readout in the viewfinder of most SLR models has a +/− exposure scale in one-third or one-half f/stop increments to show the photographer how much the exposure he selects varies from the meter reading.

## Bracketing for the Best Exposure

When photographers, including professionals, are unsure of the exposure to use in tricky lighting situations, they often rely on a simple technique called BRACKETING EXPOSURES. To bracket, you make two or more exposures that are over *and* under the exposure indicated by the meter or the exposure you think is correct.

For instance, after shooting at the "correct" exposure, say 1/125 second at f/8, you also shoot frames at f/5.6 and f/11 to overexpose and underexpose by one f/stop. (The shutter speed remains at 1/125 second.) Additional bracketing each way by *two* f/stops is even better insurance that you'll get the best exposure. In that case, you also make exposures at f/4 and f/16, in addition to those at f/8, f/5.6, and f/11 (all at 1/125 second).

While it may seem wasteful or expensive to take extra exposures of the same subject, it can mean the difference between getting or missing a great picture. Also, some subjects, such as night scenes, make interesting pictures at a variety of exposures.

Be aware that bracketing can be done by varying shutter speeds instead of f/stops. Thus, you could bracket the initial exposure of 1/125 second at f/8 by shooting two more frames at 1/60 and 1/250 second, the equivalents of one f/stop overexposure and one f/stop underexposure. To bracket with shutter speeds the equivalent of *two*

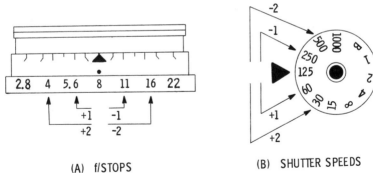

(A) f/STOPS          (B) SHUTTER SPEEDS

58. Bracketing is a good way to avoid missing a picture because of poor exposure. (A) To bracket with f/stops, shoot at the calculated exposure (f/8 in this example), and then make exposures at one f/stop more (f/5.6) and at one f/stop less (f/11). Keep the shutter speed constant. Bracketing by two f/stops or more also may be wise. (B) To bracket with shutter speeds, shoot at the calculated exposure (1/125 second in this example), and then make exposures at one shutter speed slower (1/60 second, the equivalent of one f/stop more) and at one shutter speed faster (1/250 second, the equivalent of one f/stop less). Keep the lens f/stop constant. Bracketing by additional shutter speed changes also may be wise in order to make the best exposure.

f/stops each way, you would make additional exposures at 1/30 and 1/500 second, in addition to those at 1/125, 1/60, and 1/250 second (all at f/8).

In addition to bracketing at full stops, bracketing at half-stops (or even one-third stops) is especially advised with color slide films. That's because they have less leeway for exposure mistakes, termed EXPOSURE LATITUDE, than do color print films or black-and-white films. (In addition, those two types of negative films can be "corrected" during the developing and/or printing process to produce acceptable photographs.) Note that most SLR cameras require you to use only the lens aperture to bracket by one-third stops or half-stops; very few models allow shutter speeds to be adjusted to intermediate settings equal to one-half stop or one-third stop.

Some SLR cameras feature AUTOBRACKETING, which makes it easier and faster to make pictures of the same scene at varied exposures. After the autobracketing mode has been selected using the camera's control dial, every time you fully depress the shutter release button, three film frames are successively exposed—each at a different exposure. One is at the "correct" exposure, one is an overexposure, and one an underexposure. You preselect the bracketing

59. If in doubt about exposure, as when a bright sky might influence the meter reading and result in underexposure, bracket exposures so you have a choice of results. It's worthwhile shooting a few extra frames of film rather than miss getting the picture because of a poor exposure.

range: by one-third stops, one-half stops, two-thirds stops, or full f/stops, depending on options offered by the camera mode. When finished, remember to cancel the autobracketing mode, or else three exposures will also be made of your next subject.

## Concerning Exposure Meter Photocells

Before using an exposure metering system, you should know more about two vital components: the light sensor, called a PHOTO-CELL, and the batteries that power it.

A photocell reacts to the light striking it, and the first type used in exposure meters was a SELENIUM CELL. It requires no batteries to operate, and is long-lasting. The selenium cell was responsible for the introduction of the hand-held exposure meter; light striking the cell causes a current that moves the meter's needle to indicate exposure possibilities on an adjustable scale. Later, selenium cells were incorporated into the first electric eye automatic cameras. However, these photocells are not very sensitive in low light, and they are relatively slow in registering their response to light. Although a few hand-held selenium cell exposure meters continue to be manufactured, many photographers consider them to be obsolete.

That's because progress in electronics and chemistry produced a battery-powered CADMIUM SULFIDE (CDS) CELL that is very sensitive and responds quickly to light. It prompted manufacturers to build exposure metering systems into cameras. The CdS cell was followed in the 1980s by an even more versatile light-reading cell, the SILICON PHOTO DIODE (SPD), which became a key element in the development of cameras with automatic exposure control. Subtle improvements in photocells continue to be made, such as the introduction of a SILICON BLUE CELL (SBC), which incorporates a blue filter to reduce the cell's sensitivity to infrared light and make exposure readings even more accurate.

How do you know what type of light sensor is incorporated into a camera's exposure metering system or a hand-held exposure meter? The specific photocell may be named in the TECHNICAL SPECIFICATIONS listed in your camera or meter instruction manual, but of more interest is knowing how sensitive the metering system is. In other words, what is the range of light—from brightness to darkness—that can be measured by the meter?

This METERING RANGE is indicated by a pair of numbers that gives the EXPOSURE VALUE (EV) of both the dimmest light and the brightest light the meter can read. Exposure values are a series of numbers

used to quantify levels of light: the higher the number, the brighter the light; the lower the number (including minus numbers), the dimmer the light.

The *maximum* possible range of light sensitivity for meters in modern cameras is from EV −5 to EV 21. No camera reaches *both* of those extremes, but cameras with better metering systems often cover an exposure value range from EV −1 or 0 to EV 19 or 20.

The metering range may be different for each type of meter— multizone, center-weighted, or spot—in the same camera. The metering range can also change according to the speed of the film (ISO), lens opening, shutter speed, and focal length of the lens being used. For standardization and comparison, the metering range listed in most camera instruction manuals is for exposure meters set at ISO

60. Modern exposure meters, whether built in the camera or hand-held models, have very sensitive photocells that can make readings in very low light. This couple was photographed at dusk by a campfire at a Texas dude ranch.

100 film speed, with the light transmitted through a 50mm lens at an aperture of f/1.4, and a shutter speed of 1 second.

In practical terms, the metering range is revealed only when the camera's LCD information panel or LED readout, or the meter needle, signals a warning that the light is beyond the upper or lower range of f/stop and shutter speed combinations available for a correct exposure. (See your camera manual for the specific warning signals.) If that occurs, you may still be able to take properly exposed pictures. When the light is too dim, use a flash to add more light, or switch to a high-speed (i.e., more sensitive) film that has a higher ISO number. When the light is too bright, use a neutral density (ND) filter on the lens to reduce the light reaching the film, or switch to a slow-speed (i.e., less sensitive) film that has a lower ISO number.

It is important to look in the instruction manual for other warnings, if any, concerning the use of your meter. For instance, the light sensor in older manually controlled cameras is often a CdS cell, which can suffer temporary fatigue under certain conditions. If you take a reading in bright sunlight and then take a reading in the shade, the CdS cell's circuitry may be momentarily overwhelmed, and subsequently cause a faulty meter reading in the shade. It's recommended never to point a CdS meter directly at the sun, although the photocell will recover after a while and resume making correct exposure readings.

## Dealing with Exposure Meter and Camera Batteries

Specific cautions in the instruction manual for your camera or exposure meter often concern its power source, the battery. As previously mentioned, selenium cells do not require batteries, but all other photocells do.

When your exposure meter doesn't work, the most common cause is a dead battery. And with today's fully automatic all-electronic cameras, a dead battery usually means you won't be able to take any pictures at all. In addition to auto-exposure, everything else stops working—autofocus, autowind, autoflash, and even the shutter release.

Fortunately, exposure meters and cameras with built-in meters feature a BATTERY CHECK. A button or switch activates a battery symbol on an LCD information panel, or a fluctuating needle, or light-emitting diodes (LED) to signal the condition of the battery and tell you when to replace it.

The life of a battery depends on its type and usage; smart photographers always carry spare batteries to avoid unexpected meter failure or inoperation of an auto-exposure camera. We especially recommend that you always install fresh batteries before photographing a special event, such as a wedding, or going on a vacation trip.

To conserve battery power, today's cameras have exposure metering circuits that automatically shut off if a picture is not taken within a certain number of seconds; the metering system is immediately reactivated when you slightly press the shutter release button. To turn on the built-in meter in older-model SLR cameras, either you turn a separate on/off switch or you pull out the film advance lever. Pushing the lever back in turns the meter off.

The failure of a meter or an auto-exposure camera is not always because of a dead battery. Many times a thin chemical film develops on the battery's metal contacts and breaks the electrical circuit. You may not see evidence of battery leakage or corrosion, but the whitish chemical coating that develops on the battery is enough to cause your meter to operate erratically or not at all.

To avoid these problems, wipe the battery's contacts with a clean

61. Cold weather can affect the performance of batteries that power cameras and their exposure meters, sometimes causing faulty readings or other malfunctions. To avoid missing any pictures when temperatures are very low, always carry spare batteries and keep them warm in a pocket next to your body.

handkerchief, not your fingers, and rub hard-to-reach battery contacts in a camera with a clean pencil eraser. Then replace the battery properly according to its polarity (+ and −) markings, and check the meter's operation. If it still doesn't work, even after you put in a fresh battery, you'll need a repair service. Never disassemble a meter or camera yourself unless you never want to use it again.

When changing batteries, it is imperative that you install the battery specifically recommended in the meter or camera instruction manual. Do not substitute batteries designed for other purposes, such as hearing aid batteries, unless they are listed as a replacement for your specific battery.

The smallest batteries, so-called BUTTON CELLS, power built-in meters in most manually operated cameras; they are also used in some hand-held exposure meters and automatic cameras. Some meters require two button cells. Typically rated at 1.35 to 1.5 volts, their chemical makeup varies: silver, alkaline, lithium, or zinc. Due to environmental concerns, the once popular mercury button cell has been discontinued because its disposal after use created very toxic waste; camera stores have appropriate replacement batteries for the mercury cells that may be recommended in older instruction manuals.

As 35mm cameras evolved with more and more automatic features, larger batteries were required to power them. Many camera manufacturers adopted the common 1.5-volt AA-SIZE CELLS, sometimes called PENLIGHT CELLS. A number of today's "auto-everything" cameras require from two to eight AA-size cells, which are connected in series to provide 3 to 12 volts to power all the electronic features.

There are several types of AA-size batteries. The type most often recommended in camera manuals is the ALKALINE BATTERY. Never use the inexpensive carbon zinc type designed for flashlights; its power runs out too quickly for dependable use in cameras. Increasingly popular, except for its much higher cost, is the AA-size LITHIUM BATTERY, which has a longer shelf life, gives more flash shots, and works in colder temperatures than the alkaline type.

Some photographers prefer the AA-size NICKEL-CADMIUM (NICAD) BATTERY, because it is rechargeable. Despite the initial higher investment, including the recharging unit, nicads are more economical than AA-size alkalines. They also weigh less, and recycle quicker for shorter delays between flash shots. The strength of nicads diminishes much faster than alkalines, but some brands can be recharged in one hour (provided that the recharge unit and electricity are at hand). Others require as long as overnight to recharge. A newer type

of rechargeable battery is NICKEL METAL HYDRIDE, which contains no cadmium and is less toxic to the environment when disposed of.

In addition to common AA-size batteries, there are other individual batteries—either lithium, alkaline, or silver. They provide 3 to 6 volts and are specifically designed to fit some fully automatic 35mm compact and SLR cameras. The lithium type is required by most manufacturers because the batteries have a strong output and long life to power all the auto-exposure, autofocus, autowind, and autoflash features.

Here are some GENERAL PRECAUTIONS REGARDING PHOTO BATTERIES (other warnings may be listed in your camera's instruction manual).

If you are not going to use your camera or flash unit for a few months, remove their batteries to avoid possible damage to the equipment by battery leakage or corrosion. At other times, before putting the camera or flash unit away, make certain all switches are turned off to avoid draining the batteries; nothing is more frustrating than taking out your camera or flash and finding that the batteries are dead.

When changing AA-size batteries, use fresh batteries and change all of them at the same time. Also, always use the same type together (alkaline, lithium, or nickel-cadmium), and use the same brand of battery.

There is a special concern with RECHARGEABLE BATTERIES, because some are fast- or high-charge types, while others are slow-charge types that take longer to recharge. Make certain the recharger unit is specifically designed for the type of battery you are using. Also, never try to recharge alkaline, lithium, or other nonrechargeable batteries; they will not recharge, and may leak or explode.

Most batteries get sluggish in cold weather, causing exposure meters and electronic camera functions to slow down or to quit altogether. Lithium batteries are the least susceptible to cold; AA-size lithiums are rated to operate as low as $-40°$ F $(-40°$ C). Next in preference are rechargeable nicads, which surpass alkalines for performance in low temperatures. Whatever the type, when shooting in cold conditions, keep a spare set of batteries in a pocket next to your body to keep them warm. If the operation of your camera gets sluggish, exchange the cold batteries for the warm ones in your pocket, and warm up the cold batteries in the same manner for reuse later.

## Considering Hand-held Exposure Meters

When the match-needle exposure systems of HAND-HELD EXPOSURE METERS were first adapted for use inside 35mm cameras, it was a major technical achievement as well as a wonderful convenience for photographers. And thanks to computer-chip technology, that basic built-in metering evolved into the truly remarkable auto-exposure cameras that we enjoy today. While many photographers now rely exclusively on exposure metering systems that are built into their cameras, you should also know about hand-held exposure meters.

Aren't they passé? Not at all. Hand-held light meters have kept pace with exposure metering advancement and continue to be trusted pieces of photographic equipment, especially for professional studio work. Amateur photographers, and pros who work in the field, also have reasons for using hand-held meters.

62. To make correct exposure readings with a hand-held exposure meter, the film's speed must first be set on the meter's ISO dial. This model, which features digital readouts in an LCD panel, has been set to ISO 100. A light reading was made that indicates an exposure of f/5.6 at 1/125 second. The white translucent dome at the top of the meter can be positioned to cover the light-sensitive photocell in order to make incident-light readings instead of reflected-light readings (see text and Illustration 63).

When your camera is on a tripod, a hand-held exposure meter will give you more freedom to make light readings by allowing you to move the meter independently of the camera. It also presents a full range of exposure possibilities, not just a single exposure setting. (After taking a light reading, you simply look at the meter's calibrated scale or LCD information panel to select the f/stop and shutter speed combination that is best for your purposes.) More important, a hand-held meter is designed to analyze light in a variety of ways to help you obtain optimum exposures.

Meters built into the camera make only REFLECTED-LIGHT READINGS. Hand-held meters do the same thing: they measure the brightness of the light *reflected by* the subject. But most hand-held meters are also able to measure the intensity of the light *falling on* the subject, which are called INCIDENT-LIGHT READINGS. When used for incident readings, a translucent white plastic dome, disc, or panel covers the light-sensitive photocell.

When reading the light reflected by your subject, the meter is aimed at the subject from the camera's position. When making an

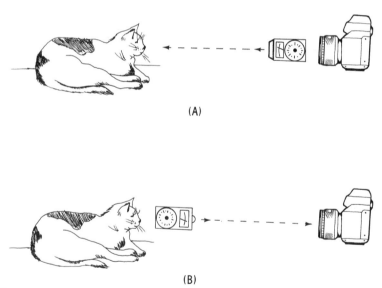

(A)

(B)

63. Exposure readings are made in two ways with a hand-held meter, depending on whether you are making a reflected-light reading or an incident-light reading. For a reflected-light reading (A), the meter is kept at the camera position and aimed toward the subject area in order to read the light *reflected by* the subject. For an incident-light reading (B), the meter is aimed toward the camera position from the subject area and reads the light *falling on* the subject. Whether hand-held or built into the camera, most meters make reflected-light readings, although many hand-held models also will make incident-light readings.

incident-light reading of the light falling on the subject, the meter is positioned at the main subject and pointed toward the camera.

A reflected-light reading is by far the most common method of determining exposure. This is because with a reflected-light meter you can read the various areas of contrast (lightness and darkness) in your picture area and set your exposure accordingly. An incident-light reading, on the other hand, measures only the intensity of light falling on the main subject. It doesn't indicate how much of that light is reflected or absorbed by other objects in the picture area (i.e., their relative brightness). Incident meter readings are most often made in studios where the lighting can be controlled by the photographer.

Some hand-held exposure meters also serve as FLASH METERS, which are frequently used by professional photographers in their studios. These meters take the guesswork out of flash exposures by measuring the brief burst of light from electronic flash units. They are especially valuable for determining exposure when several flash units are used; all the flash units are test-fired at once, and the meter reads the total amount of flash light to determine the f/stop to set on the camera for a proper exposure.

The most versatile hand-held exposure meters can be set to measure flash light, or ambient (continuous) light, or both at the same time. And they can make reflected-light and incident-light readings.

There also are special COLOR TEMPERATURE METERS used by professional photographers in studios and on location. These meters analyze all light sources illuminating the subject and indicate specific filters to use to "balance" the light so that the subject appears in its natural colors in the photograph. Instead of being set with the ISO film speed, the meter is set with your film's color temperature (such as 5500 K for daylight films; see page 201). Such meters are held at the subject's position and aimed toward the main light source.

Hand-held meters incorporate the same light-reading photocells described earlier for built-in camera meters, but especially the SPD (silicon photo diode) or the SBC (silicon blue cell). All photocells require battery power, except selenium cells, which are mostly found in older exposure meters. To obtain readings in low light with these less sensitive selenium meters, some have a booster attachment, which is an accessory light-sensitive screen placed over the photocell. Others feature a high/low switch to adjust the meter's sensitivity for bright and dim lighting conditions.

Depending on the model, a hand-held light meter has an LCD information panel, LED indicators, or a needle pointer to indicate the correct exposure. But it also displays an extended range of f/stop

64. Because light sources vary indoors, filtration may be needed so that subjects will appear in their natural colors in a photograph. Special color temperature meters can be used to determine the proper filtration. Fortunately, ordinary color print films are color balanced with filters during the printing stage rather than when shooting.

and shutter speed combinations and/or exposure value (EV) numbers for comparative exposures you might use, which is a major advantage of hand-held meters.

Another feature is an EXPOSURE LOCK that preserves the exposure reading for your reference until another reading is made; some with an LCD information panel will recall the last reading even after the meter has been turned off and then turned on again.

Most hand-held meters are AVERAGING METERS that read the light intensity of an overall area, but some can be fitted with an accessory attachment so they can be used as a SPOT METER to read the light value for a very limited area. A few hand-held meters are designed exclusively for spot metering.

Before using any hand-held meter, you should know its ANGLE OF ACCEPTANCE, the specific area that is read by the meter. This acceptance angle or measuring angle is measured in degrees (°) and is listed in the meter's instruction manual. The angle of coverage varies considerably: it may be 30° for reflected-light readings, and 180° for incident-light readings. Spot meters can measure an area as limited as 1°. They have an optical viewfinder with a circle in the center to help you aim the spot meter and measure a small area of your subject with pinpoint accuracy.

65. For precise measurement of light, a hand-held spot meter with its own lens and viewfinder can be aimed like a camera to read as little as one degree (1°) of the subject area. Spot metering is also a feature of some advanced single lens reflex (SLR) cameras.

Whatever type of hand-held exposure meter you use, treat it with care. Keep the meter on a strap, and the strap around your neck. Don't let the meter bang against your body or your camera equipment. If the light-reading indicator (a needle, LCD, or LED) gets out of adjustment because the meter is handled carelessly, you may be able to recalibrate it yourself and avoid having to go to a repairman; look for advice about ZERO ADJUSTMENT, if any, in the meter's instruction manual.

Regarding exposure meters, we suggest that if your camera has a built-in meter that makes accurate light readings for all the types of pictures you want to take, then the camera's metering system is all you need. However, exposure readings are often easier to make with a hand-held meter, especially when your camera is on a tripod and you're shooting indoors with tungsten lights or flash units. Consider buying a hand-held meter if it would be helpful for the particular type of photography you enjoy, such as studio-style portraiture.

## Simple Alternatives for Setting Exposures

If your built-in camera metering system or hand-held light meter ever fails, how do you decide what is the best exposure to use? A simple solution is to follow the exposure guidelines in the FILM INSTRUCTION DATA printed directly on the inside of the film box or on a

66. In lieu of an exposure meter, suggestions for exposure settings are included with boxes of film. This Norwegian farm boy was photographed in the doorway of a barn with ISO 100 film by following the guidelines for open shade: 1/250 second at f/4.

separate sheet. Specific exposures are suggested for different light conditions, such as these listed with Kodak color print films: bright or hazy sun on light sand or snow; bright or hazy sun (distinct shadows); weak hazy sun (soft shadows); cloudy bright (no shadows); and heavy overcast or open shade. The suggested exposures increase by one f/stop from one light condition to the next one in descending order. The exposures are always for *average* subjects that are not too dark or too light. Bracketing exposures is also a good idea when using the exposure guidelines in film data.

Another starting point for making an exposure without a meter reading is following the so-called F/16 RULE OF THUMB: Set the lens opening to f/16 and adjust the shutter speed to the setting that is closest to the ISO speed of the film in your camera. If the film is ISO 100, the shutter speed would be 1/125. With a ISO 200 film, set the shutter speed to 1/250 second, and so forth. Bracketing exposures is also suggested.

A final suggestion for determining exposure when there is no meter to rely on is to make AN EXPERIENCED GUESS. If you consistently shoot the same type of subject in the same type of light on the same type of film, your basic exposure setting should be much the same as

you've used in the past. But don't trust your luck to one exposure—
be sure to bracket.

## Making Accurate Exposure Readings

Although a built-in or hand-held exposure meter is a popular and
accurate device for determining exposures, it is only a tool. A meter's
major limitation is really the person operating it. If you don't know
how to make and interpret exposure readings under a variety of
lighting conditions, any poor results are your fault. The meter
should not be blamed, although it frequently is.

The reason for using an exposure meter is to make what is vari-
ously termed as A PROPER EXPOSURE, a correct exposure, or an accu-
rate exposure. For a snapshooter, a proper exposure is one that
produces a picture that looks just like the scene he photographed.

For the true photographer, a proper exposure is one that
produces the photographic result he envisions. For instance, when
photographing a person against a bright background, do you want to
see detail in that person's face, or do you want the person to appear
as a silhouette? The f/stop and shutter speed you decide to use will
determine the result.

Always remember that exposure meters and photographic films
are not equal to your eyes and brain in terms of their range and

67. Prior to taking an exposure reading, analyze the scene with your
eye in terms of contrast and whether you specifically want details
to show in the highlight or shadow areas (see text). This field of
sunflowers was photographed near Arles in the south of France.

ability to record an image. You are personally able to see more than a picture can reveal, particularly the details in both the HIGHLIGHTS (very bright areas) and the SHADOWS (very dark areas).

For many of the pictures you make, the goal is to use an exposure that will show as much detail as possible in *both* highlights and shadows. When film is *underexposed*, the resulting print or slide will be too dark; highlights will lose their brilliance and there will be little or no detail in the shadows. When film is *overexposed*, the resulting print or slide will be too light; highlights will have no detail and appear washed out, while the shadows will have too much detail.

The most important thing to remember is that a built-in or hand-held reflected-light exposure meter interprets the relative brightness of the light it reads to give an exposure that produces a so-called MIDDLE TONE, meaning an average tone, in the photograph. Regardless of whether the meter reads a subject that is just average in contrast or is all very bright or all very dark, the exposure reading will result in an image with a medium tone.

Obviously, this is ideal for subjects of average contrast. But what of subjects that are all very bright or all very dark? Or subjects that are of very high contrast because they have both very bright and very dark areas? Since your exposure meter doesn't know the results you want, you must be able to use the meter skillfully to read EXTREMES IN CONTRAST and interpret its results carefully in order to get the picture you desire.

For instance, a meter reading of a snow scene will indicate an "average" exposure that gives too much detail to the snow. If you want to represent snow as it more naturally appears—very bright and without much detail—the actual exposure must be *more* than the meter reading, probably an increase of two f/stops.

Likewise, a reading of a coal mine tunnel will give an "average" exposure that gives too much detail to the tunnel. If you want the tunnel to be represented in the photograph as it more naturally appears—very dark and without much detail—the actual exposure must be *less* than the meter reading, probably a decrease of two f/stops.

In both cases, it's your call. Depending on how you want a very bright or a very dark subject to be represented in the photo, you can follow the meter's exposure reading or adjust it for more or less exposure.

Also, in the case of high contrast, when a scene or subject includes *both* very bright and very dark areas, the photographer must

68. For properly exposed scenic views, make a reading of the most important part of the picture area; be careful a bright sky does not cause underexposure of the landscape. To focus attention on the Grand Canyon, which was the center of interest, an unattractive sky was eliminated almost entirely by being composed in the viewfinder at the very top of the frame.

69. The cloud formations were the main feature of this expansive view in Alberta, Canada; the exposure was made for the clouds and sky rather than the darker landscape, which was composed in the viewfinder to occupy only the very bottom of the frame.

choose the portion of the picture he wants to emphasize, if any, and base his exposure on the meter reading of the bright area *or* the dark area.

Exposure problems can arise if too much of a less important picture area is very bright, because an overall meter reading will result in underexposure of the main subject. Similarly, if an overall meter reading includes a less important picture area that is very dark, the main subject will appear overexposed in the photo.

For instance, if you're photographing the Grand Canyon, your viewfinder may include a bright and uninteresting sky. If the canyon itself is your main subject, you should make a reading of the canyon only; do not include the sky in the reading. Otherwise, the meter averages the dark of the canyon and the bright of the sky, and neither is emphasized. Exposing for the canyon alone will lighten the sky somewhat but give detail to the canyon, the most important part of your picture.

If, however, a vivid blue sky with fleecy white clouds hovering over the canyon becomes the center of interest for your picture, exposing for the sky and cloud area would be best. Because the canyon would

70. Always be alert for very dark or very bright areas in a picture that might influence a meter reading and cause an incorrect exposure of your main subject. To avoid that problem here, a spot reading was made only of the Swedish girl's face, the picture's center of interest.

turn out darker in the photo, the emphasis would appropriately switch to the sky and clouds.

To summarize, when subjects in your picture are of *extreme* contrast (some very bright and some very dark), generally it's best to aim your meter at the most important part of the picture to take an exposure reading. With a *less extreme* contrast range, separate readings of the dark and bright areas can be made and then averaged to determine the exposure setting (see later in this section). Of course, when your subject area has little variation in contrast, an overall reading will do.

We must reemphasize: Be alert for extremes in contrast. For example, when making a portrait of a fair-skinned person in dark clothing against a dark background, reading the entire area seen in your viewfinder would indicate an exposure greater than required to capture detail in the person's face, the picture's center of interest. Unless a meter reading is made for the face, the excessive dark clothing and background will give an exposure reading that overexposes and lightens the face too much.

By the way, a common reason for poor exposures is inadvertently pointing the meter, especially a hand-held meter, toward the sky. The result is an underexposed picture. Aimed above the horizon, the meter thinks the scene is bright and indicates this. And the picture area you want, below the horizon, turns out too dark. Again, that's your fault and not the fault of the meter.

In this discussion of making accurate exposure readings, we've referred to aiming the exposure meter and metering specific parts of the picture area. Since most photographers use their built-in camera meter rather than a hand-held meter to determine exposure, there are some special concerns, especially with MULTIZONE METERING SYSTEMS found in most modern SLR cameras.

As explained earlier, an exposure meter typically averages the brightness of the light its photocell receives and gives a reading that will reproduce the subject in a medium tone in the photograph. However, thanks to computer technology, a multizone metering system does much more than that. First, its multisegmented light sensor reads the brightness of a number of individual sections of the overall subject area that's framed in the viewfinder. Then a computer chip evaluates that information and uses so-called FUZZY LOGIC to choose what it considers to be the best lens opening and shutter speed from a selection of preprogrammed exposures.

Thus, a multizone metering system attempts to compensate *automatically* for exposure readings of subjects in very diverse lighting

71. If your camera features two or three exposure metering systems, you must decide when to choose one over the other. For this lake scene in Austria, multizone metering was the best choice.

72. Spot metering was ideal for reading this Caribbean boy's shadowed face. However, the exposure was then decreased slightly so that details of his sun-splashed woven palm hat would not be washed out.

73. To prevent the bright reflections in this indoor pool from giving a reading that would underexpose these aqua exercisers, center-weighted metering was selected.

situations, which is something photographers themselves had to do by manual control in the past.

Take note that whenever you switch from the camera's auto-exposure control to set exposures manually, *do not* use multizone metering if you are making an exposure reading of a specific part of the picture area. Instead, use spot metering or center-weighted metering, which average the light to give an exposure reading in the traditional manner without the influence of the computer chip's fuzzy logic.

The way to make the most accurate readings of specific portions of the picture area is to use SPOT METERING rather than center-weighted metering. A spot meter covers a very limited area, as defined by a small circle in the center of the viewfinder. Recalling the previous example of making a portrait of a person in dark clothing against a dark background, a spot meter can be aimed solely at the face, so that the excessive dark areas surrounding the much brighter face will not influence the exposure reading. (However, you may want to increase exposure slightly, in order to add some detail to the dark clothes and background.)

Photographers can also use a spot meter to take readings that give the best overall exposure for a subject that includes both bright and dark areas. A common way to do this is to make *individual* readings of the bright areas and the dark areas in the picture, then average the results and set the exposure. Or you can include in one spot reading *equal* portions of both a bright area and a dark area, and use the exposure indicated.

A spot meter reading is especially useful when a subject is strongly backlighted because the subject will be much darker than the background. Also, when a subject is too far away to approach for a close reading, spot metering will do the job because it reads such a small portion of the picture area.

Without a spot meter, if you're unable to get close enough to your subject for a reading, try reading a nearby area that is similar in lighting and contrast. For instance, taking a reading off the palm of your hand is a convenient and effective substitute for reading the face of a person of similar skin tone who is some distance away. This HAND READING can be made with center-weighted metering, or even multizone metering, as long as the image of your palm fills the viewfinder. Be certain the angle and intensity of light falling on your palm is the same as that falling on your subject.

Another option, if your subject is not of extreme contrasts, is to take a reading of a PHOTOGRAPHIC GRAY CARD and use the result for your exposure. That piece of gray-colored cardboard reflects 18 per-

cent of the light it receives, which represents the middle or medium tone to which all exposure meters are calibrated. Make sure the gray card fills the entire viewfinder so the reading of it will be accurate. Buy a gray card that will fit in your camera bag so you can use it wherever you go.

Regardless of the type of meter or metering mode—overall averaging, multizone, center-weighted, or spot—you must know its limitations and abilities, and how to use it best. Experience will guide you as to which type of metering to choose, depending on the lighting situation, your subject, and the results you want. Nevertheless, whenever you are uncertain about the exposure, BRACKETING can save the day. Take several different exposures to make certain that at least one frame of film records the picture as you imagined it.

Always keep in mind that different types of film vary in EXPOSURE LATITUDE, which is the ability to reproduce a wide range of subject brightness or contrast.

Color slide (transparency) films require the most exacting exposures; even overexposure or underexposure by one-third or one-half f/stop can make a difference. That's because the film you expose becomes the actual color slide you project on a screen or see through a magnifier or slide viewer, and the image cannot be lightened or darkened. When subjects have a wide range of contrast, many color slide shooters find the results more pleasing if they expose for the subject's brighter colors. If they expose for the darker colors, the brighter colors will be washed out, and thus will be very distracting when projected.

On the other hand, color print films allow considerable latitude regarding exposure—even up to two f/stops overexposure or underexposure, and sometimes more. That's because the film you expose becomes a negative from which a print is made, and improper exposures can be corrected during the printmaking stage. In fact, today's computerized processing machines that produce most snapshot-size color prints automatically compensate for improper exposures.

That becomes a problem when you bracket exposures with color print film to purposely overexpose and underexpose extra film frames by one or two f/stops, because the chances are the resulting prints will look identical in exposure. To get the print result you envisioned when taking the picture, often you must ask the photofinisher to remake the print with instructions to show more detail in the bright areas or in the shadow areas.

Black-and-white films have more exposure latitude than either color print or color slide films. Like color print films, black-and-white films also produce negatives, which allow correction for im-

74. The Zone System for determining exposure is popular with landscape photographers (see text).

proper exposures when they are developed and/or when the prints are made.

Normally, with subjects offering a full range of light contrasts, black-and-white film users prefer to expose more for the darker areas in order to get shadow detail on their film. Highlight areas, which will be recorded as too bright, can be darkened to more natural tones during the development and/or enlarging processes.

For more exacting exposure guidance for black-and-white films, photographers can utilize the ZONE SYSTEM originally created by well-known photographer Ansel Adams. His exposure system (and modified zone systems developed by other photographers) requires thorough understanding and extensive practice, but it gives the black-and-white photographer excellent exposure help, and confidence. Basically, Adams divided the range of subject brightness, or contrast, into ten tones that he identified as zones and numbered from 0 through 9. Zones 0 and 1 represent black (no detail), while Zone 9 represents white (no detail). The other zones represent various shades of gray, with Zone 5 indicating middle gray, the average tone of a subject as always read by an exposure meter.

This Zone 5 middle gray tone can be darkened or lightened to any degree desired by the photographer. Since each change of zone is equivalent to one f/stop, the photographer decides the zone (i.e., tone) he wants and adjusts the lens opening (or shutter speed) accordingly. You always decrease exposure to change to a lower zone

number (darker tone), and increase exposure to change to a higher zone number (lighter tone).

Obviously, to use this Zone System, the tonal value of each zone must be understood. For example, an exposure meter reading of a person's face will be equal to Zone 5 (middle gray tone), but average skin tones reproduce best as medium light gray, Zone 6. Thus, the photographer would adjust his exposure reading by opening up the lens by one f/stop. A number of books are available on the Adams Zone System of exposure, and variations of it, and they should be read in order to gain a thorough understanding of its rules and applications.

The Zone System teaches one of the most important guidelines for successful photography: *Learn to read the light with your eyes before reading it with your exposure meter.*

Here is some final advice: If your photographic results are *consistently* too light or too dark when shooting in an auto-exposure mode, there could be something wrong with the camera—or something wrong with you. Study the instruction manual again to make sure you're operating the camera properly. Also, read and set exposures *manually* to compare results with the auto-exposures before giving the camera to a repairman. An inaccurate metering system, shutter speeds that are out of adjustment, or a lens aperture that sticks can all be reasons for poor exposures, but more often than not, the photographer is at fault.

For every photographer who understands his exposure system, there are a hundred more who do not—and don't want to. They are responsible for the popularity of so-called point-and-shoot cameras. "We just want to take pictures," they say, "and not fiddle with camera controls." As long as their results are what they expect them to be, okay.

But if you have to sacrifice a good picture because your SLR camera is too automated for you to use it creatively, then your photographic abilities will be hindered rather than helped. It's especially important to understand and know how to best use your camera's automatic exposure controls.

After reading this chapter about the various aspects of exposure, you may be discouraged, or at least confused. Don't worry. All this information about film speeds, f/stops, shutter speeds, and exposure metering will become clear to you, especially after some practical experience.

We suggest that you make some pictures and judge the results. Then analyze what went wrong, if anything. And even with good results, figure out how the pictures might be made even better.

Always be critical of your work. The more critical you are, the less critical viewers of your photos will be.

After a while you'll learn how to "read" a photograph to determine how and why it was made. You'll begin to judge other photographers' work with a more discerning eye. But you must understand the abilities and limitations of a camera, its lenses, and other photo equipment. So don't give up. Read on.

# Choosing Lenses

The evolution of camera lenses has been responsible for much of the ongoing fascination with photography. The first amateur cameras featured built-in lenses that created an image on film similar in scale to what was seen by the photographer's eye. But early-day photographers knew how telescopes could bring a distant subject close up, and how microscopes could enlarge a subject to produce a bigger-than-life image. Why couldn't cameras do the same things?

They could, of course, when equipped with the appropriate lens. But no one wanted a camera that made only telescope-type shots or only close-ups. Thus, the concept of INTERCHANGEABLE LENSES was born. Instead of being manufactured with a permanent lens, camera bodies were designed to accept lenses of various types that could be interchanged.

75. A wide selection of lenses is available for all brands of 35mm single lens reflex (SLR) cameras. Some lenses are made by camera companies, like Pentax, for their specific camera models. Other lenses are produced by independent manufacturers to fit a variety of camera brands and models.

Leica and other early rangefinder cameras were the forerunners, but the advent of single lens reflex (SLR) cameras established a new era of interchangeable lenses. Nowadays, the camera bags of most SLR owners hold several lenses, and the shelves of camera stores are lined with dozens of other choices—zoom lenses, telephoto lenses, wide-angle lenses, macro lenses, and more. Which types of lenses are best for the types of photography you do?

To help you decide, you need to know that all lenses are classified by FOCAL LENGTH, which is represented by a number. Technically, focal length is the distance from the optical center of a lens focused at infinity to the point behind the lens where a sharp image results. For lenses on cameras, that distance would be measured from the optical center of the lens to the film (see Illustration 34A).

The distance is measured in millimeters (abbreviated mm); the number is engraved on the front lens ring or elsewhere on the lens barrel so you'll know what the focal length of that lens is. Occasionally the focal length appears in centimeters (cm); just multiply by 10 to determine the equivalent in millimeters. Also note that focal length may be indicated in inches for the lenses of large-format cameras and for the lenses of slide projectors.

There are two important reasons to know the focal length of any camera lens. First, it indicates the relative IMAGE SIZE of your subject that the lens will produce: the greater the focal length (i.e., mm), the greater the subject's image size on the film. Second, the focal length of a lens also indicates its relative ANGLE OF VIEW, also called FIELD OF VIEW, which is the subject area the lens covers, as measured by degrees (°); see Illustration 79.

Focal lengths for lenses on 35mm cameras currently range from 6mm to 2000mm. Once you know the millimeter of a lens, you'll know what general type of lens it is considered to be: normal, telephoto, or wide-angle. Following is an introductory summary of various types of lenses; they are discussed in more detail later in this chapter.

## Types of Lenses

A NORMAL LENS, sometimes called a STANDARD LENS, covers an angle of view that is similar to what your eyes see. Traditionally, a normal lens was supplied with any new SLR camera, although nowadays many SLRs are sold as camera bodies alone so that you can choose a lens of any type and focal length.

The normal lens for a 35mm SLR camera frequently has a focal

76. As shown by these three photos, shooting from the same camera position with lenses of different focal lengths (or a zoom lens set to different focal lengths) effectively changes the subject's image size. This overall view of an abandoned building and wagon on the Nebraska plains was photographed with a 35mm (wide-angle) lens.

77. Photographed with a 50mm (normal) lens.

78. Photographed with a 135mm (medium telephoto) lens.

length of 50mm, which covers a 45° angle of view. However, the lens that is designated "normal" by a camera manufacturer may actually range from 35mm to 58mm, depending on the camera model.

A TELEPHOTO LENS has a longer focal length than a normal lens, and covers a smaller angle of view. Telephoto lenses for 35mm cameras generally range from 85mm up to 2000mm, with their corresponding angles of view covering from 28° to 1°.

As you will recall, the greater the focal length, the greater the image size, so if you are shooting from the same camera position, a telephoto lens will produce a larger subject image on the film than a normal lens. For example, a 100mm telephoto lens will double the size of the image produced by a 50mm normal lens. Likewise, a 500mm telephoto will give an image ten times larger in scale than a 50mm lens. That's because the longer the focal length of a lens, the smaller the angle of view, and the subject image appears proportionally greater on the film.

A WIDE-ANGLE LENS, on the other hand, has a shorter focal length than a normal lens, and covers a wider angle of view. For 35mm cameras, wide-angle lenses range from 13mm to 35mm, with corresponding angles of view from 118° to 63°. A wide-angle lens will produce subject images that are smaller than those taken from the same spot with a normal lens or a telephoto lens.

Some extreme wide-angle lenses are called FISH-EYE LENSES because the lens surface bulges out like a fish's eye, and its angle of view is similar, too. The common characteristic of these lenses is that all straight lines of your subject will appear curved except those going through the center of the image. Fish-eye lenses can cover a 220° angle of view, but with most the coverage is 180°. Their focal lengths range from 6mm to 16mm.

With many of these lenses, commonly known as CIRCULAR FISH-EYE LENSES, the camera records a subject area that appears round on the film. Some fish-eye lenses, commonly known as FULL-FRAME FISH-EYE LENSES, have an angle of view of 180° but are designed to cover the entire rectangular format of 35mm film instead of just producing a circular image on the film.

There are also a few ULTRA-WIDE-ANGLE LENSES that produce full-frame, not round, images but do not cover such an extreme wide angle of view or cause curvature of straight lines. Although they have focal lengths in the upper end of the fish-eye range, such as 13mm, 14mm, or 15mm, their corresponding angles of view are 118°, 114°, or 110°, rather than the 180° typical of many fish-eye lenses.

A list of ANGLES OF VIEW (in degrees) of various focal length lenses for 35mm cameras appears on page 106 to help you compare their

## ANGLES OF VIEW FOR 35MM CAMERA LENSES

| Lens Focal Length (in millimeters) | Angle of View (in degrees) |
|---|---|
| 6mm (fish-eye) | 220° |
| 13mm through 16mm (fish-eye) | 180 |
| 13mm | 118 |
| 14 | 114 |
| 15 | 110 |
| 16 | 115 |
| 17 | 104 |
| 18 | 100 |
| 19 | 96 |
| 20 | 94 |
| 21 | 90 |
| 24 | 84 |
| 28 | 75 |
| 35 | 63 |
| 50 | 45 |
| 60 | 39 |
| 75 | 32 |
| 80 | 30 |
| 85 | 28 |
| 90 | 27 |
| 100 | 25 |
| 105 | 23 |
| 135 | 18 |
| 150 | 16 |
| 180 | 14 |
| 200 | 12 |
| 210 | 11 |
| 250 | 10 |
| 280 | 8.5 |
| 300 | 8 |
| 350 | 7 |
| 400 | 6 |
| 500 | 5 |
| 600 | 4 |
| 800 | 3 |
| 1000 | 2.6 |
| 2000 | 1 |

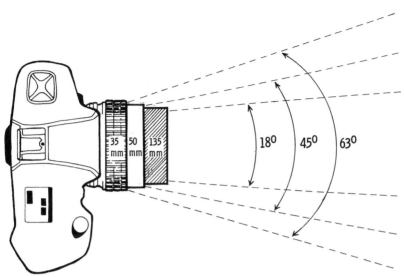

79. The subject area covered by a lens, which is called its angle of view or field of view, is figured in degrees (°) and varies according to the focal length of the lens. In this example of lenses for a 35mm single lens reflex (SLR) camera, a 35mm (wide-angle) lens has an angle of view of 63°, a 50mm (normal) lens covers a 45° angle, and a 135mm (medium telephoto) lens has a field of view of only 18°.

areas of coverage. With lenses of short focal length, the exact angle of view of a specific lens may vary a degree or two, depending on its manufacturer.

Note that these measurements are for the diagonal (corner-to-corner) measurements of the rectangular 35mm film format. Angles of view will be less if given for the horizontal or the vertical measurement of the film format.

You should be aware that classifying lenses as normal, wide-angle, or telephoto according to their focal lengths changes with the size of the film. For example, while the normal lens of a 35mm camera might be 50mm, an 80mm lens is considered to be the normal lens of a medium-format 6 × 6 camera using 120-size 2¼-inch roll film.

So far we have discussed only lenses with a FIXED FOCAL LENGTH, which is also referred to as a SINGLE FOCAL LENGTH. In order to change your subject's image size, you have to change from one fixed focal length lens to another lens with a different focal length, or move the camera closer to or farther away from the subject. However, ZOOM LENSES, an advanced generation of lenses adopted from movie cameras, allow you to vary focal length within a single lens. That means you can increase or decrease the angle of view, and thus the subject's image size, without changing lenses or moving the camera's position.

Not only are zoom lenses very convenient to use, they make it very easy to carefully compose the picture in your viewfinder. No wonder zoom lenses have become more popular than fixed focal length lenses among many photographers. By our count, there are more than 250 different zoom lenses for 35mm single lens reflex cameras now being manufactured by twenty lens and camera companies.

The zoom range varies according to the lens. Most common are focal lengths ranging from a minimum wide-angle lens to a minimum telephoto lens, such as 35–70mm, and also those of greater tele-photo range, such as 80–200 mm. Other types are in the wide-angle range, such as 20–35mm, or cover more extensive wide-angle to tele-photo ranges, such as 28–105mm.

A drawback of many zoom lenses is that their maximum lens opening may be limited, which makes it more difficult to shoot in low-light situations unless you use a high-speed film. A maximum lens opening of f/2.8 is considered a "fast" zoom lens; more com-monly, the largest aperture of a zoom lens aperture is f/3.5, f/4, f/4.5, or even f/5.6.

Actually, most of today's zoom lenses range between *two* maxi-mum apertures, such as f/4–f/5.6, a design that cuts down on the size, weight, and cost of a zoom lens. With these VARIABLE APERTURE ZOOM LENSES, the effective maximum lens opening gets smaller as you zoom to a longer focal length. One drawback is that the image you see in the viewfinder gets slightly darker as the maximum opening gets smaller.

There are always trade-offs. If you buy a zoom with a wide maxi-mum opening that does not vary (our personal choice), it's usually larger in size, heavier, and more expensive. But it is also easier to use in low light. That means you won't need to switch to a higher-speed film or attach a tripod to hold the camera steady, as you might in low-light situations with a variable aperture zoom lens.

A special kind of lens is a MACRO LENS (sometimes called a MICRO LENS), which allows the photographer to focus very near his subject for extreme close-up pictures, and to make photographs at regular distances as well. Some have a focusing range from a few inches or centimeters to infinity. Purchase one with the widest maximum f/stop available, especially if you also plan to use it frequently for non-close-up photography.

Because macro lenses play two roles—as a regular lens and a close-up lens—they have a fixed focal length and are not available as zoom lenses. The most common focal lengths of macro lenses are 50mm, 100mm, and 200mm, although lens manufacturers offer slight variations, such as 55mm, 60mm, and 105mm.

80. A macro lens is especially convenient for close-ups because it allows you to focus at minimum distances to subjects, such as this miniature Eskimo ivory carving in Alaska.

A macro lens is the most convenient way to make close-ups and is able to produce a life-size (1:1) image on the film. Be aware that some telephoto and telephoto zoom lenses have a "macro" setting for closer-than-normal focusing, but they are not true macro lenses. That's because they can only produce an image that is one-half (1:2), one-third (1:3), or one-quarter (1:4) life-size. To create a life-size (1:1) image with these lenses, an EXTENSION TUBE must be added between the camera body and the so-called macro lens.

Another way to get closer to your subject and thus produce a larger image size is by using CLOSE-UP LENSES. These are accessory lenses that attach to the front of a normal, telephoto, or zoom lens. The strength or power of a close-up lens is represented by its DIOPTER, a series of numbers that ranges from +1 to +10 and indicates how close you can focus to a subject. To increase the close-up magnification even more, EXTENSION TUBES or an EXTENSION BELLOWS can be inserted between the camera body and the camera lens.

All lenses for 35mm cameras had to be focused manually until AUTOFOCUS LENSES were introduced. They were a major innovation that helped create a market for compact cameras and also boosted

the popularity of single lens reflex cameras. Autofocus has become prevalent in all types of SLR lenses: normal, telephoto, wide-angle, zoom, and macro. Optical sensors in the lens or the camera activate a motor to automatically adjust the lens until your subject appears in sharp focus in the viewfinder. Some autofocus lenses can only be attached to specific models of SLR cameras, while others have been designed with a variety of lens mounts so they can be used on a number of the major brands of SLR cameras.

Before reading about the various types of lenses in more detail, you should remember that some cameras have permanently mounted lenses that cannot be interchanged. Mostly these are 35mm compact cameras and other rangefinder cameras with between-the-lens leaf-type shutters. However, many of the compact models feature a ZOOM LENS with focal lengths that can be adjusted, or a DUAL LENS with two focal lengths that can be switched from wide-angle to telephoto. A few so-called BRIDGE CAMERAS, also known as 35mm ZLR (ZOOM LENS REFLEX) CAMERAS, have a permanently mounted zoom lens. Full interchangeability of lenses is possible with all other 35mm SLR cameras, as well as with a few rangefinder models that have focal plane shutters, such as Leica cameras.

## Determining the Quality and Cost of Lenses

Computer-generated designs and controls are responsible for the consistent quality of today's camera lenses, but this adage still holds true: The more you pay for a lens, the better it usually is. (Sometimes, of course, you're also paying for the vast amount of advertising done by some camera and lens manufacturers.)

Reading advertisements or brochures to learn about specific lenses can be confusing because of all the technical jargon and trade names and unexplained abbreviations for particular lens features. For example, manufacturers variously label their lens optics as being LD, ED, or UD, which really means the glass is of low, extra-low, or ultra-low dispersion to keep light rays from scattering into various colors of the spectrum. It's difficult to make comparisons and judge which lens is best, although Vivitar is one company that distinguishes its better lenses from its own run-of-the-mill lenses by giving them a special name, "Series 1."

The COST OF LENSES varies considerably. Much of the value of a lens is determined by its OPTICAL QUALITY, and making fine optics is

81. The price of a camera lens often reflects its optical quality, especially in regard to sharpness and its ability to show fine detail, as of the mane of this lion in Africa.

neither easy nor inexpensive. German and Japanese camera makers have well-deserved reputations for outstanding optics, although nowadays some of their lens factories are likely to be located in countries with lower labor costs, including Taiwan, China, Malaysia, and Thailand.

In addition to the precision with which the glass (or plastic) elements within a lens are ground or molded and polished and mounted, its quality depends on the ruggedness of the lens barrel and the durability of its mount. Especially important is how effectively the lens is designed to eliminate distortion, reduce flare, and ensure accurate color renditions.

For instance, camera lenses are really a number of optical elements arranged in a number of groups. Those lenses described as being ASPHERIC or ASPHERICAL indicate that the conventional spherical design of the optical elements has been altered with the inclusion of aspherical elements to reduce any aberrations that degrade the image. Although they generally cost more to manufacture, aspheric lenses require fewer elements, which means the lenses are shorter in length and lighter in weight, and thus more convenient to use.

A major factor affecting the cost and overall value of a camera lens is its MAXIMUM LENS OPENING. Generally, the wider the maximum f/stop, the greater the lens price, because maintaining sharpness at a wide aperture is optically difficult. But lenses with wide maximum lens openings enable photographers to shoot when light levels are low, and many pros are especially willing to pay a higher price for

this lens feature, such as having a f/2.8 maximum aperture on a zoom lens.

Above all in the consideration of the quality of a lens is its SHARP-NESS. Is the picture it produces sharp from corner to corner, or are edges fuzzy? Whatever lens you purchase, if you find it does not produce sharp images, return it to the photo equipment dealer for replacement.

A simple test for sharpness can be done by photographing a page of classified newspaper ads taped flat against a wall. Shoot with slide film; prints will not give a reliable result for this test. Use a tripod to keep the camera steady and the film plane parallel to the wall. Besides inspecting the slide images with a magnifier for overall sharpness (watch for edges of the picture that may be out of focus), also see if the exposures are uniform (look for edges that may be darker than the center of the picture). Make several test exposures at different f/stops. For more scientific and detailed lens tests, you can check current and back issues of *Popular Photography* magazine for its monthly technical review of selected new lenses.

Lens designers are continually making improvements. A significant advance was INTERNAL FOCUSING (IF), which moves optics *within* the lens to achieve sharp focus. The result is a lens that is smaller, weighs less, and does not change in length. Since the front of the lens barrel on most IF lenses does not turn during focusing, polarizing filters can be used more easily, too (see page 234).

Another lens innovation, IMAGE STABILIZATION (IS), was introduced by Canon in 1995 in a 75–300mm telephoto zoom lens. This feature allows you to get a sharp image at slower shutter speeds by counteracting any camera shake that would normally cause a blurred image at the same slow shutter speeds. Image stabilization is achieved within the lens by a vibration sensor, a microcomputer, and a motor that moves a compensating set of optics to effectively minimize any camera movement. In practical terms, if you are hand-holding the camera and normally have to shoot at 1/250 second to get a non-blurred image with the lens at its longest focal length, 300mm, you can get the same sharp results shooting at 1/60 second when image stabilization is turned on.

Besides studying the manufacturer's literature to familiarize yourself with the features of any lens that interests you, try to find someone who uses that specific lens and ask what he likes and dislikes about it. Always request a hands-on demonstration by the dealer before purchasing a lens (bring your own camera to try it on), and inquire about the store's return policy in case you buy the lens but then decide you don't like it.

82. Make certain the lenses and other photographic equipment you buy have warranties that will be honored by their manufacturers. You don't want to miss any great pictures, as of India's spectacular Taj Mahal, because a new lens malfunctions and is difficult to get replaced or repaired.

For optimum results, most pros recommend that you buy lenses that are the same brand as your camera, especially the lens (or lenses) you expect to use most often. If you expect to use a lens only occasionally, such as a very powerful telephoto, a less costly lens from an independent lens manufacturer should be satisfactory.

As you'll discover when shopping for lenses, today's breed are compact, lightweight and well built. The majority feature autofocus and auto-exposure, as well as manual focus and f/stop control. The most useful (and expensive) also have a wide maximum lens opening.

For peace of mind, any lens you buy should be covered by a manufacturer's warranty that is valid in the United States (or your home country). Beware of so-called GRAY-MARKET LENSES that have been imported without going through the lens manufacturer's official U.S. distributor. They will not have a U.S. warranty, and often will not be accepted by the lens company's authorized service center, even when you are willing to pay for repairs.

Besides the lack of a U.S. warranty, clues that a lens (or camera) is "gray market" are an especially low price, a model name or number that is not listed in the company's U.S. products catalog, metric-only (not foot/inch) scales, and/or an instruction manual only in a foreign language (no English version). Even if a dealer denies he is selling you a gray-market product, you take a big chance whenever you buy photo equipment without any warranty, or a warranty that is not valid in your own country.

## Mounting Lenses

Although lenses for 35mm single lens reflex cameras are described as being interchangeable, not all 35mm lenses can be mounted on all 35mm camera bodies. That's because the lens mounts are of different designs and vary with the camera manufacturer and the camera model.

However, there are three basic types of lens mounts. The most common and the easiest to use is called a BAYONET MOUNT. A bayonet mount is aligned and inserted according to markings on the lens and camera, and then a twist of the lens locks it into position. On a few older SLR camera models, a BREECH-LOCK MOUNT is used. After the mount is properly positioned on the camera, a ring on the lens is turned to secure the lens to the camera. Some other early SLRs use a less convenient SCREW MOUNT for manual-focus lenses. The lens must be turned around and around to screw it onto the camera, and quick alignment of the grooves is not always easy. Some lenses with a screw base can be fitted with a bayonet mount adapter so they can be used on cameras designed for a bayonet type of lens mount.

Unfortunately, there is no industry-wide standardization regarding lens mounts, partly because camera manufacturers want you to buy the lenses they make specifically for their cameras. However, the major independent lens manufacturers, such as Sigma, Tamron, Tokina, and Vivitar, design supplemental lenses for interchangeable use on a variety of camera bodies. Of course, the lens mount must be compatible with your specific camera model. When buying any lens, always take your camera to the store to make certain the lens attaches properly and makes the internal connections to operate its auto-exposure and autofocus features.

83. Autofocus
lenses featuring
continuous focus
help you get sharp
pictures of moving
subjects, such as
this pelican.

## All About Autofocus Lenses

The majority of lenses made for today's 35mm single lens reflex cameras feature AUTOFOCUSING and are identified as AF LENSES. Most can be focused manually as well. Lenses that are *exclusively* manual focus are commonly identified as MF LENSES.

Many autofocus lenses that can also be manually focused have a FOCUS CONTROL SWITCH on the lens barrel, which must be set to M for focusing manually or to A for autofocusing.

In addition, the SLR camera body usually has a FOCUS MODE SELECTOR that must be set to M for manual focusing, or to a choice of two modes for autofocusing. Those two modes are generally known as single shot focus and continuous focus.

Most commonly used for autofocusing is the SINGLE SHOT (S) FOCUS mode, because only one shot can be taken when you press the shutter release button. In addition, this single shot mode features FOCUS PRIORITY, which helps prevent out-of-focus pictures. When you activate the autofocus lens by *slightly* depressing the shutter release button, the lens adjusts until your subject in the center of the viewfinder comes into sharp focus, then it locks in the focus at that distance and permits the shutter to be fired. In other words, no exposure can be made until your subject is in focus.

Once the focus locks in, the focus will not change as long as your finger remains on the shutter release. If your subject moves to another location at a different distance before you take a picture, you must momentarily remove your finger from the shutter release but-

ton, then slightly depress it again to reactivate the autofocus. When the subject is once again in sharp focus, the lens locks at that distance—until you fully depress the shutter release to take the picture and/or remove your finger from the button.

The other autofocus mode, CONTINUOUS (C) FOCUS, is activated by keeping the shutter release button slightly depressed. Continuous focus is preferred for moving subjects, because the lens continues to focus on the subject as you follow the action in the viewfinder. This mode features RELEASE PRIORITY, which only locks in the focus the moment you fully depress the shutter release to take the picture. As long as your autofocus lens has a quick focusing response, the moving subject will be in sharp focus in the picture. Some cameras offer continuous focus with focus priority, which means the shutter will not fire until the subject is in focus.

To ensure that your moving subject will remain in focus after you fully depress the shutter release to take the picture, advanced SLRs feature PREDICTIVE AUTOFOCUS in the continuous mode. During the very brief time it takes the SLR's viewfinder mirror to flip out of the light path and the lens aperture to automatically close down to the predetermined f/stop for a proper exposure, the AF computer calculates the speed of your moving subject and refocuses the lens to the distance it predicts your subject will be when the shutter actually opens to expose the film.

In some cameras, predictive autofocus only works when subjects are moving toward or away from the camera at a constant rate of speed. More sophisticated and effective is predictive autofocus that works with subjects that are moving in any direction and at any speed. Check the instruction manual for details concerning the predictive autofocus operation of your particular camera.

Also note in the manual if your camera's single shot, continuous, and predictive autofocus are affected in any way by the FILM ADVANCE CONTROL. It determines how many frames of film are exposed when you fully depress the shutter release button. If the control is set to SINGLE FRAME ADVANCE (S), one film frame will be exposed and the film will automatically advance to the next frame; you must press the shutter release button again to take the next picture. If the control is set to CONTINUOUS ADVANCE (C), film frames will continue to be exposed and advanced as long as you keep the shutter release button fully depressed. Use it for action or sequence photography.

This setting for continuous shooting offers at least two choices, HIGH SPEED (H) AND LOW-SPEED (L) CONTINUOUS ADVANCE, which determine the number of frames that will be exposed per second. The actual number of frames per second (fps) varies according to the

84. To help capture subjects in action, a film advance control on some cameras has a continuous (C) setting that will make a series of exposures for as long as you keep the shutter release depressed.

camera model, such as 4 fps at the high-speed setting and 2 fps at the low-speed setting; check your camera's instruction manual. Choose the continuous high-speed setting to capture fast action in a series of rapid-fire exposures, or use continuous low-speed for slower-moving subjects in order to make fewer exposures and conserve film.

How do you know when an SLR autofocus lens is in sharp focus? The most obvious way is to see if the image looks sharp on the FOCUSING SCREEN in your viewfinder. But a more accurate way is to listen and/or look for the signals given by the camera's ELECTRONIC RANGEFINDER to indicate that your subject is sharply focused.

The moment a lens is properly focused, most AF cameras will tell you by sounding an electronic beep or two. This *audible* IN-FOCUS INDICATOR can be turned off when you want to be quiet and less conspicuous, as at a wedding ceremony.

There is also a *visual* in-focus indicator, a small circular light or symbol that appears in the viewfinder when the lens is properly focused. In addition, there are usually two small opposing lights or symbols shaped like arrows that indicate when the lens is out of focus, and in which direction the lens should be turned (when focusing manually) to achieve sharp focus. If the right-facing arrow

glows continually, it may indicate that your subject is too close to the camera to be sharply focused; move back from subject to the minimum focusing distance of the lens.

The arrows may flash, or another signal in the viewfinder may glow, to indicate that autofocusing is not possible because of the lighting or other conditions (see later in this section).

How do you know exactly what portion of your subject the lens is focusing on? The specific FOCUS DETECTION AREA is marked on the focusing screen in the center of the viewfinder, usually by a circle, a rectangle, or a pair of brackets. Some SLRs offer a choice of wide or spot focus detection areas to accommodate different autofocusing situations.

Of course, the camera doesn't know what part of the picture area you want to make certain is in sharp focus. But camera manufacturers assume that it will be in the center of your viewfinder. Early autofocus cameras had a single AF sensor there that worked well enough when the camera was held horizontally. Then came a CROSS-TYPE AF SENSOR that improved a camera's ability to autofocus when the camera was turned vertically. Finally, MULTI AF SENSORS were added in order to cover areas of the viewfinder where the subject might extend or be located off-center.

This is known as WIDE AREA AUTOFOCUSING and it works well for most subjects, especially if incorporating a cross-type sensor in the center and multi sensors to the left and right. The subject, however, should be large enough to dominate the space within the brackets that mark the wide focus detection area in the viewfinder. If the subject is too small, or if there are two or more subjects within the

85. For accurate autofocusing, your main subject must be located within a pair of brackets (or a circle) that appears in the viewfinder. Some sophisticated single lens reflex (SLR) cameras feature two sets of brackets and offer a choice of wide area autofocusing or spot area autofocusing, which you select with a switch according to the photographic situation (see text).

brackets, the lens might focus on the brightest subject or the subject closest to the camera.

In such situations, you can switch to SPOT AREA AUTOFOCUSING, which limits focus detection to a small area that's usually marked by a circle or by brackets in the center of the viewfinder. It also works best when you want to make certain that a particular part of the subject is in sharp focus, such as the eyes of a person in a portrait, or when the subject is strongly backlighted, such as a person in front of a bright window. Likewise, if your subject is partially obscured by objects in the foreground, such as an animal behind a fence in the zoo, use spot area autofocusing. Look in the instruction manual for specific advice concerning the AF sensors and focus detection area(s) in your camera.

At least one camera model features unique EYE-CONTROL AUTO-FOCUSING, a remarkable system that utilizes multi sensors to automatically focus on whatever part of the picture area you are looking at in the viewfinder. To work effectively, this Canon autofocus system must first be calibrated for the photographer's particular vision under different light conditions; step-by-step calibration procedures are described in the camera manual.

Multi AF sensors and wide area focus detection have helped solve the problem of autofocusing when subjects are off-center. However, with cameras that have only a small focus detection area in the center of the viewfinder, other techniques can be used for FOCUSING ON OFF-CENTER SUBJECTS. They'll help you avoid a common blunder when photographing two people: the focus detection area falls *between* their heads and autofocuses on the background.

In the single shot or continuous autofocus mode with focus priority, aim the viewfinder's focus area circle or brackets at your main subject, slightly depress the shutter release button to activate and lock in the autofocus, then recompose the picture in the viewfinder and fully depress the shutter release to make the exposure.

In the continuous autofocus mode with release priority, there's an extra step. After centering the focus area on your off-center subject and slightly depressing the shutter release button to autofocus, press the camera's AUTOFOCUS LOCK button to hold that focus, then recompose the picture and fully depress the shutter release. (Note: Not all AF cameras have an autofocus lock button. Also, on some AF cameras, an autofocus lock may be combined with the auto-exposure lock.)

Technically, the autofocusing system in most SLR cameras is called PASSIVE PHASE DETECTION, which relies on optical sensors to react to the light coming through the camera's interchangeable lens

86. A camera featuring wide area autofocusing will automatically focus on off-center subjects, such as this horse carriage driver. Otherwise you can aim the camera to focus on a subject that's off-center, activate the autofocus lock, and then recompose the picture in the viewfinder.

and activate the AF mechanism. The system works very quickly and accurately with well-illuminated subjects of good contrast and detail. Unlike the ACTIVE INFRARED AUTOFOCUS SYSTEM utilized in compact cameras, SLR AF cameras will focus at any distance, through glass windows, and on reflections in mirrors.

However, SLR autofocusing may react slowly or even fail completely, especially when you are shooting in dim light and/or when your subject shows little contrast or detail. Subjects that are strongly backlighted, and very bright subjects with a shiny surface, as when the sun is glaring off water in a lake or off chrome on a car, can also cause autofocus to falter. Some filters may confuse the AF system, too, especially a linear (rather than the recommended circular) polarizing filter, a soft-focus filter, and some solid color filters, such as red (see page 230). Many cameras flash a warning in the viewfinder to alert you if the autofocus is incapable of working. The instruction manual will describe any troublesome autofocusing situations specific to your particular camera, and remedies.

One way SLR manufacturers have improved their autofocus systems is to incorporate an AF ASSIST, sometimes called an AUTOFOCUS ILLUMINATOR BEAM. It enables cameras to focus automatically in dim light, and also when the subject is of low contrast. The feature is

built into the camera or into its accessory flash unit to project nearly invisible infrared or red LED beams that reflect off the subject so that the AF system can function. The distance of your subject and the focal length of the lens limits the operating range of the autofocus assist; refer to the camera or flash instruction manual.

Also check the manual for other AUTOFOCUSING LIMITATIONS. In general, a camera lens must have a maximum aperture of f/5.6 or wider in order for an SLR autofocus system to operate. This is usually not a concern unless a filter, a lens extender, or another lens attachment is added to the camera lens which makes its *effective maximum aperture* smaller than f/5.6 (see pages 129 and 230).

Some advanced SLR models feature INTERCHANGEABLE FOCUSING SCREENS, which vary in design to help you compose and focus for general or specialized photography. For example, one type is etched with horizontal and vertical lines to aid architectural photographers in making certain that the lines of buildings appear straight in their pictures. Before buying a focusing screen to replace the one supplied with your camera, make sure it is compatible for use with your autofocus lenses.

By the way, a useful but less common feature of a few SLR autofocus cameras (or their accessory multifunction backs) is FREEZE FOCUS, sometimes called TRAP FOCUS. It allows you to get a sharply focused picture of a moving subject at a predetermined spot. You *manually prefocus* at a certain distance, such as just above a fence that a show horse and rider will be jumping, press the shutter release, and when your subject appears in the focus area of your viewfinder, the shutter will open to make the exposure. By automatically firing the shutter, freeze focus can be helpful to wildlife photographers, such as when waiting for a bird to return to its nest.

## Praising Zippy Zoom Lenses

Zoom lenses have become the favorite lenses of many photographers. Instead of buying an SLR camera with a normal 50mm lens, they opt for a zoom that includes the focal length of a normal lens but also covers a wide-angle to telephoto range, such as 35–70mm. A zoom lens, which allows you to vary the focal length and thus the image size, is both convenient and versatile.

There are no delays or missed pictures, as may be the case when changing from one fixed focal length lens to another. Control of composition is easier, too. Photographers making color slides for projection especially like zoom lenses because they can easily fill the

87. With a zoom lens you can easily compose pictures of moving subjects, such as this parasailer, by adjusting the lens focal length while following the action in the camera's viewfinder.

viewfinder and film frame with exactly the picture they want to show on the screen. They get closer to (zoom in) or farther away (zoom out) from their subjects simply by adjusting the lens. Other photographers create interesting photographic effects, including one of motion, by zooming the lens in or out during the actual exposure. To allow time for this action, the shutter speed must be relatively slow (see page 338).

Although early zoom lenses were sometimes criticized for their fuzzy images, the more recent generations of computer-designed zoom lenses produce very sharp pictures. As previously mentioned, a main reason for their popularity is that one zoom lens will do the work of several lenses of single focal lengths. Most photographers don't mind that a zoom lens may be larger and heavier and have a smaller maximum aperture when compared with lenses of single focal lengths; they favor the convenience of a zoom lens over those drawbacks.

However, you should be aware that there are a few so-called zoom lenses that do not keep the subject image sharply focused as you change the focal length. These are more accurately called VARIABLE

FOCAL LENGTH LENSES or VARIFOCAL LENSES because you have to refocus them every time you zoom in or zoom out.

True zoom lenses will always remain in focus when the focal length is changed. For that reason, some photographers who focus zoom lenses *manually* first zoom to the greatest focal length so that the subject will appear larger in the viewfinder and can be focused more critically, and then they readjust the zoom control to compose the picture as desired.

There are two types of controls for manually focusing and changing the focal length of a zoom lens. A ONE-TOUCH ZOOM has a single ring that you push and pull to change the focal length and also twist to focus. A TWO-TOUCH ZOOM has two control rings: one you push and pull or twist to adjust the focal length, the other you twist to focus.

Many photographers prefer one-touch zooms because they can be operated more quickly. However, you have to be careful not to inadvertently change the focal length when manually focusing, and also watch out that you don't twist the lens out of focus when zooming. Of course, accidentally changing the focus is not a concern if it is an autofocus zoom lens and has been set to automatic (A) focus instead of manual (M) focus.

With a two-touch zoom there is never any worry about unintentionally changing the focus while you adjust the focal length, and vice versa. But it takes longer to manually make both those adjustments

88–89. Recomposing a picture is very convenient with a zoom lens. By simply changing the lens focal length you can go from an overall view to a close-up. These totems in Vancouver, Canada, were shot with a zoom telephoto lens at each end of its range, 80mm and 200mm.

because you have to move your fingers from one ring to the other. Of course, if it's an autofocus zoom lens, you only have to make the focal length adjustment manually if the lens is set to automatic (A) focus instead of manual (M) focus.

We regularly use an autofocus zoom lens of medium focal length, 35–70mm, as our normal lens, because it makes composing and focusing a picture in the viewfinder very quick and easy. To reduce the number of extra lenses in our camera bags, especially when traveling, we carry two other autofocus zoom lenses: an AF wide-angle (20–35mm) and an AF telephoto (80–200mm). These three lenses give us a very wide and graduated range of focal lengths, from 20mm to 200mm, which is almost like having 180 lenses, each with one millimeter's difference in focal length. Try out several zoom lenses before deciding which one would be a good investment for you. They vary considerably in features and price, depending on the manufacturer.

## Tips for Using Telephoto Lenses

For photographers who prefer fixed focal length lenses instead of zoom lenses, the favorite type is often a telephoto. Telephoto lenses put you where the action is, especially at sports events where fans and photographers are often required to keep their distance. Nature photographers count on telephoto lenses to get near subjects without disturbing them, a necessity for bird and other wildlife pictures. For travel photographers, telephotos capture informal portraits of people without making subjects aware of the camera. And distant scenes, or portions of them, can be brought closer for detailed and dramatic effects.

Filling your frame with the subject is a basic rule for making an effective picture, and telephoto lenses do that quite easily. The specific lens focal length to choose depends on the distance to your subjects and how large you want their images to appear on the film. Popular telephoto focal lengths include 105mm, 135mm, and 200mm.

Since 35mm cameras are designed to be small and convenient, a big telephoto lens will alter those features. Beyond 200mm, they can get heavy and awkward to use. Lenses of great focal length, which range up to 2000mm, are described as being LONG, EXTREME, POWERFUL, or SUPER TELEPHOTO LENSES. They are most frequently used by

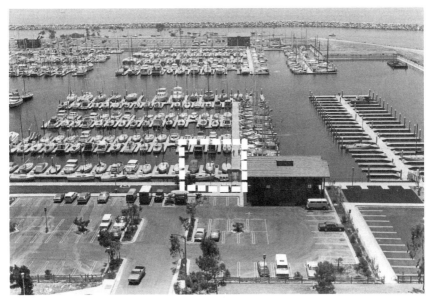

90. Compare focal lengths in order to know how much larger or smaller your subject will appear when you change lenses or zoom lens settings. A 50mm (normal) lens captured this overall view of a marina as seen from a cliff top in Southern California.

91. A small section of the marina (see area outlined by the white box in the photo above) was increased in size eight times (8X) when photographed from the same spot with a 400mm telephoto lens.

wildlife photographers and professional sports photographers. Often a TRIPOD is needed to support these long lenses and keep them steady; most have their own tripod socket to ensure proper balance of the heavy lens and lighter-weight camera.

Since only a small picture area is encompassed by a lens of great focal length, even slight CAMERA MOVEMENT will cause a blurred picture. If hand-held, a camera with a telephoto lens (or zoom telephoto) requires a fast shutter speed to avoid this problem. As a rule of thumb, *use a shutter speed at least as fast as the millimeter focal length of the lens,* such as 1/250 second with a 200mm telephoto. Even then, other support is often needed to get the sharpest pictures possible. Some photographers use a PISTOL GRIP or SHOULDER BRACE to help steady their telephoto lenses when making candid pictures.

Camera movement becomes a particular concern when you are shooting in low-light situations with a telephoto lens. That's because many telephoto lenses have a limited MAXIMUM LENS APERTURE, which requires slower shutter speeds for correct exposures. One solution is to shoot with a high-speed film, such as ISO 400 or faster.

A better idea is to buy a telephoto with a fast lens—one that has a wide maximum aperture, such as f/2.8. Unfortunately, it will be bigger, heavier, and costlier than the more common telephotos, which have a nominal maximum lens speed of f/3.5, f/4, f/4.5, or f/5.6. For further comparison, you should remember that normal lenses almost always have a larger maximum f/stop opening, often from f/2 to f/2.8. Thus, normal lenses are usually the fastest of the two types and the easiest to use in low light.

Another consideration with telephoto lenses (including telephoto zooms) is that the greater their focal length, the less DEPTH OF FIELD. The area of the picture that can be put into sharp focus is reduced as the focal length (mm) of a lens increases. Thus, focusing with a 200mm lens is more critical, and there is less depth of field possible, than with a 100mm telephoto. Of course, the distance between the subject and the camera, and the f/stop used, also affect focus and depth of field.

The limited depth of field characteristic of a telephoto lens is often used creatively. For instance, such a narrow zone of sharpness enables a photographer to easily isolate and therefore emphasize his subject by keeping an unwanted foreground or background, or both, out of focus.

Telephoto lenses offer many advantages, even though you must focus critically because of limited depth of field and must often use a

92. Telephoto lenses are ideal for photographing wildlife because you can fill the film frame without getting physically close with the camera or disturbing your subjects, such as these young male elk locked in playful winter battle in Wyoming.

camera support and/or a fast shutter speed to get sharp results. Telephotos of medium focal length—such as 85mm, 105mm, and 135mm—are popular for portraits because your subject's features will not be distorted, and you do not need to get uncomfortably close with your camera to fill the film frame.

We would advise against purchasing an extremely powerful telephoto, such as anything greater than 400mm, unless for wildlife or sports photography. It is impractical for general photography, because you are frequently too close to subjects to find the lens very useful. Its cumbersome weight and size, its f/stop and depth of field limitations, as well as its high cost, make a telephoto lens of very great focal length an extravagance rather than a necessity for most photographers.

There is a less expensive way to increase the focal length of a normal or telephoto lens and therefore increase the size of your subject: Use a LENS EXTENDER, also called a LENS CONVERTER, a TELE-EXTENDER, or a TELECONVERTER. This is an optical device inserted between the camera body and the lens which increases the lens focal length—and thus the subject image size—by $1\frac{1}{2}$, 2, or 3 times, depending on whether it is a 1.5X (sometimes 1.4X), 2X, or 3X extender.

For example, with a 1.5X extender, a 50mm lens becomes a 75mm lens, and a 200mm lens becomes a 300mm lens. Likewise, a 2X extender doubles the focal length of a 50mm lens to 100mm, and a 200mm lens to 400mm. When used with a 3X extender, a 50mm

93. You don't need a big, expensive telephoto lens to produce larger images of your subjects. One option is to mount a lens extender, also called a teleconverter, between the camera body and any lens to increase its effective focal length. The 2X extender shown here will double the focal length. For example, a 105mm lens will effectively become a 210mm lens, and thus double the image size.

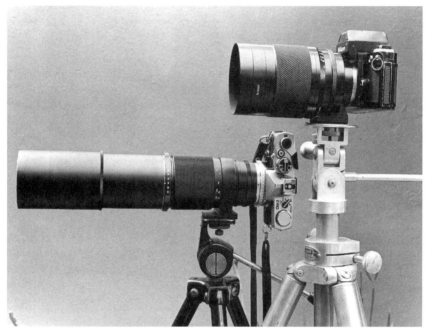

94. Another option to the bulk, weight, and cost of a conventional telephoto lens is a reflex-type telephoto lens, shown in the foreground. This 500mm mirror telephoto is shorter in length, lighter in weight, and even more powerful than the 400mm telephoto lens behind it. To avoid blurred images caused by camera movement, use a tripod when photographing with telephoto lenses; the lenses shown here have a special tripod socket on the lens itself for better balance and support than offered when the tripod is attached to the camera body.

lens effectively triples its focal length to 150mm, and a 200mm lens to 600mm.

Lens extenders work with zoom lenses as well as fixed focal length lenses.

A drawback of lens extenders is that exposures must be increased, because light travels a greater distance to reach the film when the lens focal length is increased. Generally, a 1.5X (or 1.4X) extender requires an exposure increase of about one f/stop, a 2X

extender an increase of two f/stops, and a 3X extender an increase of three f/stops.

A camera with a through-the-lens exposure metering system usually gives a correct reading when a lens extender is attached (see the camera's instruction manual). On some models, the extender couples to the auto-exposure and/or automatic aperture f/stop control; otherwise, f/stops must be set manually. When a hand-held exposure meter is used, refer to the exposure compensation information that accompanies the specific extender and figure the correct f/stop to set manually on the lens.

Be aware that a lens extender may prevent autofocusing, because most autofocus lenses require a *minimum* f/5.6 opening in order to operate. If you have trouble with autofocusing, figure what the *effective lens opening* would be for the particular lens and lens extender. For instance, a lens with a maximum opening of f/4 is effectively an f/8 lens when used with a 2X extender, and probably will not be able to focus automatically. Focus manually instead.

One caution: The quality of optics varies in lens extenders. Overall sharpness may be lacking, and the edges of your picture may be slightly darker than its center area. (3X extenders are rarely used because they have the poorest image quality.) Nevertheless, if your need for a stronger telephoto is only occasional, a lens extender can be an inexpensive and very acceptable solution.

Mention must be made of REFLEX-TYPE TELEPHOTO LENSES, commonly called MIRROR LENSES and formally called CATADIOPTRIC LENSES. They follow the design of telescopes in order to reduce the length, weight, and price of traditional telephoto lenses of greater focal lengths—those from 500mm to 2000mm. To do this, the image coming into the lens is bounced off a mirror at the rear of the lens to a mirror at the front of a lens that reflects it back to the film.

Because of this unique design, a mirror lens has a fixed aperture, often f/8, which cannot be changed. In order to get proper exposures, the only thing you can do is adjust the shutter speed control (or use neutral density filters to reduce the intensity of the light reaching the film).

Another limitation of mirror telephoto lenses is that depth of field cannot be controlled because the f/stop is always the same. Also, bright spots in an out-of-focus background often appear as doughnut-shaped images, which can be appealing or distracting, depending on the picture's subject.

95. Because of their exceptional depth of field, wide-angle lenses make it possible for everything in the picture area to be in focus. A 20mm wide-angle lens and a small lens opening (f/stop) were used to keep this churchyard fence sharply focused from the foreground to the background.

## Working with Wide-Angle Lenses

When photographers want to cover a wider angle of view than is possible with a normal or telephoto lens, they switch to a wide-angle lens. These lenses have shorter focal lengths, such as 35mm, 28mm, 24mm, or 20mm. The shorter the focal length, the wider the view—which means the subject's image size will be smaller in the view-finder and on the film.

Wide-angle lenses are especially useful when shooting in close quarters, such as narrow streets or room interiors. When you cannot move back to include more of your subject, a wide-angle lens will do the trick.

Panoramic landscapes are also possible with wide-angle lenses, although the image size of the subject becomes smaller. Towering mountain scenery can be overwhelming when you are photographing it, but if it is shot with an extreme wide-angle lens, the resulting pic-ture is often less impressive than you expected because the moun-tains appear will appear very small. Many travel photographers become disenchanted with wide-angle lenses after trying to make

dramatic scenic shots. One way to overcome this is by including an object that will appear large in the foreground.

A plus factor when using wide-angle lenses is that they offer remarkable depth of field, so focusing is less critical and sometimes even unnecessary. A 28mm lens, for example, will be in focus from 5 feet to infinity when its aperture is set to f/8. At a smaller f/stop, f/16, the in-focus range increases down to $2^{1}/_{2}$ feet through infinity. By comparison, a normal 50mm lens set at f/8 has a depth of field of only 15 feet to infinity.

Because of their extreme depth of field, wide-angle lenses are the choice of photographers who want to emphasize a subject in the foreground by getting close to it, and still keep the background in sharp focus. When used in this way to make your subject large and dominant in the film frame, wide-angle lenses produce very eye-catching photographs.

However, a wide-angle lens may cause DISTORTION when the camera is close to a subject. Be especially aware that full-frame por-traits of people made with wide-angle lenses can be unflattering. That's because those portions of a subject closest to the lens are exaggerated, with startling results. For example, when taken with an extreme wide-angle lens, a picture of a pig's snout is more likely to look like the nose of an anteater.

96–97. Distortion of parallel lines can be a problem (or a creative asset) when a wide-angle lens is tilted up or down; note how Great Britain's Parliament building and its Big Ben clock tower lean inward. In order to straighten up the clock tower somewhat in the companion picture, the camera was turned vertically and repositioned, and its zoom wide-angle lens was ad-justed to a longer focal length (35mm instead of 20mm).

Wide-angle lenses are smaller in size and lighter in weight than telephoto lenses. However, because it is designed to take in a greater field of view, a wide-angle lens may have a front lens element that bulges out. To protect that optical glass from scratches or other damage, use a UV or skylight filter. Also, to help block direct sunlight from the lens and avoid flare in your photographs, use a lens shade. *Whenever you attach a filter or a lens shade to the front of a wide-angle lens, always check in the viewfinder to be sure it does not obscure the corners of the image.*

Photographers enjoy shooting with wide-angle lenses, but may also discover some of the peculiarities of *extreme* wide-angle lenses. For instance, because of their very short focal lengths, a few extreme wide-angle fish-eye lenses of older design are so close to the film plane that they prevent use of the viewfinder in SLR cameras. The reason is that the camera's instant-return mirror must be locked up out of the way in order to attach the lens, thus cutting off the reflected subject image seen by the photographer. But since focusing and framing is not a problem with these fish-eye lenses, photographers adapt to this limitation.

A partial reason is that shooting with fish-eye and other extreme wide-angle lenses is an occasional thing. Professional photographers save them for a unique shot. Too many extreme wide-angle pictures, with their bothersome distortion and tiny subject images, become monotonous if not displeasing. However, the more nominal wide-angle lenses, such as 28mm, 24mm, and 20mm, are favorites of many photographers, including photojournalists. While any of these focal lengths would be a good choice if you're considering purchasing a wide-angle lens, make some test shots to see which focal length you prefer for the type of photography you do.

Another caution: Distortion caused by a wide-angle lens may be very noticeable in regard to parallel lines. If you shoot horizontally and level with the subject, any vertical lines will appear straight. But if the camera is tilted up, those vertical lines or objects seem to bend inward at the top of the picture. Thus, if you shoot upward, square building exteriors will narrow at the top, an effect that's called KEYSTONING.

Likewise, tilting the camera down tends to bend lines or objects inward at the bottom of the picture. Corners of rooms also tilt inward or outward, depending on the angle of the camera. Additionally, wide-angle lenses of shorter focal lengths may distort subjects at the far edges of the picture by making them appear wider than they actually are.

To prevent distortion of parallel lines, especially for architectural

photography, pros use a special PERSPECTIVE-CORRECTION or PERSPEC-TIVE-CONTROL (PC) LENS, which is also called a SHIFT LENS. Turning a thumbscrew shifts the axis of the lens up or down so that the film plane can be kept parallel to the subject and you can avoid the convergence of lines that occurs when the camera itself is tilted up or down. However, this lens is expensive, requires careful adjustment and manual focus, and may have a limited maximum lens opening—all of which combine to make a PC lens impractical for general photography.

Most PC lenses are available in wide-angle focal lengths of 24mm, 28mm, or 35mm. Canon offers 45mm and 90mm PC lenses as well, but identifies them all as TS lenses, for "tilt/shift," because they feature a second adjustment to tilt the lens for increased depth of field at wide f/stops. Because correction of distorted parallel lines can be accomplished to a considerable degree in the enlarging process, photographers who make color or black-and-white prints in their own darkrooms are less concerned with the problem.

## Making It Big with Macro Lenses

A macro lens is a dual-purpose lens because it can be used for making close-ups as well as serve as a normal or telephoto lens on SLR cameras. As mentioned earlier in the introductory information about macro lenses, their focal lengths range from 50mm to 200mm. Some manufacturers call their macro lenses MICRO LENSES or CLOSE-FOCUS LENSES. A macro lens is designed primarily for close-up work; a *true* macro lens can produce images on the film that are life-size, known as a one-to-one (1:1) REPRODUCTION RATIO.

Close-up photography is especially easy with a macro lens because you don't have to bother with additional close-up lenses or other attachments, such as an EXTENSION TUBE or an EXTENSION BELLOWS (see later in this chapter). You're reminded, however, that some so-called macro lenses will reproduce your subject only to one-half (1:2), one-third (1:3), or one-fourth (1:4) life-size; the addition of an extension tube between the camera body and the macro lens will be required to create a life-size (1:1) image.

Before purchasing any macro lens, study its technical literature to learn the maximum reproduction ratio the lens can achieve. Also note the minimum distance the camera must be to your subject to produce that maximum image size. If you like to work at a greater distance from your close-up subjects, choose a macro lens with a longer focal length, such as 100mm instead of 50mm. The extra

98. A macro lens enabled the photographer to focus within inches of this rose blossom for a close-up look at its unfolding petals.

shooting distance may help avoid disturbing the subject, or give you more room to position reflectors or flash units to illuminate the subject.

If you do close-up photography infrequently, a drawback of buying a macro lens instead of a normal lens or a telephoto lens of an equivalent focal length is that the macro will often have a maximum lens opening that is one or two f/stops smaller, and thus be less useful for regular photography in low-light situations. Because of its specialized optics and design, a macro lens is also more costly. (An option for making close-ups is to use accessory close-up lenses; see the section that follows.)

Since focus is critical in close-up photography, a macro lens has a minimum aperture of f/22 or f/32, which is advantageous because the smaller the lens opening, the greater the depth of field. Of course, a small f/stop usually means a slower shutter speed is required for a proper exposure, and thus some support is needed to keep the camera steady. Use a tripod to support the camera and avoid blurred images caused by camera shake. A tripod also helps maintain the critical lens-to-subject distance after focusing.

Using flash will provide extra light so a faster shutter speed or a smaller f/stop can be used to sharply capture close-up subjects on film. Light from an electronic flash is bright but brief and generally will stop any movement of the subject. To make extreme close-ups

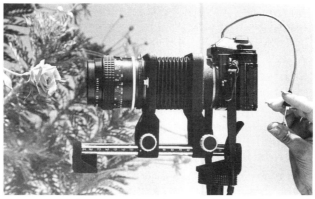

99. For versatility in making close-up photographs, an adjustable extension bellows can be mounted between the camera body and the lens. Here it is being used to show the interior of a flower (see Illustration 98). Because of the great magnification, the bellows is mounted on a tripod for support; a cable release is used to prevent the camera from being moved inadvertently during the exposure.

without shadows, photographers use a RING LIGHT, a special flash unit that encircles the lens and uniformly illuminates the subject.

By the way, if you don't have a macro lens available, an interesting and inexpensive way to make close-ups is to REVERSE A NORMAL OR WIDE-ANGLE LENS. Many photographers have made emergency close-up shots by removing a normal or wide-angle lens from their SLR cameras and turning it end for end. This allows a decrease in the distance between camera and subject, and thus an increase in the subject's image size on the film.

A special LENS REVERSING RING, sometimes called a MACRO ADAPTER RING, is available for some SLR cameras in order to mount a lens in reversed position. Without one, you'll have to hold the lens in place. Use your fingers to make as effective a lighttight collar as possible between the lens and camera body. Prefocus at infinity, and then move your head and camera slowly back and forth to bring the subject into focus through the viewfinder of your SLR. Try it.

For instance, if the minimum focusing distance for a 50mm lens is 18 inches (45.7cm) from the film plane to the subject, it will cover an area measuring $6^{1}/_{4} \times 10$ inches ($15.9 \times 25.4$cm). Reversing that lens allows you to get the film as close as 8 inches (20.3cm) to the subject, and reduces the area covered to only $1^{1}/_{4} \times 2$ inches ($3.2 \times 5.1$cm). Thus, in this example, by reversing the lens you have increased the image size of your subject five times.

Of course, just as autofocusing will not work when the lens is in

reversed position, neither will the lens's automatic exposure control. With most lens reversing rings, the f/stop must be adjusted manually for the proper exposure. When set to manual (M), the built-in exposure meters of SLR cameras should give an accurate reading as you turn the f/stop control ring, although the picture you see through the viewfinder will get dimmer as the lens is stopped down to smaller apertures. Despite what may seem a strange procedure, reversing a normal or wide-angle is a good way to make occasional close-ups.

Another option for making close-up photographs, which is easier than reversing the lens and less expensive than buying a macro lens, is attaching a close-up lens to one of your regular lenses.

## Creating Large Images with Close-up Lenses

Close-up lenses are a special category of lenses because they are ACCESSORY LENSES rather than primary lenses. They screw into or snap onto the front of a normal, telephoto, or zoom lens to allow the camera to focus closer to the subject than usual and thus produce larger images.

Although close-up lenses became outmoded for most single lens reflex camera owners with the advent of macro lenses, they remain a less expensive alternative for SLR photographers who like full-frame pictures of small subjects, such as flowers and insects. Close-up lenses are also utilized for copying photographs or other flat, two-dimensional objects, although the image may not be uniformly sharp unless exposed at a small f/stop.

Accessory close-up lenses are the only option for making close-up pictures with cameras that have permanently mounted lenses, including compact cameras, unless the camera features a macro mode or close-focus mode.

The strength or power of a close-up lens is referred to as its DIOPTER, and is indicated by a plus sign with a number, such as +2. The higher this number, the closer you can get to the subject, and thus the larger the image size on the film.

The following chart indicates how close you can get to your subject (i.e., the focusing range) according to the diopter of the close-up lens or lenses being used.

| Close-up Lens (diopter) | Focusing Range from Subject (in inches) | (in centimeters) |
|---|---|---|
| +1 | $20^3/_8$ to $38^3/_4$ | 51.8 to 98.4 |
| +2 | $13^3/_8$ to $19^1/_2$ | 34   to 49.5 |
| +3 (+1 and +2) | 10   to 13 | 25.4 to 33 |
| +4 | 8   to   $9^7/_8$ | 20.3 to 25.1 |
| +5 (+1 and +4) | $6^1/_2$ to   $7^7/_8$ | 16.5 to 20 |
| +6 (+2 and +4) | $5^5/_8$ to   $6^1/_2$ | 14.3 to 16.5 |
| +8 | $4^5/_8$ to   $5^1/_8$ | 11.7 to 13 |
| +10 | $4^1/_4$ to   5 | 10.8 to 12.7 |

The most popular set of close-up lenses is of three powers: +1, +2, and +4. They can be used alone, or two can be combined. For example, a +1 and a +4 equal a diopter of +5. Put the strongest of the two lenses closest to the camera lens. The maximum strength of a close-up lens is +10.

Some zoom-type close-up lenses offer a range of powers, such as from +3 to +7 diopters or even +1 to +10. These VARIABLE CLOSE-UP LENSES can be adjusted to vary magnification, and thus alter the subject's image size with ease. After each adjustment, however, the lens must be refocused.

Most close-up lenses screw into the camera lens directly, just as many filters do. Buy screw-in close-up lenses in the same millimeter (mm) size as the screw-in filters that fit your specific camera lens. Some close-up lenses are not threaded to screw into the camera lens but fit into a LENS ADAPTER that screws into or snaps onto the camera lens. The sizes of these nonthreaded close-up lenses are identified by a *series number*, which ranges from 4 to 9; do not confuse the series number with the diopter number. Before buying any close-up lens, check that it fits your camera lens or the lens adapter.

A welcome aspect of close-up lenses is that they require no increase in exposure; attaching one or two of them to your camera lens will not change the exposure.

The main concern with close-up lenses is their very limited depth of field. The closer you are to the subject, the more critical focusing becomes. For this reason, and that of parallax error (see later in this section), single lens reflex cameras are the most convenient cameras to use with close-up lenses, because you focus and frame as usual through the SLR's viewfinder.

With most non-SLR cameras, focusing and framing with close-up lenses cannot be done visually through the viewfinder. Instead, to

100. When a subject is used with close-up attachments, such as accessory lenses or extension tubes or bellows, the subject's image size changes considerably. This sunflower was photographed with a 50mm lens at its minimum focusing distance.

101. The same sunflower photographed with a 50mm lens with a +1 close-up lens attached.

102. Details of the sunflower's center are seen when photographed with a 50mm lens with a +1 close-up lens and a 1-inch extension tube attached.

focus, distances between the close-up lens and your subject are measured with a ruler, and the focusing scale on the camera lens is set according to the strength or power (i.e., diopter) of the close-up lens that is attached.

Likewise, the viewfinder of a rangefinder camera will not show you what the camera lens sees at close range to the subject, an effect called PARALLAX ERROR. You must disregard the viewfinder and frame the picture in another way, most often with a homemade framing device that extends from the close-up lens to the subject. It can be made of wire fastened to the camera, or you can frame with the aid of a cardboard diagram that's held between the lens and the subject. Mount the camera on a tripod to keep the distance and framing position exact.

Take note that a few rangefinder cameras accept an accessory attachment that can be mounted on the viewfinder and gives the photographer visual correction for focusing, angle of view, and parallax when using close-up lenses.

## Nonoptical Options for Making Close-ups

Nonoptical lens attachments can be used on SLR cameras in order to make close-up images with regular camera lenses, including those already fitted with accessory close-up lenses. Least costly and most common are EXTENSION TUBES. These are plastic or metal rings that are mounted between the camera body and the regular lens to position the camera lens farther from the film, thus allowing you to get closer to your subject and increase its image size on the film.

An EXTENSION BELLOWS is an adjustable extension device that acts on the same principle. By turning knobs, you can easily extend the flexible bellows to increase the subject's image size, even as much as four times (4:1) life-size. Although far more versatile than extension tubes, bellows are more expensive and cumbersome to use. See Illustration 99.

With either extension device, exposure is affected because the camera lens is moved farther from the film. Since light has to travel a greater distance from the lens to the film, a longer exposure is required. Through-the-lens exposure metering systems will compensate and give correct exposures. Some extension tubes and bellows allow use of a camera's auto-exposure or automatic lens aperture controls; otherwise, f/stops must be set manually for correct exposures.

If using a hand-held exposure meter, you have to calculate and

increase the exposure according to the lens-to-film distance. For guidance, consult the charts provided with the extension devices that indicate the increased exposure factors, which depend on the amount of magnification and the focal length of the camera lens being used.

Equipment and techniques for close-up photography are described in more detail beginning on page 369.

# Finding Out All About Flash

Photographers most often count on natural light from the sun to provide illumination for their photographs. However, there is a very portable, powerful, and versatile source of artificial light—flash—that in recent years has become a photographer's best friend. It's no longer used just indoors or after dark. These days, flash is often fired outdoors during daylight to make a more pleasing picture; it adds light to harsh shadows caused by the sun.

This is called FILL FLASH, and it's one of the many features of today's flash units—whether built into the camera or an accessory flash that's mounted on the camera. To fully develop your photographic skills, you should learn all about flash and how very useful it can be. This lengthy chapter describes the various types of flash, the abundance of features found on modern flash units, and the many flash techniques that can add new dimensions to your photography.

Early-day photographers created "instant sunshine" in the mid-1800s by igniting magnesium powder to provide a very bright but potentially dangerous "flash" light. Over the years, safer and more convenient FLASHBULBS evolved, but they have been superseded by ELECTRONIC FLASH. Today's flash units have become the most popular source of instant artificial light for professional and amateur photographers alike.

Basically, an electronic flash uses batteries to build up a high voltage that is discharged into a gas-filled tube to create a brief flash of brilliant light. Unlike a flashbulb, which must be replaced after each flash, an electronic flash can be fired again and again—with only a momentary delay between flashes while the batteries restore high voltage to the unit's electrical capacitor.

103. Autoflash adjusts automatically for a proper exposure, which makes it an easy-to-use and effective light source, even outdoors. Fill flash helped illuminate this patriotic young girl, who was standing in the shade of some trees to watch a Fourth of July parade.

## Day and Night Uses of Flash

Granted that many snapshooters still consider flash just in a basic role—to illuminate a dark subject—but there are many other

creative possibilities. As you'll discover, electronic flash is much more than just a handy source of illumination when little or no natural light is present. One important feature is that the duration of the flash light is very brief, at most only a millisecond (1/1000 second), which makes it easy to stop fast action and "freeze" your subjects. The quick burst of light also means you'll avoid blurred pictures caused by inadvertent camera movement. And you can bounce flash off a ceiling or wall to improve interior shots being exposed by natural light.

Besides providing light for photography indoors, flash is a big help outdoors IN DAYTIME to fill in any shadows on your subjects, especially people's faces. The extra light will give detail to facial features and add a sparkle to the informal portraits you shoot in daylight. On overcast days, flash can be fired to brighten up nearby subjects and/or to eliminate a distracting background. In some backlighted situations, such as when photographing people in front of a sunset, flash will illuminate your subjects so they won't appear as silhouettes.

AT NIGHT, off the camera, flash can be fired several times during a time exposure to light up a large subject, like a statue or the front of a building. And it can be fired several times to expose the same frame of film to make a multiple exposure. Flash is also valuable for close-up photography, because the bright flash light lets you use small lens openings for better depth of field. In addition, flash can be used with colored filters to create special effects.

## Farewell to Flashbulbs

Because of the popularity of electronic flash units, which are sometimes called SPEEDLIGHTS or STROBES, flashbulbs are rarely used nowadays. However, some older snapshot cameras require them. These cameras, including the popular Instamatic, were designed for a specific type of flashbulb system, such as the MAGICUBE, an inch-square self-contained unit that has four small flashbulbs and reflectors. The Magicube revolves after each flash so a fresh bulb is in position and ready to fire. It succeeded the FLASHCUBE, which looks the same but requires batteries to trigger it. Some snapshot cameras were designed for other self-triggering, batteryless flashbulb devices, called FLIPFLASH and FLASHBARS, which offer eight to ten flashes in a single slim pack.

These flash devices appeared in the 1970s and were great

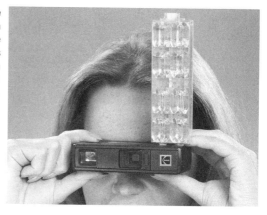

104. Electronic flash has made flash bulbs obsolete, although older cameras may require them. This simple model is designed for flipflash, a throw-away reflector with eight tiny flash bulbs.

improvements over the earlier flashbulb-and-reflector system that required the time-consuming chore of replacing the bulb after each flash. In addition to juggling the hot, used flashbulb while inserting a fresh bulb into the flash reflector, photographers had to make calculations and camera adjustments for a proper flash exposure. To determine the f/stop, they had to figure the distance between the flash and their subject, then use a chart calibrated for the speed (ISO) of the film and the size and type of flashbulb. The shutter speed also had to be set to synchronize the shutter opening with the firing of the flash, and a connecting cord from the flash reflector unit had to be attached to the camera.

All that fiddling and frustration with flash is a thing of the past, thanks to electronic flash units and cameras that have both become fully automatic. These AUTOFLASH units, like today's cameras, incorporate sophisticated microcomputers and offer dozens of options that take flash photography far beyond what was conceivable only a decade or two ago.

## Types of Flash Equipment

Before learning about various flash techniques that can enhance your photography, you should become more familiar with modern flash equipment. Unlike early electronic flash units that were bulky, high-priced, and found mostly in photographic studios, current models are compact, relatively inexpensive, and easy to carry with you. There are two basic types for 35mm cameras.

Most convenient, of course, is a flash unit that's built into the camera. BUILT-IN FLASH is common to 35mm compact cameras as

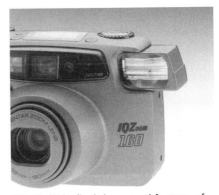

105. Built-in flash is a usual feature of APS and compact 35mm cameras; some extend from the camera for use.

106. Of the several types of flash equipment, shoe-mount flash is most often used with 35mm single lens reflex (SLR) cameras.

107. More powerful handle-mount flash units are most commonly used with medium- and large-format cameras.

108. As its name suggests, studio flash is designed for use in photographic studios. This umbrella model produces soft light.

well as APS cameras, and is also a feature of several models of single lens reflex cameras. Some are pop-up types that retract into the camera body when flash is not required.

A big advantage of built-in flash is that the flash is always ready to use; some cameras even turn the flash on automatically, or signal you to use flash, whenever the existing light level is low. Another welcome feature is that the cameras automatically compute and set the proper exposure for the built-in flash.

Built-in flash has some drawbacks, however. Most frustrating is its limited light output, which restricts the distances at which your subjects will be properly exposed. Always check the camera instruction manual for the AUTOMATIC FLASH OPERATING RANGE to learn the minimum and maximum distances your subjects can be from the camera. For example, it may be 4 to 12 feet (1.2 to 3.6 meters), which means subjects closer than 4 feet (1.2 meters) will be overexposed, while those beyond 12 feet (3.6 meters) will be underexposed.

Be certain to memorize the operating range of your built-in flash, or put a sticker on your camera listing the flash's minimum–maximum distance limits, so you won't waste film shooting flash photos that will be poorly exposed.

Another limitation is that the position of a built-in flash cannot be changed. The flash is located just above or to one side of the camera lens and commonly produces flat and often harsh lighting. Also, because built-in flash is in such close proximity to a camera lens, using a lens shade or hood may cause a shadow from the flash on subjects close to the camera; check your camera instruction manual for any specific cautions. In addition, built-in flash frequently causes annoying RED-EYE in pictures of people and animals, although some cameras have a RED-EYE REDUCTION feature to diminish this problem (see later in this chapter).

Much more useful than built-in flash is an ACCESSORY FLASH UNIT, which is sold separately and must be attached to the camera. Every photographer who owns a 35mm single lens reflex camera, or any camera that can be equipped with an external flash, should have an accessory flash unit. The most popular type is SHOE-MOUNT FLASH, so called because the flash unit is inserted into the HOT SHOE or an ACCESSORY SHOE located on the top of SLR and some other cameras. The various features of shoe-mount flash are described later in this chapter.

Also available is HANDLE-MOUNT FLASH, which attaches to the camera with a FLASH BRACKET that screws into the tripod socket. It is favored by wedding and other commercial photographers, who have

nicknamed the flash a "potato masher" because of its appearance: a round handle or grip (often containing batteries) that is topped with a big flash head. The handle makes it convenient to hold the flash off-camera for more varied and dramatic lighting effects. A connecting cord is required between the camera and flash so the flash will fire when the shutter release is pressed. Although larger and heavier than a shoe-mount flash, a handle-mount flash has a greater output of light. Also, most models can be connected to accessory high-voltage battery packs to reduce the recycle time required between flashes and to ensure dependability.

STUDIO FLASH is another but far less common type of flash. It is used mostly in photo studios by professional photographers who make portraits and images for advertisements, often with medium-format or large-format cameras. Studio flash units are more powerful in light output, and larger in size and weight, than handle-mount and shoe-mount flash. They are usually mounted on adjustable light stands. Many feature MODELING LIGHTS that illuminate the subject to help the photographer position the flash units and see what the lighting effect will be prior to tripping the shutter and firing the flash. Studio flash units require a connecting cord between camera and flash, as well as a cord to connect the flash power pack to an electrical outlet.

Finally, there is a very specialized type of electronic flash, commonly called a RING LIGHT or MACRO FLASH, which encircles the camera lens and is used for close-up photography. This flash unit screws onto the front of a lens like a filter, and its ring of light produces virtually shadow-free flash images. The best models incorporate two to four opposing flash tubes and a selector switch to fire only one flash tube when you want to give direction to the light and some shadow to your close-up subject.

## Determining Flash Power

Regardless of the type of flash, its usefulness is often judged by the unit's FLASH POWER, which is also referred to as LIGHT OUTPUT. Photographers prefer the more powerful flash units because they have a greater light output; their flash will reach subjects that are farther away. Also, with more powerful units, smaller f/stops can be used for better control of depth of field.

In general, the larger the size of the flash unit, the more powerful it is. However, the only way to know the power of a specific flash unit

is to check the camera or flash instruction manual for the unit's FLASH GUIDE NUMBER. These numbers range from 40 to 160; the higher the guide number, the more powerful the unit. (Technical data in the manuals for some units indicate flash power with a number rating for beam-candlepower-seconds [BCPS] or watt-seconds [WS], but flash guide numbers are the most common way to show the light output of built-in and accessory flash units.)

Flash guide numbers are determined by the flash manufacturers based on several factors, including the speed (ISO) of film being used and whether the flash-to-subject distance is measured in feet or meters. In addition, if a flash unit has a ZOOM FLASH HEAD or LIGHT OUTPUT CONTROL (see later in this chapter), the guide number will vary whenever the zoom head position or light output is adjusted.

If you are buying a new flash and using flash guide numbers to compare the power of various units, be certain those guide numbers are based on *identical* factors. Watch out that you don't compare a guide number based on ISO 100 film speed with one based on ISO 400, or a guide number based on metric measurement with one based on feet. You must carefully read the flash data in advertising

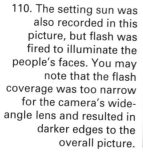

109. The setting sun made silhouettes of this group of friends posing for a picture at the beach in wintertime.

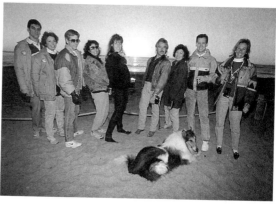

110. The setting sun was also recorded in this picture, but flash was fired to illuminate the people's faces. You may note that the flash coverage was too narrow for the camera's wide-angle lens and resulted in darker edges to the overall picture.

brochures and flash instruction manuals when making comparisons of flash guide numbers.

By the way, knowing the guide number of a flash unit is important if you figure *manual* flash exposures in the traditional way—by dividing the flash-to-subject distance into the flash guide number to find the f/stop number to set on the camera lens. Fortunately, 400, modern flash units help photographers figure manual flash exposures with a built-in microcomputer or a calculator dial or chart, and there is little need to know or use the flash guide number.

Nevertheless, some photographers wonder if flash guide numbers are really accurate, especially after setting flash exposures manually in the traditional manner and then seeing some underexposed or overexposed flash pictures that were the result. Well, you may notice in flash instruction manuals that the manufacturers list "suggested flash guide numbers." That's because guide numbers are determined by manufacturers under a set of "average" conditions for flash use: indoors, in a small room with white or light-colored walls and ceiling, and subjects of medium tone.

As such, the suggested flash guide number will not apply to all real-life situations. For instance, if your subjects are outdoors at night where there are no walls or ceiling to reflect some of the flash light back onto your subjects, the suggested guide number probably will not be accurate for a proper manual flash exposure; compensate by increasing exposure by one-half to one f/stop.

Flash manufacturers usually urge you to make your own FLASH EXPOSURE TEST to check the accuracy of any flash guide number. You can do this by setting the flash and camera for manual (M) flash exposure, and keeping everything identical for each flash shot, except the f/stop. Bracket by one-third or one-half stop; print the f/stop you use in large numbers on a piece of paper and include it in the picture for reference when looking at the photo results. For accurate exposure comparisons, shoot with color slide film, not color print film. That's because color print films have more EXPOSURE LATITUDE, and photofinishing machines automatically make some correction for underexposures and overexposures when making prints, which will invalidate the flash test.

## Understanding Flash Synchronization

You need to be aware of FLASH SYNCHRONIZATION when making flash pictures. In brief, the flash and the camera must be synchronized so

that the shutter is *fully* opened to expose the film when the flash goes off. Otherwise, the result is a dark or only partially exposed picture. With single lens reflex cameras, when a portion of a flash picture is perfectly exposed and the adjoining portion is black (unexposed), the obvious problem is faulty flash synchronization.

As described earlier in Chapter 1, with FOCAL PLANE SHUTTERS common to SLR cameras, one shutter curtain opens and then a second curtain follows behind it to control the time of an exposure (i.e., the shutter speed). Since both curtains must be completely out of the light path in order for the entire film frame to be exposed by the brief light of the flash, you cannot use a shutter speed that is too fast.

In modern SLR cameras with electronically controlled shutters, the top shutter speed permitted with flash is 1/250, 1/200, or 1/125 second, depending on the camera model. (There are exceptions for flash units featuring HIGH-SPEED SYNC, which is described later in this chapter.) For built-in flash, as well as for older SLRs with mechanical shutters, the shutter speed allowing proper flash synchronization is often no faster than 1/100, 1/90, or 1/60 second.

Be sure to check your camera's instruction manual to learn the FASTEST SHUTTER SPEED you can use for flash synchronization. As a

111. Flash synchronization is of little concern when modern single lens reflex (SLR) cameras are used with built-in or dedicated TTL autoflash (see text). But be alert when using *older* SLR cameras and accessory flash units. This illustration is to remind you that the maximum shutter speed for flash synchronization may be 1/60 second (A), unless otherwise indicated in the camera manual. Also, if using a flash connecting cord, it must be plugged into the camera's "X" flash synchronization socket (B) to ensure the flash goes off when the shutter is fully opened (see text).

reminder, the flash synchronization speed is often marked in color or with an X on cameras that have a shutter speed dial or exposure control dial.

Take note that flash will also be synchronized when used with shutter speeds that are *slower* than those synchronization speeds just mentioned. That's because with electronic flash photography, shutter speed is not used to control flash exposure. Unlike light from the sun and other sources, which is continuous, flash light lasts only a fraction of a second. In fact, it is the *duration* of the flash, not its brightness, that determines the exposure—along with the f/stop. *Flash* is well named, because that burst of light lasts no longer than 1/1000 second, and can even be as brief as 1/50,000 second.

Today's popular autoflash units make electrical connections to the camera for flash synchronization when they are mounted in the camera's HOT SHOE. Otherwise, a connecting cord from the flash plugs into a FLASH CORD SOCKET on the camera. On older camera models you may notice two sockets, or a single socket with a synchronization switch, because those cameras are also synchronized for flashbulbs. For electronic flash synchronization, use the socket or switch position marked with an X or a lightning bolt symbol. The other socket or switch setting for synchronization with flashbulbs is marked with the symbol of a lightbulb or an M or FP (which refers to a class of flashbulb—medium or focal plane). (The flash cord socket on modern cameras usually is unmarked, because it is synchronized only for electronic flash.)

If you ever pick up an older camera and are unsure whether the flash will be synchronized to fire an electronic flash when the shutter is fully open, just set the shutter speed to 1/30 second (or slower) and use the X socket or X switch setting.

By the way, a FLASH SYNCHRONIZATION TEST can be made with any single lens reflex camera, old or new, *when there is no film in the camera.* Connect and turn on the flash unit, set the flash and camera for manual (M) exposure, set the maximum flash synchronization shutter speed given in the camera or flash manual, open the lens to its widest f/stop, and open the camera back. (Remember to take care not to touch the delicate shutter curtain.) Face a white wall 1 to 2 feet (0.3 to 0.6 meters) away, look at the shutter curtain, and press the shutter release button. When the shutter opens, you should see a full circle of light—if the shutter and flash are synchronized. A partial circle or star pattern of light, or no light at all, indicates faulty synchronization. Test it again at a slower shutter speed.

112. Built-in or dedicated TTL autoflash units automatically adjust the shutter for proper flash synchronization when the flash is turned on. Fill flash added a sparkle to this woman and her peppers at a vegetable market in Mexico.

Regarding this flash synchronization test, note that some automatic cameras will not fire if the camera back is open, or if there is no film in the camera. In the second instance, you can try to "fool" the camera by loading a roll of unwanted film, shooting a few frames, and then opening the camera back to remove the film by pulling it from the take-up spool by hand; do not press or turn any rewind buttons or knobs. Turn on the flash and proceed with the test.

In the past, photographers often fouled up when taking flash pictures by forgetting to set a shutter speed that allowed flash synchronization. But that's rarely a problem with modern SLRs, especially if you are using a dedicated autoflash unit mounted on a compatible camera (see later in this chapter). That's because whenever you turn on the flash unit, the camera automatically sets the shutter speed for proper synchronization.

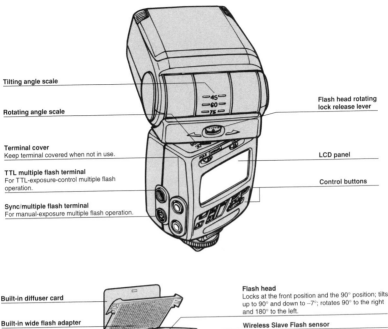

Tilting angle scale

Rotating angle scale

Flash head rotating lock release lever

Terminal cover
Keep terminal covered when not in use.

LCD panel

TTL multiple flash terminal
For TTL-exposure-control multiple flash operation.

Control buttons

Sync/multiple flash terminal
For manual-exposure multiple flash operation.

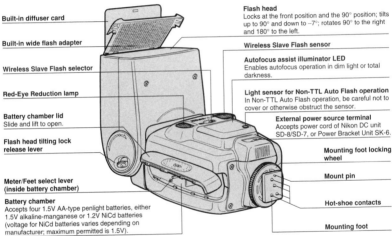

Built-in diffuser card

Built-in wide flash adapter

Wireless Slave Flash selector

Red-Eye Reduction lamp

Battery chamber lid
Slide and lift to open.

Flash head tilting lock release lever

Meter/Feet select lever
(inside battery chamber)

Battery chamber
Accepts four 1.5V AA-type penlight batteries, either 1.5V alkaline-manganese or 1.2V NiCd batteries (voltage for NiCd batteries varies depending on manufacturer; maximum permitted is 1.5V).

Flash head
Locks at the front position and the 90° position; tilts up to 90° and down to –7°; rotates 90° to the right and 180° to the left.

Wireless Slave Flash sensor

Autofocus assist illuminator LED
Enables autofocus operation in dim light or total darkness.

Light sensor for Non-TTL Auto Flash operation
In Non-TTL Auto Flash operation, be careful not to cover or otherwise obstruct the sensor.

External power source terminal
Accepts power cord of Nikon DC unit SD-8/SD-7, or Power Bracket Unit SK-6.

Mounting foot locking wheel

Mount pin

Hot-shoe contacts

Mounting foot

113–114. Today's sophisticated accessory flash units have many features, as indicated by diagrams in flash instruction manuals. These show one of Nikon's dedicated TTL autoflash units, the SB-26 Autofocus Speedlight. See also Illustration 115 for details of the LCD panel and other controls. (Illustrations courtesy of Nikon Corporation.)

## Features of Shoe-Mount Flash

Accessory flash units that mount in the camera's hot shoe are the choice of most single lens reflex camera owners. The shelves of camera stores are loaded with a wide selection of these shoe-mount flash units, many of them made by Canon, Minolta, Nikon, and other

well-known camera manufacturers specifically for their particular SLR models. Other units are products of flash and photo equipment companies, such as Vivitar, Sunpak, and Metz, and are designed for use with various brands of cameras.

Before purchasing any flash, consider the variety of features described in this section, and consult the unit's instruction manual for technical data to see if the flash is compatible with your camera and will fulfill your flash needs.

Don't be surprised to find that the instruction manuals for advanced electronic flash units are often as lengthy and detailed as the manuals for advanced SLR cameras. That's because computer-chip technology has made it possible to produce modern autoflash units with a remarkable number of FEATURES. Among them are automatic exposure with through-the-lens (TTL) metering, automatic fill flash, tilting and rotating flash head, auto-zoom flash head, "use flash" signal, ready light, sufficient light indicator, red-eye reduction, repeating or multiple flash, rear or second curtain sync, slow sync, high-speed sync, exposure compensation, light output control, exposure bracketing, remote wireless or slave flash, and autofocus assist.

Do you really need all these features? Some are standard on all flash units, while others are only found on the most expensive units—and are rarely utilized. Following are descriptions of the flash features just listed to help you understand how they function and decide whether they will be of any assistance.

For easy and effective use of flash in your photography, a DEDICATED AUTOFLASH UNIT is a necessity. The microcomputers in this accessory flash unit and its compatible auto-exposure single lens reflex camera "communicate" with each other to make a variety of adjustments that result in superior automatic flash exposures. In effect, the flash and camera are dedicated to each other. Their electronic connections are made through two to four metal contacts on the flash mounting foot that slips into the SLR's HOT SHOE, which is usually located atop the pentaprism just above the camera lens. A LOCKING WHEEL is turned on the flash mounting foot to hold the flash unit in place on the camera.

To identify a camera that will work with a dedicated flash, look for a hot shoe with more than one electrical contact; the more contacts, the more dedicated flash features possible. With the most advanced dedicated autoflash units, these direct flash-to-camera connections provide not only proper flash synchronization but automatic flash exposures, auto-zooming of a power flash head, flash indicators in the viewfinder, and triggering of a light beam to allow autofocusing in dim light.

In order to fully communicate with each other, the dedicated autoflash unit and the camera must be perfectly matched; do not buy a dedicated flash unless it is designated for the specific camera model you are using. Camera manufacturers make dedicated flash units for their own models of compatible cameras. But there are also less expensive UNIVERSAL DEDICATED AUTOFLASH UNITS made by independent flash equipment companies. However, these require a specific HOT SHOE MODULE to adapt them to a particular camera model. Before you buy such a flash, make certain it allows all of the same functions as the camera manufacturer's dedicated flash unit.

Take note that older cameras only have an ACCESSORY SHOE for mounting a flash unit. Unlike a hot shoe, it has no electrical contacts. That means a connecting cord is required between the flash and the camera in order for the flash to fire when the shutter release button is pressed. Because the connecting cord is limited to making this single connection, dedicated flash units are not manufactured for older cameras.

Whether or not it is a dedicated unit, the most welcome and worthwhile feature of any flash is AUTOMATIC FLASH EXPOSURE CONTROL. This is generally known as AUTOFLASH, and it is responsible for revolutionizing flash photography. That's because photographers no longer have to figure flash exposures manually. Instead of measuring the distance from the flash to the subject and then dividing it into the flash guide number to determine the f/stop to set on the camera lens, they let their autoflash cameras or accessory autoflash units do the work.

Most sophisticated are dedicated TTL AUTOFLASH UNITS, which utilize the THROUGH-THE-LENS (TTL) METERING SYSTEMS of single lens reflex cameras. The instant the shutter opens and the flash fires, the flash light reflected back from your subject through the camera lens is read at the film plane by the metering system, which controls the duration of the flash light to give a proper exposure. This is sometimes called OFF-THE-FILM (OTF) FLASH METERING. The camera's microcomputer may even consider the distance at which the lens is focused when computing TTL flash exposures.

In most cases, all the photographer has to do is set the unit's FLASH MODE SELECTOR to TTL, turn on the flash, and preset the f/stop desired; some cameras even set the lens opening for you. Thanks to the dedicated flash/camera connections, the shutter speed is preset for flash synchronization, the flash unit is calibrated to the speed (ISO) of the film in your camera, and the amount of reflected flash light received by the TTL metering system automatically controls the flash duration to make a proper exposure.

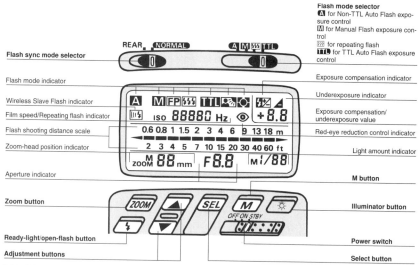

115. Many autoflash units feature an LCD (liquid crystal display) panel with information to help you make successful flash photos. Illustrated here is the LCD panel and other controls located on the back of the Nikon SB-26 Autofocus Speedlight, a dedicated TTL autoflash unit. Note that all figures and marks shown in the panel here do not appear simultaneously. See also Illustrations 113–114. (Illustration courtesy of Nikon Corporation.)

Dedicated TTL autoflash units on compatible SLR cameras also calculate and set the best exposure for AUTOMATIC FILL FLASH, which has become an exceptionally popular use of automatic flash exposure control. Here the flash is not the main source of light but augments the existing light to reduce shadows, such as those on the faces of people being photographed in bright sunlight.

Take note that dedicated TTL autoflash usually works best for both average and unusual flash conditions, including fill flash, when used with an SLR camera featuring MULTIZONE METERING (see page 71).

There is a more elementary type of autoflash that is often referred to as NON-TTL AUTOFLASH, because it has nothing to do with the camera's through-the-lens metering system. This autoflash depends on a PHOTOCELL SENSOR at the front of the unit to automatically control flash exposure. When light from the flash reflects off your subject back to the unit's photocell sensor, it activates a microcomputer in the flash unit that controls the duration of the flash light for a proper exposure.

Many older electronic flash units and less expensive nondedicated flash models feature this type of autoflash, as do basic dedicated units. It is also an option on advanced dedicated TTL units, in case you want to use the flash with a camera that does not have through-

the-lens metering; you set the unit's FLASH MODE SELECTOR to A (automatic/non-TTL) instead of TTL.

To use non-TTL autoflash, first you make certain the flash unit is set to the speed (ISO) of the film in your camera. Then you set the flash unit and the camera lens to the same f/stop, which is determined by the unit's AUTOMATIC FLASH OPERATING RANGE—the minimum and maximum distances your subjects can be from the flash for a proper flash exposure. Even if the position of your subject or camera is changed, as long as the flash-to-subject distance remains within this operating range, the flash exposure should be correct.

Read the instruction manual to learn just how close to and how far away from subjects a specific autoflash unit can be to produce a proper flash exposure. For example, a versatile accessory shoe-mount flash may have an automatic operating range from a minimum of 2 feet (0.6 meters) to a maximum of 60 feet (18 meters), or more. The flash light from a less powerful unit may only reach half that maximum operating distance, or less.

Some autoflash units offer a choice of several flash operating ranges at the non-TTL setting. These ranges, which overlap, allow a greater choice of f/stops for CONTROL OF DEPTH OF FIELD. For example, a flash unit set for use with ISO 100 film may offer four automatic operating ranges: 1.5–17.5 feet (0.45–5.25 meters) at f/8, 2.5–25 feet (0.75–7.5 meters) at f/5.6, 3.5–35 feet (1–10.5 meters) at f/4, and 4.5–50 feet (1.4–15 meters) at f/2.8.

Depending on the f/stop you decide to use, the specific flash operating range is shown by an INDICATOR BAR on a DISTANCE SCALE appearing in an LCD INFORMATION PANEL on the back of the flash unit (see later in this section). Instead of an LCD panel, some units have a color-coded distance scale or dial to indicate flash operating ranges.

When using non-TTL autoflash, be aware that the unit's photocell sensor, which reads the reflected flash light to determine exposure, may be fooled by very dark or very bright *subjects.* Dark subjects won't reflect much light to the sensor, so the flash duration will be longer, causing overexposure. Likewise, a bright subject may reflect too much light to the sensor, resulting in a shorter flash duration, and underexposure.

Very dark or very bright *foregrounds* and *backgrounds* can also fool the photocell sensor. That's because the sensor has a fixed angle of view—about 22°, which is almost equal to the coverage of a 105mm lens. When you are shooting with a lens that has an angle of view wider or narrower than that of the sensor, it may react erroneously to less (as in the case of a wide-angle lens) or to more (as in

the case of a telephoto lens) of the foreground or background than will appear in the picture.

Keep in mind that it's possible to remove non-TTL as well as TTL autoflash units from the hot shoe and position them off-camera for different lighting effects. However, special connecting cords must be used between the camera and the flash unit in order for flash exposures to be controlled automatically. These cords and off-camera flash techniques are discussed later in this chapter (see page 171).

You should also know that many autoflash units, both TTL and non-TTL models, allow you to set flash exposures manually in order to give you full control of your flash photography. For MANUAL FLASH CONTROL, you must set the flash mode selector to M (manual) instead of TTL (through-the-lens) or A (automatic/non-TTL). A few flash units, especially older ones, are manual-only models. How to calculate and set MANUAL FLASH EXPOSURES is explained later in this chapter, beginning on page 173.

Two features are found on every good dedicated flash unit. One is an LCD INFORMATION PANEL on the back of the unit, which displays various flash and camera settings whenever the unit is turned on. (See Illustration 115.) A button can be pressed to illuminate the panel so it can be seen in dim light or at night.

The other feature is an ON/OFF POWER SWITCH with a battery-saving *standby* position or an *auto-off* feature. It automatically turns off the flash unit whenever the camera's exposure metering system is

116. To provide uniform illumination for this wide-angle picture of a quilt being made in Arkansas, the head of an accessory flash unit was tilted up to bounce its light off the ceiling.

turned off. The metering system and the flash unit immediately reactivate when you partially depress the camera's shutter release button. When putting your flash away after use, always make sure its power switch is set to "off."

All dedicated flash units have FLASH STATUS SIGNALS to help the photographer. Most common is a READY LIGHT that glows in the viewfinder to indicate that the flash has been turned on and its capacitor is recycled and ready for the flash to be fired. The ready light is a small LED, sometimes in the shape of a lightning bolt. A ready light also appears on the back of every electronic flash unit, but having one inside the camera's viewfinder means you can keep your eye on your subject and won't have to look at the flash unit itself to see if it is ready to fire.

Two warnings: If you take a picture *before* the ready light comes on, the flash may go off but it may not have sufficient power to make a correct exposure, especially in the manual exposure mode. In addition, many ready lights come on when the capacitor is only 75 percent charged. To be certain the flash will be at full power, knowing photographers wait several seconds after the ready light glows before taking the picture.

Also conveniently located in the camera's viewfinder, and activated by a dedicated flash unit, is a SUFFICIENT LIGHT INDICATOR. Sometimes called a CONFIDENCE LIGHT, this LED lights up or blinks momentarily to signal whether or not the flash light was adequate for a proper exposure. If it warns you that the light was insufficient, get closer to your subject, or use a wider lens opening, or switch to a higher-speed film. Although a similar indicator is on the rear of every electronic flash unit, you'll know instantly while still looking through the viewfinder whether or not the flash picture you just took will be underexposed.

One caution regarding the sufficient light indicator: Don't depend on it to indicate a correct exposure for subjects very close to the flash. In some cases, the flash illumination may be more than sufficient, and the result is an overexposed photo. The indicator light is most useful for avoiding *underexposed* flash pictures.

To keep from wasting film, check for possible underexposure by pressing the OPEN FLASH BUTTON (also known as the FLASH TEST BUTTON) on the rear of the flash unit. It fires the flash without taking a picture, and you can see from the sufficient light indicator whether or not the flash output is adequate. If it isn't, move closer or set a wider f/stop or change to a higher-speed film, and then make another test by pressing the open flash button.

Note that this test for sufficient flash light must be done with the

unit's flash mode selector set to A (automatic/non-TTL autoflash) so that the light will be registered by the unit's own photocell sensor. Don't try to make this sufficient light test with the flash mode set to TTL; a reading cannot be made of the flash light coming through the lens because no picture is taken when the open flash button is pressed. However, the test results when the flash mode is set to A also indicate whether or not the flash light will be sufficient for exposures at the TTL setting.

A TILTING AND ROTATING FLASH HEAD is common to most shoe-mount flash units. It allows you to adjust the direction of the flash light to bounce it off a ceiling or wall for softer and almost shadowless illumination of your subject. A scale and click stops mark the head's position at various degrees, ranging from 0° when it is facing straight forward in the horizontal position to 90° when it is tilted straight up. Some flash heads can be tilted down slightly to ensure full flash coverage of subjects at close ranges of 5 feet (1.5 meters) or less. When you turn the camera to frame your subject *vertically*, the head can be rotated to as much as 90° (straight up) to bounce the flash light off the ceiling.

A few accessory flash units have a nonadjustable SECONDARY FLASH HEAD that serves as a fill light when the main flash head is directed away from the subject for bounce light. The chief purpose of this smaller and weaker flash is to put a sparkle of light in your subject's eyes. This is called a CATCHLIGHT. It prevents what some photographers refer to as "raccoon eyes." The built-in flash found on some SLR cameras can also serve as a catchlight when an accessory flash is used for bounce light. If your camera has built-in flash but does not allow an accessory flash to be used in the hot shoe at the same time, consider using a wireless SLAVE FLASH (see later in this section).

Some other accessory flash units create a catchlight with a built-in or accessory BOUNCE CARD, a small white plastic reflector that is pulled up or mounted above the flash head. When the head is aimed toward the ceiling for bounce light, the card reflects some of the flash into the eyes of your subject to give them a little sparkle.

Although rarely used except by professional photographers in their studios, BARE-BULB FLASH is a feature of a few flash units. The flash head's reflector and lens is removed so that the flash tube becomes a "bare bulb" and spreads its light in all directions. The effect is to give both direct and bounce light to the subject and the surroundings.

The better dedicated autoflash units feature an AUTO-ZOOM FLASH HEAD, which incorporates a small motor to adjust the beam of flash light according to the focal length of the lens on your camera. It auto-

matically broadens the beam so the edges of the image will not be dark when a wide-angle lens is used, and concentrates the beam so that it will reach a greater distance when a telephoto lens is used. When a zoom lens is mounted on the camera, an auto-zoom flash head changes whenever you adjust the lens focal length. Some SLR cameras with *built-in* flash even feature an auto-zoom head. Although a few accessory flash units have a nonmotorized zoom head that must be adjusted manually, it takes thought (and time) to change its position when you change lenses or focal lengths—and many photographers forget.

The width and height of FLASH COVERAGE, often called the ANGLE OF ILLUMINATION, changes in steps with a zoom flash head. Auto-zoom heads adjust to a number of positions, such as 24mm, 28mm, 35mm, 50mm, 70mm, 85mm, and/or 105mm, to cover the angle of view of the lens being used. The specific focal length position of the flash head is indicated on the flash unit's LCD information panel. Manual zoom heads may have only a few basic positions, which are marked on the head itself in specific focal lengths or simply "tele," "norm," and "wide."

Check the flash instruction manual for the actual coverage of the flash light, which is often listed in degrees (°) according to the lens focal length. The oblong flash head of shoe-mount flash units is appropriate to the rectangular shape of a frame of 35mm film, so coverage varies horizontally and vertically. For instance, with its zoom head position set for 28mm, a flash mounted on the camera may offer 70° horizontal coverage and 53° vertical coverage.

Whenever you buy a flash unit, with or without a zoom head, be certain its angle of illumination or coverage is great enough for the widest-angle lens you intend to use. Otherwise, the edges of flash pictures taken with your widest-angle lens will be dark. Most of today's flash units cover 28mm or 35mm; some go to 24mm, while a few have narrow coverage to only 50mm. See Illustration 110.

For very wide coverage, such as 18mm, 20mm, 21mm, or 24mm, a built-in or accessory WIDE-ANGLE FLASH ADAPTER OR DIFFUSER that is placed in front of the flash head may be required to spread the light. Likewise, some units accept a TELEPHOTO FLASH ADAPTER, which is a plastic Fresnel lens that snaps onto the flash head to concentrate the light for longer focal length lenses up to 200mm or so.

Take note that using flash adapters, or changing the position of the zoom flash head to different focal lengths, may change the minimum/maximum automatic operating range of the flash. To preview what the flash operating range will be at different lens focal lengths, a ZOOM ADJUSTMENT BUTTON on the flash unit lets you manually set the

117. Some dedicated flash units feature an autofocus illuminator beam to assist the camera in focusing automatically in dim light; it ensured this sharp flash image of a hula dancer in Hawaii.

zoom head position; watch the indicator bar as it moves on the distance scale in the LCD information panel.

Also be aware that the flash operating range can be altered by using a slower- or faster-speed film, and/or by adjusting the lens opening. You can preview changes to the flash operating range at different film speeds and lens openings by first pressing adjustment buttons on the flash unit to manually change its ISO and/or f/stop settings, and then observing the indicator bar as it moves on the distance scale in the LCD panel.

As you'll see, high-speed films, wider f/stops, and/or the zoom head position at its maximum focal length allow the flash to reach a greater distance. Conversely, for proper flash exposures at close range to your subject, choose slower-speed films, smaller f/stops, and/or the widest focal length of the zoom head.

An AUTOFOCUS ILLUMINATOR BEAM is another useful feature of a dedicated autoflash unit. This AF ASSIST, as it is also known, allows an SLR camera to autofocus its lens in dim light or even total darkness. When the flash is turned on and the shutter release button slightly depressed, a steady red LED (light-emitting diode) or infrared beam from the flash unit gives your subject enough illumination for the camera's autofocus mechanism to operate.

The effectiveness of this AF assist is limited by the distance and reflectiveness of your subject, and by the camera lens being used;

check that the camera's IN-FOCUS INDICATOR lights up in the viewfinder or makes an audible signal. Depending on the flash unit, the effective *maximum* distance of this focusing aid ranges between 15 and 50 feet (4.5 and 15 meters).

RED-EYE REDUCTION is a feature of many dedicated shoe-mount auto-flash units, as well as SLR and compact cameras with built-in flash. Its purpose is to diminish an unwanted effect, commonly known as RED-EYE, that is all too common in flash portraits of people and animals. Because the pupils of your subject's eyes open wide in dim light, flash can illuminate the retina or interior of the eyes, which records on color film as bright red spots with people and white spots with animals. To prevent this, you activate the red-eye reduction feature, which triggers a quick series of PREFLASHES, or a continuous beam of light from the flash, causing the pupils to constrict before the actual flash exposure is made.

Some photographers find these preflash lights distracting to their subject (as well as a drain on the flash batteries), and try other techniques for red-eye reduction. Among them is using bounce flash or off-camera flash (see later in this chapter) to change the angle of the flash light so it will not reflect back from the retina into the camera lens. Another is having your subject look slightly away from instead of directly at the camera.

118. Many autoflash units and cameras feature a way to reduce or eliminate the annoying red eyes that sometimes appear in flash pictures of people (see text).

If all else fails, you can eliminate any red-eye that appears in photo prints by using a special RED-EYE REDUCTION PEN, which is sold at camera stores. Just dot the eyes in the prints with green ink from the pen's fine tip, and the red eye spots will turn black.

Be aware that the farther you are from a subject, the less chance red-eye will be evident because the eyes will be smaller (unless you are using a telephoto lens). Also, red-eye will not be a problem when the *ambient light* is bright, such as outdoors when flash is being used for fill light, because the pupils of your subject's eyes will be constricted. To keep subjects from being annoyed and to prolong battery life, remember to turn off the preflashes for red-eye reduction whenever the ambient light is bright.

A few dedicated autoflash units and their compatible cameras feature FLASH EXPOSURE BRACKETING, which automatically makes three successive exposures at different flash light outputs. The first exposure is what the TTL metering system calculates to be the proper flash exposure. It is immediately followed by two other exposures, at shorter and longer flash durations, to purposely underexpose and overexpose extra film frames by one-third, one-half, or one f/stop, as you choose.

Some autoflash units offer FLASH EXPOSURE COMPENSATION to reduce or to increase flash light output. This is useful when you want to *manually* adjust the ratio of fill flash so it will be more powerful or less powerful than that determined by the camera's automatic exposure control. The specific amount of compensation is set with adjustment buttons on the rear of the flash unit; for built-in flash, check the camera manual for compensation adjustment instructions. Flash exposure compensation may range up to plus or minus (+/−) three f/stops, adjustable by one-third stop or one-half stop increments, depending on the accessory flash or camera model.

Remember that flash exposure compensation is used to make your *flash subject* lighter or darker; to lighten or darken the background (which is illuminated by the ambient light, not flash), you should use the camera's exposure compensator (see page 74).

Some better flash units feature LIGHT OUTPUT CONTROL, also called VARIABLE POWER CONTROL, which enables you to set the output or power of the flash light for more control of *manual* exposures. By pressing the adjustment buttons on the rear of the unit, you can select 1/2, which is half power, and smaller fractions of light output: 1/4, 1/8, 1/16, 1/32, 1/64, and sometimes even 1/128 and 1/256. On some units the light output is set with a sliding switch on the back of

the flash, or with a dial in place of the photocell sensor on the front of the flash. A few units have a high/low switch and offer only a choice of two powers. Manual exposures and light output control are discussed in more detail beginning on page 230.

The most sophisticated dedicated flash units and their corresponding SLR cameras offer some SPECIAL SYNCHRONIZATION CHOICES. One is SLOW SYNC, which sets longer auto-exposure times so that the background that's illuminated by ambient light (not the flash light) will also be recorded on film. With normal flash synchronization, the shutter speed is automatically set to maximum sync speeds, usually from 1/60 to 1/250 second, ensuring that light from the flash rather than the ambient light exposes your main subject. If you use a slower shutter speed, a background that would otherwise appear dark will be exposed by the existing light while your main subject in the foreground will be properly illuminated by flash—which makes for a more realistic and often more pleasing picture.

"GHOSTING" sometimes occurs at slow sync speeds, which can add eye-catching appeal to a photo, or be a major distraction. Ghost images of your subject may appear when the ambient light is bright enough to record any movement of your subject before or after it has

119. Slow sync is a feature of some accessory flash units to automatically slow the camera's shutter speed so that ambient light as well as flash light will be recorded by the film. The result is a picture with more natural illumination, as of the interior of this historic store in New Brunswick, Canada.

been exposed by the flash. This can be used effectively to show action or to create a special effect.

In fact, to effectively portray action with a blurred ghost image, you can use REAR-CURTAIN SYNC (sometimes called SECOND CURTAIN SYNC or TRAILING SYNC), which is a feature of some dedicated flash units. It creates a natural-looking blur of light from a moving subject by firing the flash at the *end* of the exposure that's made at a slow shutter speed, just before the rear or second shutter curtain closes. Thus, the streak or blur of light recorded by ambient light appears to follow or flow from your subject, which is exposed in sharp detail by the flash.

Except when you are creating this special effect, most flash pictures are taken with the flash set to NORMAL SYNC (also called FIRST CURTAIN SYNC or LEADING SYNC), which fires the flash at the *beginning* of the exposure, just after the first shutter curtain opens. You set the flash for normal sync or rear sync using a switch on the back of the flash unit.

To stop the action of a fast-moving subject with flash, but *without* creating a ghost image because of very bright ambient light, you can use HIGH-SPEED SYNC, which is offered by some dedicated units. Also, it allows you to take fill flash pictures with high-speed film while using a wide lens opening to limit depth of field in order to separate your subject from the background. That's because with high-speed sync you can shoot a flash picture at faster than normal flash synchronization shutter speeds—anywhere in the range from 1/250 to 1/4000 to 1/8000 second, depending on the camera model.

This is possible because the flash fires repeatedly as the first and second shutter curtains travel across the film plane. The exposure is made with a "slit" of light from the rapid-firing flash, which appears continuous to the naked eye and to the film. Because the recycle time between flashes is almost instantaneous, the light output of each flash is limited, so your subject must be fairly close for a proper exposure. The maximum flash-to-subject distance is determined by the shutter speed and f/stop you choose, the film speed (ISO), and the position of the zoom flash head. In reality, rear sync and high-speed sync are "nice to have," but are only occasionally utilized by photographers.

Some dedicated autoflash units have another feature that may be of occasional use. Called REPEATING FLASH, MULTIPLE FLASH, or STROBO-SCOPIC FLASH, it makes a series of multiple flash exposures on a single film frame. The repetitive flashes dynamically portray action by "freezing" the successive movements of your subject, such as a

120. On an overcast day, light from an off-camera flash gave detail to this Indian weaver selling her handicrafts at an outdoor market in Ecuador.

dancer on a stage. The effect is best when your subject is against a dark background. If your subject is stationary, you can give it motion *panning* the camera as the flash fires repeatedly.

Adjustment buttons on the rear of the flash unit are used to set the number of flashes, the time delay between each flash, and the light output or power of the flashes. The flash instruction manual will tell you how to figure the f/stop and shutter speed to use with repeating flash for a proper multiple flash exposure. Bracketing at different lens openings may be required because of underexposure or overexposure of overlapping images. By the way, MULTIPLE FLASH has another meaning: taking a picture with two or more flash units (see page 188).

An option with most accessory flash units is to use it as an EXTENSION FLASH, more commonly called a SLAVE FLASH, which is positioned away from the camera to give additional light and an extra dimension to a flash photograph. To fire the slave flash, a flash cord can be used to connect it to the camera or the main flash. Much more convenient is a WIRELESS REMOTE FLASH, also called a REMOTE SLAVE FLASH, which has a built-in or accessory photocell sensor that fires the slave unit after receiving the light from the main accessory flash or the camera's built-in flash. Another option is to trigger an off-camera

flash with a RADIO SLAVE signal device. Read more about slave and other flash lighting later in this chapter.

In addition to all of the features of shoe-mount flash described earlier, you should be aware of a feature found in auto-exposure SLR cameras with built-in or accessory flash, as well as in 35mm automatic compact cameras. It is a "USE FLASH" OR "FLASH NEEDED" SIGNAL, which is a visual or audible warning to turn on the flash because the ambient light is too low for a proper exposure. Whenever dim ambient light requires a slow shutter speed, some cameras with built-in flash are even programmed to activate the flash automatically so you won't blur the picture by inadvertent camera movement during the exposure.

However, remember that some subjects are best photographed by the existing light rather than flash light, such as night scenes, fireworks, stage shows, and artworks in museums (where flash is often banned). Your camera instruction manual should explain how to turn off or cancel an automatic built-in flash; some compact cameras have a flash-off switch for this purpose. Otherwise, you can try to circumvent the autoflash by covering it with your fingers, or by pushing a pop-up or retractable-type flash back into the camera body and holding it in place.

## Facts About Flash Batteries

Flash units usually rely on batteries to supply the electrical energy they need. Built-in flash draws current from the camera's batteries, while an accessory unit carries its own. Most shoe-mount flash units require four AA-size batteries; less powerful units only need two.

You have a choice of using *replaceable* alkaline or lithium batteries, or *rechargeable* nickel-cadmium (nicad) or nickel metal hydride batteries. Which type you decide to use is often guided by two factors: the flash unit's RECYCLE TIME between flashes, and the NUMBER OF FLASHES that can be fired before the batteries must be replaced or recharged. These figures vary according to the specific flash model and will be listed in the flash instruction manual.

As you will recall, before each flash, the batteries must charge the flash unit's electrical capacitor to provide the energy that creates the bright burst of light. Recycle time can range from 2 to 30 seconds, depending on how fresh the batteries are. The shorter the recycle time, the better for your flash photography. Whenever recycle time

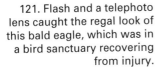

121. Flash and a telephoto lens caught the regal look of this bald eagle, which was in a bird sanctuary recovering from injury.

exceeds 10 seconds, consider changing or recharging the batteries. Otherwise, you might miss the action, or bore your subjects, while waiting for the unit to become ready to fire again. (See page 159 for cautions about relying on the flash unit's ready light to indicate when the flash is fully recycled.)

A feature to look for in an accessory flash is POWER-SAVING CIRCUITRY. This prevents the capacitor from losing all its electrical charge after the camera's TTL metering system or the unit's non-TTL photocell sensor cuts off the flash when sufficient light has been provided for an exposure. Technical data in flash instruction manuals often identifies energy-saving units as having THYRISTOR CIRCUITRY or other special circuitry. In practical terms, this means they provide shorter recycling times and longer battery life.

As for choosing replaceable or rechargeable batteries (if your unit permits use of both types), it depends on your personal preference. Comparing replaceable-type batteries, LITHIUM AA-size cells surpass ALKALINE AA-size cells for flash use; they recycle faster, last longer, are lighter in weight, and perform better in cold and hot temperature extremes. Unfortunately, lithium batteries are considerably more expensive than the more common alkaline type.

As for rechargeable NICKEL-CADMIUM (nicad) and nickel metal hydride batteries, there is the extra initial expense of the recharging unit, in addition to the cost of the AA-size cells themselves. However,

the major drawback for most photographers is the inconvenience of recharging them, especially while on a vacation trip. You need access to electrical current, and the time to recharge; it's wise to carry a second set of batteries so that one set will always be charged. The major reasons for using rechargeable batteries is that they recycle the flash quickly and work well at low temperatures. However, they offer fewer flashes than replaceable batteries before recharging is required.

Some accessory flash units can be powered by separate BATTERY PACKS that plug into the flash head to give faster recycle times between flashes, as well as a greater number of flashes, before batteries must be replaced or recharged. Built-in flash may also benefit from accessory battery packs that can be attached directly to some SLR cameras, although they add extra weight.

Take note that frequent use of a *built-in flash* can drastically reduce the life of the camera battery that powers it. As an example of BATTERY LIFE, tests of the lithium battery in one autofocus, auto-exposure SLR camera indicated that fifteen rolls of 24-exposure film can be taken if built-in flash is used all the time. If flash is used only 50 percent of the time, twenty-five rolls can be exposed. And if the flash is never used, the camera battery will last long enough to expose sixty rolls of film.

Although accessory flash units use their own batteries instead of the camera's batteries, the all-inclusive models with auto-zoom, AF assist, and other features can drain batteries rather quickly. Look in the flash instruction manual to learn the approximate number of flashes possible with various types of batteries before the batteries must be replaced or recharged. Those figures are usually based on flashes fired at full power; the number of flashes will increase in actual autoflash operation because flash durations vary and are not always at full power.

Something to remember is that if an accessory flash unit (or a camera) fails to work after you turn it on, you may *not* need to replace or recharge the batteries. Before checking the batteries with a BATTERY TESTER, first clean the metal contacts on the batteries and in the flash unit (or in the camera) with a dry cloth or pencil eraser. That's because an invisible chemical film can develop on these contacts and break the electrical circuit. After cleaning the contacts, reinstall the batteries and see if the flash will fire.

Additional information about batteries, including their care and use, was given in Chapter 2 (see page 81), and will also be found in the instruction manuals for your camera and flash unit.

By the way, some accessory flash units permit the use of an AC ADAPTER for 110-volt or 220-volt operation from an electrical outlet. That can be a battery-saver when you take flash pictures in a fixed location, such as for tabletop photography.

## Concerns About Flash Cords and Connections

As mentioned previously, shoe-mount flash units are more powerful than built-in flash, and they are also more versatile. However, many photographers foolishly limit the use of an accessory flash by always keeping it mounted in the camera's hot shoe. The result is flat and frequently harsh lighting. Some variation can be achieved if the flash head is tilted or rotated to bounce the flash light off a ceiling or wall instead of firing it directly at the subject.

However, the most effective lighting is often when the flash is held away from the camera, which is commonly called OFF-CAMERA FLASH. For a portrait, holding the flash slightly high and at your arm's length to the left or right of the camera gives texture, form, and depth to your subject's face instead of the usual flat, frontal lighting. (You can also use an adjustable flash bracket, a clamp, a light stand, or a friend to hold the flash off-camera.)

Varying off-camera flash positions creates other effects. For example, if the flash is placed below the subject's face, a criminal, almost evil look will result. Or, when the flash is placed behind the subject and aimed at a wall or backdrop, a silhouette can be made. Also, when the camera is aimed at shiny or reflective objects, such as a mirror or a glass window, taking the flash off the camera and positioning it at an angle to these objects will diminish or eliminate flash reflections.

To use the flash off-camera, you need a FLASH CORD to connect the camera with the flash so it will fire when the shutter release button is pressed. Flash cords come in various lengths, either straight or coiled. When buying one, take your equipment to the camera store to make certain the cord will attach properly to your particular camera and flash.

To utilize the various features of a dedicated TTL autoflash, including automatic flash exposure, the cord must have a terminal that fits into the camera's hot shoe. At the other end of this TTL SYNC CORD or TTL REMOTE CORD is a hot shoe–like terminal that accepts the mounting foot of the autoflash unit. That terminal usually has a

tripod socket so that you can mount the off-camera flash on a tripod or a light stand; it may also have PC-type sockets (see below) for attaching flash cords to additional flash units for multiple flash photography.

To allow automatic exposures with a non-TTL autoflash used off-camera, the unit must have a removable photocell sensor that remains at the camera position, usually mounted in the hot shoe. A special REMOTE SENSOR CORD makes the connection between this on-camera sensor and the off-camera flash unit.

To use manual flash units off-camera, most are connected with a PC CORD. This cord has pin-type PC connector plugs at both ends, which push into PC sockets on the camera and the flash. (While PC can be thought as meaning "push contact," it is actually an abbreviation for Prontor-Compur, an early brand of shutters that first used this type of flash cord connector.) The best PC plugs and sockets have threads that lock, so the connection will not pull apart. On nonthreaded types, if the flash doesn't fire, the plug's rounded

122. Off-camera flash allows you to try a greater variety of lighting effects, indoors or outdoors. This dedicated autoflash is connected by a coiled TTL flash cord to the camera's hot shoe in order to maintain all of its shutter synchronization and through-the-lens exposure features.

tip can be squeezed carefully so it fits better and makes electrical contact.

Flash cords can become damaged or broken when frequently unwound and rewound, twisted, or kinked. If your flash unit fails to work, its connecting cord may have been severed internally. TO TEST FOR A FAULTY CORD without taking a picture, disconnect the cord from the camera and short-circuit the contacts in the flash cord plug with a paper clip or other piece of wire. (Don't worry about getting a shock.) If the unit does not flash, wiggle the cord while short-circuiting the plug. If it flashes then, the wires in the cord are probably broken and are making contact only occasionally. Buy a new cord.

Look on your camera and in the instruction manual to see if your SLR camera has a flash cord socket. If there isn't one, buy a HOT SHOE FLASH SOCKET (PC) ADAPTER that mounts in the camera's hot shoe to provide off-camera flash cord connections.

Finally, to employ off-camera flash but avoid the use of a flash cord, which takes time to connect and can also get in your way, WIRE-LESS REMOTE FLASH is an option with some flash units and cameras. The remote flash, also called a SLAVE FLASH, is triggered through a photocell sensor that reacts to the flash light from another unit, usu-ally the camera's built-in flash or an accessory flash mounted in the hot shoe. The sensor is a built-in feature of the off-camera slave flash, or you can attach an accessory REMOTE FLASH SENSOR to any flash for off-camera use. As an alternative, electronic impulses from a RADIO SLAVE signal device can also be used to trigger off-camera flash. Read more about off-camera and slave flash beginning on page 188.

## Figuring Manual Flash Exposures

For many photographers, *manual* flash is a last resort because they have to figure the exposure to use. Manual flash does not depend on microcomputers in the camera and/or the flash unit to automatically control flash exposure—it's up to you. Nevertheless, there may be times when only manual flash will work, and you should know how to use it. For instance, manual flash is often the solution when your subject is beyond the autoflash unit's automatic operating range.

As mentioned earlier in this chapter, there are very few shoe-mount flash units made only for manual flash. Most modern flash

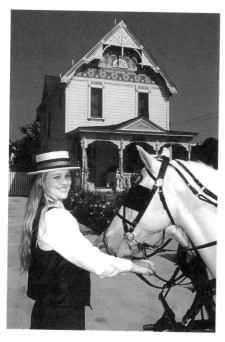

123. Flash was used to fill in the shadow on the girl's face that was caused by her straw hat. However, the flash's light was reduced by adjusting the flash unit's light output control so as not to overpower the natural light (see text).

units are TTL autoflash and/or non-TTL autoflash units that also may be used for manual flash exposures. You must set the *flash unit*'s FLASH MODE SELECTOR to M (manual) rather than TTL (through-the-lens) or A (automatic/non-TTL).

In addition, be sure to set the *camera*'s EXPOSURE MODE SELECTOR OR CONTROL DIAL to manual, or to aperture-priority if permitted by your camera, but not to the programmed, shutter-priority, or automatic exposure mode settings.

In order for manual flash exposures to be accurate, the speed of the film (ISO) in your camera must first be set on the flash unit; this is done automatically by dedicated autoflash units. In addition, you must select either feet or meters for the distance measurements shown on the flash unit.

Once the ISO and measurement preference are preset, most modern autoflash units will compute (but not set) proper manual exposures. Accurate exposure computations will be made even if you adjust special features of the unit, such as a zoom flash head and/or a light output control. If not, a chart in the flash instruction manual should list the flash guide numbers (for feet and for meters) to use to figure manual exposures at various zoom flash head positions and/or light outputs.

Actually, figuring and setting flash exposures manually is not dif-

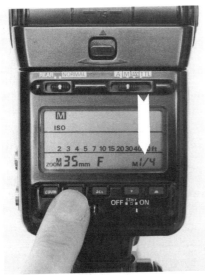

124. The light output of accessory flash units can be controlled in various ways. Most convenient is a control button or dial that sets the flash power. As indicated in the LCD information panel, one unit has been adjusted to ¼ power (arrow), which is equivalent to a two-f/stop reduction in its maximum light output. The other unit has been set to ⅛ power, a reduction in full light output equivalent to three f/stops (see text and charts).

ficult—it just takes more time than if you let autoflash do the work. As explained earlier, the traditional way to determine a manual flash exposure is to divide the distance from the flash to the subject into the flash unit's FLASH GUIDE NUMBER. The result is the f/stop that you must then set on the camera lens for a proper flash exposure. For example, if the flash-to-subject distance is 10 feet (3 meters), and the flash guide number is 80 (or 24 for meters), the correct lens aperture to use is f/8. At 20 feet (6 meters), the f/stop would be f/4.

Fortunately, flash units have an LCD information panel, or a calculator dial or chart, to help you figure manual flash exposures. All you need to know is the flash-to-subject distance, then refer to the LCD panel or the dial or chart to find the f/stop to set on the camera lens. (When the flash is mounted on the camera, the flash-to-subject distance is easily determined by focusing on your subject and noting the footage or meters on the LENS DISTANCE SCALE.)

A major difference between manual flash and TTL and non-TTL autoflash is that the light output for manual flash is always at the same intensity and uses the unit's full power. (A side effect is that manual flash takes a longer time to recycle between flashes.) Unlike with autoflash, the duration of manual flash does not vary; it's nor-

mally 1/1000 second. That's why you adjust the camera lens opening to control the amount of flash light reaching the film.

However, more sophisticated flash units offer a feature, called LIGHT OUTPUT CONTROL or VARIABLE POWER CONTROL, that gives you another way to regulate the flash light. This is especially helpful when you want to use a specific f/stop in order to control depth of field (see page 53). By pressing adjustment buttons on the back of the flash unit, you can change the duration of the flash light and effectively reduce the light output. The unit's LCD information panel will display the fraction of the unit's full power you select: 1/2, 1/4, 1/8, 1/16, 1/32, or 1/64. (Some units offer fewer than those six choices, or just have a high/low switch to choose between two powers.)

How much is the light reduced when the light output control is set below 1/1, which indicates full power? It can be expressed in terms of f/stops, as listed in the following chart:

## FLASH LIGHT OUTPUT CONTROL SETTINGS

| Light Output 1/1 | Equivalent f/stop Reduction from Full Power |
|---|---|
| 1/2 | −1 f/stop |
| 1/4 | −2 |
| 1/8 | −3 |
| 1/16 | −4 |
| 1/32 | −5 |
| 1/64 | −6 |

In practical use, however, you set the camera lens to the f/stop you want to use, press the flash adjustment buttons on the flash unit, and watch the LCD panel until it indicates that the light output is correct for the distance your subject is from the flash.

For example, at f/8, say the flash at its full power setting (1/1) gives a proper exposure at 20 feet (6 meters). However, your subject is only 10 feet (3 meters) from the flash. By readjusting the light output to 1/4 power, you change the flash-to-subject distance to 10 feet (3 meters) for a proper exposure. Using this example, the following would be the flash-to-subject distances for correct exposures at various flash powers:

## FLASH LIGHT OUTPUT / FLASH-TO-SUBJECT DISTANCE

|  | (in feet) | (in meters) |
|---|---|---|
| 1/1 | 20 | 6 |
| 1/2 | 15 | 4.5 |
| 1/4 | 10 | 3 |
| 1/8 | 7.5 | 2.2 |
| 1/16 | 5 | 1.5 |
| 1/32 | 3.75 | 1.1 |
| 1/64 | 2.5 | 0.75 |

Before considering the practical uses of flash, it would be worthwhile to examine the interrelationship of FILM SPEEDS, FLASH-TO-SUBJECT DISTANCES, and F/STOPS in regard to flash exposures. Whenever you change any one of those three factors, the other factors are affected, as you'll see by studying the following flash exposure chart.

Check how the exposure (f/stop) changes when the flash-to-subject distance or the speed (ISO) of the film is changed. For example, a film that is twice as fast allows you to use one f/stop smaller for a flash subject at the same distance. Similarly, a film that is four times as fast allows two f/stops less flash exposure for a subject at the same distance.

(In this chart, the unit's flash guide number for ISO 100 film is 80 for feet, 24 for meters; just figure: 10 feet × f/8 = 80 (or 3 meters × f/8 = 24). For ISO 200 film, the guide number is 110 for feet, 33 for meters; and for ISO 400 film, it is 160 for feet, 48 for meters.)

## FLASH EXPOSURE COMPARISON CHART FOR FLASH UNIT WITH GUIDE NUMBER OF 80 FOR FEET (24 FOR METERS) WITH ISO 100, ISO 200, AND ISO 400 FILMS

| ISO Film Speed | Flash-to-Subject Distance in Feet (in Meters) | | | | | | |
|---|---|---|---|---|---|---|---|
|  | 3.75(1.1) | 5(1.5) | 7.5(2.2) | 10(3) | 15(4.5) | 20(6) | 30(9) |
| 100 | f/22 | f/16 | f/11 | f/8 | f/5.6 | f/4 | f/2.8 |
| 200 | 32 | 22 | 16 | 11 | 8 | 5.6 | 4 |
| 400 | — | 32 | 22 | 16 | 11 | 8 | 5.6 |

## Fill Flash for More Flattering Photos

Good flash pictures take more effort than just making sure the exposure is accurate. For instance, if part of your subject is closer to the flash than another part, it will be overexposed unless the flash or your subject is repositioned. Techniques for making appealing flash photos vary. Among them are fill flash, bounce flash, off-camera flash, multiple flash, and open flash.

As mentioned previously in this chapter, one of the most popular uses of flash is called FILL FLASH. It's also known as FILL-IN FLASH. In the days when flashbulbs were more common than electronic flash, it was called SYNCHRO-SUNLIGHT FLASH. In general, the purpose of fill flash is to add light to shadowed areas in order to make a more pleasing picture. A frequent use is to reduce or get rid of unpleasant shadows on the faces of people in bright sunlight. Also, when there is strong backlight, fill flash helps to prevent your subject from appearing as a silhouette. Fill flash is the reason why you see smart photographers firing their flash units outdoors in the daylight.

The goal when using fill flash is to achieve a good balance with the ambient light, not overpower it. Otherwise, the result is an obvious flash picture. When flash dominates the exposure, your subject is fully illuminated by the flash, and the background is often dark. In a properly balanced fill flash photo, sunlight or other ambient light is the main source of illumination; it may not even be evident that flash was used to add some light to improve the picture.

The thing to remember about fill flash is that exposure is based on an exposure reading of the ambient light; light from the flash is secondary. There are several ways to control the precise amount of fill light from the flash. The easiest way is to use an SLR's built-in flash or an accessory dedicated TTL autoflash, and let the camera's automatic through-the-lens exposure system determine the duration of the flash light for well-balanced fill flash. Consult your camera and/or flash instruction manual for specific guidance and any restrictions regarding the automatic exposure mode you select on the camera.

In general, when using a DEDICATED TTL AUTOFLASH FOR FILL FLASH, you just make certain its flash mode selector is set to TTL, and check the unit's LCD information panel to be sure the distance of your subject is within the flash's minimum/maximum automatic operating range. (If your subject is beyond the maximum flash distance, move closer or use a wider lens opening.) When the shutter release button is pressed, the camera's TTL exposure system reads

125. Flash is a portable light source that often can improve pictures, even outdoors. In this initial shot *without* flash, the harsh, overhead sun shadowed the faces of these beauty contestants.

126. Then the photographer wisely decided to use fill flash, which illuminated the shadows and made the girls and the picture much more appealing.

both the ambient and flash light, and its microcomputer determines when to quench the flash light for a well-balanced exposure with fill flash.

Using a NON-TTL AUTOFLASH FOR FILL FLASH involves more steps. Instead of the camera's through-the-lens metering system measuring and controlling the flash light, this is done by the photocell sensor on the front of the flash unit. First, set the flash mode selector to A (automatic/non-TTL). Also, be sure the flash unit is set to the speed of the film (ISO) that's in your camera. If your flash has a zoom flash head, be certain it is positioned to the focal length of the lens on your camera.

Next, set the camera's shutter speed to the fastest speed for flash synchronization, and take an exposure meter reading to set the lens opening for a proper exposure based on the sunlight or other ambient light. Finally, set the same f/stop on the flash unit, and check its LCD information panel or calculator scale to make certain the distance of the subject you are going to fill with flash falls within the flash's minimum/maximum automatic operating range for that f/stop.

If it does not, select an f/stop on the LCD information panel or calculator scale that is within the required flash operating range, set that f/stop on the camera lens, then readjust the shutter speed for a proper ambient light exposure; that speed must not exceed the camera's fastest flash synchronization speed. Before taking the picture, you can check whether the fill flash light will be adequate. Do this by pressing the open flash button to fire a test flash and then observing the sufficient light indicator.

Using MANUAL FLASH FOR FILL FLASH also requires a number of steps. Begin by setting the flash mode selector to M (manual). That adjusts the unit to full power for maximum light output, usually 1/1000 second; the flash duration does not change as it does to control autoflash exposures. Next, set the film speed (ISO) and zoom head (if available) on the flash unit as just described. Then take an exposure reading to manually set the camera's lens opening and the shutter speed (do not exceed the maximum speed for flash synchronization) for the sunlight or other ambient light.

Finally, based on the f/stop you've chosen, you refer to the flash unit's LCD information panel, or the calculator scale or chart, to determine the distance the flash must be from your subject for a proper fill flash exposure. If the flash is too close to the subject, it will overexpose your subject, and if too far away, the fill flash effect will be lost.

Fortunately, there are a number of ways to make ADJUSTMENTS FOR

127. Because of the strong backlight, flash was used to illuminate the subject and prevent her from becoming a silhouette.

MANUAL FILL FLASH when the flash is not at the proper distance for the f/stop on the camera lens. Just set the flash-to-subject distance on the unit's LCD information panel or calculator scale in order to determine the correct f/stop to use; you'll also need to readjust the shutter speed for the proper ambient light exposure (and be certain it allows for flash synchronization).

For example, say the flash-to-subject distance is 8 feet and requires an exposure of f/16, but your original exposure setting for the ambient light is f/11 at 1/125 second. All you need to do is reset the lens opening to f/16 and the shutter speed to 1/60 second for an equivalent ambient light exposure.

There is another convenient option, if you have one of the better flash units that features LIGHT OUTPUT CONTROL (also called VARIABLE POWER CONTROL) to regulate the duration of the flash. You simply adjust the flash power instead of physically moving the flash to the required flash-to-subject distance. This was described earlier in this chapter (see page 176).

If your flash has a ZOOM FLASH HEAD, manually changing its settings for lens focal length, as indicated in millimeters (mm), can alter the effective flash-to-subject distance by spreading (i.e., reducing) the flash light in the wide-angle range and concentrating (i.e., increasing) it in the telephoto range; check the unit's LCD information panel to note the revised distances. Although the area of flash coverage (i.e., angle of illumination) will be narrowed in the telephoto range, any

loss of flash light at the edges of the picture probably will not be evident because ambient light is providing the main illumination and the flash is only being used to fill in shadows on the subject.

Another way to compensate is to REPOSITION THE CAMERA AND FLASH at the proper flash-to-subject distance for the f/stop you've chosen, and use a zoom lens to control the picture's composition. Of course, if you don't want to change the camera's position, you can remove the flash from the hot shoe and position it at the required flash-to-subject distance with the use of a flash connecting cord—as long as that distance isn't too great.

If you must move the flash back because it will be too bright for your subject, but you are without a flash cord, a simple trick is to reduce the flash light by COVERING THE FLASH HEAD WITH A CLEAN WHITE HANDKERCHIEF. (Take care not to cover the photocell light sensor on a non-TTL autoflash unit.) One layer of handkerchief will generally cut the amount of flash in half, which is the equivalent of one f/stop.

Here's how to determine the number of handkerchief layers that would be needed to reduce the flash light. First, calculate the flash exposure by using the flash unit's adjustment buttons and viewing the LCD information panel, or by using the unit's calculator dial or chart, then compare it to the exposure for the ambient light to figure the difference in f/stops.

For example, say the flash-to-subject distance is 5 feet and requires a small lens opening of f/22 for a proper flash exposure. If the proper exposure for the ambient light is f/11, then the flash light output must be reduced by two stops. One handkerchief layer would reduce it by one stop to f/16, and another layer by one more f/stop to f/11. So with two layers of handkerchief in front of the flash head, the flash unit could be kept at the camera's distance of 5 feet to provide the proper amount of fill light.

Always keep in mind that light from FILL FLASH IS SECONDARY TO THE SUN or any other main source of light. If the fill flash equals or overpowers the main light source, the lighting effect will appear unnatural. Since the purpose of fill flash is to reduce the darker shadow areas and give more detail to the subject, it must provide a lower level of illumination than the main light source.

If that's true, you may be wondering about the fill flash examples given above. They described various ways to manually adjust the flash light output in order to *match* the exposure for the sunlight. So why won't the fill flash light appear equally as strong as the ambient light? That's because the microcomputers or calculator dials or charts of flash units used to figure manual flash exposures take into

128. A dockside shelter shaded this Bahamian fisherman and his prize catch, so fill flash was used to illuminate them and balance the intensity of the sunlight in the background (see text).

consideration a certain amount of reflected light that can be expected when flash is fired in a room. But outdoors there is no such reflection, so the flash units give about one f/stop less light than would be needed for a correct manual flash exposure if flash was the only source of illumination. In reality, this means the light from the flash will provide about half of the illumination of the sunlight—which gives a good balance of fill light outdoors.

When *indoors*, especially in studios where all lighting is controlled by the photographer, the relative brightness of the main light in relation to the brightness of the fill light is often indicated as a LIGHTING RATIO. A lighting ratio of 1:1 means the lights are of equal power. A ratio of 2:1 indicates that the main light (the first number) is twice as bright as the fill light. Stated another way, the fill light is half as bright as the main light. Common lighting ratios for fill flash in studios range from 3:1 (one-third as bright) to 8:1 (one-eighth as bright).

One way to interpret a lighting ratio is to consider it in terms of f/stops. For instance, with a 2:1 ratio, if the proper exposure for the main flash has been figured to be f/5.6, the fill flash should produce only one-half that amount of light, which is equivalent to one f/stop less exposure (i.e., f/8).

To interpret and compare flash lighting ratios, you can use the

chart below. (If it seems confusing, remember that light intensity decreases in proportion to the square of the increased distance.)

| Lighting Ratio of Main Flash to Fill Flash | Light Output of Fill Flash Compared with Main Flash | Equivalent f/stop Reduction in Light Output of Fill Flash | Distance of Fill Flash to Subject Compared with Main Flash |
|---|---|---|---|
| 1:1 | 1/1 | — | — |
| 2:1 | 1/2 | −1 | 1.4X |
| 4:1 | 1/4 | −2 | 2X |
| 8:1 | 1/8 | −3 | 3X |

This chart can be helpful when arranging a main flash unit and a fill flash unit for portrait photography at home (see Illustration 132). As for general photography outdoors, remember that it is easiest to make well-balanced fill flash photos with a dedicated TTL autoflash unit because microcomputers in the flash and its compatible camera will automatically figure and adjust the exposure settings.

## Bounce Flash for Better Pictures

As mentioned earlier in this chapter, FLAT FLASH, also called ON-CAMERA FLASH, is the most common type of flash lighting. It is most convenient for the photographer because the flash is built into or mounted on the camera. However, on-camera flash is often the least pleasing because the light is falling on the subject directly from the front and seems unnatural. The resulting lighting would be similar to what you'd see if everyone walked around with coal miners' lamps on their heads.

One way to avoid the harshness and directness of flat flash is to bounce the flash light off the ceiling or a wall. BOUNCE FLASH gives soft, indirect illumination. White or ivory ceilings or walls are best when you are using bounce flash with color film, because light reflecting off colored surfaces can alter the color of your subjects.

Bouncing the flash is a good way to avoid reflections that can occur with direct flash when subjects are in front of a mirror or any shiny surface. Similarly, glass objects or objects behind glass can often be photographed best with bounce light. Sometimes bounce light from flash is used simply to supplement the overall ambient light in a room, or to add illumination to a dark area of a room.

129. Carefully compare these two flash photos. When flash is aimed directly at your subject from the camera, the light sometimes appears harsh and uneven.

130. For a more pleasant and uniformly exposed picture, try using bounce flash instead of direct flash (see text).

While a built-in flash cannot be adjusted for use as a bounce light, a shoe-mounted accessory flash unit with a tilting and rotating flash head can easily be re-aimed at a ceiling or wall. Remember, however, that if the ceiling or wall is too far from your subject, the bounced light from the flash may be too weak to be effective as the main source of illumination. That's because the light has to travel from the flash to the ceiling or wall and then back to your subject. In addition, some of the light is absorbed or scattered when it hits the reflective surface, so the intensity of the flash will be reduced.

A BOUNCE LIGHT REFLECTOR that attaches to a flash unit to spread the light when its flash head is tilted vertically helps solve these problems. Some have metal brackets that snap onto the unit and hold a large white card, while others are fan-shaped white vinyl devices that are attached with Velcro. With these portable reflectors, you don't have to find a low ceiling or a convenient wall to bounce the flash light.

Fortunately, BOUNCE LIGHT EXPOSURE FOR DEDICATED TTL AUTOFLASH UNITS is controlled automatically. The same is true for those non-TTL autoflash units with a photocell sensor, as long as the sensor is at the camera position. In both cases, the flash exposure metering system in the camera or in the flash unit receives the bounced light reflected back from the subject and controls the duration of the flash.

The only thing you must do is make certain your flash's maximum automatic operating range covers at least *twice* the total distance the light must travel from the flash to the bounce surface to the subject; refer to the distance scale on the unit's LCD information panel or calculator scale. Doubling the distance the bounce flash travels is a good rule of thumb when bouncing off a ceiling or wall because so much of the light is absorbed or scattered by those surfaces.

After an exposure, always check the unit's SUFFICIENT LIGHT INDICATOR to see if the flash light was adequate to make a proper exposure. Or, you can avoid the possibility of underexposure in advance. Just check the sufficient light indicator after pressing the unit's OPEN FLASH BUTTON, which test-fires the flash without taking a picture (see page 159).

If the bounced flash light is not adequate for an *automatic* flash exposure, you have several options: select a larger lens opening, shorten the bounce flash distance by removing the flash from the camera's hot shoe and using a connecting cord to position the flash closer to the ceiling, use faster film, or switch to manual flash exposure. Manual flash uses the unit's full power for its maximum light output; exposure is controlled by the lens opening you set.

To set MANUAL EXPOSURE FOR BOUNCE FLASH, first figure the total distance the light has to travel from the flash to the ceiling to the subject. Use the flash unit's LCD information panel or calculator scale or flash guide number to find the f/stop for that distance, but increase the exposure by about two f/stops to compensate for the fact that the flash light reaching your subject is not direct and will be absorbed and scattered by the ceiling. For example, if the recommended lens opening for direct flash is f/8, set it to f/4 for bounce flash. It's usually worthwhile to bracket manual bounce flash exposures.

Be careful not to misaim bounce flash. Direct the flash so the light reflecting off the ceiling or wall will fall on your subject, not behind it. One technique to help you aim the flash when using it horizontally off-camera is to hold the unit so that your forefinger is centered on top of the flash head to serve as a natural pointer.

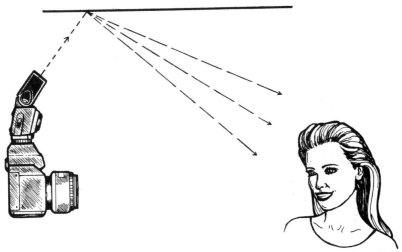

131. The correct technique for bouncing flash off a ceiling is to tilt the flash head up (or remove the flash unit from the camera) so that the light reflecting from the ceiling will fall on your subject, not behind it. Unless you are using TTL (through-the-lens) autoflash, figure the exposure by determining the distance from the flash to the ceiling to the subject, and divide this distance into the flash guide number (or consult the flash unit's calculator scale or LCD information panel). The resulting f/stop should be increased by about two f/stops because the light reaching the subject is not direct and is scattered by the ceiling.

For portraits with bounce flash, you'll get predictable and much better results using a PHOTOGRAPHIC UMBRELLA than if you simply bounce the light off a wall or ceiling. To use this umbrella-shaped light reflector, the flash is taken off the camera and positioned so its light bounces off the inside of the umbrella back to the subject. Manual exposure is figured as just described, after you measure the flash-to-umbrella-to-subject distance. Dedicated TTL autoflash units automatically determine the exposure for umbrella bounce flash, as will any non-TTL autoflash unit when its photocell sensor remains at the camera position.

## Other Useful Flash Techniques

Photographers who frequently use flash, especially off the camera, will find it worthwhile to invest in a FLASH METER. This is a hand-held exposure meter that reads the amount of electronic flash light falling on or reflected by the subject and calculates the correct f/stop to set on the camera. It's especially valuable for determining exposures for multiple flash, bounce flash, fill flash, and close-up flash.

The more sophisticated exposure meters are multipurpose models that can be used for making ambient light as well as flash exposure readings, either separately or both at the same time. The earlier chapter about exposure describes flash meters as well as ambient light meters in more detail (see page 87).

As mentioned previously, positioning the flash away from the camera often improves a photograph because light coming from an angle gives more detail and dimension to your subject. However, there is something to remember every time you use OFF-CAMERA FLASH. The flash head is rectangular in order that its light completely covers the rectangular format of 35mm film, so whenever the camera is turned from a horizontal to a vertical position, you must also position the flash head vertically in order to provide full flash coverage of the film.

Flash pictures are often more pleasing when two or more flash units are used to illuminate your subject. This is generally termed MULTIPLE FLASH, and it is especially effective for making portraits. Any secondary or auxiliary flash unit is called a SLAVE FLASH, a REMOTE

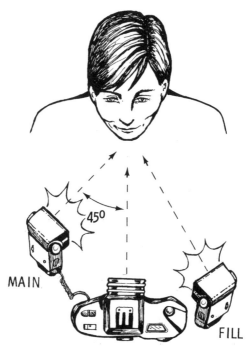

MAIN

FILL

45°

132. When using two flash units to make a portrait, the main flash should be placed at a 45° angle to the direction of the camera lens. It also should be closer to the subject than the fill light, which usually is kept near the camera. Exposure is figured on the distance between the main flash unit and the subject.

FLASH, or an EXTENSION FLASH. A secondary flash usually serves as a fill light to soften the shadows created by the main flash. For portraits, additional slave units are often used to illuminate the background and/or to highlight the subject's hair. (See page 352 for details about portrait lighting.)

Exposure for multiple flash is set manually on the camera, and the f/stop you use is based on the distance from the *main* flash to your subject. A slave flash is always placed at a greater distance from the subject than the main flash, or its light output control (if any) is set to a lower power, so that the secondary flash will not be stronger than the main flash. Some photographers buy one or two less powerful (and less expensive) flash units to use for slave flash.

For proper synchronization, the main flash and all slave flash units must fire at the same time. (A slower-than-normal sync speed, such as 1/60 second, may be required; see your flash instruction manual.) The secondary units can be connected with flash cords, but it is more convenient to trigger the slaves remotely via photocell sensors (or radio signal devices). A wireless light-sensitive REMOTE-

133. During a time exposure of the city lights of Los Angeles in the background, Griffith Observatory was illuminated with the open flash technique. A flash unit was aimed and manually fired several times at the side of the building from different locations that were out of sight of the camera. To avoid overexposure by electric lights on the building and in the distance, an assistant covered the lens with a piece of black paper during the times the photographer moved from one flash position to another.

FLASH SENSOR is built into some flash units, or you can buy one as an accessory to attach to any flash unit. When the main flash goes off, its light is received by the remote sensor and instantly fires the slave flash unit.

Another technique for creative flash photography is firing MULTIPLE FLASHES from the same unit. This is effective when you have only a single accessory flash and want to illuminate a large subject, such as a building. Other reasons to fire multiple flashes are to add more light in order to reach subjects at greater distances, or to reduce the f/stop for increased depth of field.

A technique known as PAINTING WITH LIGHT is done with multiple flashes from a single flash unit that is fired from different positions to illuminate a large picture area at night. The unit is removed from the camera and fired manually by pressing its OPEN FLASH BUTTON (also called a TEST FLASH BUTTON); a connecting cord between flash and camera is not used. Firing an off-camera flash in this manner is called OPEN FLASH. The camera is placed on a tripod, and the shutter speed control is set to B or T in order to hold the shutter open while the multiple flashes are being fired.

Painting with light works best when the picture area is very dark, because if any extraneous light enters the lens while the shutter is open, it will also be recorded on the film. You can reduce exposure to other light by having someone hold a black card in front of the lens in between flashes. As with manual flash, the lens opening to use for a proper exposure is determined by the flash-to-subject distance. (Refer to the flash's LCD information panel or calculator scale, or divide the flash-to-subject distance into the unit's guide number to select the f/stop.)

For uniform lighting of your subject, the flash must be the same distance to the subject each time it is fired. Also, try not to overlap the flashes, or else those portions of the subject will be overexposed. Likewise, areas of the subject may be underexposed if the flash coverage is not adequate. Practicing with your particular flash unit, and bracketing the f/stop, will help ensure that you get uniform and correct open flash exposures. One caution: When firing each flash, keep a low profile or hide behind foreground objects so your image won't appear as a silhouette between the camera and flash.

Multiple flashes can also be fired from one flash unit TO INCREASE THE LIGHT reaching a subject. For instance, when your subject is too far away for a proper exposure because the camera lens opening is at its widest aperture, firing the flash two times will double the amount of light on the subject. That means if the maximum opening of your

lens is f/4, but the flash-to-subject distance requires an aperture of f/2.8, firing the flash twice will give a proper flash exposure.

Similarly, if you purposely want to use a small f/stop TO INCREASE DEPTH OF FIELD so more of the picture area will be in sharp focus, you can fire multiple flashes to increase the total amount of light illuminating your subject. For example, if the manual flash-to-subject exposure requires f/5.6, firing the flash two times doubles the amount of light and enables you to set the lens opening to f/8 for a proper exposure. Firing it twice more (a cumulative total of four flashes) will allow an exposure of f/11, and so on.

When using multiple flashes from one unit to increase the flash illumination, use a tripod and keep the camera shutter open with its B or T setting, as described above. An option is to use your SLR camera's MULTIPLE EXPOSURE CONTROL, if any, which keeps the same film frame in position while two or more exposures are made (see page 387). Another choice is to use the REPEATING FLASH MODE on your flash unit, if available, for exposing the subject several times on the same film frame (see page 166). In any case, the subject (and your camera) must remain stationary while the exposures accumulate with each flash, or else the film will record an underexposed multiple image instead of a well-exposed single image of your subject.

By the way, using two side-by-side flash units of identical power and at the same distance from the subject will double the amount of flash light and allow a one-f/stop reduction in exposure. For each additional f/stop reduction required or desired, another identical flash unit would be needed, which is obviously a less practical (and more expensive) option than using multiple flashes to increase the amount of light.

Photographers will have some fun creating eye-catching images by using FLASH WITH COLOR FILTERS. The effects can be quite bizarre, especially when using filters with fill flash and ambient light to change the color of your subject or the background. This filtration can have a practical purpose, too. An example is correcting the color balance to reduce or even eliminate the annoying greenish tint in pictures shot under fluorescent light with daylight color slide film.

A CC30M magenta filter placed over the camera lens is commonly used to properly balance fluorescent light so subjects appear in photos in the same colors as seen by your eyes. However, if fill flash is also used, because light from the flash is balanced for daylight color film, the flash-filled subject will appear somewhat purplish. To cancel this magenta cast, a CC30G filter that is green (the complementary color of magenta) is attached over the flash head. The result is a natural-looking, fill flash color photo.

To purposely change to *unnatural* colors, use FILTERED FILL FLASH for pictures outdoors. To alter the colors of your flash-filled subject, but not the background, use a color filter of your choice only over the flash. For instance, you could change a white horse to a purplish color by exposing it with a magenta filter over the flash; since the flash did not illuminate the background, the background remains in its natural colors.

To change the colors of the background, but not the fill-flash subject, use a color filter over the camera lens, and attach a filter of its complementary color over the flash head. As an example, with a magenta filter over the camera lens and a green filter over the flash, these complementary colors would produce a natural-color rendition of the flash subject—the white horse—while turning white clouds and other light colors in the background to a purplish hue.

Some units have accessory kits of color filters that attach over the flash head, or you can buy acetate filters and tape them in place. Read more about filters and complementary colors in Chapter 7, then experiment with your flash.

You should be aware that filters are unnecessary for regular flash photography with most color films. That's because the light from electronic flash has a color temperature similar to that of sunlight at noontime (5500 K), so it is COLOR BALANCED for use with all color print films and all daylight color slide films (see page 201). This means flash will produce pictures with the same color renditions as we see with our eyes.

The exception is when the flash is used with TUNGSTEN COLOR SLIDE FILM, which is color-balanced for tungsten light, such as household lamps. To color-balance tungsten film for use with flash, a No. 85B (yellowish-orange) conversion filter must be used over the camera lens. If the flash is to be used only as a fill light instead of as the main source of illumination for the tungsten film, a No. 80A (dark blue) conversion filter must be used over the flash head (see page 244).

FLASH FOR CLOSE-UP PHOTOGRAPHY is often a necessity because it enables you to use small lens openings for maximum depth of field and therefore get more of the subject area in sharp focus. Flash also stops any action of subjects and thus avoids blurred images. In addition, you can control the illumination. See page 379 for details about using flash when making close-up pictures.

## Practical Considerations with Flash

Here are some practical considerations and tips when using flash.

First of all, never leave your accessory flash unit behind. Carry it in your camera bag so it's always handy, or even keep the flash mounted in your camera's hot shoe so it's ready to use.

When shooting with flash, be certain to position it so your subject(s) will be uniformly illuminated. For example, a Ping-Pong match photographed from one end of the table with on-camera flash would result in one player being too bright and the other too dark. Bouncing the flash off the ceiling to illuminate the entire table and playing area evenly is one solution. Another is to fire the flash from one side of the table to light both players equally. As you know, proper flash exposure is based on the distance between the flash and the subject; you must always take the depth and width of your subject into consideration when figuring out how to make an effective flash picture.

Shadows in the background, such as a black outline of the subject cast on a wall behind, are common distractions caused by flash. This can be avoided in several ways. If the flash is mounted or held directly above the camera lens, the shadows from the flash light will

134. Fill flash will greatly improve pictures of people outdoors, especially when harsh sunlight causes shadows on their faces, as with this girl in an African village.

fall directly behind the subject and not be recorded on the film. If the hot shoe that holds an accessory flash unit is located to one side of the camera lens, remove the unit in order to position the flash directly above the lens.

Also, when you turn a 35mm camera from a horizontal to a vertical position, a top-mounted flash will now be at the side, and unpleasant shadows can result. To avoid this, take the flash off the camera, attach a connecting cord, and hold the flash above the lens. Just before you press the shutter release to take the picture, remember to check the angle of the flash head to make sure it is pointed at the subject.

If your camera has a built-in flash located to one side of the lens, whenever you turn the camera vertically, check that the flash is positioned at the top of the camera and not at the bottom. When at the top, the flash is above the lens and shadows fall behind the subject; at the bottom, the flash is below the lens and shadows fall unnaturally upward, casting a distracting shadow above the subject.

You can avoid shadows in the background by bouncing the flash off the ceiling, if possible. Otherwise, move your subject away from the background so any shadows will be lost in the darkness behind the subject. If the flash light cannot reach the background, shadows from the subject will not be recorded.

Beware of shiny objects in the background which may cause a glaring reflection of the flash light. Windows or mirrors are the worst. Highly polished wood paneling or furniture, and enamel-painted walls, throw back distracting flash reflections, too. Move your subjects away from shiny surfaces, or place the flash unit at an angle to such surfaces so the reflected light will not return into the camera lens.

Likewise, if your subject wears eyeglasses and is looking into the camera, keep the flash angle higher than the camera to avoid a reflection. With built-in or on-camera flash, have your subject tilt his head down slightly so that any flash reflection from the glasses will be angled below the camera lens.

Using flash is a smart solution if the person you are photographing would otherwise squint from the bright sun or artificial light. With flash, your subject's eyes will be open naturally. The brief burst of flash light is an especially good choice for babies, because continuous bright light usually disturbs them. Flash also makes it easier to capture the action of babies, who move and change expression so quickly.

Contrary to what most photographers do, do not tell your subjects when you are going to take the picture (i.e., fire your flash),

because they may anticipate the bright light and close their eyes. If someone says they blinked when the picture was taken, ask them if they saw pink or white light. If the answer is pink, they saw the flash through their eyelids and so their eyes were probably closed during the exposure. Make another.

Even if your camera has a built-in flash, an accessory autoflash unit is much more versatile and will be a worthwhile addition to your gadget bag. Whenever you buy a new accessory flash, be sure to try all its features so that you won't miss any important flash pictures in the future. Set up different flash situations and make some test shots using each of the flash modes—TTL, A (automatic/non-TTL), and M (manual)—to see how your flash and camera best handle each situation.

# SELECTING FILMS

Regardless of your camera and equipment, the film you use has much to do with the outcome of your pictures. There is such a vast selection of films—including more than 125 films for 35mm cameras—that it may seem impossible to pick the ones that will be best for your photographic pursuits. However, after experimenting with several films, undoubtedly you'll discover one or two films that will become your favorites. This chapter has all the information you need to make those choices. At the end of the chapter is a list of specific films available for 35mm, medium-format, and APS cameras. First, here are some basic things to know about film.

Several NAME BRANDS OF FILM are popular today, although the Eastman Kodak Company still sells the majority of the film in the United States. Fuji, Konica, Agfa, Ilford, Scotch, and other brands offer worthy competition to films in Kodak's ubiquitous yellow boxes. You will also see dozens of films with PRIVATE LABELS, known as STORE BRANDS, such as Focal films, which are sold by Kmart. Films with private labels are produced by three companies: Imation of the U.S., Agfa of Germany, and Konica of Japan.

For essential information about a specific film, look on the FILM BOX. You'll find the brand name, film name, film type, and sometimes its use, such as for color prints. Also printed on the box is the film's size, speed, number of exposures, and expiration date. In addition, there is a two- or three-letter abbreviation that is the manufacturer's code for the film. For example, RD is Fuji's identification for its Fujichrome Sensia II 100 color slide film, while GB identifies Kodak's Gold 200 color print film.

Additional FILM DATA, including recommended exposures and processing information, is printed on the *inside* of the film box or on a separate DATA SHEET packed in the box.

135. Most black-and-white films for general photography are termed panchromatic, which means they are sensitive to all colors of visible light. This Mexican couple, in colorful folkloric dance costumes, are reproduced on film in black, white, and various shades of gray.

Before buying any film, always check the box for the film's EXPIRATION DATE, which tells you whether or not the film is "fresh." Out-of-date film no longer meets the manufacturer's standards, because the speed, contrast, and color characteristics of a film deteriorate with age. The expiration date indicates the end of the film's so-called SHELF LIFE, which supposes that the film will be kept in temperature conditions similar to those of films for sale in a camera store. If a film is subjected to extreme heat or humidity, expiration of the film will occur before the date indicated. Never buy film that is vulnerable to hot or humid conditions, such as film sold in outdoor vending machines directly exposed to the sun.

Storing fresh film in a refrigerator or freezer can retard changes in the film's characteristics, but this will not prevent the inevitable changes in film speed, contrast, and color after the expiration date. The degree of deterioration of out-of-date film varies; some films will show little obvious change months or even a year or two after the expiration date.

Because manufacturers do not guarantee film after the date printed on the box, expired film is often sold at greatly reduced prices. Some photographers buy out-of-date film to save money or to

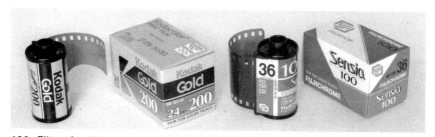

136. Films for 35mm cameras are available in a wide range of brands, types, speeds, and numbers of exposures. An initial decision is whether you want to shoot color print film, color slide film, or black-and-white film.

experiment, but our recommendation is always to make certain that any film you purchase has not reached its expiration date.

You'll notice that some film is labeled as PROFESSIONAL FILM. This generally means the film will perform at the *specific* characteristics given in its data sheet. A professional color film, for instance, has its optimum color balance, contrast, and film speed at the time of manufacture. To stabilize those characteristics, the film often carries a notice to keep the film refrigerated before use, at 55° F (13° C) or less, and to process it promptly after exposure. In reality, professional films can be kept at room temperature for about two weeks before exposure, and if processed within a week after exposure, there will be no significant shift in color balance or contrast.

Films without the professional label are considered to be CONSUMER FILMS or AMATEUR FILMS. These are designed to remain stable in varied temperatures and for a considerable period of time before and after being exposed. Refrigeration is unnecessary for amateur films, although Kodak recommends REFRIGERATED STORAGE for *all* its films when temperatures exceed 75° F (24° C) for extended periods, as in tropical regions or during hot summer months. If you do refrigerate film, store it in its original, sealed vapor-tight plastic canister or foil wrapper. And remember to allow one to two hours for refrigerated film to warm up to room temperature before use to prevent condensation on the surface of the film.

Professional films, as you might expect, are more expensive than amateur films. However, a few amateur films are marketed by their manufacturers as PREMIUM FILMS and sold at a higher cost than other amateur films of the same brand, type, and speed. For example, Kodak's more expensive color print film, Royal Gold, is advertised for "those special moments" like weddings and birthdays, implying that it is a better choice than Kodak's regular Gold series of films.

When choosing a film, don't worry whether it is amateur or professional (unless you're concerned about the price). Just pick the

brand and type of film that pleases you most. (Professional photographers often shoot with amateur films.) Keep in mind, of course, that your photographic results also depend on the quality of processing given the film and/or its prints (see later in this chapter).

## Types of Film

The hundreds of films on the worldwide market can be categorized as three general types. The most popular is COLOR NEGATIVE FILM, which is more commonly called COLOR PRINT FILM because it is used for making color prints. More than 95 percent of all color film shot in the United States is color print film. It is the preference of amateur photographers because they can have the film processed quickly at fast-photo minilabs for almost instant enjoyment of their color snapshots.

Another basic type of film is technically called COLOR REVERSAL, COLOR POSITIVE, or COLOR TRANSPARENCY FILM. Nonprofessionals commonly call it COLOR SLIDE FILM because they use it to create color slides to be projected on a screen. One advantage is that the film produces a direct positive (not negative) image, and it can easily be viewed by placing the processed film in front of any light source. Color reversal film is popular among professional photographers

137. Color print films produce negatives for making prints, while color slide films produce positive transparencies for projection. However, you also can have color prints made from slides, and slides made from color negatives.

who take pictures for publication. To meet the various needs of the pros, there is a greater choice of color transparency films than color negative films. The majority of color reversal films are designated as professional films.

The third general type of film is BLACK-AND-WHITE FILM, most of which is negative film for making black-and-white prints. It is often used by photojournalists, but has also found favor with advertising, architectural, landscape, and art photographers. In recent years there has been renewed interest in black-and-white photography, and film manufacturers offer a considerable number of black-and-white films.

Although a film is designed to produce either prints or slides, there are other options. For example, black-and-white prints and color slides can be made from color negatives. And color prints can be made from color reversal (slide) films. For best results, however, choose the type of film intended for the primary results you want—prints or slides.

By the way, you can sometimes identify the type of a color film just by looking at its name. The suffix "color," as in Fujicolor, indicates that it is a color print film for making prints, while the suffix "chrome," as in Kodachrome, indicates that it is a color slide film for making slides. On the other hand, black-and-white films have nothing in their names to distinguish between a negative or a reversal type because almost all black-and-white films produce negatives.

There is more to choosing a film than just selecting one of the three basic types. That's because each type of film has its own characteristics. You should be aware that every color film—whether color print or color slide—is generally categorized as being either a DAYLIGHT FILM or a TUNGSTEN FILM. This refers to the primary type of light by which the film should be exposed—daylight or tungsten. What's the difference?

In photography, DAYLIGHT generally refers to light from the sun, while tungsten commonly refers to light from incandescent light sources, such as a household lightbulb or a halogen light in a photo studio. More precisely, TUNGSTEN LIGHT refers to any lightbulb with a tungsten filament that becomes incandescent when heated by an electrical current.

The fact is that light sources do not all produce the same quality (i.e., colors) of light, even though it may appear so to your eye. Because photographers expect color films to accurately reproduce the colors of their subjects, films are made for specific light sources—daylight or tungsten—in order to faithfully record the colors just as you saw them.

In reality, most photographers are not concerned about light sources when shooting color negative films. That's because photofinishers use filtration to achieve proper COLOR BALANCE at the time the negative is exposed to photo paper to produce the color print. On the other hand, color slide (reversal) films should be appropriate for the light source—daylight or tungsten—in order to provide correct color balance at the time of shooting. That's because the reversal film itself becomes the final photograph; there is no opportunity to use filtration to achieve proper color balance during the processing stage.

How do you know if a film has a color balance that matches a certain light source? Films are manufactured to be color balanced for a specific COLOR TEMPERATURE, a numbered scale that indicates the color quality of the light source in units of measurement called KELVINS, abbreviated K. For instance, sunlight at noontime has an average color temperature of 5500 K, so daylight color films are

138. Daylight color films can be used indoors without flash if there is sufficient sunlight in the room. When the indoor light is predominantly from incandescent electric lights, you should use a filter or switch to tungsten film so that the colors of your subjects will look natural in the photograph (see text).

color balanced to match that color temperature. Since the light from electronic flash units also has a color temperature of about 5500 K, daylight color films are color balanced for use with flash light as well.

The color temperatures of tungsten light sources are much different than the color temperature of daylight and electronic flash (which produces light with a gas-filled tube, not a filament). So tungsten films are made to be color balanced with those light sources. Take note that you must know the color temperature of the *specific* tungsten light source in order to choose a tungsten film that is specifically color balanced for it. For instance, the white photoflood bulbs sometimes used for amateur portrait photography have a color temperature of 3400 K. To color balance with that light, Kodak makes Kodachrome 40 tungsten color slide film.

As you'll notice from the list of films beginning on page 218, most films are categorized as daylight films, not tungsten films. That's because the majority of pictures are taken using light from the sun or electronic flash, and daylight films are color balanced for those light sources.

If a color film is not specifically balanced for the light source, you always have an option. LIGHT-BALANCING FILTERS or CONVERSION FILTERS can be attached to the camera lens to achieve correct color balance at the time the film is exposed. You'll read how to choose and use these filters in the following chapter.

As for black-and-white films, the concern of photographers in regard to light sources is for the COLOR SENSITIVITY of those films, not color balance. Most black-and-white films for general photography are termed PANCHROMATIC films, which means they are sensitive to all colors of visible light. They record those colors in a variety of gray tones, which should be reproduced with brightness similar to that which you saw with your eyes. To change the relative brightness (i.e., gray tone) of a color, you can use filters on the camera lens to alter the color sensitivity of the black-and-white film; details are given in the following chapter. The important thing to know is that panchromatic black-and-white films can be used with *all* light sources, whether daylight, electronic flash, or tungsten.

One characteristic of all films—color and black-and-white—is of particular interest to photographers. It is called DEFINITION and refers to the clarity of detail that you are able to see in an image. It's important to use a film that has good definition when you want to make enlargements, especially from small negatives. SHARPNESS (or ACU-TANCE) between the edges of the details in the image is one indicator of a film's definition. Does the edge between a dark and light subject

139. If you plan to make enlargements of your photographs, use a fine-grained film because it has good definition that provides clarity of detail in big images. The Teton Mountains are a spectacular background for this weathered barn in Jackson Hole, Wyoming.

area appear sharp, or does one area blend into the other and the line between the two look fuzzy?

Definition is also influenced by the RESOLVING POWER or RESOLUTION of a film. This refers to the fine detail that a film is able to record. Proper exposure helps maintain a film's resolution. However, be aware that the resolving power of the camera lens affects definition, too; an inexpensive lens with poor resolving power can adversely affect the resolution of an image.

Another factor affecting the definition of a film is GRAININESS. Chemical action during development can give the light-sensitive coating of films a sand-pebble appearance in the resulting negative or slide. When enlargements are made, these so-called grains become larger and reduce the definition of a photograph (although not necessarily the effectiveness of the picture). The graininess of a film is affected by the type of developer used, as well as the time and method of development.

You'll hear photographers most often talk about the graininess of a film in regard to definition. This is because the more graininess, the less resolution and sharpness a picture usually has. In general,

graininess increases with the speed (ISO) of a film. For that reason, slow-speed films are often described as fine-grained films; they are the best choice when big enlargements are to be made.

## Special-Purpose Films

Several 35mm films are considered special-purpose films. Photographers can enjoy some unusual images when shooting INFRARED FILMS, which are exposed through colored filters on the camera lens and produce black-and-white negatives or color slides. Kodak Ektachrome Infrared color film as well as Kodak High-Speed Infrared and Konica Infrared black-and-white films record infrared radiation as well as visual light rays, creating either startling "false" colors or abnormal gray tones. Infrared films are discussed in detail in Chapter 12.

COPY FILMS and DUPLICATING FILMS are designed for making extra copies of color slides or color negatives, or to create 35mm color transparencies by copying color negatives, and vice versa. Kodak's Ektachrome SE Duplicating Film and Vericolor Slide Film are two of these films that are available in 35mm cassettes.

Other special-purpose films include the remarkable INSTANT SLIDE FILMS produced by Polaroid, the pioneer in instant picture films. These include a color slide film, PolaChrome, and a black-and-white slide film, PolaPan, which can be exposed in any 35mm camera. After the films are processed in about 60 seconds in Polaroid's manual AutoProcessor or motorized PowerProcessor, the positive film images can be mounted as slides and projected immediately. (Do not confuse these instant films with Polaroid's *conventional* 35mm color print and slide films, known as Polaroid HighDefinition films.)

Polaroid's instant 35mm slide system was developed in 1983 for business, industrial, medical, and other professional uses where fast results are desired. But amateur photographers also became intrigued by the opportunity to create positive slide images almost instantly. The PolaChrome color film has a speed of ISO 40, while the PolaPan black-and-white film is rated at ISO 125; both are available in 36-exposure cassettes. Other instant film choices are two high-contrast versions, PolaChrome High-Contrast color slide film and PolaGraph black-and-white slide film, and one that produces white-on-blue images for title slides, PolaBlue.

In all cases, the instant film cassette is loaded and exposed in a 35mm camera in the normal manner. (One caution: The films' very

140. With Polaroid's instant slide system, special color and black-and-white films can be shot in any 35mm camera and then developed on the spot in one minute. Each roll of 35mm instant film comes with a processing pack that's used in Polaroid's manual AutoProcessor or motorized PowerProcessor. The system also includes devices for mounting the slides.

reflective surface can confuse built-in exposure metering systems that measure off the film; consult your camera's instruction manual.) Once the roll is exposed, it is rewound into the cassette and ready for processing.

To process Polaroid's instant slide films, the cassette and a processing pack that is supplied with each roll of film are placed in the AutoProcessor, their leaders are attached to a take-up spool, and the processor's cover is closed to make it lightproof. Then you turn a crank to coat a strip sheet from the processing pack with the processing fluid and laminate it to the exposed film. After waiting 60 seconds for the film to develop, you turn the crank again to rewind the film back into its cassette and the used processing strip back into its pack. Then the AutoProcessor is reopened and you remove the disposable processing pack and throw it away. The cassette with its dry, developed film can be inserted into Polaroid's slide mounter, where each film frame is cut from the roll and put into a plastic slide mount. For frequent use of instant slide films, Polaroid's Power-Processor is recommended because the film winding and timing are automatic rather than manual, as with the AutoProcessor.

The color images produced by instant slide film have noticeable grain but remarkable sharpness. Although the film's color renditions and density in highlights may be bothersome to photographers who compare PolaChrome side by side with regular color slide films, the

images are quite acceptable when projected. Polaroid deserves high praise for making it possible to create color and black-and-white slides in a matter of minutes with any 35mm camera.

To create positive black-and-white slides, you can shoot with Agfa's Scala professional film, a 35mm panchromatic BLACK-AND-WHITE REVERSAL FILM that requires special processing by a custom lab. And there is Kodak's T-Max 100, ordinarily a negative film, which will produce positive black-and-white slides when given direct-positive processing by a custom lab. Or you can do it yourself using a special direct positive film processing kit from Kodak.

Also considered special are Ilford XP2 400 and Kodak T-Max T400 CN for making black-and-white prints. They're called BLACK-AND-WHITE CHROMOGENIC FILMS because they utilize color film technology to produce negatives with chemical dyes instead of with the metallic silver normally found in all other black-and-white negatives. An advantage of these films is that they are processed in the same chemicals as color negative films and can be developed quickly at any fast-photo minilab. The resulting fine-grain images have exceptional detail in both highlight and shadow areas. Another benefit is a wide exposure latitude—from two f/stops overexposure to one f/stop underexposure. While nominally rated at ISO 400, the films can be exposed anywhere from ISO 100 to ISO 800 for XP2400 and ISO 25 to ISO 1600 for T-Max T400CN; you can even change the exposure meter film speed setting in the middle of the roll! Set a lower film speed when you want the least amount of grain, and a higher ISO when the light level is low and you need to build up contrast in the image.

Mention should be made of what we call TWO-FOR-ONE FILMS, which have also been dubbed GIMMICK FILMS by one photography magazine. These are 35mm films that provide you with both color prints and color slides from each roll of film. They are sold by a few mail-order photo processing labs and must be returned to the same labs for processing. The films usually are color negative motion picture films that the labs respool from long rolls into 35mm cassettes and then give particular names or identity numbers as well as ISO ratings.

These two-for-one films are exposed as ISO 100-, 200-, 400-, or 500-speed color negative films, processed, and then printed in the usual manner to make snapshot-size color prints. In addition, the negatives are printed onto motion picture film to make a set of positive color slides. The lab sends you a pair of positive images (print and slide) for every exposure, plus the color negatives, and another roll of two-for-one film. Besides the convenience of getting both a print and a slide from a single shot, the price for all of this is less

than if you bought and processed individual rolls of print film and slide film.

However, there is a big question: How good is the quality of two-for-one prints and slides? It varies from lab to lab, but in the opinion of many photographers, the results with respect to color balance and contrast are disappointing for either the prints, or the slides, or both. While the negatives can be reprinted to improve the prints and/or slides, few people bother. Our advice is to shoot with films designed for still photography, not motion pictures, and choose the specific type of film for the results you want—color prints or color slides.

## Speeds of Film

Photographers often select a certain film because of its speed, designated by an ISO NUMBER, which indicates how sensitive the film is to light. Film speeds range from ISO 25 to ISO 3200; the higher the number, the more sensitive the film. Films generally fall into three categories of speed: slow, medium, and high. Slow-speed films are ISO 50 or less, medium-speed films are ISO 64 to ISO 200, and high-speed films are ISO 400 to ISO 3200. High-speed films are also called FAST FILMS.

The speed you choose commonly depends on the lighting situation. For average lighting situations, such as outdoors on a sunny day, MEDIUM-SPEED FILMS are the most popular. In very bright light, a slow-speed film may be preferred. In very low light, a high-speed film is a smart choice.

Traditionally, the SLOW-SPEED FILMS produced the best photos in terms of sharp images, minimal graininess, and superb color renditions. They are the favorites of many pros. However, ongoing improvements in films have narrowed the once obvious differences in quality between slow-speed and high-speed films. The faster films—especially ISO 400 color print films—have become increasingly popular for a number of reasons.

HIGH-SPEED FILMS allow you to use a faster shutter speed to stop action and also avoid blurring caused by accidental camera movement. And that makes it easier to get sharp images when you are shooting with a telephoto lens, which is more difficult to hold steady. Another advantage of fast films is that you can shoot at smaller lens openings to increase depth of field and get more of the picture area in focus. High-speed films also extend the useful range of your elec-

141–142. A high-speed film can be advantageous, especially when light levels are low. The greater sensitivity of so-called fast film made it possible to shoot in a dark forest on a foggy morning, as well as indoors at a cowboy hat store, without using a tripod to hold the camera steady or a flash to provide more light.

tronic flash, so you can make flash pictures of subjects at greater distances.

Although fast films cost slightly more than medium-speed or slow-speed films, the advantages just described are worth the extra expense. This is especially true when shooting with a 35mm automatic compact camera because you have little or no control of the f/stop and shutter speed settings; they are preprogrammed by the camera's computer and are dependent on the speed of the film in your camera.

When you are comparing film speeds, it's important to remember that ISO NUMBERS indicate the RELATIVE SENSITIVITY OF FILMS to one another. For instance, comparing the slowest-speed film, ISO 25, with faster films, an ISO 50 film is twice as sensitive. Likewise, an ISO 100 film is 4 times as sensitive as an ISO 25 film, an ISO 200 film 8 times more sensitive, and ISO 400 film 16 times, an ISO 800 film 32 times, an ISO 1600 film 64 times, and an ISO 3200 film 128 times as sensitive as that slow-speed ISO 25 film.

Also, ISO numbers can be used to figure EXPOSURE EQUIVALENTS in terms of f/stops and shutter speeds. For example, each time a film speed is doubled, it is equivalent to one f/stop, or to the next adja-

cent shutter speed. For example, if you are using a very wide lens opening, such as f/2.8, with a slow ISO 25 film, a twice-as-sensitive ISO 50 film can be exposed at f/4 at the same shutter speed. Likewise, compared with the ISO 25 film, you can expose an ISO 100 film at f/5.6, an ISO 200 film at f/8, and ISO 400 film at f/11, an ISO 800 film at f/16, an ISO 1600 film at f/22, and an ISO 3200 film at a very small lens opening, f/32.

Or, if you keep the lens opening unchanged and shoot the slow ISO 25 film at 1/30 second, an ISO 50 film can be shot twice as fast at 1/60 second. Likewise, compared with the ISO 25 film, you can shoot with an ISO 100 film at 1/125 second, an ISO 200 film at 1/250, an ISO 400 film at 1/500, an ISO 800 film at 1/1000, an ISO 1600 film at 1/2000, and an ISO 3200 film at 1/4000 second. The relationship of film speeds and exposure was discussed in detail in Chapter 1; see page 35.

A few high-speed films are unique because they can be rated at different film speeds than their normal ISO. This allows you to expose them at a slower or faster film speed, depending on the photographic situation you encounter. These versatile films include some black-and-white, color negative, and color reversal films, especially those of ISO 1000, ISO 1600, or ISO 3200. While photographers may prefer not to use these ultrafast films on a regular basis, they carry a roll or two in order to be ready for very low light conditions or when a very fast shutter speed is required.

The alternative ISO you choose to use becomes the EFFECTIVE FILM SPEED, also known as the film's EXPOSURE INDEX (EI). To compensate for a film speed rating that is higher or lower than its normal ISO, the film requires what is termed PUSH PROCESSING or PULL PROCESSING, which means its normal development time must be extended or reduced. A few professional films are specially marked "for push processing," such as Kodak's Ektachrome P1600, which can be exposed at ISO 400, 800, 1600, or 3200. Whatever effective film speed you decide to use, the *entire roll* must be exposed at that same exposure index, and developed accordingly. Read more about special processing later in this chapter.

As explained in Chapter 1, film speeds were originally designated arithmetically in the U.S. by the American Standards Association (ASA) and logarithmically in Europe by the German standards group, Deutsche Industrie Norm (DIN). As a result, a film speed of ASA 100, for example, was the same as DIN 21. In 1982, to clear up any confusion and establish worldwide standards, the International Standards Organization combined both numbers into an ISO DESIGNATION. Thus,

a former film speed of ASA 100/DIN 21 is now identified as ISO 100/21°.

*As mentioned earlier, for purposes of clarity in this book, the DIN equivalent is dropped and film speeds are indicated only by the former ASA equivalent, such as ISO 100.*

By the way, film manufacturers commonly include the film speed (ISO number) as part of the names of most films. Examples are Kodak's Ektachrome Elite 100 and Fuji's Fujicolor Super G Plus 200.

Of course, for proper exposure readings, the correct film speed must be set in order to calibrate the exposure metering system built into your camera, or a hand-held exposure meter. Always be certain whenever you change to a film of a different speed that the exposure meter's ISO setting is also changed.

Fortunately, the problem of remembering to reset the ISO number has been alleviated by 35mm films that carry a DX (DATA EXCHANGE) SYMBOL and 35mm cameras that are compatible with those DX-coded films. DX indicates that the film cassette has a black-and-silver-checkered code that electronically programs auto-exposure cameras for the film's specific ISO speed. (By the way, don't confuse the ISO's checkered code with the bar code, which also appears on 35mm cassettes and the film itself; the bar code aids automatic film processors by indicating the film's manufacturer, type, speed, length, and developing process required.)

Of course, you must still set the specific ISO on all cameras that only have manual exposure, as well as on auto-exposure cameras manufactured before DX coding was introduced in 1982.

Also remember that the FILM SPEED CONTROL on modern auto-exposure 35mm single lens reflex (SLR) cameras must be set to DX in order for the cassette's DX code to calibrate the metering system with the correct film speed. Most 35mm automatic compact cameras, on the other hand, have no film speed control and use the DX code to automatically set the ISO when the film cassette is loaded into the camera.

A film's effective speed (i.e., exposure index) will change when certain FILTERS are attached in front of the camera lens and alter the intensity of the light reaching the film. Through-the-lens (TTL) metering systems will usually compensate for filters and give correct exposure readings, but the ISO setting on hand-held and non-TTL camera meters must be readjusted. The film data will indicate the revised ISO to use with a conversion filter, or the filter factor to use to refigure exposures with a light-balancing filter. Read more about filters and how to use them in the following chapter.

143. Although high-speed films are often recommended for low light situations, medium- and slow-speed films can be used as long as the camera is on a tripod or has other solid support to avoid camera shake. This time exposure of the Mormon Temple in Salt Lake City, Utah, was made with ISO 100 film from the top of a nearby building.

Mention must also be made of another characteristic of films, the RECIPROCITY EFFECT, which may result in underexposure and/or a change in color balance when exposure times are longer than 1 second or shorter than 1/1000 second—the usual exposure range for which general photo films are designed. This reciprocity effect varies according to the specific film; look in the film data for advice, if any, as to when and how much to compensate by increasing exposure. In practice, photographers rarely worry about the reciprocity effect when making time exposures; although the results are often unpredictable, they are usually acceptable. Of course, bracketing time exposures is always a good idea in order to get the pictures you want. That's especially true when using color slide film, because it has less exposure latitude than color print film or black-and-white film.

## Sizes of Film

More films are made for 35mm cameras than for any other type of camera. The official film size for 35mm cameras is 135, but it's commonly just identified as 35MM FILM. The film is 35mm wide and has sprocket holes along both edges. It comes rolled on spools sealed in lighttight metal or plastic CASSETTES (Kodak calls them

magazines). Extending from the cassette is a short tongue, called the FILM LEADER, that attaches to the camera's film take-up spool.

Rolls of 35mm film vary in length and number of exposures, although the cassettes that hold the film are all the same size. The longest film is about 5 feet (1.5 meters) and is designated for 36 exposures. Shorter lengths of film offer 12 or 24 exposures. (There also are SINGLE-USE CAMERAS preloaded with 35mm film; those that advertise extra or bonus exposures feature 15 shots instead of 12, or 27 shots instead of 24.)

Some 35mm film is available in much longer rolls of 100 feet (30.5 meters). This is known as BULK FILM or LONG ROLLS. You have to load your own plastic reusable cassettes with shorter lengths in order to use bulk film in a camera. Buying long rolls can save on the cost of film but is not very convenient.

Smaller in size than 35mm film is 24mm-wide APS (ADVANCED PHOTO SYSTEM) FILM, which is supplied in lighttight plastic cassettes. However, these have a different design than 35mm film cassettes and are loaded with 15, 25, or 40 exposures. (See Illustration 3 for a comparison of film sizes.)

Film used in medium-format cameras is commonly called ROLL FILM. Instead of being in a lighttight cassette, it is wrapped on a spool with an opaque paper backing. This backing prevents light from fogging the film before it is loaded into the camera and when it is removed after exposure. The free end of the paper backing serves as a leader that attaches to the camera's film take-up spool. Roll film is available in two sizes, 120 and 220, which are official designations as well as common names for the film; 220 film is twice as long as 120 film.

Current 120 and 220 roll films will make from 10 to 30 exposures, depending on the camera's format (square or rectangular) and the length of the film roll. Size 120 roll film allows ten $2^1/_4 \times 2^3/_4$-inch (6 × 7cm), twelve $2^1/_4 \times 2^1/_4$-inch (6 × 6cm), or fifteen $2^1/_4 \times 1^3/_4$-inch (6 × 4.5cm) exposures, while size 220 film gives twice as many exposures of the same dimensions.

Other roll films that fit older or discontinued camera models are no longer manufactured, including sizes 127, 620, 828, 116, and 616. However, some of these sizes are available with respooled Kodak film by special order to Film for Classics, P.O. Box 486, Honeoye Falls, NY 14472; telephone (716) 624-4945.

In addition to roll films and films in cassettes, some film is supplied in plastic cartridges. These are designed to drop into the camera for easy loading, as with Kodak's Instamatic cameras.

The larger-size CARTRIDGE FILM is 126, which produces square images measuring 26.5 × 26.5mm. The smaller pocket Instamatic cameras take 110-size cartridge film, which yields 13 × 17mm rectangular images. Like roll films, cartridge films also use an opaque paper backing to prevent fogging of the film. The exposure frame number is printed on this backing and appears through a window in the cartridge and in the back of the camera. The 126-size cartridge films come in 12- or 24-exposure lengths, and the 110-size in 24 exposures only. A code notch on the cartridge sets the appropriate film speed (ISO) on automatic cameras when the cartridge is inserted.

Although rare, there are also SUBMINIATURE FILMS, such as 8 × 11mm-size films supplied in cartridges for tiny "spy" cameras, like certain models of the Minox. Those films offer 15 or 36 exposures. Don't expect to find DISC FILM, a unique subminiature film that was a wheel of 15 minuscule 8.2 × 10.6 mm images. (For comparison, 35mm film images measure 24 × 36 mm, nearly ten times larger.) Production of disc film ended in 1997; the color-only film was especially designed for disc cameras that Kodak introduced fifteen years earlier but soon discontinued.

Film also comes in large formats as individual sheets. This SHEET FILM is loaded in the darkroom into lighttight FILM HOLDERS for use in view, studio, or older press cameras. Each film holder holds two sheets of film, one on each side. Once the film holder is inserted into the camera, a black slide is removed from the holder so the film can be exposed. The black slide must be reinserted into the holder before the holder is removed from the camera and turned over to expose the second sheet of film on the other side. The sizes of sheet film (also called CUT FILM) are measured in inches (or centimeters). Available sizes include 4 × 5, 5 × 7, 8 × 10, and 11 × 14 inches (10.2 × 12.7, 13 × 18, 20.3 × 25.4, and 28 × 35.5cm). Sheet film is packaged in boxes of 10, 20, 25, 50, or 100 exposures.

More convenient to use than sheet film in large-format cameras are individual FILM PACKETS. Called QuickLoad by Fuji and Readyload by Kodak, each packet contains one or two sheets of 4 × 5-inch (10.2 × 12.7cm) film in a lighttight envelope that can be loaded under normal light conditions into a film holder for use in the camera. Each sheet of film is attached to a paper tab that the photographer pulls so that the film emulsion can be exposed. Film packets are packaged in boxes of 20 exposures.

Don't expect to find all types of films in all sizes. Some may just be available in 35mm, APS, roll, cartridge, subminiature, sheet, or

bulk form. A list of films available in 35mm, APS, and 120 sizes begins on page 219.

## Processing of Films

While some photographers prefer to process their own film, most depend on local fast-photo minilabs, professional custom processing laboratories, wholesale photofinishers, or mail-order photofinishers. The quality of developing and printing varies considerably from one lab to another, so pick your photofinisher with care.

The tradition of bringing your film to a camera store or mailing it to the film's manufacturer for processing changed rapidly with the introduction of FAST-PHOTO MINILABS, which are now found everywhere across the country and around the world. These independent or chain-store photofinishers operate on a volume basis and mostly cater to amateur snapshot processing.

Fully automated processing machines brought this revolution to film processing, which also renewed interest in still photography because the finished photos could be ready for you to view in one hour or even less. The convenience is hard to beat, but the pictures you get back can be a disappointment. Although the sophisticated developing/printing machines are computer-controlled, they rely on an attendant, who is frequently ill-trained or careless. The result is that your photographs may show poor color renditions, scratches, streaks, stains, or dust marks.

Worse, in our opinion, is that the customer does not complain, even continuing to take his film to the same sloppy minilab. We think if you spend the money for a good camera and film, plus the time to compose a good picture, your result should be the best possible. Don't let the final step, processing, ruin your investment and photographic efforts.

*Always demand good quality.* If you are unhappy with your pictures, especially because of obvious processing errors, such as dust marks or untrue colors, ask the lab to remake the prints. In many cases, the negatives have been developed correctly; the problems occurred when the prints were made. When you request reprints, the attendant should handle the negatives more carefully and monitor the machine more closely.

A significant attempt to improve automated photofinishing of snapshots came in 1996 with the introduction of APS (Advanced Photo System) cameras, films, and processing machines. They feature an exchange of information about exposure and lighting condi-

144. You might look as sad as this orangutan if your color prints have been carelessly processed by a fast-photo minilab. If you don't like the results, especially if your subjects are the wrong colors, first check the negatives to make sure they were properly exposed, then insist the prints be remade with attention given to the proper filtration (see text).

tions for each picture. This is recorded by the camera on the magnetic coating of APS films, and then is interpreted by the processing machine to print each photograph correctly.

Fortunately, photofinishing is now a very competitive industry, so you have plenty of choices when looking for a lab that is worthy of your business. CUSTOM LABS are preferred by professional photographers because of the personal attention paid to each roll of film and each photo print. They also provide SPECIAL PROCESSING, when a film must be underdeveloped or overdeveloped according to the other-than-normal film speed you purposely or accidentally used.

For example, Fuji's Fujichrome Provia 1600 film is a high-speed color slide professional film that is processed normally if shot at an exposure index (EI) of 400. When exposed at higher film speeds, it requires a longer time in the first developer: if shot at EI 800, a one-stop push (designated P-1 processing); at its rated ISO 1600, a two-stop push (P-2); and at EI 3200, a three-stop push (P-3). The film cassette must be marked with the exposure index (ISO) you used for exposures, so the lab will know how to process it: normal time, P-1, P-2, or P-3.

Photographers take a considerable amount of film to camera

145. While this street photographer in Argentina processes his black-and-white pictures on the spot, much of the world's photofinishing of popular color print films is now done by computerized machines at fast-photo minilabs.

stores, drugstores, and supermarkets for processing, where it is often sent on to WHOLESALE PHOTOFINISHERS. These may include laboratories operated as subsidiaries by film manufacturers, such as Kodak, Fuji, and Konica. Camera stores usually offer other processing choices, such as sending your film to a custom lab or developing it at the store in its own automated minilab. A special service that may be available is to electronically transfer images from your films or prints to a PHOTO CD (compact disc) or a FLOPPY DISK so your pictures can also be displayed, transmitted, or printed by using your personal computer; read more about digital imaging beginning on page 307.

Another processing option is to send your film directly to one of a number of MAIL-ORDER PHOTOFINISHERS, which solicit photographers through magazine and direct-mail advertisements. Payment for processing is made in advance by check or money order.

You can also purchase PREPAID PROCESSING MAILERS at camera stores and other retail film outlets. Most common are mailers for slide and print film processing services offered by Kodak through its own photofinishing laboratories in the United States. Film mailed to the lab nearest you will be processed and sent postage-paid to your return address. Using prepaid processing mailers when on vacation

or traveling is a good way to have your photographs ready and waiting upon your return home.

Besides the considerations of convenience and any urgency in having films processed, the COST OF PROCESSING may influence your choice of a photofinisher. Obviously, a custom lab will be considerably more expensive than a mail-order lab. Shop around and compare prices, but don't sacrifice quality. Watch out for excuses from the lab salesman or worker who denies responsibility and blames you for the poor results.

For instance, if your photo prints look dull and without contrast, or have inaccurate color renditions or little color saturation, don't accept such remarks as "You underexposed the film" until you closely inspect the negatives yourself. (An underexposed negative will appear somewhat clear and without much density to the image.) Often it's just a botched printing job, which is most prevalent at fast-photo minilabs.

Make certain in advance that any lab will remake prints without charge if you are unhappy with the original results or with reprints. If negatives or slides are ruined during developing, there is little or no recourse. About all you can demand is not to be charged for the faulty processing, plus a free replacement of the ruined roll of film. Then take your business elsewhere.

Many professional and amateur photographers develop their own films, either because they don't trust others or because they want full control of the results. With some practice, it's not difficult to process most black-and-white, color negative, and color slide (reversal) films yourself. (Kodachrome film is an exception because its processing is much more involved than the processing of all other color slide films.)

Films should be developed according to the manufacturer's specifications, although photographers sometimes prefer to use chemicals or procedures that are different than those recommended. Many films can be altered during processing, which means you can unintentionally or purposely overexpose or underexpose a film, then compensate by underdeveloping or overdeveloping it to get a good result.

Read more about processing in Chapter 14, which describes basic do-it-yourself black-and-white developing and printing in a home darkroom.

## Color and Black-and-White Films Currently Available

As you'll see from the long list that follows, there is a wide choice of films available to amateur and professional photographers today. Included in the list are film brands and names, ISO speeds, and their availability in 135 (35mm) cassette, APS cassette, and 120 roll film sizes. (If you are using cartridge, sheet, or other size films, inquire at a camera store which films on the list are also available in your particular format.)

It's a good idea to try several different films to find the ones that please you the most. If you don't know where to begin, here's some advice about CHOOSING A FILM. First decide on one of the three basic types of film; color negative film (for color prints), color reversal film (for color slide transparencies), or black-and-white film (for black-and-white prints). Next, refer to the separate section that follows which lists all the films of the type you decide to shoot. To narrow the field, skip those films designated "Pro" (for professionals). Then select a film speed, and pick a particular film to try first. Regarding film speeds for general photography, we suggest an ISO 400 film as your initial choice for color negative and black-and-white films. For color slide film, we recommend that you begin with an ISO 100 film.

Unless an ISO number appears in the "Tungsten" column of the following charts, all films listed are balanced for daylight (which includes illumination by electronic flash). A filter can be used on the camera lens to convert color reversal tungsten films for daylight use, and vice versa.

Be aware that film manufacturers continually upgrade their films by introducing new ones and discontinuing old ones. Or they may change a film's name when significant improvements are made in order to market the film as "new." For example, Kodak's Kodacolor color negative print film, introduced in 1942, was improved over the years and renamed at various times as Kodacolor-X, Kodacolor II, Kodacolor VR, Kodacolor VR-G, and Kodacolor Gold. In 1992 the Kodacolor name was dropped when the films became the Kodak Gold series.

Finally, here's some advice: Don't be frugal with film. The more film you shoot, the more experience you'll have with your camera and various photographic situations—and the better photographer you'll become. Whenever you see a great picture and want to capture it on film, don't just shoot a frame or two and hope for the best.

Make lots of shots—that's what the pros do to get the images that inexperienced photographers envy.

## COLOR NEGATIVE (PRINT) FILMS

NOTE: APS films are listed separately at the bottom of this section.

| Manufacturer/<br>Film Name | ISO Film Speed<br>*Daylight/Tungsten | Film Sizes |  |
|---|---|---|---|
|  |  | Cassette<br>(135) | Roll<br>(120) |
| **KODAK** |  |  |  |
| Gold 100 | 100 | x |  |
| Gold 200 | 200 | x |  |
| Gold 400 | 400 | x |  |
| Gold Max | 800$^†$ | x |  |
| Royal Gold 25 | 25 | x |  |
| Royal Gold 100 | 100 | x |  |
| Royal Gold 200 | 200 | x |  |
| Royal Gold 400 | 400 | x |  |
| Royal Gold 1000 | 1000 | x |  |
| Ektar 25 Pro | 25 | x | x |
| Ektapress 100 Pro | 100 | x |  |
| Ektapress Multispeed Pro | 100 to 1000$^†$ | x |  |
| Ektapress Plus 1600 Pro | 1600 | x |  |
| Pro 100 | 100 | x | x |
| Pro 400 | 400 | x | x |
| Pro 400 MC | 400 | x | x |
| Pro 1000 | 1000 | x | x |
| Pro 100T | —/100 |  | x |
| Vericolor III Pro | 160 | x | x |
| Ektacolor Pro 160 | 160 | x |  |
| Vericolor Slide | varies | x |  |
| **FUJI** |  |  |  |
| Fujicolor Reala | 100 | x | x |
| Fujicolor Super G Plus 100 | 100 | x | x |
| Fujicolor Super G Plus 200 | 200 | x |  |
| Fujicolor Super G Plus 400 | 400 | x | x |
| Fujicolor Super G Plus 800 | 800 | x |  |

*Color negative films are color balanced for use with daylight and electronic flash. For optimum results with tungsten light, filters should be used. However, most of the films offer acceptable color balance without on-camera filtration because color corrections can be made during the printmaking stage.
$^†$Multispeed film; can be exposed at wide exposure index (EI) range.

| Manufacturer/ Film Name | ISO Film Speed *Daylight/Tungsten | Film Sizes Cassette (135) | Roll (120) |
|---|---|---|---|
| Fujicolor Super HG 1600 | 1600 | x | |
| Fujicolor 160 Pro S | 160 | x | x |
| Fujicolor 160 Pro L | —/160 | | x |
| Fujicolor 400 Pro HG | 400 | x | x |
| | | | |
| AGFA | | | |
| Agfacolor HDC 100 | 100 | x | |
| Agfacolor HDC 200 | 200 | x | |
| Agfacolor HDC 400 | 400 | x | |
| Agfacolor Ultra 50 Pro | 50 | x | x |
| Agfacolor Optima 125 Pro | 125 | x | |
| Agfacolor Optima 200 Pro | 200 | x | x |
| Agfacolor Optima 400 Pro | 400 | x | |
| Agfacolor Portrait 160 Pro | 160 | x | x |
| Agfacolor XRS 400 Pro | 400 | x | x |
| Agfacolor XRS 1000 Pro | 1000 | x | x |
| | | | |
| KONICA | | | |
| Impresa 50 Pro | 50 | x | x |
| VX 100 | 100 | x | |
| VX 200 | 200 | x | |
| VX 400 | 400 | x | |
| SR-G 160 Pro | 160 | x | x |
| SR-G 3200 Pro | 3200 | x | x |
| | | | |
| IMATION | | | |
| Scotch HP 100 | 100 | x | |
| Scotch HP 200 | 200 | x | |
| Scotch HP 400 | 400 | x | |
| | | | |
| POLAROID[††] | | | |
| OneFilm | 200 | x | |
| High Definition 100 | 100 | x | |
| High Definition 200 | 200 | x | |
| High Definition 400 | 400 | x | |

[††]Polaroid-brand color negative films are not instant print films; they are conventional 35mm print films manufactured by 3M.

## APS Color Negative (Print) Films

| Manufacturer/<br>Film Name | ISO Film Speed<br>Daylight/Tungsten |
|---|---|
| **KODAK** | |
| Advantix 100 | 100 |
| Advantix 200 | 200 |
| Advantix 400 | 400 |
| Advantix Chrome 100* | 100 |
| **FUJI** | |
| Fujicolor SmartFilm D100 | 100 |
| Fujicolor SmartFilm F100 | 100 |
| Fujicolor SmartFilm A200 | 200 |
| Fujicolor SmartFilm H400 | 400 |
| **AGFA** | |
| Futura 100 | 100 |
| Futura 200 | 200 |
| Futura 400 | 400 |
| **KONICA** | |
| JX200 | 200 |
| JX400 | 400 |

*APS color reversal (slide) film

## COLOR REVERSAL (SLIDE) FILMS

| Manufacturer/<br>Film Name | ISO Film Speed<br>Daylight/Tungsten | Film Sizes<br>Cassette<br>(135) | Roll<br>(120) |
|---|---|---|---|
| **KODAK** | | | |
| Kodachrome 25 | 25 | x | |
| Kodachrome 25 Pro | 25 | x | |
| Kodachrome 40 (Type A) | —/40 | x | |
| Kodachrome 64 | 64 | x | |
| Kodachrome 64 Pro | 64 | x | x |
| Kodachrome 200 | 200 | x | |
| Kodachrome 200 Pro | 200 | x | |
| Ektachrome Elite II 50 | 50 | x | |

| Manufacturer/ Film Name | ISO Film Speed Daylight/Tungsten | Film Sizes Cassette (135) | Roll (120) |
|---|---|---|---|
| Ektachrome Elite II 100 | 100 | x | |
| Ektachrome Elite II 200 | 200 | x | |
| Ektachrome Elite II 400 | 400 | x | |
| Ektachrome Pro E100 | 100 | x | x |
| Ektachrome Pro E100S* | 100 | x | x |
| Ektachrome Pro E100SW* | 100 | x | x |
| Ektachrome 64 Pro | 64 | x | x |
| Ektachrome 64X[†] Pro | 64 | x | x |
| Ektachrome 64T Pro | —/64 | x | x |
| Ektachrome 160T | —/160 | x | |
| Ektachrome 160T Pro | —/160 | x | x |
| Ektachrome 100 Pro | 100 | x | x |
| Ektachrome 100X[†] Pro | 100 | x | x |
| Ektachrome 100 Plus Pro | 100 | x | x |
| Ektachrome 200 Pro | 200 | x | x |
| Ektachrome 320T Pro | —/320 | x | |
| Ektachrome 400X Pro | 400 | x | x |
| Ektachrome P1600 Pro | 1600[††] | x | |
| Ektachrome Infrared EIR | 200[§] | x | |
| Ektachrome SE Duplicating | varies | x | |
| **FUJI** | | | |
| Fujichrome Sensia II 100 | 100 | x | |
| Fujichrome Sensia II 200 | 200 | x | |
| Fujichrome Sensia II 400 | 400 | x | |
| Fujichrome Velvia Pro | 50 | x | x |
| Fujichrome Provia 100 Pro | 100 | x | x |
| Fujichrome Provia 400 Pro | 400 | x | x |
| Fujichrome Provia 1600 Pro | 1600[††] | x | |
| Fujichrome 64 T Pro | —/64 | x | x |
| Fujichrome 100 D Pro | 100 | x | x |
| **AGFA** | | | |
| Agfachrome CTx 100 | 100 | x | |
| Agfachrome CTx 200 | 200 | x | |
| Agfachrome RSX 50 Pro | 50 | x | x |
| Agfachrome RSX 100 Pro | 100 | x | x |
| Agfachrome RSX 200 Pro | 200 | x | x |
| Agfachrome 1000 RS Pro | 1000 | x | x |

| Manufacturer/<br>Film Name | ISO Film Speed<br>*Daylight/Tungsten | Film Sizes | |
|---|---|---|---|
| | | Cassette<br>(135) | Roll<br>(120) |
| **KONICA** | | | |
| KonicaChrome R-100 | 100 | x | |
| | | | |
| **IMATION** | | | |
| ScotchChrome 100 | 100 | x | |
| ScotchChrome 400 | 400 | x | |
| ScotchChrome 1000 | 1000 | x | |
| ScotchChrome 640T | —/640 | x | |
| | | | |
| **POLAROID** | | | |
| High Definition Chrome | 100 | x | |
| Presentation Chrome | 100 | x | |
| PolaChrome‖ | 40 | x | |
| PolaChrome High Contrast‖ | 40 | x | |

*S indicates that the film produces saturated colors; SW indicates warm saturated colors.
†X in the name of a Kodak color reversal film indicates that the film has a warmer color balance that its companion film of the same name.
††Film speed can be varied with push/pull processing.
§Varies according to filter used; suggested exposure index (EI) with deep yellow (orange) No. 12 filter and development in process E-6.
‖Instant color slide film; requires Polaroid AutoProcessor.

## BLACK-AND-WHITE FILMS

| Manufacturer/<br>Film Name | ISO Film Speed<br>Daylight/Tungsten | Film Sizes | |
|---|---|---|---|
| | | Cassette<br>(135) | Roll<br>(120) |
| **KODAK** | | | |
| Technical Pan | 25/25 to 125 | x | x |
| Plus-X Pan | 125 | x | x |
| Verichrome Pan | 125 | | x |
| Tri-X Pan Pro | 400 | x | x |
| Tri-X Pan | 320 | | x |
| T-Max 100 Pro | 100 | x | x |
| T-Max 400 Pro | 400 | x | x |
| T-Max P3200 | 3200* | x | |

*Film speed can be varied with push/pull processing.

| Manufacturer/ Film Name | ISO Film Speed *Daylight/Tungsten | Film Sizes | |
| --- | --- | --- | --- |
| | | Cassette (135) | Roll (120) |
| T-Max T400CN[††] | 400 | x | x |
| Recording 2475 | 1000 | x | |
| High-Speed Infrared | 50/125[†] | x | |
| | | | |
| ILFORD | | | |
| Pan F Plus | 50 | x | x |
| FP4 Plus | 125 | x | x |
| HP5 Plus | 400 | x | x |
| Delta 100 Pro | 100 | x | x |
| Delta 400 Pro | 400 | x | x |
| XP2 400[††] | 400 | x | x |
| SFX 200[§] | 200 | x | |
| | | | |
| FUJI | | | |
| Neopan 100 Pro | 100 | x | |
| Neopan 400 Pro | 400 | x | x |
| Neopan 1600 Pro | 1600* | x | |
| | | | |
| AGFA | | | |
| Agfapan APX 25 Pro | 25 | x | x |
| Agfapan APX 100 Pro | 100 | x | x |
| Agfapan 400 | 400 | x | x |
| Scala 200 Pro[‖] | 200 | x | x |
| | | | |
| KONICA | | | |
| Infrared 750nm | 32 | x | x |
| | | | |
| POLAROID | | | |
| PolaPan[¶] | 125 | x | |
| PolaGraph[¶] | 400 | x | |

[†]Suggested exposure indexes (EI) with red No. 25 filter.
[††]Chromogenic film processed in color negative film chemistry.
[§]Can create infrared-type effects when used with deep red No. 29 filter.
[‖]Black-and-white slide film; requires special processing.
[¶]Instant black-and-white slide film; requires Polaroid AutoProcessor.

# IMPROVING PHOTOS WITH FILTERS

Filters play an important role in photography by altering the light that reaches the film or photo paper in order to improve the image. They help to reproduce subjects in a picture in the same colors or tones as originally seen by the photographer. Filters are also used for special purposes, such as creating a soft-focus effect to obliterate minor blemishes on the face of a portrait subject. And sometimes filters are used just for fun to transform your subject with bizarre colors or an unnatural appearance, such as a multiple image.

146. A polarizing filter was used to darken the sky and make this arresting picture of a kite soaring high in the sky.

Unfortunately, many photographers—even those who carry several filters in their camera bags—are unfamiliar with filters and their effects. Read this chapter to learn all the things that filters can do, and which ones will be worthwhile for the kinds of pictures you like to make. Before we describe various types and uses in detail, here are some general facts about filters.

Keep in mind that filters are not used exclusively on a camera lens. Sometimes they are placed in front of the light source, such as lights in a photo studio, and they also modify the light from an enlarger when exposing color or black-and-white photo papers.

Filters are categorized by names and/or colors, and more specifically by numbers. As to those commonly used on cameras, some are designed only for color films, while others are only for black-and-white films. A few filters work with both types of film. A polarizing filter, for instance, can be used with color and black-and-white films to reduce reflections and glare from subjects.

Filters are made of a variety of materials. The best are dyed optical glass, or colored gelatin cemented between two pieces of optical glass. Others are colored optical-quality resin, thermoplastic, acetate, or gelatin. The better glass filters are multicoated on both sides to increase light transmission and to reduce flare and internal reflections that can degrade the image.

Some lens attachments are often classified as filters but are better described as ACCESSORY LENSES. That's because their optical designs produce unusual effects, such as giving starlike rays to bright points of light. These include multi-image, close-up, and split-field lenses that multiply or magnify your subjects.

Conventional filters, as well as accessory lenses, are most often mounted in a metal or plastic ring that is threaded to screw directly onto the barrel of the camera lens. This ring is also threaded on its outer edge so that a second filter or a lens shade can be attached in front of it.

Filters with threaded mounting rings are known as SCREW-IN FILTERS. They come in various diameters to fit camera lenses of various sizes. The filter's diameter is designated in millimeters (mm), which is etched on the mounting ring. Be aware that this millimeter number does *not* indicate the focal length of the lens on which the filter can be mounted. The instructions for camera lenses list the millimeter (mm) size of filter that is required; the larger the number, the larger the filter. The more common screw-in filter sizes include 49, 52, 55, 58, 62, 67, 72, 77, and 86mm.

Screw-in filters have an obvious drawback: If the filter fits only one size of camera lens, you need duplicate filters for every lens of a

different size. This would not only be costly; it would also be inconvenient to carry around so many extra filters. Fortunately, there is a solution called a STEP-UP RING. It's a threaded adapter that lets you use a large filter with a camera lens of a smaller diameter. So instead of purchasing duplicate filters to fit each size of lens barrel, you only buy step-up rings, which are less expensive and more convenient to carry.

But what about filters for some of the more powerful telephoto lenses that have very large front lens diameters? To avoid the awkwardness and expense of using oversize filters on the front of big lenses, filters are screwed over the much smaller *rear* lens element before the lens is mounted on the camera.

Less common than threaded screw-in filters are SERIES FILTERS, which are round filters in *unthreaded* metal rings. They drop into a FILTER ADAPTER that screws into the camera lens barrel, and are held in place by a retaining ring (or lens shade) that screws into the adapter. The diameters of camera lenses that the filter will cover is indicated by a series number, which commonly ranges from 5 to 9; the larger the number, the greater the filter size.

Refer to the chart below for the range of lens diameters that each series number will cover. Note that coverages overlap. For example, a series 7 or a series 8 filter could be used on a camera lens with a 52mm diameter, with the appropriate adapter.

## COVERAGE OF SERIES FILTERS

| Number of Series Filter | Lens Diameter Coverage (*not* Lens Focal Length) |
|:---:|:---:|
| 5 | 28 to 36mm |
| 6 | 31 to 47mm |
| 7 | 44 to 56mm |
| 8 | 51 to 69mm |
| 9 | 62 to 85mm |

Some camera lens barrels have no threads, or have been accidentally damaged so that a filter or adapter cannot be screwed in. In those cases, a SLIP-ON ADAPTER or a SET-SCREW ADAPTER can be used for mounting filters. There are also a few filters and adapters with turn-and-lock BAYONET MOUNTS for some lenses.

Not all filters are round. A considerable number are square or rectangular filters that slide into a FILTER HOLDER that is mounted

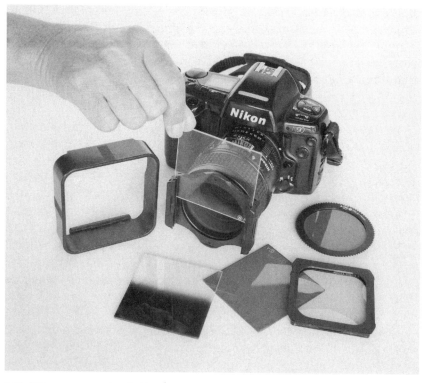

147. Filter systems by Cokin and other filter manufacturers offer an extensive variety of filters that slip into a filter holder that's screwed onto the camera lens. In order to use the filters on all your lenses, make sure they'll cover the lens that has the largest diameter.

onto the lens barrel with a screw-in adapter ring. Some filter holders are designed for use with compact 35mm and other point-and-shoot cameras that lack threaded lenses; the holder is screwed into the tripod socket or attached to the camera with Velcro straps. The holder has two or three slots so that it can hold more than one square filter at the same time, if desired.

Sizes of popular square filters are 2 × 2, 3 × 3, and 4 × 4 inches (50 × 50, 75 × 75, and 100 × 100mm). Buy the largest size that will enable the filters to be used with all your lenses. Square filters are often sold in starter kits or in sets as part of FILTER SYSTEMS. These are extensive collections of filters produced by several worldwide filter manufacturers, including Cokin of France, Hoya of Japan, and B+W of Germany. Those companies also make round screw-in and series filters, as do other major filter manufacturers, notably Tiffen and Vivitar of the United States. In addition, Nikon and most other

name-brand camera manufacturers offer round screw-in filters for their own SLR camera lenses.

Whenever you plan to purchase a filter, take your lens or lenses to the store to make certain it or the adapter ring will fit properly. Note that threads on screw-in filters can vary in pitch; do not use force to screw in a filter because you could damage the threads on the lens barrel as well as the filter.

By the way, here's a tip for REMOVING A SCREW-IN FILTER THAT SEEMS TO BE STUCK on the lens barrel: Pinch the rim of the filter at *one* point with thumb and forefinger instead of grasping it on opposite sides of the rim. Or unscrew it with a special squeeze wrench that uniformly grabs the filter around the entire circumference of its mounting ring.

There are five general categories of filters: LIGHT-BALANCING, CONVERSION, COLOR COMPENSATING, CORRECTION, and CONTRAST. A universal filter numbering system has evolved to identify filters more specifically. However, be aware that some manufacturers give their own codes to their own filters. Or they use discontinued filter names established long ago by the Eastman Kodak Company for its so-called Wratten filters (originally the name of an English filter manufacturer).

The important thing when buying any filter is not just knowing the filter number and its color but reading the manufacturer's description of what the filter is designed to do. For example, a No. 8 filter is medium yellow in color. It slightly increases contrast between blue sky and white clouds to make the sky and clouds look as natural in a black-and-white photograph as in real life. Lists of popular filters with their identification numbers and color descriptions and/or effects appear later in this chapter.

When using or storing filters, always handle them carefully to avoid scratches that will degrade the image on the film. Also, remove dust and fingerprints from filters by cleaning both sides with a microfiber lens cleaning cloth, or by using liquid photographic lens cleaner with lens cleaning tissue (see page 19). For gelatin filters, which are more delicate than glass, resin, or plastic filters, get rid of dust with a camel's-hair brush or with moisture-free compressed air from an aerosol can, such as Dust-Off.

There are two special cautions when using filters. *Beware of* VIGNETTING, which darkens the edges of your image. This is caused when a filter or a filter holder extends too far in front of the lens barrel and is recorded on the film. It can also occur when two or more filters are mounted together, or when a lens shade is mounted on a filter and extends into the picture area. With an SLR camera, you can check for vignetting by looking through the viewfinder while

148. A soft focus filter is a popular way to diffuse the features of portrait subjects, but it may confuse your camera's autofocusing system. If so, use autofocus *before* attaching the filter, or focus manually.

aimed at a uniformly bright area, such as the open sky or a white wall. Stop down the lens and use the camera's depth of field preview button or lever, if available, to help bring any extended lens attachments into sharper focus so you can see if vignetting will occur. If it does, use a filter or filter holder of greater diameter so its edges cannot be seen by the lens, and/or remove the lens shade.

*Some filters can affect the autofocusing of cameras and lenses.* Among them are linear polarizing filters, diffusion or soft-focus filters, some colored filters, and dense filters. If the autofocus system fails to operate, or you are uncertain whether the autofocusing is accurate, use autofocus *before* attaching the filter. Or use manual focus when the filter is on the lens. See your camera manual or the filter's instructions for specific advice.

In regard to autofocusing lenses with SLR cameras, a lens opening at least as wide as f/5.6 is required so that there is enough light to activate the autofocusing system. Problems can occur when a dense filter blocks the light and its filter factor (see the next section) requires a wider opening than the lens permits. For instance, if the maximum opening of a lens is f/4, a filter with a 4X factor makes that lens have an effective opening of two f/stops less, f/8. Because the minimum lens opening required for autofocusing is f/5.6, the autofocusing system doesn't receive sufficient light to operate. If that happens, attach the filter *after* using autofocus, or else focus manually when the filter is in place.

Before considering the different types and uses of filters, you should first know how filters affect exposure.

## Understanding Filter Factors

Because a filter alters the light coming through the camera lens, a change in exposure is usually necessary. Most filters decrease the amount of light reaching the film, so an *increase* in exposure is required. How much the exposure must be increased is indicated by a number called the FILTER FACTOR.

This number represents the extra amount of light needed to make a correct exposure when using a particular filter. A filter factor of 2X, for example, means that twice the amount of light is required when using that filter. In other words, it needs twice the exposure of a meter reading made without the filter. Thus, a regular exposure of 1/250 second at f/8 would have to be increased one f/stop to f/5.6 for a filter factor of 2X. Of course, the amount of light could also be increased two times by slowing the shutter speed to 1/125 second from 1/250 while keeping the lens opening at f/8 (see the exposure chart on page 232).

Filter factors are written with an X to indicate "times" the number given. For example, a filter that has a factor of 4X requires four times the exposure without a filter, which means you should open up the lens by two f/stops or set a slower shutter speed that's only one-fourth as fast. Thus, a no-filter exposure meter reading of 1/250 second at f/8 would mean you should either change the lens opening to f/4 at 1/250 second *or* change the shutter speed to 1/60 second at f/8 when a 4X filter is used.

Likewise, using a filter with a factor of 8X indicates that eight times more light is needed; increase the exposure eight times. With the unfiltered reading of 1/250 second at f/8, an 8X filter would alter the exposure to 1/250 at f/2.8 *or* 1/30 second at f/8.

*It's important to remember that the filter factor number is not the specific number of f/stop or shutter speed positions to change.* Don't make the all-too-common error of thinking that a filter with a factor of 2X, for example, means you should open up the lens two f/stops or slow the shutter speed by two positions. Check the exposure chart that follows.

Remember this simple guideline for exposure compensation with filters: Each time the filter factor doubles, open up the lens one f/stop, *or* reduce the shutter speed by one-half. The chart that follows gives examples of the exposure changes required when filters of different factors are used.

## CHANGES REQUIRED IN EXPOSURE BY VARIOUS FILTER FACTORS

| Filter Factor | Increase f/stop by: | or Reduce Shutter Speed* to: |
|---|---|---|
| 1.5X | $^2/_3$ | |
| 2X | 1 f/stop | 1/2 (1 speed slower) |
| 2.5X | $1^1/_3$ | |
| 3X | $1^2/_3$ | |
| 4X | 2 f/stops | 1/4 (2 speeds slower) |
| 5X | $2^1/_3$ | |
| 6X | $2^2/_3$ | |
| 8X | 3 f/stops | 1/8 (3 speeds slower) |
| 10X | $3^1/_3$ | |
| 12X | $3^2/_3$ | |
| 16X | 4 f/stops | 1/16 (4 speeds slower) |

Example: If an exposure reading *without* a filter is 1/250 second at f/8, exposure can be corrected in the following ways, depending on the factor of the filter used:

| Factor | Keep the shutter at 1/250 and change the f/stop from f/8 to: | or | Keep the f/stop at f/8 and change the shutter speed from 1/250 second to: |
|---|---|---|---|
| 2X | f/5.6 | | 1/125 second |
| 3X | between f/5.6 and f/4 | | |
| 4X | f/4 | | 1/60 second |
| 6X | between f/4 and f/2.8 | | |
| 8X | f/2.8 | | 1/30 second |
| 12X | between f/2.8 and f/2 | | |
| 16X | f/2 | | 1/15 second |

*Setting the shutter speed *between* the marked positions on its dial may not give the supposed speed and may damage the shutter. Therefore, intermediate shutter positions are not recommended unless your camera manual states otherwise.

Filter factors are indicated in the instructions packed with the filter. Some are engraved on the filter's mounting ring, such as "2X." Various filters and their exposure factors are listed on pages 239 and 248. Remember that filter factors are determined by the filters' manufacturers. They are only intended as a guide for exposure compensation and may not give the results you want. Bracketing at various exposures is always a good idea when trying out a new filter.

It's not always necessary to apply filter factors. If you are using an SLR camera's through-the-lens metering system when a filter is on the camera lens, normally the meter will compensate for the loss of light and make a correct exposure reading and/or auto-exposure.

However, you should also be aware that certain filters can confuse a TTL meter and cause incorrect readings and auto-exposures. These include linear polarizing filters, graduated filters, deeply colored filters (especially red), and some special effects filters.

*To check whether a camera's TTL meter is giving accurate readings when a filter is over the lens,* conduct the following test. Note the exposure reading when a filter is in place, then remove the filter and make another reading. Calculate the filter factor in relation to that second unfiltered reading, and compare the exposure settings. If they are identical, you can confidently use the camera's metering and auto-exposure system with that filter on the lens.

For example, say the reading with the filter is f/5.6. Without the filter, the second reading is f/11, a two-f/stop difference. If the filter has a factor of 4X, it requires two stops more exposure, which is f/5.6—so the camera's TTL meter and/or auto-exposure system would be accurate with that filter. Look in your camera's instruction manual for any special advice regarding through-the-lens exposures with filters.

Of course, if you use filters on a camera with a built-in metering system that does *not* make through-the-lens exposure readings, then filter factors must be applied. Also, you need to apply filter factors to exposure readings made with a hand-held meter.

By the way, if you use a HAND-HELD METER to make readings for exposures with filters, you can reset the film speed (ISO) on the meter to allow for the filter factor. That way you'll get direct exposure settings without extra calculations. Just divide the filter factor into the ISO of the film you are using. For example, with a filter that has a factor of 2X and a film with a speed of ISO 400, the hand-held meter should be reset to ISO 200 for correct readings. Similarly, with a filter factor of 4X and an ISO 400 film, the film speed to reset on the meter will be ISO 100. (Don't forget to reset the hand-held meter's ISO back to the film's actual speed after removing the filter.)

## Three Filters for All Films

Three types of filters can be used with both color films and black-and-white films: ultraviolet filters, polarizing filters, and neutral density filters. The first two filters are special favorites of 35mm photographers and should be part of everyone's photo equipment.

The ULTRAVIOLET (UV) FILTER can be kept on any camera lens. Commonly called a HAZE FILTER, it cuts down the ultraviolet light unseen by the photographer, but to which all photographic films are sensi-

tive. Because the filter improves photographs by diminishing (but not eliminating) visual haze, it is especially valuable for scenic photographs (also see page 20).

Of great importance is that this colorless UV filter does *not* require an increase in exposure. Its filter factor is 1X, which means the exposure is the same as when you are not using the filter.

A major role of the UV filter is serving as a lens protector. Many photographers, ourselves included, screw these filters onto all their lenses and leave them there (except when using another filter). Even camera manufacturers recommend using a UV filter to guard lenses from scratches and other inadvertent damage. What could be better than a filter that gets rid of unwanted ultraviolet light, requires no change in exposure, and can be used with both color and black-and-white films?

As an alternative, you can use a SKYLIGHT (1A) FILTER, which has similar characteristics as a UV filter but is designed for use specifically with color films. Its slightly pinkish color helps reduce the bluishness that is sometimes evident in photographs made on overcast days or in open shade.

A POLARIZING FILTER acts much the same as Polaroid-type sunglasses do to cancel reflections and glare from shiny surfaces, such

149. What a difference a polarizing filter can make. When photographed *without* any filter, this tropical Hawaiian scene seems pretty enough.

150. But the picture has extra impact when a polarizing filter is adjusted in front of the camera lens to darken the blue sky, make the white clouds stand out, and reduce some of the glare from the water.

as water, glass, plastic, polished wood, and painted metal (but not bare metal). By removing or reducing reflections, this filter helps to enrich the colors of subjects on color film. The optical glass in a polarizing filter appears grayish. It is a neutral filter, which means it does not directly change the colors of light; it only alters *reflections* of the light.

A polarizing filter rotates 360° in its mount and is adjusted by turning its outer ring to control the amount of reflection. However, the extent to which any reflection can be reduced depends not only on the position of the polarizing filter in its mount but in the camera's angle to the reflective surface. Reflections can be entirely eliminated only when the camera lens is aimed at a 35° angle to the reflective surface.

By diminishing reflected light in the atmosphere, a polarizing filter can also enrich a blue sky on color film and darken it on black-and-white film, which makes clouds stand out more vividly. The increase in blueness or the amount of darkening of the sky depends on the camera's angle to the sun. The effect is greatest when the camera lens is aimed at right angles (90°) to the sun.

For instance, when the sun is directly overhead and the camera with a polarizing filter is pointed toward the horizon, the sky will appear darkest blue along the horizon. Be aware that the effect will not be uniform when using extreme wide-angle lenses because they cover such a wide area and only a portion of the sky's light will be polarized.

Visual haze in the atmosphere can also be reduced by use of a polarizing filter. Although the colors of the light are not actually changed, landscape views appear more vivid on color films because the filter cuts through some of the haze. With black-and-white films, other types of filters do a better job of penetrating haze for scenic shots; they are described later in this chapter (see page 251).

A polarizing filter is easiest to use on a single lens reflex camera because you see in the viewfinder exactly what the film will record. While slowly turning the filter's outer ring, you can *visually* check the changing effects of the filter to precisely control the amount of reflection, blue-sky darkening, or haze penetration.

For instance, if photographing fish in a shallow pond, you may decide either to eliminate all the reflection in the water or to include a small amount of reflection to help indicate the depth of the swimming fish. (Be warned: Eliminating all of the sky's reflection from lakes and other bodies of water can literally turn them from blue to black, and thus ruin some scenic pictures.)

151. A polarizing filter eliminated the glare from the water in this tidepool and enabled the marine life to be photographed in better detail.

Remember, regardless of the camera used, if you adjust the polarizing filter when the camera is in its usual horizontal position and then you decide to turn the camera vertically, the filter must be readjusted to retain the prior effect. Likewise, whenever you rotate a lens barrel to refocus the lens or to change the focal length of a zoom lens, a polarizing filter must be readjusted or else its prior effect will be altered.

Take note that there are two types of polarizing filters, although they affect the image in the same way. The type to use depends on your camera. For single lens reflex *autofocus* cameras, use a CIRCULAR POLARIZING FILTER, which has been designed to prevent interference with autofocusing and auto-exposure systems that react to polarized light. "Circular" does not refer to the physical shape of the filter, but is used to differentiate it from the original type of polarizing filter, which is now called a LINEAR POLARIZING FILTER and can be used with any camera except SLR autofocus models.

In reality, both filters linearly polarize the light, but the circular type has technical improvements to keep it from affecting the partially polarized light that a beam-splitting prism in an autofocus SLR camera sends to the autofocus sensors or the auto-exposure metering system. In practical terms, this means you should always use a circular polarizing filter with an SLR autofocus camera or you may have problems with autofocus or auto-exposure.

152. Reflections on the window glass made it difficult to see the girl and her cat who are inside the house.

153. To make the girl and cat more visible, a polarizing filter was attached to the camera lens and adjusted until it canceled out most of the reflection.

Even so, there could be other restrictions; some SLR camera instruction manuals advise making exposure readings in the center-weighted exposure mode rather than the multizone mode when using a circular polarizing filter.

It's important to know that a circular polarizing filter can be used on any type of camera, so if you also have a nonautofocus camera in addition to an autofocus SLR, there is no reason to buy both types of filters. A drawback is that a circular polarizing filter is more expensive than the linear type. By the way, when the only polarizing filter available is the *linear* type, you can use it on an SLR autofocus camera after you *manually* focus and set the exposure according to the appropriate filter factor.

Take note that if "circular" is not written on the mounting ring, it is probably a linear filter; older linear filters may just be marked "polarizer," "pol," "pola," or "polar."

A polarizing filter is more troublesome to use with *non-SLR* cameras, because those cameras have separate lenses for viewing and for recording the subject. The first step is to hold the polarizing filter up to your eye and adjust it until the desired effect is seen. Then place the filter in exactly the same position in front of the camera lens that

154. Although a high-speed (ISO 400) film was in the camera, a neutral density (ND) filter reduced the light reaching the film so that a slow shutter speed could be used to purposely blur an ocean wave splashing over rocks near the shore.

transmits the subject's image to the film; a mark made on the filter's mount will help you realign the filter correctly on the camera.

Regarding exposure, a polarizing filter has a filter factor in a range from 2X to 3X, depending on its manufacturer; check the instructions for your particular filter. Whenever you read and set exposures manually, that means you must open the lens aperture an additional 1 f/stop if the filter factor is 2X, 1$^1/_3$ f/stops if the factor is 2.5X, or 1$^2/_3$ f/stops if the factor is 3X. You can forget making exposure adjustments for filter factors when using a camera with a through-the-lens exposure metering system; it will automatically compensate when a polarizing filter is on the lens, unless your camera manual advises otherwise.

In addition to polarizing and UV filters, there is a third type that can be used with both color and black-and-white film. It's a NEUTRAL DENSITY (ND) FILTER and its purpose is to reduce exposure by decreasing the amount of light reaching the film. This gray-colored filter does not alter the light in any other way. Unfortunately, few amateur photographers realize how valuable these filters can be.

With today's high-speed films, the most practical use for neutral density filters is to prevent overexposures by reducing the light on bright, sunny days. They allow you to use wider lens openings to better control depth of field, such as putting the background out of

focus when making portraits outdoors. They also permit you to use slower shutter speeds to purposely blur the action to show motion. In addition, neutral density filters can reduce the bright light of flash for close-up (macro) photography.

Neutral density filters are available in a variety of densities. These are identified by a DENSITY NUMBER or a filter factor. Following is a filter chart showing density numbers, the percent of light each filter will transmit, its filter factor, and how much the exposure is reduced in terms of f/stops.

## NEUTRAL DENSITY FILTER CHART

| Filter Density and No. | Percent of Light Transmission | Filter Factor | Exposure Reduction by f/stops |
|---|---|---|---|
| 0.10 | 80 | 1.25X | $1/3$ |
| 0.20 | 63 | 1.5X | $2/3$ |
| 0.30 | 50 | 2X | 1 f/stop |
| 0.40 | 40 | 2.5X | $1^{1}/3$ |
| 0.50 | 32 | 3X | $1^{2}/3$ |
| 0.60 | 25 | 4X | 2 f/stops |
| 0.70 | 20 | 5X | $2^{1}/3$ |
| 0.80 | 16 | 6X | $2^{2}/3$ |
| 0.90 | 13 | 8X | 3 f/stops |
| 1.00 | 10 | 10X | $3^{1}/3$ |
| 2.00 | 1 | 100X | $6^{2}/3$ |
| 3.00 | 0.10 | 1,000X | 10 f/stops |
| 4.00 | 0.010 | 10,000X | $13^{1}/2$ |

You can use this chart to determine the appropriate neutral density filter to use. For an example, say you are doing close-up photography with high-speed film and flash. Your camera lens only stops down to f/16, but the short distance between flash and subject requires an exposure of 2 stops less, f/32. By using an ND 0.60 filter, which has a filter factor of 4X, the flash light will be cut the equivalent of the required 2 f/stops and the picture can be properly exposed with the lens opening set at f/16.

Neutral density filters are available as round glass screw-in filters, or squares of optical-quality thermoplastic that slide into a filter holder. Two can be used together; just add their densities to determine the equivalent filter factor or exposure reduction. For example, an ND 0.70 filter and an ND 0.80 filter have a density of 1.50, which

is equal to a filter factor of 30X, or a reduction in exposure of 5 f/stops (see chart).

If buying only one ND filter, choose a dense one, such as 0.90, the equivalent of 3 f/stops, to enjoy a useful range of wide lens openings and slow shutter speeds. (When less light reduction is desired, use your polarizing filter as a substitute ND filter; it has a density range of 0.30 to 0.60, depending on the manufacturer, which means an exposure reduction of 1 to 2 f/stops.)

For more versatility, buy two ND filters of significantly different densities, which can also be used together for an even greater exposure reduction. For example, an ND 1.00 filter and an ND 2.00 filter used together are equivalent to an ND 3.00 filter, and offer a choice of $3\frac{1}{3}$, $6\frac{2}{3}$, and 10 f/stops of exposure reduction (see chart).

Putting this to practical use, say you were photographing a waterfall cascading over rocks and chose to stop the action with an exposure of 1/1000 second at f/5.6. Then you decide to blur the water, and switch to the lens's smallest opening, f/22, which requires a shutter speed of 1/60 second for an equivalent exposure. To blur the water even more, you keep the lens aperture at f/22 and use your neutral density filters in succession for greater reductions in shutter

155. A graduated neutral density filter helps balance the light intensity in this scene at sunrise in Yosemite National Park in California. The filter was positioned over the camera lens to reduce the bright light in the upper portion of the film frame so that the snow-banked river in the lower part of the frame would not be underexposed.

speeds and a wider choice of results: $1/8$ second with the ND 1.00 filter, 2 seconds with the ND 2.00 filter, and 15 seconds with both filters (ND 3.00).

There is a variation of a neutral density filter that is known as a GRADUATED NEUTRAL DENSITY FILTER. Half of the filter has a specific density and gradually fades to a clear area on the other half. This practical filter is most often used to reduce the brightness in one area of the picture in order to balance the exposure. For instance, if the sky is too bright in a landscape photograph, the graduated ND filter can be positioned to reduce the light of the sky while the area below the horizon is normally exposed through the clear portion of the filter.

Adjust the filter up or down in its holder (square graduated filters are preferred over screw-in graduated filters) so the horizon disguises the transition from neutral density to clear. Make a through-the-lens exposure reading with the filter in place if its density balances the area below the horizon, or read only that below-the-horizon area with the filter removed.

To check the filter density required to balance the below-the-horizon exposure, tilt the camera down to read that area only, then tilt it up to read the sky only, and compare how much brighter the sky is. For instance, a two-f/stop difference requires a graduated filter with a factor of 4X or ND 0.60 (see chart). Filters of greater or lesser density than 0.60 would darken or lighten the sky in relation to the area below the horizon.

GRADUATED FILTERS are also made in various colors for special effects. A blue graduated filter, for example, can be used to color a whitish overcast sky. Or turn the filter upside down to add blue to a dull ocean or seascape. If you're shooting a sunset on a drab day, use an orange or red graduated filter to make it appear more brilliant. Other special effects filters are discussed later in this chapter.

## Filters for Color Photography

Although the three filters just described—neutral density, polarizing, and UV—can be used with most types of film, other filters are intended specifically for color films.

There are three categories: LIGHT-BALANCING FILTERS, CONVERSION FILTERS, and COLOR COMPENSATING FILTERS. In general, they make subtle or significant changes to the colors appearing in your photographs. One of their major roles is to give images proper color balance. For example, these filters can help prevent pictures from

156. Filters will color balance color films for tungsten, fluorescent, and other indoor electric light sources so that subjects appear in their natural colors in your photographs (see text). This collection of early phonographs is at the museum home of inventor Thomas A. Edison in Fort Myers, Florida.

having a bluish tinge on overcast days, a greenish cast from fluorescent lights, or an orangish hue from household lamps.

Which filters you select, and the way you use them, depends on whether you are shooting color negative film for color prints or color reversal film for color slides.

The fact is that putting filters on a camera lens when exposing popular color negative (print) films is unnecessary. That's because the color compensating filtration needed to match the colors of your subjects in the color prints to those in real life is done later, when the color negatives are printed by photofinishing machines or in a darkroom. On the other hand, professional photographers shooting professional color negative films sometimes use filters on their camera lenses rather than counting entirely on color balancing the prints with filtration in the darkroom.

When shooting color reversal (slide) films, however, the pros always use filters on their camera lenses, when necessary, and you should, too. There are two reasons. First, these films turn directly into positive transparency images when processed; since there is no printmaking step, there is no opportunity to use color compensating filtration in the darkroom.

Also, as explained in the previous chapter, there are two types of color reversal film, DAYLIGHT and TUNGSTEN, and each is designed for a specific light source, either natural daylight or artificial tungsten light. Daylight color films are balanced for the light from the sun at midday, which has a color temperature of 5500 K (kelvin) and is virtually white because it contains almost equal amounts of red, blue, and green light. Tungsten slide films, on the other hand, are balanced for the color temperatures of artificial light sources, which have more red and yellow light than the midday sun. As a result, they produce pictures of normal coloration only when shot with tungsten light sources that have color temperatures of 3200 K or 3400 K, for which the tungsten films are balanced.

What this really means is that you should expose color reversal film with its appropriate light source, or else the colors of your subjects will look different in the color slides than they do in real life. However, you can achieve proper color balance by using a conversion filter or a light-balancing filter on the camera lens.

LIGHT-BALANCING FILTERS come in shades of blue to offset excessive yellow light, and in shades of yellow to counteract excessive blue light. The bluish filters are identified as series No. 82, while the yellowish filters are known as series No. 81. Their range of coloration is rather subtle; relative densities are indicated by letters from A (lightest) to EF (darkest). The filters require an increase in exposure that varies from 1/3 to 2/3 f/stop. Specific filter factors are given in the instructions for each filter.

The following chart lists some of the effects of light-balancing filters. For example, to reduce the bluishness of subjects photographed with daylight film under an overcast sky, use a No. 81A, No. 81B, or an even stronger filter in the yellowish 81 series. The same filters can also be used to diminish the subtle blue cast caused by some electronic flash units with daylight color film.

| Light-Balancing Filter No. | Effects |
| --- | --- |
| 81A | With daylight films, diminishes bluish results of an overcast day, open shade, or electronic flash. Balances tungsten Type B film (designed for 3200 K light) for use with 3400 K light. |
| 81B | Diminishes the blue of an overcast day, open shade, or electronic flash more than No. 81A. |
| 81C | Same as No. 81B but with slightly warmer results. |

| Light-Balancing Filter No. | Effects |
| --- | --- |
| 81EF | The warmest of all 81 series filters. |
| 82A | Diminishes the red or yellow cast evident on daylight film shot in the early morning or late afternoon. Balances tungsten Type A film (designed for 3400 K light) for use with 3200 K light. |
| 82B | Allows household incandescent lightbulbs of 100 or 150 watts to be used with tungsten Type B film. Gives more accurate color balance to daylight color films used with blue photofloods (4800 K). |
| 82C | Allows household incandescent lightbulbs of 60 watts or less to be used with tungsten Type B film. |

There are two other series of filters that you can also use to balance the light, or enhance it. A dark bluish series is No. 80, and a dark yellowish orange series is No. 85. Yellowish filters, such as the No. 85 series, are sometimes called WARMING FILTERS because they reduce the cold and uninviting bluish appearance of scenic shots taken on overcast days. They can also be used to enrich lackluster sunset pictures.

A major role of series No. 85 and No. 80 filters, however, is to serve as CONVERSION FILTERS. Series No. 80 filters allow daylight color reversal films to be exposed with tungsten light, while series No. 85 filters allow tungsten color reversal films to be exposed with daylight.

For example, if you have daylight slide film in your camera and then go indoors where tungsten-halogen lights are used, the colors of your subjects will appear yellowish red unless a No. 80B conversion filter is used. Likewise, a tungsten (Type B) film that is made for tungsten light but shot outdoors with daylight will record the scene with a bluish cast unless a No. 85B filter is used.

*To convert daylight color reversal (slide) films for use with tungsten light,* use the appropriate bluish filter of the No. 80 series below:

| Filter No. | Tungsten Light Source |
| --- | --- |
| 80A | 3200 K light; also best for household incandescent lamps |
| 80B | 3400 K light |

*To convert tungsten color reversal (slide) films for use with daylight or electronic flash,* use the appropriate yellowish-orange filter of the No. 85 series below:

| Filter No. | Tungsten Film Type |
|---|---|
| 85 | Type A film; normally used with 3400 K light |
| 85B | Type B film; normally used with 3200 K light |

Conversion filters require increases in exposure that range from $2/3$ to 2 f/stops; through-the-lens (TTL) metering systems will compensate to give correct exposures when the filter is on the camera lens. For hand-held meters, filter factors are normally not used in the traditional way. Instead, film manufacturers indicate an effective film speed called an EXPOSURE INDEX (EI) to use with conversion filters. For instance, when used with a No. 80B filter, an ISO 400 daylight color slide film will have an exposure index that is equivalent to ISO 125. When that ISO is set on a hand-held meter, it compensates (by the equivalent of $1 2/3$ f/stops) to give correct exposures.

Quite truthfully, because of the inconvenience and the slower film speeds that result, photographers rarely bother with conversion filters. They just buy the type of color slide film that's designed for the light source they are using—daylight or tungsten.

However, there is a common light source for which no film is specially made. Fluorescent lamps are frustrating for photographers because they turn your subjects a sickly green on daylight color slide films, or an equally nauseating blue on tungsten color slide films. Fortunately, there are special filters to correct for the deficiency of red light in fluorescent lamps that causes those color balancing problems.

These are screw-in FLUORESCENT LIGHT FILTERS. They vary in name, depending on their manufacturer, but usually are identified as FL-D or FL-W for daylight films, and FL-B or FL-T for tungsten films. They appear light purplish (for daylight films) or orangish (for tungsten films) and have a filter factor of 2X, which requires a one-f/stop increase in exposure.

Unfortunately, these FL filters don't always produce the natural colors you might have expected in the pictures. The reason is that there are at least a half-dozen types of fluorescent lamps, each with a different color temperature. The filters just mentioned usually work best with "cool white" fluorescent lamps.

For more exacting color balance with fluorescent lighting, the

pros use COLOR COMPENSATING (CC) FILTERS. These square gelatin filters are more commonly found in the darkroom to filter the enlarger's light during the color printing process. For use on cameras, they can be placed in a mount that slides into a filter holder you attach to the camera lens.

These filters are available in various densities of photography's three primary colors (red, blue, green) and three secondary colors (yellow, magenta, cyan). Color compensating filters are identified by density and color, such as CC30M, denoting a density of .30 and a magenta color.

A 30M filter, in fact, is a good choice as a single universal CC filter to balance the color of fluorescent lamps (magenta is the complement to green) so the colors of your subjects appear in the picture as if photographed in daylight. Another option is the slightly stronger 40M filter. Either one requires an increase in exposure of 2/3 f/stop, for which a TTL metering system will compensate when the filter is on the camera lens.

Take note that a 1/60 second or slower shutter speed is advised for proper exposures. Such speeds avoid possible underexposures caused by momentary changes in the fluorescent lights' brightness and color as they flicker almost imperceptibly with each pulse of alternating current.

Keep in mind when photographing city skylines at dusk or at night that you can use a magenta CC30M or CC40M filter, or a screw-in FL-D or FL-W filter, to prevent the unattractive greenish glow of fluorescent lights from the windows of skyscrapers and other office buildings.

For optimum results, professional photographers take into account the type of lamps (white, cool white, cool white deluxe, warm white, warm white deluxe, or daylight) and the specific film being used, and refer to a filter chart to determine the recommended combination of color compensating (CC) filters to use. For example, shooting Ektachrome daylight color slide film with "warm white" fluorescent light, the suggested filtration is 20C (cyan) + 40M (magenta) with a one f/stop increase in exposure.

For most of us, it is far easier to use one of the popular color print films, particularly those of higher ISO speeds, which will produce acceptable color results under most types of lighting—including fluorescent—without the use of filters on the camera lens. Nevertheless, some photographers like to experiment with various color compensating filters and other light sources, such as electronic flash (see page 191).

157. Colored filters change the tones of subjects exposed on black-and white film. Without a filter, the red leaves of this poinsettia plant photographed a dark gray.

158. When a red filter was placed over the camera lens, the leaves were recorded in a lighter tone.

## Filters for Black-and-White Photography

Popular black-and-white films are described as PANCHROMATIC films because they record all colors. However, they are often unable to record the relative brightness of the colors as you see them. In other words, although two colors may appear to your eye to be of different brightness, they will record on film in the same shade of gray. CORRECTION FILTERS are used to give the picture a different range of gray tones to indicate the relative brightness of various colors as you originally saw them.

CONTRAST FILTERS, on the other hand, cause colors that appear to your eye to be of similar brightness to have a different brightness when recorded on the film. In other words, the filters will lighten or darken the colors to a different range of gray tones. In general, a filter will lighten a subject of its own color, and will darken a subject of its complementary color. Some common uses of these two types of filters are to darken a blue sky to make the clouds stand out for a

more dramatic effect, reduce atmospheric haze in scenic shots, and darken or lighten skin tones in portraits.

Filters for black-and-white photography are primarily of four colors—yellow, red, green, or blue—and come in various shades and densities (see the chart that follows). Standardized numbers are now in use to identify specific filters, but the discontinued Kodak Wratten filter names may be marked on older filters. Also, some filter manufacturers have assigned their own filter designations. All of these colored filters require an increase in exposure; their filter factors range from 1.5X to 16X.

The following chart lists the identification numbers of popular filters for black-and-white films, as well as their discontinued Kodak Wratten filter names. Also given are the filter colors, the filter factors for daylight, and the equivalent exposure increase required (in f/stops). These factors are intended only as a guide; they sometimes vary for tungsten light (which produces an excess of red light), and for certain types of films. See film and filter instructions for specific advice and filter factors. Be aware that *color* descriptions for filters of the same number can vary according to the manufacturer. For instance, some filter makers identify a No. 15 filter as deep yellow, while others call it orange.

## POPULAR FILTERS FOR BLACK-AND-WHITE FILMS

| Filter No. | Former Name | Color | Filter Factor (Daylight) | Exposure Increase Required (in f/stops) |
|---|---|---|---|---|
| 6 | K1 | light yellow | 1.5X | $2/3$ |
| 8 | K2 | medium yellow | 2X | 1 |
| 11 | X1 | yellowish green | 4X | 2 |
| 13 | X2 | dark yellowish green | 5X | $2 1/3$ |
| 15 | G | deep yellow (orange) | 2.5X | $1 1/3$ |
| 25 | A | medium red | 8X | 3 |
| 29 | F | deep red | 16X | 4 |
| 47 | C5 | blue | 6X | $2 2/3$ |
| 58 | B | green | 6X | $2 2/3$ |

To decide which color of filter to use in order to achieve the effect you desire, you should understand the characteristics of light and color in regard to photography. White light is a mixture of three

159. Overlapping color wheels show the primary and secondary colors for photography. White light is a mixture of red, blue, and green, called the primary colors. Secondary (or complementary) colors—magenta, yellow, and cyan—are a mixture of two primary colors.

basic or PRIMARY COLORS: red, blue, and green. Objects that appear red have absorbed blue and green and reflect red. Objects that appear blue have absorbed red and green and reflect blue. And green objects have absorbed red and blue and reflect green.

If any two of these primary colors are mixed, they produce one of three other (secondary) colors: yellow (red plus green), magenta (red plus blue) or cyan (blue plus green). These are often called the COMPLEMENTARY COLORS of the primary colors. Refer to Illustration 159.

A filter acts in a similar manner, absorbing some colors while allowing other colors to pass through. For this reason, photographers using filters with black-and-white films should memorize the following: (1) To make a color appear brighter than seen, use a filter which transmits that color, and (2) To make a color appear darker, use a filter which absorbs that color. Absorption characteristics of color are given on the following chart.

| Color | Colors Absorbed | Colors Transmitted |
|---|---|---|
| red | blue and green (cyan) | red |
| blue | red and green (yellow) | blue |
| green | red and blue (magenta) | green |
| yellow | blue | red and green (yellow) |
| magenta | green | red and blue (magenta) |
| cyan | red | blue and green (cyan) |

Put this knowledge to use. For example, a red flower and its green foliage may appear as similar shades of gray in your picture. To increase contrast and make the red flower stand out, use a red filter such as No. 25. Because red transmits red, the flower will now appear lighter than its leaves. For the opposite effect, a green filter such as No. 58 could be used to lighten the green leaves so that the red flower appears darker in the picture.

Here are some OTHER ATTRIBUTES AND USES OF FILTERS for black-and-white films. Correction filters like the medium yellow No. 8 and yellowish green No. 11 are often used with many subjects to make them appear more natural on film; one example is more pleasing skin tones in portraiture work. The other contrast filters are used more often to alter one color or another so the change in contrast on the film will emphasize the desired subject.

Panchromatic film tends to be extra sensitive to blue-violet and ultraviolet light. Since this light is prevalent in scenes where the sky is visible, the sky looks brighter in your photograph than it did to your eye. To record the more natural scene, a correction filter that absorbs blue and ultraviolet light is needed, such as the medium yellow filter No. 8. It produces scenes with skies that record darker

160. Black-and-white panchromatic films are sensitive to all colors and represent them realistically in black, white, and varying shades of gray. Visualize and compare the actual colors of the various items in this picture. For example, as you'd expect, the red apple appears darker in tone than the orange.

on black-and-white film than when such a filter is not used. A yellowish green No. 11 filter will darken the sky slightly more than the No. 8 filter.

Since the sky and clouds are often a part of pictures, they can be emphasized to various degrees by contrast filters. An orange (deep yellow) No. 15 filter, for instance, will darken the sky to an even greater degree than a No. 8 or No. 11 filter. A medium red No. 25 filter will make the sky even darker, while the deep red No. 29 filter turns the sky almost black, giving a moonlight effect. Clouds are dramatically portrayed against such skies.

These sky-darkening filters also help reduce haze in landscape scenes. A red No. 25 or No. 29 filter will reduce haze the most; with black-and-white infrared film, those same filters will eliminate haze entirely. On the other hand, haze can be *added* for special atmospheric effects by using a blue No. 47 filter.

Filters for black-and-white photography are often used in copy work. They can emphasize or deemphasize colors in the original work being copied. Stains or unwanted lines can be eliminated by using a filter of the same color as the stain or line. Or to darken and thus bring out a faint color, a filter which absorbs that color should be used.

Filters are important for any photographer who wants to make creative photographs on black-and-white film, including infrared film, which gives dramatic results when exposed through a red filter (see page 384).

## Filters for Fun and Special Effects

There are many filters that you can place in front of the camera lens in order to create different light patterns or other special effects on both color and black-and-white films. It's fun to see the results.

One of the most interesting to use is a STAR FILTER, also called a CROSS-SCREEN FILTER. This clear glass filter is etched with a series of horizontal and vertical lines to give a crosshatch pattern that breaks up bright points of light into starlike rays. Others are made with a cross screen sandwiched between two pieces of clear glass. These filters are often used to turn the sun into a star, or to make the reflections of sunlight on water resemble sparkling diamonds. They also add impact to night scenes by giving star rays to street lights.

Star filters come in a choice of 2, 4, 6, 8, or 16 star points. The size of the crosshatch or grid pattern also determines the effect. Small grids produce more stars and some diffusion, while larger

grids produce fewer stars and very little diffusion. The direction of the rays can be changed by rotating the filter.

Star filters do not require an increase in exposure. However, the vividness of the star pattern is affected by the f/stop you choose. Try an aperture of f/5.6; star effects tend to diminish with small lens openings. Check the effect at different apertures by looking through the viewfinder while using the depth of field preview button or lever available on some SLR cameras to stop down the lens.

You can make your own star filter by holding a piece of fine mesh window screen wire in front of the lens to create four rays from bright light sources. Two of these screens turned 45° against each other will produce eight-pointed stars. Since the screen diffuses the entire image reaching the lens, the overall picture will be slightly unsharp. To avoid blurring the image even more, tape or mount your homemade filter to the lens so it won't get moved inadvertently during the exposure.

161. Bright spots of sunlight reflecting off these sailboats were turned into star-like rays when a star filter was put on the camera lens.

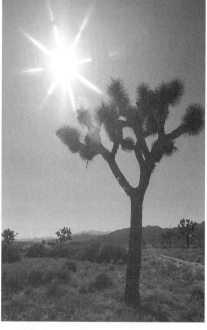

162. A star effect can also be created *without a filter* by stopping down the lens to a very small aperture (f/16 or smaller) and aiming the camera directly at a bright light, such as the sun in this desert scene at Joshua Tree National Park in California.

By the way, a variation of the STAR EFFECT can be achieved *without* a filter by simply using a small lens opening, f/16 or smaller, when your picture includes bright points of light. For instance, shooting into the sun with a small lens opening will turn the sun into a star and make your photograph look as if it were taken at night. Similarly, using a small f/stop to photograph the sun glittering off water should produce a picture with a myriad of stars. Check the effect in advance of exposing the film by pressing the SLR camera's depth of field preview button or lever, if available.

Another popular special effects filter diffuses the overall image. This DIFFUSION FILTER or SOFT-FOCUS FILTER is a favorite of portrait photographers to soften the features of their subjects, especially to diminish wrinkles and skin blemishes. The filters are available with different degrees of diffusion. The greater the softness of the image, the greater the apparent reduction in contrast. To enhance the diffusion effect, use wide lens openings (f/5.6 or greater) instead of small apertures. Diffusion filters generally require no change in exposure. Manual focusing may be necessary with an autofocus camera.

Diffusion filters can also be homemade. Try a variety of materials, such as a piece of nylon stocking secured to the lens barrel with a rubber band. Use a neutral color, like gray, black, or beige. White mesh nylon stockings greatly reduce contrast by scattering more light. Other materials for diffusion include a clear plastic bag or a piece of glass smeared with a thin layer of Vaseline petroleum jelly.

A modified diffusion filter, called a SPOT FILTER or CLEAR-CENTER FILTER, produces a round center area that is in sharp focus while the surrounding area is diffused. This focuses attention on the subject in the center of your picture. A similar effect can be achieved by applying a thin layer of Vaseline to a piece of glass except in the center area (or wherever your main subject is located). Outside the clear area, the petroleum jelly breaks up the light rays entering the lens to blur the image slightly. Autofocus cameras may have to be focused manually.

Another variety of diffusion filter is called a FOG FILTER. It is used to give a misty look to landscape and other scenic shots. The filter is available in different densities to vary the dreamlike effect; some square fog filters are graduated so that half of the filter is clear in order to keep the foreground in sharp focus. Use a small lens opening to increase sharpness, a larger f/stop to maximize the fog effect. Manual focus may be required. Likewise, the scattering of light by a fog filter can affect some auto-exposure systems and result in slight underexposure. It may be necessary to bracket exposures manually.

163. A multiple-image accessory lens attached to the camera lens will make additional images of your subject, as it did with this single rose. Use a large lens opening and contrasting background for the best results.

A MULTIPLE-IMAGE LENS is often categorized as a filter but is really an ACCESSORY LENS. It creates eye-catching images by reproducing your subject in three, five, or six identical images. Depending on its design, the images appear in parallel, circular, or other patterns. Rotate the filter to change the orientation of the images. The image in the center is usually the brightest and sharpest, while the others appear slightly darker and diffused. Avoid using a wide-angle lens, which may darken the edges of the outer images. No exposure compensation is required.

A SPLIT-FIELD LENS is another accessory lens that some photographers categorize as a special effects filter. Half of the lens is a close-up lens, the other half is clear. Depending on how you align the lens, it puts a close-up subject in the foreground in sharp focus with the background. Or you can turn the lens to deliberately put the foreground or the background out of focus. Use a small f/stop for the best effect and follow instructions that accompany the split-field lens.

More special effects are created by DIFFRACTION FILTERS, which break up bright light sources into bands, streaks, circles, or star-bursts of various colors. Another filter produces rainbows. Other types give a feeling of action with zoom, whirlpool, or swirl patterns that surround a subject appearing clearly in the center. There are even MOTION FILTERS that create parallel streaks flowing in one direction from the subject. Filters also can be used with flash to create special effects (see page 191).

Filters add an extra dimension to creative photography. Your challenge is to find subjects and situations that work well with filters. One approach is to always ask yourself if a filter could improve the image. Using a filter for a special effect is frequently more harmful than helpful, unless the picture is purposely bizarre or gives a feeling of fantasy. All too often the effect loses its novelty and becomes very trite to viewers of your photos. Nevertheless, experiment with all types of filters to see how you like the results.

# CONSIDERING ACCESSORY EQUIPMENT

Some photographers think that the more accessory equipment they own, the better photographers they are. Actually, the quality of photographs depends more on the photographer's creativity than on his equipment. Of course, in addition to camera and film, a few more tools can be of help. The list of "extra" equipment for photography is extensive, so make your choices carefully.

The major accessories are discussed in detail in other chapters of this book. To learn about the wide selection of INTERCHANGEABLE LENSES, as well as lens extenders (tele-converters) and other optical accessories, see Chapter 3. Also see Chapter 4 for ACCESSORY FLASH UNITS, Chapter 6 for FILTERS for black-and-white and color films, Chapters 3 and 12 for CLOSE-UP (MACRO) EQUIPMENT, Chapter 2 for HAND-HELD EXPOSURE METERS, and Chapter 15 for SLIDE PROJECTORS, projection screens, and related equipment.

You should also consider some other worthwhile photographic accessories, which will be discussed in this chapter: TRIPODS, CAMERA BAGS, MULTIFUNCTION AND DATA BACKS, and MOTOR DRIVES. A number of additional accessories—sometimes necessary, sometimes not—have been mentioned throughout this book. Refer to page numbers in the Index to find descriptions of specific items that interest you.

## Tips About Tripods

Photographers often need a sturdy and convenient means of support for their cameras in order to avoid blurred images. A TRIPOD is the most common type of support, although a C-clamp, pistol grip, shoulder brace, beanbag, and unipod are other useful devices for steadying the camera during exposure.

164. A tripod is a necessary accessory for time exposures, as of British Columbia's Parliament Building in Victoria, Canada.

Why use a tripod? Quite simply, because it's difficult to hand-hold a camera steady, especially when exposures require a shutter speed of 1/30 second or slower. With telephoto lenses of longer focal lengths, camera shake is a problem even at faster shutter speeds because your subject's image is greatly magnified.

Remember, the smaller the area covered by a telephoto or telephoto zoom lens, the greater the camera steadiness required. A rule of thumb is to shoot at a shutter speed that is at least equal to the focal length of the lens you're using, such as 1/250 second with a 200mm telephoto lens. If that's not possible, then you need to support the camera on a tripod.

In addition to steadying powerful telephoto lenses, a tripod is most frequently used at night, when longer exposures are required. But it is also helpful in many other situations. For instance, when

extreme depth of field is needed to put more of the subject area in sharp focus, a small lens opening is required and the shutter speed must be slowed to compensate, so a tripod solves the problem of holding the camera steady. Likewise, when you want to show motion by using a slow shutter speed so that a moving subject is purposely blurred, a tripod maintains the camera's position during the extended time the shutter is open. Or, if your subject is stationary and you want to depict motion by panning the camera or changing the focal length of a zoom lens during exposure, a tripod gives you better control of these creative effects.

A tripod also holds the camera in position to permit precise framing and focusing, which makes it a must for close-up and copy work. The same exacting alignment is necessary for multiple exposures, as well as for TIME-LAPSE PHOTOGRAPHY. And when the photographer wants to be included in the picture, a tripod keeps the camera properly positioned so you can activate the self-timer to delay shutter release while you pose in front of the lens.

Steady support is also necessary for OPEN FLASH at night (see page 190). After mounting the camera on a tripod and then framing your subject and opening the shutter, you're free to fire the flash from any distance and angle to properly illuminate the subject. For OFF-CAMERA FLASH, either a tripod can be used to hold the flash unit away from the camera, or the photographer can hold the flash while the camera is on the tripod.

When objects block the photographer's view, a tripod is useful for positioning the camera beyond the obstruction. The following technique is especially helpful at parades or other public gatherings that are too crowded to allow a normal camera angle. You just present the focus and exposure (unless using autofocus and auto-exposure), activate the self-timer, then gather together and hold onto the tripod's legs to raise the camera so it avoids the heads of the people in front of you; frame the subject by watching the angle of the lens. Use the same technique to provide a camera angle that would otherwise be impractical, if not impossible, such as suspending the camera over the side of a tall building or a cruise ship.

When using a tripod in the traditional manner—with its three legs spread open and its feet on a solid surface—beware of moving the camera inadvertently. CAMERA SHAKE happens most often when you press the shutter release button, so it is always smart to attach a cable release or a remote cord, or use the camera's self-timer, for hands-off triggering of the shutter.

Most convenient is the SELF-TIMER because it is built into the camera and ready to use. After you activate the self-timer, the

opening of the shutter is delayed about 10 seconds, so you are not touching the camera immediately before or during the exposure. A drawback is that you cannot control the exact moment the shutter will open because of the time delay after you activate the self-timer. Also, the length of any time exposure will be limited by the shutter design of your specific camera. SLR cameras featuring automatic exposure allow long exposure times, often up to 30 seconds. But for most automatic compact cameras, as well as cameras with mechanical shutters, the shutter will open only for 1 second or less. See your camera's instruction manual to learn the maximum time the shutter is able to stay open.

For more complete control of the shutter while avoiding camera shake, a better choice than the self-timer is to attach an accessory cable release or remote cord. They both allow you to release the shutter without directly touching the camera, and to keep the shutter open for any length of time exposure. However, some cameras are designed for a cable release, others for a remote cord; consult the instruction manual for your specific camera.

The more traditional CABLE RELEASE is a flexible wire-, plastic-, or fabric-covered cable that screws into the camera's cable release socket and trips the shutter when you depress its plunger. Common lengths are 12, 20, and 40 inches (30.5, 50.8, and 101.6cm). The most useful ones have a lock screw that you can tighten to hold the plunger in when the camera's shutter speed control is set to B for a TIME EXPOSURE; when the lock screw is untightened, the plunger is released and the shutter closes. If the shutter control has a T setting, the initial push on the cable release plunger opens the shutter, and a second push on the plunger closes the shutter after the time exposure.

Many of today's electronically controlled cameras must be fired by a REMOTE CORD, which is also known as a REMOTE RELEASE CORD or REMOTE CONTROL CORD. The remote cord has a push button at one end and a plug at the other end that is connected to a REMOTE RELEASE SOCKET on the camera body. When making a time exposure with the shutter control set to B, you depress and *hold down* the push button on the remote cord to open the shutter and keep it open for the time desired, then release the button to close the shutter. If using the shutter's T position, you press the remote cord push button *once* to open the shutter, then press it a *second* time to close the shutter at the end of the time exposure.

Selecting a tripod that works well with your camera and the type of photography you do is not so simple. There are dozens of TRIPOD BRANDS with different types of construction and features. A few of the

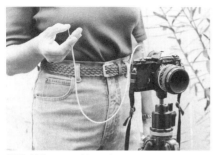

165. When making time exposures, you can use a cable release to trigger cameras that have a mechanically controlled shutter, thus avoiding blurred images that can result from inadvertent camera movement.

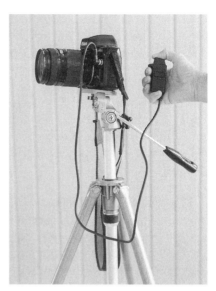

166. For cameras with an electronically controlled shutter, a remote cord can be used to trigger the shutter release without touching the camera.

better-known tripods are the Italian-made Bogen, French-made Gitzo, and Japanese-made Slik. Others include Benbo, Cullen, Davis & Sanford, and Vivitar. Prices range from about $30 to hundreds of dollars.

Basically, a tripod consists of three extendable legs connected to a head or yoke that holds a knobbed screw to attach the tripod to the camera. This TRIPOD SCREW is often ¼ inch in diameter, but may be ³/₈ inch; check that it will fit the treads of your camera's tripod socket. If you have a long and/or heavy telephoto lens that has its own tripod socket, make certain that the tripod screw fits it, too.

Some tripods feature an elevator post and special heads for precise positioning of the camera. Among basic considerations are the tripod's rigidity, maximum height, its collapsed size, weight, materials and construction, leg locks, and feet.

Most important when choosing a tripod is its STURDINESS. If a tripod fails to support the camera rigidly, it's not worth using. Obviously, the size of your camera helps determine the size of the tripod you need. In any case, avoid the small metal multisection, spindly-leg models with spring-loaded pinlocks.

While some studio tripods are wooden, most types for general use are made of high-impact fiber-reinforced plastic, or metal. A titanium tripod features the strongest and lightest-weight metal, and

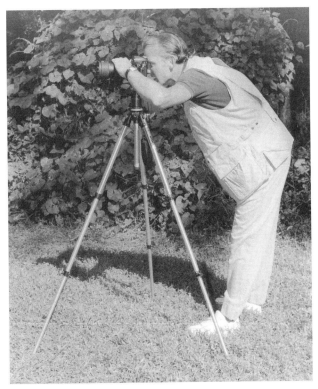

167. Position a tripod so that one leg is pointed in the direction of the camera lens. That way you'll have room to stand between the two legs at the rear and avoid tripping over the tripod.

commands a very high price. Less expensive and most commonly used in tripod construction is aluminum; the best is anodized or Teflon-coated. Round, rectangular, or pentagonal aluminum legs have more strength and less weight than those with U-shapes (open channel) or welded square shapes.

TRIPOD LEGS extend by means of telescoping sections; the fewer the sections, the more rigid the tripod and the easier it is to put up and down. The bottom sections of some legs are sealed to make them waterproof, a good choice for nature photographers who work on wet terrain and in snow.

There are many types of LEG LOCKS to keep the tripod at the height you desire. Quickest to use are thumb locks that you rock or flip up or down or sideways. Pinch locks work easily with just your thumb and forefinger. Especially convenient are lever-type locks, located at the top of the tripod where the three legs join (the yoke), which release and secure all sections of a leg at the same time. Other locks

take more time to operate, including collar, knob, and wing-nut locks that you twist to tighten and release.

A key consideration is how high the tripod will extend. For the most versatility, and to avoid bending your back, the tripod should put the camera's viewfinder at eye level. This is often accomplished with the use of an ELEVATOR POST that rises from the yoke for easy and precise height adjustments of the camera. However, when extended on this post, there is more chance of camera movement because the camera is actually supported only by a single pole (the elevator post) instead of three legs.

If buying a tripod with an elevator post, also called a CENTERPOST, make certain it is mounted in a sturdy yoke and can be securely locked. Some operate by means of a geared post and a crank, others by friction or pneumatic control. A REVERSIBLE ELEVATOR POST may seem useful to hold the camera below the tripod's legs for ground-level shooting, but in reality the camera's controls are upside down and it's difficult to position yourself between the legs for framing and focusing. A TILTING ELEVATOR POST offers some versatility, but check that it remains sturdy when positioned at an angle.

To prevent slippage, you should be certain that the tripod legs spread to a preset angle. Some have CENTER BRACES for more rigidity; get the type that locks so the legs can be adjusted to a narrower-than-normal stance. Center braces are unnecessary for 35mm cameras, unless you are using long and heavy telephoto or zoom lenses.

Far better is a tripod that allows the legs to spread wide for low-angle shooting, a frequent requirement for macro and nature photography. In such cases, if the tripod also has an elevator post, you'll need to buy an optional short elevator post for low-level work.

TRIPOD FEET vary depending on where the tripod is going to be used. Rubber tips (avoid plastic) are basic for indoor and outdoor use, although some are round, some angled, and others have a ball-and-socket joint for a self-adjusting grip. Spike tips are useful for fieldwork; some multipurpose feet feature a rubber tip that can be retracted to expose a metal spike. If the feet of your tripod are too small to grip securely, try expanding them with rubber tips designed for canes or crutches. Casters can be attached to some feet so the tripod can be rolled around studio floors.

A tripod's value is enhanced by the type of HEAD it has: a ball-and-socket type or a pan-and-tilt type. Commonly known as ball heads and pan heads, they allow you to position the camera exactly as desired. Some tripods are sold with the head attached; others allow you to select the head that's best for your purposes. They come in different sizes for different sizes and weights of cameras.

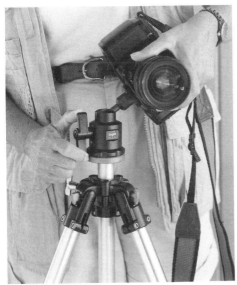

168. A ball head on a tripod makes it easy to turn a camera from a horizontal position to a vertical position or to any other angle.

Before buying any tripod or tripod head, make certain you are able to easily attach and use the camera in both its horizontal and vertical positions.

For simplicity of use, a BALL HEAD is hard to beat; you turn one knob to reposition the camera. Beware of cheaper ball heads that are not strong enough to lock and hold the camera precisely as you position it; some will slip, especially when a long or heavy lens is attached. One version of the ball head has a pistol grip, instead of a knob, that you squeeze to release and lock the camera in position.

A PAN HEAD has two or three knobs or handles that you twist to lock the camera in place. One is the pan control for side-to-side movement, another the tilt control for up-and-down movement. A third control allows you to reposition the camera to a vertical or a horizontal format without loosening and retightening the tripod screw to turn the camera. Knobs are usually preferred to handles, especially long ones, which are more useful for video cameras and just get in the way when you're looking through the viewfinder of a 35mm camera.

Some tripod heads feature a QUICK RELEASE so that the camera can be mounted on the tripod, or removed, without taking the time to screw or unscrew it. A quick release plate or knob, which is initially screwed into the camera's tripod socket, slips into the tripod's quick-release shoe and locks in place with a lever. Quick-release attachments can also be purchased for other tripod heads. Quick release is nice if you frequently use a tripod, but the protrusion and

extra weight of the attached knob or plate can be a bother when you are hand-holding the camera.

A small but welcome feature on many tripods is a SPIRIT LEVEL, also called a bubble level, that you can watch to determine when the camera is level. It's especially helpful for architectural shots, landscapes, and copy work. If your tripod doesn't have a spirit level, buy a small one at a hardware store and attach it to the tripod head.

Also available at hardware stores is another inexpensive convenience: round TUBES OF FOAM INSULATION designed to fit around plumbing pipes. Cut three sections of this closed-cell foam to slip onto the legs of your tripod, which insulate your hands on wintry days from the tripod's cold metal, and make the tripod more comfortable to carry when you are resting it on your shoulder.

A padded TRIPOD CARRYING STRAP suspended from your shoulder will also ease the burden of toting a collapsed tripod. It's more convenient than trying to strap the tripod to your camera bag. For traveling, buy a canvas TRIPOD CARRYING CASE that can be slung over your shoulder. It offers extra protection, especially when checking the tripod as baggage on an airplane. You can use the same bag to carry a beanbag (see later in this section) and a collapsible umbrella.

Of course, two of the most important considerations when buying a tripod are its weight and its compactness when collapsed, especially if you like to travel, or go off the beaten path for nature photography. Don't purchase a tripod that is so heavy or bulky that you just end up leaving it at home.

Fortunately, there are some other options for camera support whenever you need to travel light or are in the field. One is a small TABLETOP TRIPOD, sometimes called a MINIPOD, that can easily be carried in a camera bag. When equipped with a ball head and properly adjusted, this small tripod can even be held against the photographer's chest to give extra support and steadiness when using a telephoto lens or making long exposures. (Take a deep breath, or exhale, just before you press the shutter release button.)

A PISTOL GRIP or SHOULDER BRACE are other portable supports preferred by some photographers using powerful telephoto or zoom lenses. These screw into the camera or lens tripod socket and may have a built-in cable release to operate the shutter.

More common is a photographic C-CLAMP, with a ball head, which can be fastened to almost anything to provide support for a 35mm camera. One model is marketed as a "car window pod."

A homemade cloth BEANBAG, filled with lightweight Styrofoam

pellets instead of heavier dried beans, can be used to cushion and support the camera in awkward locations and positions.

Perhaps least useful is a UNIPOD, which offers only one-legged support. It keeps the camera at a certain height, but the photographer must hold it steady to prevent sideways movement. Besides, bringing the legs of a tripod together will substitute for a unipod when desired.

*Here are a few more tips for using a tripod successfully.* Always try to place the tripod on a solid surface to give full and safe support to the camera and avoid accidental movement. When setting up the tripod, place one leg forward in the direction of your subject and work between two legs at the rear; there is less chance you'll trip over those legs, and the front leg will give better balance for longer lenses.

Also, when extending a tripod, start by releasing the lowest sections of the legs so you won't have to stoop over as the tripod is being raised. A good technique to speed the collapsing of a tripod after use is to invert it so that the legs fall by gravity to their shortest position as you release the locks. To add more stability to a tripod in the field, especially on windy days, hang your camera bag from the yoke; just make sure the bag doesn't swing in the breeze.

Always be certain the tripod legs are on a solid foundation. If the ground is soft, put something firm under the legs so they won't slowly sink into the earth. Obviously, the foundation itself must be stationary; it's worthless to use a tripod on anything that is moving, such as the deck of a boat. Beware of vibrations, too, as when someone walks by your tripod on a wooden floor during a time exposure.

A final caution: Don't become so addicted to a tripod that you lose the ability to photograph spontaneous situations. Constant use may make tripod operation easy, but it is still time-consuming to extend and level the legs. In close situations, tripods can also be an obstruction and a danger to other people. For that reason, they are often banned in museums and other public places, so don't count on being able to use a tripod everywhere you go.

Nevertheless, tripods are valuable aids to camera users and are worth the investment. But take care when selecting a tripod to be sure it will fulfill not only your needs but its main purpose—to provide sturdy support for your camera.

## Considerations About Camera Bags

A CAMERA BAG is one of the most important accessories for photographers. Instead of being draped with individual cases holding your camera, extra lenses, and rolls of film, you can carry all your gear in a single "gadget" bag that makes everything easily accessible. As with tripods, there is a wide choice of camera bags. A good camera bag has three characteristics: it's convenient to use, well constructed, and provides adequate protection for your photo equipment.

All sorts of soft-sided camera bags are on the market, but a quality HARD CAMERA CASE offers the ultimate in protection. A top-of-the-line Zero Halliburton–brand hard case, for instance, is made of a tough aluminum alloy with a neoprene-lined tongue-and-groove lip to seal out dust and moisture. It comes with a solid foam rubber insert that you cut out to cradle your specific camera and accessories. However, for most casual picture takers a hard case is too heavy, too awkward, and too expensive. Besides, since it is most often used by professional photographers, a hard photo equipment case is a tempting target for thieves.

SOFT-SIDED CAMERA BAGS are the favorite of professional news, sports, and outdoor photographers, as well as vacationers who want a convenient and lightweight carrying case for their camera gear. Among the popular brands are Tenba, Lowepro, Domke, and Tamrac. The bags come in all sizes, shapes, colors, and prices. Compare them side by side before deciding which one is best for you.

Start by checking the BAG MATERIAL. Especially durable is heavyweight ballistic nylon that has been treated with a urethane waterproof coating. Another good option is waterproof Cordura nylon (however, its rougher surface can wear your clothes). A canvas bag should have a waterproof coating or a waterproof layer between its inside and outside shells.

Inspect the stitching carefully, looking for double-stitched seams and cross-stitches at stress points, such as where the shoulder strap is attached. The thread should be heavy-duty nylon. For extra security, a supporting strap for the shoulder strap should wrap under the bottom of the bag.

If the SHOULDER STRAP is attached to the bag by metal D-rings, they should be welded shut or designed so the strap cannot slip off or accidentally become detached. Ease your burden by making sure the shoulder strap is a wide one; a padded and/or anti-slip section sewn to the strap where it rests on your shoulder will make you happier,

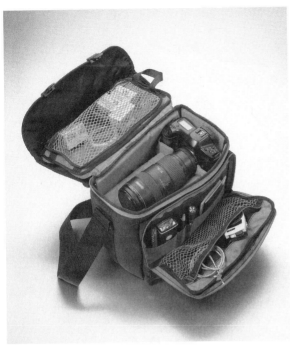

169. Many photographers favor soft-sided camera bags with a sturdy shoulder strap for carrying and protecting cameras and other photo gear. Tenba makes this versatile model with adjustable inserts and several pockets.

170. Very comfortable and practical for use in the field are photo backpacks, like this Tenba model that can be unzipped to its full length for easy access to equipment.

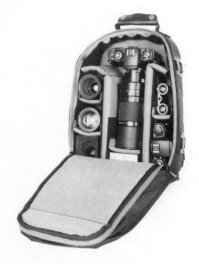

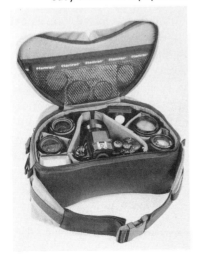

171. Half-moon hip bags, including this spacious model made by Tamrac, strap around your waist and take the weight of camera and lenses off your shoulders.

too. Some bags have optional padded waist belts that snap on to redistribute the weight to your hips and legs.

Check that BAG CLOSURES such as zippers are heavy-duty and easy to operate; plastic zippers will not corrode like metal ones. Exterior zippers should be covered with a flap of waterproof material to repel rain and snow. Flaps on exterior pockets should also be designed to fully protect the contents from inclement weather. Outside pockets should have zippers or quick-release plastic or metal buckles, not just Velcro, to keep them closed. If you tote a tripod, some bags have exterior straps to hold it securely. To best protect your equipment, the bag should be lined with shock-resistant, closed-cell foam. Some manufacturers also sew a piece of plastic, fiberboard, or plywood into the bottom of the case for added durability.

When checking the usefulness of any bag, consider the EASE OF ACCESS to your equipment. The most versatile bags have adjustable inserts you can move around to custom-design the interior with compartments that hold your specific camera, lenses, flash, filters, and other accessories, as well as a supply of film. Look for padded inserts with Velcro strips that keep the gear from bumping together and permit varied configurations. Interior pockets of mesh material allow you to easily see what's stored in them. It's a good idea to take your photo gear to the camera store and see how well everything fits into the case before you buy it.

Whatever type of bag you choose, make sure it has a wide adjustable shoulder strap so your hands will be free to operate your camera. Try it on for size and comfort; beware of extra large bags that are awkward to carry or can become too heavy with equipment. A case with only handles has to be put down while you shoot, and it's difficult to keep your eye on your equipment and take pictures at the same time. If you put your camera bag down while shooting, put one foot through the shoulder strap so no one will be able to snatch the bag while you are looking through the viewfinder and your attention is focused on your subject.

Take care that your camera gear is within easy reach but won't fall out if the case accidentally opens. As a precaution, carry the camera bag so its opening catch or catches are next to your body. That way the top opens outward and there is less danger that it will flop down on the equipment you're trying to take out or put back in.

Of course, the price of a camera bag may determine its desirability. The better soft-sided cases range from $50 to over $250, depending on their size, construction, and features. The more valu-

able your equipment, the higher the price you should be willing to pay for a quality bag. Some manufacturers back their bags with a guarantee; every Tenba camera bag, for instance, is guaranteed for five years.

Once you buy a new camera bag, be sure to put PERSONAL IDENTIFI-CATION on and in it in case your photo gear is lost or stolen. For extra security, some photographers use an electric pencil to etch their telephone or Social Security number on their cameras, lenses, and accessories. A final caution: Don't mistreat your camera bag and its contents. A padded soft-sided bag absorbs many of the thumps and bumps of travel, but it can't protect equipment from a big fall or careless battering.

Besides the traditional camera bag, there are other ways to carry your photo gear. Smaller variations are so-called HALF-MOON HIP BAGS that strap around your waist, and CHEST BAGS that strap over your shoulders and are held in place with a strap around your back.

Especially popular among hikers and nature photographers are PHOTO BACKPACKS. Those with waist belts distribute the weight to your hips and legs and reduce the strain on your shoulders and back. As with any camera bag, make certain the backpack is waterproof and has large easy-to-use zippers with rain flaps, padded adjustable dividers for your gear, and padded shoulder straps.

A comfortable alternative for many on-the-go photographers is a PHOTO VEST that slips on like a sleeveless jacket and has a multitude of inside and outside pockets to hold your gear. Make certain the vest has adequate zippers, buckles, or Velcro closures so you won't lose any items from the pockets. The main problem for many photo vest users is remembering the exact pocket where you put a specific piece of equipment.

## Multiple Choices with Multifunction and Data Backs

Some advanced 35mm single lens reflex cameras offer a choice of special functions that are built into the camera. These functions often include exposure bracketing, flash exposure bracketing, multiple exposures on a single frame, sequence shooting for a certain number of frames, exposures at desired time intervals, and very long preset time exposures. If your SLR model doesn't offer these functions, they may be available in an ACCESSORY CAMERA BACK. This optional back, which is known as a multifunction back, a multi-

control back, or a data back, replaces the camera's regular hinged back that swings open to load the film cassette.

The most basic of these interchangeable backs is a DATA BACK, which imprints the film with the date (day/month/year) and/or time (day/hour/minute). Even when this data function is built into a camera, as it is with a number of 35mm compact cameras, many photographers avoid using it on a regular basis. That's because the data, which is permanently recorded on the film, can be a distraction in the photograph. Nevertheless, a data back is a welcome option when you want to record the date (or time) of an event, such as a birthday party.

In addition to recording the date and/or time on film, a MULTI-FUNCTION BACK, which is also called a MULTICONTROL BACK, will imprint other data, such as the film frame number or the f/stop and shutter speed that were used for the exposure. And it offers many of the other special functions just listed. Consult the instruction manuals for both your camera and its accessory data back or multifunction back (if available) to see which specific functions might be valuable for the types of photography you do.

## Fast Filming with Motor Drives

Many of today's 35mm cameras have built-in AUTOWINDERS that automatically advance the film and cock the shutter after each expo-sure so that the camera is ready for the next picture. Those that are especially quick in accomplishing this are usually called MOTOR DRIVES. Some will wind the film, recock the shutter, and fire the camera as rapidly as one to ten FRAMES PER SECONDS (FPS). Motor drives make it easy to record action sequences, as at sporting events.

There are accessory motor drives that can be attached to some older SLR models that do not have a built-in motor drive. They not only bring manual-wind cameras up-to-date but make your life less complicated because the film advances and the shutter recocks auto-matically so you can concentrate immediately on the next shot.

The SPEED OF A MOTOR DRIVE depends on the setting of the camera's film advance mode: high speed or low speed, and single frame or continuous shooting. With single frame, you must press the shutter release button for each exposure; with continuous shooting, as long as you hold down the shutter release button, exposures continue to be made. Other factors that affect the speed include the freshness of the camera or motor drive batteries, and the shutter speed being

172. Capturing action is often easier when your camera is equipped with a motor drive, which rapidly and automatically advances the film and recocks the shutter after each exposure. Here an exuberant young man is caught in midair as he jumps down a sandy hillside at Gunsight Canyon in Utah.

used; at slower shutter speeds, it will take a proportionally longer time for each frame to be exposed.

A problem with the use of motor drives is that some photographers think that if they hold down the shutter release for a series of continuous exposures, they will get the perfect picture. All too often the best action happens *between* exposures. Most pros set the exposure mode for single rather than continuous exposures, then count on their expert judgment and quick reflexes to trigger the shutter release at the moments of the best action.

Motor drives (and autowinders) are useful for close-up and macro work, because there is no danger that the camera will accidentally be moved by the photographer while the film and shutter are automatically advancing and recocking. For this reason, a motor drive is also vital for time-lapse photography. A BULK FILM BACK that holds up to 250 exposures is available for some SLR cameras when a prolonged series of exposures is required, or when fast actions of the subject do not allow the photographer time to change regular rolls of film.

For TIME-LAPSE PHOTOGRAPHY, the camera, its multifunction back, or an auxiliary interval timer is programmed to automatically trip the shutter at preset seconds, minutes, hours, or days in order to make a series of images over a period of time without the photogra-

pher being present. A popular example is recording the growth of a plant or the blossoming of a flower.

Because a motor drive makes it unnecessary for the photographer to cock the shutter and advance the film, the camera can be triggered by REMOTE CONTROLS. This allows the camera to be hidden from the subject's view, as when wildlife and bird photographers want to keep from disturbing their prey. Remote controls are also used in situations that could be physically harmful to the photographer, such as shooting an acrobatic airplane from one of its wing tips.

Motor driven cameras utilize remote control extension cords, infrared, or audio devices to activate them. Other remote firing techniques include the beam of a photoelectric cell that is broken by the subject, or a trip wire that is touched by the subject, which triggers the camera's shutter and activates the motor drive to advance the film. More simply, an extremely long cable release or remote cord can be used to trip the shutter.

Although motor drives are a featured part of many of today's SLR cameras, some photographers dislike the weight and expense of the extra batteries required to operate them, as well as the whir of the motor which may attract attention. In addition, motor drives offer the potentially expensive temptation to shoot many extra frames of film. However, everyone appreciates that a motor drive prevents you from ever again missing a picture just because the film was not advanced or the shutter cocked.

## Buying Used Accessory Equipment

Purchasing used accessory equipment can be a good bargain, especially if you plan to use it only occasionally and cannot afford new equipment. Camera shops often carry a variety of used photo gear taken as trade-ins. Be sure to ask whether this equipment is guaranteed. If so, find out how long the guarantee is valid, and get it in writing on your receipt. Always test all used accessories and return faulty equipment immediately.

Also look for used photo gear in newspaper classified ads. You may find equipment being sold by photographers who have switched to a different type of camera or have just lost interest in photography. Here you have the chance to ask the owner the actual amount of use the photo gear has had. Be certain to check carefully for worn or abused parts. (Ask for instruction manuals, too.) Prices of used accessories in classified ads are often less than they are in camera

stores. However, always compare prices and specific equipment to be sure you're getting the best deal.

Remember, ownership of a multitude of accessories doesn't make you a better photographer, although some carefully selected pieces of extra equipment can help you make better pictures.

# USING POINT-AND-SHOOT AND OTHER CONVENIENCE CAMERAS

There has been a growing demand in the past few decades for what we call CONVENIENCE CAMERAS, ones that are small and easy to operate. They are very popular for making snapshots, but are not generally used for serious photography. One reason is that some convenience cameras use small-size films, so the quality of their pictures often decreases when larger-size prints are made.

The trend toward convenience cameras began in 1963 with the introduction by the Eastman Kodak Company of the first INSTAMATIC CAMERA, noted for its drop-in plastic film cartridge. It meant that snapshot shooters no longer had to thread a roll of film onto a take-up spool in the camera, or to remember to rewind the film after use. With the Instamatic came a new film size, called 126, which recorded square images. They measure 28 × 28mm, which is about 10 percent smaller than the rectangular 24 × 36mm image area of size 135 film used in 35mm cameras.

Next, in 1972, came the POCKET INSTAMATIC CAMERA, along with another new and much smaller size of film, called 110. It records a rectangular image measuring 13 × 17mm, which is about one-fourth the image area of a frame of 35mm film.

A truly pocket-size camera appeared in 1982, another Kodak invention called the DISC CAMERA. It featured a revolutionary film cartridge, a small wheel of film holding 15 exposures that measured a subminiature 8.2 × 10.6mm, nearly ten times smaller than a 35mm film frame. As novel as the disc film was, its tiny image size and availability only as an ISO 200 color print film were major limitations. As a result, disc cameras are no longer manufactured.

Most important, however, the disc camera was a showcase for early microcomputer technology. The hand-size camera, which measured about 3 × 5 inches (7.6 × 12.7cm) and less than an inch

(2.5cm) thick, was virtually automatic. A split second after you pressed the electronic shutter release, the camera's exposure meter read the scene, set the proper shutter speed and lens opening, activated the flash if necessary, took the picture, advanced the film, and recharged the flash.

The disc camera was the forerunner of today's popular COMPACT 35MM CAMERAS, which are commonly called POINT-AND-SHOOT CAMERAS. Their handy size and easy, almost foolproof operation spurred a new interest in 35mm photography. Contributing to the boom were a host of new and improved 35mm films, especially for color prints, and the mushrooming of fast-photo minilabs to process and print the 35mm film in little more than one hour.

In response to the trend toward small, fully automatic cameras— and the ongoing need to excite the vast amateur photography market—another innovative camera system was introduced in 1996. The ADVANCED PHOTOGRAPHY SYSTEM, or APS, was a joint development of five major players in the photo industry: Kodak, Fuji, Canon, Nikon,

173. Because of their automatic features and handy size, point-and-shoot APS and 35mm compact cameras are popular for recording family activities. This engaging young girl is dyeing eggs at Easter.

and Minolta. It features a new 24mm film size with an image area 16.7 × 30.2mm, which is about 42 percent smaller than the image size of 35mm film.

More remarkable is the APS camera's choice of three picture formats: classic (C) format for common snapshot-size photo prints, full-frame (H) format for slightly longer prints, and panoramic (P) format for long and narrow photo prints. The format you select when taking a picture is encoded on the film so that processing machines will automatically produce the photo image size you desire.

Also fulfilling a role as convenience cameras are small, no-frills SINGLE-USE CAMERAS, also known as ONE-TIME-USE CAMERAS. Introduced in 1986 by Fuji, and initially known as throwaway or disposable cameras, they spurred a renewed interest in still photography that has resulted in millions of additional color pictures taken each year. The camera is inexpensive, simple to use, and produces excellent images on 35mm film that is already loaded in the camera when you buy it.

You just wind, aim, and shoot—and then give the entire camera to a film producer. Color negatives and photo prints are returned to you, but not the camera. With concern for the environment now considered good for business, many of these single-use cameras are being recycled by their manufacturers. That helps keep their prices low and reduces unnecessary waste.

An older type of convenience camera that continues to intrigue photographers who can't wait to see the pictures they've just shot is the so-called INSTANT CAMERA. It's better known by its proprietary name, POLAROID. After you press the shutter release, Polaroid's unique film self-processes snapshot-size color photographs in only a few minutes.

All of these varied convenience cameras—35mm compacts, APS models, Instamatics, disc cameras, and instant cameras—will be discussed in this chapter. A separate chapter is devoted to easy-to-use DIGITAL CAMERAS and the evolving era of electronic images generated by computer technology.

## Mastering 35mm Compact Cameras

POINT-AND-SHOOT CAMERA is a generic name that most often refers to AUTOMATIC 35MM COMPACT CAMERAS. They are also called P&S CAMERAS. In reality, either because of their simplicity, as with single-use cameras, or their fully automatic features, as with many single lens reflex

174. Although 35mm compact cameras vary in size, they all are smaller and lighter in weight than 35mm single lens reflex (SLR) cameras.

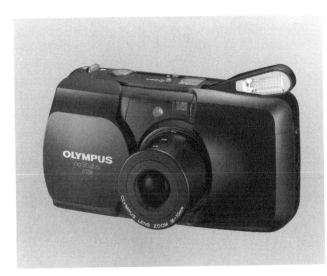

175. Autofocus, auto-exposure, and autoflash are common to 35mm compact cameras; the most versatile models also feature a zoom lens.

(SLR) cameras, the majority of today's cameras are also point-and-shoot cameras. You just aim and fire. Even the first Kodak, introduced by George Eastman in 1888, can be considered a point-and-shoot model.

The early 35mm cameras were rangefinder types, followed by SLR models; both required manual adjustment of several controls, including focus, lens opening, and shutter speed, before the picture could be taken. A milestone in photography was reached in 1979 when Canon introduced the Sure Shot, the first truly compact 35mm camera with all-automatic features: autofocus, auto-exposure, auto-flash, auto film advance, and auto rewind.

Nowadays compact 35mm cameras are the choice of many ama-teur photographers, as well as being the most popular backup or casual cameras among professional photographers. The main differ-ences between 35mm compacts and single lens reflex models is that the compacts do not have interchangeable lenses, their viewfinders do not "see" through the lens, and they feature leaf shutters instead

of focal plane shutters. Sometimes 35mm compact cameras are referred to as LENS-SHUTTER CAMERAS because the shutter is incorporated into the lens; shutters for SLRs are located in the camera body at the film plane.

Compact 35mm cameras are noted for being convenient to carry and easy to use, and for allowing the use of the great variety of 35mm films: color print, color slide, and black-and-white. But not all 35mm compact cameras are created equal. Some are miniaturized shirt-pocket models with fixed focal length lenses, while others are larger models with zoom lenses.

Photographers are faced with an astounding selection of 35mm compact cameras—more than 150 different models at last count. One to a dozen models are produced by nearly every camera manufacturer, including Ansco, Argus, Canon, Contax, Fuji, Kodak, Konica, Leica, Minolta, Minox, Nikon, Olympus, Pentax, Ricoh, Rollei, Samsung, Vivitar, and Yashica.

None of the worthwhile 35mm compact cameras are inexpensive. Their list prices range from $200 to $500 and more, although they sell for considerably less at discount stores. A few models with titanium-metal bodies, top-quality lenses, and manual-override features carry list prices above $1,000, which is more than many SLR cameras cost.

Other than the limitations of your budget for buying a camera, how do you decide which model is best for your photographic purposes? Following is a review of various features—from essential to "nice to have"—that you should consider when purchasing a 35mm compact camera.

Common to all 35mm compact cameras is AUTOFOCUS, which begins when you slightly depress the shutter release. There are two types of autofocusing systems, both of which operate through a pair of windows at the front of the camera. (Beware that your fingers, camera strap, or some other obstruction does not block one or both of those windows.)

Most models feature the so-called ACTIVE INFRARED AF (AUTOFOCUS) SYSTEM, which projects an infrared beam or multibeams from one window toward the subject, where it is reflected back to the other window. A sensor determines the direction in which the lens elements are moved to achieve sharp focus. The less common PASSIVE PHASE DETECTION AF SYSTEM involves an electronic rangefinder that receives two viewpoints of the subject through the two windows and triggers the focusing motor until the pair of images match up in sharp focus. The latter system most often is a feature of SLR cameras rather than compact cameras.

176. Take care when aiming an autofocus camera that your main subject is covered by the focusing frame brackets in the viewfinder. If the brackets are centered between the two heads of people who are side by side, such as these Costa Rican children, the background may appear in sharper focus than your subjects (see text).

In low light and at night, the active infrared (IR) system works better than the passive system, which requires that the subject be of a certain brightness and contrast. (Better passive systems incorporate an AF assist light to overcome these problems.) The passive system excels when you are shooting through glass windows, however, because the active system's infrared beam focuses on the pane of glass rather than on the subject beyond it. For that reason, the better cameras with active IR autofocusing have an INFINITY LOCK; use it to lock the focus at infinity (the farthest distance) to avoid focusing on the windowpane or any other object in the foreground.

Keep in mind that whatever you see through the viewfinder of a 35mm compact camera will appear to be in focus, whether or not the camera lens is in focus. That's because the viewfinder has its own viewing window, unlike with an SLR, which allows you to look through the same lens that is used to take the picture.

Most photographers are unaware that compact cameras actually make changes in focus in a series of steps, or FOCUSING ZONES; the more zones, the more precise focusing will be. Very simple autofocus models have only three or so zones, such as 5 feet, 10 feet, and 20 feet (1.5, 3, and 6 meters). When the subject is located at distances

other than those, the camera depends on the depth of field of the camera lens to produce images that are acceptably sharp. Better models have dozens or sometimes several hundred focusing zones for more precise focus.

You should also realize that the most inexpensive compact cameras have a FIXED FOCUS LENS that does not change; it is designed to put everything from 3, 4, or 5 feet (0.9, 1.2, or 1.5 meters) to infinity in focus. Some manufacturers advertise this as a "focus-free" lens, which sounds like a virtue but is far from the quality of an autofocus lens.

Regardless of the camera's autofocusing system, you must always make certain the main subject that you want in focus is covered by the FOCUSING FRAME, which is located in the center of the viewfinder. Just remember, whatever is the object nearest to the camera covered by those focusing frame brackets in the viewfinder will become the point of focus for the lens.

Common to all autofocus compact cameras is an AUTOFOCUS LOCK, which holds the focus when you slightly depress the shutter release button. This is important because it enables you to focus on a subject that's off center, and then reframe the picture in the viewfinder for the best composition. If you want to change the point of focus before taking the picture, you must release pressure on the button, re-aim the camera, and slightly depress the shutter release button again.

It's important to know the MINIMUM AUTOFOCUSING DISTANCE of your camera, which may be 2, 3, or even 4 feet (0.6, 0.9, or 1.2 meters); if you are any closer, your subject will be out of focus. However, some cameras feature a MACRO MODE or CLOSE-UP MODE to allow focusing on subjects at 1.5 feet (0.45 meters) or closer, which produces an image on the film frame that is as much as one-fourth life-size. It's smart to put a sticker on the camera noting the minimum focusing distance so you won't forget.

Regarding the viewfinders themselves, the simplest offer a direct through-the-camera view, while others are more optically advanced and appear to have good clarity and brightness. The less desirable viewfinders are small and show unwanted distortion or flare.

Because the viewfinders of 35mm compact cameras see through their own viewing window instead of through the shooting lens, what you see may not be what you get—especially if you are close to a subject. In those cases, to avoid PARALLAX ERROR, use the alternate framing marks in the viewfinder when composing the picture, or else a portion of the subject may not be recorded by the film (see page 13). The better cameras have a viewfinder frame that visually shifts to

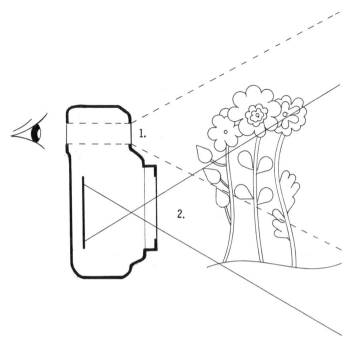

177. Parallax error can be a problem with some compact cameras when shooting subjects close-up. It occurs if you see a different portion of the subject through the viewfinder (1) than the film records through the camera lens (2). In this example, the camera must be tilted up in order to photograph the flower blossoms as desired. Some cameras have parallax correction marks or shifting frames in the viewfinder to help you compose close-up subjects correctly.

automatically compensate for subjects close to the camera so you can frame the subject just as you see it.

The best models of compact cameras with dual focal length or zoom lenses will have REAL IMAGE VIEWFINDERS. They optically change or zoom to realistically show the picture area rather than just use framing marks or a mask in the viewfinder to indicate the area covered by the lens. Cameras featuring a special mode to produce PANORAMIC IMAGES also have framing marks or a mask in the viewfinder to outline the elongated subject area that will appear in the photo print.

Just as autofocus is a standard feature of almost all 35mm compact cameras, so is AUTO-EXPOSURE. While the metering systems built into compact cameras are less sophisticated than those found in single lens reflex cameras, they are more than adequate for color print film, which is the most popular type of film used in compact cameras and has the most exposure latitude (see page 98).

Most exposures require no more involvement of the photographer

than just pressing the shutter release button; you cannot select a specific f/stop or shutter speed (except in a very few top-of-the-line models). Whenever the shutter release is partially or fully depressed, the exposure metering system reacts to a light sensor on the front of the camera and automatically sets the lens opening and shutter speed according to combinations preprogrammed in the camera's microcomputer.

However, there are a few options for OVERRIDING AUTO-EXPOSURES to purposely underexpose or overexpose a subject. The most basic is locking in a particular exposure by slightly pressing the shutter release button. That way you can use your own judgment regarding exposure by aiming the camera at a brighter or darker area, locking in the exposure reading, and then recomposing the picture in the viewfinder before fully pressing the shutter release. (Warning: When locking in the alternative exposure, you should be aiming at something located at the same distance as your main subject, because the autofocus will be locked in at the same time.)

Some cameras offer a BACKLIGHT MODE to automatically increase the exposure by one and one-half to two f/stops, which prevents your subject from becoming a silhouette when the sun or some other strong light is behind your subject. Advanced models offer more extensive EXPOSURE COMPENSATION by allowing you to automatically increase or decrease the exposure by one or more f/stops in specific plus or minus (+/−) steps.

Look for other camera features that provide more ways to control exposure in special situations. A NIGHT MODE, for instance, sets a slow shutter speed and wide lens opening, and prevents the built-in flash from firing, so you can make exposures of the city lights, fireworks, and other after-dark subjects. The BULB MODE or TIME MODE setting allows for longer time exposures. A TV MODE sets a slow shutter

178. Some compact cameras feature a backlight button or other method for auto-exposure compensation so that backlighted subjects will not be recorded as silhouettes.

speed (about 1/30 second) so no distracting electronic bands will appear in your photos of a TV or computer screen. Always consult the camera's instruction manual for specific advice about altering automatic situations like those just described that require slow shutter speeds.

The RANGE OF SHUTTER SPEEDS AND F/STOPS is more limited with a 35mm compact camera than with an SLR. Remember when buying a compact camera to check the camera's specifications; the greater the range of shutter speeds and lens openings, the better chance for accurate exposures in a variety of shooting situations. For example, a camera with shutter speeds that range from 2 seconds to 1/500 second is preferred to one that may only shoot as slow as 1/2 second and only as fast as 1/250 second.

A fast shutter speed is especially important for cameras with a telephoto zoom lens in order to prevent blurred images caused by camera shake. At least one model incorporates VIBRATION REDUCTION, a unique stability feature to counteract inadvertent camera movement at the longer telephoto settings and at slower shutter speeds, such as 1/15 and 1/30 second.

As for the range of maximum lens openings, it varies depending on the particular type of lens on the compact camera; see the discussion of lenses that follows. Always check the instruction manual to learn a camera's specific range of shutter speeds and f/stops; they are not indicated on the camera itself.

All 35mm compact cameras are designed for use with DX-CODED FILM CASSETTES to automatically calibrate the camera's exposure metering system for the ISO film speed. The greater the DX range, such as ISO 25 to 3200, the more versatile the camera, because a wider selection of 35mm films can be used. The most basic models accept DX-coded ISO 100, 200, 400, and 800 (or 1000) films. Beware if you ever use a film cassette *without* DX coding, such as infrared film, because compact cameras will default to ISO 100 or ISO 25, regardless of the actual speed of the film.

If 35mm compact cameras seem similar because of their standard automatic features, what sets them apart from one another is the focal length of their lenses. The variety includes single focal length, dual focal lengths, wide-angle to telephoto zoom focal lengths, and long telephoto zoom focal lengths.

The smallest compact cameras have SINGLE FOCAL LENGTH LENSES. Often that focal length is 35mm, but there is some variation, including lenses of 28mm, 31mm, 32mm, 38mm, or 40mm. The common maximum lens opening is f/3.5, although a few are f/4. Wider lens

179. With a dual focal length lens or a zoom lens, you can increase the size of your subject on the film without getting physically closer with your camera.

openings, such as f/2, f/2.4, and f/2.8, are only available on very high-priced models.

A step up in versatility are DUAL FOCAL LENGTH LENSES, which offer a choice of two focal lengths at the touch of a button or flip of a switch. The best of these DUAL-LENS CAMERAS will double the image size, such as 38mm/80mm. Most offer less than a significant change in image size: 35mm/50mm, 24mm/30mm, 28mm/48mm are examples. Some models actually have two lenses, while others incorporate an optical converter to increase the effective focal length of a single lens.

Be aware that the maximum lens opening also changes when the focal length is changed. The greater the focal length, the smaller the maximum lens opening. For instance, in one model, the maximum lens opening is f/3.7 when the focal length is set to 38mm, and only f/7.3 when switched to its 80mm focal length. Because more light is required for a proper exposure when a smaller lens opening is used, faster-speed films are recommended, such ISO 400.

Although larger in relative size, compact cameras with ZOOM LENSES are the most useful and have superseded dual focal length lenses. A motor changes the zoom lens focal length when you press either of two buttons, or either side of a toggle or rocker switch. The buttons or switch positions are often marked with a W or WA for the wide-angle end of the zoom range, and a T for the telephoto end of the zoom range.

As with dual focal length lenses, the MAXIMUM F/STOP of the lens changes as the zoom range is changed; the lens opening gets considerably smaller when zoomed from wide-angle to telephoto. At the shortest focal lengths (the wide-angle position), the maximum lens openings are f/3.5, f/4, f/4.5, or even f/5.6. At the longest focal lengths (the telephoto position), the maximum lens openings range from f/6 to as small as f/11. That should prompt you to use a faster-speed film, such as ISO 400 or ISO 800, even though high-speed films cost more than those of slower speeds.

Check the camera's technical data to learn its range of maximum lens openings; that information is not inscribed on the zoom lens itself. What you will find written around the edge of the lens is its range of zoom focal lengths.

Of the two general categories of compact cameras with zoom lenses, the MEDIUM WIDE-ANGLE TO MEDIUM TELEPHOTO ZOOM MODELS, sometimes called MIDRANGE ZOOMS, offer the greatest variety. They are often the most practical for general photography, especially models that have a range from 28mm wide-angle to at least 70mm telephoto, which is more than double (2X) the minimum image size. Even more versatile is one that multiplies the image size at least three times (3X), such as from 28mm to 90mm. Less satisfactory are cameras with shorter zoom ranges, which may begin at 32mm, 35mm, or 38mm.

For photographers who favor a stronger telephoto, perhaps for nature or travel photography, the LONG TELEPHOTO ZOOM MODELS, sometimes called SUPER ZOOMS, are the preferred zoom category of 35mm compact cameras. Their widest angle is usually 38mm, and most zoom to at least 115mm, which is very nearly three times (3X) the minimum image size. Some zoom to a maximum focal length of 120mm, 130mm, 135mm, and even 140mm (which is $3\frac{2}{3}$X the minimum 38mm image size). Although the lens extends considerably at its greatest telephoto focal length, the camera is still quite compact when the lens is zoomed back to the wide-angle position.

A most welcome feature of 35mm compact cameras is BUILT-IN AUTOFLASH. When the existing light is insufficient for a proper exposure, the flash turns on to provide the necessary illumination. The

180. The built-in autoflash in compact cameras provides a good balance between the flash light and ambient light. However, memorize the flash range of your camera in order to avoid overexposures or underexposures (see text).

important thing to know is the camera's FLASH RANGE, the minimum/maximum distance its light will cover without overexposing or underexposing the picture.

The minimum flash distance is usually from 1 to 3 feet (0.3 to 0.9 meters), depending on the camera model. The maximum flash distance is a more important consideration, because the flash light is often too weak to reach very far, and underexposed photos are the result. Try to choose a camera with a flash that has the greatest maximum distance.

Keep in mind that the flash distances published by the manufacturers are usually based on ISO 100 or ISO 400 film speeds, so be sure your comparisons of camera flash outputs are for the same speed of film. Also remember that the maximum flash distance will vary according to the focal length of the lens, so compare identical focal lengths as well.

In general, the longer the focal length (i.e., the telephoto settings), the shorter the flash distance. That's because the lens opening is smaller when the lens is switched or zoomed to the telephoto settings. Thus, the flash distance will be greater for the wide-angle settings because the lens opening is larger and lets in more light.

For single focal length lenses, the flash (with ISO 100 film) may

reach about 10, 11, or 12 feet (3, 3.3, or 3.6 meters). For zoom focal length lenses, the maximum flash distance may be 11 to 21 feet (3.6 to 6.4 meters) at the greatest wide-angle setting, but only 7 to 11 feet (2.1 to 3.6 meters) at the longest telephoto setting.

One flash feature found on almost all 35mm compact cameras is RED-EYE REDUCTION. Because the built-in flash is close to the camera lens, and subjects keep the pupils of their eyes open in dim light, the flash light reaches the retina and records as unnatural red dots on the film. To cause the pupils to constrict and thus reduce the chance of red-eye, a steady light, a single PREFLASH, or multiple preflashes from the camera are triggered just prior to the actual flash exposure.

Another helpful flash feature offered on some models is a FLASH-OFF BUTTON that you press to cancel the autoflash. This is necessary when you want to take pictures at night without the flash, or when you know the distance of your subject is too far for the flash to reach, or when flash photography is not permitted, as inside some museums or during a concert or stage play.

A very useful feature allows you to use flash in daylight; normally the built-in autoflash only works indoors and in other low-light conditions. The main reason to use flash in daylight, especially in bright sunlight, is to fill in any shadows on the faces of your subjects. Cameras with an AUTO FILL-FLASH MODE are best because it provides the perfect balance of flash and natural light exposure. Other cameras have just a simple FLASH-ON BUTTON to add flash illumination when you want it. If there is no switch to turn on the flash, and the camera has a pop-up flash, try covering the exposure meter light sensor (while slightly depressing the shutter release) to fool the metering system into thinking that flash light is needed. The flash should pop up and be ready to use for fill light. Push it back into the camera to turn the flash off.

Of course, two standard features on all 35mm compact cameras are AUTOWIND and AUTO REWIND. Autowind automatically loads and advances the film after you insert the film cassette, pull out the film leader to the camera's FILM LOADING MARK, and close the camera back. When the final frame of film is exposed at the end of the roll, the auto rewind feature automatically rewinds the film back into the cassette; some models require you to first press a FILM REWIND BUTTON. This button can also be used anytime to rewind the film, such as when you want to have the film processed before it reaches the end of the roll.

Most cameras advance the film to the first frame; a few models first PREWIND all the film onto the camera's film take-up spool. This is done so that subsequently exposed frames will be wound back into

the lighttight cassette and protected from ruin in case the camera back is accidentally opened. When the last frame is exposed, the film is almost all back inside the cassette and ready to be removed from the camera. Prewind is a nice feature, but uncommon.

Standard on all models is a FILM FRAME COUNTER that indicates the frame number of the film you are currently shooting. Some display the number mechanically in a tiny window, while others show it as an electronic readout in an LCD information panel (see later in this section). In many models the frame counter winds backward to indicate when the film is being rewound.

In the rear of all 35mm compact cameras is a FILM CASSETTE WINDOW that lets you see if a roll of film is in the camera. Through the window you can also read the film information printed on the cassette: its type, ISO speed, and the total number of exposures.

A part of most 35mm compact cameras is a SELF-TIMER that trips the shutter release after about 10 seconds so the photographer can also be in the picture. Another reason to use the self-timer is when you want a hands-off exposure to avoid inadvertent camera movement (see page 23). Some have a VARIABLE SELF-TIMER so you can select a shorter time delay. Other self-timers can be set to take two or three pictures in succession.

A much ballyhooed feature of a number of 35mm compact cameras is a PANORAMIC FORMAT. In reality, the film frame is simply masked at the top and bottom to give a panoramic effect in a standard photo print. (It's often more effective just to crop and enlarge a full-frame image to a wider dimension.) Cameras with panoramic capability have marks or masks in the viewfinder to help you properly frame your subject for this elongated format.

Several models of 35mm compact cameras feature an optional DATA BACK that serves as a clock and calendar and imprints the time and/or date on each frame of film. Some photographers like this feature when documenting special events, such as birthdays and anniversaries. Rather than including the somewhat distracting numbers in every picture, consider dating only one or two frames at the beginning of the film roll. Always remember to turn off the date function so you won't inadvertently date every picture you take. Also be careful not to switch on the data mode accidentally.

Various cameras may offer an assortment of other special functions that are of only limited use to most photographers. Among them are REMOTE CONTROL to trip the shutter release when you are away from the camera, MULTIPLE EXPOSURE CONTROL to take two or more exposures on the same film frame, CONTINUOUS SHOOTING to

181. A panoramic format is a feature of some compact cameras. Marks or a mask in the viewfinder indicate the picture area that will be printed by the photo-finisher, such as this line of camels transporting tourists in Alice Springs, Australia.

keep the shutter firing as long as the shutter release button is fully depressed, and an INTERVAL TIMER to automatically take a series of exposures at the interval of time you preset.

On the top side of some compact cameras is an LCD (LIQUID CRYSTAL DISPLAY) INFORMATION PANEL to indicate the status of the camera and its controls, including which special functions are engaged. Normal information includes battery status, ISO film speed, current frame number, and a flash-ready indication. More basic models may signal with LED (light-emitting diode) symbols and colored lamps in the viewfinder when the flash is ready to fire and/or when the subject is in focus.

Of course, all the automation and special features of 35mm compact cameras require BATTERY POWER. Almost all models use high-energy, long-lasting, and somewhat expensive lithium batteries. Most are 3-volt, but they come in a couple of sizes; some cameras require two of these batteries to provide 6 volts of power. Other compacts use a pair of 1.5-volt AA-size batteries. When replacing the battery or batteries, take an old one to the store to make certain you're getting the proper replacement size. Whenever you are going on vacation or photographing a special event, be certain to carry a spare battery. If you'd rather just forget about batteries, buy a SOLAR-POWERED COMPACT CAMERA, which gets its energy from the sun and stores the power in a permanent built-in battery for use at any time.

All 35mm compact cameras are generally very durable and are made of high-impact plastic, although a few have metal bodies or embellishments. Some are designed for use in inclement weather

182. Some compact cameras are advertised as weatherproof and are recommended for photography in all kinds of climatic conditions. Others are waterproof models, which are ideal for pictures at the seashore and can even be taken underwater to a limited depth.

conditions and/or underwater. WEATHERPROOF CAMERAS are sealed against rain, snow, and other moisture, as well as sand and dust. WATERPROOF CAMERAS, on the other hand, can actually be taken underwater. The depth is limited to 16 feet or so (4.8 meters), because potentially damaging pressure builds up on the camera the deeper it goes. Some waterproof cameras override autofocus to a preset focusing distance for underwater pictures.

Before purchasing any 35mm compact camera, always handle it first to see how conveniently its particular size fits in your hands, and if the controls are easy to reach and operate; some compacts have a more comfortable ergonomic design than others. Pay the most attention to the range of lens focal lengths (if a zoom), the maximum lens opening(s), and the flash distance range. Don't spend more for features you don't expect to use or that only make the camera more complicated to operate.

After buying a camera, first do two things: Attach the camera strap and use it when handling the camera, and carefully read and reread the camera's instruction manual.

## Avoiding Compact Camera Calamities

Despite being described as point-and-shoot (P&S) cameras, 35mm compact cameras require you to pay attention to what you're doing. Otherwise, there is no guarantee of getting good pictures. Here are some of the most common pitfalls you should try to avoid.

Because you see through the viewfinder, and the film sees through the separate camera lens, make certain your fingers or camera strap do not accidentally cover part of the camera lens.

Likewise, be careful that your fingers or camera strap do not cover any of the camera windows used for autofocus and auto-exposure. Also, check that nothing blocks the flash when you use it.

Besides keeping the camera lens free of dust and finger marks (use a microfiber cleaning cloth), be sure the autofocus and auto-exposure windows, and both sides of the viewfinder, are just as clean.

When shooting with backlight or side light (see page 347), check that the sun is not shining on the camera lens. If it is, use your hand or even an umbrella to shade the lens in order to avoid flare, which will degrade your photos.

If making a portrait with a camera that has a zoom lens or a dual focus length lens, shoot at the telephoto setting rather than the wide-angle setting so the face of your subject will not be distorted.

Make certain your focusing frame in the viewfinder covers at least part of your main subject, or it will be out of focus. Pay attention especially when the subject is off center, or when two subjects are side by side. One of the most common problems with 35mm compacts occurs when the focusing frame falls between the faces of two shoulder-to-shoulder people, and the camera focuses on the background. Use the autofocus lock, as previously described, to avoid this.

Also, watch that foreground objects are not included in the focusing frame, because the camera will focus on the *nearest* object. If your main subject is beyond that foreground object, it may be out of focus.

Train your shooting finger to press, not jab, the shutter release to avoid camera shake. Also, don't press the shutter release until your subject is in the viewfinder, or you may trip the shutter and take an unwanted picture. If you've locked in the focus by slightly depressing the shutter release, keep a steady pressure on the release or the camera may refocus before you fully depress the release to take the picture.

If nothing works, check the battery. Remove it and wipe the contact points of the battery and battery chamber in the camera with a dry cloth or pencil eraser. If the camera still fails to operate, it's time for a new battery.

## Better Snapshots with APS (Advanced Photo System) Cameras

A novel, small-format film, camera, and photofinishing system was introduced worldwide in 1996 by dozens of photo equipment manufacturers. At first glance the APS cameras appeared only to be smaller versions of 35mm cameras, which have long been the favorite cameras of most amateur photographers, as well as many professionals.

However, the Advanced Photo System was actually a bold attempt to create another worldwide market for traditional photography. Nearly a decade of consumer research and millions of dollars of cooperative development went into this entirely new generation of cameras and films. The goal of the photo companies that produce the wide array of compatible APS products is to make it easier for more people to take better pictures. Just what is so revolutionary about the Advanced Photo System?

First, the APS FILM. It is contained in a *sealed* plastic film cassette, which drops into the camera for easy, fast, and foolproof automatic loading. Unlike 35mm film, there is no film leader to extend over film sprockets or to attach to a film take-up spool. Also, the newly designed cassette has four FILM STATUS INDICATORS, which are numbers and symbols (icons) located on one end of the cassette that indicate the status of the film inside: (1) a circle = unexposed, (2) a half circle = partially exposed, (3) an X = fully exposed but not yet processed, and (4) a square = exposed and processed.

The fourth symbol doesn't mean the film cassette is empty. A unique feature of APS is that after the film has been developed, the negatives are returned to the cassette and sealed inside for safe storage and easy retrieval to make extra prints or enlargements. A rejection mechanism prevents you from loading your camera with a cassette that contains processed negatives or a roll of film that has already been exposed.

Another APS advantage: A cassette with a *partially exposed* roll of film can be removed from the camera at any time without ruining any pictures, in case you decide to change to another brand or speed of film. (Some models do not offer this MID-ROLL CHANGE feature.)

183. Smaller and more sophisticated than 35mm compact cameras are APS (Advanced Photo System) cameras, which use APS film that is only 58 percent of the size of 35mm film.

184. Some APS cameras are single lens reflex models that feature interchangeable lenses like their bigger brothers, the 35mm SLRs.

APS small-format film, which is 24mm wide, offers a choice of 15, 25, or 40 exposures. Initially it was available as a color print film in three popular film speeds, ISO 100, 200, and 400; an ISO 100 slide film followed soon after. Most APS films are not just smaller versions of 35mm films; they incorporate improved light-sensitive emulsions on a thinner, flatter, and stronger polyester film base.

The film's most innovative feature is a MAGNETIC COATING that digitally records information about the lighting and other picture-taking conditions. Included is scene brightness, any detection of backlight, whether flash was used and if the subject was in range of the flash, the subject's distance, and its relative magnification. This information is then used by special APS photofinishing equipment to make corrections for lighting and exposure conditions in order to automatically produce the best color prints possible.

However, beware of shooting with the least expensive APS cameras. They do not magnetically record information on the film, which

means the quality of their prints will not be optimal. Users of these cheaper cameras lose a major benefit of the Advanced Photo System.

One APS attraction is that the back of each photograph is printed with the film cassette identification number, frame number, date of exposure, and other exposure data for reference and convenience when ordering extra prints. Some APS camera models offer even more extensive BACK-PRINTING, such as a caption or title you can give to each roll or picture.

To make ordering reprints and enlargements especially easy, an INDEX PRINT is returned with the roll of negatives that is enclosed in the original film cassette. The print shows a full-color thumbnail picture of each film frame, and its number.

An original feature of APS cameras is the PRINT FORMAT CONTROL that lets you choose one of three different picture formats when taking a picture. They are H (high definition/group), which covers the entire film frame; C (classic), which trims a little off each side of the frame; and P (panoramic), which cuts a considerable amount off the top and bottom of the film frame. When you set H, C, or P on the camera, FRAMING MASKS are adjusted in the viewfinder to help you compose the picture. Also, the format you

185. Every roll of APS film is returned from the photofinisher with an index print that has a thumbnail image of each frame of film, which provides a convenient record as well as easy reference to frame numbers when ordering reprints. The negatives are returned in the film cassette for safekeeping.

select is magnetically recorded on the film to instruct the photofinishing machine as to which format should be printed for each particular film frame.

The size of APS prints depends on the format and the standard sizes offered by your photofinisher. For example, the C (classic) format can produce a print 4 × 6 inches (10.2 × 15.2cm), while the H (high definition/group) format produces a wider 4 × 7-inch (10.2 × 17.8cm) print, and the P (panoramic) format an almost double-width 4 × 11.5-inch (10.2 × 29.2cm) print. Best of all, regardless of the format you choose when shooting, the negative actually contains a *full image* on the film frame. That means standard-size prints or enlargements can be ordered in formats other than the one you selected when taking the picture.

Finally, the film's magnetic coating holds promises for the future, such as recording voices or sounds and adding them to the finished print (a "talking picture"). Already there are devices called PHOTO PLAYERS that show the pictures from a roll of APS film on your TV screen. (The H [high definition/group] format, in fact, has the proportions to fit on the screen of a high-definition television set and is sometimes designated HDTV.) And there are PHOTO SCANNERS that digitize APS color negatives or color prints electronically to display the pictures on your personal computer monitor, transmit them anywhere in the world via the Internet, or make photolike prints with a color printer.

A big question: Does the smaller film size (the APS image area is 42 percent less than that of 35mm film) produce photographs as high in quality as those taken with today's popular 35mm cameras? Keep in mind that the creators of the Advanced Photo System designed their APS films and computer-linked photofinishing equipment to please photographers content with the standard snapshot sizes of machine-made prints. Be sure to make your own side-by-side APS-versus-35mm-print comparison tests, especially for enlargements 8 × 10 inches (20.3 × 25.4cm) or greater. For the best APS print results, be certain that the processing lab you choose is designated a Certified Advanced Photo System Photofinishing Service.

As to the APS CAMERAS themselves, most are point-and-shoot (P&S) models, including many with zoom lenses, which resemble smaller versions of 35mm compact cameras. But there are also single lens reflex (SLR) models that can be used with zoom, macro, and other interchangeable lenses. The standard or normal lens focal length for APS cameras is 24mm or 25mm. The majority of APS cameras fea-

186. APS cameras offer a choice of print formats in three sizes, including panoramic (see text). (Photos courtesy of Eastman Kodak Company.)

ture autofocus, auto-exposure, and autoflash with red-eye reduction, as well as autoload, autowind, and autorewind. Inexpensive models have fixed focus. There are single-use APS cameras as well (full-frame format only), preloaded with a roll of film that's returned with the camera for processing.

If you are considering buying an APS camera, avoid the basic models that lack important features, especially the unique magnetic INFORMATION EXCHANGE (manufacturers abbreviate it as IX) between camera and film and photofinishing machine.

Finally, here are two simple but important tips. Since most APS cameras are so small, you must be careful to hold them steady, or suffer the result: blurred pictures. Also, watch out that you don't accidentally cover the camera lens or the built-in flash with your fingers.

## Simple Shooting with Single-Use Cameras

What's the ultimate in a convenience camera? The ubiquitous single-use camera, which requires that you only aim and shoot. The lens opening, shutter speed, and focus are all fixed, and even the film is preloaded in the camera. When all the exposures have been taken, the entire camera is given to a photofinisher for processing of the film and prints. Much of the camera is then recycled as parts for subsequent single-use cameras.

Basically a plastic box in colorful cardboard wrappings, this low-cost, mass-marketed, ONE-TIME-USE CAMERA sells in greater numbers than all other 35mm cameras combined. The popularity of single-use cameras has been boosted by its evolution into flash, panoramic, and waterproof models. Single-use cameras are also packaged and marketed with special themes or as limited editions, such as for weddings, the Super Bowl, and the Olympics. There is even a talking model that prompts subjects to "Smile!"

Although Kodak's Fun Saver and Fuji's QuickSnap models are best known, single-use cameras are offered by many film and camera manufacturers, including Agfa, Konica, Imation, Minolta, Polaroid, and Vivitar. Like color film, they are sold almost everywhere, but especially at grocery, drug, discount, and camera

187. There are many brands of single-use cameras, which are available with or without built-in flash. For processing of its preloaded film, the entire camera is given to a photofinisher.

stores. They are even dispensed by vending machines at tourist sites.

Perhaps you forgot your APS or 35mm compact camera, or didn't want to harm your SLR. Photographers often buy single-use cameras so they'll at least have some snapshots of a family outing or a special event. FLASH MODELS let you shoot indoors, or fill in shadows on subjects outdoors. WATERPROOF MODELS allow you to be carefree with the camera on the ski slopes or at the beach; most can be taken *underwater* to a depth of 10 or 12 feet (3 or 3.6 meters). PANORAMIC MODELS offer wide-vista scenic shots, and can include everyone in family reunion pictures; some panoramic cameras offer flash for indoor/outdoor use.

The remarkable results from single-use cameras usually surprise photographers. A main reason for the good quality of the images is that much-improved COLOR PRINT FILMS are loaded in the cameras. (Single-use cameras are not available with color slide films, but there are a few models loaded with black-and-white print film.) Some feature ISO 400 speed film, while others have twice-as-fast ISO 800 film. The NUMBER OF EXPOSURES is commonly 24, although some models boast "plus 3" for a total of 27 exposures. Others offer only 12 or 15 exposures.

The fixed focus plastic lenses of single-use cameras produce relatively sharp images, especially if enlarged only to the standard SNAPSHOT PRINT SIZES of $3^1/_2 \times 5$ or $4 \times 6$ inches ($9 \times 13$ or $10 \times 15$cm). Panoramic images are returned as double-wide prints measuring $3^1/_2 \times 10$ or $4 \times 12$ inches ($9 \times 25$ or $10 \times 30$cm).

While technical data is of no concern to most users, it is interesting to compare single-use cameras with other 35mm cameras. For example, the FIXED FOCUS RANGE of basic flash, nonflash, and waterproof models usually is from 3 or 4 feet (0.9 or 1.2 meters) to infinity, while panoramic models are focused from 1.5 or 3 feet (0.45 to 0.9 meters) to infinity.

As for LENS FOCAL LENGTHS and LENS OPENINGS, basic and waterproof models usually have 35mm lenses with a fixed aperture of f/11. Panoramic models have a 17mm f/13.5 or 25mm f/12 lens.

Depending on the model and manufacturer, the SHUTTER SPEED of a single-use camera is fixed at 1/100, 1/125, or 1/150 second. Regarding the RANGE OF THE FLASH, it usually reaches only as far as 10 feet (3 meters). In some models, a switch or button must be pushed or held to charge the flash before use.

VIEWFINDERS are either open (you see through an actual hole in the camera) or optical. Most include only 85 percent or so of the subject area, which means somewhat more subject area than you see

through the viewfinder will appear in the negative and most likely in the print.

Ever since their introduction in 1986, single-use cameras have been improved in design and quality. Within a decade, the basic box became stylishly thin and evolved into SHIRT-POCKET MODELS that have different specifications. For example, Vivitar's ultrathin models feature a 30mm f/9.5 lens with fixed focus from 1.5 feet (0.45 meters) to infinity.

Regardless of the brand or model of single-use camera, here are a few commonsense tips for frustration-free shooting and better photos. Because of the camera's small size, beware of accidentally covering up the lens or flash with your fingers. Press—don't jab—the shutter release. Remember to advance the film before the next exposure. Also precharge the flash, if necessary, by pressing or holding in the button that charges the flash on some models. And be sure to wait for the flash unit's ready light to signal that the flash is ready to fire.

Also remember that the film winds into (not out of) the film cassette after each exposure, so the FILM FRAME COUNTER shows the number of exposures *remaining*, not the number of exposures you have already taken. When the counter reaches "0," all the film has been wound back into the film cassette for removal by the photofinisher who receives the single-use camera for processing.

188. Some models of single-use cameras are waterproof and can be submerged to 10 or 12 feet (3 or 3.6 meters) for underwater photography.

The next time you'd like to take pictures but have left your camera at home, don't get upset—just buy a single-use camera. It's inexpensive, available almost everywhere, and produces some rather remarkable snapshots.

## Almost Gone but Not Forgotten: Instamatic and Disc Cameras

As mentioned at the beginning of this chapter, Kodak's Instamatic film-cartridge cameras of the 1960s triggered the ongoing desire for convenience cameras. Although the majority of snapshooters have since switched to single-use cameras or more advanced APS and 35mm compacts, there are millions of Instamatic cameras in existence. Included are the original models using drop-in 126-size film cartridges, and the subsequent pocket Instamatics that use smaller 110-size film cartridges. Also around but now useless are disc cameras that Kodak brought to the point-and-shoot marketplace in the 1980s. They used a unique disc of subminiature film that Kodak discontinued after seventeen years.

Although camera manufacturers no longer make disc cameras or 126-size Instamatic-type cameras, a few still offer updated cameras designed for 110-size film cartridges. Kodak's Cameo Motor 110 camera, for instance, features film autowind, fixed focus from 5 feet (1.5 meters) to infinity, and a flip-up flash that helps reduce the chance of red-eye. Other camera makers, including Vivitar and Ansco, also offer motorized and manual-wind 110 models, all with built-in flash.

If their popularity declines significantly, however, you can expect 110 cameras to be discontinued. It's probable that Kodak will continue to make the 110-size color print film those cameras require, just as they still produce 126-size cartridge film for Kodak's earlier convenience camera. Although these films are not readily available at most photo retailers, you should be able to order them through camera chain and discount stores or mail-order companies. Kodak maintains a toll-free telephone information service to help you locate the film you need: call (800) 242-2424.

Kodak currently makes 110-size color print film in 24-exposure cartridges with a choice of ISO 200 and ISO 400 speeds, and 126-size ISO 200 color print film in 12- and 24-exposure cartridges. Also check for Agfa, Fuji, and 3M's Imation 110-size films.

## On-the-Spot Prints with Polaroid Instant Cameras

The era of convenience cameras really began back in 1947 when Dr. Edwin Land announced the invention of his original Polaroid camera. This mid-twentieth century marvel was a so-called INSTANT CAMERA with film that produced a black-and-white snapshot picture in only a few minutes after the exposure was made. Polaroid now sells 4 to 5 million of its instant color print cameras annually to a worldwide market, thanks to significant improvements over the decades that have continued the interest in instant photography, especially outside North America. (Polaroid has few competitors; in 1986 a U.S. federal court barred Kodak from the instant camera business after finding the company guilty of violating Polaroid's patents.)

Long gone are the frustrations with the early Polaroid cameras that required the photographer to manually pull the film from the camera. That procedure was not only slow, but jerky movements by the photographer could cause an unevenly developed picture. Also, there were messy chemical-covered negatives that had to be separated from the print and then discarded. These PEEL-APART FILMS have been superseded by INTEGRAL FILMS, which automatically turn into the finished photograph after exposure. There is nothing to throw away,

189. In addition to autofocus and built-in flash, this Polaroid instant camera features a storage compartment to hold the prints during development, and afterward, so your hands are free to continue taking pictures.

because the negative remains as a part of the color print. Sticky prints are also a thing of the past; even as the print is developing, it is dry to the touch. (Polaroid's professional instant films for commercial uses are still the peel-apart type.)

Automation is the byword for Polaroid's current instant camera models. Just aim, shoot, and wait for the image to self-develop. During the motorized processing procedure that begins automatically after each exposure, the film is forced through a pair of rollers to break chemical pods that evenly cover the film for development. That ensures uniform results, as well as allowing a faster series of photographs to be made than was possible in the past.

A milestone in instant camera innovations occurred in 1993 when Polaroid introduced a more compact and totally redesigned AUTO-FOCUS SLR CAMERA, the Captiva. (In Europe the same model is named Vision, and in Japan it is called JoyCam.) It quickly captivated a new group of enthusiasts for instant photography, because unlike with all other instant cameras, the developing color prints are not ejected from the camera but held in a see-through compartment in the bottom of the camera. That means the photographer's hands are free to continue taking pictures.

The built-in storage compartment holds up to 10 prints, an entire pack of film. The last picture you shoot always appears on top; it takes about five minutes for each picture to fully develop. Any or all of the photographs can be removed from the storage chamber at any time.

The Captiva uses an innovative fine-grain film, Captiva 95, which produces pocket-size prints measuring $2^{1}/_{2} \times 4^{3}/_{8}$ inches (6.4 $\times$ 11.1cm) but with a considerably smaller image size, $2^{1}/_{8} \times 2^{7}/_{8}$ inches (5.4 $\times$ 7.3cm). You can have enlargements made by Polaroid to $3^{1}/_{2} \times 5$ inches (8.9 $\times$ 12.7cm), a standard snapshot size, or much bigger to $5 \times 7$ and $8 \times 10$ inches (12.7 $\times$ 17.8 and 20.3 $\times$ 25.4cm). Film in the 10-exposure pack has a film speed of ISO 600, and each pack includes a fresh battery to operate the camera's automatic exposure, focus, and flash features.

The Captiva camera is a single lens reflex, so you will see in the viewfinder exactly what will be recorded on the film. For shooting, the rectangular camera pulls out with a bellows to a triangular shape when you open it by pushing a button on top of the built-in flash.

The flash goes off for each picture you take, either as the main source of light or as fill light when the existing light is bright enough. The flash range is 2 to 10 feet, although the camera focuses automatically from 2 feet to infinity. The flash recycles for reuse in 2 to

5$\frac{1}{2}$ seconds, which is the maximum time you'll have to wait before taking another picture.

Other features of the Captiva include an exposure adjustment control to lighten or darken the exposure up to three-quarters of an f/stop, a self-timer with a 12-second delay, audible electronic beeps to warn you when the camera is out of film or the picture storage chamber is filled, ready-to-shoot signal lights, and a tripod socket.

Unlike the Captiva, which holds exposed prints in a compartment on the camera, OTHER POLAROID INSTANT CAMERAS automatically eject the prints from the camera immediately after the picture is taken. Among them is the popular and most inexpensive OneStep model with fixed focus, built-in flash, and a close-up setting for subjects 2 to 4 feet (0.6 to 1.2 meters) away. Other models include autofocus, autoflash Spectra cameras, and the high-tech, heavy-duty ProCam, a professional single lens reflex camera for business use. Besides featuring auto-exposure and a unique sonar autofocusing system that is effective even in very dim light, the ProCam offers a wider-angle lens, extended flash range, and the option to imprint a date or time code on each photograph.

There are several sizes and types of INSTANT FILMS, so be certain to buy the one designated for the camera model you are using. Popular Polaroid films include Captiva 95 for Captiva models, Spectra for Spectra and ProCam models, and 600 for OneStep models. Some older Polaroid cameras use Time-Zero SX-70 films.

All of these integral films produce glossy prints that are self-developing, and are supplied in 10-exposure packs. Each pack has a wafer-thin 6-volt disposable battery to power the camera's automatic features, including built-in electronic flash. (Prior to the introduction of SX-70 integral films in 1972, Polaroid cameras used color and black-and-white films that required you to peel the prints from the negatives after timing the development.)

IMAGE SHAPE AND SIZE varies according to the film. Polaroid 600 film produces square images 3$\frac{1}{8}$ × 3$\frac{1}{8}$ inches (8 × 8cm). Like Captiva 95 film, images on Spectra film are rectangular, but larger in size, 2$\frac{7}{8}$ × 3$\frac{5}{8}$ inches (7.3 × 9.2cm).

Although actual FILM DEVELOPMENT TIMES depend on the ambient temperature, it usually takes about 90 seconds for the integral film to turn into an image. In reality, the film continues to develop for several minutes, and you'll have to wait a while to see the true colors. For the best print quality, Polaroid advises you to hold the print only by its edges during development, and never to bend, flex, or cut it.

Polaroid also recommends using films within a specific range of temperatures, such as from 55° F (13° C) to 95° F (35° C). At colder

190. Different instant camera models require different self-developing films, which vary in size and shape of the image. Polaroid 600 film for OneStep models produces a square picture area measuring $3\frac{1}{8} \times 3\frac{1}{8}$ inches $(8 \times 8$ cm$)$.

temperatures, immediately put the exposed and ejected film in a warm place, such as inside your coat, during development. If you shoot at the extremes of the film's temperature ranges, prints may be too dark at the higher limits and too light at the lower limits. Try compensating by adjusting the camera's LIGHTEN/DARKEN EXPOSURE CONTROL DIAL accordingly.

Both instant films and cameras should be kept away from extreme heat (over 100° F/37.5° C), because it will have a detrimental effect on the undeveloped film emulsion and perhaps cause damage to the camera. If film and camera are inadvertently subjected to excessive heat, as in a closed car parked in the summer sun, be sure the camera and film cool off before you take any pictures.

Careful STORAGE OF THE PROCESSED PRINTS is also important, because heat and humidity can affect the dyes and cause changes in the colors. Long exposure to bright light is harmful, too. Keep your instant prints in a cool, dry place and away from direct sunlight so their color dyes and images won't fade.

While many earlier models of Polaroid cameras are no longer manufactured, the company continues to make color and black-and-white films for them. In addition, Polaroid manufactures film packs and sheets in $4 \times 5$-inch ($10 \times 12.7$cm) and slightly smaller sizes for use in special holders with medium-format and view cameras. The

company also has 8 × 10-inch (20.3 × 25.4cm) films for large-format studio cameras, and has created special professional cameras and films that produce exceptionally large instant images, 20 × 24 and 40 × 80 inches (50.8 × 61 and 101.6 × 203.2cm).

Here are a few TIPS FOR SUCCESSFULLY USING INSTANT CAMERAS. Keep in mind that prints can be unevenly developed or even jammed up if the photographer's fingers are in the way when the print is being ejected from the camera, except with Captiva models, which eject the prints into a compartment in the back of the camera. The exposed print must exit through a pair of pressure rollers without hindrance if the chemicals within it are to do their job evenly. Also prevent possible streaking in the prints by wiping the pressure rollers clean before or after shooting every 10-print pack of film.

For proper flash exposures, memorize the near and far limits of the camera's built-in flash so that you are not too close to or too far from your subject.

Be aware that the integral films for today's Polaroid cameras actually do not produce pictures as instantly as the peel-apart instant films, which yield color prints in 60 seconds and black-and-white prints in 15 to 30 seconds. The delay in seeing a fully developed color print is of some concern to photographers who may want to alter the exposure of the picture. This can be done manually by adjusting the camera's lighten/darken exposure control dial, but it takes several minutes for the print to be developed enough to enable you to decide whether the automatically controlled exposure needs to be changed in that manner.

Although instant cameras have limitations for making the variety of creative photographs many serious photographers desire, these cameras suit the countless people who simply want an easy way to record important events in their lives—and see the results within minutes.

The Polaroid Corporation has also created 35MM INSTANT FILMS for taking instant color and black-and-white slides with any 35mm camera; see Chapter 5 for more information.

## The Impact of Convenience Cameras

Convenience cameras have prompted many more people to become involved in the field of photography. As makers of photographic records, these point-and-shoot cameras are ideal. But whether they allow photographers to develop their artistic potential is questionable; serious amateurs and professional photographers

will undoubtedly hang on to their 35mm SLRs and medium-format cameras.

However, often-missed pictures have almost become a thing of the past, because the compactness of point-and-shoot cameras and their ease of use make it convenient to capture not only routine events but unexpected moments. No longer do you have to say after seeing something that's photographically exciting, "I wish I had my camera!"

Today's pocket-size cameras may look simple from the outside, but their interiors are examples of technical ingenuity. And you can expect new electronic, optical, and chemical knowledge to continue to change the future of still photography. Among more recent revelations is digital imaging, which has had a significant impact on traditional photography but can never replace it. A look at digital cameras and computer-created images follows in the next chapter.

# EXPERIMENTING WITH DIGITAL CAMERAS AND COMPUTER PHOTO ELECTRONIC IMAGING

All of the cameras discussed so far in this book have been designed for traditional photography, which requires film and chemicals to create images. But there is another breed: the filmless DIGITAL CAMERA that utilizes ELECTRONIC IMAGING and is challenging conventional types of still photography. The goal of digital cameras is the same as for all other cameras—to create a picture. But visual images composed of bits of electronic information can be reproduced instantly and utilized in more ways than pictures recorded on chemically coated film and then printed on photo paper.

Even if you don't own a digital camera, it's important to understand electronic imaging because your traditional, film-based pictures can be converted by a FILM SCANNER or PHOTO SCANNER into digital images for enjoyment in numerous ways. The scanner converts color or black-and-white images appearing in negatives, slides, and prints into an electronic form that is stored on the HARD DRIVE of your PERSONAL COMPUTER (PC), a FLOPPY DISK, or PHOTO CD (compact disc). From these storage devices, the pictures can be sent to a computer monitor or TV screen for immediate viewing, or to a color printer that makes a photolike print in a minute or so.

Be aware that electronic imaging also encompasses VIDEO PHOTOGRAPHY, which is familiar to most people only as moving video pictures taken with a CAMCORDER. However, there are two types of cameras that record single (still) pictures utilizing video technology. One type incorporates the original analog (continuous tone) method of video recording. In addition to being viewed on television screens, those taped images can be converted digitally for color printing and/or transmission worldwide on the Internet via your personal computer. The newer type of still camcorder features DIGITAL VIDEO (DV) IMAGING

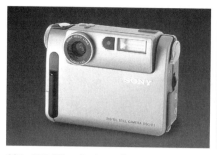

191–192. The design of most digital cameras is notably different than that of traditional film cameras. Instead of an optical viewfinder, this Sony model features a color LCD (liquid crystal display) on the rear of the camera to show you the image that will be recorded electronically.

that can be seen on TV screens and downloaded directly to a personal computer.

Keep in mind that an exciting after-exposure benefit of digital imaging is the ability to ENHANCE PICTURES using a variety of computer PHOTO EDITING SOFTWARE PROGRAMS. Although it takes patience and practice with your mouse and keyboard, if the sky in the digitized photo image appearing on your computer screen is an unattractive gray, you can change it to a beautiful blue. If the eyes of your portrait subject were closed when the shutter was released, you can open them. Or, if a tree in the background is a distraction, you can eliminate it. All of these improvements to the picture can then be preserved (saved), undone, or redone—you become a creative photographer even *after* pressing your camera's shutter release . . . and you don't need a darkroom.

On the other hand, some photographers object to the digital MANIPULATION OF PHOTOGRAPHIC IMAGES, a topic that always sparks lively pro and con discussion. Whether or not you believe it's okay to create photo images with a computer as well as a camera, being able to easily alter images after they are recorded is no excuse for taking lousy pictures. A good photographer always tries to capture the best possible image with the camera. Why waste time at a computer trying to correct mistakes you could have avoided at the time you were taking the picture?

Becoming involved with digital photography makes some people feel like electronic trendsetters. But as the computer age matures, electronic imaging will become an ordinary rather than an unusual way of making pictures. Whether it will ever totally replace traditional photography is debatable. In the meantime, you should at least be familiar with the basics of digital photography and electronic imaging, which are described later.

In the short history of digital cameras, since 1991, they have become less expensive, smaller in size, and easier to use. The very first models were bulky, multi-thousand-dollar adaptations of 35mm single lens reflex cameras. They were designed for photojournalists to drastically shorten the time it took from the click of the shutter to the moment the image appeared in a newspaper or magazine. Less than five years later, a dozen digital camera models were on the market. Some of them—reduced to the size of 35mm compact cameras and costing less than $350—were specifically designed for amateur photographers. Initially, however, these point-and-shoot digital cameras could not match the quality of pictures taken with film-based 35mm or APS cameras.

Of course, you must keep in mind that the general use for digital images by amateur photographers is not to put them in a snapshot album or to enlarge and frame them for display at home. Instead, digital photos are being shown off in other, nontraditional ways—all made possible by the computer era. Many of the pictures are being viewed on computer screens and television sets. Some are incorporated into letters, greeting cards, and announcements created on home computers. These are then outputted to a color printer and delivered by ordinary mail, or transmitted instantly via E-mail (electronic mail) to the computers of family and friends around the globe. Digital imaging has brought considerably more interest to photography in the electronic age.

## Resolution Is the Key to Digital Image Quality

One of the most important considerations regarding digital pictures compared with film-based photos is their RESOLUTION, which is generally referred to as IMAGE QUALITY. What that really means is how fine the detail is and thus how sharp the image appears to the viewer. As a general rule, whether the picture was created digitally or in the traditional, film-based manner, the larger the picture, the less sharp it appears.

However, digital images are reproduced not only on paper but on computer and television screens, which themselves are limited in resolution. In other words, a digital picture often has an acceptable appearance on a TV screen but may not have the visual sharpness you'd desire for a framed enlargement hung on a wall.

The resolution of digital images is indicated by numbers; the

193. Like this Kodak model, the smallest digital cameras are less than the size of a man's hand and have an optical viewfinder instead of an LCD screen to compose the picture.

higher the numbers, the better the resolution. For images from cameras and computer monitors, those numbers are identified as PIXELS, an abbreviation for picture elements, and sometimes given as PPI, or PIXELS PER INCH. For images from color printers, the numbers are labeled as DPI, or DOTS PER INCH.

Digital images are also identified in general terms, HIGH RESOLUTION or LOW RESOLUTION (the latter is sometimes called STANDARD RESOLUTION), instead of by specific numbers. A high-resolution image will have finer detail and appear sharper than a low-resolution image.

Digital cameras usually have a switch that gives you a choice of shooting at high or low resolution. That's because the higher resolution requires more pixels, therefore reducing the number of pictures you can shoot. However, although you'll be able to take more photos if the camera is set at low resolution, chances are you'll be disappointed with the image quality. Our advice is to keep the camera set at high resolution.

When using a digital camera, you need to know not only the camera's resolution but the resolution required for the way you intend to display the image. If it's primarily to be shown on a TV screen (either a computer monitor or a regular television set), you need to consider the resolution of the particular TV unit. If it's to be printed on paper by a color printer, you need to consider the resolution of the specific printer. The reason is that even if your digital camera is capable of recording a high-resolution image, if the device on which you view it or print it is of lower resolution, the image as viewed will be degraded.

The cost of a digital camera often depends on the maximum resolution of which it is capable: the higher the resolution, the higher the price. As a guideline, buy a digital camera with the highest resolution you can afford, or at least with a resolution that will produce an image equal in resolution to that offered by your color monitor or color printer. Also be aware that the higher the resolution, the longer

it takes to record the image in the camera, to download it to a computer, and to output it to a color printer.

When comparing digital cameras with respect to image quality, keep in mind that resolution is determined in part by the memory storage capacity of the camera or display device, technically known as its RAM, or RANDOM ACCESS MEMORY. The more RAM, the higher the resolution. RAM is indicated by numbers called MEGABYTES (MB). Some cameras have only INTERNAL RAM, meaning memory storage built in the camera, while others feature removable or expandable memory storage, known variously as PC MEMORY CARDS, FLASH RAM CARDS, or MEMORY MODULES.

Whenever the maximum number of exposures has been taken, whether at high or low resolution, you must restore the camera's memory storage (i.e., RAM) before taking additional pictures. This can be done in one, two, or three ways, depending on the camera model. On location, you can simply erase one or more of the images in the camera to free up some of the memory storage. Also, if the camera has a removable RAM card or module, you can remove and replace it with a fresh card of memory storage. Another option is to connect the camera to your portable laptop, or another personal computer at home, and download the images to store them on the computer's hard drive or a floppy disk.

## Digital Camera Details

Digital cameras vary in APPEARANCE. Some look just like point-and-shoot film cameras, while others have an oblong shape and are gripped like a pair of binoculars. (Excluded in this description of digital cameras are the very expensive professional single lens reflex models.)

Instead of the optical viewfinder of traditional film cameras, some models feature a color LIQUID CRYSTAL DISPLAY (LCD) on the back that resembles a miniature TV screen and displays the image that will be recorded. The LCD can also be used for playback to review the images you've already taken. This novel shoot-and-show feature is a major attraction.

Many of the features of digital cameras are similar to those of film cameras, such as AUTOFOCUS, AUTO-EXPOSURE, and AUTOFLASH. Also, in an effort to make the camera's characteristics sound more familiar, they are often equated with 35mm cameras in advertisements and sales brochures. The lens, for example, may be described as being "equivalent to a 43mm lens on a 35mm camera." And

194–196. The design and features of digital cameras vary, as these Epson, Casio, and Kodak models show. However, the most important consideration is the resolution of the digital images they record (see text).

although there is no film, the literature may cite film speed (ISO) to indicate the sensitivity of the camera's electronic imaging device, such as: "Exposure is equivalent to ISO 130."

Regarding LENS OPENINGS, the aperture is fixed at one f/stop, or has a choice of two f/stops, or is fully adjustable. The aperture combines with the SHUTTER SPEED, which is variable, to automatically control the exposure.

FOCUSING is either autofocus or fixed focus; the specific focusing range is given in the camera specifications. The range of the BUILT-IN FLASH (if any) is also listed. Some cameras feature on/off buttons to override the autoflash.

Other CAMERA CONTROLS usually include buttons or switches to select either high or low resolution, activate a self-timer, and erase existing images.

An LCD panel shows the NUMBER OF IMAGES (exposures) taken, and the number of images remaining, which will change when you switch from high to low resolution, or vice versa. That's because the number of exposures varies depending on the camera's memory storage capacity (RAM), and whether high and/or low resolution was selected for your previous shots. (Storing a high-resolution image requires more RAM than a low-resolution image.)

Digital cameras are powered by BATTERIES, either replaceable AA-size lithium or alkaline cells, or rechargeable nicads. (An AC power adapter may be available, too.) Unlike most film cameras, digital

cameras also have a socket to plug in a COMPUTER CABLE that connects the camera to a PC. This cable is usually included with the camera, along with computer PHOTO EDITING SOFTWARE that allows you to retrieve, preview, organize, enhance, delete, and otherwise work with the images.

Of course, as discussed earlier, the most important information to look for in any description of a digital camera is its image quality, as represented by the specific number of pixels for both high and low resolutions. Sometimes the highest resolution is engraved on the camera itself and preceded by the abbreviation CCD (CHARGE COUPLED DEVICE), which is the camera's electronic imager, the sensor that records the image.

Elsewhere in the camera's literature you may also find how many BITS OF COLOR are produced for each pixel. The higher the number of bits, the higher the NUMBER OF COLORS possible, and thus the better the image quality. As an example, to achieve photo-realistic results requires at least 24 bits per pixel, which technically means that more than 16 million colors can be created (even though a computer monitor, TV set, or color printer is unable to produce that many colors).

However, the most accurate indication of image quality is the number of HIGH-RESOLUTION PIXELS. As a minimum, make certain that this number is at least 640 × 480 (or 307,200 pixels), which is equal to the resolution of many standard computer monitors and TV screens. (One of the top SLR digital cameras has a high resolution of 3060 × 2036, a total of 6,230,160 pixels.) When comparing the quality of digital camera images with a frame of 35mm film, the film is far superior with an equivalent of 18 million to 24 million pixels, depending on the specific film.

By the way, you can figure the difference in the NUMBER OF EXPO-SURES that can be made at high and low resolutions with a digital camera by comparing their respective pixels. For example, if a high-resolution image requires 640 × 480 pixels, and a low resolution 320 × 240 pixels, you can shoot two low-resolution pictures for every high-resolution image.

When checking the specifications of any digital camera, it's also important to note the camera's TOTAL MEMORY STORAGE in megabytes (MB). It will be given with the specific number of pictures that can be taken (at high and low resolutions) before the images must be downloaded from the camera to your computer, or the camera's removable RAM card or module must be replaced with a fresh one. The number of images that can be recorded varies significantly: at high

resolution, it ranges from 16 to 96 pictures, depending on the point-and-shoot camera model.

Be aware that there is a brief delay between exposures because the previous image you took has to be recorded in memory before you can make another shot. Some cameras have a MEMORY BUFFER to hold the first image so you can re-press the shutter release almost immediately for additional exposures. The time delay between exposures is indicated in seconds and is called the RECYCLE RATE or CAPTURE RATE. It ranges from about 3 to 7 seconds, depending on the camera model.

Although the more expensive professional SLR models allow CAMERA LENSES to be interchanged, most digital cameras have either a fixed focal length lens or a zoom lens; some have dual focal lengths. To avoid limiting your photography with a fixed focal length lens, be certain to choose one that can be fitted with accessory lenses for wide-angle, telephoto, and close-up shots.

Digital cameras require as much care as film cameras, so don't bang them around. They are especially sensitive to extremes in temperature and humidity; check the instruction manual for your camera's specific operating range. Also make certain that the camera manufacturer offers easy access to technical support, such as a toll-free telephone number, faxback system, electronic bulletin board, and/or Internet Web site.

Digital cameras are sold under familiar photo BRAND NAMES, including Kodak, Canon, Nikon, Minolta, Fuji, Agfa, Ricoh, and Chinon, but there are electronic and computer companies that manufacture some of those models or their parts under license, as well as others with their own names, such as Epson, Casio, Apple, and Logitech. You'll find them at better computer and camera stores, as well as at some discount stores and photo/video mail-order companies.

The ongoing concern among photographers regarding digital images is twofold: QUALITY AND COST. Until the digital results are as good as or better than film-based pictures, and the images cost the same as or less than traditional photographs, should you consider buying a digital camera? Perhaps, but as with all computer-related products, digital cameras continue to evolve rapidly. If you decide to invest in a digital camera, keep in mind that no model remains "current" for very long.

Another thing to remember in order to get the most enjoyment from electronic imaging is that your computer equipment must be powerful enough to quickly and easily handle use of a digital camera. That means it must have sufficient memory for storage and

manipulation of the photo images, and your color monitor and its video card must have adequate resolution to view the photo images. Also, for photo-quality prints, your color printer must have high resolution.

# Composing Effective Photographs

Knowing how to operate your camera and equipment prepares you mechanically to make photographs. Using your camera artistically is the next goal. Although some people are described as being born with a "photographic eye," learning how to compose effective pictures usually comes with practice.

This section outlines the elements of composition and techniques for applying them to your photographic pursuits. It will guide you toward making effective photographs that will please both you and other people who view your pictures.

## Pictures with a Purpose

Many photographers fail to think about the stories they are trying to tell with their pictures. Every picture should have a purpose. Even so-called snapshots can be effective photographs if the photographer gives some thought to the story he wants to tell. At a Christmas gathering, are you trying to show members of the family, or the presents they received, or both? Your composition—the components of the picture and their arrangement—determines the message viewers get when they see the finished photographs. Unfortunately, many times photographers fail to tell a story.

A Chinese proverb says that a picture is worth more than 10,000 words. If that's true, you understand the responsibility you have when pressing a shutter release. No one wants to read 10,000 poorly composed words, and no one wants to look at a poorly composed picture. A picture should have a reason for being taken. And it's up to the photographer to decide how to make a picture that creatively conveys his story.

197. The guidelines for good composition that are illustrated in this chapter will help improve your pictures. Among the advice is to avoid centering your subject, which the photographer followed when he composed this photograph of a Native American selling fried bread in Arizona.

What makes a good photograph? Judging is a selective thing. Every viewer has personal criteria for what he likes and dislikes. Sometimes, regardless of its composition or technical perfection, the photograph may be judged poor because the viewer objects to the subject itself.

Most often, however, viewer reaction relates to the arrangement of the elements within the picture. And unless he is an accomplished photographer himself, the viewer rarely observes the techniques of effective composition behind the photograph. Remember, when you are composing or studying any photograph, it's worthwhile to ask yourself *what's wrong with the picture*. Analyzing the negative aspects of the photograph will lead to a more positive approach to utilizing the elements of good composition in your pictures.

Following are basic guidelines to help you make more effective photographs. By using these ABCs of composition, even so-called "record" shots of events like birthdays can be more artistic than the usual police-lineup type of pictures. However, we must emphasize that these tried-and-true suggestions for better composition are not commandments that must be obeyed. In fact, in the last section of this chapter we urge you to use your imagination and "break the rules" in order to become a truly creative photographer.

## Have a Center of Interest

There should be a main subject or center of interest in every picture. It should attract the viewer's eye. Other objects in the picture must not compete with what you intend to be the center of interest. When shooting, consider what is the main subject and if it will be obvious to the viewer.

## Put the Main Subject Off Center

Interestingly enough, as a general rule the center of interest should not be in the center of your picture. Centered subjects usually are less interesting than those placed according to the "rule of thirds." This basic concept of composition is used almost subconsciously by most successful photographers. Mentally divide the scene in your viewfinder into thirds, both horizontally and vertically. Place your main subject along one of the four imaginary lines or where two of the lines intersect. The subject should face or move toward the center of the picture, not away from it.

198. Putting your subject off center by following the "rule of thirds" is a simple way to improve composition.

With scenic views, do not let the horizon divide the picture in half. Move the horizon to the upper or lower one-third of your viewfinder. In a scene where the sky is the main center of interest, the sky should occupy the upper two-thirds of the frame and the area below the horizon should be kept in the lower third. Conversely, if the sky is unimportant, the foreground subjects should fill the lower two-thirds of the frame and the sky the upper third.

199–200. These pictures of the Lone Cypress along California's coast and an alpine paraglider in Switzerland were composed according to the "rule of thirds" (see text).

201. One of the basic ways to give a picture more impact is to get closer to your subject so that it fills the viewfinder.

## Get in Close

A key rule to remember is to get close to your subject. Fill your viewfinder only with what you want in the finished picture. This is especially important when shooting slides. Unless you mask and remount your slides, the transparencies will show on the screen everything that was included in your viewfinder. Although color print and black-and-white films can be cropped during the enlarging process, it's always better to crop in the camera. Move in. Get rid of everything that is not necessary to your picture. Don't let unwanted objects distract the viewer. Get in close with your camera to concentrate attention on your subjects.

## Keep the Horizon Straight

Keeping the horizon straight in a picture is a simple rule that is often ignored. The result is a distracted viewer who is bothered by an unlevel horizon. When shooting any subject with a horizon, even if it is very distant, check just before you squeeze the shutter release to make sure the horizon is not tilted.

202. Before you press the shutter release, always check the horizon to make sure it will appear level in your picture. This boat and water-skier are skimming across Lake Powell in Utah.

203. Be careful the background doesn't become a distraction in your picture. One technique is to put the background out of focus by using a wide lens opening to reduce depth of field (see text).

## Watch the Background

Equally distracting, and an all-too-common composition error, is a poor background. For example, a cluttered background will draw attention away from your main subject. Whenever a background looks too busy, change your camera angle or your subject's position. Get low and shoot your subject against the sky; it's plain enough to keep the viewer's attention on the subject and not the background.

204. Be alert for objects in the background that distract from your main subject. A tree growing from a person's head is a common problem that can be easily avoided.

Alternatively, if the ground is attractive and simple, use it as the background by photographing your subject from a high angle.

By all means, avoid backgrounds where trees or poles seem to be growing out of people's heads.

Always study the background before you release the shutter. One way to eliminate a disturbing background is to throw it out of focus. If your subject is far enough from the background, opening up the f/stop minimizes depth of field and will keep your subject sharp while putting the background out of focus. In any event, it's always a good idea to check the depth of field scale (if available) on your camera's lens to see how much of the background and foreground will be in focus. Unwanted foreground objects can upset your composition, too, so watch out for them. Look carefully for even small distractions, such as a piece of paper or other litter that will divert the viewer's eye from your main subject.

## Check All Angles

Study your subject and check it from all angles. Even a slight change of angle can improve the composition of your picture tremendously. Try to remember that the height of a photographer's eye is not always the best level for his camera. Kneel down or stand on your tiptoes. Some photographers get low by placing their cameras

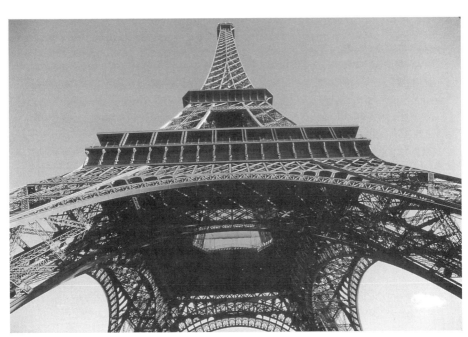

205–207. As shown by these views of the Eiffel Tower in Paris, France, the same subject can be composed in a variety of ways from different camera angles.

on the floor or ground. Others climb ladders and trees or extend the height of the camera by holding it on a tripod over their heads.

Shooting up from a low angle makes the subject look imposing and gives it a feeling of strength or power. Shooting down from a high angle tends to diminish the subject and make it appear weak or submissive. For these reasons, try taking pictures of babies, children, and animals at their own level. Do the same with small flowers and plants.

Changing your angle will alter the lighting of your subject as seen by the camera. Walk around to see if your subject would look best with front lighting, side lighting, or backlighting. In bad weather, eliminate overcast and gray skies by shooting your subject from a high angle. Always check to visualize your subject from every angle before selecting the angle best for your purposes.

## Try Leading Lines

Direct the attention of your viewers to the center of interest of your picture with leading lines. Roads, fences, and rivers commonly are used as leading lines. They must lead and direct attention into the picture, never out of it. For more interesting composition, always

208. To direct viewers to your picture's main subject, include a leading line, like this road that goes toward North America's highest mountain, Mt. McKinley (Denali) in Alaska.

look for leading lines that might add impact to your pictures. Study the picture area for all possibilities.

## Frame the Subject

A natural frame will also direct viewers toward your main subject. A frame works well to hide an uninteresting sky, too. Very common and effective is a tree or overhanging branch used to frame a scenic shot. Frames are kept in the foreground and give a feeling of depth to pictures. They can surround the subject or just border the top or one side.

Generally, frames are kept in focus because a fuzzy foreground can be distracting. Sometimes, however, to isolate and emphasize

209. Framing helps focus attention on your main subject. This doorway arch frames the Carmel Mission church in California.

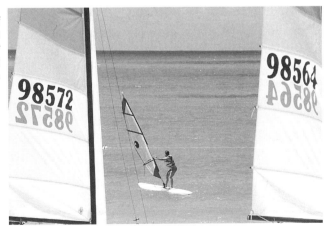

210. The sails of two boats serve as a frame for this windsurfer in the Caribbean.

211. Including tree branches in the foreground is a favorite way to frame a scenic view and improve the picture's composition.

the center of interest, the frame should be thrown out of focus by correctly figuring depth of field. Frames can be found at many levels and angles. Look around. Windows, natural arches, doorways, and fences are examples. By the way, ecologists and most photographers do not respect frame enthusiasts who cut flowers or tree branches to use as frames. Move your camera, not the frame.

## Vary the Format

Unlike cameras that offer only a square format, such as 6 × 6cm (2¼ × 2¼-inch) medium-format models, 35mm and APS cameras take rectangular pictures and can be turned to make horizontal or vertical images. Good composition usually calls for tall subjects to be shot vertically, wide subjects horizontally. For variety in your pictures, vary your format. Don't shoot everything horizontally. For an interesting effect, occasionally shoot tall objects, such as church steeples or flagpoles, on the diagonal. In the vertical camera position, frame them at an angle running from a top corner to the opposite bottom corner of your viewfinder.

212–213. When composing any picture, turn the camera vertically as well as horizontally to find the most appropriate format. Both formats were used to photograph San Francisco's Golden Gate bridge from different camera angles.

## Include Size Indicators

Too often photographers shoot scenes and other subjects without enabling viewers to comprehend their size. Use of size indicators, objects with which we are familiar, will help to tell the story. With scenery, for example, a person or a car included in the picture will help viewers comprehend the size of your main subject, whether it is a mountain or a waterfall. Check photographs in the *National Geographic* magazine to see how often its top-flight photographers utilize size indicators.

Persons or objects looking or moving toward the center of interest are often used in the foreground. They help lead the viewer to the main subject. Don't let such foreground figures look at the camera or they will hinder, not help, your photographic composition.

Besides the guidelines just given for the selection and arrangement of subjects in your picture, there are other considerations that contribute to effective composition. Mastering these additional elements for making good photographs should be the goal of all photographers.

214. By including objects of known size, the relative size of your main subject is easier to comprehend. In addition to serving as size indicators, the two people walking toward these waterfalls in Yosemite National Park help direct attention to the picture's center of interest.

## Focus for Effect

Most basic is focusing. All too often photographers simply focus on the main subject and shoot. They give little or no thought to depth of field. As you will recall, you use depth of field to control how much of the total picture area—from foreground to background—will be in sharp focus. Of course, whatever is sharply focused attracts and holds the attention of viewers of the photograph. (For a review of depth of field, see page 53.)

Depth of field is easiest to control with a single lens reflex camera that has a depth of field scale engraved on the lens barrel. For any SLR camera lens without this scale, you can refer to the depth of field chart found with the lens instructions. The depth of field chart or scale indicates how much of the picture area will be in focus according to the f/stop and the distance you set on the lens focusing scale. Also recall that some SLR cameras have a depth of field preview device to stop down the lens before exposure to let you visually

215. Focusing for effect is a key to better photographs. Here the viewer's attention is drawn to the baby's delicate fingers, the only part of the picture in sharp focus.

216. As with the top photograph, the camera was positioned close to the subject, a wide f/stop was used, and the lens was focused precisely—in this case, on the boy's eyes—in order to make a specific part of the subject stand out.

check in the viewfinder how much of the picture area will be in focus.

To effectively utilize depth of field, first you must decide exactly what you want in the picture and how much of it should be in focus. Then, after selecting a lens and positioning the camera, you should check the lens depth of field scale or chart to see if the focusing effect you want is possible. If not, you must change the lens opening or focal length and/or the position of the camera in relation to the subject.

As a reminder, when you want only the main subject in focus, open up the lens aperture to a wide f/stop that will limit the depth of field. And when you want to put most or all of what you see in the viewfinder in focus, stop down the lens aperture to a small f/stop that will extend the depth of field.

If the lens focal length is too great to allow extended depth of field, you must switch to a lens of shorter focal length, such as a wide-angle lens or wide-angle zoom lens. For instance, in a situation where a normal 50mm lens will not get all the desired picture area in focus even at its smallest f/stop, try shooting with a lens focal length of 35mm, 28mm, 24mm, or shorter. Wide-angle lenses inherently have extensive depth of field that puts much of the picture area in sharp focus, even at wide f/stops.

217. Careful attention was given to lens depth of field so that both the bow of this yacht and the fisherman's village in the background would be in sharp focus (see text).

Alternatively, if you cannot change lenses, you must change the camera's position and move farther away from the picture area you want in focus. That's because the greater the focused distance, the greater will be the depth of field.

Conversely, the closer the subject is to the camera, the more limited the depth of field. To isolate the subject by keeping everything but the subject out of focus, move in close to shorten the focused distance between subject and camera lens, thus reducing the depth of field.

To achieve a similar effect without moving the camera position, change to a lens of greater focal length, such as a telephoto or zoom telephoto lens. For example, if a normal 50mm lens causes too much of the desired picture area to be in focus even at its widest f/stop, try shooting at a focal length of 90mm, 105mm, 135mm, or longer. Telephoto lenses inherently have less depth of field than normal lenses, which makes it easier to keep the foreground and background out of focus, thus isolating your main subject.

## Expose Accurately

A potentially good picture can be ruined by poor exposure. Whether using auto-exposure or manual exposure, become competent in making exposure meter readings so that you're confident the f/stop and shutter speed is correct for the picture you want to make

218. These summer sightseers on a ski lift in Europe were purposely under-exposed to enhance the silhouette effect.

(see Chapter 2). A photographer who understands how to determine exposure can concentrate more on the other aspects of making good pictures, especially composition. Be certain to learn how your camera's particular exposure metering system works, and how to use it effectively. For example, if you purposely want to underexpose or overexpose to create a certain mood, you must know how to adjust an auto-exposure camera for exposure compensation, or how to make exposure adjustments manually. Of course, in unusual lighting situations, bracketing exposure is always suggested in order to get a properly exposed picture.

## Include Some Action

Unless you're trying to produce a mood of stillness, include action in your pictures. Far too many photographs are static and lifeless. Even though you are making still pictures, that does not mean your subjects have to be still when you photograph them. Informal pictures of people are always better if your subjects are doing something. Candid shots are superior to posed pictures because they are lifelike and reveal natural expressions and action. If someone sees you taking his photograph and stops to pose, ask him to continue his activity so the picture will appear more spontaneous.

Even if you have to organize your subjects for a picture, don't let them become stiff or appear too posed. Make sure they are relaxed. Don't tire them out by making them wait for you to get your equipment ready and the exposure reading made. Plan as much in advance as possible and be set to shoot when your subject flashes the expression you want. Don't ask him to "hold it"; the result too often seems unnatural. With portraits of babies, children, or pets, give them something to keep them occupied and their attention off you. A toy or snack treat works well.

There are several ways to photograph action. And shutter speed is the key factor. You can shoot at a fast speed to stop the action, or at a slow speed to let the action blur in your picture. STOP-ACTION is very common, and the purpose is to freeze the subject so the viewer can see it clearly. Stop-action is effective only when the viewer realizes that the subject was moving when the picture was made. A pole-vaulter frozen in midair or a diver doing a backflip into a swimming pool are examples.

Be sure, of course, to include a POINT OF REFERENCE so the viewer knows who the subject is and what he is doing. With a pole-vaulter, include his pole or the crossbar he is vaulting. The diver's picture

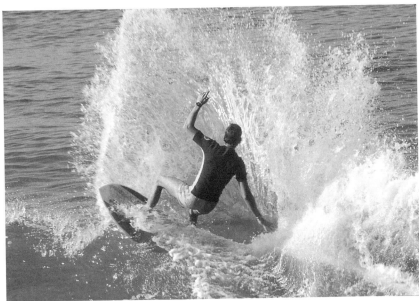

219. The movement of water, like all active subjects, can be portrayed in various ways by using different shutter speeds. A fast shutter speed freezes the spray of water made by this skimboarder.

220. A very slow shutter speed creates a foamy mist as an incoming tide tumbles over the rocks and splashes upward.

needs a diving board or a swimming pool for a reference. Otherwise, the pole-vaulter appears only as a man in a track suit suspended in midair. And the diver is simply a person in swimming trunks frozen in midair. Since the viewer doesn't know that they are a pole-vaulter and a diver, or what they are doing, the photographer failed to tell his story. So always include a point of reference, when needed, in an action shot.

The easiest way to stop action is with a FAST SHUTTER SPEED. How fast a shutter speed depends on three interrelated factors: how fast the subject is moving, how far the subject is from the camera, and the direction of the subject's movement in relation to the camera.

Obviously, a speeding race car is going much faster than a running boy. So first consider the speed of the subject you want to stop.

A train passing near you seems to be going faster than one passing in the distance. The shutter speed must be faster for a subject close to you. Always remember that the distance between subject and camera helps determine the shutter speed required to stop the action.

On a highway, the oncoming car or scenic view seen through the windshield appears to be moving slower than it does when you look through your side window and see the car or vista whiz past. A subject moving perpendicular to the camera is more difficult to stop than one moving directly toward or away from the camera. Therefore, subjects moving at a 90° angle to the camera require a faster shutter speed than those at other angles. The subject's direction in relation to the camera is the third consideration regarding the shutter speed to select to stop action.

The chart opposite will help you determine the shutter speed to use depending on the three considerations just given: speed, distance, and direction.

Another way to stop action is to trip your shutter at the PEAK OF ACTION. Shoot when the basketball players are at the highest point of their jump. Make your exposure the instant the action is suspended. Photograph a child the moment his swing pauses to reverse its direction. Stopping action at its peak is possible with a nominal shutter speed, but the photographer's timing must be perfect.

Action can also be captured by PANNING with the subject. This is one of the most effective techniques for portraying the feeling of motion in your photographs. To pan, follow the moving subject with your camera, carefully keeping it in the viewfinder. When you decide the moment is right, press the shutter release. Since the camera was keeping pace with the moving subject, the subject will be sharp and the background blurred, which gives the feeling of speed. Slower-

## SUGGESTED SHUTTER SPEEDS
## (IN FRACTIONS OF A SECOND) TO STOP ACTION

| SPEED of subject | DISTANCE of subject from camera (feet) | DIRECTION of subject in relation to camera | | |
|---|---|---|---|---|
| | | toward or away from camera | at 45° angle to lens | at 90° angle to lens |
| *Less than 10 mph* (People walking, children or pets playing) | 25 | 1/125 | 1/250 | 1/500 |
| | 50 | 1/60 | 1/125 | 1/250 |
| | 100 | 1/30 | 1/60 | 1/125 |
| *Less than 30 mph* (Athletic events, horseracing) | 25 | 1/250 | 1/500 | 1/1000 |
| | 50 | 1/125 | 1/250 | 1/500 |
| | 75 | 1/60 | 1/125 | 1/250 |
| *More than 50 mph* (Cars or boats racing, trains, airplanes) | 25 | 1/500 | 1/1000 | 1/2000 |
| | 50 | 1/250 | 1/500 | 1/1000 |
| | 100 | 1/125 | 1/250 | 1/500 |
| | 200 | 1/60 | 1/125 | 1/250 |

(A)

(B)

(C)

221. A moving subject's direction in relation to the camera must be considered in order to stop the action. Stopping the action of subjects moving toward or away from the camera (A) does not require as fast a shutter speed as when the subjects are moving diagonally (B) or parallel (C) to the film plane. Refer to the chart above.

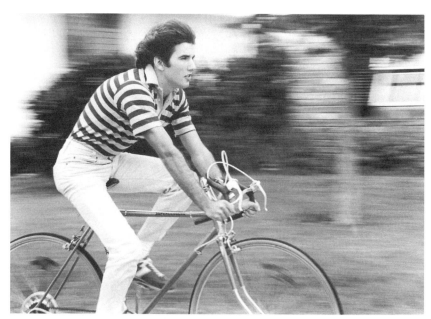

222. Panning is one of the most effective ways to show motion. The technique is to follow your subject in the camera's viewfinder and release the shutter while the camera is moving. This will blur the background while keeping the subject well defined in the picture. You can vary the shutter speed for different effects, but be aware that successful panning takes practice. For many action subjects, like this bicyclist, panning is preferred to stop-action.

than-normal shutter speeds usually produce a very action-packed effect.

Panning requires practice. Prefocus on the spot where you plan to photograph your subject; you may have to switch from autofocus to manual focusing, unless your autofocus camera features focus tracking. Stand firmly and pivot your body at the waist. Keep your camera level, or the subject and blurred background will be tilted and distracting. Most important, follow through with your panning motion even *after* you release the shutter. If you don't get in the habit of following the action after shooting, unconsciously you'll stop panning an instant before tripping the shutter and the effect of panning will be lost.

Like a golfer or tennis player, always follow through when making a panning shot. Try panning with moving subjects. You'll discover that it is an effective way to make eye-catching photographs. Remember, you can pan vertically as well as horizontally.

Another way to stop action is by USING FLASH. Instead of the camera's shutter speed, it's the brief burst of light from the flash unit

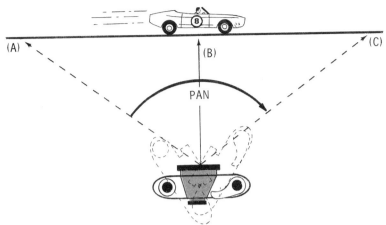

223. When panning with a subject, be sure to follow through. To portray motion effectively by capturing the subject against a blurred background, begin panning with the subject at point A, press the shutter release at point B, and continue following the subject until point C.

that freezes the action by illuminating your subject for only 1/1000 second or less. Stop-action shots with flash are possible in both interior and outdoor situations where the artificial or natural light is not sufficient to allow you to shoot with fast shutter speeds. A popular use is stopping the quick expressions and movements of babies, which is why many professional baby photographers shoot only with flash.

Don't forget when using flash with SLR cameras that their focal plane shutters require that the shutter speed be set no faster than 1/250, 1/125, or 1/60 second, depending on the camera model. This allows flash synchronization so that the shutter will be fully open when the flash goes off. When using flash, remember that the camera's shutter speed does not stop the action—the brief burst of light from the flash unit does.

Action in photographs can also be shown by having some part of the picture area blurred. Panning is one way to cause blurring and portray motion. Another approach is to use SLOW SHUTTER SPEEDS. At a car race, for example, you might pan with the speeding autos and blur the background of spectators in the stands. Emphasis will be on the race cars. But if you want to show the fans watching the race, frame the people in the stands and shoot at a slow enough shutter speed so the cars passing in the foreground will be blurred. Your main subject, the spectators, will then be emphasized. The blurred race cars help set the scene but will not distract from the people in the stands.

224–225. You can give an appearance of motion to inanimate subjects with a technique called zooming. As shown by a star on Hollywood's Walk of Fame and a marigold flower, secondary images and/or light streaks are created when you change the focal length of a zoom lens *during* the exposure.

By the way, if there is a static subject that you want to give some motion, shoot with a zoom lens and change the lens focal length *during* the exposure. ZOOMING creates light streaks radiating from the subject that transform a lifeless subject into one in action. A slow shutter speed must be used to allow enough time to zoom in or out during the exposure. Also, mount the camera on a tripod to hold it steady and maintain the composition you want while zooming. Try out this technique by photographing a parked car or some other stationary subject head on.

Slow shutter speeds can be used effectively with many subjects to show action. Experiment at various shutter speeds with flowers or leaves blowing in a breeze, children riding a merry-go-round, or a grandfather clock with its pendulum swinging. Always look around for subjects whose motion will enhance your pictures. The decision you'll need to make is how to suggest action to your viewers: stop it, blur it, or both.

## Use Good Timing

Too many photographers press the shutter release immediately after framing the subject in the viewfinder. They fail to wait for the moment of greatest interest or impact. Good timing takes patience and practice, but it is important to the success of any photograph.

Study your subject to find out what it does or might do. For instance, you spot an eagle sitting on the top of a nearby tree. A nice picture. Do you shoot it and go away? Or do you wait until the moment the eagle extends its wings and begins to lift off from its

226. Timing is important in photography; you must wait for the best moment before releasing the shutter. For example, this egret flying from its perch makes a much more dramatic picture than if the bird was just sitting on the tree branches.

227. Good timing caught this juggler in action, with one ball in midair, one caught, and the other being tossed.

perch, and shoot again. A dramatic picture. Anticipating a subject's actions is a necessary photographic habit.

Children eating ice cream cones sometimes drop them or at least get the ice cream on their faces or clothes. People in discussion gesture with their hands. Fishermen usually show excitement when they catch something. Waves splash higher on rocks with incoming tides. Consider what will be the right moment to shoot, and wait for it.

A golfer blasting out of a sand trap is more exciting than one

teeing off. A person blowing out birthday candles is more interesting than one just holding the cake. A horse galloping is much more dramatic than one grazing. Study your subjects and figure out the best time to photograph them. Shooting a second too early, or too late, can result in an ineffective picture rather than one with impact.

The TIME OF DAY is another consideration. The long shadows of early morning or late afternoon often make pictures much more effective than if they were taken at noon with the sun overhead. Decide when you think the lighting will be best, and wait for that moment. Also consider whether a night shot would be more effective than one taken during the day. Las Vegas, for example, makes a much more impressive picture at night with the glow of its colorful casino lights.

What time of day will your subjects be at their best, or worst? If you want unhappy children, take photographs when they are tired or hungry. For pictures of active kids, wait until after their meals or naps. And be sure you're ready when your subjects are. Your camera and equipment should be set up and ready to fire the moment your subject makes the move or expression you want. Good pictures often result only because of the photographer's good timing.

## Consider Color

Whether you shoot color or black-and-white film, the colors of your subject are important to the success of your photograph. Obviously, with COLOR FILM you should make sure your subjects are colorful. Also, separation of foreground subjects from the background objects can be accomplished if they are of different colors. And add impact to a dull picture area by using subjects or objects of bright color. We always carry a red jacket or sweater for someone to wear to dress up the scene on overcast days. Always consider what colors in your picture might be added or eliminated before you trip the shutter. Look for color and use it in your photographs.

Users of BLACK-AND-WHITE FILM have other matters to consider. That's because black-and-white film records not colors but the brightness of various colors. These register as shades of gray. Understanding how black-and-white film responds to colors enables the photographer to obtain the contrasts desired in his picture.

For example, a dramatic scene includes fleecy white clouds against a vivid blue sky. But because most black-and-white film is very sensitive to blue, the sky appears a light gray in the photograph. The sky looks almost as bright as the clouds, and there is almost no

contrast between them. The impact of the picture is lost. Photographers familiar with black-and-white films know that they can use filters to alter the brightness of the colors seen by the film. One result is an improvement in contrast in the resulting photograph. In this sky and cloud example, a yellow, orange, or red filter will darken the blue sky so it will not register so brightly on the film. In the resulting print, the sky appears a darker gray than that of the clouds. And now the contrast between sky and clouds provides viewers with the dramatic scene the photographer saw.

Filters were discussed in detail in Chapter 6. The basic concept you must keep in mind is that a filter lightens its own color and darkens the complementary color on black-and-white film. Without a filter, a yellow flower against a blue sky will photograph without much contrast between sky and flower. To improve contrast and thus the picture, add a yellow filter, which will lighten the flower and darken the sky. To achieve effective photographic results, you must always consider the colors in the intended picture.

## Use Your Imagination

The composition techniques a photographer utilizes for his pictures often indicate how creative he is. The elements of a great picture may be present, but you must know how to compose them in order to make the most effective photograph. Of course, there is no right or wrong way to compose a picture; the techniques of composition outlined earlier in this chapter are intended only as guidelines.

While these guidelines are time-tested and accepted by many photographers, there is another element that must be considered—imagination. The creative photographer is one who knows the "rules" but also dares to break them. He experiments. He tries different approaches with different subjects. The result may or may not please him, but at least he has attempted to satisfy his curiosity. Don't be too content with your photography. Use your imagination.

For inspiration, look at the photos featured in advertisements, where trends in photography often surface first. For instance, black-and-white photography started coming back into vogue in the mid-1990s. You'll also notice that action-packed images are especially fashionable with the pros, who use slow shutter speeds or purposely move the camera during exposure to show their subjects with a blur. Take note of heads cut off in portraits, tilted horizons, and subjects distorted by ultra-wide-angle lenses. Instead of being realistic, advertising photos often try to convey an impression and involve the

228. Photography is more enjoyable when you use your imagination. Panning at a very slow shutter speed with galloping cowboys at a rodeo in Arizona resulted in this uncommon photo.

viewer on an emotional level. For example, ads for clothing may not show the clothes in detail but suggest the lifestyle you'd enjoy by wearing those clothes.

Always ask yourself, what are the various ways to portray this subject? Then try them. Would a soft effect be best with your subject? Break the rule about having your main subject in sharp focus— use a soft-focus filter or place a piece of nylon stocking in front of your lens to make the image slightly fuzzy. Why not jostle your camera during exposure to give a feeling of motion to an otherwise static subject? How about creating a more somber mood in your photograph by underexposing and thereby darkening the subject? Or purposely overexpose to lighten the subject and give a cheerful feeling to the photograph. It's worth a frame or two of film to see if you get the effect you want.

Imagination also leads the photographer to variety in his photography. He makes night as well as daytime exposures, and shoots inside buildings as well as outside. His pictures include scenes as well as people, and animals as well as wildflowers. He frames overall views, and moves in for close-ups. He varies camera angles, too.

Everything he sees is a photographic possibility. He composes pictures in his brain before he records them on film. Even without

intending to stop and make a picture, he sees photographs of subjects while driving or walking. He becomes more aware of the world around him.

The creative cameraman photographs fish in his home aquarium, makes color pictures of celebrities on a television screen, and takes time exposures of fireworks. He shoots prayer candles in a church, and takes his camera to the theater for other existing-light pictures. He tries tricks like creating a ghost in his house by making a double exposure. He does close-ups of flowers in his garden and remembers to sprinkle the flowers and leaves with water to give an after-the-rain or early-morning dew effect.

Most important, an imaginative photographer learns to COVER A SUBJECT COMPLETELY. A day at the horse races should include much more than a few telephoto pictures of thoroughbreds on the home stretch. Get close and low to the track to fill your viewfinder with flying horses' hooves. Try fast and slow shutter speeds, and panning, to portray the speed of the animals. Shoot photographs of bouquet and trophy presentations in the winner's circle. Capture the grandstand spectators during and after a race. Show the tote boards, the betting windows, and the discarded tickets of losing bettors. With luck, you'll see and photograph the excitement of someone holding a winning ticket. It's obvious that to tell the story of a horse race, you must photograph more than just racing horses. To make sure your story is complete, always ask yourself, "What's missing?"

The creative photographer gets involved, uses his imagination, and has enthusiasm for telling his story. And he composes his pictures with care.

And remember, you must know the capabilities of your camera. Make a point of trying out your camera and equipment after you buy it, just as you would test-drive a new car. Invest in a roll or two of film and experiment with close focusing, depth of field ranges, and fast and slow shutter speeds. Use the self-timer, try the camera with flash, and make double exposures. Get to know your camera and equipment intimately so they become part of you, not just objects in your hands. Then you can devote your time to composing effective pictures, not fiddling with camera controls and wondering if you'll be able to get the pictures you want.

# Learning About Lighting

The word *photography* means "writing with light." Light is essential to making photographs, and you must understand how to use it in order to make your pictures as interesting as possible. There are two basic types of light: natural and artificial. The first comes from the sun, the other from man-made sources.

NATURAL LIGHT generally refers to daylight, although moonlight qualifies, too. For photographers, light during the day can vary. There might be a bright or hazy sun that causes shadows. Or it could be bright but cloudy with no shadows evident. Or there might be a heavy overcast. Daylight also exists in the shade, where subjects are shielded from the direct rays of the sun. Daylight exists indoors, too, so not all natural-light shots are taken outdoors.

ARTIFICIAL LIGHT is illumination produced by man. It may be an ordinary lightbulb, a fluorescent tube, a bright photoflood, a tungsten-halogen lamp, an electronic flash, or many other types. Since these types of illumination can be used outdoors, too, not all photographs shot with artificial light are taken indoors.

Photographers also talk about AMBIENT LIGHT, EXISTING LIGHT, and AVAILABLE LIGHT. Regardless of the term, this is light—whether natural or artificial—that is already present in the subject area. A photographer who shoots by ambient, existing, or available light does not provide any of his own illumination.

Just as there are types of light, there are types of *lighting* that have special significance for photographers. For instance, directional lighting, such as that provided by the sun, flash, or tungsten-halogen bulbs in reflectors, is more precisely described as being front lighting, side lighting, or backlighting.

229. Lighting greatly affects the visual impact of a photograph. These long shadows across a rippled sand dune in Death Valley, California, were cast by the setting sun.

## Basic Types of Lighting

FRONT LIGHTING is the most basic for photographers, although not the most appealing. A long-standing rule that says to put the sun at your back so it shines on the front of your subjects was established for good reasons. Early films and camera lenses were not as fast as those in use today; they required considerable light to make an exposure. Old-time camera and film manufacturers knew that bright and direct sunlight on the subject would provide an adequate image on the film, and so they recommended it. Also, a subject illuminated directly from the front shows every detail because it is uniformly lighted.

Front lighting is still popular today, but many photographers find

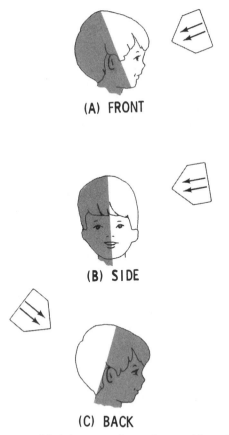

(A) FRONT

(B) SIDE

(C) BACK

230. The different types of lighting must be understood in order to achieve the best photographic results. The three basic types of directional lighting are front (A), side (B), and back (C).

231. This pensive girl
was illuminated by
side light coming
through an open
window.

it unsatisfactory for portraits and other subjects. The reason is that front-lighted subjects appear "flat" because there are no shadows to give a feeling of depth. For this reason, front lighting is commonly referred to as FLAT LIGHTING. Another disadvantage of front lighting is that people often squint because the light is shining directly in their eyes.

Photographers have found that changing their camera angle or the position of the subject so that the main illumination is from the side gives more depth and interest to many of their pictures. This is especially true when shooting close-ups of objects. SIDE LIGHTING can illuminate the left side or the right side of the subject, depending on your preference. If the shadows created on the opposite side are too dark and distracting, add FILL LIGHT (see the next section) to those shadows with a flash or a reflector. Or use backlighting.

BACKLIGHTING refers to situations where the main source of illumination is behind the subject, shining in the direction of the camera. Backlighting requires careful exposure readings so that the front of the subject will be properly exposed. If a reading is made of the backlight itself, the subject will be underexposed and appear as a SILHOUETTE. With portraits outdoors, backlighting allows your subject to have a natural expression without squinting because bright light is not shining directly on his face or into his eyes.

When strong directional light comes from *both* sides, the technique is known as CROSS LIGHTING. It is normally used in studio situations with flash or tungsten studio lights, not under daylight conditions.

232. Backlighting can create some eye-catching shadows, as with these parading flamingos.

## Outdoor Lighting Concerns

Front lighting, side lighting, and backlighting can be used indoors or outdoors. When shooting indoors with flash or tungsten lights, the lighting direction is quite easy to control because you position the light source(s). However, outdoors when the sun is the source of light, there is little choice if you don't like its direction. Either you must change your camera angle, reposition your subject, wait until a different time of day, or find a different subject.

On overcast days, DIRECTIONAL LIGHTING is not a problem because the sunlight is diffused. Actually, many photographers prefer DIFFUSED LIGHTING, especially for portraits, because your pictures will not be as contrasty as when the lighting is direct. Diffused light is often referred to as SOFT LIGHTING. Its opposite is so-called HARD LIGHTING, which comes from a concentrated source, such as the direct sun, and can create harsh, high-contrast effects.

An alternate source of lighting outdoors is flash, which can provide directional lighting from the front, side, or back of your subject. Flash can also be used for FILL LIGHT (see the next section) to soften the otherwise harsh shadows caused by strong sunlight.

Without flash, and if the sun causes unwanted shadows, often it's best to PHOTOGRAPH SUBJECTS IN THE SHADE. However, care must be taken when shooting with color film because the shaded area may transmit or reflect undesired colors onto your subject. For example, when a portrait is taken under the shade of trees, sunlight filtered by

233. Directional lighting, which is sometimes called hard lighting, is evident in this close-up of an Argentine gaucho's silver spurs.

234. By comparison, this waiter in front of a bistro in Yugoslavia is illuminated by what is termed diffused or soft lighting, which causes little or no shadows.

the leaves may give a slightly greenish cast to your subject. Similarly, with a person in the shade of the overhanging roof of a red barn, light reflecting from the barn may add an unwanted reddish cast to your subject. Even if your eye does not discern the added color, your color film may record it; always be aware of this when photographing subjects in the shade. By the way, when shooting in the shade of trees, also watch out that direct spots of bright sunlight

passing through the leaves do not cause unwanted patterns on your subject.

What are other lighting considerations when shooting outdoors? The best advice is to walk around your subject to determine the camera angle that will give the best effect for the lighting present. The location of movable subjects may need to be changed for the most effective lighting. Regardless, noontime is not the best time for making photographs in bright sunlight. If the sun is too much over-head, the effect will be one of TOP LIGHTING, and unpleasant shadows are the result.

For this reason, many photographers prefer early-morning and late-afternoon shooting when the sun is closer to the horizon. Then a camera angle can be chosen for front lighting, side lighting, or backlighting. However, take note that if you are shooting color film very early or late in the day, your subjects may take on a reddish cast because of the color of the rising or descending sun. Fortu-nately, a LIGHT-BALANCING FILTER can be used to correct these prob-lems (see page 243), although some photographers like the extra warmth the reddish light gives to certain subjects at those times of the day.

With portraits in the sun, be careful that SHADOWS do not obscure your subject's eyes. This occurs most often when the sun is overhead and the light is coming from the top of the picture. It's especially bothersome when much more of the face is in shadow because your subject is wearing a baseball cap or some other hat. To avoid these shadows, move your subject to a shaded area or wait until the sun's angle changes. However, it is often easier to fill shadows with light

235. Backlighting can produce striking photographs of water, stained glass, and other translucent subjects, such as these tulip petals (see text).

236. Sunsets make attractive pictures in themselves, but they often are more interesting when subjects are included in the foreground, as with these flats fishermen in the Florida Keys.

from a flash or a reflector. There are collapsible reflectors of silver or gold fabric designed for photography, or simply use a piece of crinkled aluminum foil or white poster board.

As mentioned earlier, portraits made using BACKLIGHTING can be very pleasing. But also consider using it to photograph translucent subjects, especially water, which will show a special sparkle. Just walk around a water fountain to see how dramatic backlighting can be when the light is transmitted through the water. By comparison, water illuminated from the front simply reflects the light back to the camera and the effect is rather dull.

Similarly, raindrops on flowers or leaves are best photographed with backlighting. Likewise, backlighted rivers and lakes often create dramatic bright pinpoints of light as the sunlight bounces into the camera from the water's surface. Star effects from these dots of light can be achieved if your lens opening is closed down to f/16 or smaller, or if you use a star filter or cross-screen filter.

Always consider how transparent or translucent your subjects are, and whether backlighting will produce a better effect than front or side lighting. For example, light passing through stained-glass windows and colored glassware produces rich colors by comparison with the pictures you would get with the sun reflecting off the front of the glass.

Some outdoor lighting conditions make effective photographs in

themselves. RAINBOWS AND SUNSETS are two examples. No special expo-
sure is required, although colors will be more vivid if you slightly
underexpose. Bracketing will provide a variety of color ranges and
moods. Light from a descending sun diminishes quickly, so make
your exposure immediately after taking the exposure reading. Read
the sky and clouds around the setting sun, or read the sun directly.
Don't include dark foreground objects in your reading or the film
may be overexposed.

## Indoor Lighting, Especially for Portraits

Indoor lighting requires other considerations. Photographers
sometimes use just the ambient light in a room, because it produces
a natural lighting effect. The lighting may be diffused and somewhat
nondirectional, as when it comes from a number of ceiling lights.
Or it may be more directional, as with sunlight coming through
windows.

Most often, however, indoor lighting is under the control of the
photographer, who mounts flash units or tungsten studio lights on
light stands and arranges them to provide the illumination he
desires. Sometimes the light is directed into an overhead UMBRELLA
REFLECTOR or at a white ceiling, which diffuses and reflects the light
downward to provide soft and even illumination. This BOUNCE
LIGHTING gives a natural effect to photographs, since we are accus-
tomed to light coming from above us.

With formal indoor portrait situations, the photographer fre-
quently prefers to use more directional lighting. Depending on the
effects desired, two to four lights can be arranged according to com-
monly accepted lighting plans for portraiture. The simplest lighting
setup for portraits involves only two lights: the main light and the fill
light.

To give depth and detail to your subject, the MAIN LIGHT is placed
to one side of the camera at about a 45° angle from the camera, and
about 45° above the subject's head. This main light should be closer
to the subject than the camera. Because the main light is off to the
side and higher than the camera, it will shadow part of your subject;
the FILL LIGHT is used to illuminate those shadows and keep them
from appearing too dark. Place the fill light farther from the subject
but near to the camera on the side that's opposite the main light. The
fill light should be slightly higher than the camera lens.

Test the effect of the main light before turning on the fill light. The

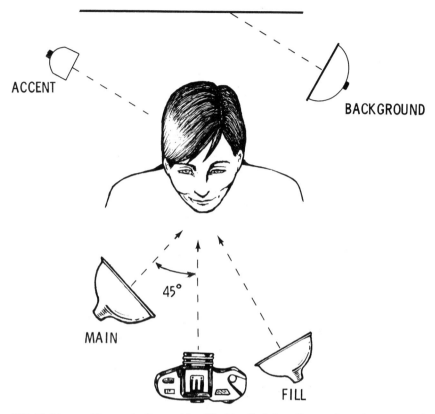

237. Lights used for portraits are identified by their function and can be arranged in this manner (see text).

shadow of the subject's nose caused by the main light should not reach his lips. If it does, adjust the main light or ask your subject to lift his head. By the way, as a matter of courtesy, portrait photographers never touch their subjects; they simply tell the person which way to move his head or body.

One or two more lights can be added to improve portrait lighting. One is called an accent or hair light, the other a background light. Most often the ACCENT LIGHT or HAIR LIGHT is used to outline or add highlights to the hair of the subject. It also helps separate the subject from a dark background. The accent light is placed behind and high to one side of the subject, and should face but not shine into the camera lens. For this reason, a spotlight is best. A cone-shaped SNOOT or adjustable flaps called BARN DOORS can be attached to the light reflector to direct the accent light and prevent it from shining into the lens.

238. In addition to the main light and fill light, an accent light was used to highlight the subject's hair and separate her from the dark background.

A BACKGROUND LIGHT helps separate the subject from the background and give the portrait additional depth. This light is directed at the background and is kept low and behind the subject. The brightness of the background is determined by how close the light is to the background. In studios, long, wide rolls of white, black, or colored SEAMLESS PAPER are often used for the background. Exposure meter readings should be made for the subject's face with the background light off so that it does not influence the reading.

The basic lighting design just described works not only with people but with most other subjects, including still lifes, such as a vase with flowers or a bowl of fruit. Only two lights are needed, but an accent and/or background light will add highlights. Additional lights are not needed and will decrease the impact of your photograph. An exception is when two main lights, one on each side of the subject, are used for a CROSS LIGHTING effect. A fill light at the camera position will decrease the shadow that usually appears down the middle of a cross-lighted subject.

There are two basic types of lighting equipment used for portraits and other studio work. The primary type is flash, and the other type is tungsten light. TUNGSTEN LIGHT is commonly called HOT LIGHT because it is continuous light from electrical bulbs, as compared with the momentary light from flash units.

The main advantage of tungsten light is that you can easily see the lighting effect you'll get as you place the main, fill, accent/hair, and

background lights to illuminate the subject. That's the reason we advise you to shoot with tungsten light rather than flash—at least until portrait lighting techniques are thoroughly understood and become second nature to you.

For portrait lighting setups at home, tungsten light most frequently is from either of two high-wattage sources: tungsten-halogen bulbs or photoflood bulbs. Both burn very bright, produce considerable heat, and require care when handled. They should be used in protective metal reflectors that concentrate the light and direct it toward your subject. The reflectors have heat-resistant sockets connected to heavy-duty electrical cords. The lights should be plugged into different electrical circuits to avoid overloading circuit breakers or blowing fuses.

The more traditional lights used in reflectors for home portrait "studios" are PHOTOFLOOD BULBS. They resemble ordinary household lightbulbs but burn much brighter, have much shorter lives, and cost considerably more. Photofloods are available in a choice of two colors, white or blue (designated B), for use with particular types of film. You also have a choice of two brightnesses in corresponding bulb sizes: 250 watts, which are smaller and designated as No. 1 bulbs, and 500 watts, which are larger and designated as No. 2 bulbs. Specific bulbs are further identified by a three-letter code.

The blue-colored photofloods have a color temperature of 4800 K (kelvin) and are designed for use with all daylight color print and

239. For informal portraits at home, you can use bright photoflood or tungsten-halogen bulbs in protective metal reflectors, such as these Smith-Victor models that are sold in a kit with light stands.

color slide films. (Although daylight films are balanced for a color temperature of 5500 K, blue photofloods give a slightly warm result that is usually pleasing for portraits; to capture the true colors of your subject, an option is to use a No. 82B light-balancing filter.) The smaller size BCA (No. B1) bulb has 250 watts of power and a rated lamp life of three hours, while the larger EBW (No. B2) bulb is twice as bright and has 500 watts of power with a rated life of six hours.

Also available are white photoflood bulbs with the same choice of brightnesses and life spans. The smaller BBA (No. 1) and larger EVB (No. 2) bulbs both have a color temperature of 3400 K, which is balanced for use with a specific tungsten color slide film, Kodachrome 40 (Type A). They can be used as well with black-and-white films. Another pair of white bulbs, ECA (No. 1) and ECT (No. 2), have a color temperature of 3200 K that is balanced for use with all other tungsten (Type B) color slide films, and can also be used with black-and-white films. These latter two bulbs have a rated life of 20 and 60 hours, respectively.

The newer and more efficient type of light source for portrait photography at home are TUNGSTEN-HALOGEN BULBS, also called quartz-halogen, quartz-iodine, or simply halogen bulbs. The style to use is the small, so-called peanut-type bulb with a two-pin bayonet end. It fits into a special adapter that screws into the lamp socket of a reflector in place of a photoflood bulb. The adapter is available in two lengths to duplicate the positions of the two sizes of photoflood bulbs in the reflectors.

Tungsten-halogen bulbs vary in color temperature, wattage, and lamp life, according to their three-letter identification codes. For example, the DVY bulb has a color temperature of 3400 K that is balanced for tungsten color slide film, Kodachrome 40 (Type A). It draws 650 watts of power and has a rated life of 25 hours. The DYH bulb has a color temperature of 3200 K to balance it for use with all other tungsten (Type B) color slide films. This 600-watt bulb has a rated life of 75 hours. With the proper bluish conversion filter, these halogen bulbs can also be used with all daylight color print and color slide films; for 3400 K bulbs, use a No. 80B filter, and for 3200 K bulbs, use a No. 80A filter. In addition, the bulbs can be used with black-and-white films.

*There are some special safety precautions when using halogen bulbs and photoflood bulbs.* You are warned not to touch the glass of any tungsten-halogen bulb with your fingers, because even the slightest perspiration can cause it to heat unevenly and possibly shatter. The bulb's filament is very delicate when heated, so move

the reflector gently when repositioning it while the lamp is on or still hot. Beware of burning yourself or your subject when handling the reflectors with their hot bulbs. If a bulb burns out, wait until it cools completely before attempting to replace it. Don't let the reflectors or their bulbs get too close to or touch any cloth, paper, or other flammable materials; be careful with homemade diffusion screens or barn-door light-control flaps you might attach to the reflectors.

Finally, you should know that the ultraviolet (UV) radiation produced by high-wattage halogen lamps can give your subjects the effects of a painful sunburn with prolonged use. Don't keep the lights on any longer than necessary; also consider using the light indirectly, such as bouncing it off the ceiling or into an umbrella reflector.

For most casual photographers, the need to take occasional portraits of family, friends, and pets can be satisfied rather inexpensively with halogen bulbs or photofloods mounted in common metal reflectors on simple light stands. Of course, those very hot and bright lights may disturb babies and children and cause them to

240. Two off-camera flash units serving as the main and fill lights can produce a pleasing home portrait, but beware of shadows if your subject is too close to a light-colored background.

241. Modeling lights in studio flash units help the photographer position each light for the effect desired (see text). Portrait photographer Don Romero arranged three flash units—main, fill, and accent—for this studio shot.

squirm or squint. In that case, flash is recommended for portraits of young subjects.

The problem when setting up FLASH FOR PORTRAITS is that you don't know exactly what the lighting results will be until you see the picture. (That's why many pros shoot test shots with Polaroid instant film prior to making flash portraits on their regular film.) In order to see in advance where the flash light will fall and any shadows that might result, use normal household bulbs in reflectors as MODELING LIGHTS to determine the best positions for the main flash and fill flash (and accent flash and background flash, if any). Then substitute the flash units to make the actual pictures. If you decide to invest in professional lighting equipment, there are studio-type flash units that incorporate modeling lights to help you position the flash units.

Anyone who becomes intrigued by portrait photography should study some of the many illustrated books devoted to the subject. Besides finding out much more about portrait lighting and equipment, you'll learn various techniques for making successful portraits in the studio and on location. You may even decide to specialize in family, baby, pet, wedding, fashion, boudoir, or one of the other varied kinds of portraiture.

In any case, experiment with indoor lighting so you'll be familiar with equipment and methods before the occasion arises when you'll need to make a picture under such conditions. Learning how to use indoor and outdoor illumination effectively is an important goal for all photographers. Because you never know under what conditions a great picture possibility will suddenly present itself, it is wise to get experience by making pictures under all lighting conditions. At least be sure your photographic capabilities include knowing how to make pictures inside buildings and after the sun goes down. We bet you'll be surprised how well some of your initial interior and after-dark shots turn out.

# PHOTOGRAPHING UNDER SPECIAL CONDITIONS

There are some special categories of photography that may interest you. These often require a different approach for determining exposure, or some extra equipment. This chapter covers existing light photography, including night exposures. It also deals with close-up and copy work, infrared, aerial, and underwater photography. And you'll find more comments on double and multiple exposures. The use of binoculars, telescopes, and microscopes for photography is discussed, too. Included are hints for successful shooting gained by experimentation and experience.

242. Nighttime exposures can give a new dimension to your photography. Buildings often photograph best when the sky still has a slight glow, which is soon after the sun goes down and the lights have been turned on. This is the classic Empress Hotel in Victoria, Canada.

## Shooting with Existing Light and at Night

While outdoor sunlight is the most common type of illumination for making photographs, many worthwhile subjects are photographed at night or indoors by EXISTING LIGHT. (Existing light is also referred to as AVAILABLE LIGHT and AMBIENT LIGHT.) The films and exposures to use will vary depending on the light sources and the shooting situation. Since light levels usually are low at night and indoors, fast films (those with higher ISO numbers) are often preferred.

For the best exposure results, you should always use an exposure meter to read the light and determine the f/stop and shutter speed. Unfortunately, some exposure metering systems built into cameras, and even some hand-held meters, may not be sensitive enough to make accurate readings in low light. Whenever your meter is not capable of making a reading because the light is too dim, use the chart on pages 362–63 as a guideline for trial exposures.

The chart suggests exposures for various subjects in different lighting situations; use the exposure settings in the column with an ISO film speed that matches the speed of the film in your camera. If your lens cannot be set to the f/stop suggested in the chart (it may not have an f/2 or f/2.8 setting), open your lens to its widest aperture and compensate by using a slower shutter speed (see page 44). Or switch to a faster film.

Regarding SHUTTER SPEEDS, the built-in exposure metering systems in modern 35mm cameras are able to make automatic or manual TIME EXPOSURES of several seconds. The shutter speed dial and/or camera instruction manual will indicate the range of specific times, such as 1, 2, 4, 8, 15, and 30 seconds. (The slowest shutter speed in many older 35mm models is only 1 second.) For time exposures of other durations, you'll have to set the shutter speed to B or T to manually hold the shutter open for the time required.

Because FLASH is an instant source of bright light, it is often considered to be a good source of illumination indoors and at night. However, flash is frequently a poor choice, especially when subjects are too distant to be effectively illuminated by the flash's light. For instance, shooting a flash picture at night of players on the field in a football stadium is a waste of film. Likewise, in certain situations, it may be impolite if not offensive to use flash, as during a wedding ceremony or a stage play. More important, pictures made with flash do not appear as natural as those exposed with the existing light. Although bouncing the flash light will soften its effect and provide

more natural-looking illumination, many photographers prefer to use only the existing light to make indoor and nighttime exposures.

When using existing light, a main consideration is film speed. Because the light usually is less bright than direct sunlight, a HIGH-SPEED FILM is often preferred. In many cases, this faster film allows you to hand-hold the camera instead of using a tripod. Also, it enables you to stop the action, such as at sporting events. Use high-speed films of at least ISO 400 for action-stopping photography, in very low-light situations, or when a small f/stop is required for increased depth of field. Even better, under some situations, are faster films with speeds of ISO 800, 1000, 1600, or 3200. With *each* doubling of the ISO film speed, you can shoot at the equivalent of one smaller f/stop, or one faster shutter speed, which offers a greater choice of exposure settings for more control of the image.

When you don't have a higher-speed film available, an option for making exposures in low light is to go ahead and shoot the film you have at a higher ISO speed anyway. For example, you can rate an ISO 200 at ISO 400, 800, or 1600, and set your exposure meter accordingly. However, because the film will be underexposed at these higher film speeds, you must compensate by overdeveloping the film, which is known as PUSH PROCESSING. Depending on the film's limitations, you can reset the ISO speed on the exposure meter two, three, or even four times higher than the film's normal ISO speed, as long as the film is overdeveloped accordingly. (The revised ISO you use is more correctly known as the EXPOSURE INDEX, which is abbreviated as EI; see page 65.)

For example, Kodak's Ektachrome P1600 color slide film is specifically designed for push processing; its nominal ISO 400 speed can be increased to ISO (or EI) 800, 1600, or 3200, when given extended development. The film cassette has a write-on area listing those four speeds so you can indicate to the processing laboratory the ISO at which the film was shot. *Remember, a film that is to be push-processed must be exposed at only one film speed; you can't change the exposure meter's ISO setting to a different film speed in the middle of a roll.*

Push processing is more common with certain color slide and black-and-white films than with color print films. That's because color print films have considerable exposure latitude; in low-light situations, you can make exposures at double their normal film speeds and still get acceptable color prints *without* special push processing of the film.

Of course, most photographers buy high-speed films to use in low-light situations rather than rating their regular films at higher

# Trial Exposures Under Difficult Lighting Conditions

| | Subject | Film Speed | | | | | | | |
|---|---|---|---|---|---|---|---|---|---|
| | | 25 | 32 to 50 | 64 to 100 | 125 to 200 | 250 to 400 | 800 to 1000 | 1600 | 3200 to 6400 |
| AT HOME | **Home interiors at night:** Areas with average light | 1/4 s f/2 | 1/4 s f/2 | 1/4 s f/2.8 | 1/15 s f/2 | 1/30 s f/2 | 1/30 s.f/2 | 1/30 s f/2.8 | 1/60 s f/4 |
| | Areas with bright light | | 1/6 s f/2 | 1/15 s f/2 | 1/30 s f/2.8 | 1/30 s f/2.8 | 1/30 s f/4 | 1/60 s f/4 | 1/60 s f/5.6 |
| | Candlelit close-ups | — | — | 1/4 s f/2 | 1/8 s f/2 | 1/15 s f/2 | 1/30 s.f/2 | 1/30 s f/2.8 | 1/30 s f/4 |
| | Indoor holiday lights and Christmas trees | 1 s f/2 | 1 s f/2.8 | 1 s f/4 | 1 s f/5.6 | 1/15 s f/2 | 1/30 s f/2 | 1/30 s f/2.8 | 1/30 s f/4 |
| OUTDOORS AT NIGHT | Outdoor holiday lights and Christmas trees | 1 s f/2 | 1 s f/2.8 | 1 s f/4 | 1 s f/5.6 | 1/15 s f/2 | 1/30 s f/2 | 1/30 s f/2.8 | 1/30 s f/4 |
| | Brightly lit street scenes | 1 s f/5.6 | 1/15 s f/2 | 1/30 s f/2 | 1/30 s f/2.8 | 1/60 s f/2.8 | 1/60 s f/4 | 1/125 s f/4 | 1/125 s f/5.6 |
| | Neon signs and other lighted signs | 1/30 s f/2 | 1/30 s f/2.8 | 1/30 s f/4 | 1/60 s f/4 | 1/125 s f/4 | 1/125 s f/5.6 | 1/125 s f/8 | 1/125 s f/5.6 |
| | Shop windows | 1/15 s f/2 | 1/30 s f/2 | 1/30 s f/2.8 | 1/60 s f/4 | 1/60 s f/4 | 1/60 s f/5.6 | 1/60 s f/8 | 1/60 s f/11 |
| | Subject lit by street lights* | — | — | 1/4 s f/2 | 1/8 s f/2 | 1/15 s f/2 | 1/30 s f/2 | 1/30 s f/2.8 | 1/60 s f/4 |
| | Floodlit buildings, fountains, monuments | 1 s f/2 | 1 s f/2.8 | 1 s f/4 | 1/2 s f/4 | 1/15 s f/2 | 1/30 s f/2 | 1/30 s f/2.8 | 1/30 s f/4 |
| | Skyline—distant view of lighted buildings | 8 s f/2 | 4 s f/2 | 4 s f/2.8 | 1 s f/2 | 1 s f/2.8 | 1 s f/4 | 1 s f/5.6 | 1 s f/8 |
| | Skyline—10 minutes after sunset | 1/30 s f/2 | 1/30 s f/2.8 | 1/30 s f/4 | 1/60 s f/4 | 1/60 s f/5.6 | 1/125 s f/5.6 | 1/125 s f/8 | 1/125 s f/11 |
| | Skyline—just after sunset | 1/30 s f/2.8 | 1/30 s f/4 | 1/60 s f/4 | 1/60 s f/5.6 | 1/125 s f/5.6 | 1/125 s f/8 | 1/125 s f/11 | 1/250 s f/11 |
| | Moving traffic on highways, etc—light patterns* | 20 s f/8 | 20 s f/11 | 20 s f/16 | 10 s f/16 | 10 s f/22 | 10 s f/32 | 5 s f/32 | 3 s f/32 |
| | Fairs, amusement parks, illuminations | — | — | 1/15 s f/2 | 1/30 s f/2 | 1/30 s f/2.8 | 1/60 s f/2.8 | 1/60 s f/4 | 1/125 s f/4 |
| | Fireworks—displays on the ground | 1/15 s f/2 | 1/30 s f/2 | 1/30 s f/2.8 | 1/30 s f/4 | 1/60 s f/4 | 1/60 s f/5.6 | 1/60 s f/8 | 1/60 s f/11 |
| | Campfires, bonfires, burning buildings | 1/15 s f/2 | 1/30 s f/2 | 1/30 s f/2.8 | 1/30 s f/4 | 1/60 s f/4 | 1/125 s f/4 | 1/125 s f/5.6 | 1/125 s f/8 |
| | Subjects lit by campfires, bonfires | — | — | 1/8 s f/2 | 1/15 s f/2 | 1/30 s f/2 | 1/30 s f/2.8 | 1/30 s f/4 | 1/60 s f/4 |

| Subject | | | | | | |
|---|---|---|---|---|---|---|
| **INDOORS IN PUBLIC PLACES** | | | | | | |
| Night football, night tennis, race track* | 1/30 s f/2.8 | 1/60 s f/2.8 | 1/125 s f/2.8 | 1/250 s f/2.8 | 1/250 s f/4 | 1/500 s f/4 |
| Moonlit landscapes† | 30 s f/2 | 15 s f/2 | 8 s f/2 | 4 s f/2 | 4 s f/2.8 | 4 s f/4 |
| Moonlit snowscenes† | 15 s f/2 | 8 s f/2 | 4 s f/2 | 4 s f/2.8 | 4 s f/4 | 4 s f/5.6 |
| Basketball, bowling, ice hockey | 1/30 s f/2 | 1/60 s f/2 | 1/125 s f/2 | 1/125 s f/2.8 | 1/250 s f/2.8 | 1/500 s f/2.8 |
| Boxing, wrestling | 1/60 s f/2 | 1/125 s f/2 | 1/250 s f/2 | 1/250 s f/2.8 | 1/250 s f/4 | 1/500 s f/4 |
| Circuses, floodlit acts | 1/30 s f/2 | 1/30 s f/2.8 | 1/60 s f/2.8 | 1/60 s f/2.8 | 1/125 s f/2.8 | 1/250 s f/2.8 |
| Circuses, spotlit acts | 1/30 s f/2 | 1/60 s f/2.8 | 1/125 s f/2.8 | 1/250 s f/4 | 1/250 s f/5.6 | 1/500 s f/5.6 |
| Interiors with bright fluorescent light | 1/15 s f/2 | 1/30 s f/2.8 | 1/60 s f/4 | 1/60 s f/6 | 1/60 s f/8 | 1/60 s f/11 |
| School performances—stage and auditorium | — | 1/15 s f/2 | 1/30 s f/2 | 1/30 s f/2 | 1/30 s f/2.8 | 1/60 s f/4 |
| Swimming pool—tungsten light (above water) | — | 1/15 s f/2 | 1/30 s f/2 | 1/30 s f/2.8 | 1/60 s f/2.8 | 1/60 s f/4 |
| Hospital nurseries/delivery rooms | 1/15 s f/5.6 | 1/15 s f/2 | 1/30 s f/2.8 | 1/60 s f/2.8 | 1/125 s f/4 | 1/125 s f/5.6 |
| Church interiors—tungsten light | 1 s f/4 | 1 s f/5.6 | 1 s f/2.8 | 1/15 s f/2 | 1/30 s f/2 | 1/60 s f/4 |
| Stained glass windows, daytime—photographed from inside | Use 3 stops more than for the outdoor lighting conditions | | | | | |
| Glassware in windows, daytime—photographed from inside | Use 1 stop more exposure than for the outdoor lighting conditions | | | | | |

**Note:** s = seconds

*When the lighting provided is mercury-vapor lamps, you should get the best results by using daylight-balanced film for color slides. However, the slides may appear greenish.

†For scenes lit by the unobscured full moon to show full detail in the surroundings. Do not include the moon in the picture; it will move noticeably during the exposure.

For critical use, use filters under fluorescent or tungsten illumination. In home tungsten lighting, use a No. 80A filter and increase exposure by 2 stops.

■ For color slides of these scenes, use tungsten-balanced film for the most natural color rendition. If you use daylight color film, slides may look yellow-red.

■ For color slides of these scenes, use daylight-balanced film or tungsten film with a No. 85B filter over the camera lens. When using this filter, increase by 1 stop exposure.

□ For color slides of these scenes, you can use either daylight or tungsten film. Daylight film will produce slides with a warm, yellowish look. Tungsten film will produce slides with a cold, bluish appearance.

**Note:** For shutter speeds slower than 1/30 second, use a tripod.

243. Metering systems in modern auto-exposure cameras are often sensitive enough to make accurate readings and/or automatic exposures of subjects at night and under other unusual light conditions. When in doubt, you can refer to the chart on these facing pages for trial exposures to set manually on your camera. Find the ISO speed of the film you are using, then go down the appropriate column to the exposure time (s = seconds) and lens aperture (f/number) suggested for your particular subject. If your lens does not have openings as wide as f/2 or f/2.8, set the lens to its widest aperture and compensate by increasing the exposure time. It's always a good idea to shoot a few extra frames of film and bracket exposures. (Chart courtesy of Eastman Kodak Company.)

244. High-speed film often makes it possible to hand-hold your camera when shooting interiors, as of the ornate St. Florian Abbey Church in Austria. With slow- and medium-speed films, you may need a tripod to keep the camera steady during longer exposures.

film speeds. The main reason is that films exposed at higher-than-normal ISO speeds and then overdeveloped lose some of their quality; increases in graininess and contrast are especially noticeable, and there may be some change in the colors. However, pushing a film often permits pictures to be made with very weak illumination when fast film isn't immediately available, and the results may be quite acceptable under the circumstances.

In addition to a fast film, a FAST LENS is often preferred for photography in low light. It allows more light to reach the film so faster shutter speeds can be used, which helps the photographer avoid blurred images when hand-holding the camera or trying to stop subjects in action. Fast lenses with a wide maximum lens opening, such as f/2 or f/2.8, often are the most versatile for existing light photography.

Of course, when you want to purposely blur a moving subject to show motion, having a fast lens is not important. That's because the lens aperture is stopped down to a small opening to compensate for the longer exposure time required to create a blur. Among favorite

245. Whenever lighting of your subjects is uneven, spot meter readings of dark areas and bright areas can be averaged as a starting point for existing light exposures. Other exposure options for difficult lighting situations are to switch to the sophisticated multizone metering system found in modern single lens reflex (SLR) cameras, and to bracket.

subjects to blur at night are moving cars and rotating Ferris wheels, which produce colorful streaks of light.

Whatever the subject, when you are FIGURING EXPOSURE, make sure you take a meter reading of the most important part of your picture, especially if the illumination is uneven. Always get close enough to your subject so your camera's metering system is not misled by overly bright or overly dark areas. For subjects that are some distance away, use spot metering or make the reading through a telephoto lens.

When making nighttime exposures, it's best to use spot or center-weighted metering to read the specific areas of the scene that are lighted. If you make an overall reading, the dark areas of the scene may influence the meter and result in overexposure. This can also be true at an indoor theater or auditorium where the dark area surrounding the stage may mislead your meter. If possible, get close enough to make an exposure reading for only the stage area, or else use spot or center-weighted metering.

Another tip for night exposures: First try to "read" the light with your eyes to determine if lights in any portion of the picture are too bright by comparison with the others. Squinting your eyes while

looking at the scene will help you locate overly bright light or areas. You may have to change your camera angle to eliminate any problem of uneven lighting so it doesn't affect your meter reading or create a distraction in the picture.

Exposures for nighttime photography have more latitude than do those made in the sunlight. Even much-varied exposures at night will all produce interesting and pleasing pictures, unless they are greatly underexposed. Regardless, bracketing exposures is always suggested. Be sure to write down the exposures used for your night shots for later reference. On dark nights, a small flashlight will help you make notes and set your camera controls.

Regarding exposure techniques for existing-light and night shots, a tripod or other camera support should be used whenever exposures are 1/30 second or longer. For exposures longer than 1 second (or whatever the time-exposure limit of your auto-exposure camera), set the shutter speed to B or T and use a cable release or remote cord to avoid moving the camera while the shutter is open. Even at shutter speeds shorter than 1 second, tripping the shutter with the camera's self-timer, a cable release, or a remote cord is a smart way to prevent camera movement.

There are a great number of subjects to be recorded at night or by existing light. Fireworks are a favorite. Here are some suggestions for capturing those brief but brilliant displays on film. Mount your camera vertically on a sturdy tripod and focus the lens manually to infinity. Check that the horizon is straight and that there are no bright lights showing in the viewfinder that will overexpose the film during a time exposure. Manually set the shutter speed control to B and keep the shutter open about 8 to 10 seconds to record several bursts of fireworks on each frame of film. A starting point for exposures is f/8 with ISO 100 film, f/11 with ISO 200 film, and f/16 with ISO 400 film. Vary the f/stop or the number of bursts; you never know the intensity of a firework until it explodes. Take plenty of shots because fireworks shows usually don't last very long and it may be a while before you have a chance to photograph fireworks again.

Colorfully lighted fountains are also fun to photograph. Shoot at a fast shutter speed to freeze the water, then switch to a slow shutter speed to let the water blur, and compare the results. If the fountain's lights change color, make a multiple exposure of several colors; reposition the camera slightly between each exposure. Try filming illuminated monuments, buildings, and bridges as well. Downtown street scenes are also colorful; after a rain, concentrate on reflections. Photograph store window displays, and make a multiple expo-

246. Fireworks are challenging as well as fascinating subjects because you're never certain where or when they're going to explode. To get ready for this successful exposure with ISO 125 film, the photographer preset the focus to infinity, the lens opening to f/11, and the shutter to B for a time exposure. Then he aimed the viewfinder to follow the trajectory of the firework when it was sent skyward, and pressed the shutter release the moment the firework exploded.

sure of lighted store signs. At Christmastime, film outdoor holiday decorations, too. Refer to the chart on pages 362–63 for exposure advice.

Try some shots of the MOON. Use a telephoto lens, perhaps with a lens extender, to make the moon as large as you can in the viewfinder. Full moons are bright enough to be accurately read by a camera's through-the-lens metering system, but bracket exposures anyway. More details will be seen when you photograph a half-moon because it is being side-lighted by the sun. To improve scenic night shots, you can add a moon to the picture by making a double exposure (see page 392).

Also try some time exposures by the light of the moon. Do the same thing with light from a campfire. And don't forget nighttime sports events outdoors. Indoor sports activities are good subjects and offer other opportunities to use existing light. Also photograph church interiors, museum displays, and art gallery objects with existing light. The results are much nicer and always more natural than if you used flash.

Photographing images on a television screen or a computer monitor is another possibility. Put your camera on a tripod to hold it steady and get close to the screen to fill the viewfinder with the image. If shooting with a compact rangefinder camera, be careful of

framing problems; use the parallax correction marks in the viewfinder. Use black-and-white, color print, or daylight color slide film and adjust the screen controls for good color, brightness, and contrast. Avoid reflections by turning off room lights. Make an exposure meter reading of the screen area only *after* you've set the shutter speed. If your shutter speed is too fast, dark horizontal streaks will show up in the photograph because it takes at least 1/30 second for the television set's electron beam to form a picture image. With focal plane shutters common to SLR cameras, set a speed of $^1/_8$ second or slower to avoid the dark lines. With leaf-type shutters common to compact cameras, a speed of 1/30 second or slower should be used.

As to FILMS FOR EXISTING-LIGHT AND NIGHT PHOTOGRAPHY, keep in mind that black-and-white films and color negative (print) films can be used with most any type of illumination. However, pay special attention when shooting with COLOR SLIDE FILMS. As you know, they are of two types, daylight and tungsten, which are designed for specific light sources in order to reproduce colors just as you see them. Daylight slide films are generally for use with sunlight and electronic flash, while tungsten slide films are for exposures with incandescent light, such as household lightbulbs.

If you are shooting color slide film when light sources are mixed, choose the type balanced for the predominant source. For example, in a room where sunlight coming through windows provides most of the illumination, use daylight film. However, if daylight slide film is shot indoors with typical household lamps, the image will have an overall yellowish or reddish-orange cast; under fluorescent lights, the image will appear a sickly green. And if tungsten slide films are shot outdoors in daylight, the images will have a bluish look. Filters can be used to correct these color imbalances; refer to Chapters 5 and 6. Also read the notes accompanying the chart on pages 362–63 for trial exposures with existing light.

Of course, when you are shooting both outdoors and indoors under a wide variety of light sources, COLOR NEGATIVE FILMS have an advantage over color slide films because untrue colors can be corrected later with filtration when color prints are being made from the negatives. Or shoot with BLACK-AND-WHITE FILMS, which can also be used with all types of indoor and outdoor lighting.

When making pictures indoors or at night with existing light, it's always a good idea to BRACKET EXPOSURES by shooting the same subject two or more times at different shutter speeds or f/stops. You can use the chart of trial exposures on pages 362–63 as a starting point, but remember that they are only guidelines.

You'll note that most columns in that chart cover a range of ISO

247. Even though many night scenes are illuminated by tungsten light, such as this fountain in Lisbon, Portugal, daylight color films usually produce acceptable results. For truer colors, you can use filters on the camera lens. Also, when color negatives are being printed, filtration in the enlarger or the automatic processing machine can be adjusted for better color balance.

film speeds, such as 64 to 100. Because of the RECIPROCITY EFFECT, which occurs when films are shot at longer exposure times or under weaker illumination than those for which they were designed, exposures can only be estimated, and so slight differences in film speeds are of little concern (see page 211).

## Creating Close-ups and Making Photographic Copies

Close-up photography offers a thrilling world of imagery. Subjects are all around you—if you just get close enough to capture the dramatic details that are often overlooked from normal shooting distances. Nature provides endless opportunities to develop your eye and skills for close-up photography. In any backyard or garden you're likely to discover the design of a spider web, the shape of a flower bud, the texture of dewdrops on a rose petal, or the pattern of a butterfly wing. The challenge—and fun—of close-up photography is to bring the details of small objects to life in your pictures.

Common sense tells you that the closer your camera is to your

248. Close-up photography shows subjects in remarkable detail. When photographed with a macro lens, this spider web with droplets of dew appears almost as a pearl necklace.

subject, the larger it will appear on the film. However, not all lenses will focus as close to the subject as you wish. For instance, you'll recall that lenses of normal focal length for 35mm single lens reflex cameras may focus only as close as 18 inches (0.46 meters), thus limiting the image size of your subject on the film.

Fortunately, there are several ways to produce close-up images with an SLR camera: Use a macro lens, remove and reverse a normal or wide-angle lens, attach extension tubes or bellows or a lens extender between the camera lens and the camera body, or add accessory close-up lenses to the front of your regular camera lens. The equipment required for these techniques was initially described in Chapter 3, "Choosing Lenses"; be certain to reread pages 133–40 for a review before continuing.

As for making close-ups with 35mm compact cameras, which have nonremovable lenses, a few models allow an accessory close-up lens to be mounted in front of the regular camera lens. Others feature a "macro" or "close-focus" setting that will increase the image size of your subject, but only to a limited degree.

Technically, recording a subject life-size or larger on the film frame is termed PHOTOMACROGRAPHY. (Techniques for photographing through a microscope, called PHOTOMICROGRAPHY, are discussed later in this chapter.) Exactly to what extent the subject is magnified is

249. Macro lenses are specially designed for close-up photography. For example, a 35mm SLR camera with a *regular* 50mm lens could only focus as close as this to a collection of postage stamps that covered a table top.

250. However, when a 50mm *macro* lens was mounted on the camera, it could be focused so much closer to the subject that a single stamp in the middle of the table (Photography USA), now fills nearly half of the area of a film frame.

termed the REPRODUCTION RATIO. When your subject is recorded life-size on the film, it is said to have a one-to-one (1:1) reproduction ratio. When your subject appears one-half life-size, it has a one-to-two (1:2) ratio; when it is twice life-size, the reproduction ratio is two-to-one (2:1).

As discussed in Chapter 3, the most convenient and popular way to make close-up pictures is to use a 35mm SLR camera with a MACRO LENS. (Nikon and a few other manufacturers confusingly call it a MICRO LENS.) Identifying a lens as a macro (or micro) lens customarily means the lens allows you to focus closer than a regular lens of the same focal length. The most common focal lengths of macro lenses are 50mm, 100mm, and 200mm, although there are slight variations, such as 55mm, 60mm, and 105mm.

In addition to serving as a normal or telephoto lens, a *true* macro lens allows you to focus from infinity to within inches (or milli-

meters) of your subject to magnify its image on the film frame to at least one-half (1:2) life-size *without any lens extension attachments*. Most versatile is a macro lens that will magnify the image to life-size (1:1) without lens extension attachments.

Be aware that some SLR telephoto and telephoto zoom lenses feature a "macro" setting that allows you to focus closer than you normally could, but not as close as if you were using a true macro lens. Some magnify the image to only one-sixth (1:6) life-size, or at the most to one-fourth (1:4) life-size, without lens extension attachments.

The DISTANCE SCALE on true macro lenses includes not only the focusing distance in feet and meters but also the reproduction ratio. If you want a life-size image of your subject on the film, for instance, you simply set the lens focusing ring to a 1:1 (one-to-one) ratio and then slowly move the camera back and forth until the subject appears sharp to your eye in the viewfinder. (Remember to set the camera for manual focus rather than autofocus.)

When buying a macro lens, you should consider that the longer the focal length, the greater the distance you can work from the subject. By using a longer focal length macro lens, there is less chance of disturbing your subjects, or perhaps shadowing them with the camera equipment. You also have more room to position a flash unit or a reflector to illuminate your subject.

By comparison, to produce a life-size image, the working distance between subject and lens will be 8.75 inches (0.22 meters) with a 60mm macro, 12 inches (0.3 meters) with a 105mm macro, and 19.4 inches (0.49 meters) with a 200mm macro. A popular choice is a 100mm or 105mm macro lens, because it is also ideal for making portraits of people within its normal focusing range.

Without a macro lens, there is a simple but somewhat limiting way to make close-ups: you can remove and reverse your SLR camera's normal or wide-angle lens end for end. REVERSING A LENS allows you to focus closer to the subject, and thus enlarge the subject's image size on the film. However, the exact distance to the subject depends on the specific focal length of your reversed lens—and that distance is only slightly variable, depending on the distance setting on the focusing ring.

A special LENS REVERSING RING or MACRO ADAPTER RING to reattach the lens to the camera is recommended; otherwise, you'll have to physically hold the reversed lens in place. Exposure and focus must be set manually with a reversed lens, because its mechanical and electronic connections are detached from the camera when the

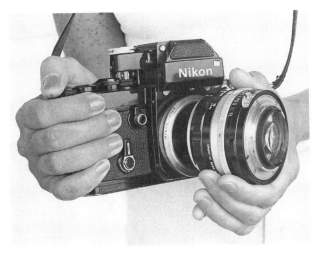

251. A simple way to make extreme close-up photographs with a single lens reflex (SLR) camera is to turn a normal or wide-angle lens end for end and remount it to the camera with a lens reversing ring (see text).

lens is turned end for end. Despite this unconventional use, when a normal or wide-angle lens is reversed, the rearrangement of its optics produce surprisingly sharp images of close-up subjects. Try it.

A third way to get close-up photos is by inserting *nonoptical* lens extension attachments between the camera body and its lens. These are either one or more rigid metal or plastic EXTENSION TUBES (also called EXTENSION RINGS), or a flexible EXTENSION BELLOWS. By increasing the distance of the camera lens from the film, the camera can be focused closer to the subject, thus increasing the subject's image size. Only single lens reflex cameras are suitable for lens extension devices because SLR lenses can be detached from the camera body. Lens extension tubes and bellows are commonly used with macro lenses, normal focal length lenses, and normal or wide-angle lenses that have been reversed. (See Illustration 99 with extension bellows in Chapter 3.)

Although more expensive, an extension bellows is more versatile because it allows greater flexibility in varying the amount of extension than do extension tubes. The extension bellows has a chart in millimeters to indicate the precise distance the bellows is extended. The extension tubes usually come in a set of short, medium, and long lengths of specific millimeters, such as 13mm, 21mm, and 31mm. The three tubes can be used singly or in combination with one another to extend to a choice of seven different lengths.

As you know, when the camera lens gets closer to a subject, the subject's image is magnified on the film. But exactly how much larger will the image appear? The specific magnification can be figured by adding the focal length of the camera lens to the distance

252. Nonoptical extension tubes of varying lengths offer an inexpensive option for making close-ups. When inserted between an SLR camera body and lens, these rings allow closer focusing that will increase your subject's image size, as with this bug in a Costa Rican forest.

it has been extended by the bellows or extension tube(s). As a benchmark, just remember that whenever the extension distance of the lens *equals* the lens focal length, the subject will be recorded life-size (1:1).

Here are some examples. (Measurement is usually in millimeters but can be in inches; see the chart that follows.) When a lens of 50mm focal length is extended by an equal length (50mm) to a total of 100mm, the image on the film will be life-size, which is a one-to-one (1:1) reproduction ratio. When a 50mm lens is extended only one-half its focal length (25mm) to a total of 75mm, a subject will be photographed one-half (1:2) life-size. A 50mm lens extended twice its focal length (100mm) to 150mm will produce an image two times (2:1) life-size. Study the chart opposite.

| Total Distance:*<br>50mm Lens and Extension<br>(mm)   (inches) | | Subject Magnification<br>in Terms of<br>Life-size / Reproduction Ratio | | Exposure<br>Factor |
|---|---|---|---|---|
| 75 | 3 | $^1/_2$ | 1:2 | 2X |
| 100 | 4 | life-size | 1:1 | 4X |
| 125 | 5 | $1^1/_2$ | 1.5:1 | 6X |
| 150 | 6 | 2 | 2:1 | 9X |
| 200 | 8 | 3 | 3:1 | 16X |

*The total distance equals the focal length of a lens plus its extension when the lens focus is set at *infinity*. Also note, the greater the image magnification, the greater the exposure increase required; either the f/stop or shutter speed can be changed to compensate by the exposure factors listed.

As an alternative to lens extension tubes or bellows to increase a subject's size on the film, you can use a LENS EXTENDER, also known as a LENS CONVERTER, TELE-EXTENDER, or TELECONVERTER. Like an extension tube, it is inserted between the camera body and its lens, but a lens extender has *optical* elements inside that increase the focal length of the camera lens—and thus the image size—either by $1^1/_2$ (1.5X), 2 (2X), or 3 (3X) times. For example, a 50mm lens with a 2X extender effectively becomes a 100mm lens and will double the subject's image size when the camera is kept at the same focus and at the same distance from the subject. The most common use of lens extenders is not for creating close-ups but to increase the focal length of telephoto and telephoto zoom lenses in order to make them more powerful (see page 127).

A fifth option for increasing the image size of a subject is to attach ACCESSORY CLOSE-UP LENSES to the front of the normal, telephoto, or zoom lens on your camera. These magnifying lenses are in threaded mounts and usually screw onto the camera lens like filters. Used singly or in pairs, they are available in various strengths or powers, called DIOPTERS. Their magnification ranges from +1 to +10 diopters; the higher the number, the closer the camera can focus to the subject and thus the greater the increase in the subject's image size on the film. See the chart on page 137 that is part of a more detailed description of close-up lenses in Chapter 3.

Also available is a VARIABLE CLOSE-UP LENS attachment that offers a range of diopters, such as from +1 to +10. Although easy to use, it may not be as sharp optically as individual close-up lenses of a specific diopter, and some vignetting may also occur; test it on your camera lens before purchasing, or make certain you have a money-back guarantee if ordering by mail. Sharpness, in fact, is a concern

253. Focusing is always critical for close-ups, because the closer a lens is focused on a subject, the more limited the depth of field. The eye of this land iguana in the Galapagos Islands was the point of focus.

with any of these relatively inexpensive close-up lenses, especially when two are used together.

While all of the other techniques previously described for making close-ups are limited to single lens reflex cameras, accessory close-up lenses can also be used with some 35mm compact cameras. However, there are problems involved in FOCUSING AND FRAMING your subject, because you do not see directly through the lens, as you do with an SLR camera. A chart comes with any particular close-up lens you buy, and it is needed for any non-SLR camera to determine the lens focus setting and the lens-to-subject distance that are required for the size of the subject image you want to record on film.

Framing must also be given special consideration when making close-ups with non-SLR cameras because of PARALLAX ERROR, which results when your subject is very close to the camera (see page 13). In brief, your camera lens and the film do not see what your viewfinder sees. You can fashion a camera framing device to correct for this, or simply tilt your camera up to *eliminate* from the viewfinder the top one-eighth of the picture area you want when using a +1 close-up lens, the top one-sixth with a +2 lens, and the top one-fourth with a +3 close-up lens.

One advantage of using accessory close-up lenses is that they are

simply attachments that magnify and thus require no increase in EXPOSURE. The other methods for close-up photography—inserting an extension tube or bellows or a lens extender, reversing the camera lens, or close focusing with a macro lens—increase the distance light must travel from the camera lens to reach the film, so an increase in exposure is necessary. Fortunately, modern 35mm SLR cameras with through-the-lens (TTL) metering will make correct auto-exposure settings and/or manual exposure readings for close-up photography, so no exposure compensation is required.

If exposure readings are made with a non-TTL or a hand-held meter, the EXPOSURE FACTORS appearing in the chart on page 375 can be used as a guideline to figure the exposure compensation necessary with extension tubes and bellows. With a macro lens or a lens that has been reversed, make several exposures, each time increasing the non-TTL or hand-held meter reading by a half-stop. For lens extenders, see page 127 for exposure guidance.

By the way, a few charts or guides for close-up focusing refer to the FILM PLANE when measuring lens-to-film or subject-to-film distances for exposure factors or reproduction ratios. Some cameras have a FILM PLANE INDICATOR, usually marked with a symbol like this, ө, engraved on the top side of the camera. If there is no such symbol, check in your camera's instruction manual to see if the precise film plane is indicated in another manner, such as being in line with the rear edge of the hot shoe on top of the camera.

Whenever an exposure increase is required in close-up photography, many times a slower shutter speed is used instead of a wider f/stop. That's because the lens opening should be kept small in order to provide some depth of field. Remember, however, that even with a lens opening of f/16, f/22, or f/32, depth of field with greatly magnified subjects is minimal—sometimes only a few millimeters or a fraction of an inch. That means FOCUSING FOR CLOSE-UPS is always critical.

Because the point of focus is so finite, you must pick out the most important part of the subject on which to focus. Don't count on a camera's autofocus mechanism to do this for you; switch to manual focus. Also, since the depth of field range is so narrow, consider the PLANE OF FOCUS when you aim the camera. For example, if you want two flowers in sharp focus, adjust the camera angle to make certain that both flowers are equidistant from the lens so they will be parallel to the film plane.

Keep in mind that DEPTH OF FIELD, the zone of sharpness, shifts when shooting close up. At normal focusing distances, it extends one-third in front and two-thirds behind your point of focus. With

subjects at very close range, depth of field extends one-half in front and one-half behind the point of focus. With SLR cameras featuring DEPTH OF FIELD PREVIEW, you can press a button or lever to visually check that zone of sharpness according to the f/stop you select. Previewing the depth of field before taking a close-up picture also helps reveal any bright or dark areas, masses of color, or other distracting elements in the background—which you can avoid by changing the camera angle.

You should be aware that when nonmacro lenses are extended for close-up focusing, they often give the sharpest results at moderate lens openings, such as f/8; stopping down to the smallest lens opening of a nonmacro lens to increase depth of field frequently diffracts the light and degrades the sharpness of the image. On the other hand, true macro lenses are optically designed to produce sharp close-up images at all f/stops, including their smallest opening, usually f/32, which offers the best depth of field.

To help get the sharpest results, use a tripod whenever possible in order to maintain the focused distance on your close-up subject, and to avoid camera movement at slow shutter speeds. It's also smart to use a cable release, a remote cord, or the self-timer so you won't be touching the camera when the shutter opens. Always be alert for potential movement of your camera or subject, because even the slightest movement is greatly exaggerated in close-up photography and will result in a blurred image.

A HIGH-SPEED FILM of ISO 400, or faster, is recommended in order

254. To steady the camera for a close-up, its macro lens was placed directly on top of the glass case displaying these historic gold coins that were recovered from a Spanish shipwreck.

to use a fast shutter speed to stop any movement, and/or to use a f/8 or smaller lens opening for increased depth of field. Among the precautions taken by nature photographers in the field is to fashion a windbreak around the subject, such as a plant or flower, to keep it still. To slow down insects, some photographers put them momentarily in an ice chest or a refrigerator.

When greater magnifications are desired for close-up subjects, the additional exposure that's necessary often calls for a bright source of illumination. With sunlight, you can use collapsible photo reflectors, mirrors, or homemade tinfoil reflectors to intensify the natural light falling on the subject. However, many photographers prefer FLASH FOR CLOSE-UPS. Its bright but very brief light (1/1000 to 1/50,000 second duration) is ideal to stop any movement of subjects, such as butterflies and other insects, as well as avoid blurred images caused by inadvertent camera movement.

Flash not only allows you to use a faster shutter speed (up to your camera's limit for flash synchronization), but its intense light permits the small lens apertures that are desired for better depth of field. In fact, a major concern when using flash is that the light will be too bright and overexpose the subject because your camera and flash are so close.

You can reduce the intensity of the flash light in a number of ways. Easiest is to adjust the variable power control that's a feature of most modern accessory flash units (see page 176). To cut down the light you can also use a diffuser (even a layer or two of white handkerchief) or a neutral density filter, bounce the flash off a white card, or position the flash at a greater distance from the subject.

Some units allow the flash head to be tilted down while mounted in the camera's hot shoe so the light will be aimed more accurately at nearby subjects. However, flash is best used off-camera for close-ups, especially to produce shadows that will give dimension to your subject. The unit can be positioned for side lighting (sometimes with a reflector on the opposite side to add some fill light to the shadows), top lighting, or backlighting. A dedicated flash unit used off-camera and connected by a compatible flash cord will automatically adjust for the proper exposure. For shadowless illumination, there are special electronic flash RING LIGHTS, or MACRO FLASH UNITS, that encircle the camera lens to provide uniform lighting at very close range. Refer to Chapter 4 for full details about flash and how to use it.

When flash is the main light source, its bright light is usually stronger than the natural sunlight, so the background will often appear black and make your close-up subjects stand out. With sun

255. Flash can be used effectively for close-ups. This flower was first photographed by the existing daylight.

256. Then flash was used as a direct source of light in order to highlight the petals and show greater detail, increase depth of field so more of the flower would be in sharp focus, and eliminate distracting leaves in the background.

lighted close-ups, you can avoid a confusing background by placing a colored cloth or poster board behind your subject. When making close-ups, experiment with lighting (try flash, existing light, and reflected sunlight) to get the results that please you most.

Many times photographers want to copy a document, picture, map, or other flat, two-dimensional object. The close-up techniques just described can be used if the subject to be copied requires mag-

nification greater than that possible with the camera's regular lens. Single lens reflex or large-format view-type cameras are preferred for PHOTOGRAPHIC COPYING because you look through the same lens that exposes the film, and that makes framing and focusing easy. Always aim the camera squarely at the flat subject so it is parallel to the film plane. This allows uniformly sharp focus and no distortion. Use a tripod to maintain framing and focus and to keep the camera steady.

Material to be copied can be mounted vertically on a wall or laid flat on a table or the ground. Some tripods have an elevator post that can be reversed to allow the camera to be mounted underneath the tripod, which helps keep the tripod legs out of your picture when shooting down on flat copy work. Easiest to use is an adjustable COPY STAND, which holds the camera and a pair or two of opposing lights to illuminate your subject.

LIGHTING OF COPY SUBJECTS must be uniform. Often outdoor illumination is very good, but be careful that no shadows fall on your subject. If the object to be copied is shiny or covered by glass, use a polarizing filter to diminish or eliminate reflections and glare (see page 234).

Indoors, two photoflood lamps can be used. They should be placed at equal distances on either side of the camera at a 45° angle to the subject (see Illustration 257 on the next page). As a quick check for evenness of illumination, hold a pencil, ruler, or a similar object perpendicular against the copy work to see if the shadows it creates are equal in density. Always use an exposure meter, built into the camera or hand-held, to determine the exposure, and make certain it reads only the subject area to be copied.

Black-and-white films suggested for copying documents or line drawings are those of a slow speed (ISO 50), such as Kodak Technical Pan and Ilford Pan F Plus. These give high contrast and sharp detail with very little graininess. Medium-speed (ISO 100–ISO 125) black-and-white films, like Kodak T-Max 100 and Plus-X Pan or Ilford Delta 100 and FP4 Plus, are preferred for copying photographs because they help preserve the highlights and shadow areas of the original.

Many photographers like to make DUPLICATE 35MM SLIDES, often copying only a portion of the original image in order to improve the composition. Others make "dupes," as slide copies are commonly called, in order to have an identical slide in case the original gets damaged or lost.

Techniques for slide copying vary. Easiest but least satisfactory is simply copying a reflected slide image projected on a matte projec-

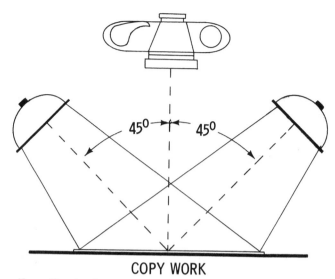

## COPY WORK

257. For uniform illumination to copy photographic prints and other flat artwork, lights should be placed in this manner (see text).

tion screen or a piece of white poster board; the camera and pro-jector lenses must be as closely aligned as possible to avoid distor-tion of the projected image.

Much better is direct copying of a slide that is held in a special SLIDE DUPLICATOR attached to your camera in place of its lens. This tubelike attachment incorporates a close-up lens and has a slide holder at the end, which is covered by a diffuser to evenly illuminate the slide with your choice of light: electronic flash, halogen bulb, photoflood lamp, or daylight. Basic slide duplicators make copies the same size as the original 35mm slide, while better models can be adjusted to enlarge portions of the original image as much as $2\frac{1}{2}$ times. For even more control over image size and the best results, photographers who have an extension bellows lens attachment for their camera can add a SLIDE COPYING ADAPTER to make duplicate slides.

To get consistent results when copying slides, first make test shots of any slide that has good color range, average contrast, and sharp focus. As to FILMS for occasional slide duplication, some pho-tographers use regular slow-speed (ISO 25–ISO 50), fine-grained 35mm color transparency films, such as Kodak Kodachrome 25 or Fuji Velvia. Often the copy slide appears more contrasty than the original, so exposures should be bracketed for the best choice.

For more frequent duping, use one of Kodak's special Ekta-chrome slide duplicating films, which incorporate low contrast and

are specifically designed for exposure either by electronic flash or daylight, or by tungsten illumination. Filtration is necessary to obtain accurate color balance; follow the advice given in the instructions for these 35mm duping films, which are available in 36-exposure cassettes.

Color slides can also be copied with regular color print film, or black-and-white film, in order to produce negatives from which prints can be made; use medium-speed films. Likewise, slides can be made from color or black-and-white negatives placed in a slide duplicator or slide copying adapter. To make color slides from color negatives, use Kodak's Vericolor Slide Film. For black-and-white slides from black-and-white negatives, use Kodak's T-Max 100 or Technical Pan films; special processing is required in Kodak's T-Max 100 Direct Positive Film developing outfit.

Successful slide duplication takes experimentation and considerable patience. It's especially important to make sure that your original slides are free of dust and spotlessly clean just prior to copying them. Fingerprints or smudges can be removed by carefully and evenly applying a liquid FILM CLEANER with cotton, after taking the frame of film out of its slide mount.

## Having Fun with Infrared Films

Infrared films produce startling images unlike those recorded by ordinary films. Grass and other greenery appear a vivid magenta or red in scenic shots made with color infrared film. Flash pictures of people show faces that are green and lips that are yellow. In landscape photographs made with black-and-white infrared film, blue skies and bodies of water turn dark gray or even coal black, while green grass and trees become an eerie white.

The reason for these abnormal images is that infrared films register invisible infrared radiation as well as light rays; they "see" what ordinary films do not. Just for fun, buy a roll of black-and-white or color infrared film and be ready for some surreal results. You'll see why many photographers find infrared films an exciting change of pace.

The films were originally designed for scientific, medical, and other technical uses. For instance, infrared films can help police detect bloodstains and fingerprints, doctors find unhealthy tissue, and art experts spot forged paintings. Color infrared film was initially developed to assist the military in discovering enemy camou-

flage. Because living plants and trees give off infrared rays that are different from those of dead or fake foliage commonly used for camouflage, an aerial photograph made with color infrared film shows what is real and what isn't. Black-and-white film is valuable in aerial photography because it eliminates visual atmospheric haze to record in detail what the human eye cannot see.

When you're shooting with infrared films, ISO FILM SPEEDS do not apply as with normal films because exposure meters do not react to infrared rays as they do to light rays. In fact, there are no specific film ISO ratings listed in infrared film data sheets, although *suggested* film speeds are given as starting points for making exposures. Note that infrared film cassettes are not DX-coded, so you must be able to manually set the film speed (ISO) for any camera that uses a built-in exposure metering system. Otherwise, use a hand-held meter. Another caution: The internal mechanisms of some camera models incorporate an infrared sensor to detect film frame advancement, and it may fog infrared film; check your camera's instruction manual to see if there is a warning not to shoot with infrared films.

Infrared colors change with the intensity of the light (front and side light give the strongest effect), and are even affected by the altitude, temperature, time of day, and season of the year. Only experience will determine the best exposure for specific situations, so it's important to bracket and to keep a record of the exposures so you can compare the results. For your experiments with infrared film, expose one and two f/stops over and under the f/stop that you figure will produce the best exposure according to the suggestions given in the film's instruction sheet.

To achieve their special effects, infrared films must be used with FILTERS—red for the black-and-white film, and often deep yellow, red, or green for the color film. The bizarre color effects in color infrared film will change whenever you change the filter's color; without a filter, a bluish cast often predominates, although green foliage and blue skies appear magenta. When black-and-white infrared film is exposed without a filter, it records the image much like an ordinary panchromatic film. Following are more specific details about each type of infrared film.

BLACK-AND-WHITE INFRARED FILM produces negatives for making black-and-white prints. Its most remarkable effect is the elimination of atmospheric haze in photographs. Scenic shots show detail that isn't evident to the photographer's eye when the picture is being taken. That happens because the red filter used with this film blocks ultraviolet (UV) radiation and sky light that visually appears as haze.

There are two brands available in 35mm size, Kodak High Speed Infrared, in 36-exposure cassettes or long rolls for self-spooling, and Konica Infrared 750nm, in 24-exposure cassettes (as well as 120-size 12-exposure rolls). They should be used with a red (No. 25) or a deep red (No. 29) filter.

(For entirely different effects, a visually opaque filter, No. 87 or 87C, can be used to block all visual light to the film and record the image only by its infrared radiation.)

To set your meter, consult the instruction sheet packed with the films, which gives suggested film speeds for starting-point exposures. When you are using a red filter, Kodak suggests ISO 50 for daylight (or electronic flash) and ISO 125 for tungsten light, which include the exposure factor for the filter; *do not make through-the-lens meter readings with the filter in place*. Remember to bracket.

Because of its sensitivity to infrared radiation, black-and-white infrared film must be HANDLED IN TOTAL DARKNESS in order to prevent fogging. (Although the film cassette is lighttight, it can admit infrared rays.) Load and unload the camera in a changing bag or some other absolutely dark place. When loading in the dark, be certain to feel that the film sprockets are engaged before closing the camera's back.

Keep unexposed film refrigerated in its sealed, totally dark can,

258. Infrared film can create some surprising images. When exposed through a red filter, black-and-white infrared film makes green foliage appear white while water and sky look black.

and return the film cassette to the original can after exposure. You can have the film processed by a custom lab or develop it yourself (also in total darkness); see the film instruction sheet for details.

Focusing black-and-white infrared film is different from focusing regular films, since infrared rays do not focus in the same plane as visible light rays. Some SLR camera lenses have a special INFRARED FOCUS INDICATOR, usually a red line, dot, or R that is next to the normal point of focus indicator. After focusing in the usual manner, *without the red filter in place*, you should note the focused subject distance on the focusing ring and turn the ring slightly to align that distance with the infrared focus indicator. Then attach the filter, but do it carefully to avoid moving the point of focus.

(There can be a problem if you focus a single lens reflex camera through the filter: its red color may confuse through-the-lens auto-focus systems of some cameras so that they become inoperative or inaccurate. Also, focusing manually when looking through a red filter can be visually difficult.)

If there is no infrared focusing mark on your lens, focus on the nearest point of your main subject and use a small lens opening (f/11 or less) so that depth of field will compensate to ensure sharp focus. For the sharpest infrared images, shoot with a wide-angle or normal focal length lens rather than a telephoto, and use a tripod to steady the camera. By the way, there is a unique film, Ilford SFX 200, which produces some of the effects of black-and-white infrared film when exposed through a red filter, but does not require special focusing or handling.

COLOR INFRARED FILM in 35mm size is limited to Kodak Ektachrome Infrared EIR film. It produces color transparencies (slides) and is available in 36-exposure cassettes. As with black-and-white infrared film, there is no specific film speed. The exposure index will vary depending on the color of the filter you use on the camera lens to expose the film. For starters, without the filter in place, use TTL metering at ISO 200 for a deep yellow (No. 12) filter, ISO 100 for a red (No. 25) filter, and ISO 40 for a green (No. 58) filter. (Develop the film in Process E-b when using these exposure guidelines.) Always bracket exposures.

As for focusing, color infrared film records a sharp image when the camera is focused in the normal manner, unlike black-and-white infrared film. In other words, the *special infrared focusing marking found on some camera lenses should be disregarded when color infrared film is used*. However, shoot with a wide-angle or normal focal length lens and use a small lens opening for the sharpest results. Also, a tripod is recommended to avoid blurred images at slow shutter speeds.

As with its black-and-white counterpart, load and unload color infrared film in your camera in total darkness, and keep the film in its lighttight film can at all other times. Also be certain your camera (or darkroom) has no infrared sensors, because they will fog the film. Heat and humidity can affect image quality, so Kodak recommends storing the film in a freezer at a temperature of 0°F (−10°C) or lower. However, you can safely keep unexposed film *for up to one month* at room temperatures not exceeding 55°F (13°C).

Take note that Kodak Ektachrome Infrared EIR film was introduced in 1997 to replace a much older version that required development in Process E-4, which had become outdated. The newer film must be developed in Process E-6 (or EA-5), now used for all current Ektachrome films.

## Making Multiple Exposures

Sometimes pictures are more effective or eye-catching when the same frame of film is exposed more than once to create a double or multiple exposure. Photographers occasionally make their first double exposures by accident—they inadvertently shoot the same roll of film twice! Surprised (and upset) as you may be to discover such a mistake, closer inspection of each double-exposed frame may reveal a few images that are novel enough to be worth saving. However, it's far better that you have full control when combining two or more images on the same frame of film.

Techniques for making double or multiple images vary. While all 35mm cameras avoid unwanted double exposures by advancing the film each time the shutter is cocked, many models feature a MULTIPLE EXPOSURE CONTROL or a MULTIEXPOSURE MODE that overrides the film advance mechanism (and film frame counter) so that the same frame of film stays in position for additional exposures.

Follow the directions in your camera instruction manual to activate this feature, which allows the shutter to be recocked and fired without advancing the film or frame number. For other 35mm cameras *without* built-in multiexposure capability, follow the procedure described on page 31 to keep the same film frame in position while you recock the shutter for additional exposures; it will not work on cameras with autowind unless that feature can be disengaged.

Proper EXPOSURE is a particular concern when making multiple exposures. Basically, you make an exposure meter reading of *each* subject you plan to include on the same frame of film. As long as your subjects are being photographed against a dark background (as

259. This is a double exposure of a magician and the Magic Castle, an old mansion where magicians gather in Hollywood, California. With the camera on a tripod and the shutter opened on B, a flash was fired to illuminate the magician. Then the lens was quickly covered, the magician moved aside, the lens focusing ring was readjusted for the mansion, and the lens was uncovered to make a time exposure of the building.

at night) and their images *do not* overlap, shoot at those exposure readings. The picture will be properly exposed because the images do not register on top of one another and thus do not build up the amount of light registering on the film.

However, when the images of your subjects overlap and are superimposed on one another, each exposure reading must be decreased so the film does not receive too much light and become overexposed. As a general rule for double exposures of subjects that overlap, cut the meter reading of each exposure in half. Set the exposure manually, and reduce the metered reading by closing down the lens opening by one f/stop, such as from f/8 to f/11, or by doubling the shutter speed, such as from 1/125 second to 1/250 second.

When there are more than two exposures of overlapping subjects, each exposure should be decreased according to the number of times the same frame of film is exposed. For instance, with four exposures of superimposed subjects, each one should be exposed for only one-fourth of the meter reading. That would mean reducing each exposure by closing down the lens opening two f/stops, such as from f/8 to f/16, or increasing the shutter speed four times, such as from 1/125 second to 1/500 second. When all four exposures are completed, each one overlaps with the others to add enough light to build up to a proper exposure.

An alternative way to determine exposure for overlapping images is to multiply the speed of the film you are using by the number of images you plan to take, then reset the camera's metering system (if possible) to that ISO. For example, if making four exposures on ISO 100 film, set the meter to ISO 400; the meter reading for each exposure will give one-fourth of the proper total exposure. Use this procedure with auto-exposure cameras that have no manual exposure control but allow you to manually set the film speed. Don't forget to return the meter's film speed setting to the film's true ISO after making the multiple exposures, or all your subsequent single shots will be underexposed.

When you plan to make several exposures on a single film frame, it's best to shoot with a slow-speed or medium-speed film so you have more leeway in setting a small lens opening (or fast shutter speed) for each exposure.

Keep in mind that you sometimes have to experiment with exposure because overlapping subject areas may record too bright or too dark. Remember that white or very bright subjects will stand out when superimposed over darker subjects. Bracketing is suggested until you become familiar with multiple exposures and those techniques that work best with your particular subjects. For instance,

260. This revolving sign was photo-graphed five times on the same frame of film with a camera featuring multiple exposure control. It prevents the film from advancing when the shutter is recocked for each additional exposure.

some photographers get better results by exposing the main subject of the total picture last.

Overlapping subject images can also lead to unexpected results in the colors of your subjects. When the colors of a subject in one exposure overlap with different colors in another exposure, entirely new colors are the result. For example, a red image overlapping a green image will record on color film as yellow. Refer to the color wheels in Illustration 159 on page 249 to help you recall the complementary colors (magenta, yellow, and cyan) that are created when the primary colors of light (red, blue, and green) overlap.

As explained earlier, the most common way to make double or multiple exposures is to recock the camera shutter for each exposure. However, if you are shooting in a very dark room or at night, an alternative technique is to keep the shutter open and fire an ACCESSORY FLASH UNIT as many times as desired. Each time the flash goes off and illuminates your subject, it makes another exposure on the same frame of film.

Try this technique by mounting the camera on a tripod, setting the shutter speed control to B (bulb) or T (time), and depressing the shutter release button to hold the shutter open; use a locking cable release or remote cord with the B setting (see page 38). Between flash exposures, cap the lens or have someone hold a black card in front of it to prevent any extraneous light from exposing the film.

The exposure you use for each flash exposure depends on whether images of your subject(s) overlap or are exposed separately against a dark background (see earlier). If images overlap, compensate by keeping the f/stop the same for each exposure and adjusting the *flash intensity* to avoid overexposure. Do this by changing the flash-to-subject distance, or by resetting the flash unit's LIGHT OUTPUT CONTROL (also called the VARIABLE POWER CONTROL; see page 176). Trigger the

flash unit manually for each exposure by pressing its OPEN FLASH BUTTON, also known as the FLASH TEST BUTTON.

If a subject is moving, a series of flashes can be made while the shutter remains open in order to dramatically portray the subject's motion. Powerful rapid-fire strobe light units are used in this way to evaluate performance, such as a tennis player's swing or a dancer's form. The resulting images are as much artistic as scientific.

Fortunately, this fluid, multi-image effect can also be achieved using some smaller accessory flash units that have a feature variously called REPEATING FLASH, MULTIPLE FLASH, or STROBOSCOPIC FLASH. The flash instruction manual will explain how to set the number of flashes you desire and the time delay between each flash (also see page 166). Try this with an active subject, such as a dog or cat at play. To give a feeling of motion to stationary subjects, pan the camera sideways or tilt it up or down during the quick series of flash exposures.

A similar rapid-fire series of multiple images can be created

261. Some accessory flash units feature repeating flash. It fires a series of flashes while the shutter is open to make multiple exposures on the same frame of film. Four repeating flashes caught the form of this cheerleader during a jump.

*without* flash, but your camera must have a motor drive or autowind that quickly and automatically recocks the shutter after each exposure. Remember to activate your camera's multiple exposure lever or multiexposure mode to prevent the film from advancing when the shutter is recocked.

This multiple exposure technique is most effective with cameras that have a shutter release mode that can be set to *continuous* shooting, which keeps the shutter firing as long as the shutter release button remains depressed. For example, when using a fast shutter speed (1/250 second or faster), SLR cameras equipped with motor drives set for continuous shooting can make from one to five exposures per second, depending on the model.

An important consideration when making double or multiple exposures is the CAREFUL COMPOSITION of your subjects in the viewfinder so they will be aligned on the film in the positions you preplanned. Problems can arise with single lens reflex cameras when the shutter is kept open during several exposures because you won't be able to see through the viewfinder. That's because the mirror that reflects images of your subject to the viewfinder is flipped up out of the lens light path when the shutter is open. SLR users must carefully stage the arrangement of your subjects and camera in advance of opening the shutter.

Composition and exposure concerns aside, making multiple exposures is more of a challenge to your imagination than to your technical ability. Following are several suggestions to get you started.

For example, make three or more color film exposures of one subject using a different color filter each time. Move your camera (or subject) slightly between each exposure to record at least three distinct images of different colors. Try red, green, and blue filters.

Another idea is to put your camera with color film on a tripod and slightly underexpose a city skyline at twilight or sunset. Then, without moving the camera, wait until dark to reexpose the same film frame after the city's lights have turned on.

When there is a FULL MOON, expose it in an upper portion of the film frame (use a telephoto lens for a bigger image), then double-expose the film with an appropriate nighttime subject. Beware of superimposing the moon above a lake or other body of water, because the moon's reflection will be absent from the final picture. Some photographers shoot moons in various sizes and positions on a roll of film, then save it to use whenever they encounter a suitable nighttime situation. Make a sketch and note film frame numbers so you'll recall the size and location of the moon on each film frame. Later, when you see a subject that would look better with a moon in

the picture, reload the roll of film with preexposed moons and make the double exposures.

GHOST IMAGES are easy to create with a double exposure technique, and here's how. First, photograph your main subject with the camera on a tripod; underexpose by one f/stop so the film receives only one-half the proper exposure. Without moving the camera or subject, pose a person covered in a white sheet wherever you want the "ghost" to appear in the picture. Then make a second exposure using the same f/stop; those two half exposures produce a proper

262. A double exposure with flash created this ghostly image in a cemetery (see text).

exposure. The sheet-covered person looks ghostly because whatever was behind it was recorded on film during the first exposure and is faintly visible through the sheet. Even without the sheet, ghostly images of any person (or object) can be made to appear in pictures by using the same technique.

You can also create GHOSTLIKE *ACTION* IMAGES at night or in a darkened room. The trick is to use both existing light and flash light to record a moving subject during a single long exposure on the same frame of film. Exposure by existing light makes the moving subject appear as a blur, while the brief flash light "freezes" the subject and makes it appear in sharp detail. The easiest way to achieve this effect is by using an SLR camera with a dedicated flash unit that features REAR-CURTAIN SYNC (also known as SECOND CURTAIN SYNC or TRAILING SYNC); see page 166 for details. As with all effective multiple images, careful planning is required to arrange the position(s) of your subject for the best composition; before opening the shutter, rehearse the action and watch through the viewfinder.

You can easily create a series of increasingly larger or smaller multiple images on the same film frame by making three or four exposures with a zoom lens at different focal lengths. Shoot at equidistant focal lengths from one end of the zoom lens range to the other, such as at 80, 120, 160, and 200mm. Choose a simple subject with clean lines and an uncluttered background. Use a tripod to keep the subject centered when you change the focal length.

Another idea is to produce something known as a PHYSIOGRAPH, which is an abstract pattern created with a moving point of light that makes a series of exposures on the same frame of film. Tape a color filter or a piece of colored cellophane over the beam of a small flashlight, then suspend the flashlight on a string from the ceiling of a *totally* dark room. Place your camera on the floor so it is aimed at the light, start the flashlight swinging like a pendulum, and open the shutter for a time exposure of 15 seconds or so. Then make a few additional exposures in the same manner, each time changing the flashlight's color, direction, and speed.

The f/stop you use for each exposure depends on the speed of your film, the intensity of the flashlight, and the density of the color filter or cellophane. Bracket exposures, and keep a record of the exposures and filters used for each physiograph. Refer to the color wheels on page 249 to anticipate the additional colors that will result when light beams of different colors overlap. You'll be surprised that a swinging light can create such fascinating photographs of multicolored abstract patterns.

As discussed previously in the chapter about filters, the effect of

multiple exposures of the same subject can be achieved in a single exposure by attaching a MULTIPLE-IMAGE LENS to the front of your normal camera lens. Depending on its design, this optical filter reproduces three, five, or six identical images of your subject in a parallel, circular, or other pattern (see page 253).

Another way to create the effect of multiple exposures without actually combining multiple images on film is to mount two or more negatives or slides together for printing in the darkroom or for projection on a screen. This is called SANDWICHING IMAGES. Slides that have been overexposed often produce the best result because the total density of the combined slides will appear nearly normal when projected. Negatives to be sandwiched often work best when they are underexposed.

## Flying with Your Camera

A creative photographer always looks for a different point of view. You'll get an unusual one by taking your camera aloft to do some aerial photography. While professional aerial photographers have specially adapted or designed cameras, films, and airplanes to get the results their clients require, other photographers can make some interesting aerial shots with their regular cameras and films from almost any commercial aircraft. Here are some GENERAL TIPS.

Whether you're aboard a big jet or a small commuter plane, try to sit on the shady side in front of the wing. That way you'll avoid sun shining through the window and into your camera lens, and the hot engine exhaust will not create a blurring effect in your photos. To avert any reflections of you or camera, use a lens shade and get as close to the window as you can without touching it. Don't rest your lens or hands on the window because the pane vibrates and may cause blurred images. Shoot at a fast shutter speed, at least 1/250 or 1/500 second.

Make sure the inside of the window is clean. Minor scratches in the window Plexiglas will not show up in your picture, although a badly scratched window may diffuse the image slightly. To minimize distortion caused by the layers and thickness of jet plane windows, try to hold the camera perpendicular to the window and avoid shooting through it at a sharp angle.

Set the FOCUS ON INFINITY unless part of the wing is to be included. Take note that automatic compact cameras with ACTIVE INFRARED AUTOFOCUS may focus on the plane's window rather than on the view

263. An airplane window can be used as a frame for aerial photographs, as with this view of the Himalayas in Nepal.

beyond it. Prevent this by engaging the camera's INFINITY LOCK, if provided, in order to lock the focus at the farthest distance (see page 279).

When flying high, look for cloud formations and sunrises and sunsets that make dramatic photographs; a zoom lens will make it easier to adjust the image size of subjects and control composition. For a feeling of depth, include the plane's wing in some shots. You can also move away from the window to use it as a frame for the clouds or other subjects outside the plane.

To take your aerial photography to new heights, board a small aircraft, helicopter, sailplane, or hot-air balloon for a sightseeing flight. They offer novel camera angles that turn ordinary ground-level subjects into eye-catching images, such as a farmer's field or suburban housing development that takes on a geometric pattern from overhead.

Always CONSIDER THE WEATHER before taking a photography flight. Pick a clear sunny day with blue sky. Subjects on the ground won't show up in vivid detail unless they're in sunshine, and aerial shots that include gray skies are uninspiring. To give the pictures depth and texture, shoot early or late in the day when shadows are long. Late-afternoon light adds warmth to the images, too. Make sure you keep the horizon level.

When you sign up for a flight in a small plane, try to reserve the

best seat for aerial photography by telling the flight organizer or pilot that you are very serious about taking pictures. Make sure that the plane's wing is overhead and won't block your view and that your seat position lets you shoot without getting a wing strut or engine prop in the picture. A whirring propeller may seem invisible to your eye, but a fast shutter speed can capture its image on film.

Most important is to use a FAST SHUTTER SPEED (1/500 second or faster is suggested in small aircraft) to prevent blurred shots because of vibration. The images in your viewfinder are always fleeting because of the speed of the aircraft, so be constantly alert for picture possibilities and always ready to trip the shutter. A camera with autowind or a motor drive is best because it automatically advances the film and recocks the film so you're instantly ready for the next shot. A zoom lens makes composition fast and easy, and you won't miss any shots while changing lenses. Manually set the lens at infinity and then forget about focusing.

To help make ground objects more distinct, shoot through an ultraviolet (UV) or skylight filter to reduce the bluish light caused by the atmosphere. Although polarizing filters effectively diminish atmospheric haze, do not use one when shooting out of a plane window unless you want a bizarre result. That's because light passing through the window's Plexiglas will be polarized by the filter in an unexpected manner and create a multicolored pattern in your photograph.

Remember that aircraft windows are often tinted to prevent glare, and a slightly bluish or other uniform color may register on the film even though it is unrecognizable to your eye when you are taking the picture. You'll have to wait until the film is processed to see whether the off-color effect is poor or pleasing. (Color negatives can be corrected with filtration at the time of printing to make the colors of your subject appear more natural.)

If you get hooked on aerial photography, charter a small plane or helicopter for your own photo safari. (Look in the Yellow Pages under "Aircraft Charter, Rental and Leasing.") Then you can tell the pilot exactly what you want to photograph and be able to make several passes over your subjects. Upon request, pilots of chartered helicopters or small planes will often open a window or remove a door so that you can shoot without obstruction; safety and insurance reasons usually prevent them from doing so on regular sightseeing flights.

If a window has been opened or a door removed, keep your camera inside so it isn't grabbed by the slipstream. Always wear the

264. Sightseeing flights by helicopter or small plane bring you closer to subjects for aerial photographs, as of this lighthouse off the coast of New Brunswick, Canada.

camera strap around your neck, and keep your seat belt or safety harness tight. Dress warmly because it gets cold when you're flying in an open plane. The wind and engine are noisy, so wear an intercom headset or work out some hand signals so you can direct the pilot to the camera angles you want. Inquire in advance as to aviation laws regarding how close he can fly to the ground so you won't ask him to jeopardize his license.

Getting the right camera angle and bracketing exposures are a lot easier when you're riding in a helicopter or a hot-air balloon, although the flight path of hot-air balloons is at the whim of the wind. A helicopter can maneuver quickly to give you the best composition and then hover while you take several shots. It's always a good idea to have a new roll of film in your camera at the start of any flight. And remember before you are airborne to bring plenty of extra film along for the ride.

## Adventuring Underwater with a Camera

Although more than 70 percent of our planet is covered by water, very few photographers make pictures below the earth's surface. That has been changing in recent years, thanks to the growing popularity of scuba diving and the greater variety and availability of waterproof cameras and housings.

Many people first discover the beauty of life beneath the seas when looking through a face mask while snorkeling. Most are surprised by the spectacular array of sea life you can view simply by floating facedown on the water's surface or holding your breath to dive a few feet below. Those who want to explore deeper can take the necessary courses to become certified scuba divers.

Whether you are an ardent scuba diver or only an occasional snorkeler, there's an urge to share the natural undersea wonders with family and friends who are still landlubbers. The easiest and least expensive way to begin taking underwater pictures to show them is with a WATERPROOF SINGLE-USE CAMERA, which can be submerged to a depth of 10 to 12 feet (3 to 3.7 meters). These simple cameras are preloaded with 15, 24, or 27 exposures of ISO 400 color print film and sealed in clear plastic. There are just two things to operate: the oversize shutter release button and film advance knob. The lens aperture is fixed, and the focus is preset from 4 feet (1.2 meters) to infinity. You just aim and shoot. Made by Kodak, Fuji, Konica, and Vivitar, these recyclable cameras are given in their entirety to a photofinisher for processing.

Slightly greater underwater depth and a little more versatility are available with WATERPROOF 35MM AUTOMATIC COMPACT CAMERAS. These models remain watertight for shooting to a depth of 16 feet (5 meters). They feature auto-exposure, built-in autoflash, autowind and rewind, and close-up capability. Although they also feature auto-focus, their active infrared autofocus mechanisms become inoperative underwater and the lens reverts to fixed focus. The in-focus range varies according to the camera model, and it changes when the close-up/macro setting is selected. You can load any type of 35mm film in these cameras, which are also called SPORTS CAMERAS and are popular for use in any kind of weather because of their waterproof exterior.

While it's fun to snap away with waterproof single-use or compact automatic cameras at limited depths, you'll need special equipment to make really spectacular full-color photographs beneath the sea. Whether you use a so-called amphibious camera designed specifically for underwater use or an underwater housing that protects your regular camera from water and pressure when it is submerged, another necessity is a submersible flash unit. That's because water changes the color characteristics of light and produces dull blue-green images—unless flash is used to restore the warmer red, orange, and yellow colors.

Before learning more about what happens to light in water, and the importance of flash, consider the choice of cameras. The first commercially available AMPHIBIOUS CAMERA was introduced in France nearly two decades after the invention of the self-contained underwater breathing apparatus that came to be known by its initials, scuba. In 1962 Nikon bought the design and manufacturing rights to the unique camera, which was renamed the NIKONOS. Continuing

265. Photographers can go safely underwater with their cameras by enclosing them in a waterproof housing like this Ikelite model made with clear polycarbonate plastic. (Photo courtesy of Ikelite Underwater Systems.)

improvements have made it the world's most popular underwater camera.

The latest version, Nikonos-V, still resembles the original model but now incorporates automatic exposure control with through-the-lens metering for both existing light and flash. Exposure can also be set manually; shutter speeds range from 1/30 to 1/1000 second. Five interchangeable lenses are designed for the Nikonos-V: 15mm, 20mm, 28mm, 35mm, and 80mm. Nikon also offers a choice of two underwater flash units, and a close-up lens attachment kit with frames that extend from the camera to show the exact image area covered and the in-focus distance to your subject. The camera can be used at depths to 165 feet (50 meters).

The most versatile (and expensive) amphibious camera was introduced by Nikon in the early 1990s, the Nikonos RS, the first SINGLE LENS REFLEX UNDERWATER CAMERA. Among its very welcome features are autofocus, auto-exposure (aperture-priority) with through-the-lens metering, an oversize and very bright viewfinder, motorized film advance and recocking of the shutter, and dedicated fill-flash control with two Nikon accessory underwater flash units. It's built to remain watertight down to 328 feet (100 meters).

There is a choice of four autofocus lenses, including the first underwater zoom, which helps overcome the problem of not being able to change lenses beneath the sea. The focal lengths of this f/2.8 lens range from 20 to 35mm. Other interchangeable lens options for the Nikonos RS also feature wide f/2.8 maximum lens openings. They are a full-frame 13mm fish-eye lens with a 170° angle of view, a 28mm lens that focuses to 10 inches (25cm), and a 50mm macro that offers a one-to-one (1:1) reproduction ratio for life-size images.

In addition to Nikon's amphibious cameras, a few other models are made by Sea & Sea Underwater Photography. However, most manufacturers of underwater photo equipment produce WATERPROOF CAMERA HOUSINGS that enable photographers to take their regular 35mm SLR cameras beneath the sea. Among those companies are Ikelite, Ewa-Marine, Aqua Vision, Delphinus, Stromm and Tussey, as well as Sea & Sea. The housings are made of aluminum or hard polycarbonate plastic except for Ewa-Marine's flexible polyvinyl chloride (PVC) plastic enclosure, which is less expensive and available for 35mm automatic compact cameras as well as SLR models.

Most of those baglike housings feature a glove-shaped fitting for your hand to operate the camera controls. Safe operating depth is up to 60 feet (18 meters), 30 feet (9 meters) for compact cameras; some Ewa-Marine housings for SLR autofocus models can be taken down

266. Considered one of the best underwater 35mm cameras is the Nikonos RS, a single lens reflex (SLR) amphibious model featuring auto-exposure, autofocus, and TTL (through-the-lens) autoflash. It also offers interchangeable lenses, including this 20–35mm zoom.

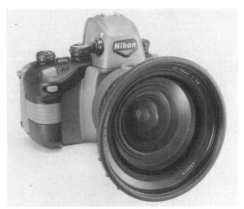

267. A longtime favorite of underwater photographers is the rangefinder-type Nikonos, a 35mm amphibious camera. This fifth-generation model, the Nikonos-V, features aperture-priority auto-exposure and TTL (through-the-lens) flash metering.

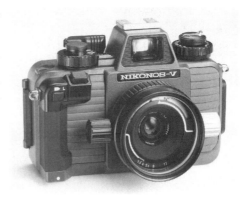

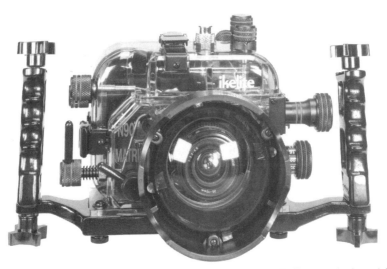

268. Hard plastic underwater camera housings made by Ikelite are designed for specific 35mm single lens reflex (SLR) Nikon, Canon, Minolta, and Pentax models or can be custom-made for your particular land-based camera.

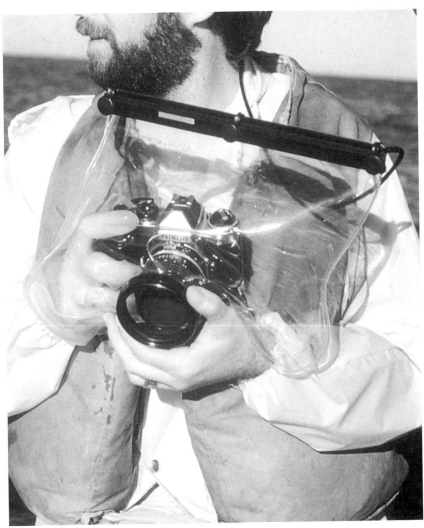

269. Flexible plastic housings are made by Ewa-Marine so that photographers can safely use a variety of 35mm single lens reflex (SLR) and compact camera models on the water and also underwater. Your hand slips into a glove-shaped fitting to operate the camera's controls.

to 90 feet (27 meters). All have optical glass ports where the camera lens is positioned.

The hard-sided housings of aluminum and polycarbonate plastic also have optically clear ports for the camera lens. Dome-shaped ports are recommended for wide-angle lenses to avoid distortion, and flat ports for normal or macro lenses. The camera controls are operated by means of corresponding mechanical or electronic con-

trols on the housing. The housings are waterproof to a depth of 200 feet (61 meters) or deeper, which easily exceeds the maximum suggested depth of 125 feet (38 meters) for recreational scuba diving.

Experienced scuba divers rarely worry that water pressure will cause leaks in their housings because they know that much of the most photogenic marine life is found at depths of only 25 to 60 feet (7.6 to 18 meters). In fact, the major concern of underwater photographers is the way water affects the transmission of light, because this significantly influences their photographic techniques. You need to consider water and light in regard to DENSITY, diffusion, and refraction.

The first thing to remember is that water is much denser than air,

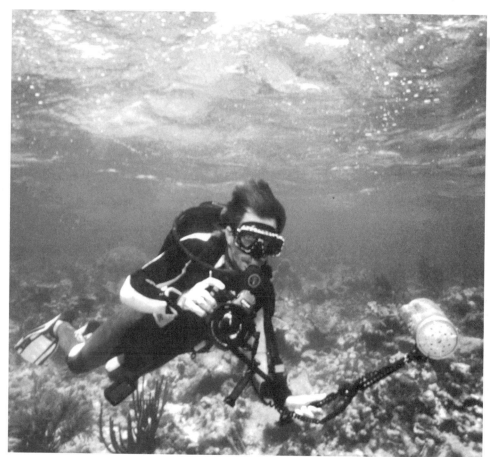

270. Even in shallow water, flash is needed to record marine life in its true colors. Expert underwater photographer Stephen Frink uses his flash a considerable distance off-camera in order to prevent backscatter (see text). (Photo courtesy of Stephen Frink Photographic.)

so there will be less natural light the deeper you go. The DECREASE IN LIGHT INTENSITY begins at the surface, where a considerable amount of sunlight is reflected by the water. The light rays penetrating underwater will be most intense on days with calm water between the hours of 10:00 A.M. and 2:00 P.M., when the sun is overhead—which is a favorite time for existing-light photography underwater. Even then, however, the falloff of light as you descend calls for significant increases in exposure—as much as three f/stops at 30 feet (9 meters), for example. Bracketing is always recommended.

If you can't use larger lens openings to compensate for the diminishing light, you must shoot at slower shutter speeds, which is not always possible because it's difficult to keep the camera steady underwater. Most often your marine subjects are moving, too. A partial solution when shooting by natural light is to use a high-speed film (at least ISO 400). But more commonly the only way to adequately illuminate your subjects is with FLASH.

Flash is often needed for another reason: WATER ABSORBS MOST COLORS of the light spectrum the farther you are from the light source. In fact, natural light from the sun begins to change color characteristics when it hits the water. For example, at just 3 feet (0.9 meters) beneath the surface, nearly half of the red from the sunlight has been absorbed. Although your eyes may still detect the warmer colors as you descend, film is less sensitive to that end of the light spectrum. Red, orange, and yellow continue to fade rapidly and at a depth of 30 feet (9 meters) are no longer recorded by the film. Green also diminishes, and by the time you reach 50 or 60 feet (15 or 18 meters), all that you'll see—or the film records—is blue (and black).

The true colors of underwater subjects can be restored by flash. But keep in mind that the density of water also reduces the intensity of the flash light and thus changes the color characteristics of that light according to the distance it travels to the subject and back to the camera. In practical terms, that means exposure must be increased as much as one f/stop for every foot (30cm) between the flash and your subject. The various colors of flash light are absorbed more rapidly than sunlight; reds, oranges, and yellows fade away quickly while traveling only a few feet to your subject.

For those reasons, and another explained below, *the most colorful underwater pictures with flash are taken very close to the subject*—from a few inches (centimeters) to no more than 5 feet (1.5 meters).

The coloration and brilliance of a subject can be considerably reduced by particles in the water that cause DIFFUSION OF THE LIGHT

RAYS from flash or sunlight. Everything from plankton microorganisms to sand and other sediment stirred up from the sea bottom will both absorb and reflect light to diminish contrast and the coloration of your subject.

An additional problem called BACKSCATTER occurs when flash light striking these suspended particles reflects back to the camera lens and records on the film as fuzzy white spots. Photographs look almost as if they were taken in a snowstorm when these particles are prevalent. Backscatter is reduced by positioning the flash some distance off-camera at the end of a flash bracket; normally the flash is extended up to an arm's length from either side of the camera, above and slightly forward of the lens, and aimed at a 45° angle to illuminate nearby subjects. Of course, backscatter can also be reduced by getting the camera as close to your subjects as possible, because the shorter that distance, the fewer the number of floating particles in front of the lens.

Underwater photographers prefer wide-angle lenses because they permit them to get close to the subject to obtain the clearest and most colorful picture. Wide-angle lenses also provide greater depth of field to help ensure in-focus images. But you should be aware that

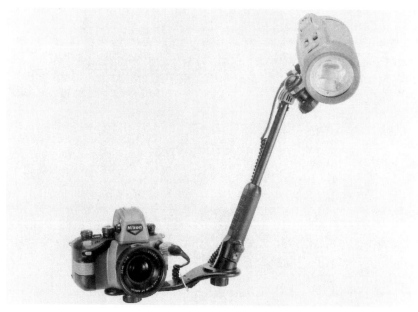

271. A flash bracket helps position the flash properly off-camera so that particles suspended in the water will not reflect light from the flash directly back to the camera. This helps prevent an annoying problem in underwater photography known as backscatter.

the effective focal length of lenses used underwater is changed by REFRACTION OF THE LIGHT.

As they pass from air into water, light rays distort (refract) in a manner that appears to magnify subjects underwater. To your eye and camera lens, subjects seem to be about one-fourth closer than they actually are. That effectively increases the focal length of a lens and decreases its angle of view. As such, a 35mm wide-angle lens underwater has an EFFECTIVE FOCAL LENGTH of 47mm (similar to a normal lens) and its angle of view is reduced from 63° to 50°. As another example, a 21mm wide-angle lens used underwater becomes equal to one of 28mm out of water and its angle of view decreases from 90° to 75°. For larger subjects, a 13mm or 15mm fish-eye or

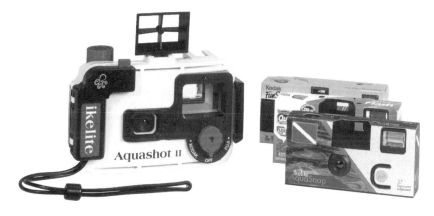

272–273. Single-use cameras offer an inexpensive introduction to underwater photography. This snorkeler was snapped near the water's surface with a single-use *waterproof* model, which is limited to a depth of 10 to 12 feet (3 to 3.7 meters). Regular land-based single-use cameras can be taken deeper in an underwater housing, such as Ikelite's Aquashot II, which will operate to 125 feet (38 meters).

super-wide-angle lens is the choice because you can remain close while it compensates for the reduced angle of view underwater.

In regard to FOCUSING UNDERWATER, 35mm single-lens reflex cameras can be focused in the normal manner (if permitted by the camera housing), because you and the film see the subject through the same camera lens. With any camera (including Nikonos models and regular SLRs), if you're setting the focus by using the distance scale on the lens, set it for the *apparent* distance you estimate the subject is from the camera. That's because the magnifying effect of water is the same for the camera lens as it is for your eye. (If ever the *actual* underwater camera-to-subject distance is measured in order to determine the focus, the lens focus point should be set to three-fourths of that distance.)

Your favorite above-water FILM—whether color print, color slide, or black-and-white—can be tried for underwater photography. Submersible accessory flash units provide plenty of light to enable you to shoot with slower-speed films (ISO 50 to ISO 100), which are favored for their fine grain and excellent sharpness. When exposing only by natural light, a high-speed film (ISO 400 or faster) is suggested because it allows faster shutter speeds to stop the action of your subjects and helps avoid blurred images caused by inadvertent camera movement.

A chief consideration in choosing a specific film is water's adverse effect on color balance. With color transparency (slide) films, avoid the tungsten type and shoot with the daylight type because it is color balanced for sunlight and flash. But even daylight color slide films vary in coloration when shot underwater, so experiment with different brands and types to find the one you prefer. Color negative (print) films are often advantageous because their colors can be corrected somewhat by filtration during printing; have the negatives reprinted if you're not happy with the results.

When out of the water, attempt to remember and write down your exposures to compare them later with the photographs. Also try to develop a shooting formula that works best for you. With flash it is especially easy to standardize your film, focus, f/stop, and shutter speed to ensure good exposures and colors every time you photograph underwater. By the way, always load underwater cameras with 36-exposure rolls so you won't have to surface or go ashore too often to change film.

After diving or snorkeling with a camera, be certain to rinse salt water from the camera or housing and flash equipment. Also keep the rubber O-rings and other waterproofing gaskets on your gear

well lubricated so they won't dry out between uses and you'll be ready for the next underwater opportunity.

In addition to becoming proficient in the technical operation of a camera underwater, there are other challenges when you're photographing beneath the sea. Composition is a constant concern, especially when you must get close to marine subjects that are often startled by your presence and swim away in the blink of an eye. Many photographers find it more rewarding to prefocus and then position themselves in one spot for a while and let the tropical fish and other sea creatures come within their camera and flash range. Remaining still also helps prevent stirring up sediment with your swim fins. Be careful not to step on or hold on to any living coral, because it can easily be damaged and take years to recover.

Of course, for personal safety reasons when photographing underwater, you should be a qualified and confident scuba diver—or else stay near the surface with a face mask, snorkel, and flippers. If you don't live near an ocean or lake, practice with your camera in a swimming pool to be ready to make underwater shots during your vacation or when any opportunity arises. Although your initial results may be disappointing, keep trying and you'll discover how rewarding underwater photography can be. A good way to improve your skills is to join underwater photo classes or workshops, which are listed in photography and scuba diving magazines.

For nonswimmers and those without an underwater camera or housing, FISH TANK PHOTOGRAPHY is a good way to capture underwater life. Here are a few tips. To avoid distortion, shoot through a flat-sided aquarium, not a round fishbowl. Change the water if it is not clear. If the aquarium has an aerator, disconnect it if the bubbles disturb your subject or composition. A single lens reflex camera lets you focus and frame easily; use a macro or close-up lens to fill the film frame with your small subjects. To keep the fish in close focusing range, place a sheet of glass in the aquarium to limit the area in which they are able to swim.

By placing the aquarium next to a window and using a high-speed film, you may be able to capture your subjects with only the natural light. A fast shutter speed is often needed to "freeze" darting fish. Depth of field is limited by use of a macro or close-up lens, so try to expose with a small lens opening when possible.

Fish tanks can also be illuminated by flash or tungsten lights. Flash is color balanced for use with all daylight color films. Color negative (print) films can also be exposed with tungsten halogen lights or photofloods. To shoot color slide film with those light

274. You don't have to get wet to photograph marine life—just shoot through the glass sides of an aquarium. This sea horse in a saltwater fish tank was exposed by natural light (see text).

sources, use tungsten-type film, or use daylight-type slide film with filters (see page 244). The flash units or tungsten lamps should be placed above the aquarium for a natural lighting effect. An alternative is to place your lights at a 45° angle on each side of the camera, but take care that they do not reflect off the aquarium glass back into the camera lens. Avoid using built-in or on-camera flash because it will cause reflections from fish tanks.

Make an exposure meter reading to determine exposure with natural sunlight or tungsten lamps. Unless you're using dedicated through-the-lens autoflash, figure FLASH EXPOSURES by checking the flash unit's LCD panel or calculator scale according to the flash-to-subject distance and your film's speed (ISO). If the resulting f/stop cannot be used because the flash is too bright, move the flash a greater distance away, or adjust the flash unit's variable power control (if any). Another option is to cover the flash head with a clean white handkerchief; each layer will reduce the exposure by about one f/stop. Refer to Chapter 4 for more advice about flash for close-ups. Experiment with lighting and exposures until you find the combination that works best for fish-tank photography.

If you have the chance, try a few underwater shots at larger MARINE AQUARIUMS, too. Stand very close or place the camera lens against the

tank glass to avoid reflections. For illumination, utilize the natural or tungsten light of the aquarium. Or hold a flash to one side of your camera at a 45° angle to the tank, but watch that its light does not reflect into the camera lens. To record the truest colors, use a wide-angle lens so you can focus on subjects closest to the glass in the aquarium.

## Shooting Through Binoculars

Some amateur photographers have found that binoculars are an inexpensive alternative to a telephoto lens to bring subjects visually closer so they appear larger on the film. Of course, the sharpness of your images will vary depending on the optical quality of the binoculars, as well as that of your camera lens. Also, because the angle of view of binoculars may be less than your camera's angle of view, the image may appear circular on your film. For this reason, wide-angle binoculars usually are best.

The easiest CAMERAS TO USE WITH BINOCULARS are single lens reflex models. Align one of the binocular's eyepieces with your SLR's normal lens; the camera lens should be focused at its closest distance and opened to its widest aperture. Focusing of your subject is done by adjusting the focus control of the binoculars until a sharp image is seen in your SLR's viewfinder. Either buy a special binocular-camera mount or fashion a homemade device to hold the two pieces of equipment in alignment. The place where the camera lens and binocular eyepiece meet should be made lighttight. Be careful that the eyepiece does not scratch your camera lens. Actually, a small space should be left between them to allow the eyepiece to move freely when focusing the binoculars.

With a *non-SLR* camera, FOCUSING AND FRAMING are more difficult because there is no direct viewing through the camera lens. One eyepiece of the binoculars is used for viewing and framing your subject; the other is coupled with the camera lens to make the exposure. First you must calibrate the focus of both eyepieces; look through only one eyepiece and focus the binoculars, then switch to the other eyepiece to make sure that it is in equally sharp focus. Open the camera lens to its widest aperture, set the focus to infinity, and couple the camera lens with a lighttight collar to one of the binoculars' eyepieces.

The EFFECTIVE FOCAL LENGTH of your camera-binoculars combination is easy to figure. Binoculars are rated by their power and the

diameter of the larger lens at the opposite end of the eyepiece. That means 7 × 35 binoculars have a power of 7 and a lens diameter of 35mm. Simply multiply the power of your binoculars by the focal length of your camera lens to find the effective focal length. For example, binoculars with a power of 7 multiplied by a camera lens focal length of 50mm indicates an effective focal length of 350mm, the equivalent of a rather strong telephoto lens.

Blurred images from camera movement can be a problem unless the camera and binoculars are supported on a tripod. You can also minimize the chance of camera movement by tripping the shutter with a cable release, remote cord, or the camera's self-timer. Another way to help prevent the unwanted effects of camera movement is to shoot at a fast shutter speed.

A fast shutter speed may require you to use high-speed film. The reason is that the EFFECTIVE F/STOP OPENING of the camera-binoculars is usually quite small, even with the aperture of the camera lens preset at its widest opening. The effective f/stop opening can be figured by multiplying the binoculars power times the camera lens focal length (as just described) and then dividing this by the diameter of the binoculars' lens. Using the earlier example, a binoculars power of 7 times a lens diameter of 50mm equals 350. Dividing this number by the binoculars lens diameter of 35 indicates the effective f/stop opening of this camera-binoculars combination is f/10:

$$\frac{7 \times 50}{35} = f/10$$

To set any camera for a PROPER EXPOSURE when shooting through binoculars, the shutter speed is adjusted while the camera lens aperture is kept at its widest opening. An SLR camera with a through-the-lens (TTL) metering system will make a reading directly through the effective f/stop opening and automatically indicate the appropriate shutter speed. However, if a non-TTL or hand-held meter is used to make the exposure reading, you need to know the effective f/stop in order to calculate the shutter speed to set on the camera.

## Trying a Telescope

Photographing through a telescope allows you to record larger images of subjects than with binoculars. The quality of the tele-

275. By using an adapter to attach a camera body to the eyepiece fitting, you can make pictures of distant subjects with telescopes and spotting scopes, such as this Celestron model that becomes the equivalent of a 1250mm telephoto lens.

scope's optics greatly determines the quality of your pictures. It's best to shoot with a single lens reflex camera because you can see in the camera's viewfinder when your subject is in sharp focus. Focus is adjusted with the telescope's focus control after you first set the camera lens focus to infinity.

Align the camera's normal lens with the eyepiece of the telescope. Fashion a connector with a lighttight collar to join the two pieces of equipment. Or buy a TELESCOPE CAMERA ADAPTER, which allows you to remove the camera lens and the telescope eyepiece to make a direct connection. Rock-steady support is required to avoid a blurred image caused by camera movement; keep the telescope mounted on its own tripod and mount the camera on another.

When making night shots of the moon through a telescope, the earth's rotation will cause a blur on your film if the exposure is longer than a few seconds. However, a full moon is relatively bright and an exposure of 1/250 second at f/8 with ISO 100 film is possible. A full moon doesn't reveal the detail of its mountains and craters, so also photograph a half-moon and three-quarter moon when side lighting from the sun causes shadows that give more depth to the moon's surface. An SLR camera's through-the-lens metering system should give accurate exposure readings, but it's always worthwhile to bracket to determine the best exposure range for your specific telescope and film.

Another choice is to photograph stars with a camera-telescope combination, but their light is far less bright than the moon's. Since a long exposure will be required for what is termed ASTROPHOTOG-RAPHY, the earth's rotation will cause the stars to leave trails of light in your photograph. For this reason, many photographers forgo a telescope and simply shoot the stars directly with their camera's

wide-angle or normal focal length lens in order to record a great number of star trails.

The most interesting pattern is a circular one achieved by aiming the camera at the North Star (Polaris), around which all other stars in the northern hemisphere appear to revolve. In the southern hemisphere, aim at the Southern Cross constellation.

Pick a clear, moonless night in a dark location when the sky does not reflect any city lights. Position the camera so any other extraneous light will not reach the film. Use a sturdy tripod on firm ground. Be certain to focus at infinity. Set the shutter to B (or T) and use a locking cable release or remote cord to hold the shutter open.

Make an EXPOSURE of at least 1½ hours. An exposure of 3 hours will make the star trails even longer, and the circle around the North Star will appear fuller, brighter, and more dramatic. For 90-minute exposures, try a lens opening between f/2.8 and f/4 with ISO 100 film. For 180 minutes, set your lens aperture between f/4 and f/5.6. To give a sense of perspective and add interest, include treetops or any interesting, nonmoving object in the foreground.

## Working with a Microscope

Photographing through a microscope enables you to capture an exciting, hidden world on film. For best results, use a single lens reflex camera because it lets you see and focus on the enlarged specimens exactly as you want them photographed. The lens is removed from the SLR so the camera body can be attached directly to the microscope's eyepiece with an adapter, which can be ordered through camera stores or photographic supply houses. Some photographers fashion their own connector, but it must be lighttight and capable of aligning the camera correctly. Compact cameras and others with nonremovable lenses can also be used, but the camera must be disconnected from the microscope after each picture in order to set up and focus on the next specimen.

Exposure varies depending on the LIGHT SOURCE. The microscope's normal tungsten illumination may be adequate to expose stationary subjects on high-speed film, but much brighter light is often required to stop the action of living specimens. In these situations, you can frame and focus with the microscope's normal illumination, and then substitute a flash unit to make the exposure with its brief, bright light. Shoot a test roll of film and bracket exposures.

If a halogen or photoflood reflector-type spotlight is used as a light source, you must shoot with a tungsten film or use a filter to

color balance the light with a daylight film (see page 244). For untrue but striking color effects, place a polarizing filter between the light source and the specimen you're photographing. Some experimentation with films and lighting is required. Unless flash is used, exposures are often a few seconds long, so you'll need a cable release or remote cord to avoid camera movement when tripping the shutter.

# TRAVELING WITH A CAMERA

One of the main reasons why photography is so popular is that people want to record their travel adventures at home and abroad. Some manage with a single-use camera or an automatic compact camera that they slip into a purse or flight bag. Others carry 35mm single lens reflex cameras and accessories that fill up a big camera bag. Regardless of your equipment, this chapter offers some tried-and-true advice for making some great travel photos. There's no reason to be satisfied with typical vacation snapshots that are usually boring to everyone but yourself.

## What to Photograph

First, keep in mind that those gorgeous travel shots you see in magazines aren't made by sticking a point-and-shoot camera up to a tour bus window and snapping away. The best pictures are often conceived in advance of the trip by photographers who do some RESEARCH. You should study travel guidebooks and brochures to discover the most interesting sights, landmarks, and activities to record on film. You'll learn a lot more about the destination than you previously knew, which will not only help you get better photographs but also make your trip more rewarding.

You might follow the lead of professional travel photographers, who always prepare a "SHOOT LIST" of subjects they want to capture on film. Most of all, they want their pictures to TELL A STORY about the city, country, or special place they are visiting. Instead of engaging in random shooting, they think of all the subjects that might become an intriguing part of their photo essay. These could include the faces of people, clothes and costumes, children, pets, farm animals, wildlife,

276. Travel photographs hold much more interest when you include local people, such as this young Guatemalan weaver whose outdoor work site overlooks Lake Atitlan.

flowers, landscapes, food, restaurants, markets, festivals, hotels, campgrounds, sports, occupations, transportation, music, handicrafts, the arts, architecture, churches, and religious subjects.

Regardless of where you travel, viewers of your pictures always want to see what the local people look like. They don't have to be in exotic costumes or performing in a folkloric show. Why not capture the smiling doorman in his uniform at your hotel, or the room-service waiter delivering your breakfast tray, or even your taxi or bus driver?

Your subjects should be doing something to add interest to the picture. Try not to let them stare into the camera. One trick is to pretend you've taken their picture, and when they relax and drop their pose for the camera, release your shutter. Your subjects will look more natural.

Excellent CANDID PICTURES can be made with a telephoto or zoom lens. If your subject sees you, ask or gesture whether it is okay to take his or her picture. Politeness pays. If your subject notices what you are doing, don't grab a shot and run, or pretend you really weren't taking his picture; ask permission instead. Most times there will be no objection, but if your potential subject says no, just smile and go away.

One important point is that if you promise to send your subject a copy of the picture, do so. Get his name and address, and mail the photograph. Otherwise, he won't be so cooperative with the photographers who follow you. Help yourself and fellow cameramen by keeping your promises. When people want money if you take their picture, we offer to send them a photograph instead. When you're at street markets, the vendors usually are happy to pose with their products or handicrafts; if not, you might offer to buy something as long as you can take the person's picture.

If kids ask for "money, money," we give them big smiles as if we thought they were only joking. We don't want to turn them into beggars or let them think that everyone who has a camera is going to give them a coin or two. If you want to reward them, carry a supply of ballpoint pens to give away. We also have some colorful balloons in our camera bags to share, but we don't hand them out until after we get the shots we want; otherwise, there will be balloons in every picture.

People don't always have to be the main subjects of a picture. They can serve as SIZE INDICATORS in your scenic shots, or in the foreground to frame your landscape photos. Be sure that they face toward the main center of interest, not toward you. For instance, when photographing a building, shoot when people are walking toward it, not away from it. When people are not the main subject of your photograph, don't let them get too close to the camera or they will dominate the picture.

277. To indicate the relative size of a building that's the main subject of your photograph, such as the Dome of the Rock (Mosque of Omar) in Jerusalem, include people or other familiar objects for comparison. The shadow of archways was included to avoid a monotonous foreground.

On the other hand, if people are your center of interest, GET IN CLOSE. Too many photographers fail to fill the camera's viewfinder with their subject. Move in. And if your subject is in costume or unusual dress, shoot close-ups of interesting parts of the clothing. Are the subject's shoes or belt buckle especially unique? Get close and photograph them. This will direct your viewer's eyes to the part of the subject you think most unusual.

Travelers should also be sure to make pictures of their various forms of transportation. Photograph your plane, train, bus, boat, bicycle, or car. And try some pictures on the move. AERIAL VIEWS are good, especially shortly after takeoff or before landing, when you are close enough to the ground to get good detail of the subjects below. Read more advice about aerial photography beginning on page 395.

If you're traveling by tour bus, try to sit toward the front so you can get out quickly when the driver makes a photo or rest stop. Ask him in advance where the stops will be and what might be interesting to photograph when you get there. Also, when you're in the front of the bus, frame a road shot or two with the windshield to show your mode of transportation. Take a few photos of the bus interior, too, with a wide-angle lens.

Shooting from the windows of buses, cars, or trains is difficult

because your subjects, especially close ones, whiz past. Most times it is just a waste of film, so forget nearby subjects unless the vehicle is stopped. If you want to try your luck, prefocus on more distant subjects, and use a shutter speed of 1/500 second or faster. Shoot with the window open, if possible. Otherwise, sit on the shady side to avoid reflections, and get close to the window. Don't touch the glass because vibrations may cause camera movement. Be aware that tinted windows can change the colors of your subject.

Alternating between OVERALL VIEWS AND CLOSE-UP PICTURES is a worthwhile technique to remember for any subject you photograph. Shoot the mountain range, then switch to a telephoto to capture just one interesting mountain peak. Photograph the whole building and then move in to emphasize a unique door or window. Always look for details in your overall views and then photograph them close up. The other guidelines for good composition are outlined in Chapter 10 and apply to travel photography, too. Use them.

Travel photographers should be warned about WAITING FOR BETTER PICTURE SITUATIONS. Don't. To avoid gaps in your travel story, never put your camera away in poor weather, at night, or when you go inside buildings. Many excellent pictures can be made under those conditions. They add variety to the usual collection of photographs made in the sunlight, too. So shoot on overcast days and when it rains, but use a camera angle that will avoid the gray skies.

For nighttime pictures, interior shots, or unusual lighting conditions, use the chart that gives exposure suggestions in the previous chapter; see pages 362–63. It's often worthwhile to use a tripod, and bracket exposures. If you need to make a time exposure but are without a tripod, place your camera on some solid support, then use the self-timer to release the shutter in order to avoid moving the camera during the exposure. Don't expect FLASH to cover great distances inside buildings; know the maximum range of your flash unit. Also remember that existing-light pictures appear more natural than those made with flash.

Travel photographs can excite your friends as well as bring back many memories for yourself. But save only the good ones to show off. Always EDIT YOUR PICTURES before putting them in a photo album or giving a slide show. Also keep in mind that you don't have to present the photos in chronological order of your trip. Instead of organizing your pictures in the usually boring day-to-day order in which you shot them, group images of similar subjects together. Show all the famous sights as a group, then people, flowers, animals, and so forth. Signs and flags can be interspersed as introductions to places you visited or to identify states and countries.

278. Always be alert for close-ups to augment the overall views that are all too common in travel photography. A telephoto lens isolated some details of the unusual uniforms worn by ceremonial guards at the Tomb of the Unknown Soldier in Athens, Greece.

Remember that pictures should have a reason for being taken, and the types you make should contribute to your story. If you organize a slide show for friends, try not to make it too personal. It's not necessary to say, "I did this" or "I went here," because your pictures should show what you did and saw. The subject of each picture should be obvious. The worst sin in any slide show is introducing each image by saying, "This is a picture of . . ." Also avoid showing shot after shot of yourself and your traveling companions; viewers already know what you look like.

Whenever you take a trip, keep the following guidelines in mind. Your pictures should tell a story. Get close to your subjects. Vary your shots between overall views and close-up details. Try candid photographs of people instead of posed pictures. Shoot regardless of the weather or the hour of the day. Take enough film and make more pictures than you normally do. Try to capture some humor in your photographs, too.

And it also helps if the traveling photographer has not only patience but a sense of humor. Your trip and picture-making should be enjoyable.

## Some Practical Advice

Following are some things to remember when making photographs on a trip. First, your camera should be ready to use, not buried in your camera bag or suitcase or the trunk of your car. Many excellent travel pictures are unplanned and suddenly just happen in front of you, so be ready to shoot.

Always KEEP YOUR PHOTO EQUIPMENT IN HAND. Don't put your camera down where it can be snatched away by a thief or where you'll forget it and walk off. At sidewalk cafés, wrap the camera strap around a chair or put your leg through the strap of your camera bag. Be extra careful in cities and busy public places.

Some photographers put their camera gear out of sight when going to their hotel room so as not to attract any thieves who might be loitering in the lobby. Avoid traveling with a fancy camera bag that looks like it might be filled with expensive equipment; a padded photo backpack may be less of an attraction. It's smart not to trust your camera bag to a hotel bellhop, who might leave it unguarded on a luggage cart or accidentally drop it and damage your equipment. If you go out of your hotel room without your camera, lock it in your suitcase or at least put it out of sight.

Never allow a taxi driver to put your camera gear in the trunk of the taxi, where it might get banged around or give him the chance to drive off with your equipment after you get out of the taxi. In some countries you must be careful when handing your camera to strangers who suggest taking your picture; the impromptu photographer and your camera may disappear. By the way, it's always a good idea to have your name and other identification engraved on your cameras in case of loss or theft. Taped-on labels are worthless.

CARRYING A CAMERA IN A CAR deserves special mention. Glove compartments, dashboards, rear window ledges, and trunks can get extremely hot in summer, and heat is bad for your camera and film. Keep the camera on the seat beside you, and hide it beneath the seat when you leave the car. Better yet, take your camera with you. If storage in the car's trunk is necessary, insulate the camera from heat by keeping it in a dry Styrofoam ice chest. This is a cool place for film, too.

By the way, a car can serve as a good camera blind when photographing wildlife from the roadside, because many birds and animals are used to vehicles. Turn off the motor to avoid vibration and roll down the window to use the window frame as a support for your telephoto lens. Remain inside; wildlife often gets frightened and flees if you open the door or step out of the car.

You will need to protect your camera in WET WEATHER. Always carry a few protective plastic bags, especially to cover your camera when it is raining or snowing. (Actually, a little fresh water won't hurt your camera if it is quickly wiped off.) The front of your lens can be shielded from rain or snow by a lens hood, and also protected by a UV or skylight filter. A small collapsible umbrella is a good companion when shooting in inclement weather because it will keep both you and the camera from getting wet. We carry a red

279. Protect your photo gear during inclement weather but don't put it away. An umbrella shielded the camera on a rainy day when these abandoned rowboats were photographed in Germany's Black Forest.

umbrella, which can also be used as a photo prop to brighten up a monotone scene that needs a touch of color.

On the beach or at sea, take special care to protect your camera because salt water can be quite harmful. Wipe off any salt spray immediately with a cloth dampened with fresh water. A worry-free option under wet conditions is to shoot with a waterproof or all-weather automatic compact camera. Regardless of the conditions or your camera gear, it is a good idea to clean all your photo equipment at the end of the day's shooting. Wipe your lenses and filters with a microfiber lens cleaning cloth; use liquid lens cleaner only when necessary, not daily.

COLD WEATHER may affect the operation of your camera, usually by making the batteries sluggish. (Lithium batteries are less affected by frigid temperatures than other batteries.) Very cold weather may cause the shutter to slow down or stick, especially a leaf-type shutter in older camera models (not SLRs). Keep the camera in its case or under an outer layer of clothing to warm it between shots.

Take care not to breathe on the camera's viewfinder or lens in cold weather because it will fog and make focusing and framing difficult or impossible. Condensation is also a problem if you go from heat to cold and back to heat. When you are changing from one temperature extreme to another, placing the camera in a plastic bag with the end closed will cause the condensation to form on the outside of the bag, not on the camera.

Film becomes brittle in cold weather, so avoid winding the film too fast. It may break, or the sprocket holes in 35mm film may tear, and the film will not advance. If your 35mm SLR has a motor drive with a power rewind feature, see if it can be switched off after shooting a roll of film. Then manually crank the exposed film slowly

back into its cassette to avoid streaks on the film caused by static electricity.

For use in arctic-like conditions, a camera can be winterized by having a repairman remove all its lubrication so it will not freeze and jam the camera. However, a winterized camera should not be used in warm temperatures, because lubrication is needed to keep camera parts from becoming worn.

Be aware of VIBRATION, which can loosen camera or equipment screws, especially during jet plane rides and bumpy road trips. Keep your camera cushioned to lessen any vibration that occurs. And carry a small set of jeweler's screwdrivers to tighten any loose screws.

The lighter your load, the easier and more fun it will be to make pictures. Find a convenient and safe way to carry the equipment required for your photographic pursuits. For instance, many nature photographers prefer a PHOTO VEST that has many pockets to hold film, lenses, flash, filters, and other accessories. Other alternatives to a cumbersome camera bag are padded waist pouches and backpacks specifically designed for photo equipment.

One ritual at the end of every day is to make sure that there is plenty of fresh film in your camera bag for the following day. Check the camera and flash batteries, too. Put the rolls of film you have exposed into a plastic bag and keep them in a safe, cool place. Each roll should be numbered as you finish exposing it (see later in this chapter).

## Equipment to Take

Travelers who want to photograph creatively during their holidays or business trips usually prefer versatile 35mm cameras, especially single lens reflex models. Although larger in size and heavier than APS or 35mm compact cameras, 35mm SLRs allow you to see in the viewfinder exactly what the film will record; there are no problems with framing and parallax. Also, SLR cameras offer a wide variety of interchangeable lenses and accessories.

Cameras with AUTOMATIC EXPOSURE CONTROL are of special benefit in travel photography because you can concentrate on capturing the ever-changing subjects and scenery without worrying about setting exposures. Since many picture situations come and go quickly, you should always be ready to shoot. Most photographers trust their camera's built-in auto-exposure metering system and don't carry a hand-held exposure meter. Be sure to BRACKET EXPOSURES if you are

uncertain about the proper exposure, or if you are shooting an especially important subject.

Whatever your preferred camera, it must be in good condition if you plan to take it on the road. If you've been having problems, especially with exposure metering or autofocusing, have it checked by a repairman. When your equipment is returned, it's important to shoot a roll of film to TEST THE CAMERA before you leave on a trip. Sometimes other problems turn up even after you've had the camera overhauled or cleaned.

It's also a good idea to shoot a test roll after purchasing a new camera or lens or any other piece of photo gear. Don't take the chance of something going wrong while you're on a trip; test your equipment beforehand. Travel with the camera instruction manual, too, in case you forget how to operate some of the controls. Before embarking, make certain a strong neck strap is attached to the camera to keep it from being accidentally dropped and damaged. Protect your lenses with UV (ultraviolet) or skylight filters, and lens caps. A polarizing filter is also worthwhile.

What LENSES should you take? Zoom lenses are ideal for travel because one zoom can do the work of several lenses of fixed focal lengths. That cuts down on the size and weight of the photo gear you carry. There is also less chance of missing a picture opportunity because you only need to adjust the zoom's focal length instead of having to change lenses or the camera's position to improve composition. With a single zoom lens you can span the range from wide-angle to telephoto, say 35–135mm. Two zooms will give you even greater coverage, such as one ranging 28–70mm and the other 70–210mm.

If you prefer to shoot with lenses of a fixed focal length, we'd suggest at least two: a 35mm wide-angle and a 135mm telephoto. Each works well for capturing both people pictures and scenic shots. Of course, if you're going to Africa or anywhere to photograph wildlife, a more powerful telephoto in the range from 300mm to 600mm is recommended. However, these big lenses are expensive to buy or rent, and sometimes awkward to handle. A worthwhile compromise is to take a 200mm telephoto or telephoto zoom lens with a 2X lens extender that can be attached to effectively double the focal length to 400mm whenever desired.

Photographers who enjoy CLOSE-UP IMAGES and want to give their travel photos more variety often pack a macro lens, which can also be used at its normal or medium telephoto focal length. Alternatively, you can carry accessory close-up lenses and a set of extension tubes; an extension bellows is too bulky. A less useful option is a

280. Zoom lenses that offer a wide range of focal lengths are especially convenient for composing pictures during your travels (see text). A wide-angle zoom was set to 20mm to fill the film frame with cafe umbrellas at a Mediterranean resort town on Italy's Elba island.

lens reversing ring that allows you to invert a normal or wide-angle lens end for end to make extreme close-ups. Reread Chapter 3 for more details about lenses and their uses.

Your traveling photo gear should include a sturdy and compact CAMERA BAG. Don't be overburdened by a large or unwieldy one. Just make certain that it provides protection and handy storage for all of the camera equipment you take on a trip. If necessary, line the bag with foam rubber to make it more shock-absorbent. The bag should have a reliable shoulder strap so your hands can be kept free. To make travel easier, women should buy a camera bag that has enough room and pockets to also serve as their purse (also see page 266).

Although pictures taken by existing or natural light are often the most pleasing, FLASH may be needed in cases where light is insufficient. But don't always depend on a camera's built-in flash, because usually it's not very powerful. More reliable for flash photography is an accessory flash unit, preferably a dedicated model that coordinates with the camera to set flash exposures automatically. Dedicated flash makes it easy to use fill flash. This will improve many of your pictures by adding light to eliminate harsh shadows on people's faces in bright sunlight.

Regardless of the type of flash unit, be certain that you know its

maximum range. For example, built-in camera flash may reach only 10 feet (3 meters) or so. Too many photographers expect their flash to cover a greater distance than it can, and underexposed images are the result. Read the instructions for your flash and memorize its limitations (also see page 157).

Always carry an extra set or two of BATTERIES for your flash, and for your camera, too. If you normally use *rechargeable* batteries for your flash, this may be a problem in foreign countries if the electrical current or outlets are not compatible with your recharging unit. Make sure the recharger can be used at various voltages, and carry a set of adapter plugs to fit different outlets.

A CABLE RELEASE or REMOTE CORD and some camera support will be needed for time and night exposures. Convenient for travel is a small sturdy TRIPOD, or a C-clamp, with an adjustable ball head (also see page 256). Don't forget a microfiber lens cleaning cloth to keep your lenses free of dust and fingerprints, and take camera lens cleaner and lens tissue, too. Also carry a few plastic, self-sealing kitchen storage bags to help protect your camera and equipment in rainy and dusty conditions.

You might consider capturing some of the music, voices, and other sounds on your trip to enliven a slide show. A small audio-cassette recorder featuring an automatic recording level is most convenient to take on your trip. Don't forget to pack extra recording tapes (with 120 minutes or more capacity), and batteries or a battery recharger.

A number of travelers CARRY TWO IDENTICAL CAMERA BODIES, or two cameras of the same family that accept the same lenses. These are mounted with lenses of different focal lengths, such as a wide-angle and a telephoto, in order to be ready for any shooting situation. In addition, if one camera breaks down, you are able to continue shooting with the other camera. Couples who are both photographers would be wise to use identical camera bodies because they can share lenses and other gear as well as the burden of carrying the equipment.

Of course, two cameras are a must if you're shooting different types of films, such as color print film and black-and-white film. If the cameras do not have automatic exposure control, the films in both cameras should be of the same film speed (ISO). That way the meter reading made for one film will apply to both films and make it easy to set the exposure on the other camera. In practice, however, your trip will be more enjoyable if you concentrate on shooting with only *one* type of film—either color print, or color slide, or black-and-white.

281. When you're taking a once-in-a-lifetime trip, such as a wildlife safari in Africa, consider carrying two cameras so you won't miss any pictures if one camera stops working or is lost or stolen.

We also recommend that traveling photographers PICK ONE TYPE OF PHOTOGRAPHY and stick to it. Don't load yourself down with a still camera as well as a video camera or an instant camera or a digital camera. So much varied equipment is too cumbersome and too confusing to use successfully on the same trip. (Of course, when you're shooting slides with a 35mm SLR and considerable accessory gear, it's fun to also carry a small APS or 35mm compact camera just to make color print snapshots for personal memories.)

One thing to always consider when deciding what equipment to take with you is how burdensome it might become. The best test is to assemble your photo gear and carry it around as if you were on a trip; after a while, you may decide that there are several items you can leave at home to lighten the load.

## Film Brands and Prices

While most travelers like films that produce color prints they can display in photo albums, some prefer to shoot color transparency films so they can present slide shows to their friends and family. Regardless of the type of film you select, you should be familiar with the specific films you take with you to record your travels. Don't

experiment with unknown films while on a trip; try them at home first and see if you like the results.

When you are traveling abroad, it's a good idea to take all the film with you. Although Kodak, Fuji, Agfa, and Konica are worldwide film brands, don't count on buying your favorite brand or type of film overseas. It may not be sold in some countries, or may only be available in limited quantities. In some cases, film may be out-of-date; always check the expiration date on the box or package of any film you buy. Also, be careful that the film hasn't been subjected to improper storage conditions, such as in a shop's display window where it is exposed to heat from the sun.

Because film prices vary greatly from nation to nation, your travel budget might suffer if you wait to buy film overseas. Films in the U.S. have a suggested list price but can be bought for less at discount and

282. Take with you all the film you expect to use on a trip. Your favorite brand and type of film may not be available in some places, such as Aswan, Egypt, where these watermelon merchants were photographed.

warehouse stores. Camera shops often reduce the price when a quantity of film is purchased. Many overseas camera stores do the same if you ask for a discount. Just remember that film is a minimal investment compared to the cost of your travels. The more pictures you make, the more memories of your trip will be preserved for the years to come.

By the way, if the price of a color slide film abroad seems considerably higher than in the U.S., it may include processing by the manufacturer. If the film box states that processing is included, a mailing envelope will be packed inside. This kind of mailer has no value and is only provided as a convenience; the film itself is coded to indicate whether processing has been prepaid. A notice on the film cassette will also indicate if processing is included.

## Which Film Speeds?

Since you will probably be shooting in all types of lighting situations, films with higher ISO speeds are a smart choice for travel photography. If you're using color print film, those of ISO 400 offer a good exposure range and excellent results. On the other hand, professional travel photographers, who most often shoot color transparency (slide) films, prefer slower-speed ISO 50 and ISO 100 slide films for their sharpness, fine grain, and color balance.

For indoor and night exposures by existing light, consider taking a few rolls of high-speed film rated at ISO 800, 1000, or even 1600. If necessary because of very low-light conditions, the film in your camera can be changed in mid-roll to one of those higher-speed films; see page 28. Another option in dim light is to re-rate the ISO of your regular film to a higher film speed and compensate for underexposure by push processing that particular roll of film; see page 209.

## How Much Film?

How much film should you take on a trip? The simple answer is to take more rolls than you think you'll need. It's important not to limit your shooting, or to run out of film. As a guideline, a photographer who plans to record every aspect of his travels should expect to shoot two to four rolls of film per day. Only take rolls with the greatest number of exposures—36 exposures for 35mm films or 40 exposures for APS films. This avoids extra roll changing, is less expensive per image, and saves space in your camera bag.

Also save space by discarding all film boxes. (Keep one of them for the film data that's printed inside, unless that information is on a separate sheet packed in the film box.) Do not get rid of the plastic storage cans for 35mm films, or the sealed foil wrappers around other films, because they offer protection against humidity.

Carry all your film in clear plastic, self-sealing kitchen storage bags so it is easy to identify and inspect by hand at airport security X-ray checkpoints. Use different bags to keep fresh film separated from exposed film. If your camera doesn't do it automatically, remember to rewind the film leader completely into the cassette after a film is exposed to avoid accidentally reloading and reexposing it.

## Protecting and Processing Film

In general, try to keep your film cool and guard it against humidity. Don't ruin your trip by letting your film get damaged, lost, or stolen. In a hotel, lock it in your suitcase. Otherwise, carry the film with you when flying or using other transportation where your suitcase is put into a luggage compartment and may get mistreated or misplaced.

A potential threat is the security inspection at airports where X-RAY MACHINES are used to check hand luggage and suitcases that are placed in the plane's baggage compartment. Despite what some airport signs may say, radiation can harm unprocessed film. Most susceptible are the high-speed films, ISO 400 and higher, which can show signs of fogging, color fading, shadow images, and other damage. The most sensitive types of films are color print films, followed by black-and-white films, and lastly color slide films.

It's best to have a hand check for your films and loaded cameras; just pull your see-through plastic bags of fresh and exposed film from your camera bag or flight bag and hand them to a security attendant. Federal regulations for U.S. airports guarantee a hand check of carry-on items, if requested by the passenger, so don't be intimidated by guards who demand that your film be put through the X-ray machine. Be aware that some foreign airports are much stricter about all carry-on items being scanned by X rays.

To avoid possible arguments with security personnel or having to take extra time for a visual check, some travelers carry their films in lead-lined polyester bags that are designed to shield the contents from X rays when they pass through the scanner. However, there is still no guarantee that your films won't suffer some damage because

283. Don't take chances that may ruin your vacation pictures. Beware of X-ray machines at security checkpoints and careless processing at unknown photo labs (see text).

X rays are *cumulative*, and multiple X-ray screening during an extended trip may add up to trouble. Also, some older X-ray machines overseas, notably in Third World countries, give higher doses of X-ray exposure than the latest devices. Play it safe and always ask for hand inspection of your film. By the way, the magnetic and ultrasonic walk-through and hand-held metal detectors used at airports to discover hijackers' weapons or bombs do not affect film.

You should know that *processed* film cannot be harmed by X-rays. That's one reason why some travelers have their exposed films processed before returning home. The FAST-PHOTO MINILABS common in many countries make it convenient to get color print films developed on the spot. However, we would not trust color slide films to these quick-process minilabs; find a professional lab instead.

Also, don't believe signs that advertise one-hour or overnight processing; ask exactly when your pictures will be ready to pick up so you won't have to change any travel plans. In addition, it's always wise to have only one roll processed to see if you like the results before giving the minilab all of your exposed film.

Manufacturers recommend that film be processed as soon as

possible after exposure, but there is really no rush if you keep it relatively cool. However, if subjected to extremely hot or humid conditions, exposed color film may lose picture quality if not processed promptly.

## Mailing Film for Processing

To avoid having to carry exposed films on an extended trip, some travelers send the film home for processing. If you use PREPAID PROCESSING FILM MAILERS, the color prints or slides will be waiting and ready to enjoy immediately upon your return. When you're abroad, it's safest to ship several rolls at a time with an international air delivery service, such as FedEx, which will also handle any customs formalities. Address the package to your photofinisher with film in prepaid mailers, or make prior processing arrangements. Or just send to it to your home or office address and have someone take the film to your local processor.

If you decide to mail exposed film from abroad instead of using an air delivery service, package at least six rolls in accordance with international postal regulations regarding minimum package size, make sure the package clears customs at the outgoing post office, and ship it via air parcel post. (Regular mail goes by sea, and your film may be subjected to a variety of temperatures during its slow trip.) Always check that your package has been properly stamped and canceled. If you hear that the country's postal service is unreliable, don't mail your film.

When mailing film from overseas, write this on the package: "Exposed, undeveloped photographic film. No commercial value. Do Not X-ray." This is for the benefit of airline or postal personnel who may be using X-ray devices to check for dangerous packages, and you'll also avoid having to pay duty to U.S. Customs.

## Identifying Film

Every roll of film should be identified before or after exposure in order to keep track of your film and identify the prints or slides after processing. An easy way is use a felt-tipped pen with permanent (not washable) ink to NUMBER EACH ROLL in the order it was shot. Write the number on the film's cassette or on its plastic storage can. Before processing, these ID numbers should be transferred to the photofinisher's film identification envelope or the film mailer's return

284. If you treasure the pictures you make on a trip, as of this shy Cuna Indian in Panama's San Blas Islands, take care about mailing the film for processing (see text).

address label. An alternative way to identify each roll is to take a picture of the ID number on the first frame of film.

It's also important to CARRY A SMALL NOTEBOOK to make a roll-by-roll and frame-by-frame record of the photos you shoot. Jot down information about each image or group of similar images corresponding to numbers on the camera's film frame counter. Otherwise you'll be unable to identify some of the pictures after you get home from the trip. (It's very frustrating when you can't remember where the mountain was located or don't recall the name of the church.) If you're too busy shooting to make notes at the moment, at least mark the roll and frame numbers on a map or in a guidebook or tour brochure for later reference; professional travel photographers always take time at the end of each day to bring their photo caption books up to date.

## Regulations Against Photography

Travelers overseas should be aware of government regulations about cameras and film. Some countries officially limit the number of cameras or films that can be brought in by any one person so the

items won't be resold there. Tourists and other noncommercial photographers usually are not bothered with these regulations, but it may be helpful when entering a country not to make a big display of your photo gear. This is another good reason for reducing the apparent size of your film supply by discarding film boxes before leaving on your trip.

Government authorities and others sometimes forbid you to photograph certain subjects, usually for military reasons. For instance, it may be officially illegal to take pictures of border areas, defense installations and factories, bridges, railroad stations and junctions, airports, or military bases and personnel. If you see a "No Photography" sign, obey it.

Art museums and religious sites are other places that are sometimes off-limits to photography, and you must leave your camera and equipment at the entrance. In some cases, you'll be allowed to shoot if a fee is paid. Even when photography is permitted in museums, tripods and flash are apt to be forbidden. That's because tripods get in the way of other visitors or might be used to damage art objects, and the bright light from flash can fade paintings and other artworks over a period of time. Hand-held cameras with high-speed film are most useful for casual museum photography.

285. Tripods and use of flash are sometimes forbidden inside museums and other public places. In order to hand-hold the camera and make exposures by existing light, load your camera with high-speed film. This statue of the Greek god Poseidon in the National Archaeological Museum at Athens was photographed with ISO 400 film.

## U.S. Customs Considerations

If you're a U.S. citizen leaving the country with foreign-made cameras or lenses, these items are officially subject to duty upon reentry to the U.S. unless you can prove that your photo gear was purchased at home. In reality, Customs inspectors rarely bother about tourists' photography equipment. However, if you want to be on the safe side, the best way to prove prior ownership is to register foreign-made items with U.S. Customs before leaving on your trip. (There's no need to register U.S.-made products.)

At international airports and seaports, take your cameras and lenses to the U.S. Customs office and fill out a Certificate of Registration. List all brand names and model and serial numbers, which are engraved on these items. A Customs officer will check your list and equipment, and sign the form. Also include any electronic gear, such as a portable tape recorder or laptop computer, if it is foreign-made. Customs registration of your equipment is good forever, as long as you retain the registration form; new items can be added at a Customs office prior to other trips. Always allow extra time before your departure for this procedure.

You can avoid the bother of registering cameras and lenses with U.S. Customs by having the SALES RECEIPTS or a CAMERA INSURANCE POLICY with you to show proof of prior ownership. Insurance is a good idea, by the way, because cameras and other photo articles will be covered against damage as well as theft. Ask your insurance agent about adding camera floater coverage to your homeowner's or renter's insurance policy.

U.S. citizens who buy a camera or lenses abroad (or cannot prove that their equipment was purchased in the U.S.) may pay duty. The amount depends on how much you might exceed the duty-free exemption, currently $400 per person ($600 if returning from a country in the Caribbean). The duty, which is based on purchase price less wear and tear, is 10 percent of the next $1,000 worth of all purchases. If your total purchases exceed $1,400 (or $1,600), additional duty then ranges from 3 percent on cameras to 6.6 percent on lenses.

Note that families traveling together and making a *joint* Customs declaration upon their return can group their personal duty-free exemptions. For example, a married couple will be allowed $800 ($1,200 if returning from the Caribbean) as a duty-free exemption, regardless of which person purchased which articles.

286. Avoid making shoot-and-run travel pictures. At home or abroad, always take time to concentrate on composition—even when pictures are solely for personal memories, such as where you spent an especially enjoyable night. A low camera angle includes the profusion of poppy flowers found at this Victorian bed-and-breakfast hotel along the California coast.

Remember, don't lie about the price you paid for equipment abroad; Customs officers keep up-to-date on the costs of photo gear. And don't be tempted to accept a camera salesman's offer for a fake receipt with a lower price than you actually paid. Smuggling new camera equipment is also ill-advised; if you're caught leaving out items in your oral or written declaration, confiscation of those articles and/or a fine is possible.

## Buying Photo Equipment Abroad

The days when Americans bought cameras and accessories overseas at bargain prices are gone. Because of the weaker U.S. dollar, you're likely to find photography equipment to be less expensive here at home than abroad. One reason is that photo equipment sold in the U.S. will usually cost 20 to 25 percent less than its *list price* if you ask the camera store salesman for a discount. You can also shop around at large discount warehouses and check the advertisements of mail-order retailers in photography magazines for low prices.

When you are overseas, especially in international airports, don't be misled by shops offering *duty-free* cameras and lenses; it just means you don't have to pay duty or taxes in the country where the shop is located. Also, when figuring the actual cost of anything purchased abroad, consider that you may have to pay U.S. Customs duties (see the previous section).

Whether you are shopping at home or abroad, check at least three stores for the lowest price offered. Most of all, always make certain that you're comparing prices for *exactly* the same equipment, not just similar camera models, or lenses that have different maximum lens apertures, for instance. Also be aware that comparison shopping between the U.S. and other countries may be difficult. That's because some cameras are made only for export and marketing in the U.S., or they are known abroad by different names or model numbers.

WARRANTY AGREEMENTS are a concern when buying photo equipment. Sometimes warranties on cameras and lenses purchased overseas will not be honored in the U.S. or other countries. The same is true for so-called GRAY-MARKET products bought in the U.S., which are often sold at low "street prices" by mail-order companies. Gray-market merchandise has not been imported from its foreign manufacturer through authorized distributors; it may be covered only by a local store warranty or a third-party warranty instead of a U.S. warranty for factory-authorized repairs. Always make sure that you'll get the manufacturer's U.S. warranty agreement before making a purchase. Otherwise, if repairs are ever needed, you may end up paying for them. (Also avoid being talked into purchasing any U.S. store's extended warranty; its cost and coverage limitations outweigh its supposed benefits.)

Of course, one problem with waiting to buy a camera or equipment abroad is that you may miss some great photographs en route to the foreign country where you plan to make your purchases. Regardless of where or what you buy, remember to shoot a test roll of film with any new camera, lens, or flash. And don't forget to ask for the instructions in English, or your native language.

To help you when buying photo goods or services overseas, a few common words are given in the following chart in six languages.

| English | German | French | Italian | Spanish | Japanese |
|---------|--------|--------|---------|---------|----------|
| camera | Kamera | appareil photographique | macchina fotografica | maquina | kamera |
| battery | Batterie | batterie (pile) | batteria | batería (piln) | batteri [or] denchi |
| electronic flash | elektronen Blitz | éclair électronique | luce portabile elettronica | flash electrónico | sutorobo |
| filter | Filter | filtre | filtro | filtro | fuiruta |
| color slide film | Dia | diapositive | diapositiva | diapositiva | karaa toransuparensii |
| color print film | Farbenfilm | pellicule en couleurs | pellicola a colori | película | karaa fuiruma |
| black-and-white film | schwarz und weiss Film | noire et blanche filme | bianco e nero pellicola | rollo de negro y blanco | shirokuro-fuirmumu |
| developing and printing | entwickein kopieren | développement (traitement) | sviluppo e stampa di un film | desarrollar copiar | D.P.E. |

# PROCESSING FILMS AND PRINTS

Once you've exposed your film, what about processing? Some photographers insist on doing their own processing, while others trust their films only to custom processing labs. However, most casual shooters simply give their exposed film to a fast-photo minilab or a camera shop for development. Who processes the film is of little concern to this latter group, but it should be. Unfortunately, too many people make no protest when they receive prints and slides with untrue colors, dark or washed-out images, dust spots, or scratches.

As we emphasized earlier in the chapter about films, after spending the time and effort to make the best pictures possible, you should demand that the final results—whether prints or slides—be of the highest quality. In short, if your photofinisher is doing a poor or mediocre job, find another. Or do it yourself.

Photographers do their own processing in order to have total control of the final results. It can be fun as well. To help you understand the basics of processing, this chapter describes the steps involved in developing black-and-white films and then making contact prints and enlargements from the negatives. The procedures for color processing are similar but require more space for a thorough description than this book allows. Complete information about processing color films and printing color photographs will be found in Tom's companion how-to photography guide, *The Basic Darkroom Book*, along with additional details and advanced techniques for black-and-white processing and printing. It is published by Plume/Penguin Books and available at any bookstore.

287. Photographers who process and print their own films have complete control of their photographic results. The black, white, and gray tones of these chinstrap penguins in Antarctica can be adjusted to the photographer's own satisfaction in his darkroom. The procedures for black-and-white film processing and print enlarging are described in this chapter.

## Processes for Color and Black-and-White Films

As you will recall, films are one of two types, negative or positive. The first type, most often labeled as PRINT FILM, involves two processing steps: (1) developing the film, which produces a negative image on the film, and (2) printing this negative image to make a positive image on photo paper. Positive film, identified variously as REVERSAL FILM, TRANSPARENCY FILM, or SLIDE FILM, produces a positive image on the film in a single step: developing the film. A second step, printing, is required if you want this positive image to be reproduced on photo paper.

With a few exceptions, all BLACK-AND-WHITE FILMS are negative films and used to make prints (see pages 223–24); Kodak T-Max 100 and Agfa Scala will produce black-and-white slides when given special processing (see page 206). COLOR FILMS are available as either negative or reversal (positive) films. Of the two, color negative films for making prints are the favorites of amateur photographers. Color reversal films for making slides or larger transparencies run a very distant second in popularity, although they are the choice of many professional photographers.

Regarding COLOR FILM PROCESSING, color negative (print) films are developed in what's known as PROCESS C-41, while most color reversal films (slide) are developed in PROCESS E-6. These designations refer to processes originated by the Eastman Kodak Company in the U.S. but are generally known worldwide. There are also equivalent processes from German and Japanese film and photo chemical manufacturers in which all color films of the same type can be developed. For example, Agfa's AP-70, Fuji's CN-16, and Konica's CNK-4 processes are equivalent to Kodak's C-41 and can be used to develop any color negative film. Likewise, Agfa's AP-44, Fuji's CR-56, and Konica's CRK-2 processes are equivalent to Kodak's E-6 and can be used for processing almost any color reversal film. An exception is Kodak's Kodachrome color reversal film, which requires Kodak's Process K-14.

Both C-41 and E-6 processes are available in COLOR FILM PROCESSING KITS designed for use in home darkrooms. These kits of chemicals make it possible for you to develop almost any color negative or color reversal film in a small processing tank. (Kodachrome color reversal films are the major exceptions; they require not only Kodak's Process K-14 but a sophisticated and very expensive processing machine as well.)

No particular processes are designated for DEVELOPING BLACK-AND-WHITE FILMS. There are many black-and-white film developers on the market, and they can be used with most black-and-white films. Of course, manufacturers recommend their own developers for their own films, but you can process an Ilford film in a Kodak developer, or a Kodak film in an Agfa developer, etc. Be aware that in addition to brand names, you have a choice of different types of developers, such as fine-grain developer, which is recommended if you want to make big enlargements from a small negative. Check at a camera store to compare the various characteristics of black-and-white film developers.

## Processing in Black-and-White

For most photographers, their first experience in a darkroom is developing black-and-white film. It's simple, fast, and inexpensive. In fact, a darkroom isn't even required; you can make do with only a lightproof changing bag and a developing tank. When it comes to the next steps—printing and enlarging negatives to make the actual photographs—a darkened room and additional equipment will be needed. However, even at that stage your investment can be minimal—or extensive. We suggest that you don't initially spend a lot of time or money building and outfitting a darkroom. That's because developing and printing your own photographs will either fascinate or bore you.

Even if you decide not to establish a full-fledged darkroom, a rudimentary knowledge of black-and-white processing will be benefi-

288. The type of film developer and the developing time help determine the degree of contrast in an image. Contrast also can be regulated when prints are made.

cial to your photographic efforts. For example, you'll understand how to get a print of good contrast from a negative that has been accidentally overexposed or underexposed.

There are three steps in processing black-and-white photographs. The first is to develop the film, which results in the negatives from which prints are made. The second step is to make contact prints of the negatives in order to see what the images will look like as positives and to make it easier to select the images to enlarge. The third step is to make an enlargement that represents the final photograph as you desire it.

For photographers who learn to "read" negatives and can readily visualize the image as a positive, or for those in a hurry, the intermediate step of making a contact proof sheet is often eliminated. However, if proof sheets are made (and filed with the negatives), they serve as an excellent catalog of all the black-and-white pictures you've taken.

Developing black-and-white film is quite easy. Basically, here's what happens. A film's emulsion is a coating of light-sensitive chemicals, silver halides. When light coming through your camera lens strikes this emulsion, an image is formed. However, it is called a LATENT IMAGE because it cannot be seen until the emulsion is acted upon by another chemical, the DEVELOPER. This developer turns the portions of light-struck emulsion black or shades of gray, depending on the intensity of the light. Where little or no light has struck, as in dark or shadowed areas of the original scene, the emulsion is unaffected by the developer.

After a predetermined time in the developer, the film is immersed in a chemical solution called a STOP BATH. As you might have guessed, this stops the action of the developer, and it rinses off the developer so it will not contaminate the next chemical in which the film is immersed, the FIXER. The fixer preserves the image and dissolves the film's chemical coatings that are no longer needed. Water is used to wash away the fixer, and the film is then hung up to dry. The images you now see will be preserved. The dark or black areas of the original scene will be clear, while the white or bright areas will be black. That is why the developed film is now called a negative.

Mention must be made here that the developing procedure just outlined does not apply to a few black-and-white films that can be processed as POSITIVE IMAGES rather than as negatives. They require either processing by a custom lab, do-it-yourself processing with a special kit, or processing in C-41 chemicals normally used for color films (see page 442).

To see negative images correctly as positives, a print must be

made. CONTACT PROOF SHEETS are made by placing the negative on top of light-sensitive photographic paper that is then exposed to light. As with film, a latent image is formed. And as with film, the paper is then run through three chemicals to produce a visible image. First the paper goes in the developer (usually a different type from the film developer), then the stop bath, and finally the fixer, after which the print is washed and dried. The negative images have reversed again to become positives and reproduce the scene as you photographed it. The print, of course, is in black-and-white and various shades of gray.

To produce ENLARGEMENTS, which are pictures bigger than the size of the negative, an enlarger is used. This projects the negative image in almost any size you desire onto photographic paper. The chemicals and processing steps for enlarging are the same as those used to make contact proof sheets. To be sure, it is quite exciting to see the first roll of negatives you've processed, but watching an enlargement emerge in a tray of chemicals is even more thrilling. Following is the complete black-and-white developing and printing process in detail.

## Developing Film

To develop 35mm and 120-size films, use a small FILM DEVELOPING TANK. Least expensive is a tank made of plastic, although one of stainless steel is more durable and a better investment if you intend to continue developing film. An accurate THERMOMETER is a must. It is used to check chemical temperatures before processing begins.

As mentioned earlier, three chemicals are required: the film developer, stop bath, and fixer. Water can be substituted for the stop bath if desired. The chemicals can be bought as a kit for film processing or can be purchased separately. The instructions packed with your film will suggest specific developers to use for that particular film. The same type of fixer can be used for both film and paper, although it is usually diluted differently. RUNNING WATER for washing is needed. FILM CLIPS or clothespins are used to hang up the film. A DARKROOM TIMER or just a watch or clock for timing the processing steps is necessary, too.

A glass or plastic vessel, called a GRADUATE, is required for mixing and measuring the chemicals. To store the mixed chemicals, use the special brown plastic bottles sold in camera stores, or regular bottles that have been covered with black spray paint. The reason for using dark bottles is to keep light from deteriorating the chemicals while they are stored. Other necessary items when developing 35mm

289. Plastic and stainless steel tanks for developing film include models with adjustable and fixed reels for various sizes and amounts of 35mm and roll film.

film are a pair of SCISSORS and a BOTTLE-TOP OPENER to help remove the film from its lighttight cassette.

The two most important considerations for successful film developing are TEMPERATURE AND TIME. Chemicals must be kept within a specific temperature range, and developing times must be exact. A guide to temperatures and times is included with the processing chemicals, and is sometimes found in the film's instructions, too.

Chemicals are packaged in powder or liquid form and must be mixed carefully and correctly. Those that are concentrated "stock" solutions require dilution with water before use. Chemicals are available in a variety of sizes. The 1-quart (or 1-liter) size is more than enough for processing a few rolls of film.

Care must be taken to avoid CHEMICAL CONTAMINATION. For instance, after mixing the developer, wash out the measuring graduate before using it to mix or measure another solution. (Or use different graduates.) Wash off the thermometer, too. Protect your clothes from chemicals by wearing an apron or an old shirt. Use rubber gloves to protect your hands, but always remember to wash off the gloves to guard against chemical contamination.

Bottles holding the mixed solutions should be labeled clearly, including their caps. Because chemicals deteriorate over a period of time, indicate the date of mixing. Also mark the bottles after each use to keep track of the amount of film developed; chemicals become exhausted and must be replaced or replenished after their USEFUL CAPACITY has been reached.

Because film developing tanks are lighttight, processing can be done with the room lights on once the film has been loaded into the tank. LOADING FILM requires a *totally* dark room; check for light leaks in the room by waiting five minutes until your eyes become accus-

290. Loading 35mm film for processing in tanks varies according to the type of reel. To load this stainless steel reel, after the film has been removed from its lighttight cassette and the film leader cut off with scissors, you curve the film slightly with the emulsion side down, slip it into the film clip in the center of the reel, and then turn the reel slowly to wind the film into the spiral grooves.

291. To load this plastic reel, after removing the film from its cassette and cutting off the film leader, the film is placed emulsion side down into the outside opening of the reel, and then the film is "walked" into the grooves by alternately twisting each side of the reel. *Note that film must be loaded onto reels in total darkness and placed inside the lighttight developing tank before the room lights can be turned on.*

tomed to the dark. An option is to use a lightproof CHANGING BAG to load the film into the tank when the room lights are on (see page 29).

Instructions for loading film come with the developing tank. Loading the film on the reel that goes in the tank is relatively easy but may require practice. A good idea is make a few test runs with an old roll of unprocessed film; close your eyes or darken the room while winding the film onto the tank's reel. The emulsion side, which is inside of the film's slight curve, goes toward the inside of the reel. Handle the film by its edges, since touching the emulsion may cause fingerprints on the negatives. Be sure your hands, and the reel and tank, are dry. The film must not touch itself while on the reel, or

the chemicals will not be able to cover the entire film surface. Patience as well as practice is often required when loading the reel, especially with 36-exposure 35mm film, which is more than 5 feet (1.5 meters) long.

When you think you have mastered loading the reel with practice film, get set for the ACTUAL LOADING OF YOUR EXPOSED FILM. Place the tank and reel in a convenient spot on a dry work space and turn out the lights. (Or put everything you'll need to load the film in the developing tank inside a changing bag, and zip it up.) Here are the steps to take with different sizes of films.

With most 35MM FILM, a bottle-top opener is used to remove one end of the lighttight film cassette. This metal container cannot be used again, so don't worry about damaging it. Ilford's film cassettes are reusable; snap off the end with your fingers. The film will emerge wrapped around a small plastic spool. Find the film's outer end, the leader, and cut off this first 2 inches (5 cm) of unwanted film with a pair of scissors. Load the film on the reel with the emulsion side inward. Handle the film by its edges only. When you reach the end, cut the tape that secures the film to the cassette spool. Place the reel in the tank, put on the tank top, and make sure that it is properly sealed.

For ROLL FILM, such as 120-size, once the lights are out, break the seal on the film's paper backing and separate this paper from the film as you load the film on the reel. Tear the piece of tape holding the film to the paper backing at one end. Handle the film by its edges only, and be careful not to touch or scratch the emulsion side of the film while loading it on the reel. Once the reel has been loaded, place it in the developing tank and secure the tank's top.

For CARTRIDGE-TYPE FILM, such as 110- or 126-size, snap the plastic cartridge in two by putting your thumbs in the middle and pulling back on the rounded ends. Separate the film from its paper backing and load it on the reel as just described.

Once the top is on the developing tank film with the loaded reel inside, the room lights can be turned on (or the changing bag unzipped) and the actual PROCESSING STEPS begun. First, check the TEMPERATURE OF THE DEVELOPER; 68°F (20°C) is recommended, so cool or warm the developer accordingly. To adjust the temperature, you can pack ice around the bottle of developer, or the bottle can be placed in hot water. Determine the DEVELOPING TIME according to the temperature, and by following the developer's instructions. Now pour the developer into the tank. Premeasure the exact amount required to cover the entire film without overflowing the tank.

Start the timer or mark the clock immediately, and agitate the

film to eliminate AIR BUBBLES, which sometimes occur when chemicals first cover the film. For tanks with tops that hold the liquid in so they can be inverted, rap the tank on the edge of the work area to dislodge the bubbles, then agitate it by inverting the tank back and forth for at least 15 seconds. Do this again for 5 seconds during every 30 seconds of the developing time. For tanks with the reel core extended so it can be rotated, twist the reel back and forth rapidly to dislodge the air bubbles, then agitate by rotation for 15 seconds. Reagitate by rotation for 5 seconds every 30 seconds.

When the developing time ends, keep the tank top on and drain the developer back into its bottle. Next, pour in the appropriate amount of stop bath and agitate the film by the inversion or rotation method. Drain the stop bath after 15 seconds and pour in the fixer. (A plain water rinse for 30 seconds can be substituted for the stop bath.) Agitate the film as just described and fix the film for the recommended time. Drain the fixer back into its bottle. The tank top can now be removed and you can take a look at the processed negatives. First, however, immerse the reel in water to rinse away the excess fixer.

Film should be washed for 30 minutes in running water to remove all of the fixer. Keep the film on the reel to allow uniform washing. Wash time can be reduced to 5 minutes by first bathing the film in another chemical, called a HYPO CLEARING AGENT or HYPO NEUTRALIZER. Finally, hang the film up to air-dry in a dust-free area. Drying time takes 2 to 4 hours. Avoid forced drying with a hair dryer or an electric fan, which may cause dust particles to adhere to the film and make rewashing necessary. Once the film is dry, you can take a good look at the negative images to see if they have been properly processed and are of good contrast; handle the film by its edges.

To prevent accidental damage, the dried negatives should be placed immediately into archival-safe paper envelopes or polypropylene (not PVC) sleeves for filing and storage. For easier handling, 35mm films can be cut in lengths of six exposures each; 120-size films can be cut in three-exposure lengths for the same reason.

## Printing Contact Proof Sheets

For most photographers, the next step toward the finished enlargement is making a CONTACT PROOF SHEET. This produces negative-size positive images that can be studied for content and contrast to help you select the negatives to enlarge. Use a magnifier, known as a LOUPE, to see each image in detail and decide if there are any por-

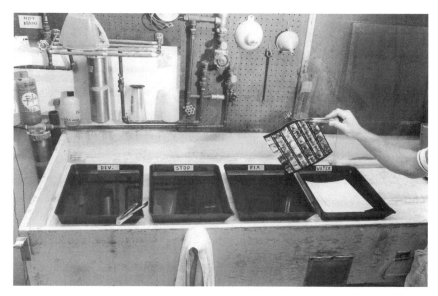

292. When processing a black-and-white proof sheet, or an enlargement, print tongs are used to transfer the photo paper from one solution to another: developer to stop bath to fixer to wash water.

tions of the picture you want to eliminate when making an enlargement. This is called CROPPING. You can make crop marks with a grease pencil on the image in the proof sheet as a reminder of exactly what you want to include in the finished photograph.

Contact sheets, when filed with their negatives, become a valuable index of all the pictures you take. In addition, they can be marked as to which negatives were printed and how many prints were made. Information about the exposure used during the enlarging process can also be marked on the proofs and utilized for subsequent printings.

Contact sheets produce positives in the same size as the negatives because the negatives are put in direct "contact" with the printing paper, and a light is turned on to make the exposure. All of the negatives from one 36-exposure 35mm film, or one 120-size film, will fit on a sheet of 8 × 10-inch (20.3 × 25.4cm) or slightly larger 8½ × 11-inch (21.5 × 27.9cm) photographic printing paper. Thus, a single exposure of those negatives in contact with one sheet of paper will produce a positive record of an entire roll of film.

The basic materials needed for contact printing can be used again for the final enlarging step. As with film processing, three chemicals are used for printing and enlarging—the DEVELOPER, STOP BATH, and FIXER—but the type and/or dilution of those chemicals are different.

The developer type depends on the type of printing paper selected. Also, you can choose between chemicals that come in powdered or liquid form. Carefully follow the instructions packed with the chemicals for proper mixing or dilution with water. As before, be aware of the chemicals' capacities and keeping characteristics.

The stop bath can be of the same type as that used for film processing. The print fixer usually is more diluted than the solution used for film fixing. For volume printing, two fixing baths are often used to ensure adequate fixing and to extend the life of the fixer solution. The three chemicals should be poured into trays that are at least the size of the contact print to be made. Arrange them in order—developer, stop bath, and fixer.

For washing, a photographic PRINT WASHER is recommended, or a TRAY SIPHON can be used to circulate the water in a tray devoted to print washing. Drying techniques and times vary according to the type of printing paper. The liquid-resistant RC (resin-coated) type of printing paper can be dried in just a few minutes with a hand-held hair dryer, or they can be placed in a DRYING RACK or on DRYING SCREENS to air-dry in 10 to 15 minutes. Conventional fiber-base printing papers can be put in an electric PRINT DRYER for almost immediate drying, or inserted between PHOTOGRAPHIC BLOTTERS to air-dry overnight. Fiber-base papers with a glossy surface must be squeegeed while wet to a piece of chrome-plated metal called a FERROTYPE TIN to obtain a high gloss; otherwise they will dry with a semigloss finish. Glossy-type RC papers are self-glossing.

To make contact prints from negatives, you can use a CONTACT PRINTER, sometimes called a CONTACT PRINTING FRAME or a CONTACT PROOFER. This is a simple device with a hinged piece of glass that keeps negatives and a sheet of photographic paper in contact with one another for exposure to light. First the glass is raised and the photo paper positioned emulsion (shiny) side up on the base of the printing frame. Next the negatives are placed emulsion (dull) side down on the paper. Then the glass is lowered and locked in order to cover and hold the paper and negatives tightly in contact.

Light from an enlarger or a desk lamp is used to expose the paper through the glass and negatives. Exposure time varies depending on the type of photo paper used and the wattage of the bulb. The paper is then removed from the contact printing frame and taken through the processing steps. By the way, a few photo papers are designed exclusively for contact printing, but papers designed for enlarging work just as well and most photographers use enlarging paper for making contact prints (see page 455).

There are some boxlike contact printers that contain their own

lightbulb. Negatives are first put on its glass top, covered by the photo paper, then both are held together by a cover while the exposure is made. Actually, most photographers who have an enlarger don't bother with a contact printing frame or self-contained contact printer. They simply use a piece of glass to hold the paper and negative flat and in firm contact on the enlarger's baseboard. The glass should be 10 × 12 inches (25.4 × 30.4cm) so that it fully covers the paper. The enlarger's light is turned on to make the exposure.

Whether you use only glass, a printing frame, or a contact printer, the glass must be clean to avoid dust spots or other marks on your prints. Negatives should be dust-free, too. Clean them with a special ANTISTATIC BRUSH OR CLOTH. Also, be sure that the negatives and paper are in direct and even contact, or a fuzzy image will result. To keep your subjects from being printed in reverse, the negative's emulsion must be facing the paper's emulsion. Just remember to place negative and paper "emulsion to emulsion."

Because it is sensitive to light, photographic paper must be handled in darkness. However, unlike with film, *total* darkness is not required. Darkroom SAFELIGHTS that have low-wattage bulbs and

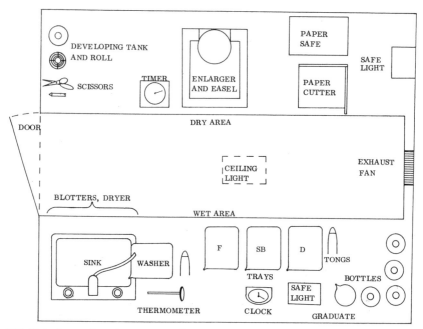

293. This floor plan shows a comfortable darkroom that is designed to prevent chemicals from accidentally harming films, negatives, or photo papers. One side is devoted to "dry" activities, like loading film into a developing tank and exposing photo paper with the enlarger, while the opposite side is for "wet" procedures, such as mixing chemicals and processing films and prints.

proper filters can be used to provide illumination. A safelight with a light amber (Kodak OC) filter or cover will not affect most black-and-white photo papers, provided that the paper is kept at least 4 feet (1.2 meters) from the light. Bulb wattage varies from 7½ to 15 watts depending on the size of the safelight; do not exceed the manufacturer's recommended wattage, or your paper may be fogged by the safelight.

After the contact print has been exposed, processing begins. As with films, there are important considerations, including temperature, time, and chemical contamination. The DEVELOPER TEMPERATURE should be about 68° F (20° C), the same as for films. You may have to cool or warm the paper developer to this recommended temperature; follow the suggestions described for film developers on page 448.

The paper manufacturer recommends a DEVELOPMENT TIME, which is the specific amount of time the photo paper should be kept in the developer to produce an image of optimum quality. This might be 1, 1½, or 2 minutes, depending on the type of paper and the type of developer you use. In addition, there is a DEVELOPMENT TIME RANGE, such as 45 seconds to 3 minutes, that indicates the minimum and the maximum time the print can be in the developer and still pro-

294. A photo paper's recommended development time indicates how long a print should remain in the developer in order to reach its optimum image quality (see text). Blacks, whites, and a full range of gray tones should be evident, as in this wide-angle view of a busy intersection in Tokyo, Japan.

duce an acceptable print. Put a timer or a clock near the developer tray so that you can keep track of the development time.

An image that develops too rapidly prior to reaching the *minimum* development time indicates that the paper has received too much exposure; make another print with less exposure time. (If the image appears too quickly and you pull the paper from the developer before the minimum development time, the print will lack contrast or be spotted because of inadequate development.) On the other hand, if a print fails to develop adequately by the *maximum* development time, it has been given too little exposure; make another print with more exposure time. (When photo paper is underexposed, there is little hope of getting a good print by keeping it in the developer longer than the maximum development time.)

Even when the image appears within the minimum/maximum development time, it takes experience to determine under the safelights exactly when a developing print looks its best and should be pulled from the developer and put in the stop bath; prints that look okay under safelights are often too light. You can turn on the room lights to check the appearance of the photo images after the prints have been in the fixer at least 30 seconds or 1 minute, depending on the type of paper.

Prints should be transferred from one chemical solution to another with PRINT TONGS. Tongs allow you to keep your hands dry and help prevent contamination of chemicals. Each tray should have a pair of tongs, and they should not be intermixed. To transfer prints, grab the corner of the print with the tongs and lift it from the tray until excess chemicals drain off. Then ease the print into the next chemical tray and use that tray's tongs to submerge and agitate the print. As with film, prints must be agitated sufficiently so that fresh chemicals come in contact with the paper's emulsion. Otherwise, uneven development and fixing will occur, resulting in spots, poor contrast, and possible discoloration sooner or later.

After development, move the print to the stop bath for about 15 seconds (check the paper or stop bath manufacturer's recommendation for the exact time), then place it in the fixer. RC (resin-coated) papers should remain in the fixer only $1/2$ to 2 minutes, depending on the type of paper and fixer. (Do not use a fixer with a hardener for RC papers, or else wash times must be increased.) Fiber-base papers require 5 to 10 minutes in the fixer, depending on the type of fixer. Beware that prints which have been over- or under-fixed may discolor with age. Also, prints that have not been uniformly bathed in the fixer may eventually stain, streak, or fade.

The next step is washing the prints in running water. The time in the water depends on the type of photo paper. Wash time for RC (resin-coated) papers is only 2 to 4 minutes. (Never keep RC prints in wash water longer than 15 minutes because water can penetrate the edges of the paper and cause it to curl.) RC papers should not be bathed in a HYPO CLEARING AGENT, which is only for reducing the wash time for fiber-base photo papers as well as films.

Wash time is considerably longer for fiber-base papers: 1 hour for single-weight papers and 2 hours for double-weight papers. You'll save time and water by first bathing those fiber-base prints for 2 or 3 minutes in a hypo clearing agent, which reduces the wash time to just 10 minutes for single-weight papers and 20 minutes for double-weight papers.

## Selecting Enlarging Papers

Once you print a contact proof sheet and study it with a magnifier to choose specific negatives for enlargement, you must select a photographic paper for making those enlargements. There are dozens of black-and-white enlarging papers on the market. Most popular are those of major manufacturers such as Kodak, Ilford, and Agfa, but there are some lesser-known brands like Luminos, Forte, and Cachet that also produce excellent results. Choosing the papers you like best is mostly a matter of experimentation. Here are some things to keep in mind when selecting photo papers.

In addition to name brands, photo papers vary in contrast, surface textures and sheen, image tones, tints, weights, and speeds (i.e., sensitivity to light). A major consideration is CONTRAST. Enlarging papers are available in a variety of contrasts because black-and-white negatives have a variety of contrasts. This enables you to make an enlargement of good contrast from a negative of almost any contrast; it doesn't matter whether the negative has good contrast or poor contrast. What's more, even when the negative has good contrast, you can purposely make an enlargement that has higher or lower contrast than the negative, if desired. In other words, the choice of contrast in photo papers lets you produce an enlargement with most any contrast you wish.

This contrast control is offered in different ways by two types of black-and-white enlarging papers: graded contrast papers and variable contrast papers.

GRADED CONTRAST PHOTO PAPERS are manufactured in *specific* grades of contrast. Numbers from 0 to 5 are most often used to indi-

Contrast in a print can be altered by using five different graded contrast photo papers, or by varying the filtration of the light from an enlarger in twelve steps when exposing variable contrast photo paper (see text). These three pictures show a sample of the possible results.

295. No. 0—very low contrast.

cate the type of negative contrast for which each grade of paper was designed. (Some manufacturers use letter designations instead.) A grade 0 paper, for example, is for negatives of very high (hard) contrast, while a grade 5 paper works best with negatives of very low (soft) contrast. Grades 2 and 3 are for negatives of good (average) contrast. Take note that not all graded contrast papers are made in all six grades of contrast.

VARIABLE CONTRAST PHOTO PAPERS, which are also known as MULTI-GRADE, MULTICONTRAST, and SELECTIVE CONTRAST PHOTO PAPERS, yield different contrast grades on a *single* paper. This is achieved with special PRINTING FILTERS that alter the light from the enlarger that is projected through the negative onto the enlarging paper. Depending on the print contrast desired, you select an appropriate filter to place in the FILTER DRAWER of an enlarger or in a FILTER HOLDER beneath the enlarger lens. The selection of filters offers a choice of 12 grades of contrast.

In general, those printing filters with whole numbers correspond to graded contrast papers: 0, 1, 2, 3, 4, and 5. But in between are filters of half grades that offer more subtle adjustments to contrast than is possible with graded papers: $1/2$, $1 1/2$, $2 1/2$, $3 1/2$, and $4 1/2$. Negatives of good contrast should be exposed through a 2, $2 1/2$, or 3 filter to produce good-contrast prints, while high-contrast nega-

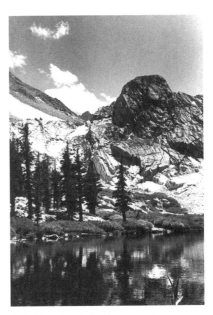

296. No. 2—normal contrast.     297. No. 5—highest contrast.

tives require a 1½ or lower-numbered filter, and low-contrast negatives require a 3½ or higher-numbered filter.

Printing filters are sold in sets. Depending on their manufacturer, the filters at either end of the contrast range may have different designations. For example, the filter to use with the highest-contrast negatives to produce the lowest contrast in a print is designated −1 in Kodak's filter set, and 00 in Ilford's filter set.

Because you need buy only one paper type instead of several graded contrast papers, using variable contrast paper is a good way to save money and storage space in your darkroom. Of course, you must invest in a set of printing filters in order to use variable contrast paper. (If no filter is used, variable contrast paper will only print as a grade 2 paper.)

There is an option for controlling the contrast of variable contrast papers without individual printing filters. That's by using an enlarger fitted with a COLOR HEAD. This is a lamphouse featuring a built-in dichroic filtration system that normally controls color balance when making color prints (see page 461). Instructions with most black-and-white variable contrast enlarging papers will suggest the color head's yellow or magenta filtration settings to use that correspond to specific grades of contrast. Note: If you use an enlarger with a color head to expose *graded contrast* black-and-white papers, it must be at its *white light* setting (no filtration).

When selecting an enlarging paper, you have a number of other decisions to make. For one thing, the emulsion of photo papers comes in different IMAGE TONES. Depending on the tone of the paper you choose, the black shades of your print will be warm (brown-black), neutral (black), or cold (blue-black). Also, the TINT of most photo papers is white, but for some subjects or special effects, you may want to choose one with a cream or a colored paper stock.

In addition, you can pick from a range of paper SURFACES. A paper's TEXTURE is variously described by manufacturers as smooth, fine-grained, suede, pearl, or velvet stipple, while the paper's finish or SHEEN is generally identified as glossy, lustre, or matte.

WEIGHT of the paper is another consideration. For example, the selection of Kodak papers includes lightweight (LW), single-weight (SW), medium-weight (MW), double-weight (DW), and an extra heavy paper called premium-weight (PW). For durability, double-weight and other heavyweight papers are especially recommended when making enlargements 11 × 14 inches (27.9 × 35.5cm) and larger.

At some camera stores you'll find PHOTO PAPER SAMPLE BOOKS from Kodak and other paper manufacturers with actual photo papers to show you the differences in weights, surfaces, tints, and image tones. These books list the contrast grades available, too, unless the paper is a variable contrast or multigrade type. As with contrast grades, be aware that not all black-and-white photo papers are available in every weight, surface, tint, or image tone just described.

When choosing an enlarging paper, some photographers also consider its PAPER SPEED, which indicates the paper's relative sensitivity to light. While paper speeds do not directly relate to film speeds, the concept is similar. As such, the speed of a paper is rated according to an ISO number; the higher the number, the more sensitive the paper's emulsion. Knowing the paper speed helps you determine the approximate exposure time when changing papers or filters to a different grade of contrast.

For example, a paper with a speed of ISO 500 is twice as fast (i.e., sensitive) as a paper of ISO 250 speed, which means the higher-speed paper would require about half the exposure time.

Photographers who want more time for manipulation of the projected image during exposure (see later in this chapter) prefer papers with slower speeds. Those who like to keep exposure times short for high-volume printing prefer papers with faster speeds. As you'll note when reading a paper's data sheet, the paper speed may change according to the paper's contrast grade or the filter used to change the contrast grade. Like film speeds, paper speeds are desig-

nated by the International Standards Organization (ISO); they replace the paper speed ratings established earlier by the American National Standards Institute (ANSI).

Your preference for an enlarging paper may even depend on the paper's base, which determines its processing characteristics. FIBER-BASE PAPERS absorb chemicals and water, while RESIN-COATED (RC) PAPERS have a liquid-resistant base. Because they are much less absorbent, resin-coated papers can be processed, washed, and dried in much less time than fiber-base papers. Because the washing time for RC prints is only a few minutes, you'll also conserve water.

When purchasing photo papers, you'll find they are available in a wide choice of standard sizes and quantities. The more popular sizes for home darkrooms are $5 \times 7$, $8 \times 10$, $11 \times 14$, and $16 \times 20$ inches ($12.7 \times 17.7$, $20.3 \times 25.4$, $27.9 \times 35.5$, and $40.6 \times 50.8$cm). A paper cutter can be used in the darkroom to cut papers into smaller sizes. Paper quantities vary from 25, 100, and even 250 sheets per package for the two smaller-size papers, and 10- or 50-sheet packages for the larger sizes.

## Choosing an Enlarger

The darkroom equipment and chemicals for making enlargements are the same as those used for printing contact proof sheets: developer, stop, and fixer chemicals, processing trays, print tongs, safelight with light amber (Kodak OC) filter, print washer or tray siphon, and drying rack or screens for RC papers or electric dryer or photographic blotters for fiber-base papers. But other equipment is needed, too.

The main item, and expense, will be an ENLARGER. Since it is often a lifetime purchase, you should check the various models and their features carefully. To start, be aware that there are two general SIZES of enlargers: smaller ones that handle 35mm and/or medium-format 120-size roll films, and bigger models for $4 \times 5$-inch ($10.1 \times 12.7$cm) and/or other large-format sheet films.

Our advice when buying an enlarger is to think ahead. If you only shoot 35mm film now but plan to use a medium-format or large-format camera in the future, consider an enlarger that will accommodate those bigger negative sizes as well. A few of the better-known brands of enlargers are Omega, Beseler, and Durst.

Many modern enlargers are modular in design so they can be fitted with different components. In particular, the enlarger lens and

the lamphouse must be changed to match the size and type of film you are enlarging, or the type of photo paper you are using.

It's important to use an ENLARGER LENS that is the appropriate focal length for the size of your negatives. As a guideline, it should be comparable to the lens that's considered to be of normal focal length for the film size of your camera. That means 35mm negatives will require a 50mm enlarger lens, while 6 × 6cm (2$\frac{1}{4}$ × 2$\frac{1}{4}$-inch) or 6 × 7 (2$\frac{1}{4}$ × 2$\frac{3}{4}$-inch) negatives should be exposed through a 75mm or 80mm lens.

Most enlargers are not originally equipped with a lens, so you must choose your own. While some may be available from the enlarger's manufacturer at a nominal price, the better-quality lenses are well-known brands and considerably more expensive. Among these are Schneider Componon, El Nikkor, and Rodenstock Rodagon. Although enlarger lenses have screw mounts of common sizes, a lens mount board may be required for your particular enlarger model.

The size of enlargements you want helps determine the quality of lens to purchase; enlargements greater than ten times the negative size (10X magnification) require a top-rated lens to get the best results possible. Enlargement of a 35mm negative to 8 × 10-inch (20.3 × 25.4cm) size is about 8X magnification.

By the way, an enlarger lens with a wide maximum aperture is helpful when focusing the negative's image, but the lens should always be stopped down to a smaller opening for the sharpest image. For your reference, the maximum-minimum aperture range of 50mm lenses designed for 35mm negatives is often f/2.8 to f/16. Apertures decrease as the focal length of an enlarger lens increases; with 75mm or 80mm lenses the aperture range is apt to be f/4 or f/4.5 to f/22 or f/32.

The other major component of an enlarger is its LAMPHOUSE, most often called the ENLARGER HEAD. The head contains a light source and a system of condensers, diffusers, and/or mirrors that project the light uniformly to the negative below. Some also have a filter system to change the color characteristics of that light. As such, a head may be designed for color printing, and/or black-and-white printing with variable contrast photo papers, or only for graded black-and-white papers. The head you use also depends on the size of the film you are enlarging; its projected light must fully cover the negative or exposure will be uneven.

Although a few enlargers have a fixed lamphouse for a specific type of printing, the most versatile ones are of modular design with

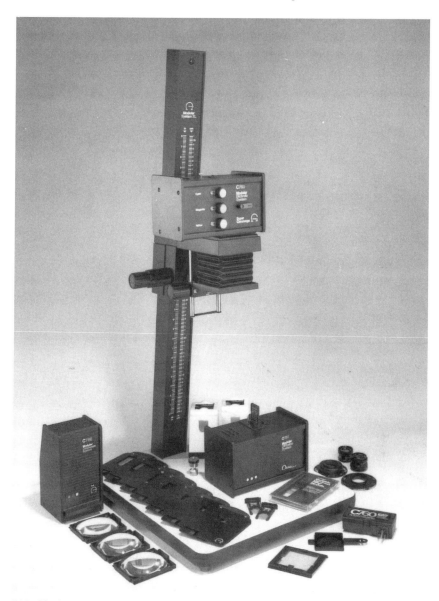

298. Modern enlargers, such as this Omega model, are of modular design and can be fitted with various "heads" that have different illumination systems for making black-and-white prints or color prints (see text).

enlarger heads that can easily be interchanged with a head of a different type.

An enlarger with a COLOR HEAD is especially useful. As its name suggests, the head is primarily designed for making color enlarge-

299. The color balance in color prints is controlled by filtering the enlarger light. With this modular enlarger equipped with a color head featuring built-in dichroic filters, dials are adjusted for various amounts of cyan, magenta, and yellow filtration. They can also be adjusted to control contrast when printing black-and-white variable contrast photo papers. The flexible bellows in this enlarger allows the negative carrier and lens board to be tilted to correct (or create) distortion in the image.

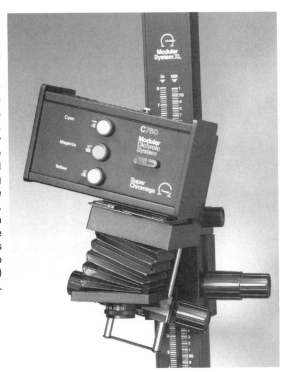

ments. It features built-in dichroic filters to regulate color balance when exposing color photo papers, but those filters can also be adjusted to control grades of contrast when exposing variable contrast black-and-white photo papers. Color heads are a *diffusion* type that scatters rays from the light source, which is helpful in obscuring any tiny imperfections in the negative.

Other types of enlarger heads do not have built-in dichroic filters. They are either a condenser or a cold-light type, and are often preferred for black-and-white printing. A CONDENSER HEAD features condenser lenses that concentrate its light source to produce prints characterized by optimum definition (fine detail) and high contrast. Unfortunately, any dust spots or slight processing flaws in the negative show up in detail, too, and must be retouched on the enlargement.

Any small blemishes in negatives are minimized by a diffusion-type COLD-LIGHT HEAD, which features a grid-shaped, gas-filled light tube. Because of the color characteristics of this fluorescent-like lamp, it can only be used for exposing black-and-white photo papers, not color papers. In addition, many only work with graded contrast papers. A few of these heads can be adjusted for exposing variable

contrast as well as graded contrast papers, but usually a different cold-light head is required for each of the two types of paper.

By the way, cold-lamp heads are named in part for their low-temperature characteristics. (Their blue-green light is also considered "cold.") Unlike heads with tungsten light sources that get very hot, particularly halogen bulbs, a fan is not required to keep the enlarger head cool. The darkroom stays cooler, too.

While cold-light lamps last for up to 10,000 hours, the more common tungsten enlarger bulbs have a much shorter life. Be warned that enlargers using incandescent-type bulbs, including halogen lamps, require special enlarger lamps; do not replace them with regular household bulbs, which may cause shadows and uneven illumination. Use only the lamp type and wattage specified for your particular enlarger.

In addition to the enlarger head and lens, a NEGATIVE CARRIER is needed and must also match the size of the film you are enlarging. The carrier holds the negative in position while light from the lamphouse is projected through it to the photo paper. The carrier also acts as a mask to keep stray light from reaching the paper.

There are two choices of negative carriers: the glassless (or dustless) type that is most popular for 35mm and 120-size films, and the glass type. GLASS NEGATIVE CARRIERS hold the negative flat between two pieces of glass and therefore maintain focus of the image. But the four extra surfaces of glass can also attract more dust and fingerprints that may degrade the projected image, and thus the print, unless you keep all of those surfaces spotlessly clean. With GLASSLESS NEGATIVE CARRIERS, you only have to be certain the negatives are clean. However, with poorly designed enlargers using glassless carriers, heat from the enlarging bulb may warp your negative slightly and throw it out of focus, especially during long exposures. Some models of enlargers accept both glass and glassless carriers.

FOCUSING is another consideration. There are both manual and autofocusing enlargers. With manual focus, you adjust the height of the enlarger head until the projected image is the enlargement size desired, and then you must sharpen the focus by adjusting the bellows. Autofocus models are designed to keep the projected image sharp whenever the position of the enlarger head is changed, although most autofocus types require fine-focus adjustments anyway.

When buying an enlarger, be sure to test how easy or difficult it is to move and lock the enlarger head each time you adjust the size of the projected image. Some enlargers require two hands—one to adjust the height and one to tighten the lock. Others use a one-

handed crank with rack-and-pinion gears, and some models feature a one-handed clamp release with a balance weight or spring to afford easy adjustments. Also check the sturdiness of the support column; any vibration of the enlarger head during the exposure will cause a blurred image on the photo paper.

The enlarger's BASEBOARD should be noted, too. It must hold the enlarger steady and be big enough to accommodate the largest size of prints you make most often. For extra-big enlargements, some base-boards can be turned around so the enlarger can be moved to the edge of the worktable and the image projected onto the floor. Other models allow the enlarger head to be turned to a 90° angle so larger images can be projected on the wall.

As previously mentioned, to control color balance in color prints or contrast in variable contrast black-and-white photo papers, many enlargers feature a color head with built-in filters. If an enlarger doesn't have a color head, it should have a FILTER DRAWER to hold the filters necessary for exposing color of variable contrast papers. This drawer is located in the enlarger head below the light source but above the negative carrier. If there is no filter drawer, filters can be placed in a FILTER HOLDER below the enlarger lens. However, some loss of sharpness or contrast in the print is possible because the actual projected image passes through those external filters, which could be dusty, scratched, or optically poor.

Besides an enlarger, a few more items are helpful in, if not essen-tial to, the enlarging process. One is an electrical ENLARGER TIMER, which controls exposure time and usually is an accessory unit con-nected to the enlarger's light cord. Depending on the timer's design, the exposure time is indicated with LEDs (light-emitting diodes) in digital readouts or with sweep hands on a luminescent clock face. Digital timers usually operate up to 99 seconds, analog timers up to 60 seconds.

Some timers must be reset manually for each exposure, while others return automatically to the preset exposure time. A few have an optional feature that marks each second with an audible beep. Some timers can be started by means of an accessory foot switch, leaving the photographer's hands free. A good timer is worth the investment; most versatile are solid-state models that can be pro-grammed to time the processing steps as well.

An ENLARGING MAGNIFIER, also called an ENLARGING FOCUSER, is very worthwhile because it enables you to focus the projected image quickly and accurately. After the magnifier is placed where the photo paper will be, a mirror in its base reflects a small area of the pro-

300. In addition to holding photo paper flat so that the image projected by the enlarger remains focused during exposure, many enlarging easels can be adjusted to crop the image to any shape and size.

jected image to the magnifier's eyepiece; you simply adjust the enlarger's focusing controls until the magnified image appears sharply focused in the eyepiece.

An ENLARGING EASEL should be purchased because it holds the photo paper flat so the focused negative remains sharp in the print. Also, an easel creates white borders around the edge of prints. Some easels are adjustable for any print size desired, while others are fixed to make borders for common-size prints, such as 8 × 10 inches (20.3 × 25.4cm). An adjustable easel for prints up to 11 × 14 inches (27.9 × 35.5cm) is suggested. The border width can be adjusted, as well as the other dimensions, to allow complete control in cropping the projected image to the exact size of print desired. Borderless easels are also available.

A timesaving darkroom accessory is an easy-to-access PAPER SAFE, or a homemade lightproof drawer, to hold the light-sensitive photo paper. Otherwise, you have to keep returning exposed or unexposed paper to its lightproof double envelope or box whenever you want to turn on the room lights.

Also be sure to have an ANTISTATIC BRUSH OR CLOTH for dusting negatives just prior to putting them in the enlarger.

## Making Enlargements

Making black-and-white enlargements is not difficult, although you become a better darkroom technician only with experience.

The first step is to arrange your equipment and materials for the most convenient use (see Illustration 293). It's best to have a "dry" and a "wet" area in your darkroom so that the enlarger, negatives, and photo paper are less apt to be splashed by chemicals or wash water. Learn to keep your hands dry, too. Cloth towels should be washed after use to prevent contamination by chemicals that have dried on the towels; avoid paper towels because their lint can cause dust marks on your enlargements.

To begin the enlarging procedure, select the negatives you want to enlarge by studying the contact proof sheets. Check these prints with a magnifier for composition and subject content or expression. Note the negative numbers opposite the film frames you select. Some photographers cut or punch a tiny notch in the film edge as a way to mark the frames to be enlarged and locate them in the darkened room. Do not cut the strip of negatives into individual frames you intend to print, because they're harder to handle and easier to get damaged or misplaced.

Clean the negative, and the negative carrier if necessary. Then put the negative in the carrier with its emulsion (dull) side facing down. Because the enlarger lens reverses the direction of your subjects, position the negative with its top edge at the bottom so you'll be viewing the projected image right side up. Room lights must be turned off for focusing (and kept off when any photo paper is removed from its lighttight package or box or the paper safe). Allow a few minutes for your eyes to adjust to the amber safelights.

Place the negative carrier in the enlarger and turn on the enlarger light for focusing. Open the lens to its widest f/stop so the projected image can be seen as brightly as possible. The image will appear even brighter if you also turn out any safelights near the enlarger; some enlarging timers will do this automatically when the enlarger light is turned on to focus or to make an exposure. Adjust the height of the enlarger head to the image size desired, and turn the focus control until the image appears sharp. Use an enlarging magnifier for quick and easy focusing.

Make sure the enlarging easel is positioned correctly for the print size and borders desired. Then stop the lens down to f/8 or f/11. This increases depth of field to help correct any minor enlarger

301. To determine the correct exposure time for making an enlargement, a test print can be exposed in several sections for different amounts of time. After the print is developed, you can compare the sections to see which exposure time produced the image you like best.

focusing errors. Of course, if the image on the negative itself is out of focus, reducing the enlarging lens f/stop will not make the picture any sharper.

Turn off the enlarger and insert a piece of photo paper in the easel, emulsion (shiny) side up. Make sure the remaining paper is in its lighttight package or paper safe so light from the enlarger doesn't accidentally expose it. To avoid guessing at exposure and wasting several pieces of photo paper until you hit the correct exposure time, a TEST PRINT is made first. This involves exposing sections or strips on one sheet of paper for different lengths of time.

With an 8 × 10-inch (20.3 × 25.4cm) sheet, start by exposing a 1-inch (2.5cm)-wide strip for 5 or 10 seconds; keep the rest of the paper covered with a piece of cardboard. Move the cardboard to uncover another inch of paper and make another 5- or 10-second exposure. Continue this procedure until the entire piece of paper has been uncovered and exposed. Remember the exposure times you gave each strip.

Now slip the test print into the developer and agitate it with the print tongs. Develop for the full time recommended by the paper manufacturer, or until dark areas are very black. Use tongs to transfer the print to the stop bath for 15 seconds, then move it to the

fixer. After ½ to 1 minute in the fixer, turn on the room lights and check the test print. (Make sure your photo paper is in its package or paper safe before switching on the lights.)

Look first to see if the paper's contrast grade or the contrast filter you used was correct for the contrast of your negative. (For most negatives of good contrast, a grade 2 or 3 paper or a 2, 2½, or 3 filter is best.) If the test print seems gray all over and lacks contrast, try a higher-contrast grade paper or higher-numbered filter. If the test print is too contrasty and has no detail in the dark and light areas, switch to a lower-contrast grade paper or lower-numbered filter.

After choosing the strip on the test print you think looks best in terms of contrast, recall the exposure time for that strip. Then set the enlarger timer to that time in order to expose your final print; leave the f/stop the same as for the test print. Turn out the room lights, put a sheet of photo paper emulsion side up in the easel, make the exposure, and process the print in the usual manner. Fix it for the time recommended by the fixer manufacturer, usually ½ to 2 minutes for RC (resin-coated) papers. Remember to agitate. Wash RC papers for only 2 to 4 minutes and do not use a hypo clearing agent. For fiber-base papers, fix 5 to 10 minutes, as the fixer maker recommends. Use a hypo clearing agent to reduced wash times for fiber-base papers: 10 minutes instead of 1 hour for single-weight papers, and 20 minutes instead of 2 hours for double-weight papers.

All RC papers air-dry in 10 to 15 minutes; a hand-held hair dryer will dry them even quicker. To dry fiber-base papers, use an electric print dryer or photographic blotters. Fiber-base papers with a glossy surface must be squeegeed to a ferrotype tin to obtain a high gloss; RC glossy papers are self-glossing.

With experience you'll learn the approximate EXPOSURE COMBINA-TIONS of lens openings and exposure times that work best with the kinds of negatives you most often enlarge. Then, instead of exposing a full sheet of paper to make a test, you only need to cut a strip of paper and expose it according to your experienced estimate. This saves time and paper. Also, by keeping the f/stop of your enlarger lens constant for most of your printing, such as f/8, you only have to figure the exposure time.

You should know that changing the lens opening of an enlarger lens affects exposure in the same way it does when you change the f/stop on a camera lens. For instance, say a negative yields a print of good contrast when exposed for 10 seconds with the enlarger lens at f/8. If you reduce the lens opening to f/11, the amount of light

reaching the paper is cut in half, which means exposure time must be doubled to 20 seconds to produce an equal exposure and a print of identical contrast.

In practice, however, you'll discover that the exposure increase required is slightly more than twice the original exposure time; in the example just given, the revised exposure time at f/11 should be 21 seconds instead of 20 seconds. That's because equal exposures do not produce equal images in terms of contrast and density if the exposure time is abnormally long (or short). This is called the RECI-PROCITY EFFECT and applies to photo papers and films (see page 211).

When changing the f/stop of an enlarger lens, instead of making another test print to determine the revised exposure time, you can refer to an EXPOSURE COMPENSATION CHART. One of the best is the adjustable enlarging dial found in the *Kodak Black-and-White Darkroom Dataguide*, available at camera stores. It also helps you determine revised exposure times when changing graded contrast papers or filters for variable contrast papers, or when changing the size of the projected image. For example, to make the image larger, the enlarger head must be raised, and the greater the distance the enlarger's light source is from the paper, the longer the exposure required.

As a practical guideline when increasing the size of the projected image, every time you double the distance between the lens and photo paper, the exposure is increased four times. For instance, say the enlarging lens is 8 inches (20.3cm) from the paper and produces a good print at f/8 with 10 seconds exposure. If the enlarger head is raised so the lens is now 16 inches (40.6cm) from the paper (twice the original distance), exposure time will be about 40 seconds (at f/8) to get a good print. Refer to the enlarging dial in the Kodak *Dataguide* to quickly figure revised exposure time for any change you make in the image size.

The easiest way to determine exposure time is with the use of an ENLARGING METER, which is worth the investment if you make a considerable number of enlargements. It enables you to skip making test prints or strips, a savings of time and paper. This special exposure meter is positioned on the enlarger baseboard to read the density of the projected image, black-and-white or color. Once the ISO speed of the photo paper you are exposing is set on the meter, overall or spot readings are made of the highlight and/or shadow areas to calibrate the correct exposure time. Some meters will also indicate the contrast grade of black-and-white paper to use.

Of course, not all enlargements turn out as you wish. For

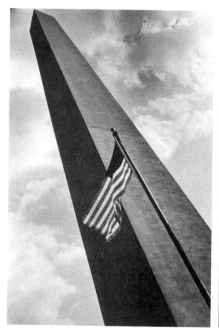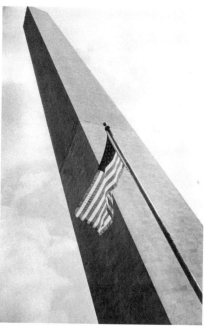

302. Photographs can be altered significantly with darkroom techniques called dodging and burning-in, which reduce or increase exposure to portions of the image, as shown with these comparison pictures of the Washington Monument.

303. In this example of dodging, a piece of cardboard was held in the path of the projected image of the darkest clouds to keep them from being exposed on the photo paper; also, the overall exposure was slightly reduced.

instance, the sky may be too light, or a face in a group picture may be too dark. These and other faults can be corrected with EXPOSURE MANIPULATION. The two techniques used most frequently to improve enlargements are burning-in, which darkens an area of a print, and dodging, which lightens an area of a print. The skill a photographer develops in using these two methods of exposure manipulation in many ways determines his worth as a darkroom technician.

BURNING-IN adds more exposure to an area of the print that would otherwise be underexposed and appear too light. Additional exposure time is given to the selected area after the regular exposure is made. Usually a hole is cut in a piece of cardboard, and the cardboard is held between the lens and photo paper. This holds back the projected image except where it passes through the hole to continue exposing the paper. The cardboard must be kept moving in a slight circle all during the exposure so the burned-in area blends with the rest of the print. Instead of the cardboard device, you can use your

hands to form the size and shape of the hole desired, or purchase an adjustable burning-in mask. Making an exposure test strip of the area to be burned-in will help determine the extra exposure time required.

DODGING is just the opposite of burning-in. During the regular exposure, part of the projected image is held back by a dodger, which is most often a homemade disk of cardboard taped to the end of a thin but sturdy wire. By holding the dodger between the enlarging lens and photo paper, you prevent the selected area from receiving too much exposure and becoming too dark. As with the burning-in device, the dodger must be kept moving in a slight circle during the exposure in order to avoid causing an outline of the disk or wire in the print. A test strip made of the area to be dodged will help determine the exact exposure time required. Incidentally, one of the reasons to stop down the enlarging lens to f/8 or f/11—besides helping to keep the negative in focus—is to allow sufficient exposure time for dodging and burning-in.

Once you have mastered basic processing and enlarging techniques, there are many other ways to use the darkroom to produce photographs with wide-ranging effects. For example, you can bathe finished prints in TONERS to give color and mood to the photographs. To create prints with MULTIPLE IMAGES, you can sandwich negatives together in the enlarger's negative carrier, or expose different negatives on the same piece of photo paper. By positioning a DIFFUSION FILTER between the negative and photo paper, you can soften the image in a print. Another technique is to place a TEXTURE SCREEN on the photo paper to add patterns; even ladies' nylon hose stretched across the enlarging easel will give texture to a photograph. Or try a technique known as the SABATTIER EFFECT (and mistakenly called solarization), which partially reverses the tones of a black-and-white image. You do this by reexposing the photo paper briefly with a dim light while the print is in the developer. A picture can even be made *without* using negatives or slide images. To create what is called a PHOTOGRAM, you arrange objects on top of the photo paper, expose the paper to a light source, and develop it until an image of various shapes, patterns, and densities appears. Certainly any photographer with imagination can be creative not only with a camera but with darkroom techniques as well.

The preliminary steps to doing your own processing and printing involve understanding the procedures, purchasing the necessary equipment, and SETTING UP A DARKROOM. While a permanent darkroom is more convenient, photographers with limited space find that

304. To soften the features of the girl in this informal flash portrait, a diffusion filter was held beneath the enlarger lens between the negative and the photo paper.

a temporary darkroom in a kitchen or bathroom works as well. The room must be without light leaks, of course, and it is desirable to have running water available, as well as adequate ventilation. Establish separate wet and dry areas when possible so chemicals and water do not splash on your equipment or materials. A floor plan for a convenient darkroom is shown on page 452. Whether your darkroom is elaborate or not, you'll find processing and enlarging your own pictures is often the best way to get the quality of black-and-white or color photographs you desire.

## Analyzing Any Faults in Your Photographs

After you've processed your own negatives (or slides) and prints, it's a good time to analyze your photographs to see if they could be any better than they are. Of course, even if you have a commercial photofinisher develop and print your films, you should also make the same critical evaluation.

In addition to composition, carefully consider TECHNICAL QUALITY. The first thing is to check whether the negatives, slides, or prints are of GOOD CONTRAST, neither too light nor too dark.

Negatives that are too dark have been OVEREXPOSED; too much light has reached the film to record the image with normal contrast. However, corrective printing in the darkroom often allows prints of good contrast to be made from overexposed negatives, whether black-and-white or color. Because they are positive images, over-exposed color transparencies (slides) have the opposite appearance of overexposed negatives: they are too light and their colors appear

washed-out. Unfortunately, little can be done to improve improperly exposed transparencies—except to avoid the problem in the future.

Why are your films overexposed? With auto-exposure cameras, usually it's the fault of the camera's metering system. Or you could be at fault. For instance, if you accidentally blocked the exposure meter windows on a 35mm automatic compact camera, it could set the exposure for darker lighting conditions than actually existed and let too much light reach the film. With SLR cameras, the film speed (ISO) setting might have been moved off the DX setting, which automatically sets the metering system for the speed of the film in your camera. Or overexposures occurred because you manually set the film speed control to the wrong ISO for your film. In many cases, your camera (or hand-held exposure meter) was aimed incorrectly when the exposure reading was made. When flash pictures are overexposed, often the flash was too close to your subject.

Negatives that appear too light or "thin" have been UNDEREXPOSED; not enough light has reached the film to record the image with normal contrast. Fortunately, corrections can frequently be made in the darkroom during printing to produce an acceptable print of good contrast. On the other hand, underexposed color transparencies (slides) have the opposite appearance of underexposed negatives: they are too dark or their colors appear too contrasty—and cannot be improved. Underexposures often occur for two of the same reasons as those for overexposures: an incorrect meter reading, or a missetting of the camera's film speed control. With flash pictures that are underexposed, often the subject was too far away for the flash light to reach it.

Sometimes your negatives will be completely clear or your slides completely black. This occurs when the film was UNEXPOSED; no light reached the emulsion to record an image. A frequent cause is improper loading of the camera, with the result that the film does not advance and no exposures are made. Other times a roll of *unexposed* film is accidentally processed. To avoid this with 35mm film, be certain the film is completely rewound into the cassette after the final exposure so that it cannot be confused with fresh film, which has its leader showing. Unexposed film also results if the shutter does not open, the lens cap is left on, or the flash does not go off. If a flash fails to fire, check if its batteries are dead or the contacts dirty. With 35mm SLR cameras, flash synchronization is the problem if only a portion of the film frame is unexposed (see page 150).

## Other Errors

While technical problems are frequently blamed for over-exposures, underexposures, or no exposures, photographers themselves are usually at fault. Fortunately, the all-too-common mistakes of photographers are easily corrected once they recognize the problem. For instance, FUZZY PICTURES most often are the result of camera movement. You either failed to hold the camera steady or else jabbed the shutter release button instead of squeezing it. Or the pictures are fuzzy because you were too close to your subject; the camera must remain at a *minimum* distance from the subject in order for the image to be in focus. (Check the instructions for your particular camera or lens.) Sometimes pictures are less sharp than expected because you simply focused incorrectly or failed to consider depth of field.

Fuzzy pictures also result when the shutter speed is too slow for the speed of the action being photographed. Use a faster shutter speed or pan with a quickly moving subject. A dirty lens or filter could cause an unsharp picture, too. Keep them free of fingerprints, which will diffuse the image reaching the film.

Sometimes BLACK SPOTS or objects appear in your pictures. Often this is caused by dirt in the camera, including small pieces of film or lint. Dust the inside of your camera carefully. Other causes of black objects include obstructions in front of the lens—a finger, part of the camera case, or your camera strap. This especially happens with compact cameras, where the photographer sees through a viewfinder while the film records the subject through another lens. Black spots on prints can be the fault of the photofinisher who carelessly developed your film. Check the negative for clear spots; these will appear black in the print. (The only remedy is to retouch the negative or the print to cover up the spots.)

LIGHT SPOTS or streaks may show up in your prints. Occasionally this occurs when rays of the sun fall directly on the lens; keep the lens shaded. Another reason for light streaks is that your film may be "fogged." This occurs when light accidentally reaches the film, as when the camera back comes open unexpectedly. Film should not be loaded or unloaded in direct sunlight or very bright daylight. When changing rolls, shade the film and camera with your body. Sometimes an ill-fitting lens or faulty camera back will cause light leaks within the camera and fog the film. If the overall image appears as if it were taken on a foggy day, there was condensation on the camera lens or film when the exposure was made. This can occur when a

305. Nothing in a picture should draw attention away from your subject. After making an enlargement, closely inspect the print to make certain there are no technical faults or other errors that might be distracting (see text).

camera is taken from a cold environment to a hot one, such as from an air-conditioned hotel to a tropical beach, or vice versa.

If OVERLAPPING IMAGES appear on your film, the film may not have been fully advanced to the next frame before another exposure was made. The film-advancing mechanism of your camera could be faulty. However, overlapping frames occur more often when photographers attempt to take extra pictures on a 35mm roll of film before rewinding it for processing. Although you might be able to crowd one or two additional pictures on the usual 24- or 36-exposure roll, don't expect them all to turn out. Besides the possibility of overlapping, the photofinisher attaches other rolls of film or identification tabs to the ends of your film and often ruins those "extra" frames.

Color films have special considerations. If your pictures have an overall greenish or reddish cast, you may have been shooting with OUTDATED FILM. Before buying film, always check the expiration date printed on the film box or package. Another possibility is that the film was stored under hot or humid conditions. Always keep film where it is cool and dry.

IMPROPER COLOR BALANCE causes pictures to appear bluish or reddish-orange when color transparency (slide) films designed for a certain light source are exposed under a different light source

without a light-balancing or conversion filter (see page 241). This occurs when tungsten slide films are exposed by daylight or flash, or when daylight slide films are used with regular incandescent bulbs or other tungsten lighting. If shot under fluorescent lights, these daylight slide films have a sickly greenish cast, which can also be color corrected with filters.

FAULTY FLASH PICTURES need to be studied closely so that you can avoid repeating the same mistakes later. Commonly, there are bright or glaring spots in the picture caused by the flash reflecting off shiny surfaces. Mirrors, windows, and enameled walls or woodwork reflect flash back to the camera. Avoid this by standing at an angle to the reflecting object or by moving your subjects away from it.

Objects in the foreground of flash pictures are often too bright, while subjects in the background are too dark. Unevenly lighted flash pictures can be avoided by keeping all of your subjects at about the same distance from the flash so they each receive an equal amount of light. Carefully study the arrangement of your subjects before making a flash picture.

People and pets may turn up with disturbing red, pink, or white eyes in color flash pictures, a familiar problem known as RED-EYE. With black-and-white film, the eyes will appear abnormally white. This occurs when your subject's pupils are opened wide and the flash reflects back from the inside of the eye. Help prevent this by using the red-eye reduction feature of your built-in or accessory flash, if available. It shines a steady light beam or gives a quick series of flashes just prior to the actual flash exposure in order to contract the pupils of your subject's eyes. You can also reduce the chance of red-eye by turning on more lights in the room to cause the pupils to contract, or by positioning the flash at a higher angle to your subject.

By careful analysis of your negatives, prints, and slides, you can discover the causes of problems that diminish the quality of your photographs. Whether you process and print your films in your own darkroom or give them to a photofinisher, always take time to critique the results in order to avoid the same problems in the future and to improve your photography.

# SHOWING OFF YOUR PHOTOGRAPHS

When your finished pictures are in hand, there are a number of things that can be done with them. Most commonly, prints are put into a photo album for more convenient viewing (or just put away in a box or a drawer); color slide transparencies are sometimes organized into a slide show. In a few cases, the very best or most sentimental images are enlarged, mounted, and framed for display at home or as gifts to relatives and acquaintances.

However, there are many other interesting ways to exhibit and enjoy your favorite pictures, especially since the advent of electronic imaging. Photos can be converted digitally to appear as screen savers on your computer monitor, or for incorporation into letters to family and friends. These photo-illustrated letters may be sent directly via the Internet or on-line services as E-mail, or printed on your computer's color printer to be mailed via the postal service.

In addition to electronic images and traditional photo prints, your pictures can be displayed on all sorts of personal items. Photofinishers can reproduce your favorite images on ceramic coffee mugs, china plates, clock faces, kitchen aprons, T-shirts, computer mouse pads, key chains, jigsaw puzzles, calendars, playing cards, Christmas cards, and much more.

Following are more details about various ways to show off your photographs.

## Editing Your Photos

The first thing to do after getting prints or slides back from the processor is to file some of your photos in the wastebasket. There's

306. Your favorite photographs can be enjoyed more if you mount and frame them for display.

no reason to bore your viewers with pictures that might have been good but are not. We know that the most difficult thing for many photographers is to toss out any pictures, but if the exposure is bad, the focus fuzzy, the subject uninteresting, or the composition poor, then throw the photos away. Before doing so, be sure to study the pictures in order to avoid making the same mistakes again. Remember, careful editing will enhance your reputation as a photographer. Don't lose friends or prestige by showing every photograph you take; share only your best images.

## Selecting the Best Images for Display

To decide which images you want to have enlarged for display (or reproduced in other ways), study the SNAPSHOT-SIZE PRINTS you get from most photofinishers. Prints from 35mm negatives are usually $3^1/_2 \times 5$ or $4 \times 6$ inches ($8.8 \times 12.7$ or $10.1 \times 15.2$cm), which is large enough to allow you to see the details of your subject.

A less expensive alternative to snapshot-size prints is to have the entire roll of film printed as a CONTACT PROOF SHEET so you can view and compare images. A 36-exposure or shorter roll of 35mm film can be included on a single sheet of $8 \times 10$-inch ($20.3 \times 25.4$cm) photo paper. (APS negatives are regularly returned from the processor with a proof sheet known as an INDEX PRINT.) Since the positive images will be the same size as the negatives, you'll need a magnifier,

also called a LOUPE, to study details of each picture. Photo loupes typically magnify images by four (4X) or eight (8X) times.

Whether making your selections from a proof sheet or snapshot-size prints, be aware that the CONTRAST AND COLORS of the images may look different in the enlargements. This occurs if the photofinisher uses filtration to expose the enlargements that is different from the filtration used to expose the snapshots or proof sheet. If you want enlargements (or any reprints) to exactly match the contrast and colors of your snapshots or proof sheet, give those prints to the photofinisher for use as a guide for making the enlargements. Also remember that contrast and colors can often be improved when printing from negatives, so you can ask the photofinisher to "lighten" or "darken" the image, or alter the color balance, such as "reduce the greenish cast" that sometimes is evident when shooting under fluorescent lights.

If you are making enlargements from color slides or other transparencies, which are positive images the size of the film frame, you can examine them in detail with a magnifier. But projecting the slide to the actual size of the intended enlargement is a better way to make your selections for printing. A piece of clean white poster board can be used as an editing screen.

Keep in mind when selecting slides to be enlarged that the resulting prints often show an increase in contrast, so try to avoid images with colors that are too contrasty. This higher contrast occurs when enlargements are made by the most common one-step procedure—printing the slide's positive image directly on color reversal photo paper to produce a positive print. However, more control of the contrast is possible by adding a second step—copying the transparency with a color negative film to make an INTERNEGATIVE that is then used to print the enlargement.

Also note that some photofinishers make enlargements from slides by first SCANNING AND DIGITIZING the image electronically. Then the automated computer printing program inverts the colors of the positive image to those of a color negative, and exposes them to color negative photo paper to produce the print. With this digital system, contrast is reduced and shadow detail is improved, but in larger sizes the print loses some resolution as well as color saturation.

Once you've chosen the slides or negatives to enlarge, you need to decide on the PRINT SIZE. Photo papers for enlargements come in some common sizes: 5 × 7, 8 × 10, 8½ × 11, 11 × 14, 16 × 20, and 20 × 24 inches (12.7 × 17.8, 20.3 × 25.4, 21.5 × 27.9, 27.9 × 35.5, 40.4 × 50.8, 50.8 × 60.9cm). Poster-size photo papers measuring 30 × 40 inches (76.2 × 101.6cm) or larger are also available.

By the way, if you want to increase the overall display size and attractiveness of small-size enlargements, you can frame them with a mat that borders the print (see the next section).

In addition to the size of the enlargement, you must choose the PHOTO PAPER SURFACE that is appropriate for the subject of your picture. The papers vary in sheen (glossy, matte, or lustre) and texture (smooth, fine-grained, suede, pearl, and others), but not all surfaces are available for every brand and type of color or black-and-white photo paper. Ask your photofinisher what choices are offered. If you are making the enlargements in your own darkroom, camera stores have sample books of photo papers to help you select the surface. For instance, portraits usually look better on a fine-grained matte paper than on a smooth glossy paper.

CROPPING the image to improve composition is possible and often preferred to printing the entire film frame. Indicate exactly what you want left out of the picture by placing crop marks on a snapshot print, contact proof sheet, or slide mount. Most photofinishers and camera stores have CROPPING MASKS that you place over the negative or slide to make certain that the dimensions of your cropped image fill a standard size of photo paper (see earlier in this section). Otherwise, you'll have to trim the enlargement with a PAPER CUTTER or frame the print with a mat that covers the unwanted portion of the image. When ordering enlargements, ask for BORDERLESS PRINTS in order to increase the overall picture size.

Be aware that if you enlarge the entire film frame, it may not fill the entire surface. For example, a full 35mm negative printed on 8 × 10-inch (20.3 × 25.4cm) paper will only produce a 7 × 10-inch (17.8 × 25.4cm) image.

## Mounting and Framing Enlargements

Depending on their size, enlargements you intend to display may curl or wrinkle if not mounted to a durable backing that's commonly known as a MOUNT BOARD or BACKING BOARD. Mounting can be done by photofinishers if requested at the same time you order enlargements. If you make prints in your own darkroom, or have some enlargements commercially made but unmounted, they can be taken to a picture frame shop for mounting and framing. Or you can do it yourself.

Mount boards of various types can be purchased at frame shops, art supply stores, and some camera stores. A major mail-order source of quality supplies for mounting, framing, and preserving

307. To set your photographs off from their frames, precut mats can be pur-
chased, or you can make your own from mat board with an inexpensive mat
cutter and a straightedge ruler.

your prints, negatives, and slides is Light Impressions in Rochester,
New York; call toll-free (800) 828-6216 for its catalog.

You can also buy or make a mat (see later in this section) to sur-
round the print with a wide border so the photograph stands out
more in a frame. But the first step is always to give the enlargement a
stronger backing with a mount board. The better mount boards fea-
ture a polystyrene foam center that makes them both strong and
lightweight. It's worthwhile investing in ARCHIVAL MOUNT AND MAT
BOARDS of cotton rag or purified wood pulp that contain no chemical
impurities to cause photo paper stock or its emulsion to stain or
fade. Archival board is often referred to as acid-free or museum-
quality board.

The best way to mount prints uniformly and permanently is with
DRY MOUNTING TISSUE. Sold at camera stores, this adhesive-coated
tissue is of two types: self-sticking and heat-sealing. The self-sticking
type is easier to use and often preferred for color prints and black-
and-white resin-coated (RC) papers because excessive heat can
change the dye colors and damage the emulsion of photo papers.

Start by trimming a piece of self-sticking tissue to the size of the
print. After peeling away its protective covering, carefully position
the tissue between the mount board and print. Cover the print face

with a clean piece of paper for protection, and then apply pressure with your hands or a rolling pin to make a smooth, uniform bond.

The more traditional heat-sealing mounting tissue is used in a professional DRY MOUNTING PRESS, which has a thermostat for precise temperature control. If you take care, an ordinary household iron can be substituted; be certain to drain any water to prevent steam. Read the instructions packed with the tissue to adjust the iron's heat setting for the required temperature.

To begin mounting, tack the tissue to the back of the print with the tip of the hot iron; be sure to leave the corners of the tissue free. Next, trim the overlapping edges of the tissue, along with the border or any unwanted portion of the print itself. Use a paper cutter, or a trimming knife with a straightedge ruler, for an even trim.

Place the print with its tissue back side down, position it, and tack the tissue corners to the mount board. Finally, cover the print's face with a clean sheet of paper that's been preheated to eliminate any moisture that might cause it to stick to the print, and "iron" the photograph to the board. Be careful you don't apply too much pressure, or else an impression of the iron's soleplate may be left on the print. Also monitor the temperature setting because too much heat can scorch the print or alter its colors.

*A special warning:* Avoid mounting photographs with rubber cement, white paste, or other ordinary glues, as well as any cellophane or masking tapes or spray adhesives, because their chemicals can bleed through photo paper and permanently discolor or damage the picture over time.

Photographs for display often look better when surrounded by a MAT, which serves as a border to set a picture off from its frame. Mats with a precut or custom-made opening the size of your print are available at art supply stores, frame shops, and some camera stores. Or you can buy mat board and a MAT CUTTER and make them yourself. Precut mats usually have a backing board attached, so you won't have to mount the print to a separate board to give it durability prior to framing.

One decision to make is what color of mat to use. White, ivory, gray, and black are standard choices, but other colors may give your photograph greater appeal. Just be sure it enhances rather than clashes with the colors in your print.

The final step before displaying a photograph is FRAMING it, which you can also do yourself. Choose from the many frames of standard sizes, or custom-fit an enlargement by selecting precut lengths of metal or wood framing material to assemble at home or at a self-service framing shop.

Framing a picture with glass gives photographs extra protection from dust and physical damage. The choice is between ordinary window glass and special NONGLARE GLASS, which reduces reflections. However, nonglare glass also dulls a picture's color and contrast somewhat, especially when used with a mat, which slightly separates the image from the glass. That's one reason ordinary glass is the most frequent choice. (It's also less expensive.)

More important, because there is a danger of photographic print emulsions sticking to any glass over time, it's recommended that a mat always be used to keep the photo and glass from direct contact. An additional way to protect the photograph, especially from dust, is to turn the frame over and seal the spaces between the rear of the frame and the print backing or mount board; use wide tape or a frame-size sheet of paper and glue.

Once a photograph is mounted and framed, carefully consider the location where you intend to display it. Heat, humidity, and light are especially harmful to photographic images. Light is more detrimental to color photographs than black-and-white photographs because it affects their color dyes and fades the image over time. Avoid exposing photographs to direct sunlight or to fluorescent lights, both of which have excessive amounts of ultraviolet light and do more damage than incandescent lights. Some photo print materials are significantly more resistant to fading and other damage. Consult with your photofinisher or custom lab about the materials and procedures they use to make enlargements; some are produced with electronic imaging instead of with photo papers and chemicals in the darkroom.

## Converting Photos for Computer and Video Display

Although the late twentieth century saw the introduction of electronic cameras—first video cameras and then digital cameras—predictions that they would cause the demise of traditional film-and-paper photography were premature. In fact, manufacturers of still cameras and films were so confident of a continuing worldwide market that they introduced the Advanced Photo System (APS) in 1996. The innovative APS small-format cameras and films (see page 292) promised to attract even more people to photography.

As also discussed in Chapter 9, digital cameras have found a market, too. More important, computerization offers additional opportunities to enjoy traditional photography for personal pleasure

308. Color negatives and slides can be digitized onto a photo CD for use in a compact disc player that will display your pictures on a TV screen. The photo disc, which was pioneered by Eastman Kodak Company, also can be put in the CD-ROM drive of a computer so the images can be manipulated, printed, or transmitted to other computers. An index print with thumbnail-size images of all the pictures on the photo CD is provided for reference.

or for business profits. Amateur photographers convert pictures from their family albums to share them with friends on the Internet, while professional photographers also use cyberspace to market the images they create with both cameras and computer software.

Do-it-yourself PHOTO SCANNERS and VIDEO PROCESSORS are sold in camera and computer stores for transferring images from prints, slides, and negatives to computer files and videotape. You can also have the transfers made professionally through camera stores, mail-order photo companies, and computer service bureaus. For example, at the same time your color negative or slide film is being processed, the photofinisher can digitize images from each frame onto a PHOTO CD (compact disc). The CD is returned to you with an index print of all the frames on the roll so you have a visual reference of every image on the disc. (Negatives and slides that have already been processed can also be transferred professionally to a photo CD.) Once you receive the photo CD, it can be put in a special photo

CD player so you can display your pictures on a TV screen. Or you can load the disc into the CD-ROM drive in your computer to display, manipulate, and print the photos, or to transmit them via the Internet to anyone else with a computer. It's difficult to keep up-to-date with electronic photo imaging because the technology continues to improve so rapidly; inquire at photofinishers, camera stores, and computer dealers for the latest developments in digital photography.

## Projecting Slides and Pleasing Your Audience

Although 35mm color slides and other sizes of transparencies can be converted electronically for computer and video viewing, or printed in a darkroom as enlargements for display, those positive color images will have the greatest impact if you project them on a big screen. However, if your slide "show" is to be successful, you must carefully sort, edit, and arrange the pictures. Otherwise, you'll produce a boring home travelogue, and end up with disgruntled viewers instead of admirers of your photographic talents.

It's especially important to spend time selecting only the very best of your slides to share; never show any of your photographic failures. Also avoid the two most common faults when presenting the pictures: flashing too many slides at too long a sitting. To keep your audience from getting restless, a slide show should last no more than 45 to 60 minutes. Prolonged commentary while the image of one slide is kept on the screen is equally disturbing. Change the slides often, and keep your remarks about each slide very brief.

Also make certain that the slides are clean. Dust them before the show with a soft camel's hair brush, or with moisture-free compressed air from an aerosol can, such as Dust-Off. Carefully clean off fingerprints and other smudges with a microfiber cleaning cloth (see page 19). Or use FILM CLEANER, a liquid cleaner that requires you to remove the slide from its mount for uniform cleaning.

Even when you project a spotless collection of outstanding images, your slide show will also be judged on how smoothly it runs and how well the pictures can be seen. A trustworthy projector and a bright screen are important to your success. When buying projection equipment, consider whether you'll only use it for yourself and a few friends or will be showing your slides to larger audiences.

The SLIDE PROJECTOR is a major purchase. First, you must choose one of two projector sizes, depending on the size of your film. Most common are 35mm projectors that show 35mm transparencies held

in 2 × 2-inch (5 × 5cm) slide mounts. Larger projectors are required to show the $2\frac{1}{4} \times 2\frac{1}{4}$-inch (6 × 6cm) transparencies of 120-size medium-format film.

The most popular 35mm slide projectors for personal use have proven to be Kodak's Carousel models. For professional, heavy-duty use, Kodak also has Ektapro and Ektagraphic projectors of the same Carousel style but with additional features. Other brands of 35mm slide projectors include Vivitar, Rollei, Leica, and Kindermann. Rollei and Hasselblad are among the makers of $2\frac{1}{4} \times 2\frac{1}{4}$-inch (6 × 6cm) medium-format slide projectors.

Regardless of its size or brand name, any worthwhile slide pro-

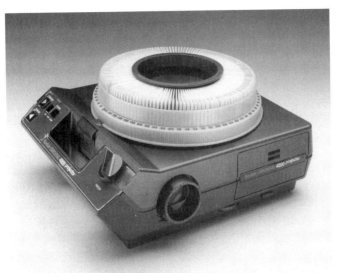

309. Home slide shows are much more enjoyable when presented with a quiet and dependable projector, like Kodak Carousel models featuring circular slide trays with gravity feed.

310. Many other projectors, including this Vivitar model, also utilize rotary slide trays, but most operate in a vertical position with push-pull feed.

311. For professional slide presentations, this twin lens Rollei projector automatically dissolves the images from one to another.

jector must produce a uniformly bright image, run quietly, and provide jam-free operation. One appeal of Kodak's projectors is their gravity-feed design, which does not require force to put a slide into position for viewing. As the round slide tray advances, a slide drops from the bottom of the tray into the projector for viewing. When the projector's forward button is pressed again, an arm pushes from underneath to lift the slide back into the slide tray above, which then rotates and drops the next slide into position. This slide exchange takes about one second.

Regarding bright images and quiet projection operation, they go hand in hand with projector models that use TUNGSTEN-HALOGEN BULBS. Not only do halogen bulbs produce brighter images at less wattage than the older-type incandescent projector bulbs, but their heat can be dissipated by a fan that runs slower and thus quieter. In addition, halogen bulbs have a longer life (about 50 to 70 hours) and maintain their level of brightness throughout that time.

When narrating a slide show, you don't want to compete with a noisy projector. Whatever model you are considering buying, always turn it on to listen to the fan, and also to make certain that the slide-changing mechanism operates quietly. Some projectors clang and bang so much during slide changes that it takes the enjoyment out of showing your photographs.

Here's something else to consider. Inside a projector, in addition to CONDENSER LENSES that help focus and produce a bright slide image, there is a piece of HEAT-ABSORBING GLASS. If this glass cracks or shatters due to age or rough handling of the projector, damage to your slides will result. This rarely happens, but if it does, first you'll notice a much brighter image than usual, and then you'll smell

smoke and see your slide image burn up on the screen. Unplug the projector and replace this heat-absorbing glass before trying to use the projector again.

With projectors using incandescent lamps instead of tungsten-halogen bulbs, another problem can occur when the bulb gets old and begins to bubble from the heat. If the bulge of the bulb touches a condenser lens, both bulb and lens may shatter. To avoid trouble, check the bulb occasionally to see if a heat bubble is developing.

By the way, it was long thought that running the projector's fan to cool the bulb after use would extend the bulb's life. But lamp manufacturers now suggest that such rapid cooling stresses the bulb more than if it cools off naturally, especially tungsten-halogen bulbs. However, moving a projector while it is still hot can be damaging to the bulb, too. So if the projector is to be subjected to much handling immediately after use, the bulb should first be cooled by using the fan.

One of the most important components of any projector is the PROJECTION LENS, which is often sold separately from the projector. Purchase the lens that best suits your needs by considering its aperture, focal length, and design. A lens opening of f/3.5 is standard for many projection lenses, although you might prefer one with an aperture of f/2.8, because it produces a somewhat brighter image.

Of more concern is the LENS FOCAL LENGTH, because that determines how far away from the screen the projector must be in order to completely fill the screen with an image. As a guide, the shorter the focal length, the closer your projector can be to the screen. And the closer to the screen, the brighter the image, because the projected light travels a shorter distance.

For use at home, a projection lens with a focal length of 85mm or 100mm usually works well. If you expect to show slides in rooms of various sizes, a better choice is a ZOOM LENS with a focal range of 100–150mm. It allows you to vary the distance of the projector to the screen, or to increase or reduce the size of slide image without changing the position of the projector.

Unless you have a zoom lens and therefore can conveniently adjust image size, the projector must be positioned manually until the image fills the screen. Here's a tip to avoid the usual guesswork associated with projector placement: Once you've established the distance your projector must be from your screen, cut a length of string or cord that equals that distance. Then, whenever you're going to show slides, set up the screen, stretch the measured cord, and place your projector at the cord's end.

Be aware that there are two designs of projection lenses for

35mm slides in order to project sharply focused images of transparencies in varied mounts. Most common are FLAT-FIELD (FF) PROJECTION LENSES, which are recommended when slides are in plastic or glass mounts, or any mixture of plastic, glass, and cardboard mounts. CURVED-FIELD (CF) PROJECTION LENSES are a better choice only when the slides are all in the same type of open cardboard mount that gives the film a slight bow; they project sharper overall images by taking the film's curvature into account. (If you have a curved-field lens, always be certain to instruct the photofinisher to mount your transparencies in cardboard mounts, not plastic mounts.)

For the sharpest possible focus, remember that slides should always be projected with their *emulsion* side toward the screen; that's the dull side with a slight inner curve to the film. Transparencies mounted between glass will be sharply focused regardless of which side is toward the screen (although the subject's direction may be reversed).

As to FOCUSING mechanisms, some projectors feature autofocus, while others require you to focus the lens manually. Some models also offer REMOTE FOCUSING, allowing you to control the focus while up to 100 feet (30 meters) from the projector. When working properly, AUTOFOCUSING is a nice feature. Once you focus the first slide, subsequent slides are automatically kept in focus, *as long as the slides are in the same type of mount.* That's important to remember. Slides in mounts that vary—cardboard, plastic, and glass—must be manually or remotely refocused; autofocusing lenses will not readjust for different types of mounts.

The value of autofocus is that the lens adjusts for sharp focus whenever a slide "pops" or buckles slightly from the heat of the projector bulb. This buckling throws the image out of focus, which is annoying to both the audience and you as the photographer. Fortunately, SLIDE POPPING can be minimized. Projectors that illuminate slides with a tungsten-halogen bulb help avoid the problem because there is less heat from this lower-wattage lamp. In addition, some projectors, such as Kodak's Carousel, reduce the chances of popping by prewarming the slides just before they advance into the viewing position. Also, using cardboard mounts that prestress the transparency in a slight curve and hold it securely will help prevent the slide from buckling during projection.

To eliminate popping altogether, as well as to protect their transparencies from physical damage, some photographers prefer to place their slides in GLASS MOUNTS. This keeps the film flat, and thus the projected image remains in focus. However, heat from the projection bulb can also affect glass-mounted slides that are projected for

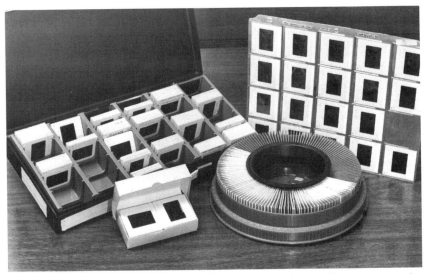

312. Color slides can be stored and protected in several ways. Use the boxes the slides are returned in by the processor, put them in large group slide trays, insert the slides in polypropylene (not PVC) protector pages, or leave them in slide projector trays (in closed boxes).

too long a time or too often. The transparency eventually becomes slightly warped between the glass and causes a changing effect of rainbowlike circles or designs to appear on the screen. These are called NEWTON'S RINGS, and they will distract your audience. To avoid this, mount the transparencies between what is called anti–Newton ring slide glass.

A very important consideration when selecting a projector is the type and capacity of its SLIDE TRAY, or SLIDE MAGAZINE, the removable device that holds the slides for viewing. The best trays have a spill-proof design to avoid accidents that could get your slides out of order or even damage them.

The earliest projectors were fed slides manually, one at a time. A significant improvement came with the introduction of a rectangular tray holding about 40 slides that was inserted into the machine. Even better was Kodak's later innovation of a circular tray that easily loads on top of the projector and has a capacity of 80 or even 140 slides. Along with it came Kodak's trademark name for the round tray and its matching projector, Carousel.

The circular type of tray has been adopted by most other manufacturers of 35mm slide projectors, although many of them utilize it in a vertical position, like a Ferris wheel. These ROTARY SLIDE TRAYS hold 100 cardboard- or plastic-mounted slides.

Slide trays of large capacity are desired by photographers who

want to show an uninterrupted series of slides. However, be aware that Kodak's 140-slide Carousel trays accept only *cardboard-mounted* slides of ¹/₁₆-inch (1.6mm) thickness; any slides that are slightly bent or have damaged corners will stick in the tray slot and not drop into the projector for viewing. By comparison, the 80-capacity Carousel trays have wider slots to hold cardboard, plastic, or glass mounts up to ¹/₈-inch (3.2mm) thick.

Sometimes a slide gets stuck in the projector or is inadvertently put in the tray upside down, so make sure that you are able to retrieve the slide without any difficulty. Before buying any projector, find out if it is easy to remove and replace a slide in the projector, or whether you have to first remove the slide tray.

By the way, most trays require you to load the slides in individual slots, but this can be time-consuming if you only intend to preview the slides or put them in order. One easy solution with Kodak's Carousel projectors is to use the accessory STACK LOADER, which serves as a temporary tray for previewing up to 40 loose slides in all types of mounts.

It is a good idea to MARK THE SLIDE MOUNTS in their proper orientation for projection. That way you can always put slides in a tray without having to look at the images themselves. For pictures to be seen right side up, and for your subjects to be left-to-right as they were photographed, slides must be put in the projector upside down with the emulsion side facing the screen. After arranging them all in this position, mark the upper right-hand corner and top of the slide mount with a felt-tipped pen. Then, whenever you pick up a marked slide, you'll know which way to put it in a tray for proper projection.

Some slide projectors have special features and accessories you may find helpful when presenting a slide show, especially remote controls. Remote focusing was already mentioned, but even more useful is a REMOTE SLIDE-CHANGING CONTROL to advance (or reverse) slides while you are away from the projector. This allows you to face your audience and give your narration from the front of the room instead of speaking at the rear where the projector is located. Hand-held remote controls are of two types, those connected by a cord, and wireless remotes that utilize laser or infrared beams.

A few projectors have a built-in AUTOMATIC TIMER to change slides every few seconds, while others offer connections for tape recorders or computers to advance slides according to preprogrammed signals. However, spontaneity is lost if you use these features to run your slide show; it's better to be able to vary the pace of the pictures according to the reactions of your audience. At the very most, a tape

recorder can be used to play appropriate prerecorded music in the background.

If you want to add a professional touch to your show, use an accessory DISSOLVE CONTROL UNIT, which requires a second projector. Two projectors are connected to the dissolve control unit, and whenever you push the button to change slides, the image from one projector automatically fades out while an image from the other projector fades in. This impressive slide transition eliminates the brief but annoying blackout period that occurs between slide changes with a single projector. (Also see Illustration 311 on page 487.)

Once you've purchased a projector (or two) suited to your needs, don't forget a PROJECTION SCREEN. Slides lose much of their impact if only shown on a living room wall or a suspended bedsheet. Instead, buy a portable roll-up projection screen attached to a tripod-style stand that can be conveniently set up anywhere. These are available

313. Projector screens for showing 35mm slides should be square so that pictures in vertical format as well as those in horizontal format images will fit on the screen.

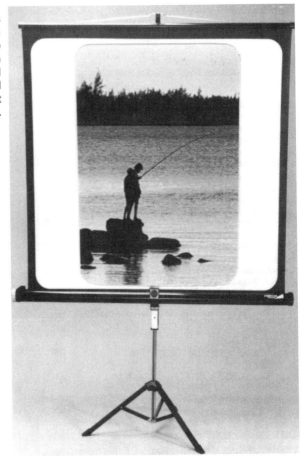

in several standard SCREEN SIZES. A 50 × 50-inch (127 × 127cm) screen is adequate for normal home viewing, but if you ever plan to show your slides to larger audiences, invest in a screen at least 70 × 70 inches (178 × 178cm).

Be certain that the screen has a square format. Even though 35mm slide images are rectangular, you'll want to show pictures shot in vertical as well as horizontal formats and be able to project them equally as large. (A square screen is also appropriate for projecting square 2¹/₄ × 2¹/₄-inch [6 × 6cm] transparencies.)

In addition to shape and sizes, you need to choose among three SCREEN SURFACES: matte, beaded, and lenticular. They have different reflecting qualities that affect both the brightness and sharpness of your projected pictures. The one you choose depends on the audience seating pattern and ambient-light conditions in the room.

Overall, a MATTE PROJECTION SCREEN will produce the sharpest possible images because it is a flat surface, often made of washable white plastic. The ribbed plastic surface of a LENTICULAR PROJECTION SCREEN and the minute glass beads that coat the surface of a BEADED PROJECTION SCREEN reflect images that appear slightly less sharp than on a smooth matte screen.

Actually, the major differences between these three screen surfaces are in brightness, rather than sharpness. A beaded screen reflects about twice the light of a lenticular screen, and about four times the light of a matte screen. However, a beaded screen works best in narrow rooms when viewers are seated within an angle of view that is no more than 25° on either side of the projection beam; those sitting at a greater angle will see a dimmer picture. It also reflects considerable ambient light, so the room must be dark. In addition, if glass beads are accidentally scraped from the surface of a beaded screen, the damaged area will show up as a dark line or spot in the projected pictures.

A lenticular screen is a popular choice because viewers can sit anywhere within an angle of view up to 35° on either side of the projection beam and see images with equal brightness. It is also the screen surface least affected by ambient light.

A matte screen provides the widest angle of view of a uniformly bright image, 45° on either side of the projection beam. However, because a matte surface reflects the least amount of light, a totally dark room is required to produce its brightest images.

When you are ready to organize a slide show, a SLIDE SORTER, or LIGHT BOX, will make it easier to put your pictures in the best sequence. This is a large illuminated viewer that stands up or rests flat on a table and enables you to see and arrange a considerable

number of slides all at once. Of course, when finally edited and in order, the slides should be projected so you can check their order and impact as large images.

The first step when selecting slides for a show is to avoid all out-of-focus and poorly exposed pictures. Never include slides that have been underexposed and are too dark, or have been overexposed and are too bright.

However, if there is an overexposed slide that is especially important, sometimes it can be salvaged for your show. To reduce its brightness when projected, try remounting the overexposed slide with a NEUTRAL DENSITY (ND) FILTER. Gelatin neutral density filters are sold at camera stores in various densities and can be cut to size. When ND filters are not available, brightness can be reduced somewhat by remounting the overexposed slide with a piece or two of clear, processed photographic film.

Aside from the technical considerations relating to quality slides and equipment, a successful slide show has other important aspects. As mentioned previously, careful EDITING AND ARRANGING are especially important. Plan your program so it tells a story. Vary the subject matter and format to keep your audience interested. Mix scenics with pictures of people, and use night shots as well as daytime expo-

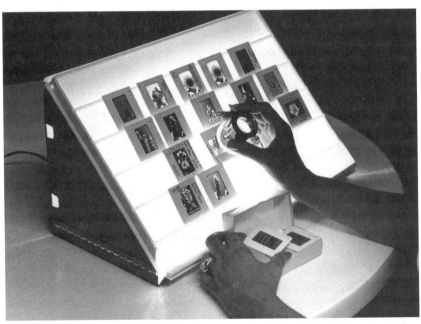

314. A convenient way to preview and edit your color slides before projecting them is to study the slides through a hand-held magnifier, known as a loupe. Then arrange them in order on an illuminated slide sorter, also called a light box.

sures. Include interior shots in addition to pictures made out-of-doors. Alternate overall views with close-ups, and vertical pictures with horizontal shots.

Arrange the slides so your story has a beginning, middle, and an end. Humorous pictures or comments will help hold the attention of your audience, too. Above all, don't introduce your slides with an obvious remark, such as "This is a picture of . . ." Remember to organize your commentary as well as you organize your photographs.

Try to avoid using typical and trite shots, such as your family standing on the rim of the Grand Canyon or in front of the Eiffel Tower. Instead, with famous landmarks, include pictures taken from angles that are different from those in the photos everyone has seen on calendars, in books, or at other slide shows. This is easier if you remember when you're shooting not to duplicate well-known photographs; create your own personal angle and approach.

By all means, keep from showing pictures that were very difficult or dangerous to take but are not especially interesting as photographs. If a slide doesn't contribute to your story, don't include it. A goal of your presentation should be to prove to your audience that you are a creative photographer, not just a snapshooter.

A good idea is to have one or two people preview your slide show and offer critical remarks. Because photographers are so personally involved with their own pictures, they often forget to consider how the audience may react. Before presenting your slide show to any group, solicit the opinions of another person or two to help determine if your pictures tell your story in an orderly, interesting, and original way.

Finally, it's show time. But there are some last-minute preparations that will ensure a successful presentation. Be sure that the table or stand holding your projector is sturdy so the projected images will not shake on the screen. Also check that there is no distortion; if the projector is tilted severely upward, the pictures will be small at the bottom of the screen and wide at the top, a problem called KEYSTONING. The solution is to raise the level of the projector, or lower the screen. (Be careful that the heads of your audience do not block the projection beam or the view of the screen.)

The projector power cord and any remote-control cord should be placed so audience members will not trip and cause injury to themselves or your projection equipment. In advance of your guests' arrival, turn out the lights to make certain the room where you're showing the slides will be dark; stray light falling on the screen

reduces image brightness and the impact of your pictures. Also check that the projection lens is free of dust and fingerprints.

Always be considerate of your audience. Besides making sure that everyone has a good view of the screen, request that there be no smoking so the projected images will not be diffused by any smoke. Have the first slide in position and prefocused so there is a smooth start to the show. And prepare for an unexpected calamity in the middle of the program by having a spare projection bulb on hand (and know how to change it). Also be certain that you know how to easily retrieve a slide that might accidentally become jammed in the projector.

By giving a brief, well-organized program featuring only your best slides, you'll keep your audience from yawning. They will also think you are an outstanding photographer, and when they say they want to see more of your slides, they will really mean it.

# FINDING YOURSELF IN PHOTOGRAPHY

U nlike many pastimes or professions, photography is familiar to almost everyone. Some people are only casual shooters who get out their automatic 35mm or APS camera (or buy a single-use camera) for birthdays and holidays. Other photographers are serious amateurs who have good camera equipment and know how to use it to make excellent photographs; they sometimes specialize in one type of photography, such as landscapes or close-ups. And for quite a few people, photography is a full-time occupation.

Photography is a wide-ranging phenomenon, attracting people with many interests. But whether the result is an album of snapshots or framed enlargements for exhibition in an art museum, your goal should always be to make the best picture possible. How can you improve your photography? The best way is to keep shooting pictures. This chapter suggests other things you can do to continue learning about photography—and really enjoy it.

## Photo Books, Magazines, and Newsletters

BOOKS ABOUT PHOTOGRAPHY range from how-to guides like this one to coffee-table books featuring fine-art photographs. Whenever you're in a public library or a bookstore, be sure to study the photo books not only for information but for picture ideas. As the photographs in books reveal, everything you see is a potential subject for your camera; the world is waiting to be framed in your viewfinder.

In addition to large-format books that feature photography, specialty publications cover the photographic field. Among them are Kodak's varied reference and general-interest photo books offered by Silver Pixel Press, technical information published by Focal Press,

315. This chapter points the way to discovering more about photography.

and in-depth user's manuals for current 35mm SLR camera models from Magic Lantern Guides. All of these publishers issue catalogs describing their books.

A few mail-order photo supply companies also list books in their catalogs; B&H Photo-Video of New York City even publishes a separate catalog of books and videotapes; telephone toll-free: (800) 947-7785. A helpful source is the *Kodak Index to Photographic Information*, a listing of some free and low-cost publications about general photo topics, as well as Eastman Kodak Company products; call the Kodak Information Center toll-free: (800) 242-2424. Of course, photography books are also sold at better camera stores.

PHOTOGRAPHY MAGAZINES help keep you up-to-date on technical advances and skills, as well as stimulate interest in a variety of photographic subjects and styles. It's especially interesting to read exactly how photographers made the pictures that were published. One caution: The extensive advertising in many of these publications may lead you to think that your own camera equipment is old or insufficient. Don't be intimidated. Also, the ads and articles often introduce you to accessories that could help improve your photography, but avoid the temptation to purchase a load of unnecessary gadgets. We believe that your photographic pursuit should be picture-oriented, not one of owning the latest camera model or as many photo accessories as you can afford.

Before you subscribe to any photo magazine, check out its typical

content and special interests by buying an issue or two at a newsstand or browsing through copies in the library. Among those to consider are *Shutterbug, American Photo, Popular Photography, Petersen's PHOTOgraphic, Outdoor Photographer, Nature Photographer, Aperture,* and *Photo Techniques,* plus seasonal and annual photography magazines. You'll also find special- and general-interest magazines that publish some stunning photographs and carry regular columns or features about photography, such as the *National Geographic Traveler.*

A number of PHOTOGRAPHY NEWSLETTERS are produced by photographers, as well as by photo galleries and museums, on a regular or irregular basis. Some charge a fee for subscriptions, while others are gratis. The newsletters usually have a particular theme, such as travel or nature photography, or simply promote the work of the photographer or the gallery or museum. For anyone hoping to sell some of their images as stock photography, a fact-packed newsletter is *PhotoStockNotes,* published monthly by PhotoSource International, 1910 35th Road, Osceola, WI 54020-5602; telephone (715) 248-3800.

## Photo Advice and Sources on the Internet, CD-ROM Discs, and Videotape

As you know, photographic information and images aren't limited to the printed page. Words and pictures are recorded electronically and displayed on computer and television screens for easy access in your own home. Thanks to digital and video imaging, you can gain photographic insights and enjoyment via the Internet's World Wide Web and on-line services, CD-ROMs and floppy disks, and videotapes.

Regardless of your level of experience or special interests, you can log onto THE INTERNET or on-line services through a computer to visit "photography" sites in cyberspace to learn from your peers and exchange information. Menus and home pages lead almost instantly to interactive photography forums, bulletin boards and chat rooms, galleries of photographs, camera and equipment manufacturers, and even courses in photography.

Among the latter is one of our own, "Michele and Tom Grimm's Internet Photo Workshop," accessible at http://www.wmbg.com/mindstore. Hundreds of other sites of interest to photographers can be found by using the on-line *search* databases.

In addition to searching the ever-changing and expanding world of

316. The Internet offers immediate access to photographic information, including our own photo workshop.

cyberspace, you can find photographic instruction and inspiration on disc for playback on your computer monitor or TV screen. The range of opportunities seems endless. It can be as simple as viewing a FLOPPY DISK or CD-ROM DISC that gives on-screen interactive lessons in photography.

Or you can have your own photographs transferred to a PHOTO CD (or scan them yourself), use a software program in your computer to change the size, color, or content of the images, and then watch as your new, digitally created photographs emerge from the color printer. Of course, while those original pictures may have been on photographic film, an option is to initially shoot with a DIGITAL CAMERA so you can go directly to the computer to view and/or manipulate the images (see page 307).

Viewing INSTRUCTIONAL VIDEOTAPES is another way to improve your photography. For instance, owners of certain models of Nikon 35mm SLR cameras and accessory flash units can watch profes-

sional photographers use the specific camera or flash and give shooting tips in "The Nikon Video Series" of videotapes. Another instructional series, Finelight Videos, is presented by pro Dean Collins, who covers location and studio techniques for portrait, advertising, and wedding photography. Check public libraries, book, camera, and video stores for other helpful photo videos.

## Photo Schools, Workshops, Tours, Clubs, and Contests

Another way to improve your photography and expand your knowledge is to go to school. High school, college, or university EXTENSION AND ADULT CLASSES are especially appealing to amateur photographers who have a full-time occupation because the sessions are held in the evenings or on weekends. Instruction is offered with or without educational credits by teachers of regular photography courses, or by specialists in various photographic fields. These classes often include assignments that get you out shooting and add to your experience with a camera. They also provide a good opportunity to meet fellow photographers in your community. As noted earlier, other photo courses are taught on the Internet. And there are home-study correspondence courses, too.

If you're aiming for a career in photography, you may want to attend one of the commercial, accredited photography-only schools providing resident courses and granting academic degrees, such as Brooks Institute in Santa Barbara, California. Many general-curriculum colleges and universities and some art institutes and museums also have degree-granting programs in photography. Among the nonprofit institutions is the respected International Center for Photography in New York City, which offers classes, seminars, lectures, workshops, and exhibitions.

Schools, camera stores, photographers, photo equipment manufacturers, and professional photography organizations offer a variety of PHOTOGRAPHIC WORKSHOPS that boost your interest in photography and develop your talents. They are led by creative professionals, including photographers with worldwide reputations, as well as others who are lesser-known masters of their craft, such as darkroom printmakers. A pioneer of these hands-on programs is The Maine Photographic Workshops in Rockport, Maine, which began in 1973 and now offers more than one hundred one- and two-week workshops during the summer. Subjects include nature, land-

scape, travel, advertising, fine art, studio, editorial, and portrait photography.

Other workshops are found all across the country, such as Ansel Adams's Friends of Photography Workshops in San Francisco and Yosemite National Park, California; Santa Fe Photographic Workshops in Santa Fe, New Mexico; Anderson Ranch Arts Center in Snowmass Village, Colorado; and Palm Beach Photographic Museum & Workshops in Boca Raton, Florida. For more choices, check the photography workshop listings and advertisements found in many photo magazines, as well as photography sites on the Internet. Also inquire at local camera stores.

PHOTO TOURS, such as Joseph Van Os Photo Safaris, often are led by freelance travel photographers and can be a wonderful way to enjoy a vacation and improve your photography at the same time. These tours are organized to allow plenty of time to take pictures—not just shoot and run. Since there is no hurry to reach the next tour stop, you have the freedom to seek out subjects and compose images carefully. In addition, personal attention and advice is available from the professional photographer accompanying your group. Inquire at travel agencies about photo tours, and check tour listings and advertisements in photography magazines, as well as on the Internet.

Another way to find out about photo tours is to ask at local CAMERA CLUBS. These are groups of amateur photography enthusiasts who gather informally to show their work and talk about camera techniques and equipment. Some have contests and give awards for the best photographs. Contact camera stores and community or retirement centers to locate a camera club in your hometown.

Many photographers like to enter PHOTO CONTESTS. These offer recognition for your pictures, and perhaps photo-related prizes or

317. Photographers don't mind being in the same boat, especially on a photo tour, where there's an opportunity to share knowledge and learn new techniques.

money to pay for more film and additional equipment. The contests are especially valuable if the judges indicate why they liked the winning pictures, instead of just making the awards without comment. Be sure to read the rules of any photo contest carefully; some are held simply as a way to get free use of your photographs for money-making publications, such as calendars, or even for advertisements. Photography magazines often have photo contests for their readers, and list others. Also check the Internet.

## Photography for Profit

Another way amateur photographers get recognition and financial reward is by SELLING PHOTOGRAPHS. Publications are always in the market for appropriate photographs, color and black-and-white. The major national and international magazines usually pay the best rates for pictures. But they are the most difficult to sell because you have competition from staff photographers and professional free-lancers who are hired on a regular basis.

Fortunately, many regional, specialty, and company magazines, as well as area newspapers, are glad to have color transparencies or prints or black-and-white prints submitted for publication. Payment can range from only a PHOTO CREDIT LINE mentioning your name to a check for hundreds of dollars. Contact the publications and ask for a copy of their guidelines for submitting photographs.

The most valuable source for finding publications that buy photographs is *Photographer's Market*, a book that is updated and published annually by Writer's Digest Books. It describes hundreds of publications, including their addresses and telephone numbers, the types of pictures they use, rates of pay, and the name of the photo editor or art director to whom you should submit your photos. Copies of this exceptional photo market guide are available at libraries and bookstores. Be certain to use only the current year's edition, because publications frequently change their picture requirements.

Pictures bought for advertising rather than editorial use pay the most money. However, use of a photo in an advertisement requires MODEL RELEASES signed by all recognizable persons. These releases give the photographer permission to use the photograph and help avoid any subsequent lawsuits by persons in the picture. Advertisers may also require PROPERTY RELEASES if a building or other identifiable property is prominent in the picture. Standard release forms are sold at many camera stores; carry some in your camera bag in case

318. This lazying cat has appeared on countless greeting cards and posters, and earned the photographer thousands of dollars.

you come across a subject you think might eventually be sold to an advertiser.

One of the best publications with down-to-earth advice about selling pictures is the *ASMP Stock Photography Handbook*, published by the American Society of Media Photographers. Copies are available at some camera stores and bookstores, or directly from ASMP, 14 Washington Road, Suite 502, Princeton Junction, NJ 08550-1033; telephone (609) 799-8300. You will learn what it takes to go into the business of photography by reading professional Cliff Hollenbeck's book, *Big Bucks Selling Your Photography*.

If you are thinking about becoming a PROFESSIONAL PHOTOGRAPHER, it's also worthwhile to read magazines published for the pros and their special interests. Among them is the newsy *PDN* (Photo District News), which covers everything from stock and advertising photography to digital imaging. It's available by subscription, and is also sold by some camera stores, bookstores, and newsstands. Others include *Professional Photographer* and *PEI, PHOTO>Electronic Imaging*, both publications of a major association, the Professional Photographers of America (PPA), 57 Forysth St., N.W., Atlanta, GA 33030; telephone (404) 522-8600.

One way to start on the road to a photographic career is to take informal portraits of friends and other people. You can improve your camera skills while making enough expense money to cover the cost

of film and prints. However, until you achieve a state of proficiency and confidence in your work, be careful that your subjects don't expect a more professional result than you can deliver.

Whenever money is involved, make certain your subjects know how much you will charge them for the photographs. And be sure that they understand you expect *payment upon delivery* of the pictures. Although people are always anxious to see the finished prints, once the photographs are in their hands they often are in no hurry to pay you; let them know you expect to be paid immediately.

Many times recognition and payment act as stimulants toward making you a photographer. Well-known photographer Philippe Halsman, whose portraits were featured on more than 100 *Life* magazine covers, put it this way: "I drifted into photography like one drifts into prostitution. First I did it to please myself, then I did it to please my friends, and eventually I did it for money."

Regardless of your specific interest or goals, the more you photograph, the more your photographs will improve. Start making photographs, then keep making better photographs. And most of all, enjoy your photography.

# APPENDIX A:
# A GLOSSARY OF
# PHOTOGRAPHIC TERMS

**AA Batteries** A common size of batteries often used to power cameras, flash, and other photo equipment.

**Accent Light** A small light often used in portrait photography to outline or add highlights to the hair of a subject; also called a Hair Light.

**Accessory Flash Unit** Refers to a flash unit that is not built into the camera. *See also Built-in Flash, Handle-Mount Flash, and Shoe-Mount Flash.*

**Accessory Lens** Any lens that attaches to the front of a camera lens; includes close-up lenses and multiple-image lenses. *See also Close-up Lens and Multiple-Image Lens.*

**Accessory Shoe** A mount on the camera for shoe-mount flash and other accessories; forerunner of the hot shoe. *See also Hot Shoe and Shoe-Mount Flash.*

**Active Infrared Autofocus** A type of autofocusing system commonly found in compact cameras. *See also Passive Phase Detection Autofocus.*

**Adjustable Camera** A camera where the shutter speed, lens opening, and focus can be adjusted by the photographer.

**Adjustable Focus Lens** A lens that can be focused at different distances.

**Advanced Photo System** Interrelated small-format cameras, films, and photofinishing system introduced in 1996; commonly abbreviated APS.

**AE** Abbreviation for auto-exposure, which is the shortened term for automatic exposure. *See also Auto-Exposure.*

**AF** Abbreviation for autofocus. *See also Autofocus.*

**AF Assist** A feature built into a camera or its accessory flash unit to enable autofocusing in dim light; uses infrared or LED beams to

reflect off a subject; the distance of the subject and focal length of the lens determine the effective range of the AF assist; sometimes called an Autofocus Illuminator Beam.

**Agitation** The movement of chemicals over photographic film and paper to ensure uniform processing.

**Amateur Film** An unofficial term for film made for general photography; also called Consumer Film. *See also Professional Film.*

**Ambient Light** Existing illumination that is not supplemented with artificial light by the photographer; also called Available Light and Existing Light. *See also Artificial Light.*

**Amphibious Camera** A self-contained waterproof camera for underwater photography.

**Angle of Acceptance** The area included in a light reading by an exposure meter, measured in degrees (°).

**Angle of Illumination** The area covered by the light from a flash unit; measured in degrees (°); also termed Flash Coverage.

**Angle of View** The area included by a lens, measured in degrees (°); also called Field of View.

**ANSI** Abbreviation for American National Standards Institute; refers to a system of numbers indicating the relative speed of photo papers; now largely superseded by the ISO (International Standards Organization) photo paper speed system. *See also ISO and Paper Speed.*

**Aperture** *See Lens Aperture.*

**Aperture-Preferred Camera** An early auto-exposure camera featuring aperture-priority exposure. *See also Aperture-Priority Exposure.*

**Aperture-Priority Exposure** An automatic exposure allowing the photographer to set the desired lens opening, after which the camera automatically adjusts the shutter speed for a correct exposure. *See also Multimode Exposure, Programmed Exposure, and Shutter-Priority Exposure.*

**APO** Abbreviation for Apochromatic. *See Apochromatic Lens.*

**Apochromatic Lens** A highly corrected camera lens that brings all colors of light into sharp focus at the same point; often abbreviated as APO Lens.

**APS** A commonly used abbreviation for Advanced Photo System. *See also Advanced Photo System.*

**APS Camera** A pocket-size camera using small-format film in a sealed, drop-in cassette for foolproof loading and removal. *See also Advanced Photo System.*

**Archival Mount Board** Board for mounting photographs for long-

term preservation; contains no impurities to degrade the photo paper or its emulsion. *See also Emulsion.*

**Artificial Light** Light from sources other than the sun, such as flash and incandescent bulbs. *See also Natural Light.*

**ASA** Abbreviation for American Standards Association; in photography, the former U.S. film speed rating system now superseded by the ISO (International Standards Organization) film speed system. *See also DIN, Film Speed, and ISO.*

**Aspheric Lens** A camera lens specifically designed to correct common lens aberrations in order to improve optical quality and produce a superior image; also called an Aspherical Lens.

**Astrophotography** Photography of the stars and other celestial bodies outside the earth's atmosphere.

**Autobracketing** A feature of some cameras to automatically make three or more exposures of the same scene at different f/stops or shutter speeds. *See also Bracketing.*

**Auto-Exposure** Refers to any camera that determines and sets exposures automatically; commonly abbreviated AE.

**Auto Fill Flash** A camera feature that automatically adds sufficient flash light to fill in shadows on the subject.

**Autoflash** A built-in or accessory flash unit that automatically determines flash exposures. *See also Manual Flash.*

**Autofocus** Refers to a camera or a supplemental lens that focuses automatically; commonly abbreviated AF.

**Autofocus Assist** *See AF Assist.*

**Autofocus Illuminator Beam** *See AF Assist.*

**Autofocus Lock** A button found on some autofocus cameras to lock in the focus on the main subject while recomposing the picture in the viewfinder.

**Autoload** A camera feature that automatically loads and advances the film to its first frame after the cassette is inserted into the camera.

**Automatic Aperture** A lens that automatically closes down to the preselected f/stop when the shutter release is pressed, and then reopens to its widest f/stop for the brightest possible view through the viewfinder of a single lens reflex camera. *See also Single Lens Reflex Camera and Viewfinder.*

**Automatic Camera** Any camera that automatically adjusts the lens opening and shutter speed to make an exposure. *See also APS Camera and Compact Camera.*

**Automatic Exposure** Refers to a camera that determines and sets the exposures automatically. Also called Auto-Exposure.

**Automatic Exposure Controls** One or more of the following auto-

matic modes that sets exposure on an auto-exposure camera: aperture-priority, shutter-priority, programmed. *See also Aperture-Priority Exposure, Multimode Exposure, Programmed Exposure, and Shutter-Priority Exposure.*

**Automatic Exposure Override** A device on an auto-exposure camera to override the automatic exposure controls.

**Automatic Flash Operating Range** The minimum and maximum distances a subject can be from an autoflash in order for its exposures to be correct. *See also Autoflash.*

**Autorewind** A camera feature that automatically rewinds the film into its cassette after the final frame is exposed. *See also Film Cassette.*

**Autowind** A camera feature that automatically advances the film and cocks the shutter immediately after the shutter release button is pressed; quickly makes the camera ready for the next exposure.

**Autowinder** *See Motor Drive.*

**Auto-Zoom Flash Head** *See Zoom Flash Head.*

**Available Light** *See Ambient Light.*

**Averaging Meter** An exposure meter that has a wide angle of acceptance; sometimes referred to as a meter that gives "overall" exposure readings. *See also Angle of Acceptance, Center-Weighted Metering, Multizone Metering, and Spot Metering.*

**B** Abbreviation for bulb; shutter speed setting for a time exposure; the shutter release button must be kept depressed in order to hold the shutter open. *See also T.*

**Background** The area behind the picture's main subject or center of interest.

**Background Light** A light behind the subject which is aimed at the background to help separate the subject from the background; often used in portrait photography.

**Backlighting** A term used when the main source of illumination is behind the subject and shines in the direction of the camera.

**Backlight Mode** A button or switch on some auto-exposure compact cameras that compensates for backlighting by increasing the exposure by $1^1/_2$ to 2 f/stops to prevent the subject from becoming a silhouette. *See also Backlighting.*

**Back-Printing** A feature of most APS cameras to automatically print certain information on the back of each photo print, including film cassette identification number, frame number, and date of exposure.

**Backscatter** An undesirable effect in underwater photography that occurs when light from a flash reflects off tiny particles in the water and records as fuzzy white spots on the film.

**Ball Head** A type of tripod head that makes it easy to adjust the camera in any position. *See also Pan Head and Tripod.*

**Bare-Bulb Flash** An electronic flash without a reflector; provides the effect of both directional and bounce lighting. *See also Bounce Lighting and Directional Lighting.*

**Barn Doors** Flaps on a studio light that are adjusted to limit and direct the light. *See also Studio Light.*

**Bayonet Lens Mount** A fast snap-lock mount for attaching a lens to a camera body.

**BCPS** Abbreviation for beam-candlepower-seconds; in photography, a system of numbers used to indicate the relative light output of electronic flash units.

**Beaded Projection Screen** A screen with minute glass beads on its surface to reflect the projected image; considered the brightest type of screen for viewers who are in line with the projection beam. *See also Lenticular Projection Screen and Matte Projection Screen.*

**Beanbag** A bag filled with Styrofoam pellets (or dried beans) used to cushion and support a camera in awkward locations and positions; simple substitute for a tripod.

**Bellows** A flexible, accordionlike lighttight chamber; part of an extension device used for making close-ups; part of most enlargers connecting the lens to the enlarger body; part of some cameras connecting the lens to the camera body. *See also Extension Bellows.*

**Between-the-Lens Shutter** A shutter built in a camera lens between some of the lens elements; also called a Lens-Shutter or Leaf Shutter. *See also Focal Plane Shutter and Leaf Shutter.*

**Bounce Lighting** A term used when the main source of illumination is reflected off a surface (often a ceiling or wall) instead of being aimed at the subject directly; provides soft, indirect illumination. *See also Diffused Lighting and Directional Lighting.*

**Bracketing** Making two or more exposures in addition to the one thought to be correct; can be done by changing either the f/stop or exposure time (shutter speed).

**Breech-Lock Lens Mount** A mount featuring a ring on the lens that is turned to lock the lens onto the camera body.

**Bridge Camera** *See Zoom Lens Reflex Camera.*

**Built-in Exposure Meter** Refers to an exposure metering system built into the camera. *See also Exposure Meter and Hand-held Exposure Meter.*

**Built-in Flash** Refers to a flash unit built into the camera. *See also*

*Accessory Flash Unit, Handle-Mount Flash, and Shoe-Mount Flash.*

**Bulk Film** Long rolls (often 100 feet [30 meters]) of 35mm film that are cut to desired lengths and loaded into cassettes by the photographer; a money-saving but less convenient way to purchase film.

**Burning-In** A technique used during enlarging to darken certain areas of the image on photographic paper by exposing those areas for an additional amount of time.

**Cable Release** A flexible cable that usually screws into the shutter release and allows the photographer to trip the shutter without pressing the release with his finger; used for time exposures to prevent camera movement. *See also Remote Cord.*

**Cadmium Sulfide Cell** A type of light-sensitive cell once common in a camera's exposure metering system or a hand-held exposure meter; now superseded by other light-sensing cells. *See also Selenium Cell, Silicon Blue Cell, and Silicon Photo Diode.*

**Camera Bag** A general description of all hard- and soft-sided containers used to hold and carry cameras and other photo equipment; also called a Gadget Bag.

**Camera Movement** Any movement of the camera during exposure that causes an unexpected and unwanted blurred image on the film; also called Camera Shake.

**Camera Shake** *See Camera Movement.*

**Candid Photograph** An unposed picture, the success of which depends greatly on the photographer's alertness and timing.

**Cartridge** *See Film Cartridge.*

**Cartridge Film** A generic name for film in a lighttight container used in Instamatic, disc, and subminiature cameras.

**Cassette** *See Film Cassette.*

**Catchlight** Refers to a sparkle in the eyes of a portrait subject caused by the reflection of a light source such as flash. *See also Secondary Flash Head.*

**C-Clamp** A simple device used to support and steady a camera; attaches to the camera's tripod socket and clamps to a variety of objects.

**CdS** Abbreviation for cadmium sulfide. *See Cadmium Sulfide Cell.*

**Celsius** A scale of temperatures used worldwide; abbreviated ° C; sometimes referred to as the Centigrade (° C) scale; slowly being adopted in the U.S. to replace the Fahrenheit (° F) scale.

**Center of Interest** The main subject of a photograph.

**Center-Weighted Metering** An exposure metering system in some SLR cameras that reads the full area seen in the viewfinder, but which is more sensitive to the central portion, as designated by a

large circle in the viewfinder. *See also Multizone Metering and Spot Metering.*

**Changing Bag** A lighttight bag with access for the photographer's arms; used any time complete darkness is required, such as when opening a jammed camera to retrieve the film without exposing it, or when loading the film into a daylight developing tank.

**Chromogenic Black-and-White Film** A novel black-and-white film that utilizes color negative film technology to produce fine grain images with chemical dyes; must be developed in color negative or special chemicals.

**Circular Polarizing Filter** A type of polarizing filter designed for use on certain autofocus and auto-exposure cameras. *See also Linear Polarizing Filter and Polarizing Filter.*

**Click Stops** Points of slight friction when turning a lens aperture ring that mark the positions of full stops and half-stops on some lenses.

**Close-Focus Lens** *See Macro Lens.*

**Close-up** A picture made with the camera close to the subject.

**Close-up Lens** An accessory lens attached in front of a camera lens to allow the camera to get closer to the subject to produce a larger image size. *See also Diopter and Macro Lens.*

**Coated Lens** A coating on lens surfaces that improves picture quality by reducing the flare caused when light strikes the lens directly. *See also Flare.*

**Cold-Light Head** A diffusion type of enlarger illumination system with a grid-shaped, gas-filled light tube for exposing black-and-white photo papers. *See also Diffusion Enlarger.*

**Color Balance** The ability of a color film to reproduce colors as the photographer sees them; color films are designed by the manufacturer to reproduce colors accurately when used with the type of light for which they were balanced, either daylight or tungsten; can be altered by using filters on the camera when exposing films, or filters in or on the enlarger when exposing color photo paper. *See also Daylight Film, Tungsten Film, and Tungsten Light.*

**Color Compensating Filters** Filters primarily used with an enlarger to control color balance when making a color photo print; sometimes used on the camera lens to control color balance, particularly with light from fluorescent lamps; often abbreviated CC. *See also Color Balance.*

**Color Head** *See Enlarger Color Head.*

**Color Negative Film** A color film that produces a negative image; the film preferred for making color photo prints; 35mm size commonly called Color Print Film. *See also Color Reversal Film.*

**Color Positive Film** *See Color Reversal Film.*

**Color Reversal Film** A color film that produces a direct positive image; also called Color Positive Film, Color Slide Film, and Color Transparency Film. *See also Color Negative Film and Color Slide Film.*

**Color Slide Film** A common term for color film that produces a direct-positive transparency image for projection; most often refers to 35mm film.

**Color Temperature** A scale of numbers used for measuring the color of light, which varies according to its temperature; expressed in units of measurement called kelvins, abbreviated K.

**Color Temperature Meter** A meter that reads the color temperature of light. *See also Color Temperature.*

**Color Transparency Film** *See Color Reversal Film.*

**Compact Camera** Generally refers to small 35mm cameras that feature automatic exposure, autofocusing, and autoflash; most are rangefinder-type cameras, while a few models are single lens reflex. Also called a Lens-Shutter Camera or Point-and-Shoot Camera. *See also Rangefinder Camera and Single Lens Reflex Camera.*

**Complementary Colors** The colors produced when two primary colors are mixed; in photography, yellow (from green and red), magenta (from red and blue), and cyan (from blue and green); sometimes called Secondary Colors. *See also Primary Colors.*

**Composition** The arrangement of the subject or elements in a picture; carefully considered composition is the key to an effective photograph.

**Condenser Enlarger** A type of enlarger illumination system with twin condenser lenses that produces images with finer detail and higher contrast than a diffusion enlarger does; favored for black-and-white printing rather than color printing. *See also Condenser Lenses and Diffusion Enlarger.*

**Condenser Head** *See Condenser Enlarger.*

**Condenser Lenses** A pair of lenses used to concentrate a light source; common in slide projectors and condenser enlargers. *See also Condenser Enlarger.*

**Confidence Light** *See Sufficient Light Indicator.*

**Consumer Film** *See Amateur Film.*

**Contact Print** A print that is the same size as the negative; made by placing the negative and photographic paper together and exposing them to light.

**Contact Printer** A frame or boxlike device to hold negatives and photo paper in firm contact with one another to make a contact

print or contact proof sheet; also called a Contact Printing Frame or a Contact Proofer. *See also Contact Print and Contact Proof Sheet.*

**Contact Printing** The process of making a contact print. *See also Contact Print.*

**Contact Printing Frame** *See Contact Printer.*

**Contact Proofer** *See Contact Printer.*

**Contact Proof Sheet** A contact print of a group of negatives; used as a positive record of the negatives, and for reference when selecting negatives for enlargement. *See also Contact Print.*

**Continuous Advance** A camera setting used to continuously advance the film and expose film frames as long as the shutter release button is fully depressed; the number of frames exposed per second depends on whether the film advance control is set to continuous high-speed or continuous low-speed. *See also Film Advance Control and Single Frame Advance.*

**Continuous Focus** A focus setting on an autofocus SLR camera that enables the lens to continue focusing until the shutter release button is fully depressed to expose the film. *See also Single Shot Focus.*

**Contrast** The range of brightness of a subject; also, the range of density in a negative, print, or slide.

**Contrast Filters** Camera filters used with black-and-white films to lighten or darken certain colors of the subject so they appear in different gray tones in the photograph.

**Contrast Grade** Indicates a specific photo paper or printing filter to use to make black-and-white prints of good contrast from negatives of varying contrasts; contrast grades range from 0 through 5; grades 0 (or 00) to 1 are used with high-contrast negatives; grades 2 to 3 are used with negatives of normal contrast; grades 4 to 5 (or 5+) are used with low-contrast negatives. *See also Graded Contrast Photo Paper and Variable Contrast Photo Paper.*

**Conversion Filters** Filters used on the camera lens to allow a color film balanced for one light source to be used with a different light source; bluish filters allow daylight films to be used with tungsten lights; yellowish-orange filters allow tungsten films to be used with daylight and electronic flash. *See also Daylight Film, Tungsten Film, and Tungsten Light.*

**Copy Stand** A device to hold a camera and flash or tungsten lights that can be adjusted to copy photographic prints or other flat artwork.

**Correction Filters** Camera filters used with black-and-white films so

that certain colors of the subject appear in more realistic gray tones in the photograph.

**Cropping** Eliminating unwanted parts of a picture; a photographer crops with his viewfinder by framing only the subject he wants in his picture, or he crops during the enlarging process to print only the desired portion of the negative.

**Cross Lighting** A term used when two sources of illumination are directed at the subject from opposite sides.

**Cross-Screen Filter** *See Star Filter.*

**Curved-Field Projector Lens** A lens specially designed for slides in cardboard mounts; takes into account the slight curvature of the slide film to project a uniformly sharp image on the screen; sometimes abbreviated CF. *See also Flat-Field Projector Lens.*

**Cut Film** *See Sheet Film.*

**Darkroom** A lighttight room used for developing film and making contact prints and enlargements.

**Data Back** An accessory camera back that replaces the regular back of some 35mm cameras; used to imprint each film frame with the date and/or time of exposure. *See also Multifunction Back.*

**Data Sheet** The instructional information packed with films and photo papers.

**Daylight Film** A color film designed to be exposed by daylight, electronic flash, or blue flash illumination. *See also Color Balance, Electronic Flash, and Tungsten Film.*

**Dedicated Flash** A flash unit that automatically activates or controls one or more flash features when attached to a compatible camera; among those features are flash synchronization, auto-exposure, auto-zoom flash head, ready light, and sufficient light indicator. *See also Auto-Zoom Flash Head, Flash Synchronization, Ready Light, and Sufficient Light Indicator.*

**Definition** The relative sharpness of a lens; also, the clarity of detail evident in a negative or photo print; sharpness of the image, graininess of the negative or print, and the resolving power of a film or lens influence a photograph's definition.

**Density** The relative darkness of a negative or print; a dense negative will not allow much light to pass through it; a dense print will not reflect much light.

**Depth of Field** The area in a photograph that is in sharp focus; figured as the distance between the nearest and farthest objects in focus; varies depending on the lens focal length, point of focus, and f/stop. *See also Point of Focus.*

**Depth of Field Chart** A chart for a specific lens that indicates its

depth of field at various f/stops and points of focus. *See also Depth of Field.*

**Depth of Field Preview Device** Stops down the lens opening to a preselected f/stop so the photographer can visually check how much of the subject area will be in focus. *See also Depth of Field.*

**Depth of Field Scale** F/stop coordinates on a lens that indicate how much of the picture area will be in focus. *See also Depth of Field.*

**Developer** A chemical that acts on exposed film or paper emulsion to produce an image.

**Diaphragm** *See Lens Diaphragm.*

**Diffused Lighting** Nondirectional lighting that gives uniform illumination with lower contrast and less shadowing than directional lighting; also called Soft Lighting. *See also Bounce Lighting and Directional Lighting.*

**Diffusion Enlarger** An enlarger illumination system that scatters the light reaching the negative and produces an image that has less fine detail and lower contrast than a condenser enlarger does; preferred for color printing. *See also Condenser Enlarger and Enlarger Color Head.*

**Diffusion Filter** A camera filter that slightly reduces the overall sharpness of the image; used to soften the appearance of portrait subjects; also called a Soft-Focus Filter.

**Digital Camera** A filmless camera that records images electronically.

**DIN** Abbreviation for Deutsche Industrie Norm; a German (European) rating system for film speeds now superseded by the ISO (International Standards Organization) film speed system. *See also ASA, Film Speed, and ISO.*

**Diopter** An optical term used to indicate the strength or magnifying power of a close-up lens; such lenses range from +1 to +10 diopters. *See also Close-up Lens.*

**Diopter Correction Control** A tiny knob on the viewfinders of some SLR cameras that adjusts the focus of the eyepiece to compensate for near- or farsightedness of the photographer; marked in plus/minus diopters. *See also Eyepiece Correction Lenses.*

**Directional Lighting** Direct lighting from a concentrated source, such as the sun or a studio light; gives higher contrast and deeper shadows than diffused lighting; also called Hard Lighting. *See also Diffused Lighting.*

**Disc Camera** A small automatic camera featuring a film cartridge of revolutionary design, a rotating wheel of film; camera is no longer manufactured. *See also Disc Film.*

**Disc Film** A thin film cartridge for disc cameras containing a flat disc of color film that rotates to provide 15 exposures.

**Dissolve Control Unit** A device used with two or more slide projectors to make a smooth visual transition when changing slides; while one projected image fades out on the screen, another image fades in.

**Distortion** Used to describe an unnatural or imperfect image; often relates to the use of lenses.

**Dodging** A technique used during enlarging to lighten certain areas of the image on photographic paper by allowing less exposure of those areas than the rest of the print receives.

**Double Exposure** Two separate exposures made on one frame of film or piece of photographic paper. *See also Multiple Exposure.*

**Dry Mounting Press** An electrical device used with heat-sealing dry mounting tissue to mount photographs. *See also Dry Mounting Tissue.*

**Dry Mounting Tissue** An adhesive-coated, self-sticking or heat-sealing tissue used to mount a photograph to a mount board for durability.

**Dual Focal Length Lens** *See Dual-Lens Compact Camera.*

**Dual-Lens Compact Camera** A compact camera with a choice of two lens focal lengths; some have two lenses, others an optical converter that changes from one focal length to the other. *See also Lens Focal Length.*

**DX** An icon meaning data exchange; printed on 35mm film cassettes to indicate that the cassette is encoded to electronically set an automatic camera with the film's speed (ISO), number of exposures, and exposure latitude.

**Easel** *See Enlarging Easel.*

**EE** Abbreviation for electric eye; name for early auto-exposure cameras; also, a photocell sensor (now rare).

**Effective Film Speed** *See Exposure Index.*

**Effective Focal Length** The actual focal length when a camera lens is combined with other optical elements, such as a lens extender. *See also Lens Extender and Lens Focal Length.*

**Effective f/stop Opening** The actual f/stop value of a camera lens aperture when the lens-to-film distance is increased by extension tubes or bellows or a lens extender. *See also Extension Bellows, Extension Tubes, and Lens Extender.*

**EI** Abbreviation for exposure index; sometimes written E.I. *See Exposure Index.*

**Electric Eye (EE) Camera** A name for early auto-exposure cameras. *See also Auto-Exposure.*

**Electronic Flash** A flash unit with a gas-filled tube that produces a high-intensity flash of light of short duration; capable of giving

repeated flashes, which caused the demise of flashbulbs; may be built into the camera or an accessory unit. *See also Flash.*

**Electronic Imaging** Refers to creating images electronically, such as with a filmless digital camera; often called Digital Imaging; an alternative to creating images on photo films and papers that require chemical processing.

**Electronic Rangefinder** A rangefinder that signals audibly and/or visually in the viewfinder when the subject is in focus; may also visually indicate with arrows in which direction to turn the lens to focus the subject. *See also Rangefinder.*

**Emulsion** The light-sensitive chemical coating of film or photo paper, usually silver halides held by gelatin or an acetate, polyester, or paper base; identified as the dull side of a piece of film, and the shiny side of a piece of photo paper.

**Enlargement** A print that is larger than the size of the negative.

**Enlarger** A device for projecting an image from a negative onto a sheet of photo paper in order to make a print the size desired by the photographer.

**Enlarger Color Head** A diffusion-type enlarger lamphouse with built-in dichroic filters that are used to control color balance when exposing color photo papers, and to control contrast when exposing variable contrast black-and-white photo papers. *See also Color Balance, Contrast, Diffusion Enlarger, and Variable Contrast Photo Papers.*

**Enlarging** The process of making an enlargement.

**Enlarging Easel** Used in the enlarging process to hold the photo paper flat to ensure sharply focused images; some easels can be adjusted to crop the image as desired; also makes white borders on the print. *See also Cropping.*

**Enlarging Meter** A meter with a photocell that reads the light of the negative image projected by the enlarger; indicates the correct exposure time and contrast grade of the photo paper to use when making a black-and-white print. *See also Contrast Grade and Photocell.*

**EV** Abbreviation for exposure value. *See Exposure Value.*

**Evaluative Metering** *See Multizone Metering.*

**Existing Light** *See Ambient Light.*

**Expiration Date** The date printed on photographic film and photo paper boxes or packages indicating the time after which the manufacturer no longer guarantees the characteristics of the film or paper. *See also Shelf Life.*

**Exposure** The amount of light acting on the emulsion of a film or paper; with cameras, exposure is controlled by the lens opening

and shutter speed; with enlargers, the lens opening and enlarger timer control exposure.

**Exposure Compensator** A camera control that permits the photographer to purposely overexpose or underexpose automatic exposures in a range that can be set from one-third to five f/stops, depending on the model.

**Exposure Index** The correct term for film speed whenever a film is rated at other than its official ISO film speed; identical to ISO numbers; often abbreviated EI or E.I. *See also ISO.*

**EI** Abbreviation for exposure index. *See Exposure Index and also ISO.*

**Exposure Latitude** The extent of a film's ability to produce an acceptable negative or slide image from a wide range of exposures; black-and-white films have more exposure latitude than color films; color print films have more exposure latitude than color slide films.

**Exposure Lock** On an auto-exposure camera, a button or other locking device that "holds" the exposure until the subject is reframed in the viewfinder and the shutter released; on a hand-held meter, it holds the reading for subsequent reference by the photographer; also called Memory Lock.

**Exposure Meter** A device, hand-held or built into a camera, that reads the intensity of light falling on or reflected by a subject; once calibrated with a film speed (ISO), it indicates the f/stops and shutter speeds that can be used for a proper exposure; also called a Light Meter. *See also Flash Meter.*

**Exposure Setting** The f/stop and shutter speed combination chosen by the photographer or an auto-exposure camera.

**Exposure Value** A system of numbers to indicate the range of sensitivity of exposure meters to levels of light; abbreviated EV; ranges from EV −5 (very dark) to EV 21 (very bright).

**Extension Bellows** A nonoptical, adjustable accordionlike device used for making close-ups; attached between the camera lens and camera body to increase lens focal length and magnify the subject. *See also Extension Tubes.*

**Extension Flash** One or more flash units used in addition to the main flash. *See also Slave Flash.*

**Extension Rings** *See Extension Tubes.*

**Extension Tubes** Nonoptical, rigid metal or plastic tubes or rings of various lengths used for making close-ups; inserted between the camera lens and camera body to increase the lens focal length and magnify the subject; also called Extension Rings. *See also Extension Bellows.*

**Eye-Control Autofocusing** A unique feature of a Canon SLR camera model that automatically focuses on the specific part of the picture area that the photographer is looking at in the viewfinder; enables the photographer to change the point of focus by simply moving his eye.

**Eye Cup** A rubber ring or shield around the viewfinder's eyepiece to prevent eyeglasses from getting scratched and to block light from the photographer's peripheral vision.

**Eyepiece Shutter** A manually activated device in the eyepiece of some SLR cameras; used to prevent stray light from adversely affecting the camera's metering system while an automatic time exposure is being made; also called an Eyepiece Blind.

**Eyepiece Correction Lens** An optical attachment to the viewfinder's eyepiece to correct for farsightedness or nearsightedness so the photographer can see the subject image more sharply. *See also Diopter Correction Control.*

**Fahrenheit** A degree scale of temperatures that is slowly being superseded in the U.S. by the Celsius scale; written as ° F.

**Fast Film** *See High-Speed Film.*

**Fast Lens** *See Lens Speed.*

**Ferrotype Tin** A chrome-plated steel sheet or surface used for drying glossary fiber-base photo papers; not used for self-glossing resin-coated (RC) photo papers. *See also Fiber-Base Photo Paper and Resin-Coated Photo Paper.*

**Fiber-Base Photo Paper** Conventional photographic paper; takes longer to process, wash, and dry than resin-coated (RC) photo paper. *See also Resin-Coated Photo Paper.*

**Field of View** *See Angle of View.*

**Fill Flash** Light from a flash unit used to augment the existing illumination or main flash unit; often used to lessen or eliminate shadows in a picture; also called Fill-in Flash and Synchro-Sunlight Flash.

**Fill-in Light** *See Fill Light.*

**Fill Light** Light from any source used to augment the main illumination in order to brighten dark areas in a picture, such as shadows.

**Film** Acetate or polyester material coated with light-sensitive chemicals, usually silver halides in a gelatin base, that registers the images formed in a camera by its lens.

**Film Advance Control** A camera control that offers a choice of single frame advance or continuous advance; determines how many frames of film will be exposed when the shutter release button is fully depressed. *See also Continuous Advance and Single Frame Advance.*

**Film Back** *See Film Magazine.*

**Film Cartridge** A lighttight film container used in Instamatic and subminiature cameras. *See also Instamatic Camera and Subminiature Camera.*

**Film Cassette** A lighttight film container used in 35mm and APS cameras; 35mm size is called a *magazine* by Kodak; exposed 35mm film must be rewound into its cassette before being removed from the camera.

**Film Cassette Window** A small window in the camera back that shows when a film cassette is in the camera; allows the photographer to read information about the film (name, ISO speed, number of exposures) that is printed on the cassette.

**Film Cleaner** A special solvent used to eliminate fingerprints and other marks from the film's surface without harming the film itself.

**Film Emulsion** *See Emulsion.*

**Film Frame Counter** A counter built into a camera that indicates the number of film frames exposed or yet to be exposed.

**Film Holder** A lighttight reusable device that is loaded with sheet film for use in large-format cameras. *See also Film Packet, Large-Format Camera, and Sheet Film.*

**Film Latitude** *See Exposure Latitude.*

**Film Leader** The narrow portion of 35mm film that extends from the film cassette and attaches to the take-up spool or mechanism in the camera. *See also Film Take-up Spool.*

**Film Leader Retriever** An inexpensive device for retrieving the leader of a 35mm film that has been wound entirely into its cassette. *See also Film Leader.*

**Film Load Indicator** An indicator on some cameras that shows whether the camera is loaded with film.

**Film Loading Mark** A mark in the film chamber of autoload 35mm cameras that indicates how far to pull the film leader from the film cassette. *See also Autoload, Film Cassette, and Film Leader.*

**Film Magazine** An attachment for medium-format and some other cameras that holds a specific type or size of film; may be designed for roll, sheet, instant or 35mm film, and/or a specific image size, such as 6 × 6cm; also, Kodak's name for a 35mm film cassette. *See also Medium-Format Camera.*

**Film Pack** A set of sheets of film that are placed in a studio, view, press, or instant camera as a package and give a specific number of exposures. *See also Film Packet.*

**Film Packet** An individual envelope with one or two sheets of film that is loaded in normal light into a film holder for use in large-format cameras. *See also Film Pack and Sheet Film.*

**Film Plane** The position of the emulsion side of the film inside the camera. *See also Emulsion and Film Plane Indicator.*

**Film Plane Indicator** A ⊖ mark on the top of some camera bodies, which indicates the location of the film plane inside the camera; used in making close-ups when accurate measurement from the film plane to the subject or lens is required. *See also Film Plane.*

**Film Pressure Plate** A broad metal or plastic plate in the back of the camera designed to keep the film flat and in the proper plane for sharp focusing.

**Film Prewind** A feature of some 35mm cameras that winds the entire roll of unexposed film onto the film take-up spool immediately after loading the film cassette; its purpose is to avoid ruining any exposed frames if the camera back is accidentally opened.

**Film Rewind Button** A button, lever, or switch on 35mm cameras that releases the camera's take-up spool mechanism and allows the film to be rewound into its cassette.

**Film Rewind Crank** A crank or knob on 35mm cameras that engages the film rewind mechanism for rewinding the film into its cassette.

**Film Scanner** An electronic device that views a negative or slide to digitally record its image. *See also Photo Scanner.*

**Film Speed** A system of numbers, commonly called ISO, to indicate a film's relative sensitivity to light; the larger the ISO number, the more sensitive the film. *See also ASA, DIN, and ISO.*

**Film Speed Control** A dial or buttons on some cameras and hand-held exposure meters used to set the film speed (ISO). *See also Film Speed and Exposure Meter.*

**Film Speed Dial** A dial engraved with ISO numbers on some cameras and hand-held exposure meters; used to set the film speed. *See also Film Speed and Exposure Meter.*

**Film Sprockets** A twin set of sprockets in 35mm cameras designed to engage corresponding sprocket holes in 35mm film so that the film advances properly.

**Film Status Indicators** Icons and numbers on one end of an APS film cartridge that indicate the status of the film inside: unexposed, partially exposed, fully exposed but not yet processed, or exposed and processed. *See also APS.*

**Film Take-up Spool** A built-in spool in cameras to which the film leader attaches when loading the camera. *See also Film Leader.*

**Film Transport Indicator** An indicator that signals when film is being properly advanced in a 35mm camera.

**Film View Window** A small window on the back of some cameras

that shows the film name, speed, and number of exposures when a film cassette or cartridge is in the camera.

**Filter** A piece of colored or coated glass, plastic, or acetate placed in front of the camera lens that alters the light reaching the film; filters are also used with enlargers for making color prints and for black-and-white printing on variable contrast photo papers.

**Filter Factor** A number that indicates the increase in exposure required when a filter is used; the filter factor is expressed with a times sign (×).

**Fish-Eye Lens** An extreme wide-angle lens that often has a bulging front lens element resembling a fish's eye and produces a circular image; fish-eye lenses designated as *full-frame* rather than *circular* are designed to produce a rectangular image instead.

**Fixed Focal Length** Refers to a lens with a single focal length; also called Single Focal Length. *See also Zoom Lens.*

**Fixed Focus Lens** An inexpensive lens with nonadjustable focus; sometimes called a Focus-Free Lens.

**Fixer** A chemical, sometimes called hypo, which removes undeveloped silver halides from film and paper, and which fixes the image on the film of paper so it does not change density by fading.

**Flare** *See Lens Flare.*

**Flash** A very bright and brief source of artificial light used to illuminate subjects for photography; may be an electronic flash unit, a flashbulb, flashcube, Magicube, flipflash, or flashbar. *See also Electronic Flash.*

**Flash Adapter** A plastic lens placed in front of the flash head to spread the flash light for greater coverage when using a wide-angle lens, or to concentrate the flash light to narrow the coverage when a telephoto lens is used.

**Flashbar** An oblong pack of tiny blue flashbulbs and reflectors that produces ten flashes; requires no battery power; designed for some older Polaroid instant cameras.

**Flash Bracket** A bracket used to attach a flash unit to the camera; screws into the camera's tripod socket.

**Flashcube** A disposable plastic cube containing four blue flashbulbs and their reflectors; requires battery power to fire the bulb; used on some older simple cameras and Instamatic-type cameras.

**Flash Guide Number** A number commonly used to indicate the light output of an electronic flash unit; varies according to the type and size of the flash unit and the speed of your film; also used to manually calculate exposures with flash: the distance from flash to subject (in feet or meters) divided into the flash guide number

indicates the f/stop to set for a proper exposure. *See also Flash Light Output.*

**Flash Light Output** The maximum amount of light produced by a flash unit; often indicated by the unit's flash guide number—the higher that number, the more powerful the flash; also called Flash Power. *See also Flash Guide Number.*

**Flash Light Output Control** A control for an electronic flash unit that varies the duration of the flash and thus its light output; the control settings indicate fractions of the full light output: 1/2, 1/4, 1/8, 1/16, 1/32, and 1/64; used for manual flash exposures; also called Variable Power Control. *See also Flash Light Output and Manual Flash.*

**Flash Meter** A hand-held exposure meter designed to read the light of electronic flash and indicate correct exposures; often a feature of regular ambient-light exposure meters.

**Flash Mode Selector** A control on an autoflash unit to select the type of flash exposure: TTL-autoflash, non-TTL autoflash, or manual flash. *See also Manual Flash, Non-TTL Autoflash, and TTL Autoflash.*

**Flash Power** *See Flash Light Output.*

**Flash Range** The minimum and maximum distances that the flash light will cover without overexposing or underexposing the picture. *See also Automatic Flash Operating Range.*

**Flash Synchronization** Internal electrical and mechanical camera controls that ensure that the shutter is fully opened when the flash goes off to expose the film.

**Flash Test Button** *See Open Flash Button.*

**Flat-Field Projection Lens** A general type of projector lens for use with slides in all types of mounts: plastic, cardboard, and glass; sometimes abbreviated FF. *See also Curved-Field Projection Lens.*

**Flat Flash** *See Front Lighting and On-Camera Flash.*

**Flat Lighting** *See Front Lighting.*

**Flipflash** An oblong pack of tiny blue flashbulbs and reflectors that produces eight flashes; requires no battery power, designed for some older Polaroid instant and Instamatic-type cameras.

**Fluorescent Light Filters** Filters used on a camera lens to color-balance the light from fluorescent lamps; sometimes abbreviated FL. *See also Color Balance and Color-Compensating Filters.*

**f/Number** *See f/Stop.*

**Focal Length** *See Lens Focal Length.*

**Focal Plane Shutter** A shutter built into the camera body just in front of the film plane; usually two flexible curtains that travel in

the same direction, horizontally or vertically; some are capable of shutter speeds to 1/4000 and even 1/8000 second; common in single lens reflex cameras. *See also Leaf Shutter.*

**Focus** To adjust a lens so the light rays transmitted by it are sharply defined on the photographic film or paper.

**Focus Control Switch** A switch or button on SLR autofocus lenses that sets the lens to autofocus or manual focus. *See also Focus Mode Selector.*

**Focus Detection Area** The area, marked by a circle or brackets in SLR viewfinders, that is covered by the autofocusing system; for sharp focus, the camera is aimed so the main subject is at least partially located within the focus detection area.

**Focusing Distance Scale** *See Lens Distance Scale.*

**Focusing Frame** A circle or set of brackets in the viewfinders of compact cameras that marks the area covered by the autofocusing system; for sharp focus, the camera is aimed so the main subject is located within the focusing frame.

**Focusing Screen** A ground-glass screen used for focusing and viewing the subject image in the viewfinders of SLR cameras; may be interchangeable with other screens featuring various aids for focusing and framing.

**Focus Mode Selector** A switch on SLR autofocus cameras that sets the cameras to autofocus or manual focus. *See also Focus Control Switch.*

**Focus Priority** A feature of autofocus lenses that prevents the shutter from being fired until the lens is in sharp focus; in effect on SLR autofocus cameras that are set to single shot focus. *See also Release Priority and Single Shot Focus.*

**Fog** Usually stray light that registers on the film or photo paper and reduces the contrast of the image.

**Fog Filter** A filter used in front of the camera lens to create the effect of fog in scenic pictures.

**Foreground** The area in focus in front of the picture's main subject or center of interest.

**Framing** A composition technique to position the camera so that the foreground objects in the picture form a natural frame at the top of, on the side of, or around the main subject; also refers to composing the picture within the viewfinder.

**Framing Masks** Masks or marks that appear in the viewfinder to indicate the size and shape of the image that will appear on the film, or in the print, as is the case with APS cameras.

**Freeze Focus** A feature of some SLR autofocus cameras that trips

the shutter automatically when a moving subject appears at a pre-focused spot; also called Trap Focus.

**Front Lighting** A term used when the main source of illumination is coming from the direction of the camera and falling on the front of the subject; offers uniform illumination that is relatively shadowless, and thus lacks a feeling of depth; also called Flat Lighting.

**f/Stop** Used to control the amount of light transmitted by a lens; technically, a number that indicates what fraction the diameter of a lens opening is in regard to the focal length of the lens. *See also Lens Aperture, Lens Diaphragm, and Lens Focal Length.*

**Full Frame Camera** Generally refers to a 35mm camera that exposes the standard frame size of 35mm film. *See also Half-Frame Camera.*

**Full Stop** Indicates a change in the lens opening from one f/stop number to the next closest number, which either doubles or halves the amount of light. *See also Half-Stop.*

**Gadget Bag** *See Camera Bag.*

**Ghost Images** Secondary images that appear in a negative or print; often caused by accidental double exposures, a faulty shutter, an optically poor lens, or too slow a shutter speed when using flash; also called Ghosting.

**Graded Contrast Photo Paper** Photographic paper in specific contrast grades for producing black-and-white prints of good contrast from negatives of varying contrasts; contrast grades numbered 0 through 5. *See also Contrast Grade and Variable Contrast Photo Paper.*

**Graduate** A plastic or glass vessel marked for liquid measurement and used when mixing chemicals.

**Graduated Filter** A camera filter with a clear portion that gradually changes to a neutral density or colored portion; used to alter the exposure or coloration of a certain portion of the picture area. *See also Neutral Density Filter.*

**Grain** The sand grain or pebble-like appearance of some negatives, slides, or prints; more evident in films with faster ISO speeds, films that have been overdeveloped, or prints that have been greatly enlarged.

**Gray Card** A piece of gray-colored cardboard that reflects 18 percent of the light it receives; used when making exposure readings to represent a medium (middle) tone.

**Gray Market** Refers to foreign-made cameras, lenses, and other photographic merchandise available from U.S. retailers who have not obtained the goods from the manufacturers' authorized dis-

tributors; usually sold at reduced prices but lacking a U.S. warranty for factory-authorized repairs.

**Guide Number** *See Flash Guide Number.*

**Hair Light** *See Accent Light.*

**Half-Frame Camera** A camera that uses 35mm film but makes an image only half the standard 35mm frame size; allows twice the number of exposures. *See also Full Frame Camera.*

**Half-Stop** An intermediate lens opening between two major f/stops; half of a full stop. *See also Full Stop.*

**Halogen Bulb** Produces very bright tungsten light; commonly used in studio lights; also called Quartz-Iodine Bulb, Quartz-Tungsten Bulb, and Tungsten-Halogen Bulb. *See also Studio Light and Tungsten Light.*

**Hand-held Exposure Meter** Refers to any exposure meter that is not built into a camera. *See also Exposure Meter.*

**Handle-Mount Flash** An accessory flash unit that has a handle for the photographer to conveniently hold or to mount on a flash bracket attached to the camera. *See also Built-in Flash and Shoe-Mount Flash.*

**Hard Lighting** *See Directional Lighting.*

**Haze Filter** *See Ultraviolet Filter.*

**High Contrast** A term used when there is an extreme difference in brightness between the lightest and darkest parts of a subject, negative, or print.

**Highlight Detail** Detail that is evident in the highlight (bright) areas of a picture; a consideration when making an exposure meter reading. *See also Shadow Detail.*

**High-Speed Film** A film with an emulsion that is very sensitive to light; has a film speed of ISO 400 or higher; also called Fast Film. *See also Medium-Speed Film and Slow-Speed Film.*

**High-Speed Sync** A feature of some autoflash units that allows flash exposures at faster shutter speeds than normally allowed for flash synchronization. *See also Flash Synchronization.*

**Hot Light** A continuously burning tungsten-type light; a term used by studio photographers to differentiate it from momentary flash light. *See also Flash and Tungsten Light.*

**Hot Shoe** A mount on the camera for shoe-mount flash units; makes electrical connections between the flash and the camera's flash synchronization and shutter system; eliminates the need for a connecting flash cord, but limits the location of the flash unit to the hot-shoe position. *See also Flash Synchronization and Shoe-Mount Flash.*

**Hyperfocal Distance** The point of focus of a lens at which subjects

from half that distance to infinity are in focus; varies according to lens focal length and f/stop.

**Hypo Clearing Agent** A chemical solution used to remove the fixer from film or fiber-base prints and thus speed up washing time; also called Hypo Neutralizer.

**Image Stabilization** Refers to a lens or camera feature that counteracts camera movement to produce a sharp image instead of a blurred one; also termed Vibration Reduction. *See also Camera Movement.*

**Incident-Light Meter** An exposure meter designed to read the light falling on the subject; placed at the subject position and pointed toward the camera.

**Index Print** A small color print showing each frame shot on a roll of film; returned by APS processing services with the negatives as a convenient record of each exposure taken and to assist in ordering reprints and enlargements.

**Infinity** The point or distance beyond which everything will be in focus; indicated by the symbol ∞ on some camera lenses.

**Infinity Lock** A button or switch on autofocus compact cameras to lock the point of focus at infinity; prevents out-of-focus pictures in some situations, as when shooting through glass windows.

**In-Focus Indicator** An audible beep and/or visual signal in the viewfinder that indicates when the subject is in focus.

**Information Exchange** A feature of many APS cameras that records exposure and other information on the film's magnetic coating, which is then read by the processing machine to produce the best color prints possible; often abbreviated IX. *See also APS Camera.*

**Infrared Film** Special film that records infrared radiation (heat intensity) as well as light intensity; available as black-and-white and color film; for best results, a filter is required on the camera lens when exposing the film.

**Infrared Focus Indicator** A special mark on the barrel of some camera lenses to indicate where to set the focusing distance when shooting black-and-white infrared film; does not apply to color infrared film.

**Instamatic Camera** A popular point-and-shoot camera that's no longer manufactured; uses 126-size cartridge film. *See also Pocket Instamatic Camera.*

**Instant Camera** A self-processing type of camera that produces its own color or black-and-white prints in a matter of minutes; often called a Polaroid camera after the company that has been the major developer of instant cameras.

**Instant Film** Color and black-and-white film designed for instant

cameras; self-develops in a matter of minutes; commonly called Polaroid film; also available in 35mm size to produce color or black-and-white slides. *See also Instant Camera and Integral Instant Film.*

**Instant-Return Mirror** A mirror in most single lens reflex cameras that reflects the image of the subject into the viewfinder to the photographer's eye, flips out of the path of light when the shutter opens so the film can be exposed, then instantly returns to reflect the subject image again into the viewfinder; also called a Quick-Return Mirror.

**ISO** A system of numbers determined by the International Standards Organization that indicates the relative speeds of films; written as a combination of two superseded film speed rating systems, ASA and DIN; the first number is the former ASA, the second number is the former DIN designated with degree (°) symbol, such as: ISO 100/21°. *See also ASA, DIN, and Film Speed.*

**Integral Instant Film** A type of instant film that automatically turns itself into the finished photograph without your having to peel apart and discard part of the film pack. *See also Instant Film.*

**Interchangeable Film Back** *See Film Back.*

**Interchangeable Lenses** Lenses that can easily be removed from a camera and replaced by others; interchangeability is restricted by the lens mount and camera model.

**Internal Focusing** Refers to the design of some lenses that move optical elements to and fro within the lens to achieve sharp focus; the lens barrel itself does not adjust forward and backward.

**Internegative** A negative made from an original color or black-and-white transparency (slide); usually an intermediate step in making photo prints or additional transparencies. *See also Transparency Film.*

**IX** Abbreviation for Information Exchange. *See Information Exchange.*

**Kelvin** A unit of measurement used to indicate the relative color temperatures of light sources; abbreviated K. *See also Color Temperature.*

**Keystoning** A type of unwanted image distortion; when the camera is tilted up, notably in architectural photography with wide-angle lenses, vertical parallel lines of the subject appear to converge at the top; when a slide projector is tilted up toward a screen, the projected slide image widens at the top.

**Large-Format Camera** A camera using a large-format film (4 × 5, 5 × 7, 8 × 10 inches [10.2 × 12.7, 12.7 × 17.8, 20.3 × 25.4cm]);

usually has a ground-glass back for focusing the subject; also called a Studio Camera or a View Camera. *See also Medium-Format Camera and Small-Format Camera.*

**Latent Image** The invisible image caused by light which registers on a film or photo paper emulsion when an exposure is made; the image cannot be seen until the film or paper is developed.

**Latitude** *See Exposure Latitude.*

**LCD** Abbreviation for liquid crystal display; electronic-powered information panels in cameras, flash units, and exposure meters that present digital readouts to the photographer.

**Leading Lines** A composition technique using natural lines, such as roads, fences, and rivers, to direct attention to the center of interest in a photograph. *See also Composition.*

**Leaf Shutter** A shutter of overlapping metal leaves usually built within the camera lens; common in 35mm compact cameras and other rangefinder-type cameras; mechanically limited to a maximum speed of 1/500 second; sometimes called a Between-the-Lens Shutter or a Lens Shutter. *See also Focal Plane Shutter.*

**LED** Abbreviation for light-emitting diode; tiny light(s) signaling or serving various functions in cameras and other photo equipment.

**Lens** Optical pieces of glass (or plastic) designed to focus rays of light so as to produce an image on film, photographic paper, or projection screen; adjustable lenses feature focusing and f/stop controls.

**Lens Aperture** The adjustable lens opening that determines the amount of light allowed to pass through the lens. The relative size of the aperture is indicated by f/stop numbers; also called Lens Diaphragm. *See also Lens Diaphragm and f/Stop.*

**Lens Aperture Ring** A ring on a lens that is turned to adjust the lens opening (f/stop).

**Lens Cleaner** A special solvent used sparingly with lens tissue to clean fingerprints and other residue off the surfaces of a lens.

**Lens Cleaning Cloth** A lint-free microfiber cloth designed to easily and safely clean lens optics.

**Lens Converter** *See Lens Extender.*

**Lens Diaphragm** The aperture mechanism, adjusted according to f/stop, which determines the size of the lens opening; also called Lens Aperture. *See also Aperture and f/Stop.*

**Lens Distance Scale** The scale of distances, in feet and/or meters, on the lens focusing ring; used to indicate the distance from the camera to the point where the lens is sharply focused, and to figure depth of field; sometimes called Focusing Distance Scale. *See also Lens Focusing Ring.*

**Lens Extender** An optical accessory inserted between the camera body and camera lens to increase the focal length of the lens, often to make it a more powerful telephoto; also called a Lens Converter, Tele-extender, or Teleconverter.

**Lens Flare** An often disturbing effect caused by light shining directly on the surface of the lens; reduces the contrast of the photographed subject.

**Lens Focal Length** Indicates the relative subject image size produced by a lens; the greater the focal length, the larger the image size; often measured in millimeters (mm); the larger the mm number, the greater the focal length; technically, focal length is the distance from the optical center of a lens to the point behind the lens where the light rays from an object at infinity are brought into focus.

**Lens Focusing Ring** The ring or portion of a lens barrel that is turned back and forth to focus the lens.

**Lens Hood** *See Lens Shade.*

**Lens Opening** *See Aperture, Diaphragm, and f/Stop.*

**Lens Reversing Ring** An adapter ring for mounting a normal or wide-angle lens in reverse (end-for-end) position on a SLR camera in order to make close-ups; also called a Macro Adapter Ring.

**Lens Shade** A metal, plastic, or rubber extension in front of a lens used to shield the lens from direct rays of light or rain; also called a Lens Hood.

**Lens-Shutter Camera** A less common name for 35mm compact camera; indicates that the shutter is built into the lens, not into the camera body, as is the case with 35mm single lens reflex (SLR) cameras. *See also Compact Camera.*

**Lens Speed** Refers to the largest f/stop opening of a lens; a lens with a very large opening (such as f/1.4) is called a fast lens because it transmits more light than a lens with a smaller maximum opening.

**Lenticular Projection Screen** A screen with a ribbed plastic surface to reflect the projected image; reflects the least amount of ambient light in a room. *See also Beaded Projection Screen and Matte Projection Screen.*

**Light-Balancing Filter** A filter used on the camera lens to balance the color temperature of a light source with the color temperature of a film; yellowish filters offset excessive blue in the light; bluish filters offset excessive yellow in the light. *See also Color Temperature.*

**Light Box** An illuminated device for viewing, editing, and arranging slides; also called a Slide Sorter.

**Light-Emitting Diode** *See LED.*

**Lighting** Usually refers to the type or direction of illumination falling on a subject.

**Lighting Ratio** Indicates the relative brightness of the main light in relation to the brightness of the fill light; a 2:1 ratio indicates that the main light (the first number) is twice as bright as the fill light.

**Light Meter** *See Exposure Meter.*

**Light Output** *See Flash Light Output.*

**Light Output Control** *See Flash Light Output Control.*

**Linear Polarizing Filter** A type of polarizing filter for general use except on certain autofocus and auto-exposure cameras. *See also Circular Polarizing Filter and Polarizing Filter.*

**Liquid Crystal Display** *See LCD.*

**Long Lens** A lens with a focal length that is greater than a normal lens; a general telephoto lens. *See also Normal Lens.*

**Loupe** Name for a magnifier that is used to examine details in a negative or transparency.

**Macro Adapter Ring** *See Lens Reversing Ring.*

**Macro Flash** *See Ring Light.*

**Macro Lens** A lens primarily designed for close-up photography, but capable of serving as a normal or telephoto lens as well; allows close lens-to-subject focusing without accessory equipment; also called a Close-Focus Lens or a Micro Lens. *See also Close-up Lens.*

**Macro Mode** A setting on some compact cameras that allows focusing very near to a subject for close-up images.

**Magazine** *See Film Magazine.*

**Magicube** A mechanically ignited flashcube that does not require battery power to fire the four flashbulbs it contains; commonly used on older Instamatic-type cameras designed especially for Magicubes. *See also Flashcube.*

**Manual Exposure** An exposure set manually and under the total control of the photographer, who selects both the lens opening (f/stop) and shutter speed; also, an exposure mode setting (M) on some SLR cameras with multimode exposure. *See also Multimode Exposure.*

**Manual Flash** A term indicating that the flash exposure is determined manually. *See also Autoflash.*

**Matte Projection Screen** A screen with a flat surface to reflect the projected image; produces the sharpest image but reflects the least amount of projected light. *See also Beaded Projection Screen and Lenticular Projection Screen.*

**Maximum Lens Aperture** Refers to the widest opening (f/stop) of a lens; also termed Maximum Lens Opening and Maximum f/Stop.

**Medium-Format Camera** A camera using films larger in size than 35mm or APS films; often described by the relative size of the image the camera produces: 6 × 6cm (2¼ × 2¼ inch), 6 × 4.5, 6 × 7, or 6 × 9cm. *See also Large-Format Camera and Small-Format Camera.*

**Medium-Speed Film** A film with an emulsion that is more sensitive to light than a slow-speed film, and less sensitive to light than a high-speed film; generally ranges in film speed from ISO 64 to ISO 200. *See also High-Speed Film and Slow-Speed Film.*

**Micro Lens** *See Macro Lens.*

**Microprism Focusing Collar** A focusing aid in the viewfinders of some manual-focus SLR cameras; a ring of shimmering light surrounding a split-image rangefinder that becomes sharp when the subject is in focus.

**Mid-roll Change** A feature of APS film cassettes allowing them to be removed from the camera, and reloaded again later, without ruining any exposed or unexposed film frames; permits switching from one type or speed of APS film to another at any time without wasting film.

**Minipod** A very small tripod that can easily be carried in a camera bag. *See also Tripod.*

**Mirror Lens** A reflex-type telephoto lens of a greater focal length (500mm to 2000mm) that incorporates mirrors to reduce the length, weight, and cost of the lens; has a fixed aperture that cannot be changed; technically called a Catadioptric Lens.

**Mirror Lockup** A device on some single lens reflex cameras to lock up the viewfinder's instant-return mirror to avoid any vibration during a time exposure. *See also Instant-Return Mirror.*

**mm** Abbreviation for millimeter.

**Modeling Light** A tungsten-type light that is a feature of some electronic flash studio lights; it is turned on in order to aim the flash prior to the exposure and show what shadows might result from the flash. *See also Studio Light.*

**Motor Drive** A mechanism built into the camera or an accessory attachment that automatically advances the film and cocks the shutter after each exposure; also rewinds the film. Sometimes called an Autowinder.

**Multicontrast Photo Paper** *See Variable Contrast Photo Paper.*

**Multicontrol Back** *See Multifunction Back.*

**Multiexposure Mode** *See Multiple Exposure Control.*

**Multifunction Back** An accessory camera back that replaces the regular back of some 35mm SLR cameras; offers a choice of functions, such as film imprinting with time and exposure data, expo-

sure bracketing, and sequence shooting on a certain number of frames or at preset intervals; also called a Multicontrol Back. *See also Data Back.*

**Multigrade Photo Paper** *See Variable Contrast Photo Paper.*

**Multimode Exposure** Varied controls on an auto-exposure SLR camera that offer aperture-priority exposure, shutter-priority exposure, programmed exposure, and manual exposure; may also have other auto-exposure options. *See also Aperture-Priority Exposure, Manual Exposure, Programmed Exposure, and Shutter-Priority Exposure.*

**Multimode Exposure Selector** A camera dial or buttons used to select a specific exposure mode. Also called a Multimode Exposure Control Dial. *See also Multimode Exposure.*

**Multiple Exposure** Two or more exposures made on the same film frame or piece of photographic paper.

**Multiple Exposure Control** A button, lever, or setting on some 35mm cameras that allows the shutter to be recocked without advancing the film or film frame counter in order to make additional exposures on the same frame of film; called the Multiexposure Mode on some compact cameras.

**Multiple Flash** Two or more flash units used to illuminate the subject; sometimes refers to a rapid series of flash exposures. *See also Repeating Flash.*

**Multiple-Image Lens** An accessory lens mounted in front of the camera lens to reproduce the subject in three, five, or six identical images; also called a Multi-Image Lens.

**Multizone Metering** An exposure metering system in some SLR cameras that utilizes multiple light-reading zones of varied number, size, and location to calculate the best exposure for the full area seen in the viewfinder; also called Evaluative, Multipattern, Multisegment, Multisensor, and Matrix Metering. *See also Center-Weighted Metering and Spot Metering.*

**Natural Light** Existing light, usually sunlight, that is not supplemented with artificial light by the photographer; sometimes called Ambient Light, Available Light, or Existing Light. *See also Artificial Light.*

**Negative** Film that has been developed in which the light and dark areas of the subject are reversed.

**Negative Carrier** A glass or glassless device in the enlarger head used to hold negatives flat and in position for making enlargements.

**Neutral Density Filters** Filters that reduce the intensity of light waves without altering their colors; often abbreviated as ND.

**Newton's Rings** Distracting rainbowlike circles or patterns which

occasionally appear on a projection screen when glass-mounted slides are heated by the projector bulb.

**Nicad Battery** A type of rechargeable battery sometimes used to power accessory flash units; short for nickel cadmium, the battery's main chemical components.

**Non-TTL Autoflash** Indicates that the flash unit does not use a camera's through-the-lens metering system to automatically determine the flash exposure; flash light reflected by the subject is read by a photocell sensor on the flash unit. *See also TTL Autoflash.*

**Normal Lens** The lens designed for a particular camera that produces an image similar in perspective to what the photographer sees with the naked eye; the focal length of a normal lens varies according to the film size and is approximately equal to the diagonal of the film; a normal lens of a 35mm camera usually is 50mm; of a 6 × 6 camera, 80mm; sometimes called a Standard Lens.

**Off-Camera Flash** A flash unit that is not mounted on the camera; avoids flat lighting; allows varied types of lighting; connection to the camera is made with a flash cord. *See also Front Lighting.*

**Off-the-Film Flash Metering** *See OTF.*

**On-Camera Flash** Flash that is built into or mounted on the camera; also called Flat Flash. *See also Front Lighting and Off-Camera Flash.*

**One-Time-Use Camera** *See Single-Use Camera.*

**One-Touch Zoom Lens** A zoom lens with one control ring on the lens barrel to adjust the focal length and the focus. *See also Two-Touch Zoom.*

**Open-Aperture Metering** A feature of SLR cameras that keeps the lens at its widest opening while the aperture ring is being adjusted to set the f/stop for an exposure; allows the brightest possible image in the viewfinder for easier focusing and framing; sometimes called Full-Aperture Metering. *See also Stop-Down Metering.*

**Open Flash** A technique for making a flash exposure with a flash unit that is not connected by a cord to the camera; the flash unit is fired manually with the open flash button while the shutter is kept open. *See also Open Flash Button.*

**Open Flash Button** A button on a flash unit that can be pressed to manually fire the flash; also called a Test Flash Button.

**Opening Up the Lens** Means the photographer is adjusting the lens aperture to a wider f/stop. *See also Aperture, f/Stop, and Stopping Down the Lens.*

**OTF** Abbreviation for off-the-film; generally indicates that the cam-

era's auto-exposure metering system reads the light from an electronic flash at the film plane; used for autoflash exposures.

**Overexposure** Excessive exposure of photographic film or paper; overexposed negatives are too dense, overexposed slides are too light; overexposed prints made from negatives are too dark, and overexposed prints made from slides are too light.

**P&S** Abbreviation for point-and-shoot. *See Point-and-Shoot Camera.*

**Painting with Light** Refers to illuminating a large picture area with a single flash unit that is manually fired a number of times from several locations while the shutter is open; open flash is used so that a connecting cord is not needed between the flash and the camera. *See also Open Flash.*

**Panchromatic** Usually used to describe black-and-white film that is sensitive to all colors of light; all black-and-white films for general photography today are panchromatic.

**Pan Head** A type of tripod head to move the camera from side to side; also has a tilt feature to move the camera up and down. *See also Ball Head and Tripod.*

**Panning** Describes the technique of photographers who follow the action of a subject in the camera's viewfinder and release the shutter while the camera is still moving; the result is a stop-action picture of the moving subject and a blurred background; gives a feeling of motion to a photograph.

**Panoramic Camera** A camera specifically designed to produce a very wide image. *See also Panoramic Format and Panoramic Mode.*

**Panoramic Format** A setting on APS cameras that masks the viewfinder to a panoramic format; also indicates to APS photo-finishing machines to print the film in a panoramic format. *See also APS Camera.*

**Panoramic Mode** A setting on 35mm compact cameras that masks the viewfinder and the film to a panoramic format.

**Paper Safe** A lightproof storage container for photo papers in the darkroom; its easy access eliminates cumbersome retrieval of photo papers from their double-envelope packages or boxes.

**Paper Speed** A system of numbers, established by ISO and ANSI, to indicate a photographic paper's relative sensitivity to light; the greater the ISO or ANSI number, the more sensitive the paper. *See also ANSI and ISO.*

**Parallax Error** A problem common in compact and other rangefinder cameras when the subject is very close to the camera because the viewfinder sees the subject at a different angle than does the camera lens; can be corrected by slightly changing the angle of the camera before making the exposure.

**Passive Phase Detection Autofocus** A type of autofocusing system commonly found in SLR cameras. See also *Active Infrared Autofocus*.

**PC Cord** A common type of flash cord used to connect a flash unit to a camera; named for the type of plug on the cord, Prontor-Compur.

**PC Lens** *See Perspective-Correction Lens.*

**Pellicle Mirror** A stationary mirror in a few single lens reflex cameras that reflects the subject image to the photographer's eye in the viewfinder and also allows the image to pass to the film.

**Penta-Mirror** *See Pentaprism.*

**Pentaprism** Optical glass or plastic in single lens reflex (SLR) cameras that inverts the image produced by the camera lens and reflects it right side up to the photographer looking through the camera's viewfinder; a similar device using mirrors is called a Penta-Mirror.

**Perspective** The appearance of objects relative to their distance and position; a necessary consideration to suggest depth in photographs; a dimension that the human eye sees but the camera lens does not.

**Perspective-Correction Lens** A camera lens that can be rotated to correct distortion, such as parallel lines that appear unparallel; also called a Perspective-Control Lens, PC Lens, or Tilt/Shift Lens.

**Photo CD** A compact disc with digitally recorded photographic images.

**Photocell** A light-sensitive cell or sensor that is commonly a part of exposure meters, automatic compact cameras, and autoflash units. *See also Compact Camera and Autoflash.*

**Photofinisher** A company that processes films and prints. Also called a Processor.

**Photoflood Bulb** A bright source of illumination that looks like an ordinary, household-type bulb; normally used in a metal reflector for portrait photography at home; available in two brightnesses, 250 and 500 watts; choice of white or blue-colored bulbs for different types of film; most have a limited life of 3 to 6 hours. *See also Halogen Bulb.*

**Photogram** A photograph made without a negative by placing objects on photographic paper and exposing it to light before processing.

**Photographic Umbrella** An umbrella-shaped light reflector that reflects and diffuses the flash or tungsten light aimed at its interior; a convenient way to create and control bounce light. *See also Bounce Lighting.*

**Photography** Literally means "writing with light."

**Photomacrography** Producing photographic images with a camera that are life-size or larger.

**Photomicrography** Producing photographic images that are larger than life-size with the aid of a microscope.

**Photo Player** An electronic device used to show pictures on a TV set from a processed roll of APS film. *See also APS.*

**Photo Scanner** An electronic device that views a photograph to digitally record its image. *See also Film Scanner.*

**Physiograph** An abstract pattern created on a film or photo paper emulsion with a moving point of light. *See also Emulsion.*

**Pistol Grip** A hand-held device attached to the camera's tripod socket and used to give the photographer more support and steadiness with his camera, especially with a telephoto lens.

**Pixels** Picture elements; the more pixels in a digital image, the finer detail it will show.

**Pocket Instamatic Camera** A small point-and-shoot camera that uses 110-size cartridge film. *See also Instamatic Camera.*

**Point-and-Shoot Camera** An unflattering term for an automatic compact camera; sometimes refers to some simple cameras; sometimes abbreviated as P&S Camera. *See also Compact Camera.*

**Point of Focus** The specific distance at which the camera lens is focused.

**Point of Focus Indicator** A mark on the camera lens barrel to indicate the specific distance at which the lens is focused.

**Polarizing Filter** An adjustable filter that blocks some light rays to diminish or eliminate glare or reflection from shiny surfaces, except unpainted metal; often used to reduce visual atmospheric haze and to darken blue skies in color photographs. *See also Circular Polarizing Filter and Linear Polarizing Filter.*

**Polaroid Camera** *See Instant Camera.*

**Portrait Lighting** Generally used to describe the arrangement of light for making portraits.

**Positive Film** A film, such as that used for making slides, which produces a positive image rather than a negative image; also called Reversal Film or Transparency Film.

**Power Zoom Flash Head** *See Zoom Flash Head.*

**Preflash** A flash or brief series of flashes preceding the actual flash exposure in order to reduce red-eye. *See also Red-Eye.*

**Prewind** *See Film Prewind.*

**Primary Colors** In photography, the three colors that combine to make white light: blue, green, and red. *See also Complementary Colors.*

**Print** A piece of photographic paper with a positive image produced by contact printing or enlarging.

**Print Format Control** A control on APS cameras to select one of three picture sizes for an exposure; sizes are indicated as C (classic), H (high definition/group), and P (panoramic).

**Printing Filters** Filters used with an enlarger to control contrast when printing black-and-white negatives. *See also Enlarger and Variable Contrast Filters.*

**Printing Paper** A light-sensitive paper that produces an image when exposed to light during the contact printing or enlarging process; also called Enlarging Paper or Photo Paper.

**Professional Film** Film with limited latitude and tolerances that is designed for exacting exposure and color results; should be refrigerated and processed promptly; some data sheets give the film's effective speed, which is more precise than the film's official ISO. *See also Amateur Film and ISO.*

**Programmed Exposure** A fully automatic exposure completely controlled by the camera; utilizes factory-programmed exposure combinations to set both the lens opening (f/stop) and the shutter speed for a correct exposure. *See also Aperture-Priority Exposure, Multimode Exposure, and Shutter-Priority Exposure.*

**Pull Processing** Developing film for a shorter period of time than usual; allows the film to be rated at a lower exposure index than its normal film speed. *See also Exposure Index and Push Processing.*

**Push Processing** Developing film for a longer period of time than usual; allows the film to be rated at a higher exposure index than its normal film speed, which is termed "pushing film." *See also Exposure Index and Pull Processing.*

**Quick-Return Mirror** *See Instant-Return Mirror.*

**Radio Slave Flash** *See Slave Flash.*

**Rangefinder** An optical device in cameras to focus a lens; may electronically signal the photographer by means of a light or symbol in the viewfinder, or an audible beep, when the subject is in focus; or may show twin or split images in the viewfinder until the lens is adjusted and those images appear as one to indicate that the subject is in focus.

**Rangefinder Camera** A type of camera that uses only a rangefinder for focusing the lens; most compact cameras are rangefinder-type cameras; unlike single lens reflex cameras, it does not have a focusing screen. *See also Compact Camera, Rangefinder, and Single Lens Reflex Camera.*

**RC** Abbreviation for resin-coated. *See Resin-Coated Photo Paper.*

**Ready Light** A light on a camera or on an accesory flash unit that signals when the flash is fully recycled and ready to be fired.

**Real Image Viewfinder** A viewfinder in some compact cameras that realistically shows the picture area by changing optically when the camera's dual focal length lens or zoom lens is changed; preferred over viewfinders that only use framing marks or a mask to indicate the area covered by the lens.

**Rear-Curtain Sync** A feature of some autoflash units that delays the firing of the flash to portray moving subjects with a blurred image that appears to follow them; also called Second Curtain Flash and Trailing Sync.

**Reciprocity Effect** A characteristic of most photographic films and papers when subjected to abnormally long or short exposures; the increase or decrease in exposure is no longer directly proportional to an increase or decrease in the density of the image registered on the film or paper emulsion. *See also Density and Emulsion.*

**Recycle Time** Refers to the time it takes for an electronic flash unit, after being fired, to recharge to its full light output capacity and be ready to use again.

**Red-Eye** The undesirable effect that occurs when flash reaches and photographs the retina inside a subject's eyes. *See also Red-Eye Reduction.*

**Red-Eye Reduction** A feature of some built-in flash and accessory flash units to reduce red-eye by emitting a brief series of preflashes or a steady LED beam from the flash or camera prior to the actual flash, causing the pupils of the eyes to constrict. *See also LED, Preflash, and Red-Eye.*

**Reflected-Light Meter** An exposure meter that reads the light reflected by the subject; pointed at the subject from the camera's position.

**Reflex Camera** A camera that uses a mirror or other optical device to present the scene or subject to the photographer exactly as the camera's film will record it; a single lens reflex camera uses one lens for both viewing and photographing, while a twin lens reflex uses one lens for viewing and another for filming.

**Release Priority** A feature of autofocus lenses that allows the shutter to be fired at any time, whether or not the subject is in sharp focus; in effect on SLR autofocus cameras that are set to continuous focus. *See also Continuous Focus and Focus Priority.*

**Remote Cord** An electrical camera cord with a push button that is used to fire a camera's electronically controlled shutter; the elec-

tronic version of a mechanical cable release; also called a Remote Release Cord or a Remote Control Cord. *See also Cable Release.*

**Remote Flash** *See Slave Flash.*

**Repeating Flash** A feature of some autoflash units to make a rapid series of flash exposures on a single frame of film; also called Multiple Flash or Stroboscopic Flash.

**Reproduction Ratio** Used in close-up photography to indicate the size of a subject reproduced on film in relation to its actual size; when both sizes are the same, the image is said to be life-size and have a reproduction ratio of one-to-one, expressed as 1:1; 1:2 indicates the subject as it appears on film is one-half its actual size; 2:1 means the subject on film measures twice the size of the real-life subject.

**Resin-Coated Photo Paper** Photographic paper that is liquid-resistant and absorbs little of the chemical solutions during processing, thus permitting shorter washing and drying times; may be treated with a resin, plastic, or polyethylene coating. *See also Fiber-Base Photo Paper.*

**Resolution** The degree of detail in a digital image; stated in general terms as high or low resolution, and in specific terms by the number of pixels; also refers to the resolving power of a lens or a film. *See also Pixels and Resolving Power.*

**Resolving Power** Refers to the ability of a lens to form sharp images; also refers to the ability of a film to record fine detail; sometimes called Resolution.

**Reversal Film** A type of color or black-and-white film that produces a direct positive image; also called Positive Film, Slide Film, and Transparency Film.

**Ring Light** A flash unit that encircles the camera lens and produces no shadows; most often used for close-up photography; sometimes called a Macro Flash.

**Roll Film** Film on a spool that utilizes an opaque paper backing to prevent exposure when not loaded in the camera. *See also Sheet Film.*

**Rule of Thirds** A composition concept that places the main subject off-center for a more appealing picture. *See also Composition.*

**Sabattier Effect** The partial reversal of the tones of a black-and-white image when the film or photo paper is exposed to light while in the developer.

**Sandwiching** General term for placing two or more negatives or slides together for purposes of printing or projecting them as a multiple image.

**Safelight** A light with special filters used to illuminate the darkroom without exposing photographic film or paper.

**SBC** Abbreviation for silicon blue cell. *See Silicon Blue Cell.*

**Screw Lens Mount** A mount that has a threaded end to screw the lens onto a camera body. *See also Bayonet Lens Mount.*

**Seamless Paper** A large roll of white, black, or colored paper suspended behind a subject as a background for portrait photography.

**Secondary Colors** *See Complementary Colors.*

**Secondary Flash Head** A small flash head in an accessory flash unit that augments the main flash head; used as a fill light when the main flash head is adjusted for bounce light. *See also Bounce Light and Catchlight.*

**Second Curtain Sync** *See Rear-Curtain Sync.*

**Selective Contrast Photo Paper** *See Variable Contrast Photo Paper.*

**Selenium Cell** A light-sensitive cell used in some exposure meters and early models of electric-eye cameras. *See also Cadmium Sulfide Cell, Silicon Blue Cell, and Silicon Photo Diode.*

**Self-Timer** A device, either built into the camera or an accessory, that automatically releases the shutter to make an exposure after a preset number of seconds.

**Shadow Detail** Detail that is evident in the shadowed (dark) areas of a picture; a consideration when making an exposure meter reading. *See also Highlight Detail.*

**Sheet Film** Sheets of film loaded in the darkroom into lighttight film holders for use in large-format cameras; sometimes called Cut Film. *See also Film Holder, Large-Format Camera, and Roll Film.*

**Shelf Life** The length of time photographic films, papers, and chemicals can be stored without deterioration. *See also Expiration Date.*

**Shoe-Mount Flash** An accessory flash unit that mounts in the hot shoe or accessory shoe of a 35mm camera. *See also Built-in Flash, Handle-Mount Flash, and Hot Shoe.*

**Shoulder Brace** An object similar to a gun stock which is attached to the camera's tripod socket and used to provide the photographer more support and steadiness with his camera, especially with very powerful telephoto lenses.

**Shutter** A device built in the lens or camera body that regulates the length of time that light reaches the film to make an exposure.

**Shutter-Preferred Camera** An early auto-exposure camera featuring shutter-priority exposure. *See also Shutter-Priority Exposure.*

**Shutter-Priority Exposure** An automatic exposure control allowing

the photographer to set the desired shutter speed, after which the camera automatically sets the lens opening (f/stop) for a correct exposure. *See also Aperture-Priority Exposure, Multimode Exposure, and Programmed Exposure.*

**Shutter Release** A button, lever, or other type of trigger on a camera that opens the shutter to expose the film.

**Shutter Speed** Indicates the precise length of time that light exposes the film; usually in marked fractions of a second.

**Shutter Speed Control Dial** A camera control with various shutter speeds that is adjusted to determine the length of an exposure.

**Shutter Synchronization** *See Flash Synchronization.*

**Side Lighting** A term used when the main source of illumination is at the side of the subject.

**Silicon Blue Cell** A type of light-sensitive cell in a camera's exposure metering system or a hand-held exposure meter. *See also Cadmium Sulfide Cell, Selenium Cell, and Silicon Photo Diode.*

**Silicon Photo Diode** A common type of light-sensitive cell in a camera's exposure metering system or a hand-held exposure meter; abbreviated SPD; more sensitive and quicker to respond than CdS cells. *See also Cadmium Sulfide Cell, Selenium Cell, and Silicon Blue Cell.*

**Silver Halides** The chemical components that are sensitive to light and make up the emulsion of photographic films and papers.

**Single Frame Advance** A camera setting used to expose and advance only a single frame of film when the shutter release button is fully depressed. *See also Continuous Advance and Film Advance Control.*

**Single Lens Reflex Camera** A camera that enables the photographer to see the subject in the viewfinder through the same lens that presents the image to the film; the most versatile type of 35mm camera; most often referred to as an SLR camera. *See also Compact Camera and Rangefinder Camera.*

**Single Shot Focus** A focus setting on an autofocus SLR camera that locks in the focus once the subject is in sharp focus; in order to refocus, the shutter release button must be fully depressed to expose the film, or the pressure from the photographer's finger on the shutter release button must be relaxed. *See also Continuous Focus.*

**Single-Use Camera** An inexpensive camera preloaded with film and designed to expose only that single roll of film; the camera is returned with the exposed film to the photofinisher for processing; also called a One-Time-Use Camera.

**6 × 6 Camera** *See Medium-Format Camera.*

**Skylight Filter** *See Ultraviolet Filter.*

**Slave Flash** Refers to a flash unit used to supplement the main flash; often triggered by a wireless photocell or radio control; sometimes called an Extension Flash or a Remote Flash.

**Slide** A color film transparency mounted in cardboard, plastic, or glass for use in a slide projector; also can be used to make color prints.

**Slide Duplicator** A tubelike device that attaches to an SLR camera in place of its lens to hold and magnify a slide transparency for copying.

**Slide Film** *See Color Slide Film.*

**Slide Projector** Uses lenses and a bright electrical bulb to project a 35mm or other size transparency to a larger image size. *See also Transparency Film.*

**Slide Sorter** *See Light Box.*

**Slow-Speed Film** A film with an emulsion that is less sensitive to light than a medium-speed film or high-speed film; has a film speed of ISO 50 or less. *See also High-Speed Film and Medium-Speed Film.*

**Slow Sync** A feature of some autoflash units that sets slower-than-normal shutter speeds for flash synchronization so that ambient light in the background will also be recorded on the film. *See also Ambient Light and Flash Synchronization.*

**SLR** Abbreviation for single lens reflex camera. *See Single Lens Reflex Camera.*

**Small-Format Film** Film that is 35mm film or smaller, especially film for APS cameras. *See also APS Camera, Medium-Format Camera, and Large-Format Camera.*

**Soft-Focus Filter** *See Diffusion Filter.*

**Soft Lighting** *See Diffused Lighting.*

**SPD** Abbreviation for silicon photo diode. *See Silicon Photo Diode.*

**Split-Field Lens** An accessory lens mounted in front of the camera lens; one-half is a close-up lens, the other half is clear; used to put a close-up subject in the foreground in sharp focus with the background.

**Split Image** The basis of some older rangefinder-type focusing systems in which the subject is seen in two parts until the lens is properly focused and the image becomes whole.

**Spot Area Autofocusing** A setting to engage a limited focus detection area in some autofocus SLR cameras; area marked by a small circle in the center of the viewfinder. *See also Focus Detection Area and Wide Area Autofocusing.*

**Spot Filter** A camera filter that is a modified diffusion filter with a

clear round center; the subject in the center is in sharp focus while the surrounding area is slightly diffused; also called a clear-center filter. *See also Diffusion Filter.*

**Spot Meter** A type of exposure meter that has a limited angle of acceptance. *See also Angle of Acceptance.*

**Spot Metering** An exposure metering system built into some SLR cameras that reads only a very limited area, as designated by a small circle in the middle of the viewfinder. *See also Center-Weighted Metering and Multizone Metering.*

**Stack Loader** A device available for some slide projectors that allows a number of slides to be projected automatically without first inserting them into individual slots in a slide tray or magazine.

**Star Filter** A camera filter that creates starlike rays from bright points of light, including the sun; also called a Cross-Screen Filter.

**Step-Up Adapter Rings** Rings of varying diameters that are attached to lenses of varying diameters so filters of a single size can be used.

**Still Camera** General term for cameras making images on a single frame of film; unlike motion picture (movie) cameras that use many frames per second to record a moving image.

**Stop-Action** The photographic effect of capturing a moving subject on film so that it can be seen clearly and in detail.

**Stop Bath** A chemical solution in film and print processing used to stop the action of the developer and prevent contamination of the fixer.

**Stop-Down Metering** The lens closes down when it is being adjusted to set the f/stop according to an exposure reading made by the camera's built-in meter; the lens does not have an automatic aperture. *See also Automatic Aperture and Open-Aperture Metering.*

**Stopping Down the Lens** Means the photographer is adjusting the lens aperture to a smaller f/stop; sometimes referred to as closing down the lens. *See also Aperture, f/Stop, and Opening Up the Lens.*

**Strobe** A term sometimes used to describe an electronic flash unit.

**Stroboscopic Flash** *See Repeating Flash.*

**Studio Camera** *See Large-Format Camera.*

**Studio Flash** *See Studio Light.*

**Studio Light** Generally refers to any lights used in a photographic studio, whether the type is electronic flash or tungsten light. *See also Flash and Tungsten Light.*

**Subject Image** The subject as recorded on film.

**Subject Image Size** The size of the subject as it appears on the film;

determined in part by the focal length of the lens. *See also Lens Focal Length.*

**Subminiature Camera** A small camera that uses 16mm or smaller film.

**Sufficient Light Indicator** A light on an automatic electronic flash or built into a camera's viewfinder that signals if the flash's light has been adequate to produce an automatic exposure; also called a Confidence Light.

**Synchronization** *See Flash Synchronization.*

**T** Abbreviation for time; shutter speed setting for a time exposure; shutter release button is pressed once to open the shutter, then pressed a second time to close it.

**Tabletop Tripod** *See Minipod.*

**Teleconverter** *See Lens Extender.*

**Tele-extender** *See Lens Extender.*

**Telephoto Lens** A lens that has a greater focal length and produces a larger subject image size than a normal or wide-angle lens. *See also Lens Focal Length.*

**Test Print** A preliminary print with a series of sections or strips that have been given different exposure times in order to determine the correct exposure time and/or contrast grade or filtration for the final print. *See also Contrast Grade.*

**Texture Screen** A commercially made or personally devised screen material placed in contact with the negative or photo paper in order to produce a pattern on the print image.

**35mm Camera** A convenient size of camera using 35mm film. *See also Compact Camera and Single Lens Reflex Camera.*

**Through-the-Lens (TTL) Flash** Indicates an automatic flash exposure that's set according to the reflected flash light received by the camera's through-the-lens metering system. *See also Through-the-Lens (TTL) Metering.*

**Through-the-Lens (TTL) Metering** A reliable exposure metering system built in the camera that reads the light coming through the camera lens; a feature of modern single lens reflex (SLR) cameras.

**Thyristor Circuitry** Circuitry in an electronic flash that provides faster recycling times and more flashes per set of batteries by diverting unused power back to the capacitor after every flash.

**Tilting Flash Head** An adjustable head on an electronic flash that can be tilted up and down for bounce light; some can also be rotated side to side to direct the flash light. *See also Bounce Light.*

**Time Exposure** Usually an exposure longer than 1 second; may require setting the shutter speed control to B or T to keep the shutter open.

**Time-Lapse Photography** A series of pictures of the same subject taken over a period of time without moving the camera or the subject.

**TLR** Abbreviation for twin lens reflex. *See Twin Lens Reflex Camera.*

**Toner** A chemical that adds color to an image after development to enhance a black-and-white photograph.

**Top Lighting** A term used when the main source of illumination is directed at the top of the subject.

**Trailing Sync** *See Rear-Curtain Sync.*

**Transparency Film** A color or black-and-white positive film whose image is viewed by light transmitted through it. Also called Positive Film, Reversal Film, and Slide Film.

**Tripod** A three-legged device designed to give support and steadiness to the camera. *See also Unipod.*

**Tripod Socket** A screw-type socket in the base of a camera, or the barrel of some large telephoto lenses, to attach a tripod.

**TTL** Abbreviation for Through-the-Lens. *See Through-the-Lens (TTL) Flash and Through-the-Lens (TTL) Metering.*

**Tungsten Film** Film designed especially for exposure by tungsten light. *See also Color Balance, Daylight Film, and Tungsten Light.*

**Tungsten-Halogen Bulb** *See Halogen Bulb.*

**Tungsten Light** Light from an artificial light source, such as a household lightbulb or a halogen lamp, which has a tungsten filament that becomes incandescent when heated by an electrical current. *See also Halogen Bulb, Hot Light, and Tungsten Film.*

**Twin Lens Reflex Camera** A camera that uses two lenses—one to project the subject to the photographer's eye, and the other to record the identical image on the film.

**2¼ Camera** *See Medium-Format Camera.*

**Two-Touch Zoom Lens** A zoom lens with two different control rings on the lens barrel to adjust the focal length and the focus. *See also One-Touch Zoom.*

**Ultraviolet Filter** Helps eliminate the ultraviolet light to which all films are sensitive; improves images of skies by reducing (but not eliminating) atmospheric haze; often abbreviated as UV Filter; sometimes called a Haze Filter or a Skylight Filter.

**Umbrella Reflector Light** Used to provide less direct studio light by bouncing light into its umbrella-shaped reflector.

**Underexposure** Insufficient exposure of a photographic film or paper; underexposed negatives are not dense enough, underexposed slides are too dark; underexposed prints made from negatives are too light, and underexposed prints made from slides are too dark.

**Underwater Camera** A camera specifically designed for underwater photography. *See also Underwater Camera Housing.*

**Underwater Camera Housing** A watertight housing designed to enclose and protect an ordinary camera for use underwater.

**Unipod** A single-legged camera support. *See also Tripod.*

**UV** Abbreviation for ultraviolet. *See Ultraviolet Filter.*

**Variable Aperture Zoom Lens** A zoom lens with a variable maximum aperture which changes in size as the lens focal length is changed. *See also Zoom Lens.*

**Variable Close-Up Lens** A zoom-type close-up lens that can be adjusted to various diopters (magnifying powers). *See also Close-up Lens and Diopter.*

**Variable Contrast Filters** Filters used to control contrast in black-and-white prints when exposing variable contrast photo paper. *See also Variable Contrast Photo Paper.*

**Variable Contrast Photo Paper** A single photographic paper that is capable of producing black-and-white prints of good contrast from negatives of varying contrasts; must be exposed through variable contrast filters; also called Multigrade, Multicontrast, and Selective Contrast Photo Paper. *See also Contrast Grade, Graded Contrast Photo Paper, and Variable Contrast Filters.*

**Variable Focal Length Lens** A lens that can be adjusted to different focal lengths but which must be refocused after each focal length change is made. *See also Zoom Lens.*

**Variable Maximum Aperture** Refers to the maximum aperture of a zoom lens that gets smaller as the lens is zoomed to a longer focal length; the maximum opening may be reduced as much as $1^{1/2}$ f/stops.

**Variable Power Control** *See Flash Light Output Control.*

**Variable Self-Timer** A self-timer that can be set to variable time delays before releasing the shutter. *See also Self-Timer.*

**Vibration Reduction** *See Image Stabilization.*

**Video Processor** A video device that transfers images from prints, slides, and negatives to videotape.

**View Camera** *See Large-Format Camera.*

**Viewfinder** The optical device in a camera used to view the subject to be photographed.

**Vignetting** An undesirable effect when taking a picture that darkens the edges of the image; often caused by a lens shade or filter ring that extends too far in front of the camera lens; also, an effect created in the darkroom during enlarging to emphasize the subject by obliterating the background around it.

**V Setting** The self-timer indicator or lever on older between-the-lens leaf-type shutters that causes a delayed-action shutter release. *See also Self-Timer.*

**Waterproof Camera** A small-format camera that is impervious to moisture; ideal for use in inclement weather; may also be used underwater to a limited depth. *See also Underwater Camera.*

**Weatherproof Camera** A small-format camera sealed against rain, snow, and other moisture, but not waterproof. *See also Waterproof Camera.*

**Wide-Angle Lens** A lens that has a lesser focal length and produces a smaller subject image than a normal or telephoto lens. *See also Lens Focal Length.*

**Wide Area Autofocusing** A setting to engage an expanded focus detection area in some autofocus SLR cameras; area marked by a rectangular set of brackets in the viewfinder. *See also Focus Detection Area and Spot Area Autofocusing.*

**Wratten Filters** A brand name used by Kodak for certain filters; originally identified by alphabetical designations, but now given numerical designations.

**X Synchronization** If indicated by an X, the camera flash cord socket or switch position to use for synchronizing the shutter with electronic flash to fire both at the same time.

**Zero Adjustment** A screw on some hand-held exposure meters used to readjust the meter indicator to zero to recalibrate the meter for correct light readings.

**ZLR** Abbreviation for zoom lens reflex. *See Zoom Lens Reflex Camera.*

**Zone Focus** Uses symbols representing various subject distances instead of exact footage or metric distances; found on the focusing rings of some simple cameras.

**Zone System** A system to help determine exposure for black-and-white films; originally devised by famed photographer Ansel Adams; various tones in the range of contrast from black to white are divided into 10 zones.

**Zoom Flash Head** An electronic flash with a reflector head that adjusts automatically or manually to provide the appropriate angle of illumination for wide-angle, normal, and telephoto lenses. *See also Angle of Illumination.*

**Zoom Lens** A versatile lens that can quickly be adjusted to varied focal lengths in order to vary the subject image size. *See also Lens Focal Length and Variable Focal Length Lens.*

**Zoom Lens Reflex Camera** A type of 35mm camera that is a single lens reflex camera with a permanently attached zoom lens; sometimes abbreviated as ZLR camera; also referred to as an All-in-One Camera or a Bridge Camera.

# APPENDIX B:
# WEIGHTS AND MEASURES

Most of the weights and measures in this book are first given in the units customarily used in the United States (i.e., inches, feet, ounces, quarts, Fahrenheit), with the metric equivalent following in parentheses. An exception is in discussions of lens focal length, which is known almost universally in terms of millimeters (mm) and centimeters (cm).

Although conversion to the metric system of weights and measures is slowly occurring in the U.S., the following will help you better understand the metric system, and convert from U.S. weights and measures to metric equivalents, and vice versa. Some figures have been rounded off.

For photography, the major units of the metric system are the *meter* (m) for linear (length) measurement, the *liter* (1) for liquid measurement, and the *gram* (g) for weight measurement. Unit abbreviations are in parentheses.

## EQUIVALENTS WITHIN THE METRIC SYSTEM

### Linear Measure

1 millimeter (mm) = $^1/_{1000}$ meter
1 centimeter (cm) = $^1/_{100}$ meter, 10 millimeters
1 decimeter (dm) = $^1/_{10}$ meter, 100 millimeters, 10 centimeters
1 meter (m) = 1000 millimeters, 100 centimeters, 10 decimeters
1 kilometer (km) = 1000 meters

**Liquid Measure**

1 millimeter (ml) = $^1/_{1000}$ liter
1 centimeter (cl) = $^1/_{100}$ liter, 10 millimeters
1 deciliter (dl) = $^1/_{10}$ liter, 100 milliliters, 10 centiliters
1 liter (l) = 1000 milliliters, 100 centiliters, 10 deciliters
1 kiloliter (kl) = 1000 liters

**Weight Measure**

1 milligram (mg) = $^1/_{1000}$ gram
1 centigram (cg) = $^1/_{100}$ gram, 10 milligrams
1 decigram (dg) = $^1/_{10}$ gram, 100 milligrams, 10 centigrams
1 gram (g) = 1000 milligrams, 100 centigrams, 10 decigrams
1 kilogram (kg) = 1000 grams

# EQUIVALENTS FOR THE U.S. AND METRIC SYSTEMS

**Linear Measure**

**U.S.      Metric**
1 inch = 25.4 millimeters, 2.54 centimeters, 0.25 decimeter, 0.025
        meter
1 foot = 304.8 millimeters, 30.48 centimeters, 3.04 decimeters,
        0.30 meter
1 yard = 914 millimeters, 91.4 centimeters, 9.14 decimeters, 0.91
        meter
1 mile = 1609.34 meters, 1.61 kilometers

**Metric          U.S.**
1 millimeter  = 0.039 inch, 0.003 foot, 0.001 yard
1 centimeter  = 0.39 inch, 0.032 foot, 0.011 yard
1 decimeter   = 3.93 inches, 0.328 foot, 0.109 yard
1 meter       = 39.37 inches, 3.28 feet, 1.09 yards, 0.0006 mile

**Liquid Measure**

**U.S.      Metric**
1 ounce  = 29.57 milliliters, 2.95 centiliters, 0.29 deciliter, 0.029
          liter
1 quart  = 946.35 milliliters, 94.63 centiliters, 9.46 deciliters,
          0.946 liter
1 gallon = 3785.41 milliliters, 378.54 centiliters, 37.85 deciliters,
          3.78 liters

**Metric**         **U.S.**
1 milliliter = 0.033 ounce
1 centiliter = 33 ounces, 0.01 quart
1 deciliter = 3.38 ounces, 0.105 quart, 0.026 gallon
1 liter     = 33.81 ounces, 1.05 quarts, 0.26 gallon

**Weight Measure**

**U.S.**       **Metric**
1 ounce = 28.35 grams
1 pound = 453.59 grams, 0.45 kilogram

**Metric**         **U.S.**
1 gram     = 0.035 ounce. 0.002 pound
1 kilogram = 2.2 pounds

## TEMPERATURE CONVERSION

In the U.S., temperatures are usually indicated by a Fahrenheit scale (F), while most of the world uses the Celsius (sometimes called Centigrade) scale (C). Two methods of converting one to the other follow.

To figure Celsius, subtract 32 from Fahrenheit and divide by 1.8, or subtract 32 from Fahrenheit, multiply by 5, and divide by 9.

To figure Fahrenheit, multiply Celsius by 1.8 and add 32, or multiply Celsius by 9, divide by 5, and add 32.

A brief list of temperature equivalents follows.

**Fahrenheit   Celsius**
| Fahrenheit | | Celsius |
|---|---|---|
| 212° | = | 100° (boiling point) |
| 194 | = | 90 |
| 176 | = | 80 |
| 158 | = | 70 |
| 140 | = | 60 |
| 122 | = | 50 |
| 104 | = | 40 |
| 86 | = | 30 |
| 68 | = | 20 (recommended developing temperature) |
| 50 | = | 10 |
| 41 | = | 5 |
| 32 | = | 0 (freezing point) |

# INDEX

(Page numbers set in **boldface** refer to illustrations.)

Abbreviations, common photography, 59–60

Abstract images, *see* Physiograph

Accent light, **353,** 353–54, **354, 358**

Accessory camera back, 269–70

Accessory equipment, 256–73

Accessory flash units, 146, 195, 390, 426

Accessory lenses, 136, 226, 254
   close-up lenses, *see* Close-up lenses, accessory

Accessory shoe, flash, 155

Action shots, 116
   composition and, 332–38
   *see also* Blurring action; Sports photography; Stop-action

Active infrared autofocus system, 120, 278–79, 395–96

Adams, Ansel, *see* Zone system for determining exposure

Adapter, filter, 227
   lens, 137

Adult education classes, 501

Advanced Photo System cameras, *see* APS (Advanced Photo System) cameras

Aerial photography, 395–98, **396, 398**

AF assist for autofocusing, 120–21, **162,** 162–63

Ambient light, 164, 344, 360
   shooting with, and at night, *see* Night photography, shooting with existing light and at night

American National Standards Institute (ANSI), 459

*American Photo,* 499

American Society of Media Photographers, 503

American Standards Association (ASA), 34, 209–10

Amphibious cameras, *see* Underwater cameras

Analyzing photographs, 472–76

Angle of acceptance, exposure meter, 88, **89**

Angle of illumination flash, **148,** 161

Angle of view, lens, 103, 105, 106, 107, **107**

Angles, camera, *see* camera angles

Antistatic brush, 452, 465

*Aperture,* 449

Aperture-preferred cameras, 68

Aperture-priority exposure mode, 46, 66, 67, **67**

Apertures, lens, *see* f/stops

APS (Advanced Photo System)
   cameras, 4, 275–76, 292–96, **293,** 478, 483
   film for, 292–94, **294**
   as point-and-shoot cameras, 295–96
   print format control, 294–95
   print size, 295, **296**
   small-format, 5

APS (Advanced Photo System) film, 212
   processing of, 214–15

Archival mount and mat boards, 481

Artificial light, 344

ASA film speeds, 34
   *see also* Film speeds

*ASMP Stock Photography Handbook,* 503

Aspherical lenses, 111

Autobracketing, 78–79

Auto-exposure, 9, 37, 45, 61, 66, **66,** 281, 311, 424
   overriding, 282

Auto fill-flash mode, 287

Autoflash, **142,** 144, 155–58, 311
   built-in, 9, 285–87, **286**
   operating range, 146

Autofocus cameras, 9, 48, 120,
  276–81, 311
  filters and, 230, **230**
Autofocus illuminator beam, 120–21,
  **162,** 162–63
Autofocus lenses, camera, 48, 109–10,
  115–21
  projector, 489
Autofocus lock, 119, 280, 291
Autoload, 9, 24, **24**
Automatic aperture, 50, 73
Automatic exposure, *see* Auto-
  exposure
Automatic flash exposure, *see*
  Autoflash
Autorewind, 27, **27,** 287
Autowind, 9, 26, **27,** 270, 287
Auto-zoom flash head, 160–61
Available light, *see* Ambient light
Averaging exposure meters, 88

Babies, photographing, 194, 332, 337
Background and composition, **321,**
  321–22, **322**
Background light, **353,** 353–54
Backlighting, 74, **74,** 291, 344, **346,**
  **347, 350,** 351–52, 379
  fill flash and, **181,** 189
Backlight mode, 74
  of compact camera, 282, **282**
Backpacks, photo, 269
Backscatter, underwater flash, **404,**
  406, **406**
Ball head, tripod, 262–63, **263,** 427
Bare-bulb flash, 160
Barn doors, for studio lights, 353–54
*Basic Darkroom Book, The* (Grimm),
  440
Batteries:
  camera, 81–84, 289–90, 292, 312,
    423
  changing, 83
  cold weather and, **82,** 84
  exposure meter, 81–84
  flash unit, 168–71
  precautions, 84
  rechargeable, 84
  spare, 82, **82,** 84
  types of, 83–84
  when traveling, 423, 427
Battery check, 81
Battery packs, 170
Bayonet mount, for lenses, 114
Beanbag, for camera support, 264–65
Bellows, extension, *see* Extension
  bellows

Between-the-lens shutter, *see* Leaf
  shutter
Binoculars, photographing through,
  411–12
Black-and-white film, 98–99, 200,
  368
  chart of available, 223–24
  chromogenic, 206
  color sensitivity of, 202, **247,**
    247–251
  composition and, 340–41
  filters for, **247,** 247–251
  infrared, 51, 386
    *see also* Infrared film
  panchromatic, **197,** 202, 247, 250,
    **250**
  for photographic copying, 381
  processing, *see* Processing of films
    and prints
  reversal (slide) film, 204, 206
  zone system for determining
    exposure of, **99,** 99–100
Black spots or objects on pictures,
  474
Blotters, photo, 468
Blurring action, **38,** 45, 337–38, 341,
  **342,** 364–65
Books about photography, 440,
  497–98
Borderless prints, 480
Bounce card, for flash, 160, 379
Bounce flash, **158,** 163, 184–87, **185,**
  193, 194
Bounce lighting, 352
  *See also* Bounce flash
Bounce light reflector, 185
Bracketing exposures, 77–79, **78, 79,**
  90, 98, 167, 352, **365,** 366,
  368, 389, 394, 424–25
  flash, 164
Breech-lock mount, for lenses, 114
Bridge cameras, *see* Zoom lens reflex
  (ZLR) cameras
  B shutter setting, 38–39, 190, 282,
    360, 366, **388,** 390
Bulbs:
  enlarger, *see* Enlarger bulbs
  flash, *see* Flashbulbs
  photoflood, *see* Photoflood bulbs
  projector, *see* Projector bulbs
  tungsten-halogen, *see* Tungsten-
    halogen bulbs
Bulk film, 7, 212
Bulk film back, 271
Burning-in, enlarging technique, **470,**
  470–71

Cable release, 23, **135,** 259, **260,** 366, 378, 390, 427
*see also* Remote cord
Cadmium sulfide (CdS) cell, for exposure meter, 79, 81
Camera angles, 322–24, **323**
Camera back, 269–70, 288
Camera bags, 18, 266–69, **267,** 422, 426
Camera case, 16–17
Camera movement, *see* Camera shake
Camera parts diagrams, **10–11**
Camera protection, 16–19, 422–23
Camera repairs, 18–19, 424, 425
Camera shake, 21, 126, 258, 269, 291, 378
Camera strap, 16, **16,** 290–91
Camera support, 21–22, 264–65
*see also* Tripods
Cameras, types of, *see* specific types, e.g. single lens reflex (SLR) cameras
Career in photography, 504–505
Cartridge film, 212–13, 448
Catadioptric lenses, **128,** 129
Catchlight, 160
C-clamp for camera support, 264–65, 427
CD-ROM discs, instructional, 500
Center-clear filter, 253
Center-weighted metering, 70, 71, **72,** 74, **96,** 97, 365
Changing bag, 29–30, 385
Chromogenic black-and-white film, 206
Circular fish-eye lenses, 105
Circular polarizing filter, 236, 237
Classes, photography, 501
Click stops, 43
Close-up lenses, accessory, 109, 136–39, **138,** 370, 375–77, 425
*see also* Macro lenses
Close-up mode, compact camera, 280
Close-ups, 133–39, 147, 369–80, 419, 421, **421**
depth of field and, 137, 377–78
exposure factors, **375,** 377
flash for, 192, 379–80, **380**
focusing and, 376, **376,** 377
macro lenses, *see* Macro lenses
nonoptical options for, 139–40, 373–75, 377
Closing in on subject, 320, **320,** 419, 421, **421**
Clubs, camera, 502
Color and composition, 340–41

Color balance, 201, **242,** 408, 475–76
Color compensating (CC) filters, 229, 242, 245–46, 341
Color film processing, 214–17, 442
Color infrared film, 386–87
*see also* Infrared film
Color negative (print) film, 98, 199, **199,** 368
chart of available, 219–21
color balancing, 201, 242
daylight, 200, **201**
processing yourself, 440, 442
tungsten, 192, 200–202, **201**
Color reversal (slide) film, 98, **199,** 199–200, 204–206, 242, 368
chart of available, 221–23
daylight, 200, 201, **201,** 243, 368
processing yourself, 440, 442
tungsten, 192, 200–202, **201,** 243, 368
Color temperature, 201–202, 243–245
Color temperature meters, 87, **88**
Color wheel, 249, **249,** 390, 394
Compact cameras, 3–4, 276–92, 277
APS cameras, *see* APS (Advanced Photo System) cameras
autofocusing systems, 276–81
avoiding calamities, 291–92
comparison to single lens reflex cameras, 6–16, **8,** 277–78
distinguished by focal length of lenses, 283–85
price range, 278
*see also specific features and functions of compact cameras*
Complementary colors, 249, **249,** 390
Composition, **22,** 316–43, 392, **437**
action, including, 331–38
angles, checking all, 322–24, **323**
background, **321,** 321–22, **322**
center of interest, 318–19
close to subject, getting, 320, **320,** 419, 421, **421**
color considerations, 340–41
exposure and, 331
focusing for effect, 328–31, **329, 330**
framing the subject, **325–26,** 325–326
horizon, keeping straight, 320, **321**
imagination in, 341–43, 392
leading lines, **324,** 324–25
off-center, putting main subject, **317, 318,** 319, **319**
purpose, having a, 316–18
size indicators, including, 327, **328**

Composition *(cont.)*
  timing and, 338–40
  underwater, 409
  varying the format, 326–27, **327**
Computers:
  digital cameras and, 307, 308,
      313–15, 483–84
  Internet, 499–500, **500,** 501
  photographing images of, 367–68
  software for photo editing, 308,
      500
Confidence light, flash, 159
Contact printers, 451–52
Contact proof sheets, 478–79
  making, 444, 445, 449–55, **450**
Contests, photo, 502–503
Continuous advance, of film, 116–17,
    **117**
Continuous focus, of lens, 49, 115,
    **115,** 116
Continuous shooting, of exposures,
    288–89, 392
Contrast filters, 229, 247–48, 250–51,
    341
Contrast grades, enlarging paper,
    455–57, **456–57,** 468
Conversion filters, 202, 229, 241,
    244–45
Copy films, 204
Copying with a camera, 380–83
Correction filters, 229, 247, 248, 250
Cropping, when enlarging, 450, 465,
    480
Cross lighting, 347, 354
Cross-screen filters, 251–52, **252**
Customs duty for camera equipment,
    436–37

Darkrooms, 46, 443
  floor plan, **452**
  setting up, 471–72
Darkroom safelights, 452–53, 466
Darkroom timer, 445, 448
Data back, 270, 288
Dedicated autoflash, 9, 152, **153,**
    154–55, **156**
  features of shoe-mount flash,
      155–68
Dedicated TTL autoflash units, **153,**
    155–56
  bounce flash and, 186
  fill flash and, 178–80
Definition, film, 202–203
Depth of field, 46–48, 53–59
  close-ups, 137, 377–78
  composition and, 328–31, **329, 330**

f/stop settings and, 44, 53–58, **54,
    55, 56**
macro lenses and, 134
multiple flashes and, 191
telephoto lenses and, 126
wide-angle lenses and, **130,** 131
Depth of field chart, 55
Depth of field preview, 58, 73, 378
Depth of field scale, 53–58, **55, 56**
Deutsche Industrie Norm (DIN), 34,
    209–10
  *see also* Film speed
Developer, film, 443, 444, 445, 449
  photo paper, 450, 451, 453–54, 467
Developing black-and-white film, 444,
    445–49, **446, 447**
Developing black-and-white prints,
    **450,** 450–51, 453–55, 467–68
Development temperature, 445–46,
    448, 453
Development time, 446, 448–49, 453,
    **453**
Dichroic filters, in an enlarger, 457,
    461–62, **462**
Diffraction filters, 254
Diffused lighting, 348, **349**
Diffusion filters, **230,** 253, 471, **472**
Digital cameras, electronic, 4, 307–15,
    **308, 310, 312,** 483–84
  features of, 311–14
  resolution and, 313–14
  resolution/image quality, 309–11
Digital video imaging, 307–308
DIN film speeds, 34
  *see also* Film speeds
Diopter correction control, on
    viewfinders, 53
Diopters, close-up lens, 109, 136–37,
    375
Directional lighting, 348, **349**
Disc cameras, 274–75, 300
Disc film, 213, 300
Distance indicator/index, lens, 51
Distance scale:
  on lens focusing ring, 50–51
  on macro lenses, 372
Distortion with wide-angle lenses,
    131, **131,** 132–33
Dodging, enlarging technique, **470,**
    471
Double exposures, 30–33, **31,**
    387–95, **388**
Drying rack/screens, for photo papers,
    451
Dry mounting press, 482
Dry mounting tissue, 481–82

Dual focal length lenses, 284, **284**
Dual lenses, 110
Duplicate 35mm slides (dupes), 381
Duplicating films, 204
DX-coded film, 63–65, **64,** 210, 283

Editing your photographs, 420,
477–78, 494–95
Effective film speed, 65, 209–10, 361,
386
Effective focal length, 127–28, **128,**
407–408, 411–12
Effective lens opening, 121, 129, 230
EI, *see* Exposure index
Electric eye camera, 65
Electronic flash, advent of, 141–44,
**144**
*see also* Flash
Electronic rangefinder, 117
Elevator post, 260, 262
Emulsion, film, 24, 33, 444, 447, 451,
452
photo paper, 451, 452, 467
Enlargements:
making, 444, 445, 455–72
choosing an enlarger, 459–65
photo papers for, 451, 455–59,
**456, 457**
the process of, 466–72
mounting and framing, 480–83
scanning and digitizing system for,
479
selecting images to be enlarged,
478–80
Enlarger:
baseboard, 464
bulbs, 463
choosing an, 459–65
cold-light head, 462–63
color head, 457, 461, **461, 462,**
464
condenser head, 462
dichroic filters, 457, 461–62, **462**
diffusion, 462
enlarger head/lamphouse, 460–63,
**460, 461**
filter drawer, 456, 464
focusing, 463–64, 466–67
lenses, 460, 466–67, 469
negative carrier, 463, 466
Enlarger timer, 464, 466, 468
Enlarging easels, 465, **465,** 466
Enlarging magnifier/focuser, 464–65
Enlarging meter, 469
Enlarging paper, *see* Photo paper, for
enlarging

Evaluative metering, *see* Multizone
metering
Expiration date, film, 197–98, 429,
475
trial exposure guidelines, chart of,
**362–63**
Existing light, *see also* Ambient light
Exposure:
accurate readings, making, 91–101,
331
auto-exposure, *see* Auto-exposure
bracketing, *see* Bracketing
exposures
double, *see* Double exposures
experienced guess at, 90–91
f/16 rule of thumb, 90
film box guidelines, 89–90, **90**
filter factor and, 210, 231–33, 238
flash exposures:
bounce flash, 186, **187**
fill flash, 178
manual, figuring, 173–77
for multiple flash, 189
high contrast subjects, 92–95, **93**
for highlights, 92–100, **93, 94, 96,
99**
multiple, *see* Multiple exposures
personal preferences, 91–101
proper, 32, 61–101, 91, 387–89
for shadows, 92–100, **93, 94, 96,
99**
zone system, **99,** 99–100
*see also specific photographic
situations and effects, e.g.
Filters; Portraits*
Exposure compensation, 74–76, **75,**
164, 282
Exposure compensation chart,
enlarging, 469
Exposure compensation dial, 74–76,
**75**
Exposure compensator, 74–76, 164
Exposure factors, **375,** 377
Exposure index (EI), 65, 209–10, 361,
386
Exposure latitude, 78, 98–99, 149,
281
Exposure lock, 73–74, 88, 282
Exposure manipulation, when
enlarging, **470,** 470–471
Exposure meters, 36–37
batteries, 81–84
built-in, 61, **62,** 63, 69–84, 86,
95
film speed, setting, 36, 61–63, **63,
85**

Exposure meters *(cont.)*
  automatic setting with DX-coded
    films, 63–65, **64,** 210
  filter factor and, 233
  for multiple exposures, 389
  purposely raising or lowering, 65,
    76
  flash, 87, 187–88
  hand-held, 61, 69, **80, 85,** 85–89,
    **89,** 95, 129, 139–40, 233
  incident-light readings with, **85, 86,**
    86–87
  metering range, 79–81
  override controls, 73–76
  photocells, 69–70, 79–81, **80**
  in compact cameras, 282
  reflected-light readings, **85,** 86, **86,**
    87
  through-the-lens metering, *see*
    Through-the-lens (TTL)
    metering
  *see also specific photographic
    situations and effects, e.g.
    Filters; Portraits*
Exposure mode selector/control dial,
  67, **67,** 174
Exposure value (EV), 79–80
Extender, lens, *see* Lens extender
Extension bellows, 109, 133, **135,**
  139, 373–75, 377, 425
Extension flash, 167–68, 173,
  188–89
Extension tubes, 109, 133, 139, **139,**
  373–75, **374,** 377, 425
EV, *see* Exposure value
Eye-control autofocusing, 119
Eyecup, 53
Eyeglasses:
  flash photography of subject with,
    194
  focusing and, 53
Eyepiece correction lenses, 53
Eyepiece shutter or blind, 23

f/16 rule of thumb, 90
Fast films, *see* High-speed films
Fast lens, 108, 126, 364
Ferrotype tin, 451, 468
Field of view, lens, 103, 105, **106,**
  107, **107**
Fill flash, 141, **142,** 156, 178–84,
  **179, 193,** 347, 348, 351
  filtered, 192
Fill light, 347, 348, 351, 352–53, **353,**
  **358,** 379
Film, 196–224

airport X-ray checkpoints, 431–33,
  **432**
  for APS cameras, 292–94, **294**
  black-and-white, *see* Black-and-
    white film
  bulk, 7, 212
  cartridge, 212–13, 448
  changing partially exposed rolls of,
    28–30, **29**
    *see also* Mid-roll change
  chromogenic black-and-white, 206
  cold weather and, 423–24
  color, *see* Color negative (print)
    film; Color reversal (slide) film
  consumer/amateur, 198
  copy, 204
  daylight, 200, 201, **201,** 243, 368
  definition, 202–203
  for disc cameras, 213, 300
  duplicating, 204
  DX-coded, 63–65, **64,** 210, 283
  emulsion, 33, 444, 447, 451, 452
  expiration date, 197–98, 429,
    475
  exposure latitude of, 98–99
  fast, *see* Film, high-speed
  film box information, 89–90, **90,**
    196
  graininess of, 203–204
  high-speed, 33–34, 207–209, **208,**
    360–364, **364,** 375
  infrared, *see* Infrared film
  for instant cameras, 301–302,
    301–304, **304,** 305
  loading the camera, *see* Loading the
    camera
  medium-speed, 33, 207
  name brands, 196
  for night and existing-light
    photography, 368
  panchromatic, **197,** 202, 247, 250,
    **250**
  premium, 198
  private label, 196
  processing of, *see* Processing of
    films and prints
  professional, 198
  reciprocity effect, 211, 369
  resolution/resolving power of, 203
  reversal, *see* Black-and-white film,
    reversal (slide); Color reversal
    (slide) film
  shelf life, 197–98, 475
  size of, 4, 5
  sizes, 211–14
  slide, *see* Black-and-white film,

reversal (slide); color reversal
(slide) film
slow-speed, 33–34, 207, 208, 209
special-purpose, 204–207
speed of, *see* Film speeds
storage of, 198, 385–86, 424, 475
store brand, 196
transparency, *see* Black-and-white
film, reversal (slide); Color
reversal (slide) film
traveling and, 428–35, **429, 432**
tungsten, 192, 200–202, **201**
for underwater photography, 408
Film advance control, 116–17, **117**
Film cassette/magazine, 24
Film cassette window, 288
Film chamber, 24
Film cleaner, 485
Film developing, 445–49, **446, 447**
Film frame counter, 26, 28, 288, 299
Film holders, 213
Film leader, 24–27, **24, 25,** 28–30
212
Film leader retriever, 29
Film load indicator, 26
Film loading mark, 24, **24,** 287
Film magazines/backs, 7
Film packets, 213
Film plane, 377
Film plane indicator, 377
Film pressure plate, 28, 32
Film prewind, 26–27, 287–88
Film rewind button, 27, 287
Film rewind crack/knob, 24
Film scanner, 307
Film speed button, 64
Film speed control, 210
Film speed dial, 63
Film speeds, **33,** 33–37, **35,** 207–11
close-ups and, 379
exposure meter setting, *see*
Exposure meters, film speed,
setting
flash guide numbers and, 148–49,
177
flash operating range and, 162
infrared film and, 384
interrelationship of, **35,** 35–36, 208
ISO rating system, 34, **35,** 207,
208, 209–10
manual flash exposures and, 174
range of, 63
shooting with existing light and at
night, 360–64, **364**
traveling, film to take when, 430
Film sprockets, 24

Film take-up spool, 24
Film transport reel, 24
Film view window, 26
Filter adapter, 227
Filter drawer, enlarger, 456, 464
Filter factor, 210, 231–33
Filter holders, camera, 227–28, **228**
enlarger, 456, 464
Filters, 225–55
autofocusing and, 230, **230**
for black-and-white photography
specifically, **247,** 247–51
for black-and-white printing,
456–57
Color compensating (CC), 229, 242,
245–46, 341
for color photography specifically,
241–46
for color printing, 242, 246, 461–62
Contrast, 229, 247–48, 250–51,
341
Conversion, 202, 229, 241,
244–45
Correction, 229, 247, 248, 250
Cross-screen, 251–52, **252**
Dichroic, in an enlarger, 457,
461–62, **462**
Diffraction, 254
Diffusion, **230,** 253, 471, **472**
fill flash, filtered, 192
film speed and, 210
filter factor, 210, 231–33
flash with color filters, 191–92
for fluorescent light, 245–46
general facts about, 226–29
handling, 229
haze, *see* ultraviolet (UV) filter
for infrared films, 384–85, **385**
light-balancing, 202, 229, 241,
243–44, 350
mounting of, 226–28
neutral density (ND), 233, **238,**
238–41, **240,** 379, 494
numbering system, 226, 229
polarizing, 225, 227, 233, **234,**
234–48, **236, 237,** 397
for regular flash photography, 192
safelight, 453
sizes, 226–28
skylight (1A), 132, 234, 397
soft-focus, **230,** 253, 471, **472**
for special effects, 251–55
spot, 253
star, 251–52, **252**
ultraviolet (UV), 20, **20,** 132,
233–34, 397, 425

Filter systems, 228
Fireworks, photographing, 366, **367**
First curtain sync, shutter, 166
Fish-eye lenses, 105, 132
Fish tank photography, 409–11, **410**
Fixed focal length lenses, 107, 283–84
Fixed focus lens, 280
Fixer, film, 444, 449
  photo paper, 445, 450–51, 454, 468
Flare, lens, 19, 111, 132
Flash, 141–95, 357, 361–62, 426–27
  autoflash, *see* Autoflash
  bare-bulb, 160
  batteries, 168–71
  bounce flash, *see* Bounce flash
  built-in, 144–46, **145**
  with close-ups, 192, 379–80, **380**
  with color filters, 191–92
  day and night uses of, 141, 143
  dedicated, 9, 152, **153,** 154–56,
    **156**
  duration of, 151, 175–76
  evolution of, 141
  exposure, *see* Exposure, flash
    exposures
  extension, 167–68, 173, 188–89
  faulty pictures, studying, 476
  fill flash, *see* Fill flash
  flat, 184
  on instant cameras, 302–303, 305
  light output, 147–48, 165, **174,**
    176–77, 181, 379, 390
  macro, 135, 147, 379
  macro lenses and, 134–35
  manual flash:
    exposures, figuring, 173–77
    fill flash, 180–81
  metering, 71, 85, 155–58
  multiple, *see* Multiple flash
  off-camera, 163, **167,** 171–73, 188,
    258, **358**
  on-camera, 184
  open, **189,** 190, 258
  practical considerations, 193–95
  recycle time, 168–70
  red-eye, 146, **163,** 163–64, 287,
    476
  shoe-mount, *see* Shoe-mount flash
  slave, 167–68, 173, 188–89
  stop-action and, 336–37
  studio, **145,** 147
  submersible flash unit, 399
  techniques, useful, 187–93
  through-the-lens (TTL), *see* Flash,
    dedicated
  travel photographs and, 420

  tungsten color slide film and, 192
  types of equipment, 144–47, **145**
  for underwater photography, **404,**
    405–406, **406**
  variable power control, *see* Flash,
    light output
Flash angle of illumination, **148,** 161
Flashbulbs, 141, 143–44
Flash confidence light, 159
Flash cords, 171–73, **172**
Flash coverage, **148,** 161
Flashcube, 143
Flash exposure bracketing, 164
Flash exposure compensation, 164
Flash exposure test, 149
Flash guide numbers, 148–49, 174,
    175
Flash head, **158,** 160, 181
Flash meters, 87, 187–88
Flash mode selector, 155, 174, 180
"Flash needed" signal, 168
Flash-off button, 287
Flash-on button, 287
Flash power, 147–49, *see also* Flash,
    light output
Flash ready light, 159
Flash ring light, 135, 147, 379
Flash sufficient light indicator, 159,
    186
Flash status signals, 159
Flash synchronization, 149–52, **152,**
    189–90, 337
Flash synchronization test, 151–52
Flash test button, 159–60, 186, 190,
    390
Flat flash, 184
Flat lighting, 347
Flipflash, 143, **144**
Floppy disks, instructional, 500
Fluorescent light filters, 245–46
Focal length, **42,** 43, 103, **104,** 105,
    **106,** 107–109, **107**
  and angles of view, 103, 105, **106,**
    **107**
  classification of lenses by, 103,
    105
  f/stops and, **42,** 43
Focal plane shutter, 14, **14,** 37, 150
Focus (focusing), 46–53, **47, 49**
  depth of field in, *see* Depth of field
  in dim light, 50, 120–21
  with compact cameras, 13, 48,
    276–81
  with SLR cameras, 13–14, 49–53,
    114–21
  *see also specific types of lenses,*

*photographic effects and*
*conditions,* e.g.
Focus control switch, 49, 115
Focus detection area, 49, 118, **118**
Focus-free lenses, 48
Focusing frame, 48, **279,** 280, 291
Focusing ring, lens, 11, 49, 50–51,
56–59
Focusing screen, 50, 117
Focusing zones, 279–80
Focus mode selector, 49, 115
Focus priority, autofocus, 115
Fog filter, 253
Framing prints, 480–83
Framing the subject, composition,
**325–26,** 325–26
Freeze focus, 121
Front lighting, 344, 345–46, **346**
f/stops, 36, **40,** 40–46
compact cameras and, 283
depth of field and, *see* Depth of field
enlarger lenses and, 460, 466–67,
468–69
focal length and, **42,** 43
interrelationships of, **41,** 41–43
lens openings indicated by, 40–41
range of, 41
shutters speeds and, **44,** 44–45, **45**
*see also specific photographic*
*conditions and effects,* e.g.
Full-aperture metering, 73
Full-frame fish-eye lenses, 105
Full stop, 43
Fuzzy logic, 95
Fuzzy pictures, 474

Gadget bags, *see* Camera bags
Ghost images, **393,** 393–94
Ghosting, 165–66
Gimmick films, 206–207
Glossary of photographic terms,
506–49
Graded contrast photo papers,
455–57, **456, 457**
Graduated neutral density filter, 241
Graduate, darkroom, 445
Gray-market lenses, 113–14
Grimm, Michele and Tom, 499, **500**
Guide numbers, *see* Flash guide
numbers

Hair light, *see* Accent light
Half stop, 43
Halogen bulbs, 356–57
Hand-held exposure meters, *see*
Exposure meters, hand-held

Handle-mount flash, **145,** 146–47
Hard lighting, 248
Haze filter, *see* Ultraviolet (UV) filter
High-eyepoint viewfinders, 52–53
Highlights, exposure for, 92–100, **93,**
**94, 96, 99**
High-speed films, 33–34, 207–209,
**208,** 360–64, **364,** 378
High-speed sync, shutter, 166
Holding the camera, **21,** 21–23
Hot light, 354–55, **355, 359**
Hot shoe, flash, 146, 153–55
Hot shoe flash socket (PC) adapter,
173
Hyperfocal distance of a lens, 58–59,
**59**
Hypo clearing agent/neutralizer, 449,
455, 468

Image size and focal length of lens,
103, 105
Image stabilization, lens, 22, 112
Incident-light exposure meter
readings, **85, 86,** 86–87
Index print, 294, **294,** 478, 484,
**484**
Infinity, 48, 51, **55,** 56, 58–59, **59,**
131, 279, 280, 298, 302, 395,
411, 413
Infinity lock, 279
In-focus indicator, 49–50, 117–18,
163
Infrared film, 51–52, 204, 251,
383–87
focusing, 51–52, 386
Infrared focus indicator, 51–52, 386
Instamatic camera, 274, 300
Instant cameras, 276, **301,** 301–305,
**304**
Instant-return mirror, 9–12
Instant slide films, 204–206, **205**
Instruction manual, 1, **2,** 32, 100,
291, 426
flash manual, 148, 167, 174–75
technical specifications, 79, 148,
285
Insurance policy, camera, 436
Interchangeable focusing screens, 121
Internal focusing, lens, 112
International Standards Organization
(ISO):
film speeds, *see* Film speeds, ISO
rating system
photo paper speeds, 458–59
Internet, 499–500, **500,** 501
Interval timer, darkroom, 289

Kelvins (K), *see* Color temperature
Keystoning, 132–33, 495
*Kodak Black-and-White Darkroom Dataguide*, 469

Large-format cameras, **6**, 7
Latent image, 33, 444
LCD (liquid crystal display):
  on digital cameras, **308**, 311
  information panel, 17, 37, 61–63, 289
    on flash units, **156**, 157, 158, 175, **175**, 176
Leading lines, in composition, **324**, 324–25
Leading sync, shutter, 166
Leaf shutter, 13–14, **14**, 277–78
Lens adapter, 137
Lens apertures, control of, *see* f/stops
Lens cap, 20
Lens care, 19–20, 132, 422–23
Lens cleaner, photographic, 19
Lens cleaning cloth, microfiber, 19, 229, 427
Lens converters, 127–29, **128**, 375, 377
Lens diaphragms, control of, *see* f/stops
Lens distance scale, 175
Lenses: 102–40
  accessory, 136, 226, 254
  angles of view, 103, 105, **106**, 107, **107**
  classification by focal length, 103
  close-up, 109, 136–39, **138**, 370, 375–77, 425
  depth of field, *see* Depth of field
  enlarger, 460, 466–67, 469
  fast, 108, 126, 364
  fish-eye, 105, 132
  of fixed focal length, 107
  interchangeable, 102–103
  macro, 108–109, **109**, 133–36, **134, 370**, 370–72, **371**, 377, 378, **378**
  mirror telephoto, **128**, 129
  mounting, 114
  normal, 103–104, **104**
  perspective-correction (PC), 133
  projector, 488–89, 496
  quality and cost of, 110–114, **111**
  telephoto, **104**, 104–105, 124–29, **125**, 207
  traveling with, 425–26
  types of, 103–110
  variable focal length, 122–23

close-up, 375–76
wide-angle, **104**, 105, **107, 130**, 130–33
zoom, 107–108, 110, 121–24, **122, 123**, 394, 425, **426**
Lens extender, 127–29, **128**, 375, 377
Lens extension bellows, *see* extension bellows
Lens extension tubes, *see* extension tubes
Lens flare, 19, 111, 132
Lens focusing ring, 13, 49, 50–51, 56–59
Lens hood, 20
Lens mount:
  bayonet, 114
  breech-lock, 114
  screw, 114
Lens openings, control of, *see* f/stops
Lens reversing ring, 135–36, 372–73, **373**, 426
Lens shade, 20, 132
Lens-shutter cameras, *see* Compact cameras
Lens tissue, photographic, 19
Light:
  accent, **353**, 353–54, **354, 358**
  ambient, 164, 344, 360–69
  artificial, 344
  available, *see* Light, ambient
  background, **353**, 354
  color temperature, 201–202, 243–45
  daylight, 200, 344
  existing, *see* Light, ambient
  fill, 347, 348, 351, 352–53, **353, 358**, 379
  fluorescent, 245–46
  main, 352, **353, 358**
  modeling, 357, **358**
  natural, 344
  photoflood, **355**, 355–56, 381
  strobe, 143
  studio, **145**, 147
  tungsten, 200, 354–57, **355, 369**
  umbrella, 187, 352
Light-balancing filters, 202, 229, 241, 243–44, 350
Light box, 493–94, **494**
Lighting: 344–58
  back, 74, **74**, 291, 344, **346, 347, 350**, 351–52, 379
  bounce, **158**, 160, 163, 184–87, **185**, 193, 194, 352
  cross, 347, 354
  diffused, 348, **349**